WORLD SNOWBOARD GUIDE 11th edition -

CONTENTS

	ODDOORSON TO THE
Intro & the team	3
Pre-holiday	5
On-holiday	7
Road trips	11
Linked areas	13
Learn to snowboard	15
Backcountry guide	19
CAT boarding	26
Heli-boarding	28
Summer glacier guide	36
Snowboard test	50
Doing a season	66
Resort reviews intro	68

WEST	ERN EUROPE	69
	Andorra	70
	Austria	77
	Belgium	271
	England & Wales	119
	Finland	122
	France	128
	Germany	171
	Greece	179
	Holland	271
	Iceland	180
	Italy	181
	Liechtenstein	271
	Norway	208
	Portugal	220
	Scotland	221
	Spain	227
	Sweden	234
	C	240

EASTERN E

Ukraine **NORTH AMERICA**

Canada

Belgium	271	
England & Wales	119	
Finland	122	
France	128	
Germany	171	
Greece	179	
Holland	271	A
Iceland	180	
Italy	181	
Liechtenstein	271	
Norway	208	A
Portugal	220	
Scotland	221	
Spain	227	
Sweden	234	
Switzerland	240	
N EUROPE	272	
Bosnia Herzegovina	294	
Bulgaria	273	
Croatia	294	
Czech Republic	278	
Kosovo	279	A
Latvia	280	
Macedonia	281	
Poland	282	
Romania	294	
Slovakia	286	
Slovenia	290	
Ukraine	295	

297 337

SOUTH AMERICA	432
Argentina	433
Bolivia	444
Chile	439
Mexico	444
Peru	444
Puerto Rico	444
Venezuela	444

AUSTRALASIA	445
Australia	446
New Zealand	452

CICA & MIDDLE EAST	4/1
Algeria	479
Cyprus	472
India	485
Iran	473
Israel	479
Lebanon	475
Morocco	476
South Africa	479
Turkev	477

United Arab Emerates 478

ASIA		480
	Armenia	508
	China	481
	Georgia	508
	Japan	486
	Kazakhstan	508
	Kyrgszstan	509
	Nepal	509
	Pakistan	509
	Russia	495
	Taiwan	509

WORLD SNOWBOARD GUIDE

It's been a long journey, with many miles of pistes descended, thousands of miles of motorways and dirt tracks driven, with new contributions from many different nationalities, from many different continents, hours on computers, and not to mention the litres of beer drunk, but we've got there. The 11th edition of the World Snowboard Guide covers more countries and more resorts than ever before, having been fully redesigned and printed in full colour. It's stuffed full of reviews, articles, and informative tips.

This is the first edition without a year in the title and we'll now be releasing a new edition of the guide every other year.

Using your unique membership code in the back of the book, you can access updated content via our website www.worldsnowboardguide.com

If you feel you've got something to say about snowboarding, then why not get involved with things here. Whether you want to join our writing team, or tell us a great bar you went to, we want to hear from you so please get in touch with us.

Have fun boarding.

Steve, Pete and the team.

>> WRITERS & CONTRIBUTORS

STEVE DOWLE

This will be his 3rd edition of the guide after taking over from Tony Brown in classic Victor Kiam style. A late snowboard bloomer, he experienced a moment of clarity in Lake Tahoe in 2000 and has since snowboarded in 12 countries

PETE COOMBS

Pete has been snowboarding for over a decade and has been an instructor for most of that time. When he's not working for WSG he's either leading adventure tours (he once climbed Kilimanjaro 9 times in one summer) or he's travelling. Recent trips have include climbing Cotopaxi and hiking around Greenland. He's also a freelance travel writer/photographer and works with inner city kids

REEN WEST

Reen is from Vienna but gets pulled over to Innsbruck every winter to ride as much as he can. He rarely goes down a piste and gets the first and the last ride with the lift. He's a professional photographer and after 16 years of riding he still can't think of a better way of making a living but the hardest decision is whether to take the camera with him or just his powdergun.

TIM WILKINSON

Tim's definitely a skibum! He's up to 18 winter seasons...16 of which have been back to back winters! Tim has worked in Switzerland, British Columbia, Alberta, Utah, Colorado, Australia and New Zealand and has boarded at 106 resorts in 8 countries!! Although having worked many winters and some as a Canadian Level 2 Snowboard Instructor, he'll be the first to admit that he's not the best rider out there! Tim currently works for the Fernie Winter Sports School and in the Southern Hemisphere winter he is a Marketing Coordinator for Mt Ruapehu, New Zealand's largest ski areas.

SAM BALDWIN

Sam hails from Shropshire, England, but recently spent two years in Japan, enjoying the sake, sumo and the sick snowboarding on offer there. He is the founder of www.

If you plan to rent snowboard equipment, it may be better to hire in-resort than before you go. That way you only pay for the days you use the equipment, and it gives you the freedom to change the board and boots if they are not right. Don't settle for substandard kit, things are much better than they used to be and most resorts will have a snow-board specialist.

A positive side to hiring before you leave is there maybe a wider choice and if you wanted a specific brand or size you should be able to reserve it. The main things to check are that the base and edges are in good condition, and that the bindings are set up for you, not just screwed on any old way, and make sure there's no excessive boot overhang.

As more kids take up snowboarding the rental equipment for little people has improved. A good store should have genuine children's kit. It's a good idea to hire kids a safety helmet and wrist-guards, as you don't want to spend your time down the valley with little Billy while he gets put back together.

Shine a torch into the ear of a boarder without insurance and sure enough there'll be light coming out the other side. Only a fool would hit the slopes without good insurance. The main things to check, in the small print of your policy, are that it states.

SNOWBOARDING

- **OFF PISTE** (you don't want to be crawling back to the piste with a busted leg)
- PERSONAL INJURY including repatriation.
- PERSONAL BELONGINGS including your board
- CURTAILMENTS, cancellation of flights etc

If hiring kit make sure it's insured on your policy or covered by the hire shop.

It's possible to get insurance with your lift pass in some countries but this will normally only cover getting you off the slopes and to the hospital.

All EU nationals (Inc UK) can get the free **European Health Insurance Card** which has replaced the old E111, pick up the form from the post office. This is no replacement for insurance but makes sure you're covered for medical care and not charged, and is valid across all member states.

If you have an annual policy, which has a limited amount of time snowboarding, they will want to see proof of dates you travelled, so don't think you can get away with doing a season on a 20 day policy.

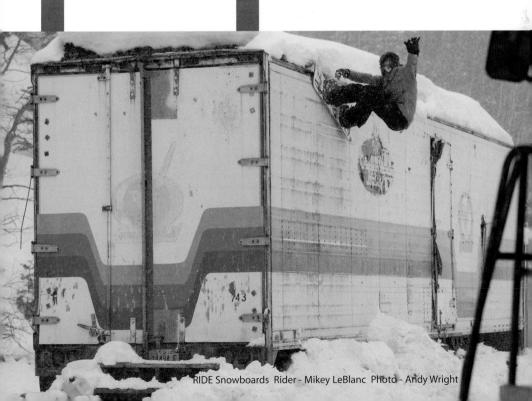

on.holiday

LIFT PASSES

Most resorts offer a range of lift passes which can usually be bought on a daily or multipleday basis. Riders staying for a few months can buy a season pass, and although expensive you'll make a massive saving in the long run. You may have the choice of one resort or an interlinked area so think about what you'll likely do before handing over the cash. Sometimes with a weeks or seasons pass, you may get a free day in a nearby affiliated resort; ask at the office when you buy your pass. Discounted passes are available for kids, old age pensioners, locals and sometimes students. You'll also find prices changes during the season; at low season you can pay around 25% less. Resorts have their own polices on reimbursement if lifts are shut.

KEEPING YOUR KIT SAFE

At least once when you go boarding you'll hear the story that a van turned up at the resort and nicked a load of boards from outside a bar. Make sure you look after your board, and that your insurance policy covers the full value of it. It's worth spending a tenner on buying a board lock, it'll ensure your boards still there when you stumble back to the bar you started drinking in 8 hours before. If you do get anything stolen then contact the police, you probably won't get it back, but it will help with your claim.

Lift Chairs, Zoë Webber Opposite: Batman & Robin caught by J.Mitchel, Jaegermeister by Tony F

8. U.S.C. WINNEW ORLUSTON ... S. GUIDE.COM

To get the most out of any snowboard trip you should have a reasonable level of fitness. You need not be an Olympic athlete but to avoid feeling like you've been hit by a truck do some exercise before reaching the slopes. In resort the best things to do each day to prevent injury is to do a warm up before that first run, even if it's just a few stretches, warm muscles won't tear as easily as when they are cold.

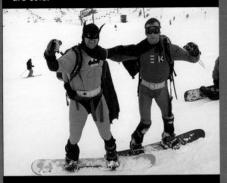

Just because a resort has hotels and chair lifts don't let it fool you, it's still a mountain and should be treated with respect. There's less oxygen at altitude and you'll find yourself puffing even on a short up hill walk. Add that to the 15 pints of beer you drank the night before, the cold air, and suddenly dehydration is a real issue, so drink plenty of water. The sun is really strong in the mountains and reflects off the snow, making your face redder than pie eating football fan's beer belly in Benidorm. Get 100%UV approved goggles and sunglasses, wear high factor sun screen and remember to reapply.

Don't dress just to look fly, make sure you're wearing the right kit. Outer layers should be water and wind proof and if possible breathable. The best way to stay warm is to wear layers rather than one huge jumper. The air is trapped between the layers and warmed from your body heat. You can buy technical tops, to wear next to your skin, which are designed to be fast drying and whip the sweat away. If you sweat in cotton it stays wet.

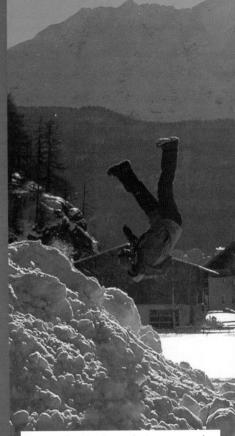

There's often loads to do in resorts other than boarding. Some resorts offer ice-climbing, snowmobiling, paragliding, some even offer tandem freefall parachute jumps. Lots of resorts will have indoor sports facilities like swimming pools, ice rinks, bowling alleys and gyms. Most importantly all will have pubs, bars, night clubs and restaurants. It shouldn't take long to find the best places to hang out, just ask a local to point you in the right direction. Try to stay away from the humourless hat wearing skiers bars that play euro pop and sell cocktails with stupid names.

Snowboarding is there for you to enjoy Party Hard but Ride Harder.

Easy Rider

Alamo is WSG's car hire partner, and with locations throughout the world and a great choice of cars, we've got it covered.

Our inclusive rates are designed for ease and peace of mind, with all the protection you need – and quick and efficient service to send you on your way.

So just relax and enjoy the ride.

call **0870 191 6938** quoting **WSG** click **worldsnowboardguide.com/alamo**

ROADTRIPS

Ten resorts, eight terrain parks, nine hotel rooms, 2000 km driven, and a broken car stereo, what does a road trip mean to you?

Budget flights and the invention of the internet have given riders the freedom to throw that overpriced brochure, with pictures of Camilla and Tarquin in matching ski suits in the bin and plan a snowboarding road trip. You can follow the snow, change your terrain, take a day off in a city down the valley, change country, pick up a mad snowboarding hitchhiker, and in general do whatever you like.

When planning a road trip there are a few things you should bear in mind. Firstly the length of time you want to board against driving and secondly if you want to set an itinerary or just free form the trip.

Risoul & Vars.

In Italy the Aosta Valley, just north west of Milan or north of Turin, is home to: Pila, La Thuile, Champoluc, Courmayeur and Cervinia, which is linked on the piste to Zermatt in Switzerland. This is all great but then when you throw into the mix the Chamonix and Grand St Bernard Tunnels which link Italy to France and Switzerland respectfully, well that's 20 to 30 great resorts all within a few hours drive of each other. Plan a route carefully and you could easily visit ten resorts, and three countries, within a two week trip. Even without missing any slope and little drinking time by driving through the night or for hours on end. But remember when sitting at home looking at a map of Europe that many of the high mountain pass's will be shut in the winter so before having to negotiate a

Choosing Resorts and Routes

In Europe it's not such an issue as it is in North America. Many of the Western European resorts are close to each other. For example in France; Couchevel, Val'd'Isere and Chamonix are all within a couple of hours drive of each other. While La Plange, les Arc, St Foy, Tignes and Val'd'Isere are all less than an hours drive from Bourg-St-Maurice, which is a snowtrain ride from London or a two to three hour drive from Lyon.

From the huge Alpe D'huez you have high the altitude resort of Les Deux Alps within a 45 minute twisty drive. This is semi-joined to the hardcore freeriding mecca of La Grave, which itself is a 30 minute drive to Serre Chevalier which has some of the best tree riding in France. From there you could head into Italy within 30 minutes via the resort of Montgenevre, or within an hour the cool resorts of

huge detour seek out some local knowledge.

In Austria Innsbruck is king. It's a lively place with plenty of partying, and although not actually a resort itself, it is flanked both sides by 8 small but great resorts. Then within 2hrs you have Hintertus, Mayrhofen, Zell am Ziller, Solden and the German resort of Garmisch within striking distance. Add to that the not out of the question resorts of the Italian Dolomites and Innsbruck is a great stating point for any road trip.

North America is a whole different ball game, or should we just say soccer instead of football? The food portions are big, the cars even bigger and the distance between resorts even bigger than that. But, and it's a big but, outside of the Ray Ban wearing police, and the ridiculously low speed limits, driving in North America is a dream, well outside of the cities

anyway. The roads are wide and traffic free. A distance that would have you gripping the steering wheel like it was the only beer left in the world and proclaiming the illegitimacy of you fellow drivers parentage, will just pass you by like a stress free stroll in a flower filled park. You won't even have to change gear, as virtually all the motors are automatic.

West coast in Canada is Whistler country in British Columbia, which is one of the only resorts in WSG with a straight ten out of ten, but it's not the best with a straight ten out of ten, but it's not the best for road trips as most of the best BC resorts are away from the coast. If it's a Canadian road trip you want then fly to Calgary Alberta, from where with some long drives, you can visit the Banff resorts of Sunshine, Mt Norquay and Lake Louise before looping around the great resorts of Fernie, Castle, Pod Bin White Silver Star and Kicking Horse. Red, Big White, Silver Star and Kicking Horse.

In the US, fly to the old style casino town of Reno in Nevada and you can tour the excellent Tahoe resorts a short distance away. Head south for 4 hours to Mammoth, another resort with a WSG 10. You could complete your trip if you've got a one-way hire by driving South again for another 6 hours until you hit Las Vegas, where you can have a final couple of runs and squeeze that last bit out of your credit card before flying out.

Denver's great to start a road trip with loop around Breckenridge, Vail, Aspen, Copper Mountain, and Beaver Creek possible, all these resorts get a WSG 8 ccor above.

If it's **east coast** then fly to Boston and tour the New England states of Vermont, Maine and New Hampshire where you can visit Stowe, Stratton, Loon Mountain and Sugar Loaf to name a few.

Accommodation

If you do plan a route in advance and you plan to If you do plan a route in advance and you plan to stick to it, then try and sort out as much accommodation as possible before you head out. This will stop you arriving somewhere late at night and finding the only bed left in resort is way over your budget. The obvious down side to booking accommodation is the lack of freedom you'll have. You may find yourself leaving a resort just as the snow is starting to fall and driving towards an ice ridden resort, because that's where you bed for night is. It's a trade off and we'd recommend you give yourself as much freedom as your budget will allow.

Routes

Don't try to do too much. After boarding hard all day it's ok to throw the boards in the motor, change your shoes, and drive three four hours, in your wet board gear, to the next resort, but not every day. Firstly you'll never have time for a beer and secondly you'll find after a few days like this you're boarding will suffer, especially if you're the only driver and all your mates sleep through the driving hours. Try to spend at least two days in each resort, one to make sure you see the best bits and two to give the driver a break and let them have a beer or two. Talk to locals to find out if roads are open and which is the best route between resorts. Always have chains, or you may find that you can't get up to resort when there's a fresh snow fall. If you're hiring a car, ideally make sure your hire car is fitted with winter tyres; these are wider grooved and give you much better grip. They are a legal requirement in winter in Austria, but if you're hiring a car in Germany and driving into Austria make sure it's been arranged before you get there. Don't try to do too much. After boarding hard all day

Try to design a looped route, so you don't have to back track, and always try to make the last resort visited the closest to the airport, if you're flying home. If you're miles from the airport you don't want to be leaving early if there's been a fresh dump and the roads are slow going.

Can't Drive

No motor can be a hassle, but it doesn't mean you can't tour resorts. Most resorts will have a bus link to major cities, but few have a good public transport link to other resorts. But if you have the time there's always a way to get between resorts. Many airports will be close to a train link and many of the European resorts are very close to stations. Chamonis Town has a station, buses go to La Plange, les Arc, St Foy, Tignes and Val'd'Isere from Bourg-St-Maurice. Trains and bus's out of Innsbruck service all the surrounding resorts. It's easy to get a train or a bus out of Geneva to the surrounding mountains and the public transport in Italy is surprisingly efficient and cheap. Slovakia has a good rail service, which is supported locally by buses, while taxis here and in Slovenia are very affordable and a great option especially if there's a few of you.

! Tuked Areas

European resorts have been linking up with their neighbors to try and claim to be the biggest and best in the world. This has lead to small little villages joining up with massive resorts and giving visitors access to hundreds of KM of pistes, Orelle in Les 3 Vallees for example. This can save you money when searching out cheap accommodation. Within our quide we've broken down linked areas into individual resort reviews, which explain their part in a linked area, so below is some information on the major linked European areas, whose resorts are covered in more depth individually within the guide. These linked areas often sell resort specific lift passes, so before you buy a more expensive pass for a large area make sure you're going to use it. You can often buy individual daily upgrades which can work out better value if you're only leaving your base resort once or twice within a week. You may also find yourself boarding from one country to another, and yes you should carry your passport with you. In the Portes Du Soleil you could see Swiss customs officers giving chase to a suspected drug runner on skis. I'm not winding you up, I've seen people have their back pack searched so leave the weed in the hotel. If you're into getting up early and covering a large area then linked areas are for you. If you're the type of boarder who gets up late and spends all day in the park or are learning, save yourself a few quid and pick a resort with a cheaper lift pass

FRANCE

Which is a popular haunt with the Brits is Courchevel, Meribel, and Val Thorens but also incorporates La Tania, Les Menuires, St Martin de Belleville, Orelle (which is a link from the once non visited fourth valley, into Val Thorens) and if some tour operators are to be believed Brides-les-Bains which is a 30min bubble ride to Meribel's base. All of these resorts make up a total of 600 km of pistes.

Without a doubt Les 3 Vallees has something for everyone; an incredibly well connected and modern lift and piste system, great accessible offpiste, plenty of bars and hotels. The main draw back is it's bloody expensive and the terrain parks are not the best by a long way, but with that much terrain the natural hits easily make up for it.

Is a huge area with fourteen resorts linked by one pass in France and Switzerland, Avoriaz and Morzine sit in the middle of a

sprawling mass of resorts which vary hugely in appeal and aesthetics. Châtel, Morgins, Champéry, and Les Gets make up the best of the rest. The Portes Du Soleil is 650 km of piste, but unlike Les 3 Vallees, the pistes aren't interlinked into a compact area they are more spread out into a huge arch and suit the boarder who likes to get a load of miles boarded in a day. The mountains aren't the highest around, little over 2200 m, but the resorts benefit from the snow created by it position next to Lake Geneva.

L'ESPACE KILLY

This area is made up of Val d'Isere and Tignes, both resorts are above Bourg St Maurice which is easily reached with the snow train from London. They are two of Frances best resorts, both have great infrastructure, fantastic pistes, good terrain parks and great off piste. L'Espace Killy is covered by one pass, it's possible to buy a single resort pass for Tignes but pointless unless you're a beginner, Holiday makers who buy a weeks pass in the Les 3 Vallees get a free day in this area and if you have a car it's well worth the day trip. Also a short drive down the road is St Foy, one of Frances best kept secrets.

AUSTRIA SKI WELT

If you're into getting of miles pistes covered in a day or a beginner who wants to get some easy terrain under your belt, then the SkiWelt is for you. Most of this area is really a long

line of low level mountains or high hills. The main resorts are Soll, Ellmau/Scheffu, and Westendorf, but also include Hopfgarten and Going. The total area has 250 km of piste and there are a few parks, but the only one of note is in Westendorf which is without a doubt the gem of the whole area, with good off piste and by far the best and most varried terrain.

The Ski Welt is surrounded by more traditional steep

Luked Areas

rocky alpine mountains, but virtually all the developed slopes here are rolling low level pistes, which often rely on fake snow. This is not a place to get the heart thumping of an advanced rider but it's perfect for the beginner or early intermediate.

ITALYDOLOMITE SUPER SKI

Not actually linked in the way of other areas, the Dolomite Super Ski has one lift pass which covers 12 valleys within the Dolomite area. Cortina, Val Gardena, are the best known resorts. The area of Dolomite Super Ski has over 1200 kmof piste and over 400 lifts. This massive area is only achievable with the aid of a car and a lot of time. The area also boasts a good Heliboarding operation to keep the rich, advanced rider happy. If you're into good food and touring small resorts, with the aid of a motor, then the Dolomites are for you.

MONTEROSA SKI

Is the Italians answer to Les 3 Vallees in France. While being much smaller in pisted area (180km) it does cover 3 valleys and as such has heaps of off piste and is home to some of Italy's best Heliboarding. Gressoney, Champoluc and Alagna make up villages for this area and all retain an old style alpine charm. The resorts are at the beginning of the Aosta valley and within easy reach of Milan and Turin. With a top area of almost 3300 meters the area is snow sure, and is a top place to visit for any intermediate and advanced freerider. Night life can be a little dull so you'll have to make your own party.

This area spans Italy and France, and is also known as the Milky Way. It is made up of Sestriere, Sauze d'Oulx, Sansicario, Cesana, Claviere and Montgenevre. Many of these resorts played host to most of the Skiing events at the Torino 2006 Olympics and are close to the resort of Bardonecchia which hosted all the snowboarding. In total there's over 400km of lift linked terrain.

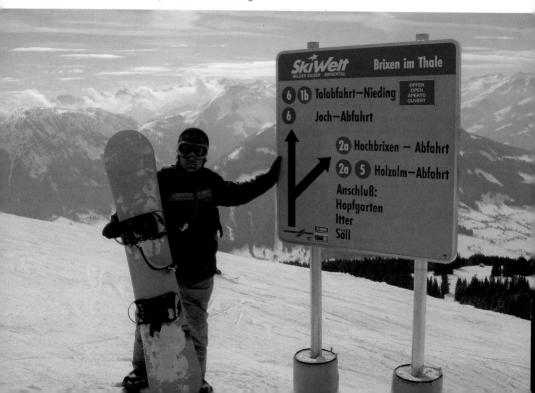

RTM are the first all British board instruction operation in Europe. Based in Courchevel and with hundreds of British boarders sliding away as satisfied customers, we at WSG thought it a good place to seek some advice on lessons.

So, you're heading off snowboarding. May be you've never done it before or perhaps you can rip up the slopes. So why take lessons?

For first timers it's pretty obvious why you need a lesson. You haven't got a clue how to do it but for intermediates or advanced boarders it might not be so clear. In reality a lesson for the intermediate is highly beneficial as it could be the difference from taking on steep terrain with confidence, stomping landings or riding off piste with ease.

Some people hear how easy it is to snowboard, and think "it can't be too hard, can it?" Maybe you've skied before and think it's the same thing. After all, it's all about sliding down a slope, isn't it?

It can be easy to pick up, especially if there is good

snow and no ice. There are other factors to also consider like how sporty you are, and whether you have done any other board sports (skating, wake-boarding, surfing, kitesurfing or windsurfing), which all rely on balance. Even if you have all these skills, you still need to know how to actually make a snow-board turn and how to control your speed and most importantly: stop.

Anybody can learn to snowboard. How well you pick it up depends to some extent on the above but also on your motivation for being there, your attitude and how good your instructor is.

The classic beginner's lessons are in a group and normally run for a week. These should get you to the point where you are happy riding down green, possibly blue, or even red runs. Group lessons provide the best value for money but you are sharing that instructor's time with everyone else in the group so you don't always get their full attention.

If you are finding it hard to keep balance, for example,

while others in the group are moving along by themselves it can feel frustrating. Don't get too disheartened. Everyone learns at different rates and at some point it will 'click'. An alternative is to take a private lesson, where you have the full attention of the instructor. You'll get the hands-on help needed to get you through these difficult stages but of course this will cost more cash.

Questions you need to ask yourself before booking are: Are you looking forward to the experience? Are you of a sporty disposition? Do you have good balance? Do you have a get up and go attitude? If the answers are 'yes', then group lessons should work well.

If you feel nervous and apprehensive, are you just doing this to please a friend, aren't really sport, or don't think your balance is too great, then maybe private lessons would be more beneficial. That is not to say that you won't learn in a group but this private lesson would give you the best possible chance for success.

What to expect in those first few days

To start with, your instructor should give you a lot of help, both technically and with encouragement. It is true that you will fall over a lot but lessons will minimise this. It is normally during the time away from the instructor when you fall more. Many past beginners will tell you they felt like they had been run over. To help get around this think about protecting yourself. Impact shorts are especially padded to help reduce the pain of falls on the derriere and aren't too expensive. Cheaper alternatives are a rolled up hand towel stuffed down the trousers, a piece of foam or even a cushion / pillow. Just remember to take it out when you're having that post boarding pint in the bar. Knee pads and wrist quards can also help. Nowadays more people, especially kids, are wearing helmets too and they can be hired from most rental shops.

Getting the right equipment

The correct equipment and set-up tailored for you will also aid the learning process. Many hire shops will try to palm you off with any size of board and binding position, so hire your kit from a snowboard specialist.

Boots

Boots must fit your feet! Your heels shouldn't lift inside the boot. If they do, the boots are either not laced up properly, are too big or are the wrong width for your foot shape. People who've skied before will find more movement than in a pair of ski boots. That is normal and part of the joy of boarding! Try boots on that are your actual shoe size or even try a half size smaller. Do not take boots a size bigger because your snowboard socks are thicker - they are not that thick!

When lacing them up make sure all of your trousers are out of the boots. The inner snow gaiter should be outside the boot as well as the outer section of the trousers. If not then you may get pressure points on your legs along with snow melting down your leg into the boot.

Bindings

Just as important are bindings. Your booted foot should be held snugly in the binding and there should be no heel lift of the boot. Make sure you can do up the bindings with ease, ensuring they fit right over the boots. Quite often rental bindings need

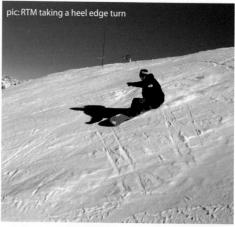

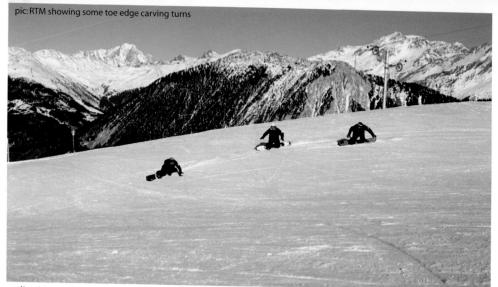

adjusting to fit smaller or larger feet, so get them to do this in the hire shop. It's a right pain to realise your kit doesn't fit when you're standing on the top of a mountain.

For all levels of rider the traditional strap binding system is still the best. For beginners they allow you to bend at the ankle joint easily when

doing manoeuvres on the toe edge. Other systems can block this movement. You will also feel more from the board so movements you are making to try to turn the board actually have an effect, rather than the foot moving and the board not.

Stances

The correct angles and stance width for the bindings are equally important. Everyone is different, so their set up needs to be individually tailored. If set incorrectly movements made by the body will feel hindered and uncomfortable, thus reducing the effectiveness of your riding. Seek advice in the hire shop if you think this is happening.

Board

Choosing the right board is also important. Decide what kind of riding you are going to be doing and be honest about your ability and body weight. All boards have a weight range which you should fall in to. At the lower end of the scale the board may feel stiffer when riding and softer if you are at the higher end of the scale. For example, the same board ridden by a 9 stone person will feel stiffer compared to someone of the same riding ability weighing 13 stones.

If you are a strong rider who likes to ride fast, the stiffer board will aid edge grip and will not bend as much as a softer board (which has a higher chance of losing edge grip). If you want to do a lot of freestyle then use a board designed for this purpose, and once again look at the weight range. Freestyle boards are shorter than freeride boards. Also, look at the width of the board.

Feet

Your feet when booted up should be centred so the toes and heels are just over the edge. If not, then it's too wide. If your feet hang well over the edges then it's too narrow, so look for a board that is wider or see if a riser plate underneath the bindings will reduce toe and heel drag while riding.

So you arrive, fully armoured up, feeling like an extra from some Sci-Fi film for the first lesson. Now you will learn how to stand correctly on the board, how to control your speed, how to change direction and maybe even how to link turns down the slope. Gradually, through the week you start to move away

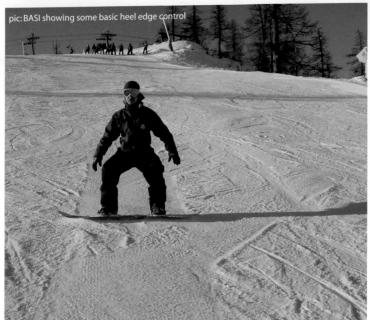

you will never develop these skills properly without a lesson.

You may also want to look at the changes needed to ride off piste, in powder or chopped up snow. These skills will enable you to get away from the crowds and truly explore the mountains. Those of you looking for the perfect holiday photo may want to try freestyle. Learning how to make those first grabs and hold them for longer, how to start spinning, or get air out of a pipe or do rails will vary your whole outlook. Of course you can try and work it out for yourself but with guidance it is often an easier, quicker and less painful process.

Another alternative for freestylers is to book into a specialist camp (see Summer Boarding). A lot

of these have pro-riders on hand to help with the coaching. Their competition background provides a massive repertoire of tricks for you to aim towards. These camps are often run in the summer months so allow you to keep getting your snowboard fix and reduce the wait for next season's first snowfall.

If you do decide to have lessons please do a little homework. Check out the different schools in the resort, see what they have to offer and try and get some recommendations.

Get out on the mountain and take the falls with the good turns. If you're not falling you're not trying hard enough! Most of all - enjoy it. The RTM team.

from the beginner's slope onto easy greens whilst developing your turns, speed and control. As you get more proficient, you learn to deal with the steeper blue runs. By the end of the week you'll hopefully be happy cruising around the same slopes that initially felt intimidating and taking in the scenery from the chairlifts, rather than feeling knackered and worrying about the next run down. You are now a snow-boarder.

Yeh but, I can board already

For those of you who can already ride around the mountain the question often asked is "why do I need lessons? I can do it".

Well, do you want to feel more relaxed and in control riding steep slopes? Can you carve? Do you want to learn techniques for riding off-piste? What about learning some tricks in the park or how to ride a pipe? Lessons are still going to help you achieve these goals.

When choosing a group be honest about your ability: what pistes are you turning on? Green, blue, red or black? Doing falling leaf (swinging side to side when coming down a slope on one edge) is not turning! Also, your confidence when coming down these slopes is important. Being a little slow or nervous on the decent can alter which group you should aim to join.

Once signed up, things to expect in the lesson are: working on improving edge grip to reducing skidding in a turn which works towards carve turns on easier slopes and control speed on steep slopes. Other techniques covered are how to improve the steering of the board on steeps, and how to develop the techniques originally learnt to ride confidently down harder pistes. If you only do one week a year

Photo credits. top, left, first page by PaulColeman © BASI page2 top by Patrick Leclerc © Oxbow Avoriaz, bottom left © Obergural Resort. All other photos © RTM

FOIDE

KCOUNTR

Back in those dark days before snowboarding, when people were thinking of new ways to descend a slope it wasn't the green run to the café or a 540 they had in mind. It was flying through a wide open powder field at full speed sending a plume of light fluffy snow skywards in their wake. That's what snowboards were made for and anyone who's had the joy of doing it will tell you there's nothing else like it. Those first turns in virgin snow will have you screaming with joy and boring your mates rotten in the bar for days.

Compact mountaineering tent by Black Diamond, Ride boots (UK size 10) www.ridesnowboards.com

Like any extreme sport there's a cost and with Back Country/ Off-piste it can be high. People die every year in avalanches boarding Back Country. 90% of people who are caught in an avalanche either set it off themselves someone in their party does.

Prior Preparation Prevents Piss Pore Performance. Before you think of heading Back Country there is knowledge and equipment you must have. Read any information on avalanches and Back Country travel you can get your hands on, watch videos, look at the web and don't skimp on equipment. If you have a transceiver and no shovel all you can do is find where you should be digging. Over 90% of people buried in an avalanche survive if dug out within 15 minutes, however digging in avalanche debris with the end of your board just doesn't work. Pack your rucksack for all eventualities. Remember the weather in the mountains can change fast: just because you started the day in sunshine doesn't mean that you won't end it stuck in a white out. Always be prepared to stay over night.

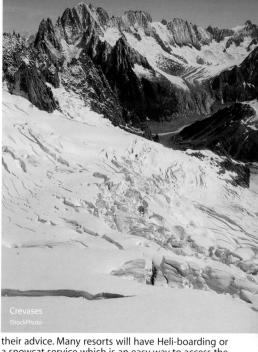

a snowcat service which is an easy way to access the Back Country and most commercially run trips will include a local guide in the price.

GENERAL ITEMS

Over-boots & Gaiters Clothing layers Spare torch batteries Mobile 'phone & batteries Collapsible poles Snowprobe poles Board tune-up kit Spare binding screws Spare binding parts 10m of avalanche cord

FOR ICE & GLACIERS • Snowshoes (forget split-Crampons & Ice axe Safety helmet Carabiners, Rope/Harness

NIGHTWISE Tent & Sleeping bag Stove & Cooking utensils

MUST HAVE ITEMS

- Avalanche Transceiver
- Maps & Compass
- Shovel
- . Slope inclinometer First-aid kit
- Whistle & Torch
- Emergency survival food and water
- Probing poles Survival sack, blanket or
- light- weight tent
- boards)
- · A Complete set of spare thermal clothing
- Hat & face Protection
- Goggles and glasses
- · Multi-use pocketknife

There is advice out there, so seek it out and take note. Avalanche Risk Warnings are always posted in resorts and often there's an advice line you can call for information on the weather and snow conditions. The resort mountain staff will know the mountain well - local inside knowledge is invaluable. Check if there are any Back Country tours available, take a local registered guide or if you can't afford one at least ask

INSURANCE

Never go back county alone or without adequate Insurance! Check the small print to make sure it states "Back Country" or "Off Piste". If you break a leg and need airlifting you're going to be paying for it for a long time if your insurance doesn't cover it.

If you are going on a pre-organised trip with a specialist snowboard or ski organisation, check their insurance cover. Find out if their instructors and guides are properly qualified with a recognised certificate and have public liability insurance.

BACKCOUNTRY LAW

In Europe you are warned not to ride outside restricted areas. However, you seldom are stopped and in many cases it is not actually illegal, although some areas are National Parks and therefore protected. If you get caught in these you could

SNOWSHOF Makes lighter work of hiking, by MSR contact www.msrcorp.com for more details

get a fine of up to 3000 Euros. In France if you set off an avalanche which ends up killing someone on the piste below you'll be charged with manslaughter.

In the US and Canada, riding in marked-off areas is simply not tolerated. The patrols are extremely strict about riding 'out-of-bounds' and apart from getting yourself kicked off the slopes, you could also face police charges.

ACCESS

Back Country Terrain can sometimes be accessed straight off a lift or you may have to hike to it. Both should be treated with the same respect. Just because you hopped off a piste doesn't make it safe. Choosing the size of your party and who's in it is very important.

When hiking, four is a good size for a group as it's easy to monitor each other and if someone has an accident one can stay with the casualty and the other two can go for help. All members of the party must be competent riders, be trusted to keep cool and help if it all goes belly up and most importantly have the correct equipment and know how to use it.

It's also important to have an experienced party leader. Decisions on route finding and if you should turn back or change the objective should fall to one person. Never split the party unless you need to send for help.

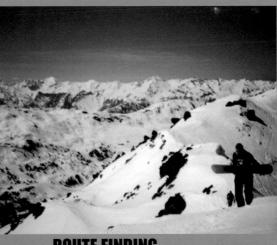

ROUTE FINDING

Route Finding is vital to safe travel in Back Country. Always listen and watch the mountain for activity and try to avoid narrow valleys or gullies as they can channel avalanches. Note the profile of the slopes: Are they straight, convex or concave? How steep is the area and what features exist? Gullies, bowls or ridges? Do you know what landscape lies under the snow? Grass, bushes, rocks or trees?

Avoid travelling along routes after heavy snowfalls where you can see previous avalanche activity, such as damaged trees, snow cookies or dirty snow slopes. If possible, always travel high and stay above large stashes of snow. If walking along a corniced ridge stay to the windward side as the cornice edge may well be unstable and could fracture with your extra weight.

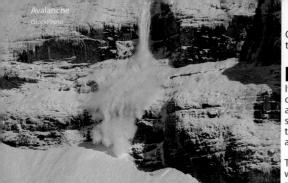

Descending or crossing a face should be done one at a time so as not to overload the slope. You should always try to enter a slope or snow stash at its top because if you enter the middle and it slides, all the snow from above could come down on you. When choosing your line down try to keep it narrow, don't cut across the whole slope as if there is a trigger point you're much more likely to find it by traversing across the whole thing.

Once you've got to the bottom move to a safe place to watch your friends descend. If they set off a slide and you're standing in its path you are in trouble. Never, ever, cut across a slope if someone is on it below you. If you do then you deserve the smack in the mouth you're likely to get.

Once your friend has descended safely, take a line next to theirs. Avoid jumping on a suspect slope as the extra weight from the landing could trigger a slide.

AVALANCHES

Avalanches are the biggest killer of back country boarders. If you don't know about the power of avalanches then you shouldn't even start to think about going Off Piste.

The 12 people who died in their chalets on 9th February 1999 in the Montroc Avalanche in Chamonix, France probably felt safe. That was until 300,000 cubic meters of snow travelling at 60miles/hr destroyed 14 buildings. If buildings can be flattened think what it could do to you.

As a guide slopes less than 30 degrees aren't steep enough to slide and slopes over 60 degrees normally can't hold enough snow to slide. 38 is the magic number. Slopes of 38 degrees are the most likely to slide. Can you tell the difference between a safe slope of 30 and a potentially dangerous one of 38? No! So get a slope inclinometer a handy little piece of kit for measuring slope angles.

Snow pits are the best way to assess the slope's stability. Learn how to dig one and how to read the snow pack. Look for indicator slopes: a slope of similar angle and position to the sun as the one you're thinking of descending. If it has avalanche debris on then it's highly likely your's will slide too. Rain on fresh snow leads to a high avalanche risk, as does high wind and severe temperature change.

Get as much information as you can, piece it all together and make a decision.

RESCUE

If you get caught in an avalanche try to board out of its side. Try to grab at a grounded object such as a tree. If you get knocked over, 'swim' with the slide trying to stay near its surface. When you feel the slide slowing down try to clear an air pocket around your mouth and reach for the surface.

Transceivers save lives. They are a small device which sends out a signal and can be switched to receive if one of your group gets buried. You and all the people in your party must wear them and know how to use them.

Survival after an avalanche is all down to the response time of your party. 92% survive after 15mins but this falls to 25% after 45mins, so knowledge of your kit is vital - every minute really does count. If one of your party gets caught then watch their path. If you lose sight of them under the snow, follow the snow's path where they were until it stops.

All new transceivers use the same frequency world wide so read and follow the manufacture's guidelines carefully. If you carry a mobile phone check that the phone doesn't interfere with the transceiver. Always wear it under your jacket, never in a pocket or in your back pack. Practice finding them and always check them before you leave home.

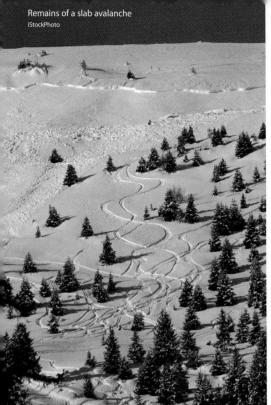

Recco produce a small reflector which, when worn, can be detected by rescue services in most major mountain resorts. However, the main problem here is response time but you can purchase

a pair for just £25, and they never need batteries. Contact www.Recco.com for more info.

One person should take charge of the rescue search. All transceivers should be turned to receive and someone should be posted to look out for secondary avalanches. You should always make sure you have an escape route as you're not going to be any help if you get buried as well.

Between 1985-2003 2694 people died in avalanches in alpine resorts world wide and around 100 a year die in the Alps. Don't be one of them.

FIRST AID

Mountain first aid is a skill that needs to be learnt and practised. Nothing could be worse than seeing a close friend in pain, when all you can do is stand there looking dumb without a clue of what to do. Buy a book on mountain first aid procedures and learn

the basics, or even better, enrol on a professional first aid course.

FIRST AID ESSENTIALS

Bandages and safety pins

Waterproof plasters,

Antiseptic cream

Gauze pads First Aid tape Asprin or other pain relief

A sling

The following is a very basic guide for immediate first aid, to help relieve pain and to stop further injury until help arrives. General rules when helping a casu-

1. Clear the airways and check the patient

frequently 2. Arrest bleeding by applying dressings and immobilise broken limbs

3. Finally treat for shock, relieve pain and then evacuate the casualty A.S.A.P.

If in doubt, do as little as possible to avoid worsening the situation. Never go backcountry riding without a well equipped first-aid kit.

WEATHER INJURIES

HYPOTHERMIA (EXPOSURE) is caused by body heat loss to below 37C. To prevent it, eat properly and wear technical, waterproof, warm clothing. To treat the casualty, get them under shelter and out of wet clothing while doing all you can to increase body heat.

FROSTBITE/FROSTNIP is full or partial freezing of the skin and its tissues, causing numbness and no reaction to pain. To prevent it, avoid exposure of bare skin, and wear suitable clothing. To treat, warm the affected areas but never apply direct heat.

SNOWBLINDNESS is temporary, partial, or total blindness, caused by direct or indirect ultra-violet light, even on dull days when the sun can't be seen. To prevent, wear suitable eyewear that has a 100% UVA & UVB rating. To treat, cover eyes and apply wet cloth to the forehead. Keep out of bright areas.

DEHYDRATION

occurs because of depleted fluids. Dizziness and nausea are early warning signs of dehydration. To prevent, drink regular amounts of fluid, such as water or healthy sport drinks. To treat, take a rest and drink as much fluid needed to re-hydrate your system.

Ted Land Interview

WSG are always looking to improve our knowledge of Back Country issues and techniques, so we asked Ted Land, one of our international review team, who puts the British Army Commando through their paces in the Arctic Circle. As a Commando himself, what he doesn't know about survival and travel in hostile areas ain't worth knowing.

WSG -If you arrive at a suspect slope which you want to cross what should you do?

TED – Do a Simple Snow Test /Shovel Shear Test. It's an easy way to evaluate the snow's stability or the likelihood of avalanche activity. Dig a pit near the area, but in a safe place. Dig to the ground area or at least below the last couple of snow falls. The Upslope side should be as vertical as possible. Insert the shovel slowly and vertically on the upside slope above the pit. Pull forward gently on the handle towards the pit.

If you have difficulty getting the column to shear off with firm force on the handle, the snow pack is probably stable. However, ask yourself if the conditions will stay the same across the whole slope.

If you encounter moderate difficulty with the shovel using medium force resulting in a neat shear, then you have a difficult decision. If the slope is steeper than the test slope it will avalanche easier, if it's not so steep it might be ok. No Difficulty with minimal pull, then the danger is high. With Extreme Ease, a natural avalanche is very high and probable.

WSG – So we've done a shovel test and it sheared with moderate difficulty and we've decided to cross the slope, how should we proceed?

Ted – Only cross if there's no other option and look for possible fracture areas, travel above them, in fact always travel as high as possible (less snow

to bury you). Look for escape options and discuss them with the group. Avoid Gullies and only wear your back pack on the shoulder that's uphill. Use an avalanche cord if you have one. If riding across undo your toe straps. Only cross one at a time, if the first person gets across don't presume it's safe.

WSG- It goes tits up and I'm caught in an avalanche what can I do?

TED-There is a number of options. Firstly try to ride out of danger. If you can, lose the backpack and try to take your board off Assess where you are in the slide: edge, middle, or bottom. Swim or roll

for the nearest side, use a double arm action swimming motion. Keep your back to the force and head up, save the greatest effort for the last few seconds, before the slide settles, and try to burst to the top. If you're in deep try to create an air space and get as close to the top as possible. If you can move try to dig yourself out but don't panic (easier said than done). If you can't move try to slow your breathing and hope your mates pull their fingers out.

WSG- What should you do if it's one of your mates who gets buried, and the fool is not wearing a transceiver?

TED- Speed is essential but don't panic. Ask yourself is there any other danger? If yes post a look out, if there are enough of you. If it is a multiple burial do a head count as necessary. Try to follow the path of the person within the avalanche and mark the last spot seen, then probe likely areas uphill of rocks and trees. If you find someone leave the probe in and dig them out. If not, form a line and probe the larger area systematically.

WSG- If you have to overnight and you don't have a tent, what are the options?

TED-The Igloo is by far the best and well worth building if you plan to stay put for longer than a few days. For just a short stay a Snow/Block Cave is best. They are really warm and totally sheltered from the wind, which also makes them very quiet. On the down side, someone has to stay awake to keep an eye on the candle, to make sure the oxygen flow is good. The best snow cave building areas are on the leeward side of the slope. Before you start check the depth of the whole area with an avalanche probe, there's nothing worse than digging for hours and then finding a big rock right in the area you planned to use as a sleeping platform. Find an area which has a steep slope at the entrance; this will make getting rid of unwanted snow a little easier. Dig the entrance to the side; make sure this is below the sleeping platform

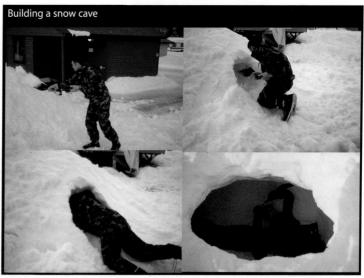

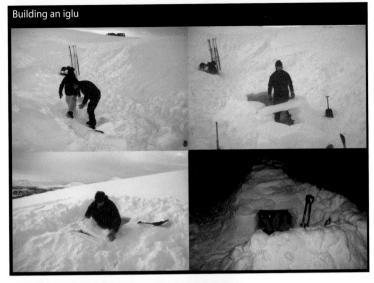

and big enough to crawl in and out of. Having the entrance below the sleeping platform will ensure all the cold air is below you while you are sleeping as warm air rises. The idea of the block and cave is in the name, you build a cave to sleep in then block up the cave entrance with blocks and use a pre-dug entrance.

If time is short due to weather or injury, a Tree Shelter is a good quick option. Find a good thick tree and use its branches to form a canopy. Clear the base area of snow, if possible, and build a wall around the tree with snow to keep out the elements. Use plenty of branches on the floor.

they make a great insulator from the snow.

Here are my top tips:

· Take off any warm clothing as digging is hot work and layers are likely to get wet.

· Keep good communication between the people

digging and the people outside.

· Have good ventilation, especially if you are using snow shelters where the entrance can become blocked by snow drifts. Use an avalanche probe or a ski pole with the basket the uppermost. These need to go in the roof of the shelter and be moved regularly so they don't become blocked.

·Mark the entrance well so it can be found in bad weather. Also mark above the shelter so unexpected visitors don't collapse the shelter.

·Always have digging tools in the shelter and outside

for emergency purposes. •If possible have the entrance below the sleeping platform; this will form

a cold trap.

·Using a candle is a brilliant form of light/heat and an indicator that oxygen is still in the snow shelter. If the candle starts to flicker or go out you have problems with your ventilation.

·Sleep with your head towards the entrance.

 Don't make the shelter too small. The last course I ran the guys made the snow cave too small which resulted in a warm shelter but the snow started to melt and their clothes got wet and then later in the niaht froze.

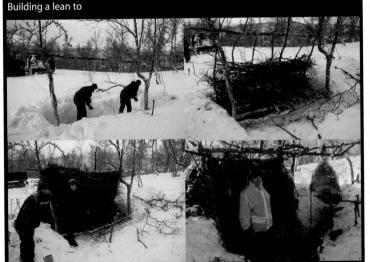

CATBOARDING

Often viewed as the "poor person's" heliboarding, catboarding has seen a rapid surge in popularity over the past decade. The goals of riders who go catboarding are pretty much the same as heliboarding; that is to ride untracked powder without hordes of other people around!

However, there are several differences between the two, with each having their own advantages and disadvantages. Probably the major reason that someone would chose catboarding over heliboarding is the cost. Snowcats are much cheaper to run than helicopters. The other major advantage of catboarding is that it isn't nearly as weather dependent as heliboarding. It's not uncommon to hear stories of riders waiting 2 weeks in places like Valdez, Alaska for the weather to clear to go heliboarding, whereas those riders who chose to go with a catboarding company usually get some runs in since the areas that catboarding companies operate in usually have large sections of below treeline terrain which provides protection from the elements.

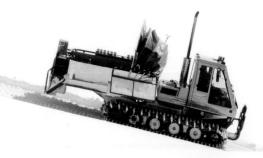

Photo courtesy of Todd Shapera & Grand Targhee Resort. Other page,(c) Mt.Potts, New Zealand Most of the time you will get more runs in when you go catboarding, however the runs are shorter than the average heliboarding runs.

Even though catboarding has seen a huge increase in new operations starting up, these have been mainly restricted to Canada and the US. The Great White North has the vast majority of catboarding operators, most of whom are located in the powder haven of British Columbia. Quite a few base their offices out of a ski resort, so when you are sick of riding the groomers consider spending a day catboarding!

CANADA

Canada is home to the majority of catboarding operators. They're pretty much all located in British Columbia except for a company that runs trips in the Blomidon Mountains in Newfoundland. There's roughly around 30 different operators to chose from! There's the more well known ones like Baldface, Island Lake, Powder Cowboy, Valhalla etc, but it could be worth checking out some of the smaller operations too, especially if they are newer and prices maybe cheaper.

This writer rode with Big Red Cats last winter and had a blast. Big Red Cats run out of the wicked Red Mountain Resort which is known for it's snow and world class tree skiing. As a new operator (just a few seasons old) they are only just beginning to explore their +18,000 acres of rideable terrain. A cool thing that BRC does is hold specific "snowboard only" days! This enables riders to have a traverse free day where the guides will lead you to areas that have consistent fall-line. We went with a mixed (skiers/boarders) group and still had a blast.....especially after doing something like 8 or 9 runs for the day!

USA

There are quite a few catboarding operators in the US, mostly located in the states of Colorado, Idaho and Alaska, as well as a few in other western states like Washington and even in Nevada! Most of them are based out of an established ski area, with the notable exception being Alaska (though Chugach Powder Guides is). A cool concept a few ski areas have done is combining catboarding with resort riding. For example at Big Mountain Resort in Montana you purchase a lift ticket and pay an extra \$100USD and you get to ride the lifts to the top, then the cat will take you outside the normal resort boundary where you drop into ungroomed terrain and ride back into the ski area to do it all over again! At Grand Targhee in Wyoming, a full day will cost you \$299 but this place does get on average over 12m of snow a year.

REST OF THE WORLD

– There are just a few places around the world that offer some form of catboarding. In New Zealand there is Mt Potts which offers both heliboarding and catboarding. With the weak NZ dollar it is very affordable. Another operation in the Northern Hemisphere 'summertime' is Ski Arpa located in the Chilean Andes. Compared to most other operators around the world, prices are extremely reasonable, especially with +1,000m descents on the menu and amazing views of Aconcagua, the highest mountain in the Americas. There doesn't seem to be any operators in Europe, except for a small company operating in Kitzbuhel, Austria.

So if you are even thinking about going catboarding, JUST DO IT!!! We promise you, you will not regret it!

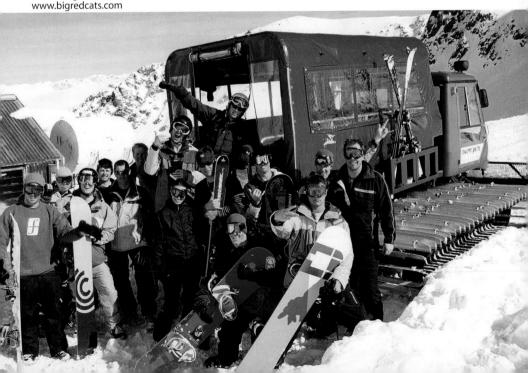

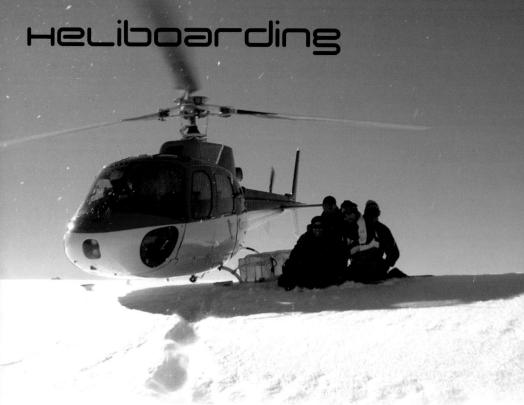

You hit the deck as the "thud thud thud" turns into a continual motorised drone. You look at the floor as a wall of powder, projected by the blades, envelopes you finding its way down your back and onto any uncovered skin. A short stooped run, and the next thing you know the floors dropping away and you're heading for virgin powder and the ride of your life. Heliboarding is untouchable, it's the ultimate. Some think it's just for the rich and famous. It's not, you don't have to be famous.

Imagine it: "Oh Mr Pilot can you drop me on the top of that, I'm just going to ride that virgin snow, and then if you wouldn't mind you could pick me and my friends up at the bottom and take us straight back to the top of that peak over there."

Having the use of a helicopter for a day or better a week, is the dream of any self-respecting boarder. Costs can vary from plain criminal to "you're having a laugh". Although it costs a lot of money, if you can wrangle a deal it may be the best money you ever spent. Instead of falling for all the marketing hype of needing the latest kit each season, blow the cash on a helicopter. Just don't buy a new board or the latest jacket, keep the old one and instead have a day you'll be bragging about years.

In Europe you have a few winter options; Switzerland has a healthy policy to heliboarding. Most of the larger resorts allow you access to the back country without you having to breaking into a sweat, other

than when you hand over the cash that is. You can also Heliboard in Spain, Georgia, Turkey or pretty much anywhere there's a mountain with snow on it if you've got the cash you can board it.

If you want to heliboard in Europe's summer then you have to head for the Central Asia or the southern Hemisphere. The US and Canada have some amazing possibilities: Fernie, Red Mountain and Whistler in Canada, Colorado in USA and the big boy Alaska, and that's just to name a few. The main difference between Europe and North America is that in Europe it's normally day hire or even ½ day. In North America it's predominantly sold as a week long package, including being airlifted in to a back country lodge and flying around the area for a week before being flown back to civilisation, with a granted number of vertical feet boarded, but this is not always the case. Some places will offer day trips as well as week long trips that cost thousands of dollars.

The most important things to find out are safety record and garneted vertical decent metres. If they don't want to discuss it, spend your cash elsewhere. Insure they insist that everyone has a transceiver and shovel and knows how to use them. Also find out what their money back policy is for bad weather days and ask if the guide will be boarding or skiing. Being the only boarder on a drop will not necessarily lead to a bad day, but it would be better to be in a group of boarders. Ensuring the guide is a boarder will guarantee you're taken to suitable terrain.

canada

Within Canada there are many options with most major resorts having a Heli-operator. Few offer day trips but shop around and you may be able to strike a deal for a day riding.

KICKING HORSE/ GOLDEN

Purcell Helicopter Skiing Ltd run day trips with 3 or 5 descents for \$610 and \$730 with the chance of additional descents at \$65pp with a minimum group of 8. They claim to have close to 200 runs offering every conceivable type of mountain terrain and exposure, and will transfer you by bus from Lake Louise and Banff for \$40. www.purcellhelicopterskiing.com

Great Canadian Heli Skiing offers 3 day and week long packages out of the village of Golden. Trips are based out of Heather Mountain Lodge on the boundary of the Glacier National Park and near Rogers Pass, where peaks resemble the Matterhorn. Most of the boarding take place in the nearby Purcell Mountains with small groups being lead by a local guide with a guaranteed 15,250 vertical meters in a 3 day package or 30,500 m in the 7 days. www.canadianheliskiing.com

CHILCOTIN MOUNTAINS

Bring it on. Only 65km north of Whistler, is the Chilcotin mountain range. This is a huge area where you can pick and choose your slopes. There are around 300 different runs, which have around an 800 meter of vertical descent, and there are also some great tree runs. This area gets a massive snowfall of 14 to 18 meters a season, so it should be steep and deep which is just what you're looking for. All this, as always, comes at a cost. Two days with lodge accommodation is \$2400. Now that is a lot of cash. Elemental Adventure offers a week trip at £2658, without international flights. Klondike Heliski offer trips to 23 different areas with over 300 descents to choose from, which encompass an area of 6,000 square km. Based out of Atlin, B.C. almost \$7000 can will get you 32,000 true vertical meters of boarding over a week with fully catering, www.atlinheliski.com

SKEENA MOUNTAINS

In the far North West of Canada just south of Alaska are the Skeena Mountains. This is a vast area of 9,000sg/km and that's big. An area that size has runs for all and endless fresh tracks. Based out of the town of Terrace, Northern Escape run heli trips in this area for 3, 4 or 7 days. A week costs \$6590. If you're in the UK you can book trips with Elemental Adventure.

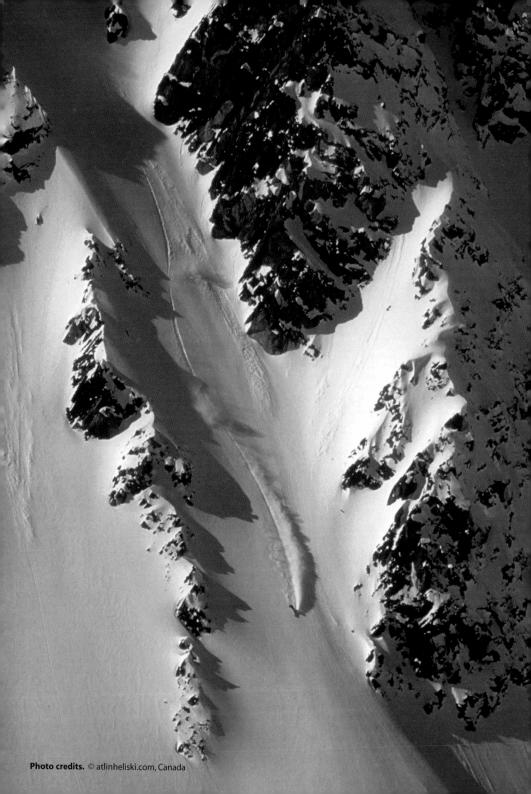

France

Heliboarding is banned in France, unless you gain special permission, as most undeveloped areas are National Park. You can fly over the border into Italy for a couple of runs, but why bother? Unless you're holidaying in France, you may as well start in Italy. From Chamonix and Tignes you fly over the border and board in the Val Grisenche and Monte Rosa areas.

6reenland

Greenland is accessible via Copenhagen. Maniitoq is right on the Artic Circle trips are run here by www. eaheliskiing.com .The season lasts from March to Mid June. From April the sun never really sets, allowing for some late night boarding, and with loads of the runs ending on the beach, this is truly a mad place to board. Most of the mountains are under 2000meters and the majority of the boardable runs are around 1000meters of vertical decent. While in the area you can also go Whale watching and sea kayaking.

Here as always is the draw back: 7500euros gets you a week without international flight or insurance, and things are expensive once you're there so make sure you get some booze at the duty free.

seorgia

In the town of Gudauri you can catch a twin turboengine MI-8-MTB-1 helicopter which can carry a capacity of four tons. The cabin seats 24 passengers so there's plenty of room for your board. There's good snow and lots of varied terrain. www.alpintravel.ch has been running trips here since 1989 so it can't be all bad. The best thing about heliboarding here is that the price of around 3000 euros will get you a week long trip with a vertical descent guarantee of 15,000 meters, a hotel with sauna and pool, food and most importantly a transceiver and ABS avalanche airbaysystem. Runs are between 1,500 m and 4,200 m, the average run being 800 to 1,200 m long, which is small in comparison to many places but then so the cost.

ındia

Surprisingly India has commercial Heliboarding operations running throughout the winter into early April. The best locations are in the Himalayan region of Hanuman Tibba, Deo Tibba, Rohtang Pass and Chandrakhani Pass, all close to the Manali valley which is a wild place where loads of marijuana is grown. Yhe Gulmarg in the Kashkir regions also offer heliboarding, but only experienced travellers and boarders should try these places, as if you have an accident, it's a long way for any help. www.himachal. com run heliboarding trips out of a small village north of Manali but expect to pay \$6500 for a week trip. The main attraction of heliboarding in India is the guarantee of great light fluffy snow and the chance to take on some fantastic Oak tree runs.

Farn

Heliboarding in Italy is limited to a few areas. There's still some good riding in the Aoste Valley especially the Monte Rosa area which is high with a summit of 4633m. Val Grisenche normally has good snow when others are suffering. Most agencies within resorts can arrange day trips for you.

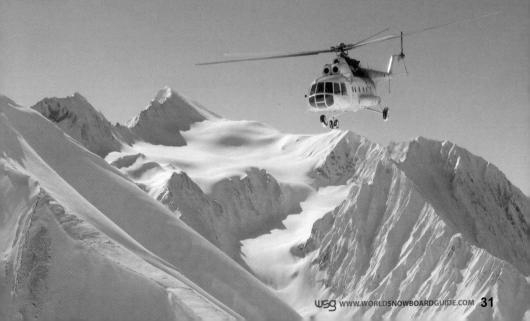

teaealelnstan

Using old soviet military helicopters which will seat up to 20 people, Kazakhstan is another adventurous place to heliboard. The choice of terrain is endless and being the only helicopters with the ability to land (and more importantly take off again!) at altitudes of nearly 6000 meters you really can just choose any hill you want. The main draw back other than cost, is the cold with temperatures of -10 a winter norm in Alam-Ata, the capital, and the high peaks can easily drop below -30. Having said that, with hundreds of peaks higher than Mont Blanc, you can forget about boarding in January and go in the summer. The cheapest and easiest way is to stay at Karkara base camp (you will need a Kyrgyzstan visa) and take a short 20min flight into the mountains. If you don't fancy camping or being stuck in only the base camp bar listening to stories of the days riding then you could stay in Alma-Ata, However, it's an hour flight and at around £1000/hr to keep the helicopter in the air, the cash could be better spent flying in the mountains than back to the city. A flight to InvIchek Glacier to see Khan-Tengri and peak Pobedy is a must. You can sleep at the climber's base camp but take a good sleeping bag. Check out www.khantengri.kz.

byrgyzstan

Cheaper than its larger neighbour Kazakhstan, Kyrgystan offers access to the same mountains at less cost. July and August are the best time to Heliboard in the Tien Shan Mountains. This is really high, ranging from 4500m up to 5800m. Using a Russian Helicopter you can fly from Karkara base camp up to the Northen Tien Shan. In a week's program it's possible for 7/8 dissents of 700/800meters a day. After a few days acclimatising to the altitude you will board from 5500 meters down to 4000meters up to 4 times in one day. On the last day if you're lucky you can board from Semeyonov Peak (5816m) down to 4000m. That's well over a vertical mile of untracked powder and there aren't many places in the world with that on offer.

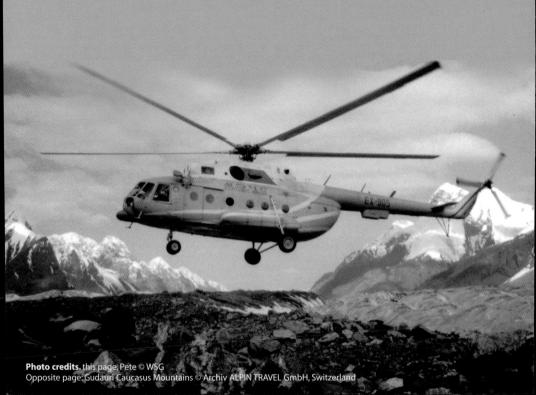

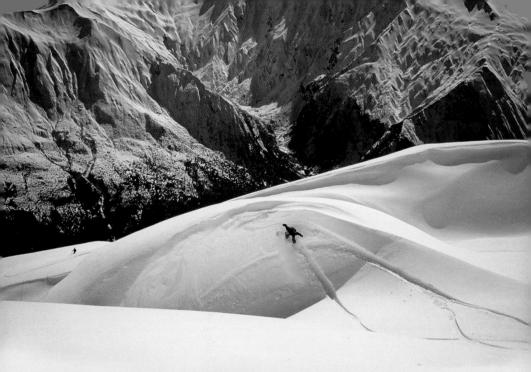

new zealand

The main bases for heliboarding in New Zealand are Queenstown and Wanaka. Unlike many heliboarding locations, both towns have the fantastic advantage of offering day trips. There is no need to sign up for an expensive week, and more importantly if the weather is bad you can just choose another day. The season runs from early July to early October and, conditions permitting, heliboarding starts up with the season. www.nzadventure.com offer some great day trip options for around NZ\$800 in the Harris Mountains, Clarke Glacier and Mount Cook areas. Methven near Christchurch offers some varied terrain with an area of 1000 square kilometres.

Mount Potts, the highest resort in New Zealand at 2200m, consists of three huge basins and has some fine slopes which are accessed with cats after you're flown up by helicopter. Also check out BCH www. heliskinz.com who are based out of Wanaka and fly daily into Mount Aspiring National Park. They sell 3 runs for NZ\$660, 4 runs for \$710 and 7 runs for \$880. In good weather you could get up to 11 runs for the price of 7.

Photo credits. this page, Backcountry Helicopters Ltd Inset: photo: Maxim Balakhovskiy © Russian Heli Project.

eussia

There are many options for Heli boarding in Russia. You can board on peaks like Mount Elbrus in the east, to Kamchatka in the very far west of the country. There truly are loads of possibilities and www.snowboarding.in-russia.com is a good site to check out where you can go. The helicopters are normally huge ex-Russian military beasts and can land as high as 5300m, carrying groups of 10 riders plus a quide.

Mount Elbrus in the Caucasus mountains, which are almost 1500km long, offers some great boarding. Operations are run from the resort of Dombai which is close to the Georgian Boarder and only a 15min flight from Elbrus where it's possible to board from its very summit, 5670 metres. There are numerous mountains over 4000 meters in the area with some great and varied terrain as well as some good tree runs. It's also possible to acess the area from the Black Sea resort of Sochi see www.eaheliskiing.com Week long trips run for around £2500.

Kamchatka the land of Reindeer, volcanoes and nomadic shepherds also offers some heliboarding on some very varied terrain. Many peaks reach over 4,000 metres and offer runs in excess of 3000 vertical metres. A 7 night, 6 day trip costs 4200 / £2838 and can be organised through www.eaheliskiing. com You will have to fly to Petropavlosk and when you get there don't expect luxury. Things here are basic but that's Russia for you.

Things here are basic but that's Russia for you. Most boarders prefer to ride at Viluchinskiy (2173 m), Mutnovskiy (2323 m), Avachinskiy (2741 m), Goreliy (1826 m), and Opala (2460 m) volcanoes. The average route length is 6 km, and the average

vertical drop is 1500 m. The helicopters can be paid on a flight time basis. The price per flight hour is \$500 - \$1800 depending on the type of helicopter. There are several agencies which provide heliboarding tours, but you need to book it at least a few months before, otherwise it will be hard to find an available helicopter. To hire the helicopter you can contact www.krechet.com. It's the only company which owns its own helicopters. www.helipro.ru also organise and run tours across Russia, Chile, Canada

sweden

Out of Riksgraensen it's possible to fly north to some unvisited areas. Although the peaks are low, its position so far north in Lapland makes it a great destination for Spring boarding. Departures run until late April. Another option is to fly south to the area around the highest mountain massif of Sweden the Kebnekaise where there are some real wild spots.

switzerland

Schweiz has many companies offering packages from 1 day to a week so do your research before you book an over priced trip.

Situated in Valais, Helicopter Service sell trips through agencies in resorts such as Zermatt. They'll fly you to glaciers and peaks on mountains between Zermatt and Chamonix. Every area offers a variety of descents ranging from 1300 to 2500 metres, suitable for all abilities. Flights operate every fair weather day from December to May. The helicopters seat 4 to 6 passengers so groups are small with all guides being UIAGM certified, www.heliservice.ch

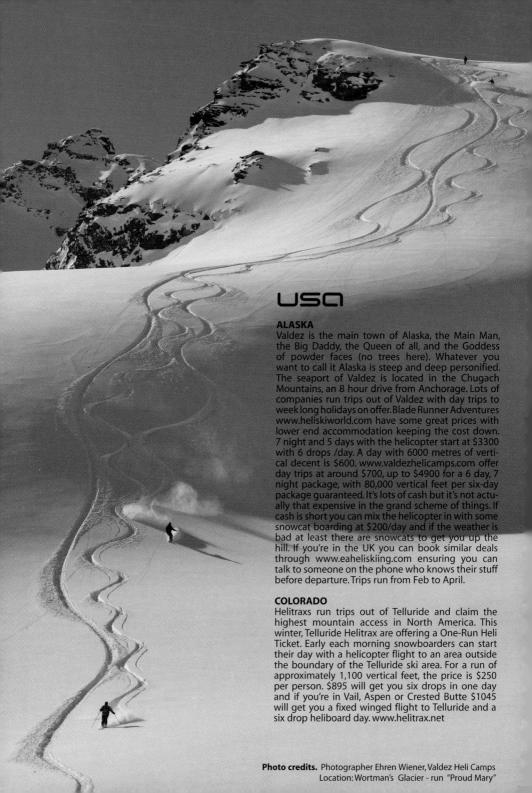

WHERE TO GO

If you do have loads of cash, and have got time on your hands, undoubtedly your best option is to head south for the winter to New Zealand, Australia or South America (see the country resort review).

These are a bit far for a weekend or even a week, so instead you could head for the Alps or North to Norway or Iceland, the lands of the midnight sun. You may even get to see the Northern Lights while boarding, and you don't have to get out of bed before the sun melts everything. How cool is that?

Another option, if the God of wealth is smiling down on you, is Heliboarding in the Himalayan massif; Kyrgyzstan and Kazakhstan are both great places to travel through as well as board, and really cheap (excluding the Helicopter!). One thing to keep an eye on is the stability of some countries: Kyrgyzstan had a revolution in March 2005 and they're planning an election soon, so it may kick off again.

Kashmir in late spring is also a great place to Heliboard but until recently was a war zone and could well be again by the time you plan a visit. The Caucasus Mountains in Russia are also great for summer boarding as long as you don't mind getting shot by the Chechen rebels or robbed by the Russian army who haven't been paid in months.

Having said that, successful camps have run on Mount Elbrus for the last few years, without any problems. The best thing to do when travelling far a field is check out www.fco.gov.uk for the latest travel advice.

Summer Glacial riding is a great way to give first timers an introduction to the sport, and if they still don't like it, you shouldn't have to look too hard for a crevasse to push them down. It's also good for those of you who've only done a few weeks to keep in practise for next season. There's nothing worse than finishing a holiday thinking you've got it sussed, then bigging yourself up to your mates all summer, only to find that 8 months off the board has seen your new found skills disappear like a turd down the u-bend.

Many of the Glacial resorts in Europe have restricted or stopped their summer programs, due to climate change and the erosion caused by boards and skis. That said, many glacial resorts give access to their higher reaches during the mornings and early afternoon, leaving most of the afternoon free for the skate park or a whole other range of summer sports. If you want to chill in the afternoons, then just sit back in the sun, drink some beer and wait for the lifts to open again.

On the slopes there's often a park to play in and normally a few short runs to keep you amused.

HUSTRIA

Austria has one of the largest options for summer snowboarding as well as some of the best glaciers. Burton Snowboards holds most of its training camps on Austria's glaciers and many national teams train here during summer. Resorts offer good local services and slopes are crowd free, although glaciers like Stubai and others within easy reach of Innsbruck do tend to get a lot of one day two-plankers on special tourist trips. Summer riding in Austria is cheaper than in winter but note some village services close during parts of May and June.

This very small resort, 20 minutes drive from Schladming, is often ignored in the winter, but being the most easterly glacier in the Alps and claming to have the "best snowpark for far and wide"! its worth a good look in the summer at least. In 7 minutes the Dachstein Gondola takes you from 1700m glacier at 2700m, and from there you'll find the park designed by Bernd Mandlbergero. The park has number of big booters and long rails, and its certainly not for the uninitiated, but kept in top condition. Depending on snow cover, there are also a few smaller kickers away from the main park, and the team don't generally mind if you want to wield the shovel and build something small yourself. If you're not into jumping then you'll get bored pretty quickly, the 3 runs are all fairly short, but you still occasionally get powder days even in the summer to spice things up from the summer slush.

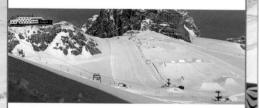

The Dachstein glacier and park, opens mid May and, snow permitting, stays open until late autumn. The mountain opens at 8:15 until around 4pm, but depending on the weather it can close earlier. There are 6 lifts, 2 of which are new and its 27euros/day for a pass. You'll need transport to get to the bottom of the gondola station; you can stay in Ramsau which is dull as dishwater but close. However the much better option is to stay in Schladming which has plenty of accommodation and some decent nightlife. There is also some very good climbing in the area. Salzburg airport is 90km away and Munich airport is 220km. www.planai.at

Kaprun is a favourite summer destination where snowboard teams spend a lot of time training. The ride area is located on one of Austria's best glaciers, the Kitzsteinhorn Glacier, which reaches an altitude of 3,203 metres, making it a perfect place to ride. Being a glacier resort, you can ride here all year and no matter what month you visit, riders of all levels will find something to shred. There is a terrain park & pipe located off the Magnetkopfellifte T-bar, Lift tickets are 27 per day. More info is available at www.kitzsteinhorn.at

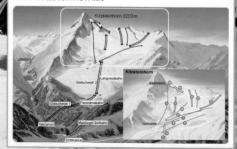

HINTERTUX

The Hintertux glacier is sat at the far end of the Zillertal valley about half an hour from Mayrhofen and its highest peak, Olperer rises to 3476m. You can board here any day of the year, and in the summer (May to October) it is open from 8.15 am to 4.30 pm. For the 29.50 day pass you can board from 3250 to 2660m and access 23km of pistes and a great terrain park.

The park, designed by Wille Kaufmann, is situated next to the Olperer drag lift. There's a pro line consisting of 4 10-15m table-tops, and a mortal's line with 6 kickers. There's also a number of a rails, a spine, and last but certainly not least, a 100m half-pipe. You'll find plenty of accommodation in the small villages close the lifts , collectively called Tux, but if you want any form of nightlife the biggest town is Mayrhofen, and is probably worth the daily commute.

www.hintertuxergletscher.at

SOLDEN

Summer sees both Sölden's glaciers, Tiefenbach and Rettenbach, open with a nearby car park at their base. Its a good size for a summer slide, and steep enough to ensure you'll never has to skate no matter how slushy things get. There are buses from town to the glacier (45mins), or to drive, follow the main town road as if driving to Obergurgl then take a right as you leave town at the sign for the glacier. At the bottom of Rettenbach glacier, you'll find a restaurant, the excellent Salomon bar and a couple of shops. The Base summer terrain park is located off run 32, and includes a stack of rails; straight, kinked, rainbow, gondola pods, you know the things, and also various size kickers.

OPEN: end of June to early of August Lift Passes: 30euros/day LIFTS: 2 Gondolas, 1 Chair, 5 T-bars ELEVATION: 2796m to 3309m TERRAIN PARKS: 2

Summer Camp BASE run 5 camps from the end of June to the end of

July. The Burton and Salomon teams are regular visitors. A 6 day camp costs from 210 euros for camping or 365 for a half board hotel. Packages include lift ticket, product testing and accommodation, but not coaching. You can pay by day if you prefer, which costs 30/day. Base Camp Sölden Phone:+43-676-436-0025, Website: www.base. soelden.com

45 minutes drive Innsbruck is Stubai to be Austria's resort although area shrinks to only of runs. The lifts 4:15pm daily

from the centre of Glacier. Stubai claims largest glacier ski in the summer the ski 4 T-bars, and a couple are open from 8am to

CANADA

The Blackcomb Mountain and glacier are the only areas which offer all year round snowboarding in the country. Nearly all of Canada's other resorts close at the end of April with a few closing in mid-May if the snow is still good.

Blackcomb and its neighbour, Whistler, are located on the west coast just north of Vancouver. You don't have to be on a camp to ride here during the main summer months, but you may not be allowed in the pipe or park if you are not.

112 acres of terrain are open from June until August, from 12pm to 3pm and serviced by 2T-bars. It takes 45 minutes from the base of Blackcomb to get to the glacier, involving 3 chairs and a bus. Once there you'll find the terrain park has between 4-6 rails/jibs, 2 spine jumps and a halfpipe. Tickets are \$45CDN per day.

Summer Camp In addition to the facilities offered by the resort, there are a number of specialist Summer Camps with access to their own private terrain parks & pipes. Prices start from \$600CDN a week including tuition, but most cost much more. Loads of summer snowboard camps are held for kids, so if you've got some cash and want your kid getting gold in the Olympics then send them along! www.campofchampions.com

If you're a big person, take a look at www.glaciersnowboardcamp.com Glacier Camps have been running week long courses out of Whistler since 1996. Based around a private half pipe, cut by the new 17-foot super dragon, they offer camps with small group sizes no more then 5 campers to 1 instructor, with a maximum of 40 campers a week. They also offer a snowboard park with jumps, hips, and a variety of rails, as well as the natural free riding around Blackcomb glacier and daily

video analysis. There are 5 sessions in June and July and a session costs £650 lasting a week, with a rest day in the

middle.

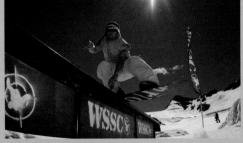

WSSC run fully inclusive summer camps on their own private park & pipe on the glacier. \$1225CDN (£570) will get you 3 days coaching, 4 nights in a hotel, all meals and some goodies, they also run a 8 day camp for \$1995 (£930) where you get 6 days coaching/boarding. Camps run from early June to the end of Jully. Visit www.whistlersnowboard-camps.com for more info

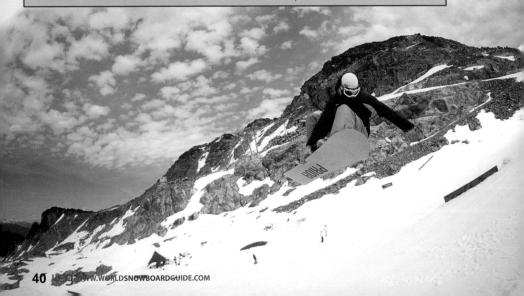

FRANCE

It's surprising that a country with so many good winter resorts has so little to offer for summer snowboarding. 99% of French resorts switch off their lift systems at the end of April regardless of how much snow is still on the slopes. The few resorts that do operate in summer provide a lot of high altitude services with snowboarding only a small part of the mountain activities on offer. Climbing and mountain biking are considered the main attractions here.

Often considered the best European summer riding resort, The high glacier allows for some fine summer riding in T-shirts, and you can reach the board area from the middle of the town in a cable car. The park is a good size and is well known for its good snow conditions and variety of hits.

Open from mid June to late August from 7:30am to 1:30pm, there are 8 runs and 11 lifts to get you around. Tickets are 30euros per day. The town is also full of off-hill sporting activities and has a kicking night life.

BIG A runs camps here for all abilities, from competitors waiting to know what judges are looking for, to first timers. The park is 650m long and is at an altitude of 3500m. It offers 2 pipes, 2 funboxes, a massive hip, a big jump and plenty of kickers for any level of riding. 2 skilifts and a handlift service the park and there is a barbecue area. It's also got boardercross courses and mountain bike courses. The Big A summer session is from June-August. www. big-a.it

Charles to be considered to the constant of th

Girlie Camps are here most summers. They are an organisation promoting board sports to girls. Their girl only (16-40)

snowboard camps have top female riders from Burton and Roxy instructing you and are open to all abilities. Around 600 euros will get you a weeks accommodation and riding with 4 hours a day instruction in groups of 8 riders, plus video analysis to keep up with your progress, test gear from their sponsors, plus off slope activities like: Climbing, Ice-skating, Yoga, Gymnastics, and Spa. www. girlieproduction.com

Kommunity run freestyle summer camps in the last 2 weeks of July. Prices are £545 per week and include tuition with British Pro riders, lift pass and half-board accommodation. For more information check out www.kommunity.com

Rossignol run excellently organised camps over a two week period in July. All the Rossignol Snowboards and Scratch teams attend the camp, offering 2 hours instruction per day (for an additional cost) while the rest of the day is yours. Prices start at 330 euros for the basic package and raise to 640 to stay in the Rider's hotel on a full board basis. For those of you with kids there is even a one week option for under sixteens, so you can ride with the kids and the Pros. www. rossignolsummercamp.com.

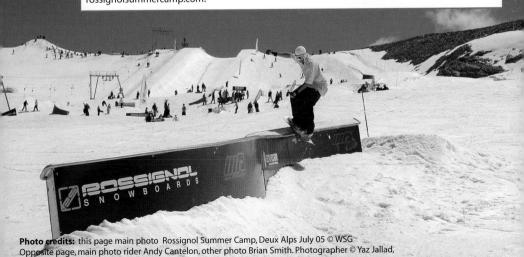

Ski pass 24.50euros a day. There are some easy runs should be open, but there are no camps as such, and no park or pipe, just 3 or 4 easy short pistes. Open from end of June to July, it is a great spot for beginners. The area was closed summer 2006 due to maintenance work.

up on the Glacier de la Chiaupe (3250 meters). Some of the board schools should be open, but there

Tignes is one of the major snowboard resorts in France, and has long been hosting national and international events. Tignes lies at 2,100m, and is without doubt, the best summer snowboard destination in France and a match for any of the top glacier resorts of Austria and Switzerland. Access to the glacier area is from mid June to early September and is accessed by taking the underground funicular train located at Val Claret. In the summer, the glacier is home to 25km of pistes with 750m of vertical. A day lift pass will set you back 30euros. The Snowpark has a range of table tops and rails to suit all levels, and there is beginners and super pipe.

TIGNES

Summer Camp Snocool is now in its eighth year and offers freestyle coaching along with many other balance based sports. There are filmed sessions everyday with viewing at night. There's a Burton test centre and an occasional visit from a big name French Pro rider. Prices range from 220 euros for instruction only to 580 euros for a week long package.

VAL D'ISÈBE

Just when you thought this was a declining section, Val d'Isère go an surprise everyone by re-introducing summer boarding on the Pissaillas Glacier. The resort installed a number of snow cannons for the 2006 season high up on the glacier, to start preparing the glacier for the re-introduction of summer boarding. Its not the easiest glacier to get to, you'll need to drive to the glacier from town or take a bus from Le Fornet. Its open from the end June to mid July and a day pass costs 23.5 euros

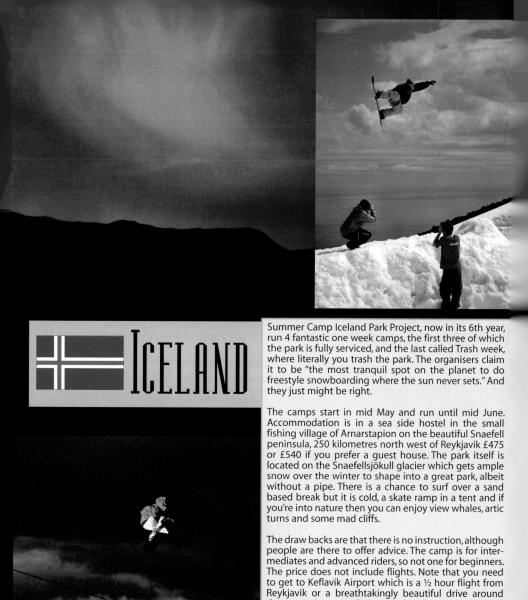

the coast. Anyone who's seen the photos on the very informative website will want to go. www.icelandpar-

kproject.com

Photo credits: this page main photo red as f*ck, insets rider Chad Photographer: ○ Tash
Opposite page main photo: Agence Nuts - Val d'Isere Tourist Office

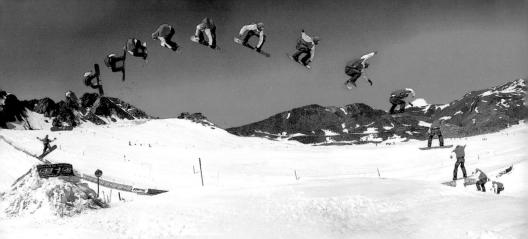

Italy offers some of the cheapest summer snowboarding opportunities in the whole of Europe. However, don't expect a great deal in terms of the size and difficulty of the terrain available. Italy's summer snow cover on its glaciers is okay but, not as good as Austria or Switzerland. You won't find many summer halfpipes or parks to ride, but there are snowboard camps with hits to get air from. One place that does hold camps is Passo Stelvio Glacier. It's the highest glacier resort in Europe and not far from Bormio. Here you get the chance to ride a good park and pipe throughout May and June.

Summer boarding at Cervinia is up at the Plateau Rosà Glacier which, at 3500-3800 metres, always has good snow. It is open from the end of June until early September. The park, known as Indian Park, has a number of kickers, rails and a superpipe. Big A run summer camps here from mid July to mid September with all-in prices from 350 euros for the week. Check out: www.big-a.it

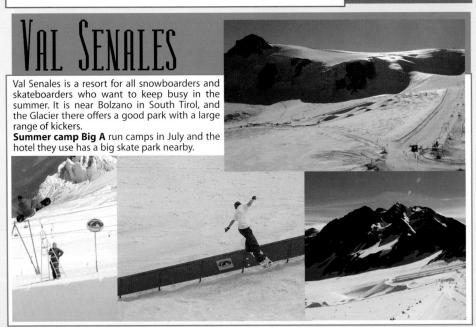

HEE NORWAY

Folgefonna is a small glacial resort a mere 1200 metres above sea level but with the snow dumped on it all winter there's plenty left for a bit of boarding in the summer. The highest point on the glacier is 1640meters and although the runs aren't all that long, the park should keep you happy. The resort is located on the west coast of Norway about 90 minutes drive including the ferry from Bergen or 7 hours from Oslo. www.folgefonna.no

Summer Camp

Folgefonn Camp has 4 one week camps here, in June and July the camps are resort run and have a minimum age of 14, but are tailored to an older age group. The park has pipes, boxes, slides, jumps, a boarder cross, music and ademo centre where you can test next years boards and equipment. Outside the park there's a full sized indoor skate ramp, mini ramps, 5 trampolines to practice inverted tricks, and there's also a small stream and a lake where you can go boating, fishing, windsurfing, swimming and wakeboarding. You can ride with tuition from 10 till 4 everyday and with basic accommodation you'll have to part with 450. euros

Folgefonna

STRYN

Stryn is located at the base of the Jostedalsbreen glacier in amongst the fjords, and is Norway's most famous summer resort (in fact the only one of note really). The glacier gets so much snow during the winter, (five metres or more), that the lifts are usually totally buried so they couldn't run them in the winter even if they wanted to!

The glacier opens at the end of May to late July. There are some beginners runs, but it's best to head for the park. It's got the usual arrangement of various kickers and rails but no pipe, although if there's enough snow they have the ability to build one. Lift passes are 280 NOK/day or 1200 NOK for 6 days.

Summer Camp Snowboard Norge have been running camps in Stryn for almost 20 years so they must be doing something right. The courses start at the end of June and prices are roughly £250 for a week long camp including instruction and lift pass but not accommodation. With the motto "No one too experienced, no one too inexperienced" this is truly a camp for all.

You can also bring the kids but anyone under 14 must be accompanied. Groups are split by ability and given instruction suited to their needs over the 5 days. It's not just freestyle-they also do basic beginners tuition as well. Depending on the snow they normally have 20 or so jumps and a boarder cross track.

There's the option of camping in your own tent 50 NOK/night or staying in a camp hut 135 NOK/175 NOK night, or if you have some cash you can book a Hotel www.hjelle.com There is also a big skate park to check out in the long warm evenings, and some great hiking. www.snowboard.no/camp

Girlie Camps run a camp here in June, with top female riders instructing Girls only, (see Les Deux Alps in this section). Price is a little over 600 euros for a week riding and Hotel. All standards are welcome and many people travel to their camps alone.

Photo credits: this page main photo Stryn summer 05

Opposite: main Big A Camp in Val Senales. Cervinia. Others Giacomo Kratter in the pipe, B/slide Filippo Kratter

RUSSIA

MT ELBRUS

In the heart of the Caucasus mountains is Mt Elbrus , just north of the Georgian boarder. At 5642 meters, it's the highest mountain in Europe, it has a glacial system which covers over 145km sq and ice over 400meter deep.

More importantly it's home to the SPC summer camps. Run in June and July they are a great laugh if you fancy some good snow, and a lot of vodka. The park (see picture) is built at around 4000 meters, so be sure to take it easy until you've acclimatised.

Once you're there its cheap-a pint is about 50p and Dinner isn't much more. There's a large indoor space at the camps Hotel which provides (bizarrely) a gun shooting room and more tamely a billiard bar, and two table tennis courts. Camps are available from one to four weeks and cost 350 euros for 8 days when booked through the very good SPC site. However, this price excludes international flights. www.spcrussia.com

SWITZERLAND

LES DIABLERETS

The glacier is open from mid June 19th to the end of July offering 4 easy pistes. The cable car runs from 8.20am until 4.50pm. One slope is open and the snowpark and the halfpipe. There are a number of summer boarding camps Euroboardtours (www.demonium-mc.com) and Choriqueso Camps (www.choriqueso-camps.ch). Visit www.glacier3000.ch for more information

Switzerland ranks equal with Austria as being the best country in Europe for offering summer snowboarding facilities. The Swiss boast a number of great destinations which all provide halfpipes or funparks and, like everything else in Switzerland, they are of a very high standard. One of the main places to check out is Saas Fee which boasts of having Europe's only all year round halfpipe and terrain park where loads of Pro-riders hold camps. Swiss local services are good and, in most cases, lodging is available at the base area of the slopes or close by.

SAAS-FEE

Saas-Fee has been a resort well known to snowboarders for many years. With its high altitude glacier, Saas-Fee also provides a mountain where you can ride fast and hard in the summer months, indeed for some, this is the only time worth visiting.

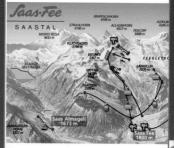

The glacier opens in early July until September with access to 20km off pistes and a terrain park with kickers, ¼ pipe, tabletops, rails and a halfpipe. A lift pass will set you back 60CHF a day.

Summer Camp Team Nitro run 3 one week camps with their Pro team in July and freestyle camps during July. For more info check out www.nitrosnowboards.ch

up on the Matterhorn, Zermatt has the largest summer boarding area in Switzerland. The glacier opens in June until September and there are a number of easy/intermediate runs and a terrain park all serviced by Tbars. The Gravity Park has a series of kickers and rails and a super-pipe alongside the lift. A lift pass will cost you 60CHF. but the area is only open from 7:30 to 1:30pm so you need to get up early before it starts getting slushy. In the afternoon you can take a look at the World's highest ice pavilion at 3810m, if you're that way inclined.

Stoked runs for 2 weeks every summer from the end of July. A 6 night package including tuition, accommodation and lift pass will set you back 630 euros. For more info take a look at www.stoked.ch

70vm The Moun is accessed

The Mount Titlis glacier is open for summer riding and is accessed from the town by Gondola. This also allows you to take your mountain bike up and there's also some wakeboarding possible nearby. The glacier isn't the biggest around but the park is cool and has a half pipe and a selection of kickers. Always check www.titlis.ch to ensure they are open as sometimes they close due to lack of snow.

Summer Camp Iceripper have been running camps here since 1988 and have gained a good reputation. There's instruction for freestyle from half pipe to rails and room for beginners. In the afternoons there's good climbing, wakeboarding, tennis, golf, mountain biking, and ice hockey. CHF 590 gets you 6 nights B+B accommodation with 5 days riding and instruction and a t-shirt. The camp has halfpipe, big airs, corner, rails, chairlift, drag lift, skatepark and some great snowside tunes with an occasional BBQ. www.iceripper.com

Photo credits: Opposite page Danny Kass competing in the Burton Aboninable snowjam in June 2005 at Mt.Hood ©2005 Dean Blotto Gray. This page. photos © Stoked Summer Camps

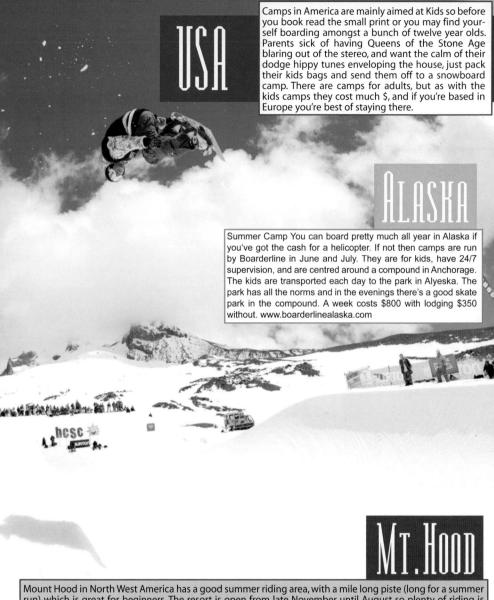

Mount Hood in North West America has a good summer riding area, with a mile long piste (long for a summer run) which is great for beginners. The resort is open from late November until August so plenty of riding is available. There is a park but it's out of bounds as it's restricted to High Cascade camp members. See www. skihood.com for prices and timings.

Summer Camp World renowned is almost a realistic claim for High Cascade summer camps with 2 pipes a huge selection of rails, hips, boxes and jumps all designed and built by Pat Malendoski of Planet Snow Design, builder of the 2002 Salt Lake City Olympic Superpipe. There are no restrictions on riding standard with even complete beginners are welcome.

Campers are split into ability groups and with jumps from 5 to 70 foot there truly is something for everyone. Places are available for 9 year olds to adults. Adult camps are aimed at all levels of progressive freestyle with a maximum of four snowboarders to every coach, and use video analysis. All camps are held in High Cascades private park and pipes. It all sounds great, but here is the drawback: \$1800 gets you a one week adult camp, kids camps start at \$1400. www.highcascade.com

Windells also run camps at Mt Hood mainly for kids, see www.windells.com

SAASTAL

The hottest July since 1911 saw a large World Snowboard Guide team meet up at Heathrow airport, wearing shorts and vest tops (the women not the men), with more snowboards than a village of rain forest pigmy's could lift. Our destination was Saas-Fee, Switzerland; our mission was to test as many of next years boards as possible.

After a few worries of missing the plane, with the tube system temporarily shutting down, the full team sat back for a pre flight beer and a test briefing. It was hard to believe that with the team fighting for the seat next to the air-conditioning outlet that we were on our way to the mountains to test next season's kit. So hard in fact that someone asked the question on everyone's lips "is the glacier going to be open in this heat?"

After I reassured everyone that I'd just got off the phone to resort and that everything was fine, the team relaxed and were happy. I saw this as the best time to let them know we would be having breakfast at 6.00 am every day, with our passes allowing us to get the staff gondola up to the glacier at 6.45 am. I felt a little like a politician guietly releasing some bad news, when an even worse story would be taking the headlines, but everyone was in good spirits and happy to be heading to the mountains.

THE PERFECT TEST

We landed in Zurich to be greeted by a laughing moustached baggage handler.

"Where you going to snowboard at this time of year?"

"Saas-Fee" was my quick response.

After a mad dash across Switzerland, with speed cameras in our wake and more hairpin bends than I'd care to remember we arrived in resort at 4.30 am. Saas-Fee is a car free traditional alpine resort, so Chris from the Hotel du Glacier picked up all the boards in an electric golf cart like car. An hour and a half later I was amazed to see all the testers sitting at the breakfast table, what a keen bunch they were. The whole team were eating while looking out of the conservatory windows at what has got to be one of the best alpine village settings in the world. Saas-Fee village, sits in a forest at the bottom of steep sided mountains, which are topped by huge crevassed glaciers, it's truly beautiful.

Two gondolas and a funicular later we were standing on a huge glacier below the imposing Allalinhorn peak. As I was organising transport of the boards to the bottom of the pipe, a steady stream of International Slalom Ski Teams crowded around the ski lockers, wearing multi coloured Lycra race suites. They were all there; Brits, French, Italians, Czechs and of course the Swiss, all rushing to claim a piece of slope to set up a gates course. There were also a few snowboarders getting off the first public funicular, dispelling the myth that boarders are lazy as it was still only 7.30.

After an incredibly scary skidoo ride trying to avoid the skiers with my lap full of boards, we set up camp at the bottom of the pipe and started the test. Saas-Fee is a great place to test, as there's a great pipe which is shaped to perfection every night and has a great transition. A park with hits of most sizes and some rainbow and box rails. Away from the park and pipe there is a boarder-cross circuit, with four gates and a series of hits, banked turns and some small rollers all of which could be taken at speed. The pistes are steep and wide, with around 20km in total to keep you busy. With all this on offer you can put a board through its paces, in all styles of riding. This was reinforced by the snowboarders off the funicular, who showed that this wasn't their first early morning, as they all got massive air out of the pipe, before styling it off and heading to the drag to ride the pipe again and again.

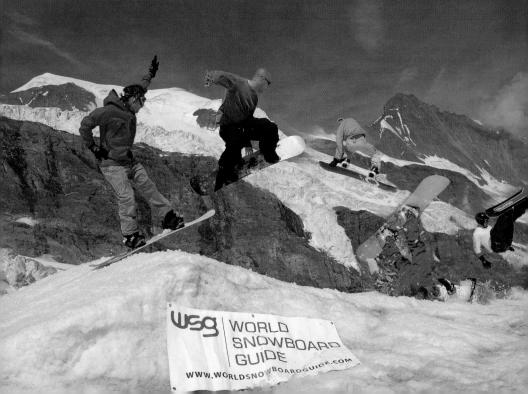

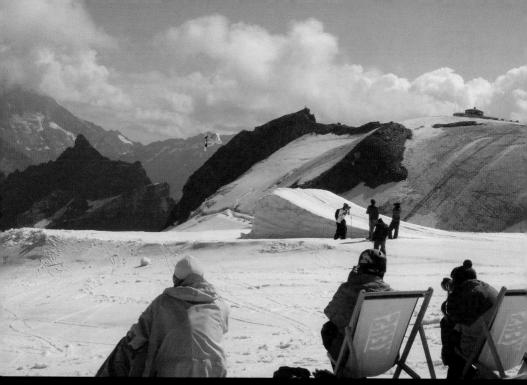

With the sun shining and the conditions perfect everyone took off on the boards they fancied. By mid morning what soon became apparent was, what one rider loved another hated, what one found a joy another found a plank.

So what is it we look for in a board? Just because you like to jib around the mountain, doesn't mean that all manufactures freestyle boards are for you. On the whole a freestyle board will be shorter than an all mountain board, mid 150's the norm for men with female boards shorter still. But the flex

varies completely across the boards on the market described as freestyle. Salomon's pro model David Benedek and Automaton's Seek and Destroy are a similar ride, with easily flexed nose and tail. While Head's Crown and Sapient PNB1 are totally different, not worse or better just different, with real stiff nose and tail. Yet all four boards are described as freestyle. All Mountain is often the name given to a board for freeriders. They will be longer than a specific freestyle board and have a deeper side cut, allowing you to crank over your turns. The holes for the bindings will sometimes be set back a little, allowing for a longer

nose, making it easier to ride powder (something to look out for if you ride goofy). As with the freestyle just because a board is described as All Mountain doesn't make it a hit for all riders who want to tour the mountain and avoid the park.

So can you tell its ride by looking at a board or by bending it in a shop, while some sales assistant talks a load of marketing shit at you? Well the answer to that is an emphatic no! So with all this confusion and marketing spiel what questions should you ask, when looking for a new board?

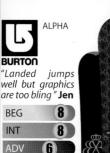

	4	DUC	HES:
NO	WBOAF	RDING	
11+	inet	fools	

"It just feels and reacts exactly how it should" Jen

DEG	U
INT	8
ADV	8
VALU	E ()
STYLE	ALL-MTN
PRICE	£360
SIZES	148
FEET	NORMAL

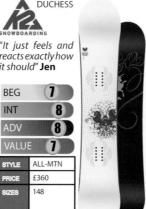

ATOMIC

FALLEN ANGEL

"Hard board yet good fun" Verón

BEG

INT	6	
ADV	0	
VALUI	■ (5)	
STYLE	ALL-MTN	
PRICE	£220	1111
SIZES	141, 144, 148, 152	
FEET	NORMAL	-

6

STYLE

ALL-MTN

NORMAL

FEELGOOD

£360 154

Excels when pushed hard"

Riggs BEG 4

INT ADV

VALUE U		
STYLE	ALL-MTN	
PRICE	£380	
SIZES	144	

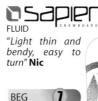

INT ADV

3111	ALL WITH
PRICE	£249
SIZES	147,151,155
FEET	NORMAL

MAIDEN

"Once again great design good for jumps and carving" Alyssa

BEG	8
INT	1
ADV	0
VALUE	7

STYLE	ALL-MTN	
PRICE	£250	
SIZES	143, 147, 153, 156	
FEET	NORMAL	

■ PEITOLLIOL

NORMAL

RADIENT

"A pleasure to ride good all mountain board" Riggs

BEG	(8)
INT	8
ADV	0
VALUE	8
No. of Concession, Name of Street, or other party of the Concession, Name of Street, or other pa	

Reservation and the second	ACCOUNT OF THE
STYLE	ALL-MTN
PRICE	£200
SIZES	139,143, 148,153
FEET	NORMAL

VERONA

"I loved this board stiff but with slight flex" Nic

BEG	10
INT	1
ADV	6
VALUE	6

AND DESCRIPTION OF THE PARTY OF		
STYLE	ALL-MTN	
PRICE	£370	
SIZES	148 151 154 157	
FEET	NORMAL	

VISTA

"Very Light and easy to manoeuvre, looks good too" Alyssa

BEG	9)
INT	9
ADV	9
VALUE	8

NESSTAGO PROPERTY.	CONTRACTOR OF THE PARTY OF THE	
STYLE	ALL-MTN	
PRICE	£280	l
SIZES	141 145 148 152 155	
FEET	NORMAL	ľ

S SCOM

ANGEL

"Okay but nothing special" Riggs

BEG	4
INT	4
ADV	4
VALU	E 6

VALUE 6		
STYLE	FREESTYLE	
PRICE	£170	
SIZES	141,146, 151	
FEET	NORMAL	

E)	4)	ſ		1	C	7	Ď,
babail				0				

FEVER

"Wicked board very fast and great for riding switch" **Angela**

BEG	9
INT	8
ADV	8
VALUI	8
STYLE	FREESTYLE
PRICE	£340
SIZES	144 147 150 153

HEAD FOUNTAIN

"Stiff, nice looking board, great fun" **Veron**

BEG	9)
INT	8
ADV	8
VALU	E ()
STYLE	FREESTYLE
PRICE	£235
SIZES	143, 149, 154
FEET	NORMAL

experienced rider "Riggs

BEG	(6)
INT	6
ADV	0
VALU	6
STYLE	FREESTYLE
PRICE	£350
105010002100000000000	

STYLE	FREESTYLE	
PRICE	£350	
SIZES	150	
FEET	NORMAL	

* PERLOCCION IVY ERA

NORMAL

"Felt good in all areas, but espe-cially off kickers" Alyssa

BEG	1
INT	8
ADV	8
VALU	■ ①
STYLE	FREESTYLE

STYLE	FREESTYLE
PRICE	£340
SIZES	144,148, 151,154,157
FEET	NORMAL
WITTER STATE	

MIX -GRETCHEN BLETCHER

"Rides pistes well for a freestyle board good in pipe" Alyssa

BEG	(1)
INT	8
ADV	9
VALU	E ()
STYLE	FREESTYLE
PRICE	£330

STYLE	FREESTYLE
PRICE	£330
SIZES	148
FEET	NORMAL

"Hard and fast for cruising heaven" Angela

BEG	8
INT	1
ADV	

STYLE	FREESTYLE
PRICE	£245
SIZES	148,153, 158
FEET	NORMAL

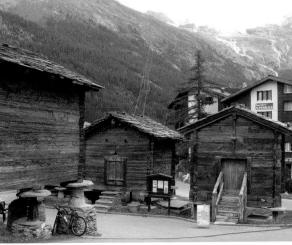

AXUM

"Great graphics for Tarantino fans" Martin

BEG	8
INT	9)
ADV	6
VALLE	0

	HALL MANNES
STYLE	FREESTYLE
PRICE	£280
SIZES	150,153, 156,159
FEET	NORMAL

CROWN

"Short and stiff great in the pipe" Pete

BEG	6	
INT	6	
ADV	0	
VALUE	6	

STYLE	FREESTYLE
PRICE	£276
SIZES	149,153, 156,159,162
PARTIES N	NORMAL

DAVID BENEDEK ERA "Great for having it in and out of jumps" Doug

BEG	1
INT	8
ADV	9
VALUE	7

The Shipping	
STYLE	FREESTYLE
PRICE	£360
SIZES	155.5
FEET	NORMAL

DH

"Held edge on the

morning ice and has crazy base graphics" Neil

BEG (5
INT	8
ADV	0
VALUE	0

FREESTYLE
£340
151 155 157 159
NORMAL

DOMINANT

VALUE

"Exceptionally stable & glued to the rails " **Steve**

BEG	8
INT	8
ADV	9

,

ALL

ATOMIC

HATCHET

"Kerang paint job on fine board" **Neil**

TOTAL CONTRACTOR OF THE PERSON NAMED IN	Contract Contractor
STYLE	FREESTYLE
PRICE	£220
SIZES	145, 149, 153, 156, 159, 162
FEET	NORMAL

AUTOMATION

NESTED DEATH "Looks the biz but real stiff and unforgiving" Doug

INT 5

VALUE 5

NAME OF TAXABLE PARTY.	HE ANDREW
STYLE	FREESTYLE
PRICE	£250
SIZES	158
FEET	NORMAL

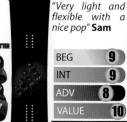

9
9)
8
10
FREESTYLE
£150
139, 144,148, 152,156,160

NORMAL

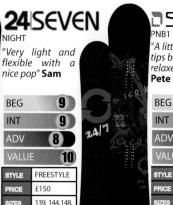

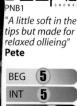

VALUE	
STYLE	FREESTYLE
PRICE	£379
SIZES	153,157,160
FEET	NORMAL

ao BUY DIREC MYE MONEY

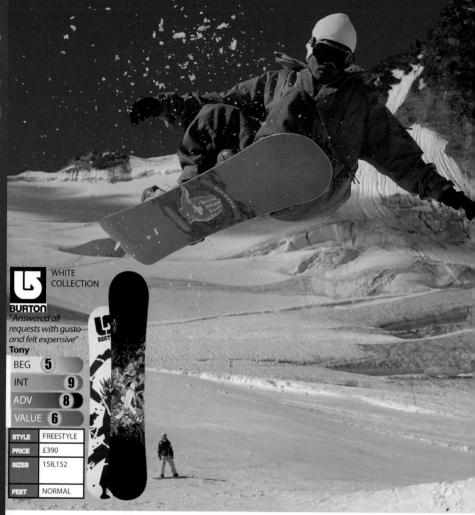

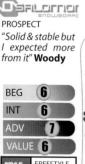

	ctea more " Woody		
BEG INT ADV	6	20	F 18 18 18 18 18 18 18 18 18 18 18 18 18
VALU	HHHHK AND		А
STYLE	FREESTYLE	L'AND	
PRICE	£300		
SIZES	153,157, 160,163		
FEET	NORMAL		

AUTOMATION

SEEK & DESTROY "Fun fun fun great for day in the park" **Sam**

BEG		
INT	8	
ADV	8	
VALUE		
STYLE	FREESTYLE	
PRICE	£250	ı
SIZES	154	-

NORMAL

S 6000	
CLIDIMAY	

SUBWAY

BEG

"Good for pistes but not to hot in the park" **Steve**

	- C
INT	5
ADV	4
VALU	8
STYLE	FREESTYLE
PRICE	£170
SIZES	142, 148, 154, 160, 16

NORMAL

24ISEVEN

"Nice and poppy great price

certainly will be telling my mates" Neil

BEG INT ADV

ALL-MTN STYLE £150 PRICE SIZES 156 NORMAL

ATOMIC

ALIBI

"Nice board, very stable when hacking it on the pistes" **Steve**

BEG	6
INT	0
ADV	0
VALU	E 6
STYLE	ALL-MTN

STYLE	ALL-MTN
PRICE	£330
SIZES	149, 153, 156, 159, 163, 166
FEET	NORMAL

BARON

BURTON

"Big foot board that doesn't feel like a boat "Steve

1
8
8
0

STYLE	ALL-MTN
PRICE	£400
SIZES	162
FEET	LARGE

All-mounta

BURNER

"Fast, stable, soaked-up the bumps and great fun" Steve

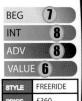

STYLE	FREERIDE	
PRICE	£360	
SIZES	157,162, 167, 172	
FEET	NORMAL	

CHEVRON

"This board will have it in style on any type of piste" Pete

BEG	8
INT	8
ADV	1

VALUE

STATE OF THE PARTY OF THE PART	RESIDENCE AND ASSESSED.
STYLE	FREESTYLE
PRICE	£350
SIZES	158
FEET	NORMAL

ATOMIC

COLDSMOKE

'A lot of board for ery little money, bargain " **Pete**

BEG	(1)	5
INT	8	ľ
ADV	8	
VALU	E 9	
STYLE	FREERIDE	ı
PRICE	£250	
SIZES	154,157, 160,163	1

CUSTOM X

"Fast, precise and stable. A top and true all mountain board" Doug

BEG	6
INT	•
ADV	(10
VALUE	0

VALUE		
STYLE	ALL-MTN	
PRICE	£470	
SIZES	147, 152,156, 158, 160, 164	
FEET	NORMAL	

DARK STAR

"Responsive with good edge control" Steve

BEG	(1)
INT	0
ADV	8
VALUE	0

STYLE	ALL-MTN	
PRICE	£300	
SIZES	157	
FEET	NORMAL	

ATOMIC

ALL

DREAMRAIDER

"Solid freeride board suit intermediate rider'

Ben		
BEG	6	
INT	5	
ADV	5	
VALUE 6		
STYLE	FREERIDE	
PRICE	£330	П

154, 158,

ALL

React Snowboards are only available direct - phone +44 [0] 845 2269172

Team Rider & Photo: ANDREW HINGSTON

that will inspire any rider to go again and again... UK manufacturer of high quality snowboards

mos.ebreedwonetsear.www

FURY "Really hated the way it turned, bit of a plank" Nigel

BEG 3 INT ADV

STYLE FREERIDE PRICE £150 163

SEOM

FUSION

"Great brainners board but not for the pro" Pete

BEG	
INT	6
ADV	(5)
VALUE	6
STYLE	ALL-MTN
PRICE	£220
SIZES	154,160, 166

BEG

PNB2

"Plenty of pop and stable base for landing" Ben

INT	8
ADV	0
VALU	E 9
STYLE	ALL-MTN
PRICE	£150
SIZES	156

NORMAL

HEAD

NORMAL

INTELLIGENCE "Ok board but not sure about the microchip flex adjustment" Tony

BEG	6	
INT	6	
ADV	6	
VALUE 5		
STYLE	FREERIDE	
PRICE	£465	
SIZES	153,157, 162,167	

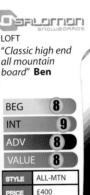

153, 156, 160

NORMAL

NORMAL

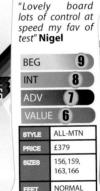

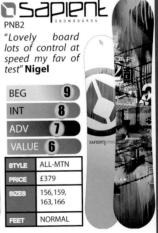

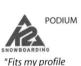

NORMAL

"Fits my profile perfectly I want one" Tony

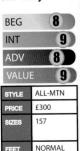

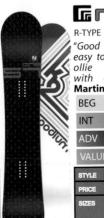

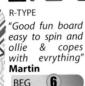

BEG	(6)
INT	6
ADV	8

VALUE (7)	
STYLE	ALL-MTN
PRICE	£350
SIZES	152
FEET	NORMAL

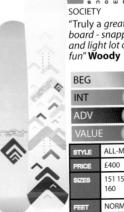

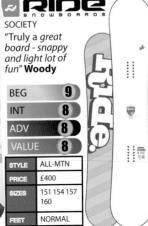

BRINGING SNOWBOARDING TO YOUR DOORSTEP

5C0T

SOLITUDE

"Nice in the turn and easv control" Nigel

BEG	1
INT	6
ADV	6
VALUI	5
STYLE	ALL-MTN
PRICE	£350

162

WIDE

		ride but is the extra	The second secon
	BEG	9	
ı	INT	•	
	ADV	9)	
	VALUE 6		
	STYLE	ALL-MTN	
	PRICE	£650	ı

NORMAL

"Good on the	and sturdy piste, could d in park"
INT	8
ADV	0
VALUI	[]
STYLE	ALL-MTN
PRICE	£370
SIZES	156

ZEPPELIN

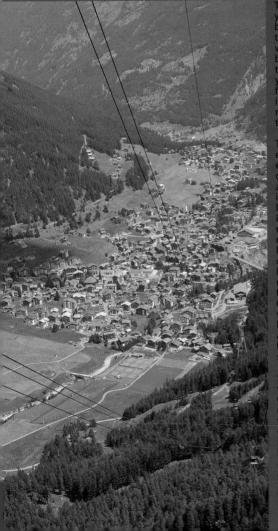

The first question is for yourself. What do you want from a board? Do you want it to be a soft ride, which will easily allow you board which will give you more spring in for the manufacture. What weight of rider is the board designed for? A board will than an 80 kg one.

NORMAL

of advice is that although most of us won't admit it, a board has to look good. Let's face like how it looks you're never going to buy it. But however cool the graphics are if the rides not right it's a total waste of your money, unless you're the type of rider who on the slopes. The only real way to know how a board rides, is yes, to ride it. Try to rent a board before you buy it, many manu-factures will have test centres in a resort. Or better still get yourself on a board test where there's many different manufactures. For a full review of the boards we tested and information on our next board test keep an eye on our website. www.world-snowboardguide.com

where we'd shared the slopes with future Olympian skiers and a group of seriously dedicated and very good local boarders, we climbed into our cars. Each tester had a different favourite board, from the test, and had exten feet. had eaten far too much cheese and drunk far too many beers. But one thing they all agreed on was they'd be back next summer, as there's nothing better than strapping next seasons board to your feet and either falling in love or filing for an immediate divorce. (HEIO WWW.WORLD GUIDE.COM 63

HOW TEST WORKED

We categorised every rider depending on their snowboarding experience and ability, and gave each rider a number of boards that matched their riding styles. Everyone was asked to fill in a questionnaire after testing a board, and the results were accumulated and averaged to give overall marks out of 10 for each ability bracket.

BEG

Beginners. You've been boarding a few weeks now, you can link turns on blue runs and are happy to take red runs and feather it down the steep bits. You're now thinking about buying your first snowboard.

INT

Intermediates. Blues, reds, bring them on, you've even taken a few black runs and are starting to pick up some speed. You've taken your first turns in powder, and headed into the park and can comfortably land small jumps.

ADV

Advanced. You're straight-lining down most pistes and only putting in turns when you really need to, nothing on the piste is now above you. Off-piste you're feeling confident and your freeriding is coming on nicely, and you can safely navigate trees. You're taking larger kickers and grabbing tricks and can spin, the rails haven't escaped, and you can 50-50 and board-slide them.

BIG THANKS

A big thanks goes out to all the people involved in making the test the smooth oiled machine that it was. Fabian Furrer at the Saas-Fee Marketing office, Susanne Voide-Dillitzer from Saas-Fee tourist office, the Saas-Fee glacier team (lads get some skidoo lessons) Chris and Santina from Hotel du Glacier, all the manufactures reps especially Ed from Board-Life whose continued support is well apriciated, and lastly the test team without whose help the test would never have happened

FURTHER INFORMATION

Saas-fee resort - www.saas-fee.ch Hotel Du Glacier - www.duglacier.ch

www.reactsnowboards.com www.atomicsnowboarding.com www.ridesnowboards.com www.k2snowboards.com www.burton.com www.scottusa.com www.sapientsnowboards.com www.ridehead.com www.salomonsnowboard.com www.automatonsnowboard.com

It's been snowing non-stop all week, now when you look outside there's not a cloud in the sky. All you can see, as you stumble back from the pub, is a moon lit untouched powder field stretching as far as the eve can see. Great, or is it? The next thing you know its 4:30 in the morning and some holiday rep is rapping on your door, telling you your holiday is over, and shift your arse on to that coach, "Bollocks" you grunt from under the duvet. So, what are you going to do? Get a job, which pays much cash and gives you loads of free time? Well if you find it let me know.

To avoid such terrible moments in one's life, there is only one realistic thing to do: a season. Doing a season is the only real way for most of us to improve our boarding, and also never miss out on all those fresh powder days.

So how are you going to do this season? Work or be a bum? Do it in Europe or North America, Argentina or New Zealand? There are loads of things to think about before doing a season. Just taking any old job, could see you stuck pouring pints all day or counting yellow gondolas while holding a four year old's hand, whilst thinking of everyone else in the powder. "Oh look, another yellow one". So before you take a job, find out what your hours are.

There are two main channels open for you: you either get a job for a tour operator or in North America the resort i.e. hotel work-chalet person, chef, bar work, dish pig (washing up), or you get a job on the slopes as a lifty or instructor.

There is a third option, boarding. This is only open

to those lucky ones who are sponsored by the like of Burton, or Ride and spend their time jumping out of helicopters with their mates who are filming them. Becoming a sponsored rider is done by competing and getting yourself noticed, and the only way to do that is to be a child prodigy, or do seasons, get good and enter those comps. As for taking pictures or making films, well it's the same deal as the riders. be talented, do seasons, and put a good portfolio together.

Tour Operators

Working for a tour operator is a good first time step into working seasons. They will get you to the resort, give you accommodation, feed you, supply you with a snow-

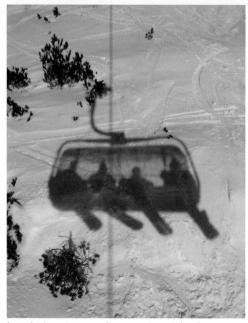

board, give you enough money to get drunk once a week, and most importantly give you that expensive Lift Pass.

This all sounds great, but what they will do is squeeze you into accommodation tighter than beans in a tin, send you to a hire shop that will try to palm you off with kit that was out of date in the 90's, work you hard and long for your beer money. Often they will even ask you for a deposit for your lift pass, which is returned at the end of the season. Having said all that, it's still good starting off point. Contact all the Tour Operators in the summer as they normally start hiring around September. They'll ship you out to the resort in the beginning of December, and expect you to work until the end of April with one day off a week.

Working For A Resort

Unlike Europe where resorts were built on land once owned by peasant farmers who suddenly became very rich when the snow sports industry was born, the resorts of North America are owned by one company. So there are no complications with someone owning the land while some else owns the lifts and someone else owns the hotel etc. Big White in Canada for instance rents the land from the Government and owns everything that's been developed there. Therefore the job options are great, from bar to bin man, from catering to cat driver. Again, contact resorts in the summer if looking for work the next season.

Resort Bum

Many people just turn up in a resort and look for work. This can be good but of course you either need a friend with a place for you to sleep or some money to keep you going. The best thing to do is go there in November or very early December if you want to rent accommodation for the season. If you're looking for work with a Tour Operator in the Northern Hemisphere, it's best to leave it until after the New Year as most operators start the season fully staffed.

By the New Year some people start to realise a season away is not for them, and run home to Mummy, leaving you a sweet job to take, having missed out on the hardest part of the season-getting set up. If you

do have your own pad, then companies are always looking for Transfer Reps on change over days. You just have to take people to the airport at the end of their holiday and pick up the new lot. If you have your own car, then there's cash to be had offering private airport transfers, but just watch out for angry local taxi drivers. There's also often random part time bar or kitchen jobs and you can always rely on other friendly resort workers to help you out with the odd meal here and there. The biggest draw back of going it alone is you'll have to buy your own lift pass and pay for accommodation. Also it doesn't matter how skint you are, anyone out there mine sweeping (stealing beers) in the bars is low, and I hope you get some nasty mouth scabs.

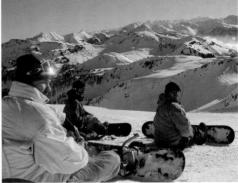

On The Piste

For almost all jobs on the slopes you'll need to be well qualified. One which is achievable for most of us is an Instructor Qualification. Courses are run by many organisations and you should check with governing bodies for affiliated members. UK www. basi.org.uk. Canada www.casi-bc.com USA www.aasi. org New Zealand www.nzsia.net .

Before you take a course find out where your resulting qualification will be valid. Instructing can be well paid, although not always. It's great to see people progress on their boards, and it can give you a real buzz introducing our great sport to new people.

The down side is that if you have a lesson booked, you have to work: whether its -20, pissing with rain, or worst of all you may find yourself watching your mates getting fresh tracks while you are picking a beginner up off their arse on a green slope, but at least there's no toilets to clean.

Whatever job option you decide upon, "Doing a Season" will be one of the best things you've ever done. Loads of boarding, loads of partying, and loads of likeminded people. But remember loads of work too.

NATIVES.CO.UK

Fancy working a season in the Alps? 100's of vacancies, including Bar, Rep, Hotel and Chalet work.

> web: www.natives.co.uk 08700 463377 email: jobs@natives.co.uk

natives.co.uk

the uk's no.l ski job website

RESORT REVIEWS

We've split the resort information into sections covering mountain, snow, facilities/prices. terrain, and location and contact.

LINKED AREAS

We don't see any point in displaying the stats for an entire linked area. We'll tell you that its linked and how big the area is, but we try and keep things local. There's little point telling you of a park that will take you half a day on lifts to get to, so we usually try and keep the stats and reviews local. So you'll often find we cover lots of resorts separatlely that make up the linked area.

MOUNTAIN STATS

The total ride area is either given in KM's as the length of the combined length of the pistes, or in acres as the whole boardable area. Generally the Europeans like the piste lengths, and the US go for mountain size.

Pistes are broken down into easy, intermediate and advanced slopes. To standardise between US and European styles, we combine Green and Blue slopes and call them easy. Red's are intermediate, and black slopes advanced. Again, the US like to break things into blacks and double blacks, but we lump them together to standardise. The percentage of slope each distinction indicates the proportion of slopes designed for that purpose.

PRICES

All lift pass prices unless stated are for an adult, and for peak season. You can expect to pay up to 25% less for lift passes during the early and late season, when not all the slopes will be open. They also tend to ramp up prices during public holidays, so watch out for that one. Lessons and rental charges stay the same throughout the season.

All the prices quoted are for the 2006/7 season, you can expect prices to rise roughly 5% per season.

TERRAIN

We split the reviews intp Freeride, Freestyle, Pistes and Beginners. There is also a little graph showing how good we think a resort lends itself to a particular style (shown to your right). The higher the Freestyle bar the better the terrain park or the more the opportunity to find good natural terrain.

SNOW

Where possible we give the average annual snowfall that a resort receives. This is a very vague figure, as it depends where on the mountain you measure it, so it is only useful as a guide. Artificial snowmaking allows resorts to open earlier and stay open for longer. Resorts employ snow cannons and other machinary to achieve this, but rather than give numbers we show how many pistes snowmaking can cover.

THE RATING

Overall ratings are very subjective, but the most important thing to consider is snowfall. No snow turns a 10 resort into just a hill. Aside from that we think a resort that earns a 10 is able to satisfy ever boarder

with a combination of the mountain and the resorts services. All resorts have something new to offer, and while a a rating of 6 may not sound very good, it will offer something for most riders except the more advanced, but please take them with a pinch of salt!

COUNTRIES

There's some pretty self-explanatory information on each of the country pages. We've included some very rough currency conversion information, it was correct at the time of going to press, but will change.

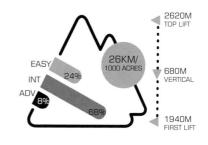

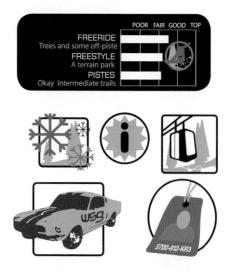

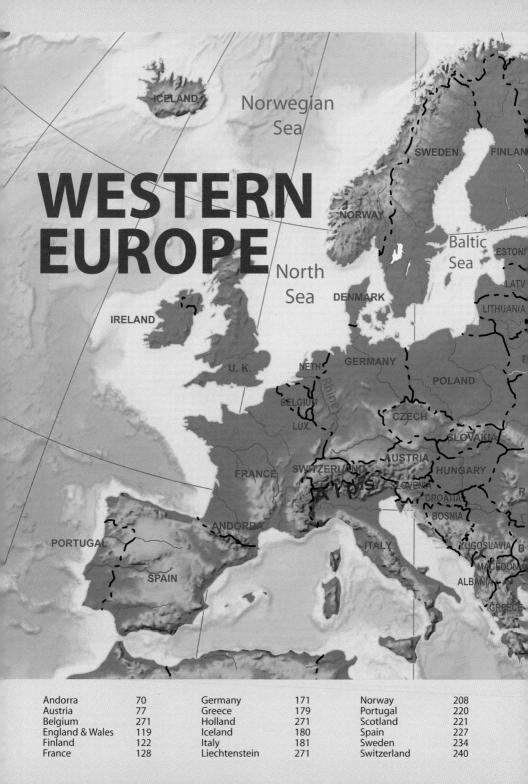

ANDORRA

Andorra is a self-governing principality under the joint sovereignty of France and Spain, and is known as the cheap snow-package tour centre of Europe. The resorts have spent time and money shaking off its cheap and tacky image, and Andorra now offers much more in the way of quality and services, although this has come at a price. Costs have increased over the years and the lift passes compare with some of the most expensive in Europe. Nonethe-less, although bar and restaurant resort prices are by no means cheap, the place is still a duty-free tax haven so you'll still pay less for your booze and eating out than you would in Alpine resorts.

Andorra has a number of very small resorts that are ideal for total beginners and just okay for intermediates on a three day visit. As has happened across much of Europe, the big thing is to offer a combined lift pass that covers many resorts, stick a few more euros onto the bill, and hey presto you now have a resort with a beast lift system offering hundreds of kilometres of pistes. Andorra now has 2 such super areas, Vallnord and Grand Valira, Vallnord (89km

pistes) covers the resorts of Pal, Arinsal, Ordino and Arcalis. The Grand Valira (193km of pistes) covers the resorts of Pas de la Casa, Soldeu, El Tarter, Grau Roig, Canillo and Encamp.

In general, though, there's very little challenging terrain for expert riders, or at least nothing that won't take more than a few hours to tackle and a week here will bore the tits off any rider who likes to ride steep, fast and challenging terrain. However if you're a beginner or intermediate rider then there's plenty to keep you smiling.

All the areas are located within a short distance of each other and can be reached via France or Spain. Andorra itself doesn't have any airport so the nearest international airport is Barcelona, or fly to Toulouse in France. There are regular bus services from both airports going to Andorra but transfer times can take up to 4 hours. There are some smaller airports such as Pau, Perpignan and even Zaragoza that many budget airlines fly into but you'll have to make your own arrangements once you land.

CAPITAL CITY: Andorra La Vella POPULATION: 69.865

HIGHEST PEAK:

Coma Pedrosa 2946m

LANGUAGE: Catalan-Spanish-French

LEGAL DRINK AGE: 18

DRUG LAWS: Cannabis is illegal and frowned

AGE OF CONSENT: 16

ELECTRICITY: 240 Volts AC 2-pin

INTERNATIONAL DIALING CODE: +376

CURRENCY: Euro **EXCHANGE RATE:**

1.5, US\$1 = 0.8, AU\$1 = 0.6, CAN\$1=0.6

All vehicles drive on the right hand side of the road

SPEED LIMITS

In towns 40kph

In rural areas 70kph

EMERGENCY

Police/Ambulance Service - 17

Fire Service - 18 TOLLS

None

DOCUMENTATION

Driving license, insurance and vehicle registration, along with your passport.

TIME ZONE

UTC/GMT+1 hour

DAYLIGHT SAVING TIME: +1 hour (March

OFFICE DE TOURISME DE LA PRINCI-PAUTÉ D'ANDORRE

Director: Sr. Enric Riba 26, avenue de l'Opéra - 75001 Paris Tel.: (01) 42 61 50 55 E-mail: OT_ANDORRA@wanadoo.fr Web: www.tourisme-andorre.net

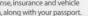

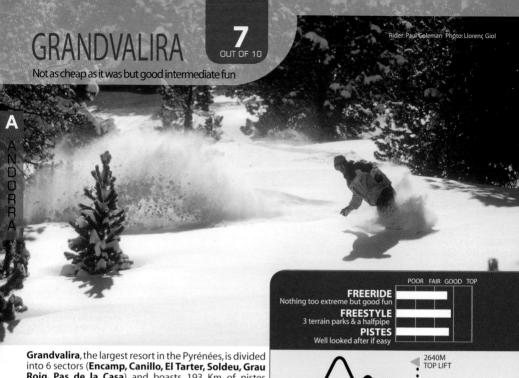

Roig, Pas de la Casa) and boasts 193 Km of pistes serviced by 64 modern lifts, 3 terrain parks, 1 half pipe, 2 permanent boardercross tracks and 4 off-piste routes accessed by a piste-groomer tow service.

The newly installed lifts are fast and efficient, resulting in minimal queuing and short uplift time. The terrain opened up by these lifts also means that there is plenty of accessible off-piste for all levels, with some great tree runs around the Soldeu and Canillo area.

Snow conditions have been exceptional over the past few winters, often surpassing those of the Alpine resorts at certain times of year. You won't experience the depth of snow that falls elsewhere, but it tops up frequently and the slopes are maintained in fantastic condition by the groomers who prepare 100% of the slopes every night.

There are snowboard school centres in each of the sectors but Soldeu is well known for its many native English speaking instructors qualified to teach snowboarders up to a high standard. Many snowboard school clients return to the resort year after year due to the good quality of the lessons

FREERIDE. While the terrain is not the most challenging for experts, there's plenty to do for snowboarders, with some good freestyle areas, miles of runs to discover and interesting off-piste to explore. What Grandvalira really lacks is long steeper runs which offer a challenge to more advanced riders.

With the ability of skiers and boarders here being relatively low, the off-piste tends to get tracked out slowly and it's not uncommon to come across great untouched

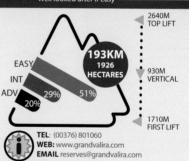

WINTER PERIOD: mid Dec to mid April LIFT PASSES

Half-day 27 euros, Day pass 37, 6 Days 180, Season 748 **BOARD SCHOOLS**

Lots but Soldeu has some dedicated English speaking instructors

TOTAL NUMBER PISTES/TRAILS: 110 LONGEST RUN: 8km

TOTAL LIFTS: 64 - 1 funitel, 3 Gondolas, 30 chairs, 25 drags,

LIFT TIMES: 8:30am to 4.00pm LIFT CAPACITY: 87,000 people per hour

ANNUAL SNOWFALL: unknown **SNOWMAKING:**35% of pistes

5 magic carpets

TRAIN: take train from Sants train station in Barcelona to Puigcerdà. Take a bus from La Cerdanya

BUS: Bus services from airports take 4 hours. FLY: Fly to Toulouse, or Barcelona, both 3 hours away.

TAXI: +(376) 86 30 00

CAR From Barcelona take the A18 a Manresa, C1411 Cadí, through the Tunnel (toll 9 euro) to Puigcerdà, Porté Puymorens to Pas. Take the Envalira Tunnel to access to Grau Roig and Soldeu

NEW FOR 2006/7 SEASON: The old Soldeu chairlift is being replaced with a spanking 6-seater.

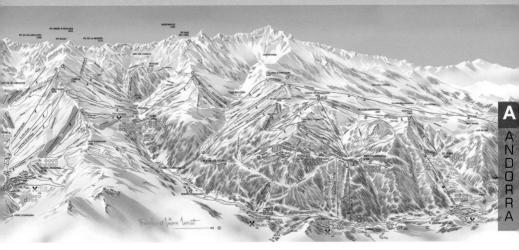

powder runs several days after a dump!

Soldeau has the best terrain in Andorra, especially for off-piste. The unpisted runs graded black and red, running down from the summit area of Pic D'enc Ampadana, are good freeriding areas. The trail starts off in a fast open section before dropping through a thick tree-lined area. For something to suit a novice rider, the red run that descends from the main summit, through the open expanse of the Riba Escorxada, is cool.

Over in **Grau Roig** there's some reasonable freeriding areas. From the summit take the main run down the hill and across the top of the black run, where you will find some okay powder fields.

FREESTYLE. The main terrain park is located in El Tarter. Here you'll find a small beginners' area, a well maintained halfpipe, rails and boxes of varying difficulty, and a selection of kickers and other jumps from challenging to the totally insane!

If this park is a bit too much for you there is a beginners' freestyle area at Pas de la Casa and a great intermediate freestyle run in the Grau Roig sector.

Away from the dedicated freestyle areas it's possible to find many small to medium sized cliff drops, gullies and rocks, but don't be expecting anything on Alaska scale! These mountains just aren't big enough. Backcountry kickers and step-ups do get shaped occasionally by the locals, get chatting to the snowboard instructors or park staff to find out where.

The resort hosts many freestyle competitions over the season culminating in the Total Fight Masters of Freestyle held in April. This event is part of the Ticket to Ride circuit and attracts many international pro riders. Hanging out in the park you may cross paths with local pros of the calibre of current British champ, Tyler Chorlton, or ex-British champ, Jamie Phillp, who are both based here.

OFF THE SLOPES

When looking for accommodation it's possible to find something to suit every budget. Encamp and

Canillo are cheap but lack atmosphere

As far as après and nightlife is concerned then look no further! Andorra is about a fun, friendly and no attitude atmosphere. The connected areas of Encamp, Canillo and El Tarter are a lot quieter and although may be cheaper for accommodation, will mean finding transport if partying is high on the

For those looking to experience activities other than snowboarding, there's plenty on offer. The Adventure Activities Centre in Grau Roig provides various options such as Husky dog-sleigh rides or snow shoe excursions, and there are others such as the newly opened spa centre or night-time snowmobile trips both available in the Soldeu village.

Soldeu certainly offers more charm and is a prettier village in general to Pas. In El Tarter look up the English run Hotel Alba for reasonably priced accommodation with a great restaurant. In Soldeu try the also English run Hotel Roc de Sant Miguel for cheap and cheerful accommodation, or at the other end of the scale check out the Hotel Sport Village, an

amazing complex overlooking the mountain just a stone's throw from the gondola. Even in a top end hotel such as this one, it's possible to get great low season last minute deals through tour operators.

Soldeu offers a less cheesy approach with some great live bands and excellent dj's. The *T-Bar* is a favourite with local boarders and holidaymakers alike, and is also the official venue for the resort famous Snowboard School parties on a Thursday night. Also try the *Avalanche* for its good selection of dj's, *Fat Albert's* for its very talented live bands, or the *Pussycat Club* for busting shapes on the dancefloor later in the night.

PAS DE LA CASA

Pas de la Casa has more of a French vibe to it and attracts a young crowd but be aware as it's still viewed by many as tacky resort with little character. For accommodation try the Hotel Bell Roc for a good deal or Hotel Font Argent for something more upmarket. Pas de la Casa is known for its mad nights of bar crawl style partying, the bars and clubs are easy to find but two of the best known are KYU and Billboard.

OVERALL

Don't be put off by precon-

ceptions. The areas forming Grandvalira have changed immensely over the years with a lot to offer and are attracting a different level of clientele. If you're looking for a fun, friendly environment with good snow conditions and plenty of snowboarding options then it's well worth a visit. Not as cheap as it used to be but still beating Alpine resort prices on many fronts. In fact, the only reason not to come here is if you're an extreme rider looking for some serious vertical drop or you require the glitz and glam of some of the more posy snowboard destinations.

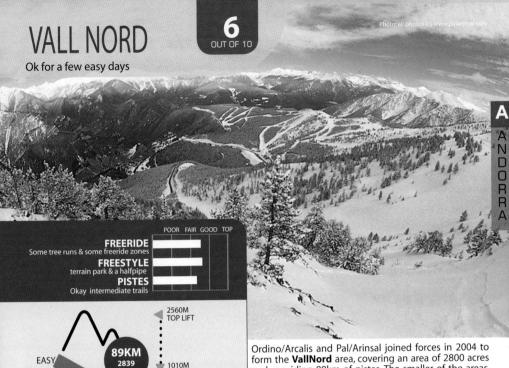

1550M FIRST LIFT TELEPHONE: Pal: 00 376 737 000 / Arcalis 00 376 739 600 WEB: www.vallnord.com

ACRES

VERTICAL

WINTER PERIOD: Dec to April LIFT PASSES

Half-day 23 euros, 1 day 30, 5 days 117 euros 6 days pass to all Andorra resorts 153 euros season 600 euros

BOARD SCHOOL

Group lessons 2hrs 18.40, 4hrs 33.50 euros

SNOWMOBILES

28/42.50 euros for 15/30 minutes. Evening trips 80euros for 1hr

TOTAL NUMBER PISTES/TRAILS: 66

LONGEST RUN: 6km

TOTAL LIFTS: 28 - 3 cable-cars, 1 Gondolas, 16 chairs, 17 drags, 4 magic carpets

LIFT CAPACITY: 50,200

LIFT TIMES: 9am to 4.00pm

ANNUAL SNOWFALL: unknown SNOWMAKING: 371 snow cannons

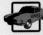

CAR From Barcelona take the C-58 motorway to Terrassa - E-09 motorway to Manresa - C-16 to the Cadí Tunnel (toll)-N-260 road through Bellver de Cerdanya as far as La Seu d'Urgell-Take the N-145 towards Andorra to the border-Andorra La Vella-Escaldes-La Massana. Take the Arinsal turn

FLY Closest airport Toloda (150km), Barcelona (200km) BUS Bus services available from most towns in France and Spain. Eurolines, tel (34) 93 490 40 00, run 4 services daily from Barcelona Daily service from Toulouse (33) 562 151 809 9 services daily from Andorra la Vella to Ordino. 0.90 euros

TRAIN L'Hospitalet près l'Andorre in France is 8km away. Puigcerdà in Spain is 60km away.

form the VallNord area, covering an area of 2800 acres and providing 89km of pistes. The smaller of the areas, Ordino/Arcalis, is not lift linked to the rest of the area so you'll need to take a ski-bus to move around.

ORDINO/ARCALIS

Ordino/Arcalis is the least known, least visited, and most remote of all Andorra's resorts. It's a fairly undeveloped area, and doesn't come with the immediate resort facilities demanded by tour operators and skiers. The 18 miles of snow-sure terrain is perched much above the tree line, and offers some of the best terrain in the whole principality, with a small number of modest but quite difficult trails. All styles will find that a day or two here is not a waste of money, but hardcore riders will soon get bored.

FREERIDERS There are some nice spots for intermediate freeriders to check out, and a special marked freeride area within the resort boundary.

FREESTYLERS There's been improvements to the resort and since 2003 they've added a small park with a few kickers and rails in, but it's not always kept in top notch condition. You'll find it between the La Portella and La Portella del medio pistes. You'll find a better park and halfpipe over at Pal

BEGINNERS. One thing the slopes do offer, is excellent areas for beginners, with easy to reach trails, that make up some 55% of the snowboard area.

OFF THE SLOPES local facilities can be found in Ordino which is about 10 miles or 16 km away. What you get is very dull, but there's a reasonable selection of restaurants. There's a bit more life in nearby La Massana

PAL

Pal and Arinsal are two villages linked via the Teleferic Arinsal-Pal Gondola. Nearby village La Massana is now also linked to the area via gondola.

Pal is a slightly bigger and better resort than that of its near neighbour Arinsal, it has more interesting terrain than Arinsal and is not quite as rowdy both on and off the slopes. The area is, however, a place for total novices and slow learning intermediates with 90% of the terrain graded blue and red.

There's absolutely nothing of note for advanced riders, no matter your style of riding. Only 10% of marked-out trails are black, and even some of these are over-rated, especially if you can ride at a competent level. Most riders will have the whole joint licked in the time it takes to smoke a good joint.

FREERIDERS. Easy-going freeriders will find some wooded areas around **Comellada** that on a good day allow for some off-piste through the trees

FREESTYLERS may find the odd log to grind, but that's about all unless you head over to the park in Arinsal

BEGINNERS have nearly the whole place to roam around with a degree of total ease.

OFF THE SLOPES Pal has very basic local services a few miles away.

ARINSAL

Arinsal is a small resort with very basic terrain,

perfect for a group of beginners on their first snowboard holiday, but nothing much for the advanced freerider. There is a terrain park and a halfpipe in its favour, and it links with the resort of Pal enabiling you to escape the place with ease.

FREESTYLE. Theres a 10 acre terrain park serviced by the Les Fonts chair lift. The terrain park has a number of boxes, rails, kickers, spines and a good size booter. Its also home to a 110m halfpipe and a boardercross circuit.

FREERIDE. The resort has a small specialised freeride area at the **Alt de la Capa**

OFF THE SLOPES. Small compact, and everything you need especially if its booze you're after. There are a number of rowdy bars, free pouring the spirits, and a disco. Its not exactly international 5* cuisine, but there is a Mexican and Chinese restaurant. You can also stay in **La Massana** which has a few good bars to pick from.

AUSTRIA

Austria is known as the snowboard capital of Europe with great resorts and a cool attitude. Their resorts aren't stretched out like the mega-sized places found in the French Alps and apart from being far more affordable than France, the slopes here are far better laid out with excellent mountain facilities, modern lift systems, easy access to the slopes, coupled with great traditional local services.

Of all the areas in Austria the most famed and the largest winter destination is the Tirol, which apart from being at 'the heart of the Alps' is also an area of outstanding beauty and home to some fantastic snowboard resorts that offer something for everyone. The Tirol resorts are spread across huge valleys, so you'll find Oetz, Solden, Obergurgl in the Otzal valley, and Zell am Ziller, Mayrhofen and Hintertux in the Zillertal Valley. So although you can see Pitzal quite clearly from Solden, getting to it will involve driving 60km into the next valley.

What really sets Austria apart from its neighbours though is their après-ski. This will work in one of two ways, you will either fall in love with it and congo around the bars until you fall on your face, or you will never come back. Its pretty much the norm to see people taking a beer before the first gondola in the morning. Lunch will obviously involve a schnapps or two, and then at 4pm the umbrella bars will fill up on the slopes and hoards of party goers will sing their heads off to the worst Euro pop whilst getting absolutely blind drunk. Oh yeah, and then at 7pm you have to board back down to the resort, probably collapse and wake up ready for the first lift, to do it all again.

ACCOMMODATION

The Austrian's don't go in for the purpose-built style resorts so common in other parts of Europe. Here there are old traditional villages adapted to accommodate modern tourists. Standards for accommodation are extremely high, and family run pensions are popular, and cost upwards for 30 euros per night. Most bookings work from Saturday to Saturday, so it can be tricky to arrange a weekend as many operators will be reluctant to split weeks. If you arrive in a resort without accommodation and the tourist information is closed, then take a wander around and look out for "Zimmer" signs outside pensions which indicate if there are any rooms available.

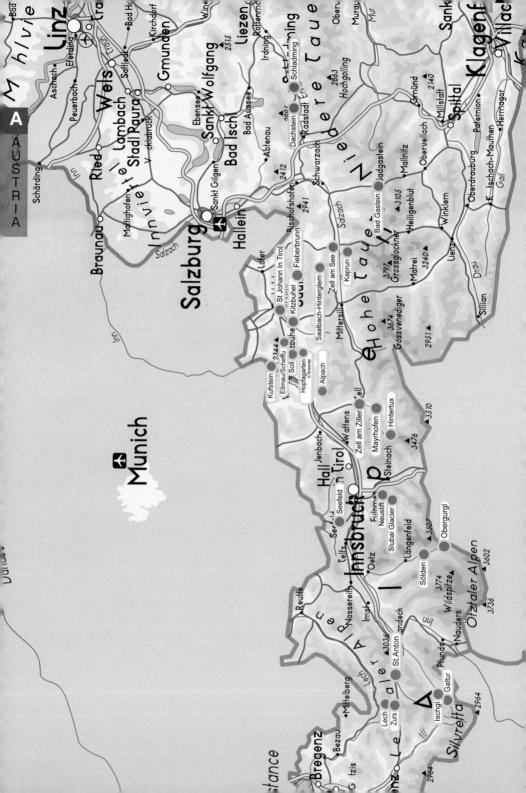

FOOD

Austrian cuisine is pretty basic, stodgy and rarely involves vegetables. You'll find dishes like Tafelspitz (boiled beef), schnitzel (Veal in breadcrumbs) or various cured hams and German-style sausages. The Tyrolean's go in for sweet and savoury dumplings in a major way. Goulash soup in this part of the world is wicked, but not so hot if you're sharing a room. A Tyrolean Gröstl is a great hangover cure (fried potato, bacon, herbs, and cheese with a fried egg on top) but can severely limit your afternoons boarding. One thing you will find is that Austria does lack is fast food joints. The major towns with have the golden arches, but while most resorts will have a take-away you'll be pressed to find one open when you stumble out of the clubs after 2am.

MONEY

It's bizarre that Austria still isn't comfortable with credit cards. Large hotels and some restaurants will take cards, but have a wad of euros or travellers cheques with you as it's certainly not the norm. There are increasing numbers of ATM machines in most resorts which will accept most foreign cards.

TRAVELLING

Innsbruck and Salzburg are the major air gateways into the country, Klagenfurt is the budget offering. However it's often a lot easier and cheaper to get a flight to Germany (Munich or Friedrichschafen) or Switzerland (Zurich) and use the excellent road, bus or train services to your destination. Most resorts are within a short distance from a train station and first-class local bus services can connect you to the resort.

Driving in Austria is convenient and easy, with the roads and resorts being well sign-posted. In some parts, snow-chains are required. Austria has a motorway tax called the Vignette which can be purchased at petrol stations near the borders. If you are caught without the tax, you'll be liable to a costly on-thespot fine, it costs 7euros for 10 days use. If you're driving from Germany, watch your speed as you cross into Austria as attitudes change and fines add up!

WORKING

If you are planning to do a working season in Austria, then EU nationals don't need either a visa or work permit and can stay for as long as they want. But if you want to teach snowboarding, you may need to have the relevant Austrian snowboard instructors teaching qualifications, and speaking fluent German is a given. There's 3 month courses teaching German and Instructing starting October in Kitzbuhel

CAPITAL CITY: Vienna POPULATION: 8.2 million

HIGHEST PEAK: Grossglockner 3797m

LANGUAGE: German **LEGAL DRINK AGE: 18**

DRUG LAWS: Cannabis is illegal and frowned upon **AGE OF CONSENT: 16**

ELECTRICITY: 240 Volts AC 2-pin

INTERNATIONAL DIALING CODE:

CURRENCY: Euro **EXCHANGE RATE:**

UK£1 = 1.5US\$1 = 0.8AU\$1 = 0.6CAN\$1=0.6 DRIVING GUIDE

All vehicles drive on the right hand side of the road

SPEED LIMITS:

Motorways-130kph (81mph Highways-100kph (62mph Towns-50kph (31mph)

EMERGENCY Fire - 122

Police - 133 Ambulance - 144

Payable on motorways and some bridges. Austrian vignette for driving on the motorways costs 7.6 euros for 10 days, available from most garages.

DOCUMENTATION

carry driving licence, vehicle registration document and certificate of motor insurance. Photo ID needed

SEATREITS

Seatbelts front & back must be worn.

TIME ZONE

UTC/GMT +1 hour DAYLIGHT SAVING TIME: +1 hour (March

- December)

fax. 0043 512 34 38 48 / 31 Email:info@powdern.com Web:w ww.powdern.com

THE AUSTRIAN NATIONAL TOURIST

OFFICE Vienna, Margaretenstr. 1 A-1040 Wien Phone: +43 (0)1 / 588 66-0

Fax: +43 (0)1 / 588 66-20 www.austria-tourism.at

USEFUL WEB LINKS

www.tiscover.com www.innsbruck-tourismus.com

BUS The PostBus run a number or services to many resorts across Austria, www.postbus. at +43 (1) 71101

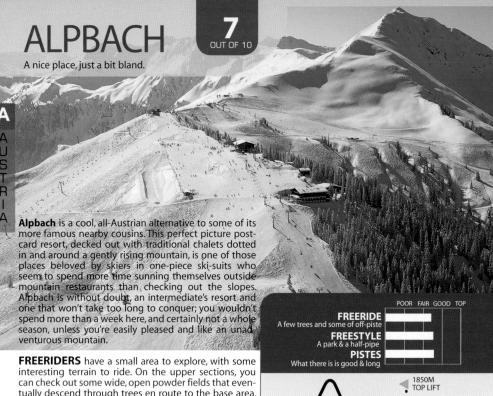

tually descend through trees en route to the base area. Advanced riders will find that the few black runs are not to be treated with arrogance. Unpisted routes from Loderstein back to the gondola station, give freeriders in soft boots a great time, as do the runs around the **Wiedersbergerhorn**, which often have excellent powder.

FREESTYLERS fed up with looking for natural hits, should make their way to the halfpipe and fun-park, located on **Gahmkopf**, where grommets can take their frustrations out in this average play area.

PISTES. Boarders with a pair of hard boots will love Alpbach. It's a full-on carver's resort, with wide pistes devoid of any trouble spots. Although there isn't an abundance of pisted runs, what is available is well looked after, and easily negotiated.

BEGINNERS have a great learner's mountain. There are some perfect flats around the base areas to start out on, with excellent wide, open novice trails up in the Skiweg area.

THE TOWN

Alpbach offers some slope side accommodation with the bulk of beds available within easy reach of the village a two minute bus ride from the base lifts. Being a resort used by package tour operators means that on the one hand, the place can become very busy, but on the other, some cheap package deals are available. The village is a relaxed affair offering a number of restaurants. swimming and skating. As for night-life, apart from a few bars, you won't find much to shout about.

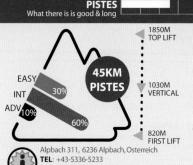

WEB: www.alpbacher-bergbahnen.at EMAILI:info@alpbacher-bergbahnen.at

WINTER PERIOD: Dec to April LIFT PASSES

Half-day pass 22,50 euros, Day pass 28,50, 6 Day pass 132 RENTAL

Schischule Alpbach charge 44 euros for a day lesson (4hr) or 5 days for 120. Private lessons 145 euros for 4hrs

NUMBER PISTES/TRAILS: 16 LONGEST RUN: 8km

TOTAL LIFTS: 21-3 Gondolas, 7 chairs, 11 drags

LIFT TIMES: 8:30am to 4.30pm LIFT CAPACITY: 20,450 people per hour

ANNUAL SNOWFALL: 6m SNOWMAKING:70% of pistes

FLY:to Innsbruck (60km), 50 minutes transfer time. Munich 170km, Salzburg 150km

CAR: From Innsbruck head east along the A12 and take Kramsach exit and drive for a further 9km to resort.

BUS: direct from Innsbruck airport.

TRAIN: fast trains to Wörgl or Jenbach then change to local railway for Brixlegg

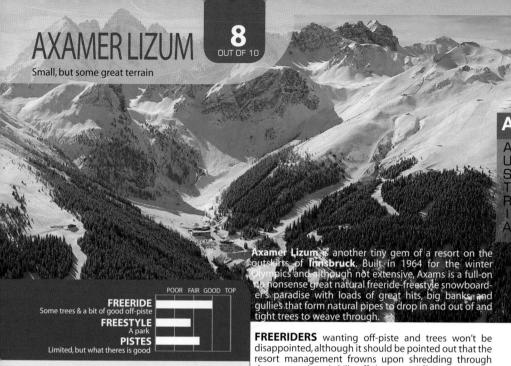

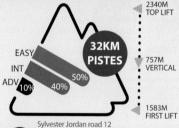

A-6094 Axams

GENERAL INFO:+43 5234 68178 WEB: www.axamer-lizum.at EMAIL:verkauf@axamer-lizum.at

WINTER PERIOD: Nov to April LIFT PASSES

Half-day pass 17,5, Day pass 23.50, 5 Day pass 99 euros **NIGHT BORADING**

LONGEST RUN: 4.3km

TOTAL LIFTS: 10 - 1 Funicular train,5 chairs, 4 drags LIFT CAPACITY: 12,042 people per hour

LIFT TIMES: 9am to 4.00pm **MOUNTAIN CAFES: 2**

ANNUAL SNOWFALL: 1.7m SNOWMAKING: none

FLY: to Innsbruck International transfer time 25 mins. Munich 2 1/2 hrs away

BUS: Ski buses from Innsbruck train station hourly for Axams and back again (45min journey). Bus services also from Munich to Innsbruck.

TRAIN: to Innsbruck International transfer time 25 mins. Munich 2 1/2 hrs away

CAR: Drive to Innsbruck via motorway A12. Axamer Lizum is 15 miles (24Km). Drive time is about 20 minutes

the spruce since it kills off the trees. Off-piste terrain is limited, but if you get the conditions, great powder can be ridden without a trek. There's a great area if you go right at the exit point off the funicular train, and follow the line of reds, Trail 4 and 3. There's also a cool powder run back under the funicular. Riders already past the novice stage and with a few bruises under their belts will be able to collect a few more down Trails 5 and 5a. Experienced riders can go for it down the blacks on Piste 10 where the trail is on a bumpy, steep run, and is not the greatest descent in the world. When snow permits its possible to board to Gotzens but you're going to need someone to show you the way.

FREESTYLERS looking for the best hits should take the funicular train to the top, and then follow the Number 1 blue run off to the left, which will bring you out onto a really cool mixture of red runs, with the best hits on Run 2. The terrain park is located at the base area and reached from the beginner's T-bars or by hiking up. The terrain parks been upgraded but still not huge, there are a couple of decent sized kickers and some rails and boxes, but with such good natural terrain, you don't need man-made hits.

BEGINNERS having their first go at snowboarding can loosen up and get to grips with the basics, on easy trails located at the base area just up from the ticket booths. The only drawback is that the easy slope is serviced by two T-bars, which may cause shy ones a few problems at first, but not for long.

OFF THE SLOPES. Staying slopeside is not recommended, unless you're a hermit. The village of Axams is only a few miles away and has a decent selection of local services, which include a few shops and a sports centre. However, the best option is to stay down in **Innsbruck**.

Bad Gastein is an old Austrian spa town that is located in the middle of the Salzburg region along the Gastein Valley and perched up at a height of some 1080 metres a short distance from the village of Bad Hofgastein. What you have here is a relatively unknown but large ridable area which is basically split into four resorts that although each are similar, they never the less offer something different. Collectively you have over 200km of marked out piste to ride though it should be pointed out that not all the areas or pistes are linked up by lifts. So study the local piste maps to ensure that you don't have any problems finding slopes and lifts. Overall this is an area that predominantly favours intermediate riders with an excellent choice of cruising runs to enjoy. Bad Gastein gives direct access to the slopes on the Stubnerkogel, Sportgastein and higher up to the summit of Kreuzkogel. You can also gain access via Bad Gastein to the half dozen or so runs on the Gravkoel where you will find some decent trees to shred. Bad Hofgastein and the area known as **Dorfgastein** are two other locations where you can do some cool riding.

FREERIDERS can basically pick and choose from any one of the areas in order to have a good time. The collection of slopes on the Dorfgastein are okay for freeriding.

FREESTYLERS might not embrace this place with its rather dull freestyle appeal. However, you will still be able to find some good hits and be able to catch some big air.

PISTES. Carvers will possibly like this place the most no matter which area you select. The whole area is littered with good pisted cruising runs, especially the runs up on the Stubnerkogel area.

BEGINNERS should think about choosing another resort as this is not really a hot place for learning snowboarding.

OFF THE SLOPES, Bad Gastein is a glamorous joint with okay services but dull night-life. Off the slopes, hotels chalets and other local facilities are in abundance but not very convenient to all the slopes and other areas. Having a car around Bad Gastein may be a good idea, local transport is not hot. Accommodations options within the area are not overpriced and cheap budget priced lodgings are easy to find. Eating out options are not mega in terms of the types of places, what you have is a lot of hotel restaurants selling much the same style of food. As for a good lively night out, forget it.

82 USQ WWW.WORLDSNOWBOARDGUIDE.COM

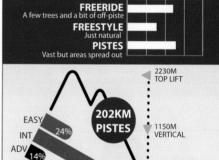

POOR FAIR GOOD TOP

1080M

FIRST LIFT

Tourismusverband Bad Gastein Kaiser Franz Josef Str. 27, 5640 Bad Gastein, Austria

TEL: +43 06434 2531-0

WEB:www.boardgastein.com / www.gastein.com EMAIL:info@skigastein.com

WINTER PERIOD: Dec to April

LIFT PASSES Day pass 37 euros, 2 Day Pass 71.50 euros 6 Day Pass 176 euros

NIGHT BOARDING Wednesday from 18.30 to 21.00 on Buchebenskiwiese area

LONGEST RUN: 8km

TOTAL LIFTS: 44 - 1 funilcular train, 7 Gondolas, 1 cablecar, 17 chairs, 15 drags

CAPACITY (PEOPLE/HOUR): 70,118 LIFT TIMES: 8.30am to 4.00pm

ANNUAL SNOWFALL: 6m SNOWMAKING: 30% of slopes

FLY to: Salzburg - 1 hours away

CAR From Salzburg head south along the A10 to junction 46 and then take the 168 route until signs for Badgastein along the 167 (1hr total). 2hrs from Innsbruck

BUS services on a daily basis from the airport to the resort **TRAIN** Straight to Bad Hofgastein and Bad Gastein

NEW FOR 06/7 SEASON: 7.4million euro spent on snowmaking, piste bashers

ELLMAU/SCHEFFU

Ellmau forms part of the massive Ski Welt which is said to be Austria's largest linked area located in only 90 minutes from Salzburg, 250km of linked piste covered by 92 lifts should mean utopia, but unfortunately this place is not hot. The resor good annual snow is not a feature of the to be fair the place has a good snow snowmaking set up to king. As for the slopes this help when the real stuff is I is a mountain that tends m a good selec of advanced freeriding ome to that, it lacks goo all. The biggest let dow natural freestyl g thing are the hordes of novice here or the m ski groups cl he place and littering the slopes hey fall over all over the place. This esort with the Dutch, which on the long lift queues but on the other and in the resorts defence, this is also an affordable destina-tion in Ellmau it's a short walk to the nursery slopes of a bus to the often busy funituals while from Scheffau it's a short bus ride from the village to the lifts, which are

POOR FAIR GOOD TOP **FREERIDE** A few trees and some of off-piste FREESTYLE park & half-pipe **PISTES** Plenty of groomed slopes

1829M TOP LIFT 250KM FASY **PISTES** 1209M VERTICAL 620M FIRST LIFT

Tourismusverband Ellmau Dorf 35, A-6352 Ellmau, Austria

GENERAL INFO:+43(5358)2301 WFR: www.skiwelt.at EMAIL:: info@ellmau.at

WINTER PERIOD: Dec to April LIFT PASSES

Day pass 34,50 euros, 5 Days 148,50 euros, Season 455 euros

TOTAL LIFTS: 94 - 1 cable-car, 1 Aerial ropeway, 10 Gondolas, 38 chairs, 44 drags LIFT CAPACITY: 130,000 people per hour

ANNUAL SNOWFALL: unknown SNOWMAKING: 70% of pistes

LIFT TIMES: 9am to 4.00pm

FLY:1 1/2 hours from Salzburg (100km) airport. BUS: direct from Salzburg airport. CAR: From Salzburg head south on routes 21 and 312 to Ellmau on the left. This is a 45 mile (70km) journey

NEW FOR 2006/7 SEASON: terrain park to be expanded

FREERIDERS who know their stuff, won't find the offerings here to their general liking. You can have a good time but nothing is that testing or too prolonged in terms of long runs and although the Ski Welt offers a lot of riding opportunities, a weeks trip would be better spent at a more adventurous resort. However an okay trail to check out from Brandstadl to Scheffau.

across a main road and next to a huge car park.

FREESTYLERS should make the trip to the resort of Westendorf, via a bus from Brixen, to check out their halfpipe and terrain park because it's the best place to get any big air from. This is not a freestylers resort whether you want natural hits or man mad offerings. Ellmau does have a park and pipe but it's a bit of a joke. But like any resort, if you look hard enough, you will find something to leap off.

PISTES. Riders of limited experience can have a great time at Ellmau or at any of the nearby linked resorts. The area boasts a lot of wide and well groomed runs that will let you cruise with ease for hours on end. Check out the Hohe Salve for some fun.

BEGINNERS are the one group who should have no problems with this resort even if the place is a bit fragmented. There are plenty of easy to reach nursery slopes and a large area with many t-bars right in Ellmau town itself. The area also boasts miles of easy slopes to progress onto.

OFF THE SLOPES. Ellmau may be a quaint Austrian village, but it is also a bit of a mishmash of a place. There's plenty of good Austrian hospitality, on or close to the slopes with many affordable pensions and plenty of package deals on offer. Getting around can be a real pain in the arse as local transport services are poor with nowhere near enough ski buses running. The Memory bar goes off between 5 and 8 but is not so hot at night, it also has internet. The Alte Post is good for a traditional meal, or there's an ok tex-mex if you don't like cabbage. **Scheffau** is a very quite place with a couple of pizzerias and some sleepy bars.

FIFBFRBRUNI

Was cool some years ago and now trying to get it back

Fieberbrunn is a rather strange tale in terms of its popularity with snowboarding. It's not a high resort, nor is Fieberbrunn an adventurous place, and most good riders will have had enough after three or four days. The area lies in a natural snow pocket receiving 50% more snow than nearby Kitzbuhel over a course of a season. Fieberbrunn has never really attracted tour operators, the result being that the slopes are mainly inhabited by either locals or their cousins from Germany. Like most resorts, the well-prepared slopes do have busy periods (mainly at weekends and holidays). A couple of years ago Fieberbrunn was the main attraction for riding the Halfpipe, they even had a Halfpipe Worldcup and you

could session it till 11pm every night. The resort started caring less about it, shaping it very occasionally and eventually it was removed and a few baron years followed. The 2005/6 season they built the Lord of the Boards Park situated at the top of the Streuboden gondola.

FREERIDERS will find that the terrain is not the most testing, with only a couple of black runs that offer nothing much for advanced riders. The main runs on **Streuboden** are reached via a short journey on an unusual gondola system that arrives at two levels: the first of which will bring you out on easy terrain around trees, whilst the second takes you to open reds and a black run.

FREESTYLERS looking for an endless supply of natural hits will be disappointed with Fieberbrunn. This is not the place to seek big air, but at least they have started building a park again. The Lord of the Boards park features a numbers of kickers and a hip.

RIDERS will find that the slopes appeal very much to intermediate hard booters, especially if you like well pisted and easy flats.

BEGINNERS have a very good choice of beginnerfriendly areas for learning the basics. As a decent novice's resort, you can avoid the drag lifts by riding the runs down off the first gondola station.

OFF THE SLOPES. Fieberbrunn is a small village. Hotels, pensions and rooms in private houses are the main form of accommodation. Some of which are very close to the slopes. Prices vary, but in general the place is affordable. Night-life is definitely not one of Fieberbrunn's strong points. Night action is very quite compared to more commercial resorts but the town centre (Dorfplatz) with its new 'village-square' is cool. The Rivershouse is a good place for beers, guinness and snacks. There is a pool table and live music most weekends. The Londoner became the Cheers pub many years ago and stripped out all the tat that was on the walls, its the most expensive place for a beer in town but cheaper than most resorts. *Biwak* is a at the bottom of the slopes which looks out onto the halfpipe and plays more upto date sounds than the oompah band in nearby **Enzianhutte**. Tenne nightclub is the place for a late beer or dance, but avoid until 1 am when the under 16s are booted out (unless this is your sort of thing). All in all - a

Pic - Fieberbrun Resor

rapidly up and coming resort with great snow and off piste but lacking the nightlife in low season. Still if you're with a good crowd of people, who cares and **St Johann** in Tirol is only a ten minute taxi ride away which is home to the legendary Bunny's Pub.

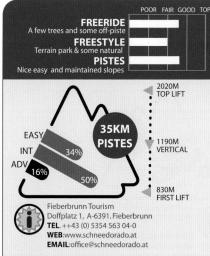

WINTER PERIOD: Dec to April

LIFT PASSES Half day 26 euros, Day pass 32.5 euros 6 Days Schneewinkel area 162 euros

6 Days Kitzbuler Alpen area 190 euros

ANNUAL SNOWFALL: Unknown **SNOWMAKING:** 40% of slopes

FLY to Salzburg - 1 1/2 hours away.

CAR from Salzburg, head west along route 312. St Johann, then turn right along the 164 to Fieberbrunn.

BUS Bus services with links from Salzburg

MOUNTAIN CAFES: 2

NEW NEW FOR 06/07 SEASON: new 8 person gondola, the ReckmoosSud

84 USQ WWW.WORLDSNOWBOARDGUIDE.COM

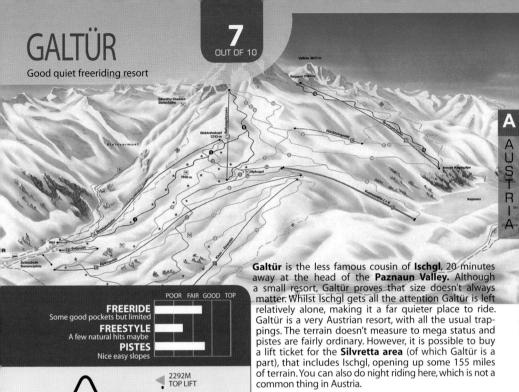

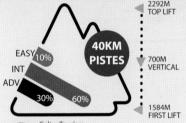

Galtur Tourism Postfach 10, PLZ 6563, A-6563, Galtur. GENERAL INFO:+43 (0) 5443 8521 WEB: www.bergbahnen-galtuer.at EMAIL: info@galtuer.com

WINTER PERIOD: Dec to April LIFT PASSES Half-day 21.5 euros, Day pass 32.5 euros 6 Days 149 (214 inc Ischgl), Season 430 **NIGHT BOARDING**

1 slope lit (2.2 km total)

LONGEST RUN: 3.2km TOTAL LIFTS: 10 - 1 Gondola, 3 chairs, 6 drags LIFT CAPACITY: 15,000 people per hour LIFT TIMES: 9am to 4.00pm **MOUNTAIN CAFES: 3**

ANNUAL SNOWFALL: 5.28m **SNOWMAKING:** 10% of pistes

FLY:Fly to Innsbruck airport 2 hours away. BUS: Ski bus runs between Landeck-Ischgl-Galtur between 8am-7pm

CAR: From Innsbruck, head west along the A12 to Landeck and then the 316 to Ischgl and the A188 to Galtur TRAIN: The nearest train stop is at Landeck, 30 minutes away.

FREERIDERS in softs looking for interesting terrain should check out the Innere Kopsalpe area. It won't test advanced riders too much, but should keep intermediates happy for a few days.

FREESTYLERS won't love Galtür as it doesn't offer any real big air opportunities - though like any resort there are hits to be found if you look. The best thing to do is either take the 20 minute bus journey to Ischal to ride their amazing fun-park, or check out the halfpipe at Samnaun, a small neighbouring Swiss resort.

PISTES. The well-pisted runs allow carvers to progress with ease, and the red and black runs on the Saggrat should give you a rush.

BEGINNERS are the one group of riders who will really like Galtür. The flats are easy to reach from the village and riders should have no real problems, unless they are scared of using the drag lifts that serve many of the runs (including the easy ones). Still, as the lift lines are nonexistent and quiet, you'll be able to keep trying without too much hassle from irate skiers. The local ski-school, which caters mainly for beginners, will help you out.

THE TOWN

Everything is within easy access of the slopes and for such a small resort, there are plenty of things to do. Galtür is a typical Austrian village with normal accommodation offerings, from pricey hotels to well priced pensions. Eating out is all Austrian, which is average but bland. There is, however, way too much après-ski which will appeal to some sad types, but not the hardcore rider who likes to party hard.

HINTERTUX

High, wide & open all year

The base of Hintertux sits at a height of 1,500m at the far end of the Zillertal valley, which is also home to the resorts of Mayrhofen and Eggalm. It now forms part of the Zillertal 3000 area offering 230km of pistes. Hintertux as a number of advantages and disadvantages: on the plus side, it's a glacial resort, and apart from being one of the best summer snowboard resorts in Europe, it also has an enviable snow record in winter. However, in winter the same pluses mean that when the lower altitude resorts of the valley are suffering from a lack of snow, Hintertux can become very busy.

Still, the open expanse of freeride terrain provides some excellent powder fields that are seldom tracked out by the morning ski masses. In summer the extent of snow cover over the length of the runs is often more than many resorts get during the winter season. Slopes are always crowd-free and riding in a t-shirt is the norm

FREERIDERS have the pick of the slopes with various terrain on and off-piste. There are huge open expanses and loads of gullies and natural walls to ride. There's no tree riding as the altitude deters their growth, but it's no big loss as the terrain is more than sufficient, especially if you take a look at what's available to ride off Number 3 chair.

FREESTYLERS have loads of hits to check out, which include a few cliff drops and a number of wide, natural gap jumps. If you're still not content, there's a fun-park and two halfpipes which they maintain all year round, although it's not always possible in July and August.

THE PISTES are really good for laying out big turns, and tend to be long with a few sharp turns here and there.

BEGINNERS may find Hintertux a bit too daunting, especially if you're a total novice. There are some easy runs, but in truth you may be better off at another resort.

THE TOWN

Hintertux has a lot going for it on the slopes, but off the mountain, the place is totally crap with little or no real local services. . It's not that cheap either, with only a few restaurants and decent drinking holes. If its aprèsski you're after though, you must check out the bar at the bottom of the gondola called Hohenhaus Tenne. Its full on, and has got the most bonkers toilets you've ever seen. The best thing is to stay down the valley at Mayrhofen, which is about a forty minute bus ride away. Mayrhofen is a cool place with loads of places to stay, lots of restaurants and heaps of other things going on.

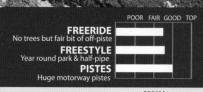

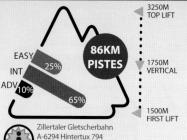

WINTER PERIOD: Dec to April SUMMER PERIOD: May to Nov LIFT PASSES

WEB: www.hintertuxergletscher.at

EMAIL: info@hintertuxergletscher.at

TEL: 0043/5287/8510-0

Half-Day 25.5 euros, Day pass 36 euros 5 Day pass 148, Covers Ski & glacierworld Zillertal 3000 linked area

NUMBER PISTES/TRAILS: 24 LONGEST RUN: 12km

TOTAL LIFTS: 21 - 3 Gondolas, 2 cablecars, 6 chairs, 10

LIFT TIMES: 8:30am to 4.00pm

LIFT CAPACITY: 30,000 people per hour **MOUNTAIN CAFES: 5**

ANNUAL SNOWFALL: unknown SNOWMAKING: 20% of pistes

TRAIN: nearest train stop is Mayrhofen, 20 mins away. Express train stop is Jenbach, taxi service availble to tux for

FLY: to Innsbruck (90km), 1 1/2 hours away. Munich 230km CAR: from Innsbruck, go west on the A12. Exit at B169 along the Zillertal Valley past Mayrhofen and onto Hintertux

BUS: Green Line run between Mayrhofen - Rastkogelbahn and Hintertux (free with lift-pass)

NEW FOR 2006 SEASON: Sommerberg - Tuxerjoch on NEW SHintertux gets snowmaking facilities. New water reservoirs. New 160 person cablecar on Ahornbahn, and improved snowmaking on Ahorn and Penken areas.

86 USQ WWW.WORLDSNOWBOARDGUIDE.COM

HOPFAGARTEN

6 OUT OF 10

Okay linked area, but Brixental itself a little boring

Hopfagarten in Brixental is a resort that forms part of Austria's largest linked area known as the 'Ski Welt' and is located just 50 miles (80km) from Innsbruck. Collectively the resorts that make up Ski Welt have over 250km of marked out pistes and lots more off-piste terrain. The area is linked across a series of mountain slopes by a staggering array of 94 lifts which are mainly chair lifts. Getting around all the areas will take some careful piste map reading, as you can easily get lost around here. The best thing is to plan the lift you want to get to and follow the signs, as if you try to follow piste numbers it's a nightmare. Like all the resorts of the Ski Welt, Brixental, which sits across the valley floor from the good resort of Westendorf, is a low laying resort with a high point of 1674m. In the past there has been a problem with a lack of real snow, however, the area has over 135km of snow-making facilities which helps to keep the runs open when the real stuff is in short supply. Brixental is a spread out affair and depending on where you stay, it may mean having to catch the ski bus to reach the slopes, not all the accommodation is close the runs.

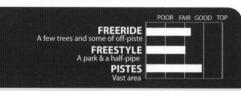

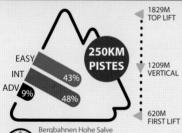

Meierhofgasse 29 6361 Hopfgarten im Brixental, Austria

GENERAL INFO:+43(5335)2238

WEB: www.skiwelt.at

EMAIL:bergbahnen.hopfgarten@skiwelt.at

WINTER PERIOD: Dec to April LIFT PASSES

Day pass 34,50 euros, 5 Days 148,50 euros, Season 455 euros

TOTAL LIFTS: 94 - 1 cable-car, 1 Aerial ropeway, 10 Gondolas, 38 chairs, 44 drags

LIFT CAPACITY: 130,000 people per hour LIFT TIMES: 9am to 4.00pm

ANNUAL SNOWFALL: unknown SNOWMAKING: 70% of pistes

FLY: 1 1/2 hours from Salzburg (100km) airport. Munich 150km, Innsbruck 70km

TRAIN: via Munich, Kufstein and Wörgl to Hopfgarten main station or Hopfgarten Berglift

CAR:via Munich (100 km) - exit Kufstein Süd towards Innsbruck.via Innsbruck (70 km) - exit Wörgl Ost - to Brixental

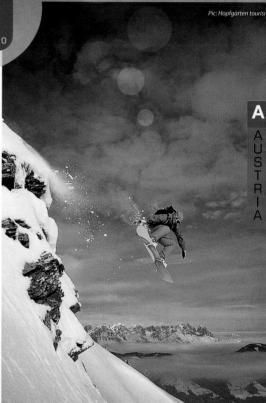

FREERIDERS who plan to take a weeks holiday in the Ski Welt could do a lot worst than this area, and although Brixen on its own would be a bit tedious after a few days if you are a competent rider, but the fact that you have easy access to a lot more of well connected terrain, means a 7 days stay will not be wasted time. The expanse of this area means that provided the snow is good and plentiful, you will be able to ride each day on a new selection of pisted slopes aided by the fact that lift queues are never that long meaning you will be able to roam freely with ease. Advanced riders should head on the bus to Westendorf, where your lift pass is valid.

FREESTYLERS have a number of options for getting air but will have to search them out. There's a small park near the **Hartkaiser** in **Ellmau** and a better one over in Westerndorf. If there's an event on they sometimes build some hits but their just left to melt after the event.

PISTES.Boarders should feel at ease here, the area offers a vast number of well groomed pistes to suite all levels making this a cool place for laying out turns on or simply a place for improving your technique.

BEGINNERS will find the slopes of Brixental are easy to get to grips with. There are some nice low down nursery slopes and once you have mastered Brixental the Ski Welt offers lots of easy opportunities to learn on.

OFF THE SLOPES Brixental offers a good choice of accommodation, restaurants, and bars and what's more this is not an expensive resort.

WSQ www.worldsnowboardguide.com 87

INNSBRUCK

European capital of snowboarding

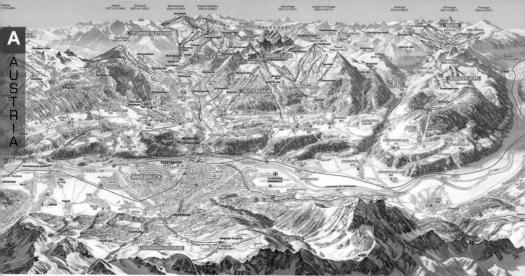

Innsbruck is the capital of the Tyrol region and comes with quite a pedigree. It has twice hosted the Winter Olympics, has 9 resorts within 45 minutes drive including NordPark that you access via funicular from town, and is home to the likes of Burton and Method Mag. With 128,000 residents and steeped in history it's a tourist attraction in its own right and with has all the services you'd expect for a City. Wander into the old town, the narrow winding streets lead into the plaza where you'll see the Gothic 15th century three-story balcony called the Golden Roof, Burton Snowboards set up their first non-American headquarters in Innsbruck in 1992. There's a shop selling some of their old gear and seconds, in their factory at 111 Haller Strasse, on the outskirts of town.

Nordpark is the only resort accessible from Innsbruck, currently you pick up a funicular train on the outskirts of the city but a new Cable-car is due to open in May 2007 which will go from the centre. There are full reviews of **Axamer Lizum, Kuhtai** and the **Stubai Glacier** within this Austria section and the other local resorts are summarised here. These are **Glungezer**, **Igls, Mutters, Nordpark, Rangger Köpfl** and **Schlick 2000**. Local bus services to all of these resorts.

Accommodation is well located; you can bed down cheaply within walking distance of the city centre and prices are extremely reasonable. *Pension Paula* the local backpacker's place, is only five minutes from the town centre and is without doubt the best place to stay in the city, with rates from 25 euros a night. There is also a hostel and numerous hotels. *Hotel Central* is a budget place that also has a bar, and is only two minutes from the city centre.

Innsbruck has a huge number of restaurants, from

international cuisine to local dishes, by avoiding some of the tourist traps you can eat well and fairly cheap.

The **Innsbruck Glacier Ski Pass** gets you access to these 8 local resorts including transport, 3 days will cost 93 euros. An extended pass that gives you access to Kitzbühel and Arlberg Regions (St.Anton/Lech) costs 203 euros for 5 in 6 days

GETTING THERE

FLY: to Innsbruck International airport which is 10 minutes from the city centre.

TRAIN. There's a train station in the centre of the town, with direct connections to Munich and Salzburg amongst others.

BUS: The bus station is next to the train station. Ski buses go from various parts of the city but all go via the bus station.

DRIVING: from Munich, head south on the A8 and A12 Autobahn routes direct to Innsbruck, journey time about 2 hours.

GLUNGEZER

Small resort located at the foot of the small town of Tulfes, 12km from Innsbruck. There's 20.5km of mostly intermediate pistes but rising from 950m to 2678m it does offer some decent vertical.

Visit www.glungezerbahn.at for more information.

IGLS

Igls is perched high above Innsbruck, 3 miles from the city centre. There's nothing here, especially for competent riders. This is a beginner's area with half a dozen trails easily accessed by a cable car. Visit www.patscherkofelbahnen.at

88 USQ WWW.WORLDSNOWBOARDGUIDE.COM

Mutters is a small rideable area nestled between Innsbruck and Axamer Lizum. But this is no match for Axams, which can be reached with a backcountry hike. There are only a few runs, mainly suited to beginners and intermediates. Mutters attracts a lot of cross-country skiers.

NORDPARK

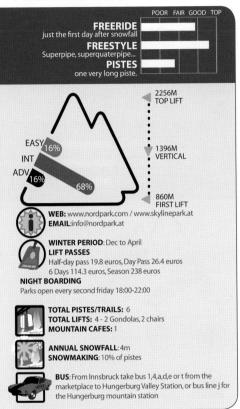

German Olympic team held their training camp for 3 weeks in the Nordpark Superpipe in preparation for the 2006 Olympics. Every other Friday they hold a Nightline session from 1800-2200 which is always a big spectacle. Beware though as the place can feel like it's a local resort for local people, with some very strict rules and etiquette, for riding, queuing for the lift, and talking to people. But the standard of riding here is usually much higher than you'll find at other resorts.

RANGGER KÖPFL

Tiny resort with 10km of pistes and 4 lifts, they claim to have a terrain park but its a poor excuse of one.

SCHLICK 2000

Schlick 2000 is an area which is unknown to many apart from the local boys.Schlick OUT OF 10 AUSTR

is found just a short drive from Innsbruck on the valley to **Stubai Glacier**. So why the secret! Its simple it's a large bowl which attracts lots of powder and keeps the weather out, when the rest are closed. Schlick isn't an area you'll head for a holiday; the area isn't great in size but you'll have lots of fun.and day is more than enough. If its been a powder day then don't give up the next day as you might find it untracked again as there is always a bit of a breeze. Its very tempting but make sure you know where you're going in the powder as there's plenty of cliffs to falls

off avalanches are common. More than likely though vou'll end up getting lost in the trees and end up in the wrong village. Visit www. schlick2000.

Nordpark is a small but extreme resort perched high above Innsbruck and accessed via the rickety old Hungerburgbahn funicular from the edge of town. Changes are planned to replace this with a gondola in the centre of town in the future. The 6 pistes offer some serious steeps with Innsbruck looming underneath you, and off-piste there's some faces that look like they should belong in Alaska, so best leave it to the locals like Flo Örley, who did the stunts in Triple X, to ride those ridges. You'll need to be quick to get any fresh lines, but there is some very good freeriding and 70% gradients available if you know where to head, but make sure you go with someone who knows what they're doing.

For most of the young local boarders the upper chairlift is the only lift they'll use all day as that's where the parks located. The Skyline park has a huge superpipe, a massive quaterpipe and two pretty big kickers and is usually impeccably maintained. The

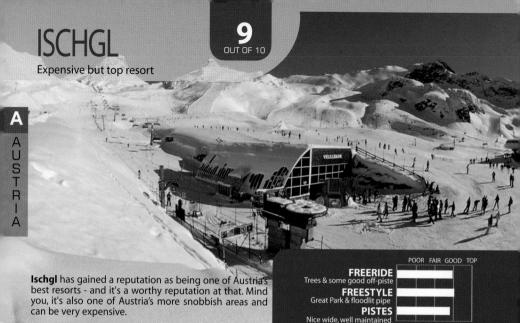

Ischgl may not be the most testing place, but it offers something for everyone, with well groomed slopes serviced by fast modern lifts. Snowboarders have been coming here for years to sample the excellent selection of wide, open, long runs which suit all standards and styles of rider. The FIS regularly stage slalom and halfpipe events here, so it must have something to offer. If what you find at Ischgl is not enough, then you can ride into the neighbouring Swiss duty-free resort of Samnaun. It can be reached by connecting lifts and is covered by the Silvretta lift pass, which can be used at

FREERIDERS have a high altitude mountain that ensures a good annual snow record, providing excellent wide open powder fields. For some easy freeriding, check out the stuff in the Idjoch area, which has a good mixture of blues and reds to play around on. Advanced riders will find plenty of stuff to keep them busy. although you won't be tested too often. Pardatschgrat, a black run leading back into the village (with the lower section cutting through some trees), is well worth a go, and you'll also find good off-piste freeriding down the runs off Palinkopf.

three other resorts, Galtur, Kappl and See.

FREESTYLERS are probably going to be the most pleased with Ischol for one reason, and one reason only the Boarder's Paradise fun-park is the dog's bollocks. It is without doubt, one of the best parks in Europe and is equipped with all sorts of interesting obstacles with marked areas such as Freeride, New School, and Mogul, which starts at the top. At the bottom there is a well-shaped halfpipe. The whole area is designed with the intention of satisfying air heads of all levels (there's also a halfpipe at Samnaun). However, freestylers who are still not content will find plenty of natural hits to get that extra air fix off, with big drop ins, banks and gullies all over the mountain.

PISTES. Boarders, especially hard boot riders, will love this resort, with its wide, motorway pistes where you can

90 USQ www.worldsnowboardguide.com

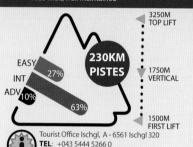

WINTER PERIOD: Dec to April LIFT PASSES

WEB: www.ischgl.com

EMAILinfo@ischgl.com

Half-day pass 33 euros, Day pass 40,50 euros 6 Day Silvretta pass 214 euros, Season 582.5 euros

NIGHT BOARDING Yes

NUMBER PISTES/TRAILS: 62 LONGEST RUN: 7km TOTAL LIFTS: 42

3 Gondolas, 2 cable-cars, 23 chairs, 12 drags

LIFT TIMES: 8:30am to 4.00pm

LIFT CAPACITY: 58,000 people per hour

MOUNTAIN CAFES: 11

ANNUAL SNOWFALL: 5.28m SNOWMAKING: 20% of pistes

TRAIN: Trains go to Landeck, then take bus to resort (55 mins, 30km)

FLY: Fly to Innsbruck (100km) International transfer time to resort is 2 hours. Munich/Salzburg 300km

CAR: To Innsbruck via motorway A12 to Ischgl, 178miles (286km). Drive time is about 2 hours

BUS: from Innsbruck, via Landeck to Ischgl on a daily basis. Landeck is 55 mins. www.lms-reisen.de tel: 00 49.28 64.88 00-188

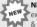

NEW FOR 2006/7 SEASON: new mountain restaurant & NEW expanded base station. Snowmaking added to 6 more pistes & improvements to pistes.

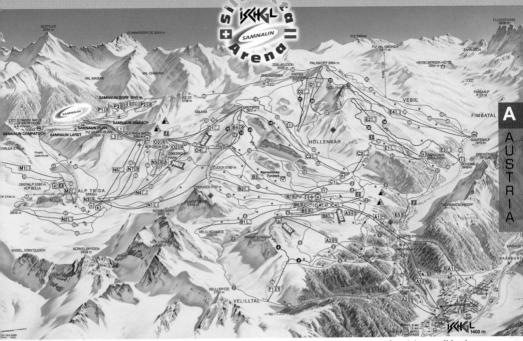

put down big arcs and easily make those 360° snow turns. Ischgl often hosts top slalom and giant slalom events so there must be good quality, fast carving terrain. The runs are so well-marked and pisted, that carving up Ischgl is a total pleasure, no matter what is on your feet.

BEGINNERS will soon see the benefits of learning here. The novice-marked runs are just that, being well located and offering some long, easy-to-negotiate trails. The only drawback is the amount of drag lifts that beginners need to use, but you've got to learn some time. The local ski school has a lot of snowboard instruction and lesson programmes are very reasonable.

THE TOWN

Ischgl is a modern resort, rather than an old traditional Austrian hamlet. However, this is a resort popular with the ski tour groups who come here by the coachload, so it can get very busy both on and

off the slopes. Ischgl is also not the cheapest of places, so skint or budget-conscious riders will need to do some serious scamming to see a seven day trip through. Around the village there are a number of attractions from the adventure swimming pool, squash courts and a number of shops (selling tack mostly). There is a few snowboard hire outlets, with prices much the same from where ever you go.

FOOD. Depending on what you're into may have a lot do with how you eat here. There are quite a lot of restaurants in Ischgl, mostly hotel restaurants. However, they are nearly all Austrian style, offering a lot of bland menus. Fast food around here is a shop-lifter running out of the supermarket with a packet of

biscuits. The Pizzeria is good, so it's not all bad news.

NIGHT-LIFE. Ischgl is known for its aprés-ski parties, which you either love or hate, but at least there are a good number of bars and late night hangouts.

ACCOMMODATION is of a very high standard but with high rates to match. There are plenty of typical Austrian hotels, pensions and a number of Austrian-style apartment suites, with self-catering sleeping 6 or more. Nothing is more than a few minutes from the base lifts, with many of the places located in areas where cars are banned. Many tour operators come here offering package deals for weekly and two week stays.

SUMMARY

Ischgl has one of the best fun-parks in Europe and offers some excellent all-round terrain for all levels. However, off the slopes things are a bit poncy.

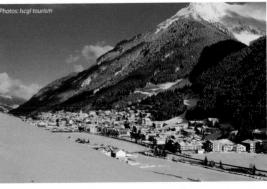

KAPRUN

Snowsure but not nothing too taxing

Winter or summer, Kaprun cuts it big style. The ride area is located on one of Austria's best glaciers, the Kitzsteinhorn Glacier, which reaches an altitude of 3,203 metres making it a perfect place to ride. Being a glacier resort, you can ride here all year and no matter which month you visit, riders of all levels will find something to shred. It has to be said however, that much of what is here (or at nearby Zell am See), is best suited to intermediate freeriders and piste lovers.

FREERIDERS wanting to gain access to Kaprun's best terrain and main runs, should head to the Kitzsteinhorn . Further up, you can reach some good off-piste powder stashes, which can often still be found in the summer months of June and July. There are also a couple of off-piste hikes to the back of the peak, one which takes you to Niedernsill but you will need to rent a guide which is 200 Euros for the day. Another good place for off piste is Wei'see Glacier which is included with the ski pass. It is 25km away so you will need to drive as the bus doesn't go there. It is very small

but not much of it is pisted so it is usual to have fresh tracks. Note it is not possible to board all the way down to the valley from the glacier.

FREESTYLERS are provided with a park at Kitzsteinhorn all year round, and a smaller park at Maiskogel in the Winter. There's also one down in Zell am See with a halfpipe. Kaprun's park is not the world's best but it still has an array of hits, but really freestylers should search out Kaprun's natural drops.

PISTES. All riders will be at ease whether they board at Kaprun or Zell am See, as both resorts have some great open carving runs. At Kaprun you can access some excellent spots from the Alpencentre, but unfortunately there is only one short black run on the glacier.

BEGINNERS can get going on a number of easy runs on the Maiskogel mountain, which is reached by a drag lift from the centre of the village. If you can't handle a drag lift, take the cable car at the north end of the village to reach the east slopes. Beginners are spoilt when it comes to snowboard instruction; Kaprun was the first Austrian resort to have an independent snowboard school. If you get bored with Kaprun, Zell am See is only a ten minute bus ride away and gives you access to an extra 50 miles of piste covered by the same pass.

OFF THE SLOPES. Kaprun is a fairly large and stretched out affair. Having a car may save a lot of walking but there is also a good and regular local bus service. Around town, you get a mixture of the old and new with a typical Austrian flavour. Accommodation options are excellent and Kaprun will satisfy both rich and skint snowboarders alike. Evenings in Kaprun are laid back - check out Polletti's for great pizzas, beer and good music, from 5pm until late. Around the square near Poletti's are a few bars, including Killys which does cocktails and has live bands or Kitch & Bitter. The Pavillion bar is open for apres ski but if you want a really late drink. stumble to the Baum Bar or Kuh Stall.

Photo: Gletscherbahnen Kaprun

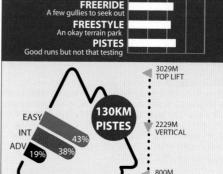

POOR FAIR GOOD TOP

FIRST LIFT

KAPRUN INFORMATION Salzburger Platz 601, A 5710 Kaprun

TELEPHONE: +43/6542/770-0

WEB:www.europasportregion.info / www.kitzsteinhorn.at EMAIL:welcome@europasportregion.info

WINTER PERIOD: Dec to April SUMMER PERIOD: May to Oct

LIFT PASSES Half-day 28 euros, 1 Day pass 37.50 euros 6 Days 179 euros (inc Zell-am-see)Board School

NUMBER OF RUNS: 59

LONGEST RUN: 8km

TOTAL LIFTS: 57 - 11 Gondolas, 1 cable-cars, 15 chairs, 30

CAPACITY (PEOPLE/HOUR): 79,268 LIFT TIMES: 8.30am to 4.00pm

ANNUAL SNOWFALL: 10m **SNOWMAKING:** 30% of slopes

TRAIN nearest at Zell an See 10 minutes away. FLY to Salzburg, 1 1/2 hours transfer. CAR from Salzburg head south on the A10 to

exit 46. Then head south west along the 168 via Taxenbach before turning left up to Kaprun (56 miles).

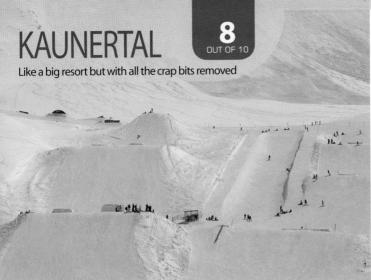

Gepatsch-Stausee reservoir and is a journey well worth making, especially when the other resorts have closed or have yet to open.

A chairlift runs from the base of the resort to the main resort centre. It's worth while parking here, rather than make the extra 20 min drive to the main car park so that you can enjoy that final run down. From the main resort centre, tbars fan out to every side, and it is within this big bowl where you'll find the excellent terrain park and pipe. The 32km of pistes provide some decent intermediate terrain, but it's the Freeriders and freestylers who will really appreciate this resort.

Kaunertal is a tiny year-round resort located on the Austria/Italy/Switzerland border in the next valley to the glacier resort of Pitzal. It is situated at the end of the valley high above the

POOR FAIR GOOD TOP **FREERIDE** Some good off-piste opportunities FREESTYLE A park & a half-pipe & good natural **PISTES** 3160M TOP LIFT 32KM 410M VERTICAL

Kaunertaler Gletscherbahnen Feichten 141, 6524 Kaunertal, Austria

TEL: +43(5475)5566

WEB: www.kaunertal.com EMAIL: kaunertal@gletscher.at

WINTER PERIOD: Nov to May SUMMER PERIOD: June to July LIFT PASSES Day pass 33 euros, 5 in 6 day pass 131

2750M

FIRST LIFT

TOTAL LIFTS: 9 - 2 chairs, 7 drags LIFT CAPACITY: 13,600 people per hour LIFT TIMES: 9am to 4.00pm

ANNUAL SNOWFALL: unknown SNOWMAKING: none

FLY Innsbruck - 90 minutes away (100km). Munich 250km TRAIN to Landeck railway station, then take a bus CAR: From Innsbruck take the motorway towards Bregenz,

ne Landeck turnoff and go through the 7km tunnel to Prutz then Kaunertal. The resort is past the reservoir and up.

BUS PostBus run a daily service to the glacier. www.postbus.at +43 (1) 71101. A Ski-bus runs runs 4 times a day from Prutz and takes an hour, last back back is 16:45

FREERIDERS. Staying within the resort boundary there is a stack of good off-piste and small rock drops as you make your way down to the bottom of the chairlift, just pick a route and enjoy. Further afield there's a good long backcountry trail that leads you into the next valley back down to Fernergries. Take the Norderjoch t-bars and then drop off the back, but you'll need a guide to show you the way. You'll need to pick up the ski-bus or hitch to get back to the resort. From halfway down the slope served by Kartesspitz t-bar you can access a huge amount of steep faces and powder fields which run all the way bottom of the chairlift. These are the areas you zig-zag through on the drive up to the main carpark, so hire a guide to show you some routes as you could face a long walk out if you get things wrong.

FREESTYLERS. There's a large terrain park which should suit all standards. The pro-line features some huge wedges, above this is the rail park which has a number of straight and kinked rails and there's some intermediate kickers. The halfpipe is kept in okay condition, and running parallel to this are some beginner jumps and a few easy boxes. Away from the park on the runs down to the chair you'll find a stack of things to jump off, and come May all the pro's arrive to finish off their latest flics so don't be surprised to see some huge booters and road-gap jumps on the drive up to the carpark.

PISTES. The resort can easily be split into two areas. The pistes serviced by the t-bars are wide and steep in places, whereas the runs down to the chairs are standard alpine fare but riders who stick to the pistes may won't to go elsewhere.

BEGINNERS may struggle a little here as all but two of the runs are serviced by t-bars. The runs are all graded as beginner and intermediate but most have a couple of steep sections that may scare.

OFF THE SLOPES. There's no accommodation anywhere near the slopes, the nearest village is Feichten about 25km away that has a few hotels but don't expect any nightlife. **Prutz** is a bit more lively. but further away

KITZBÜHFI

Cheesy skier resort

The chances are that if you know Austria, you'll know about Kitzbuhel, famed for the Hahnenkamm (a World Cup ski downhill course), and noted for ski-package tour groups. Kitzbuhel is Austria's Benidorm, due to the hoards of skiers cluttering up the slopes and making fools of themselves in the bars and around town. A shame really, for apart from the fact that it is a low-level resort, which doesn't guarantee snow cover on the bottom runs, it is a cool place to ride. Still, when the snow has dumped, no rider should get bored as

there are many slopes of all levels and lots of off piste. With the new additions of the high speed 3S gondola linking Pengelstein to Jochberg and another lift linking Pass Thurn and Mittersil there is now a long 'Safari' tour

you can take.

FREERIDERS should look under Bichlam in order to ride some cool powder, while advanced riders will find the more testing runs on Ehrenbach (a part of the Hahnenkamm), and down the steeps of Ehrenbachgraben. The Jochberg area has some easy bowls to hunt out. A great long off piste run is down to Aschau to the left of piste 56, just cut high left at the top. Some good powder is normally to be found around the blacks under the Steinberg-kogel or on the Kitzbuhel Horn.

FREESTYLERS are attracted to Kitzbuhel for its extensive amounts of natural hits, like the stuff found on Pengelstein. The park and pipe, in the Kitzbuheler Horn area, also provide plenty of air time, even if they're not that well looked after. There's a good natural pipe off run 29a.

PISTES. Advanced riders are primarily drawn to Kitzbuhel by the thought of tackling the Hahnenkamm, although this is not recommended just after the race as it is purposely cleared of snow and is sheet ice. The rest of the area has plenty of good advanced and intermediate terrain that also allows for some fast carving descents, but beware many of the blues will see you unclipping your back leg. Black 55 is often worth the trek as no-one cuts it up so you can lick it down at full speed.

BEGINNERS in particular are well suited to these slopes, as there's the chance of riding some long, easy runs serviced by chair lifts, and not just drags.

OFF THE SLOPES. Kitzbuhel has heaps of beds at average prices in pensions and apartments and loads of cheap eating joints, including take-away outlets. Boozing goes off in a number of places, allowing drinking into the early hours of the morning. But beware, skiers apres all over the place, although most are in bed by 9pm having had their two glasses of gluhwein. Popular hangouts are Take 5 and the Londoner bar (points for names 0) which has live music every night. Other bars are The Pavillion near the Hahnenkahm or La Fonda which is a chilled out bar with Mexican Food. There is also Mangos nightclub which is open until 5am.

94 USQ WWW.WORLDSNOWBOARDGUIDE.COM

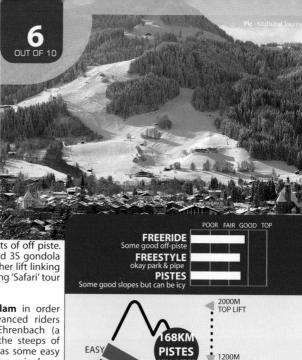

Kitzbühel Tourism Hinterstadt 18, A-6370 Kitzbühel TEL:: +43 (0) 5356 777

WEB:www.kitzbuehel.com EMAIL:info@kitzbuehel.com

WINTER PERIOD: Dec to April LIFT PASSES Day pass 37.5 euros 6 Days 175 euros, Season pass 455euros

BOARD SCHOOL Day lesson 60 euros, half-day 35, 6 days 135. Private lesson half-day 140 euros

VERTICAL

800M FIRST LIFT

NIGHT BOARDING Thursday & Friday 6:30pm to 9:30pm Gaisberg quad chairlift open in Kirchberg. 13 euros

NUMBER OF RUNS: 60 LONGEST RUN: 7km

TOTAL LIFTS: 56 - 9 Gondolas, 29 chairs, 15 drags, 3 magic

CAPACITY (PEOPLE/HOUR): 86.800 LIFT TIMES: 8.30am to 4.00pm

ANNUAL SNOWFALL: 1.8m **SNOWMAKING:** 45% of slopes

TRAIN Kitzbuhel has its own train station

FLY to Salzburg/Innsbruck airport, 1 3/4 hours transfer time. Transfers from Innsbruck call 0043 (0)512 584157 (4 seasons)

CAR From Insbruck take the A12 towards Kufstein, exit Wörgl Ost, then B178 (st. Johan), then 161 to Kitz. From Salzburg, take Federal highway to Walserberg, highway 21 towards Unken, then B178 towards St. Johann, finally the 161 Paß-Thurn to Kitzbühel (82km

NEW FOR 06/07 SEASON: t-bar on Hanglalm replaced with 6-passenger chairlift. Ehrenbachhöhe 6-passenger chairlift replaces old 3-person. Snowmaking on Resterhöhe

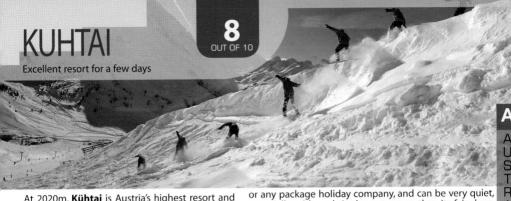

At 2020m, Kühtai is Austria's highest resort and not far from Innsbruck. The place dates back to the 15th century when it was purchased by the Holy Roman Emperor, Maximillan who must have seen the potential of it being a gem of a snowboarders resort. Kühtai sits in a valley with runs either side. The one road heads from Innsbruck to Oetz, and despite its height the road is rarely closed, but you'll need chains and your wits about you if you're heading there after a good dump of snow. With only 35km of slopes its not a big place, but it means it fly's under the radar especially mid-week. It also gets more than its fair share of snow with regular big dumps, and just as good, not that many people head off-piste.

On the sunny side of the valley, the busy HochAlterBahn chairlift takes you from the middle of town to the highest point of 2520m, and then there's a choice long reds back down. These runs are also open for the night boarding every Wednesday and Saturday. These undulating runs do have some flat bits so you'll need to keep some speed up and on a powder day there are some nice, easy and safe off-piste areas to shred. The other side of the valley is mainly in shade and so tends to keep its snow a little better. It is home to the more advanced freeriding Kühtai has to offer and also the much improving terrain park.

FREERIDING. This is a small resort so opportunities are fairly limited but what there is is very good. On the sunny side, you can head anywhere but you've just got watch out for the flat areas. On the shady side, from the top of the DreiSeenBahn chair head off the 6a piste at the hut into some nice powder fields, you can then drop into the valley down a steep, wooded slope eventually picking up the toboggan run back to the same lift. There are some really good areas which can stay untracked for weeks if you're prepared to hike; ask in the tourist information about guides.

FREESTYLERS. There's some great air opportunities scattered all over the resort, so go find, but there is also a terrain park located between the Alpenrosen t-bar and the HoheMutBahn chair. It's been improving over the last few seasons and there's a line of various rails and a couple of big table-top jumps. www.k-park.at

PISTES. The pistes are kept in an immaculate state and geared towards the intermediate rider. Most of the black runs are located in the corner of the resort and are pretty short. However the black run from HoheMutBahn chair can be hairy especially when taken with speed.

BEGINNERS. There are a few tiny learner areas located in town, but beginners may struggle on the reds, not that they are particularly testing, but the flat areas will grind after constant one-footed skating.

OFF THE SLOPES. There are a good range of hotels, apartments and some pensions starting from 25euros a night. Most of the hotels have their own restaurants so you won't find any specialist restaurants or take-aways. By 5pm the place is almost a ghost town, so if you want nightlife you may want to consider staying in Innsbruck, 35km away or Solden, 1hr away.

POOR FAIR GOOD TOP FREERIDE Some easy but hike for the best **FREESTYLE** Pretty nice park which gets sun later in day **PISTES** A few flat spots but immaculate

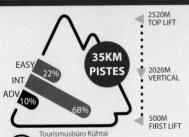

A-6183 Kühtai, Tirol TEL: +43(0) 5239 5222 WEB: www.kuehtai.info

EMAIL: info@kuehtai.co.at

WINTER PERIOD: Dec to early May

LIFT PASSES Day pass 27 euros, Half-day 24.5,6 Days 142 NIGHT BOARDING Wednesday & Saturdays 7:30 till 10pm. The Hochalter 4-seater chairlift is open. 9 euros

TOTAL LIFTS: 12 - 4 chairs, 7 drags, 1 Magic carpet LIFT CAPACITY: 16,000 people per hour LIFT TIMES: 9am to 4.00pm

ANNUAL SNOWFALL: 8m SNOWMAKING: none

FLY Innsbruck Airport the nearest, Munich approx 165km. TRAIN Innsbruck or Ötztal-Bahnhof stations, then take

CAR: From Innsbruck head towards Bregenz, take the exit Kematen-Sellrain, and drive for another 25km. If you end up in Oetz, you've gone too far.

BUS Take a bus from Innsbruck . 4 times a day 8:00,11:00,13:15,16:00 and takes an hour

LECH/ZÜRS

Fantastic mountain, awful town

The Arlberg, in the far eastern section of Austria, is home to all the top classy resorts that the country has to offer. Lech and Zürs are two of them, along with their close neighbours Stuben, St Christoph and St Anton. Lech is linked via lifts with Zürs, and between them make without doubt, Austria's number one poncy retreat. Year in, year out, this high altitude resort attracts numerous royals along with the finest from the film and pop world - and all the arse-lickers they can muster to join them. Skiers come here to be seen, not to ski, so while they pose you can ruin their immaculate slopes, and tackle some great freeriding terrain. Don't be surprised to see poodles dressed in tartan, Ferraris everywhere and by the end of the week you've probably got piles from the heated lift seats. However away from that, you'll release why Robot Food and Absinthe films come here to do the filming for their latest films, and it's the only place in Austria you can try heliboarding.

FREERIDERS will love this place, with large amounts of steeps and deep powder. The runs off Kriegerhorn are the total dog's 'B's,' as are the powder trails down from **Zuger Hochlicht**, which can take you from top to bottom free of any piste-loving pop star. On the other side of the valley, you can take the cable car to the peak of the **Rüfikopf** for some good steep terrain. From the restaurant you can take a short run, and then a 40 minute hike to access a long continuous off-piste descent back in Lech, you'll need a guide though. For an easier run take the red 38a, which you can drop off and board down to the **Schafalplift** t-bar, take that, and from there are various routes into the valley eventually joining up to with a trail back to Lech.

FREESTYLERS have an okay fun-park area, located under the **Schlegelkopf** lifts. The park is loaded with gaps, quarter-pipes, a good selection of boxes and rails, and a halfpipe. The halfpipe's not always well maintained, but like all the best areas here, its free of posing image junkies. Away from the park there are loads of cliff drops of various sizes, and plenty of banked walls to pull off tricks.

PISTES here are immaculate and groomed to perfection. You'll rarely have to queue for long for lifts, and theres a great variety of long pistes to choose from. From the top of the **Rüfikopf** you can board all the way over the Zürs.

BEGINNERS have a perfectly acceptable series of novice runs and good trails to progress on, making Lech a good first timer's resort. The only drawback is sharing the easy slopes with moaning no-hopers from the pop world, or a public school kid who thinks he's street wise (stick a finger in his eye and see what he thinks then).

THE TOWN

The towns at the base of the slopes are expensive and dripping with sad people in fur coats so expect to pay highly for everything. Even the pensions cost an arm and a leg; you may find that a stay here is beyond the reach of most. Try lodging in one of the nearby hamlets. If you do give it the one night treatment, remember night-life is pretty dull and Zürs goes to sleep early.

96 USQ WWW.WORLDSNOWBOARDGUIDE.COM

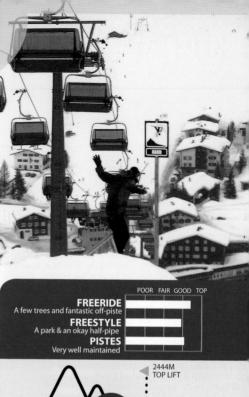

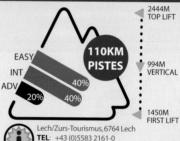

WEB: www.lech-zuers.at
EMAILinfo@lech-zuers.at

WINTER PERIOD: Dec to April

LIFT PASSES
Half-day 30 euros, Day pass 39.5 euros
6 Days 189, Season 650

HELI BOARDING

take-off from Kriegerhorn / Oberlech and from Flexenpass (Zürs) to two peaks: Mehlsack, Orgelscharte

NUMBER PISTES/TRAILS: 32 LONGEST RUN: 5km TOTAL LIFTS: 32

4 Gondolas, 18 chairs, 10 drags LIFT TIMES: 8:30am to 4.00pm

LIFT CAPACITY: 44,668 people per hour

ANNUAL SNOWFALL: 2.68m SNOWMAKING: 10% of pistes

TRAIN: Railway station Langen am Arlberg 17 km away FLY: Fly to Innsbruck (110km), 2 hours transfer. Friedrichshafen, 120km. Altenrhein, 100km. Zurich, 200km. CAR: Drive via Innsbruck, head west on the A12 to Landeck then take the 316 via St Anton and Zurs to reach Lech

BUS: Regular services from Langen station. Bus service from Zurich airport 10am,12:30,18:30 fri-sun (75 euros return) with Arlberg Express

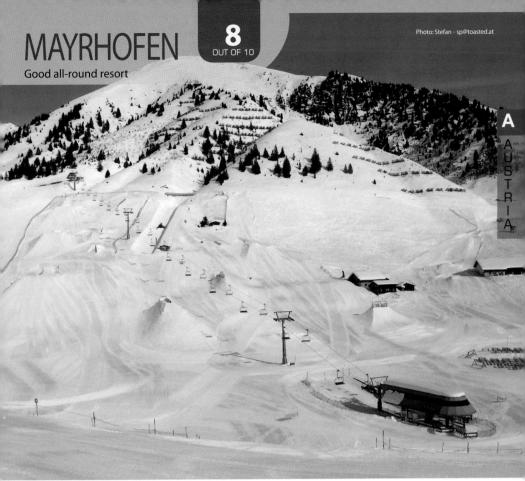

This quaint Tyrolean village, framed by beautiful mountains, is located just 43 miles from Innsbruck and welcomes hoards of British package holiday makers every year. It offers the largest ski area in the Ziller valley now it is linked with Hippach, Finkenberg and Eggalm/Rastkogel and altogether offers 146km of pistes. The highest peak is only 2500 metres, it can sometimes suffer from poor snow conditions, but there's plenty of snowmaking to cover the main trails.

In the early days, Mayrhofen had the reputation of being a bit of a hard boot carver's place; this has changed however, and today there's a good influx of freeriders and freestylers checking out the terrain. Having a Burton Park located in the centre of the resort helps guite a lot to attract all the low-pant wearing boarders. For the not so advanced freestylers they have some smaller kickers and rails just next to the one for the big guys.

For those staying in the centre of Mayrhofen, the only way up and down is the Penken bahn gondola as it is not possible to board back into Mayrhofen. Even though the lift is high speed, there can still be big queues early in the day. To avoid the crowds you can take the free ski bus to the Finkenberg or Ahorn lifts, which are popular with locals or the new Horbergbahn which is to the east.

FREERIDING. Once you exit the Penken, there is a short stroll and a drop off down to a learner t-bar or the Penken Express. The red runs on this side are good fun and have a few short tree runs, but can get quite crowded.

Drop down into the other valley for some more testing runs like the Black 14 which is fairly steep and icy but good fun.

Nearby the new 150 person cable car, the 150er-Tux, whips you up to the Horberg peak. From here you can turn right off the lift and take the Blue 6 piste then drop off the edge into the Horbergtal and go off-piste back to the terrain park. Work out where you are going to cross the river before dropping into the valley!

In this area this is also a nice wide blue learner slope next to the Tappenalm lift, which leads to the Schneekar lift. Ascend this and visit the Schneekarhütte restaurant at the top of a nice black

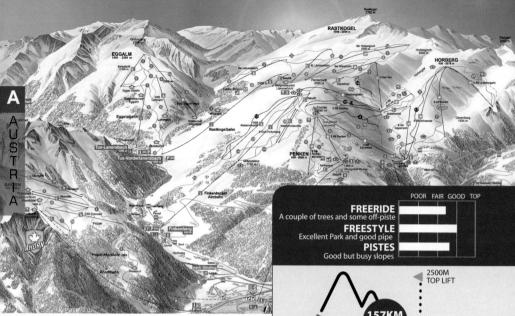

run (Route 17). It still has a big log fire and good food which can be washed down with all sorts of organic schnapps. Take Black 17 or Red 7 down which is also pleasant.

Another nice place for a day trip is the small resort of Kaltenbach. This place often has lots of untracked powder after a dump because no one goes there! You can also take the same train to Zell am Ziller, and then a bus or taxi to their lift. Unfortunately your Super Zillertal pass isn't valid here, but it is still worth a visit as it is a large area linked to Gerlos and Konigsleiten, which is famous for its tree runs.

FREESTYLE. The Burton terrain park is loaded with some big table-tops and an excellent half-pipe, as well as a separate line for those wanting less air-time. There's a good selection of rails and a chill out area. It is serviced by the Sun Jet chairlift so no walking is required. www. burtonparkmayrhofen.com

THE TOWN

There is an old tradition in Mayrhofen which states after a day's boarding you must visit the *Ice Bar* as soon as you step off the Penken and drink a Grolsch. This bar reputidly sells the most Grolsch is Europe and is only open 4 hours a day! It gets heaving but can be great fun. In 2003 they also build a Kebab shop in the bar, so you don't even have to stumble outside for refreshment.

After après boarding, late beers can be drunk at the chilled and friendly Scotland Yard pub, and then you can dance til dawn at Arena. Moe's Bar serves decent food and good cocktails too. Other tips are the restaurant under Sport Garni Strauss Hotel which serves nice Austrian food, or there is a good Chinese near Scotland Yard.

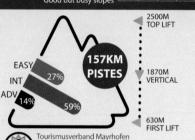

WINTER PERIOD: Dec to April SUMMER PERIOD: May to Nov (Hintertux Glacier) LIFT PASSES

WEB:www.mayrhofen.com,www.mayrhofner-bergbahnen.com

Half-day pass 25,50 euros, Day pass 35 euros Zillertal Super Ski Pass (589km pistes): 5 Day 148 euros Season 405/496 Mayrhofen/Zillertal

Dursterstraße 225, 6290 Mayrhofen

TEL: +43 5285 67600

EMAILinfo@mayrhofen.at

BOARD SCHOOL

Snowboardschule Mayrhofen Total charge 34 euros for a 2hr lesson. private lesson 101 euros for 2hrs (for 1-2 people), 4hrs 175

NUMBER PISTES/TRAILS: 109 LONGEST RUN: 9km

TOTAL LIFTS: 46 - 4 Gondolas, 1 cable-cars, 16 chairs, 19

LIFT TIMES: 8:30am to 4.00pm LIFT CAPACITY: 67,520 people per hour

ANNUAL SNOWFALL: 10m **SNOWMAKING:**50% of pistes

TRAIN: Jenbach railway station is about 35 km away. Take the Zillertalbahn train or bus to Mayrhofen

FLY: Fly to Innsbruck (110km), 2 hours transfer. Friedrichshafen, 120km. Altenrhein, 100km. Zurich, 200km

CAR:Fly to Innsbruck (65km), 1 1/4 hours transfer. Salzburg airport (170km) about 2 1/2 hr transfer. Munich airport 190km

NEW FOR 2006/7 SEASON: 160 person cable-car the new Ahornbahn set to be the biggest in Europe will replace the existing cable-car but positioned closer to the centre of Mayrhofen

Photo: Obergurgl Tourism

OBERGURGI

Good sedate carvers & wrinkleys resort

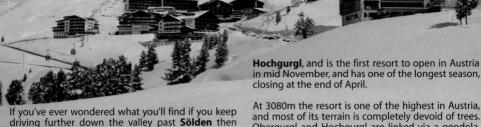

At 3080m the resort is one of the highest in Austria. and most of its terrain is completely devoid of trees. Obergural and Hochgural are linked via a gondola, theres not a huge amount to choose between the two, but you'll find the more advanced terrain at Hochgurgl. The resort shines and gets top marks is as a carver's resort, where you area treated to huge wide open intermediate slopes.

Obergural is linked, with its slightly higher neighbour POOR FAIR GOOD TOP **FREERIDE** No trees but some off-piste **FREESTYLE** No park or pipe **PISTES** Wide, smooth & plentiful

the answer is Obergurgl. Just 20 minutes from

Sölden and 90 minutes from Innsbruck, Obergurgl

is traditionally a popular haunt for more elderly

skiers; its slopes perfect for sedate snowploughing.

3080M TOP LIFT EASY 1280M VERTICAL FIRST LIFT

Hauptstrasse 108, A-6456 Obergurgl-Hochgurgl, Austria TELEPHONE:+43 (5256) 6466

WEB: www.obergurgl.com EMAIL: info@obergurgl.com

WINTER PERIOD: mid Nov to end April/May

Half-day 31 euros, Day pass 39 euros, 5 day pass 170 euros NIGHT BOARDING

8km of pistes open on tuesdays till 10pm (10 euros)

TOTAL NUMBER PISTES/TRAILS: 35 LONGEST RUN: 8km

TOTAL LIFTS: 23 - 4 Gondolas, 12 chairs,

LIFT CAPACITY: 37,000 people per hour LIFT TIMES: 9am to 4.00pm

ANNUAL SNOWFALL: 7m SNOWMAKING: 90% of pistes

FLY:1hr from Innsbruck airport.

BUS: bus from Innsbruck (4 times a day) or Ötztal-Bahnhof (8 times a day)

CAR: From Innsbruck head along the A12 and turn off on to the B186 down the Otztal Valley to Obergurgl. TRAIN: train to Innsbruck or to Ötztal Bahnhof

The resort's high altitude scores highly in its snow record with heaps of the stuff falling every year, and to keep the lower slopes open early the resort boasts snow cannons covering 90% of its pistes. Most of the 110km of runs are of an intermediate level with a series of reds, a few easy blues and only a couple of advanced black trails to check out. There's good off-piste potential, but almost no interest for the freestyler. 99% of visitors are skiers, and the resort removed the half-pipe and terrain park the other season as they said no one used it.

FREERIDERS who like jagged and rough mountain slopes with big chutes and long gullies may find things around here a little on the tame side. There are no tree runs but there are some good off-piste and powder areas that can be ridden at speed.

FREESTYLERS will largely be wasting their time up here, this is not an air head's retreat. There are of course a few natural hits as with most mountains covered in snow, but they are few and far between. The resort removing their park & pipe gives a clear indication where they see their clientele.

PISTE lovers and carvers are the ones in for a treat. Obergural is dream for those who want to arc over in style on well groomed runs that are wide and free of obstacles.

BEGINNERS should have no real problems with this place. The mountain is nicely laid out and novices can ride from the mid point all the way to the base via the number 5 and 6 trails.

THE TOWN. Off the slopes Obergurgls local services are excellent and very convenient for the slopes. There is a good choice of hotels and guest house along with shops and sporting facilities. A number of the big hotels have indoor swimming pools and gyms. Night life is a tad tame with only a handful of bars to choose from.

BERTAUL

Great untracked freeriding & good park

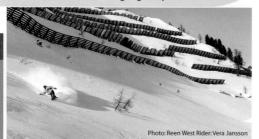

Just when you thought that Austria was all the same, along comes Obertauern. The terrain is very much freeride-orientated with lots of areas to check out suited to all levels, and its noted for its excellent snow record. Obertauern is also home to Doresia and Heidi Krings, two pretty and pretty famous Austrian boardercrossers and it's probably no coincidence that they became so good, with a training ground like this on your doorstep. You can basically pick your spot and head off-piste whenever you see some powder, and then pick up the piste further down the mountain. If you're in the know, or with someone who does then there's some excellent areas where you're almost always guaranteed to cut fresh tracks. A lot of these areas aren't particularly hard-core to get to, but they are nicely hidden from your regular piste hugger. There are also some epic freeride opportunities that you have to hike to, but make sure you're with a guide or someone who knows the area and never forget your avalanche equipment. Obertauern is usually quite stable regarding avalanches but the devil doesn't sleep, so never take anything for granted.

FREERIDERS. We've a full breakdown of all the good off-piste routes on the Obertauern review online, but you'll need to use the access code in the back of the book, but here's a summary. One of the most famous spots is the Zehnerkarrinne which is an excellent gulley, and accessed from the top of the Zehnerkarbahn cable-car. Head down the piste for about 50m, then go left over the high snow wall and you'll see the gulleys. Make sure you take a sharp right under the rock face and head through the trees back to the bottom station. The Hundskogelgully Skiroute is good after a recent dump, head to the top of the Hundskogelbahn and follow the signs, if you've got the balls then there's a massive jump over the cornice just on your left after about a 1/3rd down the gulley. Check out the Mankei SkiRoute for some great tree shredding, and from the top of the Gamsleiten-II charlift are some epic long descents but you'll need to hike to reach the best bits.

FREESTYLERS will enjoy the 1.5km Long-play Park (www.longplaypark.com) located next to the Kehrkopfbahn lift. All the big kickers are earth formed and available all-season. They run competitions up here all season, but there's plenty to occupy the non-pro with a great range of kickers and rails. Away from the park, there's some great cliff drops suitable for all from the Zehnerkar towards Gamsleitenbahn1

PISTES. Advanced riders have plenty of good, testing

blacks where carvers can leave some nice lines.

BEGINNERS have loads of nice, not too steep tracks with plenty of space to fall, slide, roll and crash, and because it's a valley, you can follow the sun to ensure it's the soft stuff you're falling into. There are some good board schools to choose from, and you'll find most of the lifts are very easy to get on and off.

OFF THE SLOPES you'll find excellent lodging and local facilities at the base of the slopes suitable for all budgets. It's a nice village on top of the Tauern in a snowsafe valley. It's far from a big town, but it's got everything you need and in typical Austria style there's some lively après-ski. You have all sorts of different 'Almen' and bars with the weirdest names as Monkey Circus or the Tower and Römerbar just to name a few. It's a tricky balance between some wicked drinking sessions, and getting those fresh lines; our advice sleep when you get home.

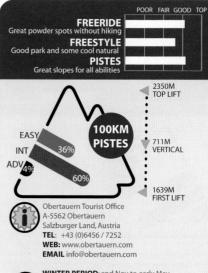

WINTER PERIOD: end Nov to early May

LIFT PASSES Half-day 27 euros, Full-day 34,50, 7 days 188 **BOARD SCHOOL** 4 main schools

NIGHT BOARDING Monday & Thursday 7pm-10pm, the Edelweiss 4-Sesselbahn lift is open with 1.5km of pistes. Free for holders of multi-day passes

LONGEST RUN: 4km

TOTAL LIFTS: 26 - 1 cable-cars, 18 chairs,7 drags

LIFT TIMES: 8:30am to 4.30pm

LIFT CAPACITY: 67,520 people per hour

ANNUAL SNOWFALL: unknown SNOWMAKING: unknown

BUS HABERSATTER REISEN run transfers from Salzburg Tel: 06452/7788 40 euros return and takes 3 hours. Taxi: 08008294783

TRAIN: to Radstadt station, 20km away. FLY: Salzburg is 1 1/2 hours away (90km), Munich 250km,

Klagenfurt 145km

CAR: From Munich take the Salzburg A10 Tauern Motorway. Take exit 63 for then onto the B99 Katschberg Federal Road. At Radstadt continue on to Obertauern

100 USQ WWW.WORLDSNOWBOARDGUIDE.COM

Pic -Ted Land

PHZIA

Snowsure resort with a good park

Pitztal is another of Austria's glacier resorts, but this little gem season is a little shorter than the others with the lifts stopping at the end of May for snow sports. With an area of 185 acres its not great in size but the terrain is ideal for a trip for beginners to intermediates and family's. Most of the area can be bagged in two days, but don't be

put off as Pitztal sister mountain, **Hochzeiger** is right next door with another 45km of pistes on offer, and a dual lift pass is only a few euros more.

The Pitztal Glacier is accessed through a 3.7km tunnel. which brings you out at the restaurant and rental shop. After a quick walk you're at the lifts, jump on the gondola to get to the highest point and take in the amazing views. One point to note is that the lifts are long and boring, so if you like a rest after each run you are laughing. Plans are in place to link the resort with Sölden but at present the Green party aren't too keen.

FREERIDING. You don't find many freeriders in Pitztal so you'll be almost guaranteed to ride powder every day and most of it un-tracked. The best option is to jump on the 4 x cable cars which take you to the highest point follow the 9a and head for the middle station, then cut onto the black 10 cutting through to the chair lift 1a. This run cuts out the long T bars.

FREESTYLE is where Pitztal pulls it out of the bag. They have a number of parks, a rail park with a large selection on offer and they are well maintained. There's also a short half pipe, and a boarder cross track will some nice banks. You'll also discover a number of sets of rollers dotted around the mountain.

BEGINNERS. The designated areas are very small and a waste of time, use 1a if your planning to use Pitztal as your training ground as its longer than the recognised areas and its serviced by a chair lift.. Pitztal is definitely an area perfect to log your first turns.

OFF THE SLOPES. The beauty of the Pitztal valley is it's at altitude so there's no need to sit on a packed bus for the 20 min journey to the base station, getting taken out by ski poles. The lifts are on your door step or at least just a few stops. The main night time hang out is at the Hexenkessl which is good for food and often has live music. Other than that it's a quite night in. Eating options are good but are a little pricey. The nearest large supermarket is a 15 min drive down the valley. In the summer month's there's lots to do in the valley, a vast amount of mountain biking routes, a large climbing wall and a small skate park further down the valley. Accommodation. Haus Berghein is a nice B&B just a short ride/walk to the base station 0043 541 386226. Landhaus Edelwiess is ideal if you want to stay in an apartment which offers friendly service and great meals 0043 541 38320 www. edelweiss-pitztal.at

POOR FAIR GOOD TOP FREERIDE No trees just untracked powder fields FREESTYLE A park & a small half-pipe **PISTES** Well maintained never icy slopes

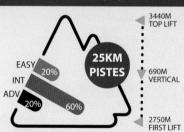

Pitzal Tourist Office Unterdorf 18, A-6473 Wenns im Pitztal

TEL: +43 (5414) 86999

WEB:www.pitztaler-gletscher.at / www.pitztal.com EMAIL:info@pitztal.com

WINTER PERIOD: Sep to mid May LIFT PASSES Half-day pass 22.5 euros Day pass 34.50 euros, 6 Days 164 euros

NUMBER OF RUNS: 16 LONGEST RUN: 6km

TOTAL LIFTS: 8 - 1 Funicular, 2 Gondola, 2 chair, 2 drags, 1 learner tow

LIFT TIMES: 0830-1630hrs

ANNUAL SNOWFALL: Unknow SNOWMAKING: none

TRAIN nearest station is 38 km away in Imst, which have frequent runs from Innsbruck and to Pitzal. FLY Innsbruck is 55 km, 1hr 20 min.

CAR From Munich go either via Garmisch and the Fernpass route and Imst or via take the autobahn towards Salzburg then take the A12 via Kufstein, Innsbruck and Imst

NEW FOR 06/7 SEASON: new 6-person chair and 2-stage 8-person gondola replaces the old Mittelbergjoch 1 t-bar.

AI BACH/HINTERGI FIVM

Good easy freeriding & apres

Saalbach and Hinterglemm are two villages at the end of the Glemm Valley, and combined with **Leogang** create the Saalbach ski circus giving you access to 120miles of pistes. The cul-de-sac layout means no matter where you start you can loop in either direction back to the start.

The area is perfect for beginners to good intermediates with mile upon mile of well groomed and wide pistes. The pistes are very spread out giving you a huge area to roam on and off the pistes, picking out powder staches to throw spray turns in. You can literally pick lines from the lifts, pushing yourself as far as you want to, great for wannabe freeriders.

Advanced riders may find things a little tame with only a few black runs. The run under the Schattberg x-press in Saalbach is long and steep, but the other under the Zwölfer-Nordbahn in Hinterglem can be a windswept icy mogul nightmare. The black/red from the top of the Zwölferkögel is good for opening things up and speeding down and plenty wide enough to find a clear path.

The last few seasons have seen huge investments in the lift system and a series of new gondolas have replaced many of the rickety old chairs. There are still a few bottlenecks for the 3-seater Sesselbahn and Mitteregg lifts. T-bars tend to service a lot of the short beginner runs and the park in Hinterglemm, avoid that area and you can get to most other parts via chairs. The Bergeralm lift provides a shortcut to Leogang from Saalbach but the t-bar's 1.3km long and 52° in places, and it feels even worse.

The resorts lie at quite a low elevation and rise to a modest 2020m, but due to its position in the valley it gets plenty of snow, with regular snow throughout the season. All of the main slopes have snowmaking facilities to cover any shortfall. There is a regular skibus service between the two villages and a taxi will cost around 10. Do give yourself plenty of time to get back from Leogang, if you miss the last lift you'll be looking at a 40 taxi back. For a change of scenery Zell am See is only 30 minutes away by bus (from the bottom of the Schattberg lift), and the high altitude resort of Kaprun about 45 minutes.

FREESTYLERS. There are two terrain parks; one in Hinterglemm the other in Leogang. The Hinterglemm park is aimed more towards beginners and is served by its own t-bar. There are a couple of kickers and rails, and at such a low elevation it usually doesn't get going until later in the season. The park at Leogang is much better and aimed much more toward the advanced airhead. The lines are always changing, but there's usually a couple of rollers and boxes to get you started, and an advanced rail and kicker line. The parks are designed and maintained by Austrian Xgamer Mario Fuchs. The halfpipes are being removed, but the resort does insist the effort is switching to improving the parks. There is talk of replacing the t-bar at the Hinterglemm park with a chair, and build-

ing a boarder cross circuit above where the park is. Away from the parks you'll find a good number of lumps you can throw yourself off, but there's not much in the way of cliff drops.

FREERIDERS. The layout of the lifts and mountains ensures that there's a huge amount of accessible off-piste, albeit between pistes, and not too steep and taxing. There's a couple of nice small runs down to the bottom of the WetterKreuz lift from the top of the Reiterkogel and Bernkogel peaks, you'll need to duck under the ropes so watch yourself. Towards Leogang the area under the Polten lift is always good fun with a mixture of trees and dips that can be taken at speed.

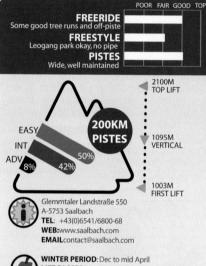

LIFT PASSES

Half-day 30.6 euros, Day pass 37,50 euros 5 days 157,50euros, Season 525 euros

BOARD SCHOOLS

Snowboardschule Saalbach. Beginners 1/2 day lesson 54 euros, week 244. Freestyle/freeride 163 for 3 day course. Backcountry & private lessons available. www.board.at for more info

RENTAL

Board & Boots from 29 euros a day

LONGEST RUN: 7km

NIGHT BOARDING

Small park and beginners area lit in Hinterglemm

TOTAL NUMBER PISTES/TRAILS: 61

TOTAL LIFTS: 55 - 13 Gondolas, 14 chairs, 28 drags

LIFT TIMES: 8:30am to 4.00pm LIFT CAPACITY: 87,000 people per hour

ANNUAL SNOWFALL: unknown SNOWMAKING: 20% of pistes

TRAIN: to Zell am See (12 miles), then taxi or local buses run every 1-2hrs daily.

BUS: Buses from Salzburg, can be taken to Zell am See, then transfer by local bus to Saalbach.

FLY: to Salzburg International (90km) transfer time to resort is 1 1/2

CAR: From Salzburg take Tauern Autobahn A10 towards Villach, at Bischofshofen interchange take the B311 towards Zell-am-see. Follow signs for Maishofen, there heads towards Glemmtal follow for 14km

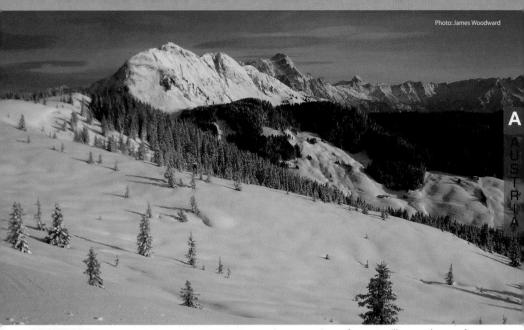

BEGINNERS will find things pretty much perfect. The blue run under the **Berkogel Sesselbahn** gets busy but is rarely moguled even at the end of the day. The area from the top of the **Kohlmaiskopf** back down into Saalbach is huge and open and great for progressing. The blue down from the Schattberg to Vorderglemm can be a little narrow at times but it meanders for 7km and its gradual pitch shouldn't present any problems. You will also find this an easier way to reach Leogang. The beginner's areas at the bottom of Hinterglemm and in Saalbach can get very icy, so it's recommended to get higher up the mountain as none of the slopes are too intimidating to tackle.

ACCOMMODATION

There's a good range of accommodation to suit most budgets. Unlike other resorts, location isn't too

important in so far as you'll never be too far away from a lift. You can find Pensions from 20 euros per night. For a full listing take a look at their website, or if you're already there then you'll find the tourist information in Saalbach on **Glemmtaler Landesstrasse** who should be able to find you something

EATING

You certainly won't starve here, but as with any resort if you have the cash you can eat like a king. There's many restaurants serving mainly Austrian cuisine, but you'll also find Italian and French restaurants. Both villages have a supermarket for take-outs and some very late night kebab and burger houses. On the slopes it's the usual expensive story, however the Alte Schmiede in Leogang serves fantastic made to order pizzas, and the Goasstal a mean gröstl

NIGHTLIFE

If you're not a fan of après ski then this place may be best avoided. If you're still reading then there's a choice of 32 après ski bars to pick from. Without question the *Hinterhag Alm* is the pick of the bunch, located at the top of the turmlift t-bar in Saalbach. You'll struggle to get in after 4:30 and the live band ensures everyone's dancing on the tables. At 7pm you'll stumble out and remember the only way back is to board back down the piste, and funnily enough, waiting at the bottom is the famous *Bauer's*

Ski Alm which is open till 3am. Over in Hinterglemm the Goasstal kicks off with strippers and live goats (no kidding), its also a good place for lunch. Away from the après ski scene the Londoners open till 4am and the Alm bars pretty good (yes there's a tree inside the bar). In Saalbach you can get your pool/darts/skittles and football fix at Bobby's pub, and theres a few clubs open till the early hours around the main square.

www.worldsnowboardguide.com 103

SCHLADMING

Good all-round resort

Schladming is fast becoming a magnet for snowboarders, providing a lively base for visiting the connected local mountains. Dachstein is an all year-round resort, with summer riding on the Dachstein Glacier, and is home to the Burton Superpark. The riding is spread out over a number of areas which offer basic intermediate terrain. and perfect beginner stuff. Schladming is not a hardcore or advanced rider's destination, but that's not to say there aren't any testing runs. The four mountains Planai, Hauser Kaibling, Hochwurzen and Reiteralm make up the local area. The Hauser Kaibling mountain has lots of intermediate terrain, with a series of long reds that are ideal for carvers. There are excellent novice trails, with the option to ride a long blue all the way down to the base at the village of Haus, just up the road from Schladming. Hochwurzen, which rises up to 1,850m, has lots of trees for freeriders to drop through, and a number of reds at the top that base out into simple blues, with easy runs back to Schladming Theres also a small well shaped park from Christmas time onwards which is floodlit at night. The Planai Mountain holds the main trails and is reached from the edge of Schladming by gondola. Planai's runs offer something for everyone, with some interesting intermediate freeriding terrain. The Reiteralm area is much the same as Hochwurzen and although it has a bigger riding area, it's less convenient for Schladming. Snow cover is pretty good with snowmaking facilities 90% of the Planai and Hochwurzen pistes. The lift pass covers the entire Ski Amade region, 865km of pistes.

FREERIDERS will find that any of the areas listed above can suit their needs, with some cool tree runs to be found on the Planai, and favourable powder to be found at Hauser Kaibling.

FREESTYLERS will find natural hits in most areas, with the Planai and the Dachstein Glacier having the best spots. There are also two halfpipes and fun-parks in the area to catch air on. One of the pipes is also well maintained during the summer months. The park on the Dachstein Glacier really comes to life in Autumn and Spring when the park season kicks off. The Home to the

Pleasure Jam and the Superstar Session are held here every year.

BEGINNERS will find the Rohrmoss area at 869m is flat and boring, but should still appeal to novices. Snowboard instruction is very good, and they even have a children's snowboard school. Blue tomato run a snowboard school on the Planai

OFF THE SLOPES. Accommodation is spread out around a large area, but the old town of Schladming has the biggest selection and offers the best facilities. Prices vary throughout the area, but as there is a youth hostel with cheap bunks, life is made easy for riders on a budget. Food wise, Schladming offers everything from typical meaty Austrian faire in the Vorstadtstube, Italian in Giorgios, and a quick yet very filling snack in the form of Schnitzel burgers and Sausages at the take away Ums Eck. Night-life is improving every year. The Hanglbar on Salzburgerstraße is a great friendly bar which offers bowling in the caves underneath. Marias Mexican Bar, La Porta cocktail bar are good and finish the night off in the Sonderbar disco which is always rammed at weekends. The area offers a vast amount of sporting facilities.

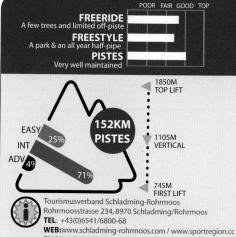

EMAIL info@schladming-rohrmoos.com

WINTER PERIOD: Dec to April LIFT PASSES Half-day 29 euros, 1 Day pass 34.5 euros

5 Day pass 154 euros, Season pass 415 euros RENTAL Blue tomato have a huge test centre www.blue-

NIGHT BOARDING 3km piste floodlit at Hochwurzen, open every day except Sunday

TOTAL NUMBER PISTES/TRAILS: 74 LONGEST RUN: 7.7km

tomato.com

TOTAL LIFTS: 88 - 7 Gondolas, 14 chairs, 65 drags

ANNUAL SNOWFALL: 5m SNOWMAKING:30% of pistes

TRAIN: The nearest train stop is Schladming FLY:to Salzburg, 90km away. Munich 290km, Graz 190, Innsbruck 320km

CAR: From Salzburg go to Radstadt on highway A10, then on federal road (B 320) 18 km to Schladming. From Graz to Liezen on highway A9, federal road B 320 to Schladming

NEW FOR 2006/7 SEASON: Hauser Kaibling area investing 4.7million euros on 40 new snow cannons

104 USQ www.worldsnowboardguide.com

SEEFELD

Pretty, but nothing too pulse racing

Seefeld is a tiny picture post card resort and every thing you imagined an Austrian village to be. This low key retreat is only 20 kilometres from Innsbruck and can be reached with ease along the A12 Autobahn via Zirl. Seefeld is noted more in the winter for being a cross country ski retreat and in the summer a popular holiday destination attracting visitors to sample the beauty and the tranquillity of the area. The German resort of Garmisch is only a short distance away across the Austrian German boarder and both resorts can be ridden with the one ski pass called the 'Happy Card', which can be used in other resorts in various countries.

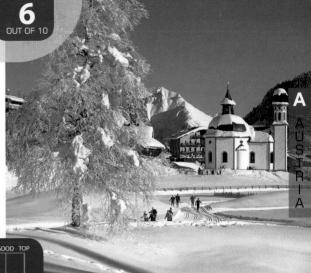

Pic -Seefeld Tourism

POOR FAIR GOOD TOP
FREERIDE
Some scattered trees & small ok off-piste
FREESTYLE
A park, no pipe
PISTES
A few good fast slopes

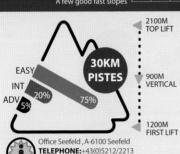

WEB: www.seefeld-tirol.com
EMAIL: info@seefeld.at
WINTER PERIOD: Dec to April

LIFT PASSES
Half-day 23 euros, Day pass 28 euros, 2 Days 54
NIGHT BOARDING

mon,tue,wed & friday on Rosshütte from 6:30 until 10pm. The lower Härmele slope

BOARD SCHOOL

1 day (2hr) lesson 46 euros, 5 days 135 Private lesson 40 euros per hour

RENIAL

Board & Boots 34 euros a day

TOTAL NUMBER PISTES/TRAILS: 36 LONGEST RUN: 6km TOTAL LIFTS: 25 - 3 Gondolas, 5 chairs, 18 drags LIFT TIMES: 9am to 4.00pm

ANNUAL SNOWFALL: 3m SNOWMAKING: 90% of pistes

FLY:Innsbruck 21km away, Munich 138, Zurich 300 CAR: East: Highway A12 / Exit Zirl east, head 12km in a northerly direction following the signs for Garmisch Partenkirchen

West: Highway A12 / Exit Telfs east + 12 kms **TRAIN**: take the Karwendelbahn from Innsbruck to Garmisch

On its own Seefeld is not noted for its hard-core down hill skiing or snowboarding, but nevertheless this is still a fun mountain with riding possible up to an altitude of 2100 metres and descends back down to the village outskirts. The ride area is split across two separate areas that of the **Gschwandtkopf** and the **Rosshutte**. The smaller of the two, being the Gschwandtkopf, is rather limited with only a few easy slopes for novices to try out. However, its still easy to get around and is a good spot for beginners to spend a few days learning on. The Rosshutte is a little more extensive with longer trails and wider slopes, but nothing that adventurous.

FREERIDERS will find riding here is done at sedate pace. Nothing is going to take you to long to conquer and good intermediate and expert riders will have this place licked within a day or two at the most. Still, there is a few spots to make a visit here a worth the while. The top section of the **Seefelder Joch** gives access to a few interesting spots which includes a few trees that line the lower parts of the main run down to the base area and the village.

FREESTYLERS are offered the delights of a fun park located on the **Rosshutte** area and reached by taking the funicular train that takes you up to 1800m. There's an okay assortment of jumps, quarter pipes, rails & boxes but the past days of glory are long gone. Out of the park, good natural hits are hard to come by.

PISTES. The open wide runs of the Rosshutte area are superb for laying out fast turns on.

BEGINNERS have a resort that is in the main all theirs. Very little of the place is out of bounds to novices.

THE TOWN

Off the slopes Seefeld is quaint village with superb local facilities. Five star hotels and well appointed guest houses make up this almost car free hamlet. There are also good sporting attractions as well as decent restaurants and okay bars.

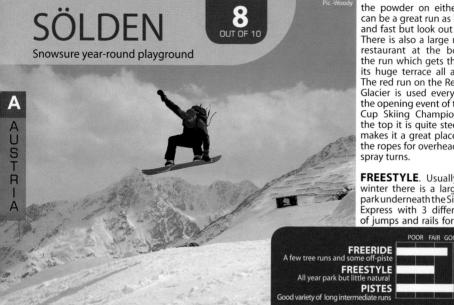

This World Class Resort is located 90 km (56 miles) from Innsbruck and 40 km (25 miles) from **Ötztal** (the nearest train station), and is just down the road from the better known resort of Obergurgl. The area consists of "The Big 3" mountains, Schwarze Schneide, Gaislachkogel and Tiefenbachkogel, which are all over 3000 metres and serviced by high speed lifts with stunning views into Italy from their summits. At the top are 2 glaciers offering Austria's biggest glacial ski area and 147km of pistes overall, which are all perfectly groomed when the lifts open at 8am. More importantly, there is least double this distance in easily accessible off-piste terrain. One night a week the Gaislakogel opens in the evening and you can go nightboarding on a few of the slopes if you buy the extra night ticket. There is also a big ski / snowboard and firework show on the same night which is worth a look. The Giggijoch gondola serves the other end of town and both are linked with a frequent bus service. Every Friday there is a big party at the top of the gondola with bands playing. Rettenbach also hosts a huge outdoor musical every April incorporating 500 actors, lasers and fireworks. At the bottom of the World Cup Run on Rettenbach, next to the Stadium there is the Salomon station with a really cool bar upstairs.

FREERIDING. The Gaislakogel mountain is quite limited in terms of high altitude pistes with only one red run from the top, but there is a large area of off-piste right underneath the gondola in the Wasserkar valley. However, this is very avalanche prone, so check the risk level and your route before you shred it. There are also routes off the side of this peak down to the Ski Route, but it is easy to end up at the top of some very big cliffs so it is advisable to go with a guide! There is easier off piste under straight under the Giggijoch gondola through trees. You will come to a road, where you can walk up for 10 minutes then board through the trees back to the black run, or you can stop short and join back to the piste at the Sonnblick bar and drink a beer before descending. On the way to the glacier from the Giggijoch, be sure to try the Schwartzseekogl and make some tracks in

the powder on either side. It can be a great run as it is steep and fast but look out for rocks. There is also a large mountain restaurant at the bottom of the run which gets the sun on its huge terrace all afternoon. The red run on the Rettenbach Glacier is used every year for the opening event of the World Cup Skiing Championship. At the top it is quite steep, which makes it a great place to duck the ropes for overhead powder

FREESTYLE. Usually in the winter there is a large terrain park underneath the Silverstrass Express with 3 different lines of jumps and rails for differing

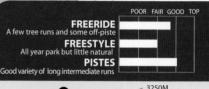

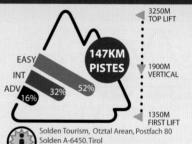

TEL: +43 (0) 5254 2120 WEB: www.soelden.com EMAIL: info@soelden.com

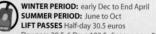

Day pass 39.5, 6 Days 193.5, Season pass 501 euros 1 Day (summer) 35.5 euros

BOARD SCHOOLS various board schools in town. Schischule Sölden, Yellow Power, Aktiv, Vacancia all run english speaking group and private lessons for all abilities.

NIGHT BOARDING Wednesday evenings theres a night ski show and night skiing on the 4km no.10 run

LONGEST RUN: 12.8km TOTAL LIFTS: 34 - 7 Gondolas, 19 chairs, 8 drags

LIFT TIMES: 9am to 4.00pm **MOUNTAIN CAFES: 20**

ANNUAL SNOWFALL: 5m SNOWMAKING: 27% of slopes

FLY to Innsbruck International (85km), transfer time to resort is 1 1/4 hours. Munich (223km) possible, take train to innsbruck, then change for Otzal

BUS from Innsbruck go direct to Solden with daily return services from Innsbruck train station.

TRAIN to Otztal, then 20 minutes local bus or taxi to Solden. CAR: From Munich or Salzburg take A93 Autobahn to Kufstein - A12 Autobahn past Innsbruck, take the Ötztal turn off onto B186 Federal Road (35 km) to Sölden

106 USQ WWW.WORLDSNOWBOARDGUIDE.COM

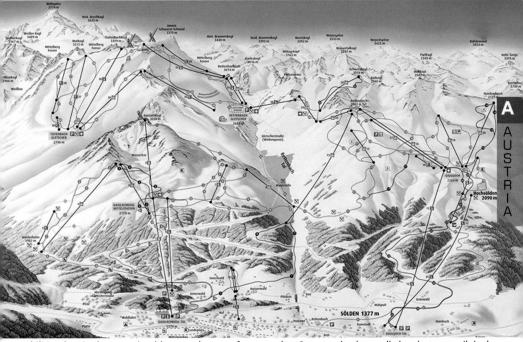

abilities, but its been noticeable over the past few years seasons their declining interest in building things. The pro line always has at least 2 monster kickers, and a set of very long straight, kinked and rainbow rails including the classic one over a small gondola car. Entering into the beginner/intermediate area there's a set of rollers to get you started. Then on the left there's a few rails and a box, and on the right 2 kickers next to each other. In the summer the park is relocated to the Rettenbach glacier for the BASE Boardcamp in June. Away from the park you'll struggle to find any decent natural hits.

PISTES. Solden is a great resort for piste lovers, with lots of long intermediate trails but very few real testing black runs. The runs down to town get very busy and moguled at the end of the day.

BEGINNERS. The main runs at the top of the Giggijoch get very mogulled late in the day, but this is where most of the board schools will take you. For the best beginners pistes, proceed through the ski tunnel to reach the Tiefenbach glacier and its huge, wide, cruising blue run which is great for learners or trying out new ground tricks. There are also 2 T bars feeding quiet red runs and some steeper off-piste opportunities.

OFF THE SLOPES. Very few English people stay here so the place is filled with Dutch, Germans and an increasing number of Russians who like to board and party. In contrast to some French resorts, the locals are extremely friendly and very helpful. The town stretches out along the main road for a couple of miles with the 2 main gondolas at each end of the town. The Gaislakogel gondola is in the West, and the Giggijoch is in the East. The queues at both of these gondolas can get quite bad, so miss the ski school rush at 9am, or take the small, slow, but tranquil single chair lift hidden away just to the west of the Giggijoch.

ACCOMODATION. There's around 10,000 beds in town, but it can be extremely difficult to get accommodation here so it is better to book through the Tourist Office before arriving. If Solden is full then try nearby Vent or Obergurgl, but you might need a car as the buses finish early.

FOOD. There are plenty of restaurants in the town. Those definitely worth visiting are the Alm Haus with its wooden exterior and traditional Austrian fodder, the Nudeltopf for great pizzas and pasta or Monty burger for rubber burgers. The Otzi Keller is now a posh restaurant for a slap up meal

NIGHTLIFE. After the lifts close at 4pm, the party commences with most of the après ski bars full of people wanting to do some serious drinking. It is possible to board right to the door of Marco's bar which is near the Post Office. This is a great spot to sit outside next to a heater and watch the sun set over the peaks then eat a burger from the BBQ outside. For more serious partying and dancing on tables there is the Bla bla Bar and Hinterherr which is opposite the Dutch bar, Alm Rausch. These three bars get crowded but the staff are highly efficient and always manage to serve you pretty quick. Once you have eaten dinner enjoy a digestif at the *Grizzly* bar which is very chilled with log fires. After a couple of quiet years Fire & Ice has picked up and is usually pretty rammed. The new modern Party Haus a bit further along has an open plan dancefloor/bar on the ground floor, a VIP bar, and even a Kebab shop upstairs. Lavina's nightclub isn't half as busy as it was but you can dance till 6am, then head over the bridge to the Stamperl bar or Kuhstall until 8am ready for the slopes.

SÖLL Okay for beginners

9

of the Ski Welt. Its traditional and appealing village makes it one of Austria's most popular resorts for package tour operators. The Brits and the Dutch are here on mass, silly hats and dancing on the tables in your ski boots are the norm as is skiing, you'll be lucky to see more than 20 other boarders a day. Söll is located along a main road which links Scheffau, Ellmau and Going, this road means that the one bubble up to the slopes (which is often mobbed) is a good 10/15 minute walk away from the village, although there's a free bus.

All the resorts of the ski welt are similar in style and character yet still have something different to offer, whether on the slopes, or around one of the traditional styled villages. The slopes here are ideal for boarders who think they can when everyone knows they can't. The reds here should be blue and the blues often go up hill. It's a great area for beginners but anyone else should stay and board in Westendorf which is by far the best riding area for anyone who can link turns.

Getting to this resort is very easy however, trying to appreciate the opportunities on the slopes when you arrive is a different matter. Expert riders will soon tire of the resort while slow piste riders and beginners will love it. This is also a cool place if you're on a tight budget and planning to take a cheap package holiday.

FREERIDERS will find this place a bit limiting. However, the black graded slope that runs down from the **Hohe Salve** is not a bad trail and shouldn't be treated too lightly, although if you sneeze you'll miss it. If the snow's good you can pick an off piste route down the south face on the mountain. Slope 2 which heads down towards the **Brixen Gondola** is good for a blast and has a high-speed 6 man lift to get you back up to the top.

FREESTYLERS have little to play on; the best park in the area is at **Westendorf**. There is another park on the **Ellmau** hill but it's not up to much unless there's a comp on.

BEGINNERS will be in heaven if the snow's soft. Söll has wide well groomed slopes with hardly a t-bar in sight. Piste 25 is long steady and great once you can turn a little. The only down side is that it's low altitude means you're often on fake snow and the pistes can be bullet when falling on your knees.

OFF THE SLOPES Quaint sums it up. Söll is a small village that offers high quality services, there's loads of cheep accommodation around the central church. Bars are a plenty and the wheat beer is great as is the food. There are lots of restaurants and surprisingly nightlife around here can be very good. There is a good choice of bars and a few night spots which are not over-priced, it's just over full with sad skiers doing après crap. The *Whisky Muhle* is open till four most nights has bands DJ's and best of all the English Football.

108 USQ WWW.WORLDSNOWBOARDGUIDE.COM

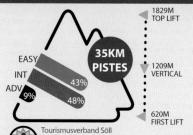

A-6306 Söll, Dorf 84, Austria

TEL: +43 5333 5216 WEB: www.soell.at / www.skiwelt.at

EMAIL :info@soell.com

WINTER PERIOD: Dec to April

LIFT PASSES Half Day 26,50 euros, Day Pass 34,50 euros 6 Days pass 168 euros, Season 455 euros

BOARD SCHOOLS

2hr group lesson 40 euros, 2hrs for 3 days, 88 euros. Private lesson 50 euros per hour

TOTAL NUMBER PISTES/TRAILS: 15

LONGEST RUN: 7.5km

TOTAL LIFTS: 14 - 2 Gondolas, 1 cable-car, 8 chairs, 3 drags LIFT TIMES: 8:30am to 4.00pm

LIFT CAPACITY: 37,000 people per hour

ANNUAL SNOWFALL: unknown SNOWMAKING:70% of pistes

TRAIN: Train to Kufstein or Wörgl, then 12km away via local

BUS: Bus services direct from Salzburg airport

FLY: to Salzburg airport 100km away (90 minutes). Munich 160km, Innsbruck 70km

CAR: From the Inntal Valley Motorway A12, exit KUFSTEIN SÜD/south or WÖRGL OST/east both 12 km away from Söll

Best resort in Austria, but a little snobby

Those who know about where to ride would have to agree that **St Anton** has the best terrain in Austria, making this place an absolute must. This is a resort that has it all and will suit all styles of riding, though favouring freeriders the most. Whether you're a freestyle freak, a piste carving poser, a freeride speed king or simply a nappy-wearing new kid, you will love this place. The area does have the reputation for being expensive and

FREERIDE Some tree runs and awesome off-piste **FREESTYLE** Small park & plenty of natural hits **PISTES** Wide & some testing slopes

2811M TOPLIFT 60KM PISTES 1507M VERTICAL 1304M FIRST LIFT

Tourismusverband A-6580 St., Anton am Arlberg TEL. +43 (5446) 2269-0

WEB:www.stantonamarlberg.com EMAIL:info@stantonamarlberg.com

WINTER PERIOD: early Dec to end April LIFT PASSES 1/2 day 31 euros, 1 Day pass 40.5 euros 6 Day pass 194 euros, Season pass 650 euros

BOARD SCHOOL 4hr group lesson 57 euros, Private 4hr lesson 221 HIRE Board & Boots around 35 euros a day

NUMBER OF RUNS: 134 LONGEST RUN: 10.2km

ANNUAL SNOWFALL: 7m

TOTAL LIFTS: 86 - 10 Gondolas, 39 chairs, 37 drags

LIFT TIMES: 8.30am to 4.00pm

LIFT CAPACITY (PEOPLE PER HOUR): 123,496

SNOWMAKING: 30% of pistes

FLY to Innsbruck International, transfer time to resort is 1 1/2 hours (100km). Friedrichshafen 140km, Munich 250km, Zurich 200km

BUS from Innsbruck go direct to St Anton with daily return services from Innsbruck. A service runs from Friedrichshafen to St.Anton visit www.airport-bus.at for more details

TRAIN various express trains direct to St Anton center, including the Orient Express

CAR From Innsbruck take A12 motorway for 70km take Landeck (E60) turnoff for 15km, picking up the B197 straight to St Anton. Drive time is about 1 1/4 hours, 100km total

NEW FOR 06/07 SEASON: the slow Galzigbahn chair is being replaced with a 24-person gondola

attracting the fur-clad, Ferrari-owning skiers, but whilst they sip pink gins in mountain bars, snowboarders can roam freely over miles of excellent terrain. With steeps, deep powder, air, and trees on all sides of the mountain slopes, it's hard to beat. The Arlberg ski pass allows you to ride the linked areas of St Christoph and Stuben, and (via bus) the resorts **Lech** and **Zürs** which all offer great snowboarding terrain, with amazing amounts of powder.

FREERIDERS are best suited to St Anton as it's the perfect playground, with a little of everything: steeps, powder, trees and big drop offs. Riders who know what they're doing should worm their way up to Kapall where they'll find loads of great freeriding terrain, with good natural hits. Alternatively, head to the mid station of Valluga Grat via the Galzig cable car to reach some major off-piste, with long runs back down to St Anton and St Christoph. Note you can only go to the summit of Valluga with your board if you are with a guide. Intermediates just getting it together will find loads to ride, especially on Gampen and Kapall. The runs on Galzig are easier, but tend to get busy with skiers. Advanced riders will love **Rendl**, a separate mountain on the opposite side of St Anton across to the Gampen runs. Whenever there's a fresh dump, expect to find the locals and ski-bums cramming into Rendlbahn for first tracks. This area is absolutely amazing for full-on freeriding terrain with tight and open trees and crowd-free slopes. Within a few days of a good dump, you'll be amazed to find much of the off-piste area to be completely tracked out. This is a serious Freeriders resort, with the right conditions and definitely with a guide, its possible to board from the top of the Valluga into Zürs, and off the back of Rendl from the top of the Riffelscharte, but do not underestimate the risks. Another great off-piste run is from the top of Albonagrat down to Stuben or Kloesterle. You will have to walk about 10 minutes from the peak but it is worth it for the long powder runs in large open bowls. At the bottom you may have to get a bus back from

FREESTYLERS spending a month or two here will never find every natural hit - the resort is simply littered

Pic -James Woodward

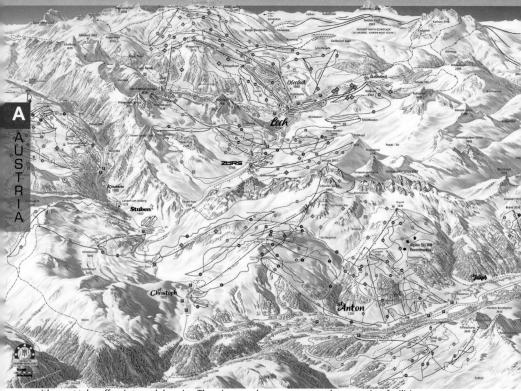

with great take off points and drop ins. There's a good area running parallel to run 17 to St.Christoph that's packed with drops offs and several natural half-pipes. It's a great freestyler's place, but lovers of man made obstacles will be disappointed. The park at **Rendl** feels cramped, but has some large kickers and rails. A better park and a half-pipe is located in **Lech**.

PISTES. Everynight the pistes are bashed to perfection, but the mass of skiers make sure they're moguled by the end of the day. The variety of pistes is fantastic; from the Mach 5 runs down from the Valluga to the gentle runs off the Gampen and Galzig. Fast carvers will enjoy the black Kandahar run down from the Galzig, and beginners will love the pitch of run 5.

BEGINNERS with a little adventure will be able to handle St Anton, but wimps may have trouble if they stray too far from the easy runs. A learner's slope at Nasserein provides a good starting point for a number of easy blue trails. Runs 4 & 5 from the Galzig are great for beginners, but there are a few flat bits at the bottom of run 4; stick your thumb out and try and hitch a pole from the passing skiers. If you're after lessons then its worth hunting around to find a specialist boarding instructor.

OFF THE SLOPES. St Anton is without doubt one of Europe's most prestigious resorts with a reputation for attracting the rich and famous. Unlike nearby Lech though, the snobbery of the place won't prevent you from enjoying yourself off the slopes, but you'll need a big fat wallet to get the most out of the place. There are plenty of fancy shops, but luckily also some supermarkets, banks, internet cafes and 110 USQ www.worldsnowboardguide.com

numerous other sporting facilities.

ACCOMODATION. There's plenty of lodging but nothing's cheap and anyone on a low budget will find it hard going. B&B's are available in the hamlets of Bach, St Jakob and Nasserein, all are less expensive than St Anton, there's also a free regular ski-bus linking them and taxi to the outskirts shouldn't cost more than 10euros

FOOD. As you would expect there are some seriously expensive places to eat, but look around and you'll find places for mortals as well. The *Funky Chicken* is reasonable, *Pizzeria Pomodora* as well as serving excellent cheap food, is the only place that'll let you in after 8pm with your board boots on. There's a serious lack of late night takeways around, so make a bee line for *Snackattack* on the main high street which is the only take-away open until 2am

NIGHT-LIFE is lively. You can kick off the evening's entertainment descending on run 1 (the Zammermoos). The *Krazy Kangaroo* is the first stop, as the name suggests it's an Ozzy bar and always loud and rammed with boarders. Next door is the more chilled *Taps*, then take the slope further down and you'll find the packed *Mooserwirt* but don't forget you've still got a kilometre or so before you can take your board off. Back into town and *Piccadilly*, and the *Post-Keller* are good options, the *Kandahar* is chilled with its own DJ and does great curries. *Bar Cuba* is a little soulless, Funky Chicken's okay as long as the bar staff don't catch you on the tables. For a chilled beer and a chat, the small and friendly *Pub 37* makes a pleasant change.

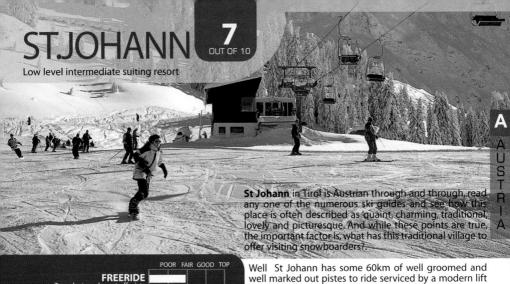

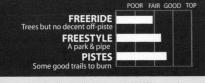

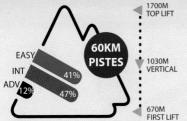

St Johann Tourist Office Poststraße 2. A-6380 St.Johann in Tirol, Austria

TELEPHONE:+43(5352)63335 0

WEB: www.st.johann.tirol.at / www.bergbahnen-stjohann.at

EMAIL: info@stiohanntirol.at

WINTER PERIOD: Dec to April LIFT PASSES

1/2 day 27 euros, 1 Day Pass 32 euros, 6 Day Pass 162 euros **NIGHT BOARDING**

Monday, Wednesday, Friday 7.00-9.30pm Rueppen run (1,2km) Wednesday 7.00-9.00pm Eichenhofrun (1km)

BOARD SCHOOL

Full day lesson 58 euros, 3 days 98euros

RENTAL

Board & Boots 23/138 euros per day/week

TOTAL NUMBER PISTES/TRAILS: 19

LONGEST RUN: 5km TOTAL LIFTS: 17 - 2 Cable-cars, 6 chairs, 9 drags LIFT TIMES: 9am to 4.00pm

ANNUAL SNOWFALL: 5.6m **SNOWMAKING:** 45% of pistes

BUS services run regulary from the airport daily.

TRAIN Station at St. Johann. 80mins from Innsbruck, 2.5hrs

FLY to Salzburg 90mins away (80km). Innsbruck 100km CAR From Salzburg head south on the route 312 direction

Wörgl to reach the resort. From Innsbruck take the A12 towards Kufstein, take the Wörgl Ost turn off on B178

system comprising of 3 gondolas, 4 chair lifts and 10 drag lifts. The Schneewinkel lift pass gives you access to 170km of pistes around the local area, including the resorts of Oberndorf and Fieberbrunn but they are only connected via ski-bus.

An important point to note about St Johann is that this is a very popular resort with a large number of British and German visitors. The resort is usually buzzing through the winter months especially over the Christmas and new year periods and from mid January through to the end of March. Although this is not a high altitude resort, St Johann can still boast a decent annual snow record of almost 6m a season and should the real stuff not fall, the resort has snowmaking facilities that cover over 45% of the marked out slopes. In terms of terrain, an advanced rider will have this place licked within a matter of two days, intermediates four days while beginners will enjoy a full week exploring the slopes, which are collection of reds, a handful of blacks and a load of easy blues. Still slope facilities are very good and the unusually for a place of this size, there are some 15 mountain cafes and bars.

FREERIDERS, if you are a basic intermediate freerider then this mountain will suit you and should provided you wil a number of intresting options that should easily take a week to muster. The best thing for advanced riders to do is check out the offerings at the nearby resorts of Kitzbuhel or Saalbach-Hinterglem.

FREESTYLERS have fairly decent halfpipe and terrain park to play in. Whilst around the slopes riders will be able to find plenty of good natural hits to get air from. But by any stretch of the imagination this is not an adventrious freestylers place.

BEGINNERS who holiday with their parents and don't plan to do a lot of riding in their lives will love this place as its perfect for novices.

THE TOWN

Around the town you will find lots of hotels, Pensions (B&B's) and other local services close to the slopes and at affordable prices. Nightlife options are excellent with a good choice of bars and restaurants to choose from.

STUBAI GLACIER

Good open flat runs, but weekend crowds

Stubai Glacier is the biggest resort under the Innsbruck area. It's also the only Innsbruck resort that has summer snowboarding. Stubai is a great mountain to try and offers the chance to ride fast on wide, open runs that are well groomed and serviced by a set of efficient, modern lifts. The only drawbacks are that, being a high glacier resort, it can be stupidly cold in the winter where the temperature can make it almost impossible to ride, and there's very little tree cover. The other problem is that because Stubai nearly always guarantees snow when lower areas are short on the stuff, the masses head here, making the place very busy, especially at weekends. Munich is only

two and a half hours away and so the place also gets a regular German overload. Access to the slopes involves a twenty minute cable car ride, but once up, you're presented with a great selection of runs. There's 2 rental & service centres at the top of the eisgrat and gamsgarten gondolas, they promise a 20 minute service while you take a beer.

FREERIDERS will find an abundance of trails to ride, but none of them are too demanding and lack a bit of variety. The 4 black runs on offer are pretty short, but trail 8 should keep you on your toes. The majority of the resort is above tree level, the only trees are below the Mittelstation, just watch out for crevaces and avalanches. From the gondolas you should be able to pick a few nice decents and drops without hiking. The Wilde Grubn is a 10k run back to the base, its not always properly marked so make sure you know where you're heading.

FREESTYLERS have a park & halfpipe but its not particularly well maintained and a little hit and miss. You'll find some natural hits over the place though.

PISTES. The management take great care in preparing the slopes; they don't just piste bash at night, but throughout the day, so there's plenty of opportunity to cut the corduroy. There's plenty of nice wide, well maintained pistes available.

BEGINNERS are well taken care of with a number of perfectly well-appointed, easy, flat blue runs. But watch out for the drag lifts. For the tots and the seriously bad, they've added a number of magic carpet lifts, and they're even covered.

OFF THE SLOPES. Theres many small villages on the road to Stubai, the main one of note being **Neusift**, a 20 minute drive from the glacier. There you'll find a good selection of hotels and pensions, some bars and restaurants. Probably the best place to stay is in **Innsbruck**, although it takes about an hour by car to get there.

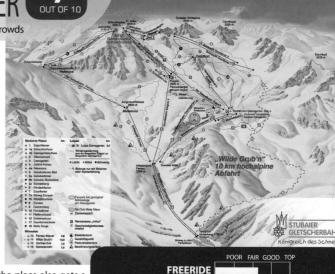

A couple of trees and limited off-piste

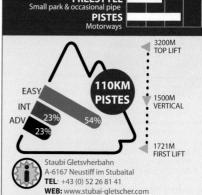

FREESTYLE

WINTER PERIOD: Dec to April SUMMER PERIOD: May to Nov LIFT PASSES

EMAIL:info@stubai-gletscher.com

Half-day pass 26 euros, Day pass 35.5, 5 Days 146.5 euros BOARD SCHOOLS 1 day 60 euros, 4 days 139 euros RENTAL board & boots 24-37 euros for 1 day

TOTAL NUMBER PISTES/TRAILS: 22 LONGEST RUN: 10km

TOTAL LIFTS: 19 - 5 Gondolas, 8 chairs, 9 drags, 3 Magic

LIFT TIMES: 8:30am to 4.45pm

LIFT CAPACITY: 36,000 people per hour

ANNUAL SNOWFALL: unknown SNOWMAKING: 10% of pistes

TI B

TRAIN: The nearest train station is Innsbruck. **BUS:** Free shuttles run daily from late September to early May between Schönberg and Stubai Glacier

FLY: to Innsbruck airport, 40 mins away.

CAR: Drive Via Innsbruck towards the Brenner Autobahn take the Schönberg exit, pay your 5 euro toll charge and continue on the B183 for 30km until you reach Stubai

WESTENDORF OUT OF 10 Best resort in the Ski Welt BRECHHORN FLEIDING 1892 m GAMPEN 1956 m BRECH TALKASER 1760 m MITTELSTATION 13 ALSTATION 789 mely WESTENDORF HOLZHAM POOR FAIR GOOD TOP **FREERIDE** Some steeps & okay off-piste **FREESTYLE** park & pipe Some good trails but can get icy

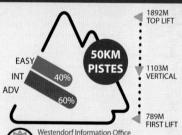

Westendorf information Office
Schulgasse 2, A-6363 Westendorf, A-Austria
WEB: www.westendorf.net
EMAIL: info@westendorf.net

WINTER PERIOD: Dec to April LIFT PASSES

Half-day 24 euros, Day pass 31.5 euros

TOTAL NUMBER PISTES/TRAILS: 19 TOTAL LIFTS:13 - 3 Gondolas, 7 chairs, 3 drags LIFT TIMES: 9am to 4.00pm

ANNUAL SNOWFALL: unknown SNOWMAKING: some

TAXI tel: 05334 30044 - they also run shuttles to Munich for 95euros return and other airports.

TRAIN Westendorf station is 1.5km from the town **FLY** Innsbruck airport 80km, Salzburg airport 80km, Munich airport 150km

CAR Take the A12 motorway from Innsbruck/Munich and take the Wörgl/Ost exit turn onto the B170 before you get to Soll and continue to Westendorf

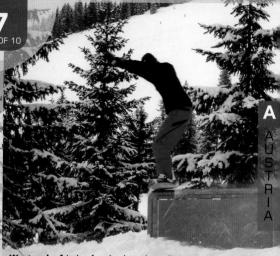

Westendorf is by far the best boarding spot in the Ski Welt area. Unlike the other resorts which make up the ski welt Westendorf stands alone and is only linked to the other resorts by road. If you're anything but a beginner don't let this put you off, as Westendorf is home to the only park of note in the area, some steep long off piste tree runs and some of the areas steepest and highest terrain. The backside of the mountain now connects up to the Kitzbuhel valley by an eight person bubble and a short bus ride (you will need a separate pass to ride in Kitzbuhel). Riding here you'll be in the company of other boarders who are trying to escape the beginner friendly cruising pistes of the main ski welt area.

FREERIDING. There is scope here for the advanced rider to let rip. There's loads of trees to shred through, but don't get carried away or it could be a long walk or a hitch back to the lifts. The back side of the mountain has many long truly off piste descents, so watch out as this area's not monitored and its south facing. Without the proper back country kit and knowledge the back face should be left alone.

FREESTYLE. There's a great little natural half pipe off the side of piste 118a which is great as the run leads down to the chair for the park. The park is quite well looked after; has a few rails, some well spaced kickers and an okay pipe. Away from the park you'll find some reasonable natural terrain to fling yourself off which is more than can be said for the other resorts of the Ski Welt.

PISTES. At almost 1900m the snowfalls normally good, so the high pistes are well groomed and good for the people who don't like to leave the groomed stuff. There's a long red from the top all the way to the bottom bubble but as you descend it gets icier and more dependent on the fake stuff.

BEGINNERS. It's fine for beginners who've mastered the very basics, but if it's your first time on snow you'd be better off in nearby Soll.

OFF THE SLOPES its not as quaint as the other ski welt resorts, but Westendrof can offer good night life, plenty of restaurants and a good chose of lodging. There's also a sporadic bus service to Brixen Thale where a bubble will take you up to the rest of the ski welt.

ZELL AM SEE

6 OUT OF 10

Not a bad resort but too busy

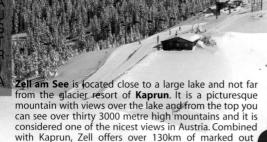

piste, much of which is treelined. A third of the runs

are covered by snowmaking facilities, which is a good

thing, as this resort doesn't have the greatest annual

snow record.

The management do frown when it comes to riding in the trees, as you are not allowed to snowboard through the wooded sections. Zell's main disadvantage is its own popularity as it's high on tour operators lists and therefore very crowded especially with the Brits. Whatever level of a rider you are or whatever style of riding you do, this place will give you the opportunity to practice your skills, and most people will be able to make a 5 day trip well worthwhile.

FREERIDERS have a varying selection of runs to choose from. Advanced riders may want to take the cable car up to the **Berghotel** where you will be able to gain access to a couple of good steep sections. There are also a number of cool runs down the Sonnkogel which is east facing, and therefore always in the sun, and the T Bar in this area has now been replaced by the **Hochmaisbahn**. Black 14 is a good run where the locals race and the average time to beat is 9 minutes. Look out for wooden or snow sculptures at the side of the piste or in the trees as you board. You can also be pulled by a skidoo up to the **Pinzgauer Hütte Restaurant** where there is an amazing view. There are not really any off piste possibilities here unless you hike a very long way, so if you are looking for deep powder and open bowl riding, then head on up to the glacier at Kaprun.

FREESTYLERS can choose to ride the park and pipe at Zell (which isn't very well shaped unfortunately) or try out the park at Kaprun. There is also a bar made of ice next to the fun park here! Around Zell locals often build their own hits but if you can't be bothered, you will be able to find lots of natural stuff to fly from.

PISTES. Riders have an ordinary mountain to cut up with plenty of well groomed trails to try out, more so at Zell than at Kaprun.

BEGINNERS have lots of nursery areas as well as spots that allow for easy progression making this a good

114 USQ www.worldsnowboardguide.com

novice resorts. The **Glocknerbahn** is a perfect slope for beginners to learn on.

OFF THE SLOPES zell am See is a busy village with a lot going on and plenty of accommodation at all price ranges. The village is a lively one and as well as having loads of restaurants, mainly hotel ones. Night-life here is also quite good with some okay bars to check out, including the Resi Dutch bar, and the friendly Crazy Daisy's. The village is a lively one and as well as having loads of restaurants, mainly botel ones.

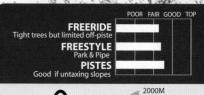

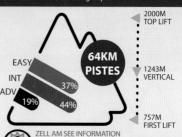

ZELL AM SEE Brucker Bund TEL: +43/654

Brucker Bundesstrasse 1a, A-5700 Zell am See TEL: +43/6542/770-0 WEB: www.zellamsee.com

EMAIL: welcome@europasportregion.info

WINTER PERIOD: Dec to April

WINTER PERIOD: Dec to April SUMMER PERIOD: May to Oct (Kaprun) LIFT PASSES

Day Pass 35 euros, 6 Day Pass - 168 euros BOARD SCHOOLS

Private lesson 185 euros for full day, Group lesson 55 euros for full day

TOTAL NUMBER PISTES/TRAILS: 49

LONGEST RUN: 4km
TOTAL LIFTS: 57 - 11 Gondolas, 1 cable-cars, 15 chairs,30 drags

LIFT TIMES: 8:30am to 4.00pm LIFT CAPACITY: 77,068 people per hour

ANNUAL SNOWFALL: unknown SNOWMAKING:30% of pistes

TRAIN: The nearest train stop is at Zell am See, 10 mins away.

BUS:Free shuttle service in and between Zell am See and Kaprun. 30min bus to/from Saalbach 5 times a day, also direct buses from Innsbruck

FLY: to Salzburg - 1 1/2 hours away (80km). Munich 180km CAR: from Salzburg head south on the A10 to exit 46. Then head south west along the 168 via Taxenbach

ZELL IM ZILLERTAL

7 OUT OF 10

Okay beginners & intermediates area

Zell im Zillertal is situated in the spectacular Zell Valley which is a mere 40 miles from **Innsbruck**. What you have here is a traditional Austrian village set out over the valley floor with ridable slopes that rise to a respectable high point of 2480m. Zell am Ziller forms part

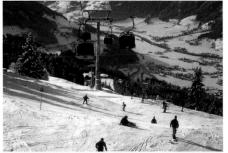

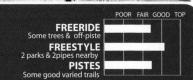

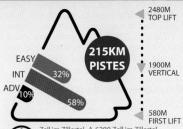

Zell im Zillertal, A-6280 Zell im Zillertal
TELEPHONE:+ 43 05282 2281
WEB: www.zell.at / www.zillertalarena.com

WEB: www.zell.at / www.zil EMAIL: info@zell.at

WINTER PERIOD: Dec to mid April LIFT PASSES Half-day pass 26,80 euros, Day pass 35 euros 5 Days pass 148 euros, Season 496 euros

BOARD SCHOOL 3 day 2hrs per day lesson 80-94 euros Private lesson 35 euros per hour

RENTAL Board & boots 24 euros per day

LONGEST RUN: 5km
TOTAL LIFTS 65 - 7 cable-cars, 30 chairs, 28 drags
LIFT CAPACITY: 93,920 people per hour
LIFT TIMES: 9am to 4.00pm

ANNUAL SNOWFALL: unknown SNOWMAKING: 32% of pistes

BUS services run regulary from the airport daily. **TRAIN** Station at St. Johann. 80mins from Innsbruck, 2.5hrs to Munich

FLY to Salzburg 90mins away (80km). Innsbruck 100km CAR From Salzburg head south on the route 312 direction Wörgl to reach the resort. From Innsbruck take the A12 towards Kufstein, take the Wörgl Ost turn off on B178

of what is known as the Zillertal Arena which along with resorts such as **Gerlos, Krimml and Konigsleiten/Wald** offers some 215km of terrain, and although the 65 plus lifts are not all linked on the slopes, they are linked by a single lift

ticket which costs from E120 for 5 days. All the resorts that form part of the arena have something different to offer but in general this area can best be described as suiting intermediate freeriders and piste loving carvers. Zell and its neighbouring resorts are all well designed and spread out giving a nice sense of open space but note, this open space attracts quite a lot of weekend skiers, although in general lift lines are not very big apart from the early morning first gondola ride up from the village. Zell's terrain is spread out above the tree line offering some wide open runs and some nice off-piste powder areas. Most of the upper runs are graded red, but some of them are a bit over rated and there's not a great deal for expert riders to ride down.

FREERIDERS can spend a week here and still not ride half of what is available through out the Zillertal Arena. With much of the terrain best suited to intermediates, what freeriders can achieve is a fun easy time that will allow them to explore some cool off-piste areas that on occasions has some deep powder stashes. You will also be able to shred down some decent gullies and through some open tree sections. The **Krimml Express** chair gives access to a really cool long red trail that can be ridden either back to Zell or down into the connecting resort of **Gerlos**.

FREESTYLERS are best provided with facilities at Gerlos under the name of 'Boarders Town'. Gerlos has a good large fun park which is packed with various jumps, spines, waves and 100m half-pipe pipe draggon shaped halfpipe. In Krimml, a fair distance along from Zell, theres a 700m park with numereous toys and a 80m halfpipe.

PISTES. Carvers have mountain that should keep then happy for the duration of their stay be it a week or two. The pistes are well maintained and there are some nice long trails.

BEGINNERS are the ones who should appreciate this area the most because this is a first class beginners resort and any novice spending a week here will leave a competent intermediate rider.

OFF THE SLOPES Zell has good local services with affordable accommodation, shops, restaurants, a post office and sporting facilities all next to the slopes. Nightlife is very quiet; there is a disco should you want to strut your stuff but you're better off in **Gerlos**

ROUND-UP

AUFFACH /

Wildschonau Valley

Auffach is the largest resort in the Wildschonau Valley with around 20km of marked piste set out on the Schatzberg mountain slopes. Niederau, Oberau, and

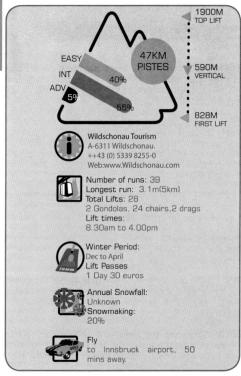

Thierbach make the other resorts of the Wildschonau Valley which provide an area that's relaxed, void of any crowds, very laid back and with out any of the hustle and bustle of the bigger and more popular destinations favoured by the tour operators and ski crowds. This collection of resorts would be idea for a family group on a weeks holiday, but would not appeal to hard-core riders in terms of the mountain or larger louts looking for an action packed resort bustling with night life. The majority of visitors here are either cross country skiers or middle aged downhill skiers. But with most things, there's always something that will appeal to most and although there are only a couple of black graded runs, proficient riders will be able to take advantage of the reds that are open planed and free of crowds. No one queues up long around here, and although none of the resorts link up on the slopes, getting around them is easy.

Auffach offers the highest altitude riding in the area

with a nice series of red runs set out over a wide open plateau. It is also the home to the areas main halfpipe and fun park, which is located up on the upper regions. One point to note about Auffach is that 99% of the lifts are drag lifts, so be warned novices.

BAD HOFGASTEIN

Bad Hofgastein is located centrally in the Salzburg region, and forms part of one of Austria's largest rideable areas. Intermediate carvers are well suited to these slopes, with a nice long seven mile run to practice some wide carves. Total beginners will love it, and it's not bad for freestylers with a good pipe. There is plenty of slopeside lodging and good local services

BAD MITTENDORF

Bad Mittendorf is a spa town that likes to shroud itself in strange old tales. What isn't fiction is that this is not the greatest of snowboard destinations. The 15 miles of piste rarely allow an adrenalin rush, although there are a couple of okay black trails and the odd red that's worth a look. Crap for freestylers but perfect for beginners. Off the slopes you will find simple and affordable slopeside accommodation and services.

IMST

Imst is a relatively small resort just north of the A12 motorway running through the centre of Austria. But the beauty of this area is the location is just a short drive/train from the likes of St Anton, Pitztal and Innsbruck. So bring your family to this area learn your turns then move on to the more expensive options. The area also has an awesome alpine coaster winding its way down from the top of the first lift a total ride of 3.5km. This is a great low cost area for all the family.

FREERIDER The upper most part of the area has the best free ride terrain but don't expect too much.

FREESTYLE Imst doesn't have a dedicated fun park. To be honest there's no where to put it, but they do have a small hand full of rails.

BEGINNERS This place is an ideal area if your starting your first turns or only a few days under your belts. The area around the hotel complex is where you need to be and once you've linked your turns head over to the chair lift.

OFF THE SLOPES Accommodation there are lots of options in the town centre which are well priced or stay in the Pitztal valley and visit some of the other resorts in the area. Night life wise there are a couple of crazy apres ski bars.

NEUSTIFT

Neustift is the small gate way village for a number of small ridabe mountain areas that link directly with the village as well as being the last out post for one of Austria's most popular, and in the eyes of some, best all the year round ridabe glaciers. 'Stubai Gletscher'. Neustift is ideally suited to novices and slow learning intermediates and in general this area has a good annual snow record, so you won't always need to

take the 20 minute drive and 15 minute cable car ride up to Stubai's slopes. Located close to Neustift are the runs on the Elferhutte, which rises to 2080m. Although not extensive, the runs on the Elferhutte are perfect for intermediates and easy going carvers with mainly red runs and the odd blue trail to master, but riders who rate them self's as experts will need to

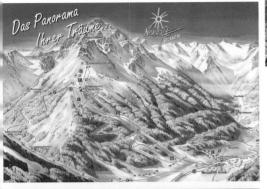

travel up to the Stubai Glacier to find some adventurous terrain. If you decided to hangout around Neustift, access to the slopes is easily done from the village.

Neustift is a well appointed village with a good local services. There is a good selection of hotels, quest house's and pension. You can even get a room in a farm house. Prices are very reasonable and standards high. The choice of restaurants are limited in terms of what is on offer and most are hotel outlets.

Niederau is the second largest resort in the Wildschonau Valley with just 14km of piste and is the first resort you come to along the valley floor. The slopes have one black run and some okay reds but all-in-all this place can be ridden with ease in day.

Oberau part of the Wildschonau Valley is basically a place for total beginners with only 10km of piste and just 8 runs. There is simply nothing here for intermediates of advanced riders to really try out.

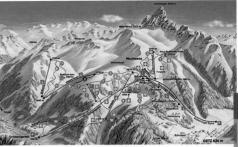

Oetz is a small town at the head of the Oztal Valley which is also home to Solden and Obergurgl and not far from Kuhtai. The gondola from town takes you to a number of easy trails, and you can board down to nearby village of Ochsengarten. More than a day and either be bored shitless or brain dead, but there is a small terrain park to keep a bit of interest.

Schruns is a tiny resort close to the Swiss boarder. The slopes make for an okay one day visit if you can ride or a week if you can't. The place only has one noted black trail but it also has a long 8 mile run which will keep an intermediate freerider happy. Great place for beginners, but crap for freestylers, and very basic but good local facilities at the base of the slopes.

Ride Area: 13miles Top Lift: 2400m Total Lifts: 13 Contact:

Tel - ++43 (0) 556 721 660 Fax - 0043 (0)5556/72554

Getting there:

Fly to: Innsbruck - 2 hours away

Serfaus is a cool place with a decent mountain. Overall, the area provides good all-round snowboarding, no matter your style or standard. Well appointed and affordable local services. It has 21 lifts and 50 miles of pistes and lies 2 hours from Zurich

Top Lift: 1427m Total Lifts: 21 Contact: Serfaus Tourist Board Untere Dorfstra'e 13 A-6534 Serfaus, Austria Tel: +43 (0) 5476 / 62390

Ride Area: 50miles

Fax: +43 (0) 5476 / 6813 Getting there:

Fly to: Zurich - 120 minutes away

ST.WOLFGANG

St Wolfgang put simply, is not a good snowboarding resort. There is nothing much here, not even for beginners and its 9 lifts provide access to 24km of slopes. Granny may manage a few turns, but others will soon tire of it. Freestylers do have a small park and pipe, but don't blink or you'll miss it. In truth, this is a family-orientated, beginner's ski resort. There's lots of close by accommodation

Ride Area: 24km Top Lift: 1600m Bottom Lift: 1200m Total Lifts: 9 St Wolfgang Tourist Office Postfach 20 A-5360 St. Wolfgang Austria Tel: +43 6138 2239 Fax: +43 6138 2239 81 Getting there: Fly to: Salzburg - 45 minutes away

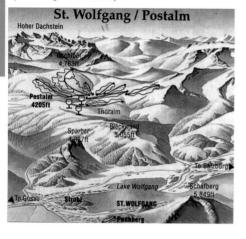

THIERBACH

Thierbach is much the same as Oberau, and really only of interest to first time skiing grannies and grand dads. Even novices may even have this place licked after a few hours.

WAGRAIN

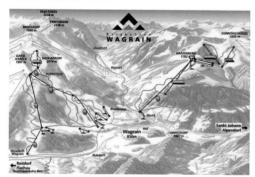

Useful as a base to reach any one of a dozen other ride areas, offering over 200 miles of linked cool, freeriding terrain. There are a number of good parks and pipes, piste-hugging carvers, are also spoilt for choice here with dozens of well groomed trails. Beginners are spoilt for choice. Off the slopes, its Austrian picture postcard stuff, but dull.

WALDRING

Waldring is a dull geriatric heaven, and of interest only to those who are brain-dead. Its only saving grace is that the place is close to other resorts so you can at least escape the tedium of the place. Anyone planning more than an hour's stay here needs to see a shrink. Local services consist of a few old people's homes and a morgue.

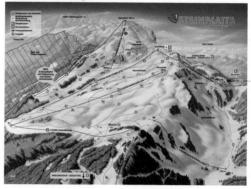

WINDISCHGARSTEN

Forget it totally with only 4 runs this place is crap

Zams is a relatively unknown and small resort. There are a grand total of 15 run adding up to 25km of pistes, all suited to beginners going backwards. The best thing to do is pass by and check out the Kaunertal Glacier which is far better. Off the slopes forget it, the place may be traditionally Austrian, but it is dull.

Ride Area: 26km Runs: 16 Top Lift: 2212m Bottom Lift: 780m

Total Lifts: 8 Easy 50% Intermediate 40% Advanced 10%

Zams Tourist Board, Hauptplatz 6, A-6511 ZAMS Tel - +43-(5442)633 95

Fax - +43-(5442)633 95 15 Getting there: Fly to: Salzburg - 90 minutes away.

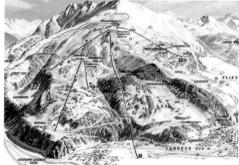

FIGURE AND ENVALES BRECON BEACONS There's no lifts or anything but whenever

Wait a minute, just before you start laughing or just at least just hold off for a second. Did you know that it is possible to snowboard outside in England at a proper(ish) resort with lifts and piste bashers? Consider yourself told, now obviously don't start booking that alpine holiday in the Pennines just yet, but check the weather over the winter and give it a try for a totally different experience and no doubt to witness some truly impeccable lift queuing. Most resorts tend to get enough snow to open for 2-3 weeks a season. They are generally open at weekends between December and April and occasionally during the week.

ALLENHEADS

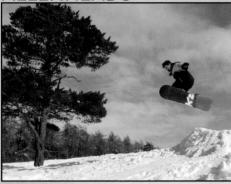

Allenheads is located in the North Pennines. They have 2 100m rope tows that run parallel to each other, and a portable 120m tow they can set higher up the hill when conditions are good. Membership is £20 per year, or it'll cost £10 to turn up and ride. There's no base lodge or anything that grand so bring your Thermos, or walk into Allenheads town and have a beer in the local.

There's no lifts or anything but whenever there's snow and a hill, its time to go snowboarding. Pen y Fan is known as the most dangerous peak in Wales, but that didn't stop one of our writers, Andrew McClure, hiking up and getting fresh tracks down North slope. There's not much chance of getting involved in avalanches but you'd best take a helmet as there's plenty of hidden rocks. (Picture overleaf)

LAKE DISTRICT SKI CLUB

This is probably the most demanding area, and beginners should probably head elsewhere. The one tow serves a number of intermediate and advanced lines back down to the base. Basically from the top head left for the steepest, right for the easier trails. It's an hours walk from the carpark to the foot of the tow. Membership is £23 and then it costs £5 per day for use of the tow. www.ldscsnowski.co.uk

SWINHOPE

Located in the Wear valley, The resort has 2 pomo

es SNO!zone - the UK's Premier Indoor Real Snowslopes SNO remier Indoor Real Snowslopes SNO!zone - the UK's Premier 10!zone - the UK's Premier Indoor Real Snowslopes SNO!zone eal Snowslopes SNO!zone - the UK's Premier Indoor Real Sno

For events updates and slope offers

register online at www.snozoneuk.com

or www.xscape.co.uk or text 'snozonewsg' to 84222 with your name and email or postal address. Texts cost 10p plus usual standard charge

SKI & SNOWBOARD LESSONS • FREESTYLE COACHING • GROUP DISCOUNTS PARK AND FREESTYLE SESSIONS • KIDS ACTIVITIES & PARTIES • STUDENT SESSIONS

SNO!zone at Xscape Milton Keynes

XSCAPE 14 M1

Tel: 0871 222 5670

SNO!zone at Xscape Castleford

*** XSCAPE 32 M62

SNO!zone at Xscape Braehead

XSCAPE 26 M8

Tel: 0871 222 5671 Tel: 0871 222 5672

tows, one after the other, and a piste basher and snowblower. With decent snow there are 5 or 6 runs with some opportunity to venture outside the fences. Membership is £25, or you can pay £15 on the day www.skiweardale.co.uk

THE SNOWPARK

Located in the mountainous county of Kent in the town of Strood is Diggerland, where you get the opportunity to place with JCB's in the mud. In the winter they build a real snow slope, at 70x50m its not massive, but there's also a separate beginners area and a tubing park all serviced by a 60m tow. You

should find a rail or two to grind and possibly a kicker. They offer lessons at £25 an hour www.thesnowpark.co.uk

YAD MOSS

Some lottery money has gone into upgrading the facilities here. There's a day lodge, one 560m pomo lift and 2 piste bashers to keep things smooth when the snow arrives. It costs £25 to become a member which then gives you the reduced day pass price of £5, non-members pay £12. Yad Moss is located 7 miles from Alston. www.skicarlisle.skiers.co.uk

>> Indoor snow slopes

BRAFHFAD

This is the latest of the 3 Xscape centre's and is located just outside Glasgow, has a 200 meter slope and was opened spring 2006. They hold freestyle sessions with mostly rails and there's even a picnic bench to slide on, 4 hour sessions cost £35 and run Friday night 7-11. www.xscape.co.uk

CASTLEFORD

Castleford has a 170 meter slope and a healthy freestyle attitude. Thursday and Friday being freestyle nights 4 hours at £35 and a new Freestyle Friday which runs from 9am to 11pm with at least 2 rails out all day long. www.xscape.co.uk

MILTON KEYNES

has 2 parallel 170 meter slopes and a shorter begin-

>> Outdoor artificial slopes

The UK has hundreds of artificial slopes, be it Dendex or Snowflex this is what the UK does well. Most of them are simple a tow and one run down, but many do offer freestyle nights where the local welder can show off their new rail. Visit www.worldsnowboard-guide.com or www.snowboardclub.co.uk/slopes for a full listings.

SHEFFIELD SKI VILLAGE

Europe's largest artificial ski resort, and a right old freestyle playground to boot. The legend Terje Håkonsen, said it was the strangest place he'd ever snowboarded, but this is certainly not your average ner slope and runs a board only night on a Friday where they bring out some rails and a kicker or two. This place used to get real snow brought in from Scandinavia but now uses snow cannons to generate fake snow, it took them a while to get the snow right, but its pretty good these days. They were the first indoor resort to build a half-pipe, it was all shaped by hand but a decent 100m in length, however the are no plans to repeat it. www.xscape.co.uk

TAMWORTH

Tamworth was the UK first indoor slope, its 170 meters long and goes around a corner. It's £15 an hour and £22 an hour Friday after 8 and all weekend. They hold a ramp night on a Friday with beginners getting some advice from 8-11pm as long as you pre book it. www.snowdome.co.uk

artificial slope. It has a halfpipe, spine, kickers and rails, as well as 3 or 4 separate runs. There's also a big pool at the end of two big jumps to practice those big spins without popping a knee. There's currently a proposal to build an indoor snow slope next to the existing one. One hour will cost you between £10-15 depending when you go and a half-day £16-28 www.sheffieldskivillage.co.uk

JOHN NIKE/BRACKNELL

Monday and Thursday they get the ramps and rails out, price £10. www.bracknellskislope.co.uk

FINLAND

Finland produces some of the best young freestylers in the world. You may ask how such a small country, with a small population, can do this, well the answer must lie in the fact that Finnish resorts offer so little in terms of terrain that the main challenge is the halfpipes. Finlands resorts are small. Max drop of runs is 50-120m (for southern Finland) depending on the resort. There are usually 5-6 runs per resort (although they claim more - if there's a tree on the piste, that makes it 2 runs)

All resorts have ski/snowboard hire and a restaurant. Many also have lessons available in English. The season seems to be from early December to late March for southern Finland (south of Tampere). Central Finland keeps going until the end of April and northern Finland can be open until early June. At the start of the season, there is generally little natural snow but most resorts have snow cannons and they do a good job. From early March (in southern Finland), the snow starts to melt and the conditions are not particularly reliable. The easy runs tend to be closed first with most resorts only half open by the end of March.

Temperatures vary quite a lot. In the south, -5 to -10 is the typical winter daytime temperature but -15 to -20 is not uncommon.

Travelling: Fuel is actually cheap (around 1 euro/litre or 60p/ litre). If you are based in Helsinki, there are buses to most of the local resorts. Language: Although the official languages are Finnish and Swedish, almost everyone speaks very good English. Finns are also friendly and very reserved (except when drunk, which is quite often).

Crowds: The Finns are fair-weather skiers and boarders. If it's a nice sunny afternoon, they flock to the resorts and it gets rather busy (although nowhere near as bad as the Alps). If it's a bit too cold or dull or it's late in the day, some of the places are practically empty.

Resorts are usually open from around 10am to 8 or 9pm. Since it's dark by 4pm in the winter, most runs are floodlit although some places only keep a few runs open, particularly if it's not

osts do vorwa bit but in general 4 hours equipment hire cost 0 euros. A llic pass will set you back 23 euros.

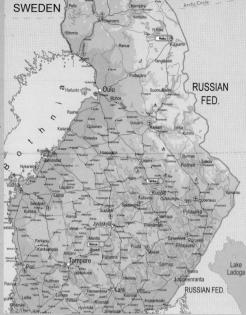

CAPITAL CITY: Helsinki
POPULATION: 5.2 million
HIGHEST PEAK: Haltia 1328m
LANGUAGE: Finnish and Swedish

LEGAL DRINK AGE: 18 DRUG LAWS: Cannabis is illegal and frowned

AGE OF CONSENT: 16

ELECTRICITY: 240 Volts AC 2-pin INTERNATIONAL DIALING CODE: +358

CURRENCY: Euro EXCHANGE RATE: UK£1 = 1.5 US\$1 = 0.8, AU\$1 = 0.6, CAN\$1=0.6

DRIVING GUIDE

All vehicles drive on the right hand side of the road

SPEED LIMITS:

Motorways-120kph (74mph Highways-100kph (80mph) Towns-50kph (31mph) EMERGENCY All - 112

TOLLS None
DOCUMENTATION

carry driving license, insurance certificate and vehicle registration, along with your passport

TIME ZONE UTC/GMT +2 hour

Daylight saving time: +1 hour

FINNISH TOURIST BOARD Head Office: PO. Box 625, Töölönkatu 11, 00101 HELSINKI, FINLAND TEI.: +358 (0)9 4176 911 www.visitfinland.com

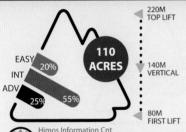

Himos Information Cnt
Himosvuri 42100 Jamsa. Finland
TEL: ++358 42 786 1051
WEB:www.himos.fi

EMAIL:markkinointi@himos.fi

WINTER PERIOD: Nov to May LIFT PASSES Day pass 30euros (9am-5pm) Night pass 19 euros (4pm-8pm) 7 day pass 144euros (9am-8pm)

BOARD SCHOOL private 50min 37 euros Group lesson 2x50min lessons 37 euros HIRE Board and boots 32 euros a day, helmet 10/day

NIGHT BOARDING all lifts lit & all pistes open untill 8.00pm

NUMBER OF PISTES/TRAILS: 21 TOTAL LIFTS: 13 - 10 chairs,3 drags LIFT CAPACITY (PEOPLE/HOUR): 11,200 LIFT TIMES: 9,30am to 5.00pm

ANNUAL SNOWFALL: 80cm SNOWMAKING: 100% of slopes

BUS services direct from Helsinki airport.

FLY to Helsinki, 3 hours transfer time. Nearest airport is Tampere, 95 km away.

DRIVE via Helsinki, head north on motorway 4/E75 direction Lahti (115km from resort) and then Jämsä (9km) to reach Himos which is a distance of 140 miles (225 km).

Most resorts in Finland are tiny blips spread over rolling hills and although **Himos** is small, it is by no means the smallest resort in the country. Located in the southern part of the country and three hours by road from the Finnish capital of **Helsinki**, Himos is a very popular resort with a large number of Finnish snowboarders, especially freestylers. The resort opened in 1984 and first impressions will have you wondering what the hell you are doing there. The tiny hill that rises above the shores of the frozen lake is split into two slope areas, both offering the same terrain: a mixture of flat, unadventurous trails. The two sides of the resort have recently been linked with lifts saving you a hike/bus.

FREERIDERS are not going to find this place up to much as there's nothing really to excite. The longest trails are on the north slopes, with one black and a couple of red runs on offer. The runs on the west slope offer a few more challenges, with some blacks that weave through the trees, but don't expect powder.

FREESTYLERS will get the most out of this place. You're provided a super-pipe and 2 terrain parks, comprising of a good selection hits and rails which at least make up for the boring terrain. Locals often build the odd hit and you may even find a few logs to session in the trees.

PISTES.The longest trail only just manages about 1000m, the slopes on the west hill give you the chance to shred at speed down some well prepared black trails and the short red runs are good for carvers who want progress.

BEGINNERS have only a few, very short green trails to get started, but as the blue trails and even the reds are overrated difficulty-wise, novices have more on offer than it first seems. To help total first timers, there is a slope with a free lift. Most novices should have this place sorted in three days, if not, take up cross country skiing as you'll be more in tune with that.

OFF THE SLOPES. Accommodation, which is spread out but within easy reach of the slopes, is offered mainly in chalet form with a number of hotels, but nothing is cheap! Don't expect any happening night life: the main place is the *Himos Hotel* which is dull to the extreme. The place isn't totally crap, it just doesn't offer very much.

WSQ www.worldsnowboardguide.com 123

RUKA

6OUT OF 10

Terrain that allows some freeriding

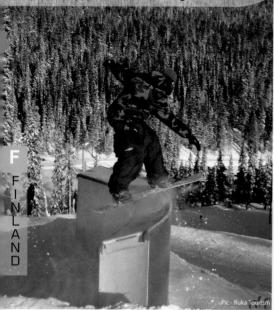

Finland is generally a flat country with lots of lakes and the Kusamo region, where this typical Finnish resort is located, is no exception. The journey to Ruka involves no great uphill climbs or winding mountain passes, you simply arrive to see the hill popping out of the landscape like a volcano. Ruka is just about Finland's largest resort and has hosted some major snowboard championships, indicating that the place has something to offer. Don't get too excited though as this is not hardcore freeriding territory and you can explore the whole area in half a day. However, the mainly intermediate slopes do offer carvers some nice flats to carve up and the slopes can be accessed with ease from any of the 5 car-parks dotted along the road that circles most of the hill. Trees cover much of the mountain, so all the trails are cut through the forest giving you the feeling you are on a different run every time, rather than just riding 100 metres across from where you were originally. All the slopes are well groomed and pisted constantly, so bumps don't get a chance to build up. Most of the area has blue and easy red runs, with only a couple of blacks down the front side.

FREERIDERS will find some interesting terrain to explore, although it won't take too long. There are some nice areas to ride including open and tight tree sections, especially round the side of the ski jump. Ruka is also known for having some good powder stashes. Although it's never super deep, it's still good fluffy stuff.

FREESTYLERS have two fun park areas and three halfpipes, all serviced by T-bars. Both parks have a good range of gaps and table tops of all sizes and are groomed daily, so you won't need to hike up with your own shovel to shape hits. One of the parks and pipes are

located up off lift number 17, where it gets cold but you will find a shelter with a wood fire burning to warm you up between runs. Don't leave your gloves drying above the fire though, as a pair of \$200 smoked Fishpaws are not as trendy as you may think.

PISTES. Riders are provided with flats and well spaced out trails, allowing for some interesting carving, most of which needs to be done on a series of red runs. The runs off the 7 lift are nice, long descents which allow novice carvers the option to move across from some tamer blue trails. Lift 15 also gives access to a good tree-lined carving trail that can be taken at speed.

BEGINNERS are presented with plenty of gentle runs that allow for long descents from the summit, making Ruka a good place to learn the basics. Lifts stay open with the help of flood-lights until 8 pm most nights, so you can get loads of riding in if early

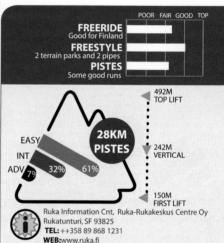

WINTER PERIOD: mid Oct to May LIFT PASSES 1 Day pass 28 euros Afternoon to eve 26 euros

6 Day pass 107 euros, Season pass 389 euros RENTAL board & boots 24 euros/day, 70 euros 6 days

NUMBER OF PISTES/TRAILS: 28 LONGEST RUN: 1.3km TOTAL LIFTS: 18 - 4 chairs, 14 drag

EMAIL: info@ruka.fi

LIFT TIMES: 9.00am to 8.00pm
MOUNTAIN CAFES: 4

ANNUAL SNOWFALL: 3m SNOWMAKING: 100% of slopes

CAR Drive to Helsinki via Kuusamo, its 800km Drive time is about 14 hours.

TRAIN Helsinki to Oulu, from which the 217 km coach trip to Kuusamo takes only approximately three hours. Contact www.matkahuolto.fi for bus details

FLY to Helsinki international then onto Local airport Kuusamo, 20 miles from resort. Shuttle bus from Kuusamo to resort always available and takes 30mins

BUS from Helsinki can be taken via a change over at Kuusamo with a jouney time of around 14 hours.

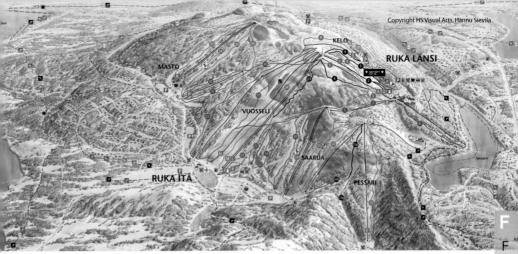

mornings aren't your thing. Instruction facilities are very good here and you can get tuition for riding the flats or the halfpipe.

OFF THE SLOPES

Ruka is an all year round tourist destination, so add that to the fact that Finland is an expensive country, and what you get is a super expensive but good resort. Ruka, which is only half hour bus ride from **Kuusamo** airport, has a good selection of well appointed local facilities which include a damn fine sports centre and a number of shops. If Ruka is not your thing, Kuusamo is the nearest big town with a far greater selection of everything with slightly lower prices, which will help the budget conscious rider.

ACCOMODATION. The choice of accommodation is extremely good, both at the slopes and back along in Ruka. Options range from very expensive hotels to very expensive shared chalets. If you find staying in

Ruka or at the slopes is just too expensive then the town of Kuusamo is only 20 miles away and offers a greater selection of places to stay with a wider price. You will have to commute to the slopes however.

FOOD. The options for eating out are fairly good, with a choice of restaurants around town and near the slopes, but it hurts having to pay so much money even for a burger. Still *The Ampan* is well known for serving up a good pizza, while *Ali-Baba* does great grills to order, burnt or rare, it's your call.

NIGHT LIFE in Ruka is tame and not bright lights and disco style. However, things are very lively and the Fins know how to party hard (mind you how they manage to get drunk with the cost of booze in this place is a mystery). The only main night time hang out is *Ruka Mesta Club*, forgetting how much things costs, will initially take a while and it won't be until you're drunk that you can loosen up.

TAHKO

Not up to much

Tahko is regarded by many Finnish snowboarders as their premier resort, which when compared with what else is on offer in the country is easy to see why. It is a resort that attracts many cross-country skiers, but these strange creatures that dress in spray-on clothing set off into the trees and thankfully aren't seen again until the later hours of the day. Lucky, as the terrain is not very extensive and can easily become clogged up with two plankers of all types. The riding on the **Tahkovuori** hill is not going to excite you for very long: a few hours and you have done the lot. Still, the terrain is not bad and the pistes are well looked after, with full snowmaking facilities to help when the real stuff is in short supply. All the runs are cut through trees, offering slopes to suit intermediate and novice riders, but absolutely nothing for advanced riders to get their teeth into.

FREERIDERS have nothing to write home about. There are some tree areas which most of the runs are carved out of, but most are unrideable. However, on a good day there are some okay powder spots, but don't get up late they're all gone within an hour.

FREESTYLERS have a well shaped halfpipe located at the lower section alongside the tree line. Apart from the pipe, locals like to build their own hits, but as for big natural hits, forget it. There are a number of banks to ride up, however.

PISTES. Carvers who dare to be seen in hard boots here will find some decent trails, with a couple of good red pistes to cut big wide turns on. But you won't be putting in too many before you hit the bottom and are being stared at again by everyone else in the lift queue who will be in soft boots for certain.

BEGINNERS have an ideal resort with half of the runs suited to novices, even if all the lifts are drags. Snow Valley is an area set aside for kids and first timers, but if you're a 300 pound, hairy arsed learner with no sense of control, stick to the main beginner runs as wiping out three year olds is not funny, and not on.

OFF THE SLOPES Tahko has a small, but good selection of accommodation options near the slopes. You can opt to sleep in a hotel, chalets or a bungalow. Alternatively if you're driving here, and on a tight budget, you could park up in a caravan spot, but it will be freezing in mid winter. Night life is quite sad and expensive, but there are worse haunts

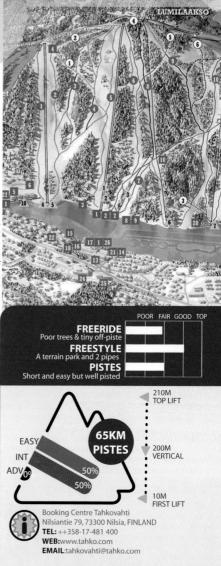

WINTER PERIOD: Nov to May **SNOWMOBILES** 600km of routes **NIGHT BOARDING** 5 slopes 11km

NUMBER OF PISTES/TRAILS: 23 LONGEST RUN: 1.2km

TOTAL LIFTS: 13 - 1 chairs, 10 drags, 2 children's lift LIFT CAPACITY (PEOPLE/HOUR): 12,000

LIFT TIMES: 10.00am to 4.00pm **MOUNTAIN CAFES: 5**

ANNUAL SNOWFALL: 0.66m SNOWMAKING: 100% of slopes

BUS services with transfers will take around 10 hours. FLY to Helsinki 445km transfer.

Kuopio airport 40km

DRIVE via Helsinki, head north on motorway 4/E75 to Lahti and then take the M5 to Heinola and then A5 to Siiliniarvi via Kuopio before taking the B75 to Tahko.

ROUND-UP

ISO-SYOTE

Iso-Syote is one of Finlands biggest resorts with a total of 21 runs. What you have here are two small mountains, offering you an area of gentle snow-board terrain that allows for some okay freeriding with some fantastic novice trails from top to bottom. There is a good halfpipe and some of the trails are flood lit for late riding! Lots of very basic lodging is available near the slopes in cabins and chalets. You can also party late but not hard.

RUNS: 21, TOTAL LIFTS:5 TOP LIFT: 432m

HOW TO GET THERE: Fly to: Helsinki- 14 hours away by car

KAUSTINEN

Small halfpipe, Located 10 hours from Helsinki RUNS: 5 TOTAL LIFTS:4

KOLIN HIIHTOKESKUS

Flat and very dull. Located 7 hours from Helsinki

LAKIS

Not worth the effort. Located 10 hours from Helsinki. RUNS: 3 ,TOTAL LIFTS:3

LEVI

Levi is a small resort that boasts 140 miles of trails although 125 of them are for oldies on cross country skis. The terrain is set out over a stump of a hill and offers freeriders a little bit of uneven rough to ride, including some trees. Freestylers have a natural halfpipe and a 100 metre man made version. Carvers have a few good trails.Levi is also ideal for beginners. Local facilities are well located

RIDE AREA: 29km NUMBER OF RUNS: 45

Easy 41%,Intermediate 51%, Advanced 8%

TOP LIFT: 530m BOTTOM LIFT: 200m VERTICAL DROP: 325m

TOTAL LIFTS: 26 - 1 Gondola, 25 drags

NIGHT BOARDING:13 slopes and halfpipes illuminated

HOW TO GET THERE:

FLY: Fly to Kittila airport Transfer time to resort = 20 minutes Buses from Helsinki can be taken via Rovaniemi to Levi on a daily basis. Rovaniemi is 1h 45 mins. Trains go to Rovaniemi – 1h 45 min and to Kolari – 1h. DRIVING: From Helsinki via Rovaniemi to Levi its a 20 hours drive by car (1028km)

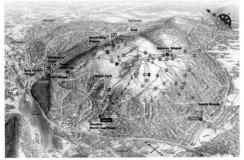

MERI - TEIJO

Small halfpipe, 8 hours from Helsinki RUNS: 8 ,TOTAL LIFTS:3

MYLLYMAKI

Small halfpipe,7 hours from Helsinki RUNS: 5.TOTAL LIFTS:4

OLOS

Flat area with a pipe, 1 hour from Rovanemi RUNS: 6,TOTAL LIFTS:4

OUNASVAARA

Tiny area with a pipe, Located 1hour from Kittila RUNS: 9,TOTAL LIFTS:4

PUKKIVUORI

Small halfpipe,8 hours from Helsinki Runs: 15,Total Lifts:2

PYHA

Phya is as small as they can possible get, with just eight or so runs and nothing longer than two turns on a long carving board. However, it is a snowcovered hill that has a half-pipe and a couple of fairly steep runs. A good intermediate will manage quite easily, but an advanced rider really shouldn't bother with this place. Actually, only novices should give it a go, if you live locally because its not worth trecking up other-wise.

SALLA

Salla seems a rather remote resort but it's no more remote than any other Finnish outback. This place is located in the mid to northern section of the country and on the Russian border, infact you can take a snowcat trip in to the Russian side to ride back down. Y The 9 runs on the Finnish side are basic but an easilypleased freerider may find it okay. At the base are there is a hotel and not much more

SAPPEE

Sappee is one of the closest resorts to Helsinki and a place that attracts a few weekend city dwelling snow-boarders. However never to the point of bursting, which is surprising because this place is small, half a dozen riders giving it shit at mach 6 would crowd the slopes as well as clear them. Great for novices and ideal for freestyles who like man made hits, crap for any one else. Expensive but okay lodging and local services are in easy reach

YLLAS

Yllas is much in keeping with what is found at most Finnish resorts and while it is bigger than many places, it's not mega. It is also linked with Levi. What you get is a hill rising above the tree line, which allows for some okay intermediate freeriding, as well as some powder spots and decent carving terrain. Freestylers are usually found in the halfpipe, or pulling air off one of the many natural hits. Ideal for novices. Local facilities can be found in two small villages nearby

USQ WWW.WORLDSNOWBOARDGUIDE.COM 127

FRANCE

The French have a saying; "God created the Earth in six days and on the seventh he created France" bless them for being so magnanimous, and anyone who's been to a Parisian slum may have a different opinion. But when it comes to the French mountains, both the Alps and the Pyrenees, they may just have a point. Chamonix and Serre Chevalier should be on the calling card of all snowboarders, looking for a full on ride. Many of the high resorts are purpose built 70's monstrosities while the lower ones are often in a more traditional alpine village style. All resorts will offer good food and drink options, if sometimes at a ridiculously high price.

Those flying in from other areas of Europe will find an airport within striking distance of all resorts and a good road system enabling easy road trips. Bus travel can be expensive and often runs at stupid times while train links can be great, with good overnight services from London.

EU nationals won't need a visa to work in France; however, France is the worst country in the world to get a job as a snowboard instructor. The authorities are very protective of their own. If you're caught teaching on the slopes and don't hold the French instructor's certificate, you will be arrested and jailed or maybe set upon by a group of red all in one wearing ESF instructors. However, more mundane forms of work such as bar and chalet are permitted.

Accommodation is normally mid to high end. Many resorts also offer self catering apartments and many are starting to develop their budget accommodation. Last minute deals are often on offer by UK based holiday companies, and if you can hold your nerve you could get some amazing deals.

Language isn't a problem, as most of the bar and chalet staff will be English, and those that aren't will probably speak English in that sexy French way. Night life is nothing compared to Austria, but some resorts do kick off. It's best to start and finish early as the night clubs are a rip off.

For a holiday, or a season, France offers some of the world best resorts, but God didn't create France on the seventh day, I think he went to the bank to apply for an overdraft.

PH

CAPITAL CITY: Paris
POPULATION: 60 million
HIGHEST PEAK: Mont Blanc 4808m

LANGUAGE: French LEGAL DRINK AGE: 18

DRUG LAWS: Cannabis is illegal and frowned upon

AGE OF CONSENT: 16 ELECTRICITY: 240 Volts AC 2-pin

INTERNATIONAL DIALING CODE: +33

CURRENCY: Euro

EXCHANGE RATE: UK£1 = 1.5 US\$1 = 0.8 AU\$1 = 0.6 CAN\$1=0.6

DRIVING GUIDE

All vehicles drive on the right hand side of the road SPEED LIMITS: Toll Motorways - 130 kph Motorways - 110kph, Main Roads - 90kph, Towns - 50kph EMERGENCY Fire 18 / Police 17 / Ambulance 15 TOLLS Payable on motorways & some bridges DOCUMENTATION Driving licence must be carried along with motor insurance.

TIME ZONE UTC/GMT+1 hour Daylight saving:+1 hour

FRENCH TOURIST BOARD

178 Piccadilly, W1J 9AL, London Tel: 09068 244 123 (60p/min) E-mail: info.uk@franceguide.com Web: www.franceguide.com

FRENCH SNOWBOARD ASSOCIATION

Route du Parc du Souvenir. 06500 Menton, France tel+33 492418000 web:www.afs-fr.com Email: afs@afs-fr.com

TRAINS www.sncf.com - National Service www.eurostar.com - Eurostar www.autocars-martin.com - run bus transfers from Bourg St.Maurice to Les Arcs, Tignes, Val d'isire

AIRPORT TRANSFERS/BUSES

www.vfd.fr - provide transfers from Grenoble to Deux Alps & Alp d'huez amongst others. www.satobus-alps.com - provide transfers from Lyon to Alp d'huez_Courcheval, Tignes, val Thorens etc www.intercars.fr - provide transfers from Geneva www.altibus.com run bus services to 50 resorts in the alps, tel: 0820 320 368 / +33(0)4 7968 3296

AIRPORTS

www.lyonairport.com - Lyon Airport www.gva.ch - Geneva airport www.grenoble-airport.com - Grenoble Airport www.annecy.aeroport.fr - Annecy

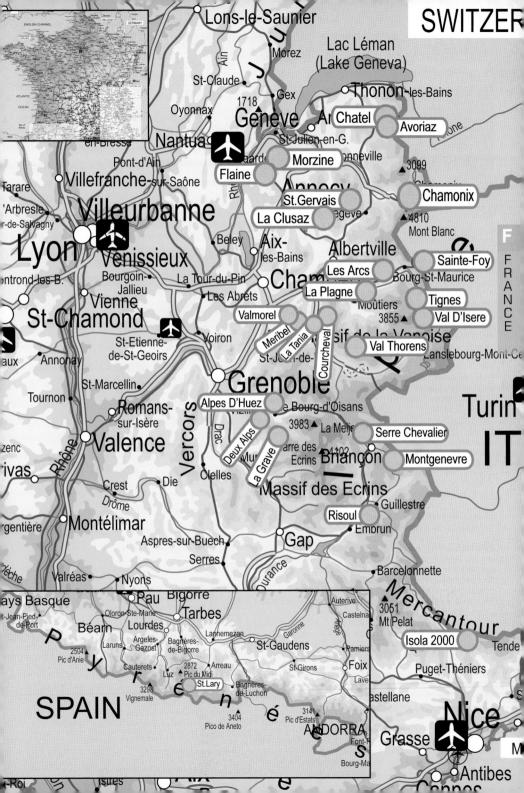

ALPE D'HUE7

Supersized resort that draws a lot of people to its slopes

Anyone planning a two-week trip to Alpe d'Huez, will not have enough time to ride all the amazing and varied terrain that this place has to offer, set in 10,000 hectares with 800 hectares of pistes this place is big. Each year, this high altitude resort offers amazing amounts of great powder days covering some fantastic backcountry and wide open plateaus, but the terrain is as much for the novice as it is for the advanced rider. The resort has quite a history, being the first place in the world to have a ski lift installed back in 1936 and the long windy uphill approach to the resort plays host to one of the Tour-de-France stages in the summer. Due to its location and mostly south-facing slopes, the runs here get a lot of annual sunshine. This has the benefit of letting you ride in great sunny conditions and also helps to soften up certain areas early on in the day. There's heaps of snow here so don't be worrying if the odd bit thins out early. The resort has a well-equipped and fast lift system that can shunt over 100,000 punters up the mountains per hour. Unfortunately, its popularity with overseas holiday crowds means that Alpe d'Huez can get a bit clogged up. especially at weekends. Holiday periods are absolutely crazy, so avoid this time at all costs if you want to escape millions of day-glow two-plankers. However, during normal periods you can ride freely all week long from top to bottom, on and off-piste, without having to crosstrack your own path or that of another skier. The resort of Les Deux Alps is 45minutes away, and a 6-day lift pass includes a free day over there.

FREERIDERS can be forgiven for thinking that they are in heaven. Alpe d'Huez is a backcountry freeride gem with miles of off-piste powder, in areas such as the Gorges de Sarenne and Glacier de Sarenne which is part of the worlds longest run at 18km, and a full on black run at that. There's some great off-piste that starts from the top of the Pic Blanc many of which require no hiking and end up in the neighbouring villages. Please note that, riding without a guide is total folly. For assistance seek out the services of a local guide through one of the ski-schools or via Planet Surf snowboard shop.

FREESTYLERS are provided with a 2 terrain parks located near the main area. The beginner park at the base near the Troncon lift, you'll find a couple of kickers and some bumps. The advanced park's much more interesting with a number of big wedges and a good variety or rails, you'll find it near the Poutran lift. The lack of snow over the last couple of seasons has meant they haven't built a halfpipe for a while. Away from the park there are loads of natural air spots you'll feel spoilt for choice.

PISTES. Riders are teased with so many well groomed trails, that picking one as a favourite is iust not possible.

BEGINNERS have a huge area perfect for learning on accessed by the Troncon cable-car from the base. It does get busy but the lower slopes are wide enough to handle it.

OFF THE SLOPES. The main town, 1860 is built on a slope and is pretty cheesy and very tacky but provides great all-round affordable local services close to the slopes. You can dine very affordably with cheap pizza restaurants in abundance. Night-life ranges from a cinema to loud partying which is brash and full-on, although this place does go in for a lot of après ski shenanigans. You can choose to stay at some of the neighbouring villages which are connected via the lifts if you prefer the quieter life but you should always be able to find somewhere to stay, with 32,000 beds in the area.

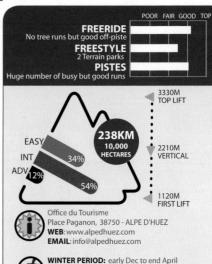

LIFT PASSES Half-day 27.3 euros, 1 Day 36.20 euros 2 days 70.50 euros, 6 days 187 euros BOARD SCHOOLS ESF do a 2 1/2 hr/day over 6 days

freestyle and freeride courses for 115 euros NIGHT BOARDING Tues & Thurs, Signal Slalom Stadium

piste. 8.5 euros/free if 2 day pass+ GUIDES Roughly 300euros for a day Tel +33(0)7680 4255

NUMBER OF RUNS: 121 LONGEST RUN: 16km

TOTAL LIFTS: 85 - 10 Gondolas, 6 cable-cars, 24 chairs, 41 drags, 3 magic carpets

CAPACITY (PEOPLE/HOUR): 101,000 LIFT TIMES: 8.30am to 4.30pm

BUS services go direct from Lyon airport to the resort. Transfers from Grenoble visit www.vfd.fr

FLY to Lyon with a transfer time of around 2 hours. DRIVE From Grenoble take the motorway A480. Take

the No.8 exit (Vizille - Stations de l'Oisans) onto the N91 until you reach Bourg d'Oisans. Alpe d'heuz a further 13km. 163km from Lyon

TRAIN To Grenoble or Lyon

NEW NEW FOR 06/07 SEASON: one new chair lift in Auris-en-Oisans and 15 new snow-guns.

AVOIRIAZ

Great all round boarders resort

Avoriaz is easily one of the top French snowboard resorts and is seen by many as the snowboard capital of Europe. The management have been very positive in promoting snowboarding here since day one. For instance, Avoriaz was one of the first areas to have a snowboard-only section, including a pipe, a park-and-ride area and its own lift. Furthermore, the resort has been producing a snowboarder's passport, covering all aspects of Avoriaz, for a number of years.

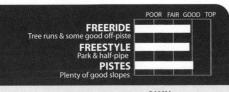

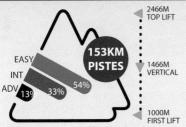

Avoriaz Tourist Office, Place Centrale 74110 Avoriaz, France

TELEPHONE: + 33 (0)4 50 74 02 11 **WEB:** www.avoriaz.com

EMAIL:: info@avoriaz.com

WINTER PERIOD: mid Dec to end April LIFT PASSES

Day pass to snowboard park area, 15.7 euros full day pass 30.5 euros (saturday 19 euros) Day pass to Ports du Soleil area 36euro, 6 days 176 euros

HELIBOARDING

arranged for nearby Italy, minimum of 4 people, from 240 euros/pp excluding guide.

TOTAL PISTES/TRAILS: 50 LONGEST TRAIL: 5km

TOTAL LIFTS: 37 - 2 Gondolas, 1 cable-cars, 18 chairs, 16 drags

LIFT TIMES: 8:30am to 4.00pm MOUNTAIN CAFES: 20 ANNUAL SNOWFALL: 9m

SNOWMAKING: 17% of pistes

FLY: to Geneva international 2hrs away. Annecy airport 96km, Lyon 200km

BUS: Bus services from Geneva airport in Switzerland, are available 3 times daily to Avoriaz via Cluses, tel:

33(0)4 50 38 42 08

TAXIS: +33(0)450740211

TRAIN: TGV Trains stop at Cluses (20 mins) and Thonon-les-Bains, then take a bus or taxi. tel: 33(0)4 50 71 00 88 / 33(0)4 50 98 01 67 for bus from Cluses/Thonon

CAR: From Geneva, drive to Avoriaz is 52 miles (80km). Head to Cluses then turn onto the D902 through Taninges and Morzine a further 15km to resort. Note: Traffic free resort, so you'll need to park up. Costs 40 euros for a week or 6.50 a day.

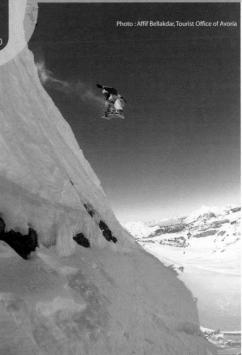

153km of piste in Avoriaz links up with **Les Portes du Soleil**, a group of resorts straddling the French/Swiss border, creating one of the largest circuits in Europe with some major off-piste to shred. The terrain on offer in Avoriaz is more than amazing and will suit every level and style of rider: trees, big cliff drops, powder bowls and easy, wide flats - it's all here. And as everybody gets the odd off day and fancies doing something other than riding, Avoriaz puts on a choice of services that are normally found only in US resorts: quad-bike riding, snowmobiling and climbing are all an alternative buzz.

Lindaret is accessible for any level and offers fun runs off piste when there is fresh snow. **Mossets bowls** in Avoriaz is another fun adventure for intermediates and up. When there is new snow this is unbeatable. There are also some mellow spots for building jumps around this area.

Overall this mountain is worth exploring, with a few tips and pointers in the right direction you can find a little bit of everything. And if there is no new snow you can head to the park and jib all day instead. If this isn't enough Chamonix is one and a half hours drive away and Flaine, Les Cluzas, Samoens and Morillion are all just a short drive.

FREERIDERS with bottle will find the steep blacks on **Hautes Forts** well worth the effort, where you can cut some nice unspoilt terrain at speed and in style. However, riders who really want to explore the major off-piste terrain can do so by going heli-boarding, since Avoriaz is one of the few resorts in France that allows this pursuit.

FREESTYLERS flock here for the natural hits and big

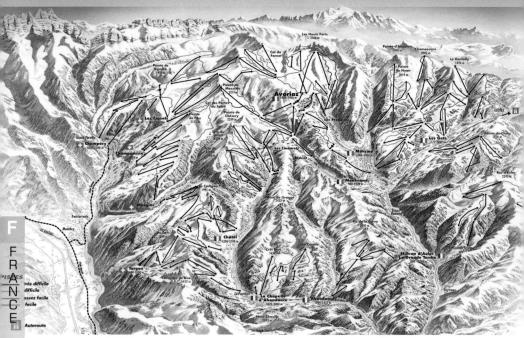

air opportunities, of which some of the best are found around the tree-lined Linderets area. Avoriaz's fun-park has been established for years now and is located at the top of the main chair lift in the centre of the resort and is easily accessible. It features jumps of all sizes and is well groomed, most of the time. There is also a selection of rails and boxes of varying difficulty.

A drag lift runs along side the park so access is convenient and tunes are blasting all day so there is usually a relaxed vibe. There is also a pipe located in the centre of Avoriaz just down from the piste side cafes. It is built to international specifications and is kept in good shape although unfortunately in France they do not normally shape their pipes everyday so it can sometimes be disappointing, especially towards the end of the season. Another option is the park in Les Crosets which is accessible just across the boarder in Switzerland. It takes about half an hour to ride there from Avoriaz and is easy to find as long as you get directions. This park includes jumps and rails for all abilities with the small course running down the side of the park layout. There are several decent size kickers of approx 8m-12m with nice smooth raised take-offs. They are well maintained and have decent landings. On a good day this is easily the best park in the area. A drag lift allows maximum use of the park. There is also a short pipe set in between the drag lift and the park, it is smaller than the Avoriaz pipe and not generally in a good condition.

PISTE hounds will love it here, the resort is as much suited to you as any other rider, with plenty of wide, open slopes for the French hard booters to lay out a lot of Euro's carves. The reds down **Chavanette** and **Arare** are good for cranking it over.

BEGINNERS. There are plenty of easy flats around the base area to try out your first falls, before

progressing up to the higher blues and reds reachable by chairs (which will help those who can't get to grips with T-bars and the Poma button lifts). One note of caution is that a lot of ski classes use the easy runs, which means they can be very busy at times, so expect congestion.

OFF THE SLOPES

As for the local services, what you get is a wonder of contemporary architecture - a purely purpose-built resort perched way up the mountain with most of the buildings being made of wood. However, whatever your opinion on the looks, the resort provides excellent access from all accommodation to the slopes, with riding to your door the norm. Overall Avoriaz caters well for snowboarders and is not too fancy (in fact it's pretty damn cheesy and down market). There are heaps of local attractions with a number of sporting complexes and cinemas to help while away your evenings, although most people just party the night away.

ACCOMODATION. There are loads of wooden apartment blocks, with self-catering being the main choice. Prices vary but you can get great deals. Chalet Snowboard +44(0)208 1334180 offer good holiday packages and are based close to the slopes.

FOOD. Cheese Cheese Cheese. Yes as in the rest of France it's Pizza's, Fondue, and Over priced pieces of meat. Some of the bars do simple pub grub but if your hear for the food your in the wrong resort.

NIGHTLIFE here is self comntained as your way up in the mountains, but there are several bars with good tunes and plenty of beer flowing throughout night. Best to ask a local if anythings going on while your there, as there's often quest DJ's in town.

CHAMONIX

A rough diamond, but a freeriders Mecca

As you drive into the Chamonix valley on a two lane elevated road your stomach empties, not from the bad food on the plane or the tight bends of the road, but from that tingle of anticipation the very name Chamonix excites even the most hardened of pro's and it doesn't disappoint. On your right towers above Europe's highest mountain, Mont Blanc, (don't tell the French about Mt Elbrus) the blue ice from a brimming glacier tumbles towards the road threatening to break off and take you out. Once in the town you pick up on the hardcore vibe of the place. Early morning there's skiers and board-

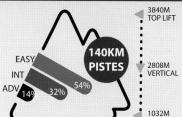

FIRST LIFT Tourist Office Chamonix, 85 Place du Triangle de L'Amitie F74400 Chamonix, Mont Blanc

TEL: +33 (0) 450 53 00 24

AVLANCHE INFO: +33 (0) 836 681 020

WEB: www.chamonix.com EMAIL:info@chamonix.com

WINTER PERIOD: Dec to April LIFT PASSES 1 Day pass 40 euros, 6 Days pass- 176

HELI BOARDING No

BOARD SCHOOLS Group lessons 3 x 3 hr 100 euro Group Freeride Freestyle 5 x 3 hr 135 euros. Private 2hr 80 euro Full day 230 euro

BOARD HIRE Beginners 1 day 20 euros, 6 days 105 Pro 1 day 23 euros 6 day 150 euros

NUMBER OF RUNS: 74 LONGEST RUN: 21km TOTAL LIFTS: 47 - 6 Gondolas, 7 cable-cars, 16 chairs, 11 drags, 1 train, 1 magic carpet

Capacity (people/hour): 52,660 LIFT TIMES: 8.30am to 4.00pm **MOUNTAIN CAFES: 14**

ANNUAL SNOWFALL: 9.6m SNOWMAKING: some

CAR from Calais drive to Geneva. From Geneva. Chamonix is 50 miles away, approx 1 hour drive. FLY to Geneva international, 85km away. Grenoble 153km. Lyon 220km

TRAIN stop in Chamonix. TGV sometimes available to nearby Saint-Gervais Le Favet station.

BUS services from Geneva airport in Switzerland, are available on a daily basis to the centre of Chamonix.

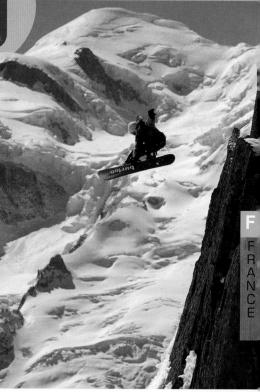

ers stuffing a pastry into their mouths whilst rushing to get first lift, a rope over one shoulder a transceiver over the other and a waist full of carabineers. Chamonix was a town long before anyone thought of making purpose built ski resorts and unlike most French resorts it's an all year round destination, with climbers flocking here when the snow melts like migrating geese. The place benefits from this with loads of bars, cheep eats and all kinds of shops. The lift system is antiquated and should have been sold to the Hungarians years ago. The pistes are unkempt and the gueues for the bus home can be a joke, but that's the Chamonix experience it's not polished like some of it's neighbours it's infrastructure is rough and so are it's slopes, great. The valley is really a collection of ski areas **Le Brevent** out of Chamonix town. La Flegere out of Les Praz and at the head of the valley are Argentiere and Le Tour, both with great terrain. The best way to deal with Chamonix is to have a car if not there is a bus service and a train.

FREERIDERS

Chamonix can be heaven and hell. With good snow it's the big one when it come to hard core riding. You've got it all steep faces, glacial runs, trees and couloirs. With little snow you may find yourself spending more time on

Coach & Air packages to Chamonix & the 3 Valleys

www.boardbreaks.com

the lifts and in the pub than on the slopes. With a 6

USQ WWW.WORLDSNOWBOARDGUIDE.COM 133

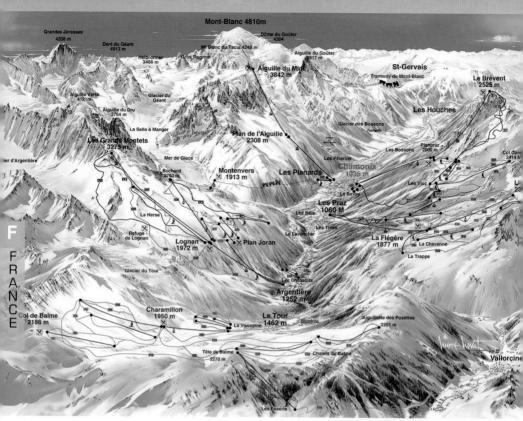

day pass you get 2 rides on the Grands Montets cable car (after that you've got to get your hands in those pockets) from it's top there are two black pistes Point de Vue and Pylones, with heaps of offpiste alternatives, including skirting the impressive Glacier d'Argentiere. From the top of the Bochard bubble you can head into the Combe de la Pendant bowl for 1000m of unpisted descent. The runs down are amazing with loads of cliffs, hits and chutes, but the area can be avalanche prone. Out of La Tour are some fun tree runs towards the Les Esserts chair with small drop offs just big enough to make you keep your wits about you, don't get carried away and head down to far as you'll end up walking back up to the lift. The world renowned Vallee Blanche is great it takes 4/6hrs, involves a cable car ride, a few uphill sections and sphincter testing ridge walk. Although the 20km decent isn't the most challenging of terrain, the surrounding ice and scenery are fantastic. You'll need to stump up for a guide as there's crevasses to fall into and it's best to do it early on a week day as it's less crowded.

FREESTYLERS don't need a fun-park here as there's lots of natural hits and drop off's. La Tours is a good place to head. It seems that the attitude is to build a pipe for competitions and then leave it to melt, and after 2005's late cancellation and future move of the chamjam to the Pyrenees who knows when the next comp will be. Anyway Chamonix is a freeride mountain resort if you want some man made things go else where. Having said that there is now a perma-

nent pipe on the grands montets but it's not the best.

PISTES. Lovers of perfect courdroy slopes will be out of luck as the pisters here spend

more time drinking pastis and smoking gauloises than grooming the slopes.

BEGINNERS will find Chamonix's slopes a little sporadic, there are greens and blues but they are so spaced out that it's best to learn to ride elsewhere and then come here when you've got it nailed.

OFF THE SLOPES. One of the plus sides of Chamonix being a real town is the fact that there's no attitude. The locals are used to visitors all year round and know that's where the cash comes from. You'll see people skateboarding to work something you'd never see in the more stuck up French resorts. There are also plenty of things to do in Chamonix with a large sports centre, swimming pool, climbing wall, arcades and a bowling alley. **Argentiere** at the head of the valley has a good choice of bars and restau-

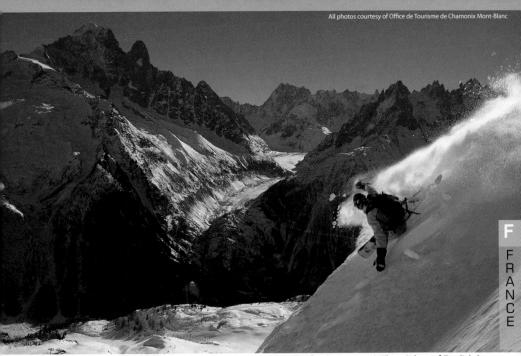

rants and is a great place to stay as it's close to the two best board areas. Le Praz is very quite with little on offer, if you are going to walk into Chamonix town take a torch as the French drive like white van man.

ACCOMMODATION is varied you can get a bed in a bunk house for £10 or get yourself a nice hotel room. The tourist office are really helpful if you arrive needing a bed. Go to www.chamonix.net for a good range of accommodation. There's lots of self-catering apartments particularly in Chamonix sud. For an all inclusive snowboard centred chalet holiday and also training weeks go to www.mcnab.co.uk. If you've got a car there's a great bunk house at the head of the

valley on the road towards Italy near Le Tour.

FOOD choice is good here, there's the French norm of pizzas and melted cheese but there's also a whole choice of pub food and cellar restaurants. In the main pedestrian area is a great hole in the wall fast food joint, which always has a fast moving queue outside try their Americana sandwich.

NIGHTLIFE. It can be a real party town with lots of bars having happy hours and cheep jugs of beer. The centre of town has a bar for most and a few late night clubs like Dicks Tea Bar and the Jeckyl and Hyde (Dicks is set to re-open for 2006/7

after the fire last season). There's lots of English bars, some popular with the Swede's there's even a Queen Vic a good night can be had at the Cantina. The Office bar in Argentiere is good for a beer and has a tex-mex menu which is reasonably priced. There are also a few French bars which are a little cheaper. Le Praz has a couple of very local bars.

SUMMARY Chamonix offers some truly excellent freeriding and great natural freestyle terrain. It's not great for beginners and can suffer if there's not much snow. It's rough round the edges but that's its charm. If you can wait till there's fresh snow then jump in your car.

HAIL

Good for families or day board from Geneva.

Chatel, part of the Portes du Soleil area, has the heart of a traditional village and is surrounded by new flats and chalets, all of which have the compulsory wood cladding to give it that alpine feel. While other resorts suffer from lack of snow Chatel can get more than it's fare share. Due to it's proximity to lac Leman (the French for lake Geneva). The water of the lake evaporates and if the wind is favourable falls on the nearest mountain as snow Chatel. You get some great view over the lake when you're up on the slopes of Super Chatel the main pisted area. It's accessed by an over crowded gondola which then gives way to a series of lifts allowing you easy access to Morgins and with a short walk through Morgins town to Champoussin, remember your passport as both are in Switzerland. It's been known for customs officers on skis to stop people and search their backpacks. A drive up the valley from Chatel leads you to Linga and Pres la Joux there's a free bus. From Pres la Joux it's a couple of chairs to Avoriaz or Les Crosets. It's not the best placed resort within the Portes du Soleil to explore the 680km of piste but you almost feel like your in a traditional French alpine village, well almost.

FREERIDERS could find it hard to get the most from Chatel but if you take a real close look and don't mind a bit of a walk in or out you may just find some truly great off piste runs. There are some easy pitch tree runs from Tour de Don towards Barbossine. From the top of Col-des-Portes you can take a long sometimes tricky route down the Morgins Valley into Morgins village and if you're up for a walk try Pointe de Chesery and head down to Les Lindaretts. Head to Pre-la-Joux if you fancy some steep blacks.

FREESTYLERS are in for a treat as in amongst the trees of Super Chatel and accessed by a gondola and the new ski-tow Les Bossons is the new snowpark which has a large half pipe 120meters, 3 different graded slope style runs and an 800 meter board cross track. At last Chatel is trying to rival it more prestigious neighbour Avoriaz. Also avalable is a Special "smooth park" pass @ 19/14 euros day/half, www. smoothpark.com

PISTES. Riders will enjoy Chatel with its groomed intermediate piste and access to the miles of Portes du Soleil. You can get off on trying to get as much done before racing the lifts home.

BEGINNERS will find Chatel ok. The draw backs are not the runs as there are plenty of blues and greens, although some are a bit flat which leads to a bit of hopping. The main problem is the drag lifts up high, there's loads of them and the runs down into resort are often over crowded. Having said that it's possible to board from near the top all the way into resort on a blue, snow permitting.

OFF THE SLOPES

Off the slopes, Chatel's fairly chilled with a few bars. The Avalanche Bar features wide screen TV's showing English Premership Matches and internet access. La Tunnel bar is busy and has a regular DJ. Bars stay open

late until 4am. Accommodation is mainly chalets, a lot of which have been brought by the Swiss as property is cheaper in France than Switzerland. For hotels there's a limited choice but a lot of British tour operators sell holidays here so it's best to book before you arrive, there's also 3 and 4 star hotels with and without board. Food wise, we're talking pizzas, pizzas, pizzas. The best place for a pizza with a friendly group of staff and a vibe of Ben Harper music washing your food down along with the wine is Basse Cour on the lower road of the main village. There's also plenty of cheap eats to suit all budgets. Crepes, Burgers and Pizza to a full-on three course meals.

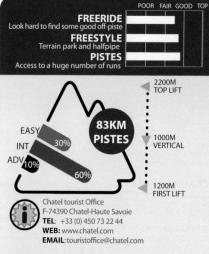

WINTER PERIOD: mid Dec to end April LIFT PASSES

Portes du Soleil

Half-day 29 euros, day pass 38,6 day pass 184, Season 724 Chatel only

Half-day 22.50 Day 30 euros 6 days 136 euros **NIGHT BOARDING**

Thursday nights 7.30/9.30 the Linga piste is floodlit

TOTAL LIFTS: 44 - 2 Gondolas, 13 chairs, 29 drags

ANNUAL SNOWFALL: 4m **SNOWMAKING:**10% of pistes

TRAIN services are possible to Thonon les bains which is 45 minute away. In Switzerland nearest station is Aigle or Monthey then take a taxi

FLY to Geneva, 1 1/2 hours drive away

CAR via Geneva, head north west on the N2 turning on to the D902 at Thonon, Chatel lies along the D22

BUS: service from Thonon visit www.sat-leman.com From Geneva visit www.Altibus.com, tel: +33(0)4 7968 3296

TAXI: 33 (0)4 50 73 21 26

NEW FOR 2006/7 SEASON: new 6-seater chairlift Combes located in the Linga area replaces the old 3-seater

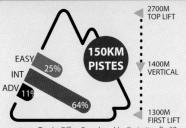

Tourist Office Courchevel, La Croisette - Bp 37 73122 Courchevel.
TELEPHONE: +33 (0) 4 79 08 00 9

WEB: www.courchevel.com EMAIL:: pro@courchevel.com

WINTER PERIOD: early Dec to end April LIFT PASSES

3 Vallees

1 Day pass 43 euros, 6 Days pass 215, Season 935 euros just courchevel

1 day 36,50 euros, 6 days 174, Season 775 euros NIGHT BOARDING In 1650

HELI-BOARDING You Fly into Italy Monta Rosa area

TOTAL PISTES/TRAILS: 117

LONGEST TRAIL: 5km

TOTAL LIFTS: 65 - 10 Gondolas, 1 cable-cars, 16 chairs, 36 drags

LIFT TIMES: 8.30am to 4.00pm, 4.45pm late season **MOUNTAIN CAFES:** 10

ANNUAL SNOWFALL: 6m SNOWMAKING: 26% of pistes

CAR Highway A6 between Paris and Lyon, then Highway A43 between Lyon and Chambery, then Highway A430 between Chambery and Albertville, then Road RN90 between Albertville and Moutiers (express

road 2x 2 way), then Road D91 between Moutiers and Courchevel. Paris/Moutiers: 630 km, Moutiers/Courchevel: 25 km

FLY to Lyon international, transfer time to resort is 2 1/4 hours, 187km away. Chambery 110km away, Geneva 149km

TRAIN snow train and euro star to Moutiers, 15 miles on from station

BUS services from Lyon or Geneva airport in Switzerland, are available on a daily basis to the centre of Courchevel.

TAXI: +33 (0) 479 00 30 00

of the world renowned Trois Vallees ski area. It offers a complete range of terrain, a fantastic modern lift system, an ok park and a reasonable snow record. All that comes at a cost; it's one of the most expensive resorts in Europe, full of very rich French in Versace ski suit and furry boots closely followed by wannabe Brit snob. At the end of the week you won't think twice about paying £1.50 for a bag of crisps and washing it down with a £5 pint of euro fizz. There are four stations all named after their altitude. 1850 home to flash hotels, luxury chalets and Michelin star restaurants with a good connection over to Meribel. 1650 has had a lot of money spent replacing most of the drag lifts, which means all those hidden spots have been opened up. It's almost a resort to itself with a new very slow second hand chair added to a couple of old chairs linking it to 1850. 1550 with direct access to 1850 has lots of chalets, which can be a long walk from the lifts. 1300 (le praz) the only alpine style village is good if you want to chill out at night but is sometimes short of snow early and late season. There's two bubble lifts one going direct to the fun park, there's also an Olympic ski jump if you fancy breaking your legs. If you've got loads of the green or manage to get a cheep chalet deal then Courchevel can be a fantastic resort, but don't go during school holidays as the place is mobbed.

FREERIDERS will love this place; there's everything from wide rolling pistes of 1650 to steep rock shoots under the saulire cable car. Theres so much piste that it doesn't get chopped up and they have a huge fleet of piste bashers to flatten it out each night. There's some good off-Piste straight off the lifts, under the Vizelle bubble and Dou des Lanche chair, besides the Chanrossa chair and down through the trees to Le Praz a must in bad visibility. If you don't mind a walk check out the back of the Creux Noirs. One great spot which must be treated with the utmost respect in the Vallee des Avals which is prone to a slide but has a great refuge and is stunningly beautiful, access is from the Chanrossa chair and a short walk.

FREESTYLERS will find the big snow-park under the Plantrey chair, there's some good hits and two pipes.

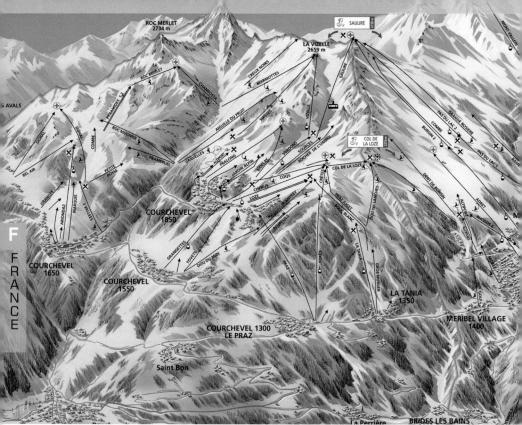

If the suns out get there early as by afternoon one walls slush and the others bullet, there's a free drag. The top of the Verdon's got some man made dunes and some good kickers. A small drop off can be found by the Bel air and Signal drags 1650. Go to the top of the Suisses if your looking for some big drop offs.

PISTE lovers will be in heaven. They reputedly spend £20,000 a night grooming the pistes, so get up for first lift and you can carve your way down the Saulire racing the cable car. When everyone else gets up, head over 1650 for motorway wide runs.

BEGINNERS should head for the Biollay and Bellecote both have a good sustained pitch, the Biollay even has a travelator at the bottom for total beginners. 1650 has some great wide runs but still a lot of drag lifts so watch out. If looking for a lesson, check out rtmsnowboarding.com a British board school who hold beginners, freestyle and carving clinics. A special pass giving access only to the beginner lifts is available for 14 euros a day.

OFF THE SLOPES everything but **Le Praz** is a purpose built 70's nightmare, although they've stuck up some wood to try to add some charm it's still an ugly place. The lift access from most accommodation is great, and there's plenty to do with ice rink, climbing wall cinema, bowling and gyms. If you've got strong pants you can organise a tandem freefall, flying out of the tiny airport (March only). But remember to bring those Euros in Courchevel as cash is king.

ACCOMMODATION. If cash is short the best thing to do is get a half board chalet, so you don't do all your cash on food. You can get some great last minute deals on the web. If your wallet is fat then there are some great French hotels and some amazing chalets with under ground swimming pools and huge fire places. All the big tour operators have chalets/hotels. If you've got kids try Le Praz.

FOOD. If you are catering for yourself then it's pizza, melted cheese in various guises or raw meat cooked at the table on a hot stone. If you've loads of dough then get out your Michelin guide. The *D'Arbeilo* in Le Praz is good rustic place.

NIGHT-LIFE has been slowly dieing as the French reclaim the resort, leaving people with little choice, there are a few English bars or some rip off French clubs. 1850 it's the *Jump bar* and the tiny *TJ's*. Both

hot and packed with bad rugby tops and chalet girls with pearl earings. In 1650 the Bubble, which looks like an airport departure lounge, is cool and run by attitude free staff. If you're staying in 1550 the Tavernas a good place for a pint.

or contact **rob** on: (summer time) **07989 988 774** (winter time) **0033 615 485 904**

FLAINE

Okay slopes, pretty tacky off

Flaine is a purpose-built, 1960's mess, whose architects must have designed the resort in the space of five minutes, then built it with five million tonnes of waste concrete. Ugly? Yep, and designed purely for hordes of skiers. However, as far as snowboarding is concerned, Flaine offers some great and varied terrain for different abilities. Flaine sits in a big bowl and forms part of Le Grand Massif area, which includes the linked resorts of Samoens, Morillon, and **Les Carroz,** offering good off-piste.

FREERIDERS have some great opportunities for offpiste riding, with long, interesting runs to tackle. The area above the **Samoens** lift is pretty good, but alternatively, you should check out the trees in Les Carroz, where you will get a good lesson on how to treat wood at speed. Advanced riders should check out Combe de Gers, which is a steep back bowl that drops away with 700 metres of vert (don't bail this

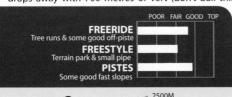

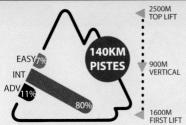

Flaine Tourist office Galerie des Marchants, 74300 Flaine

TELEPHONE: +33 (0) 450 90 80 01 WEB: www.flaine.com / www.grand-massif.com

EMAIL: welcome@flaine.com

WINTER PERIOD: mid Dec to end April

LIFT PASSES Flaine area: Half-day 21.50 euros, Day 30 Grand Massif: 1 day 35 euros, 6 days 173.50, Season 760 **BOARD SCHOOLS**

private lesson 1hr 32 euros, group 3hr/6 days 118 euros BOARD HIRE Board & Boots 100-150 euros for 6 days

TOTAL PISTES/TRAILS: 52 LONGEST TRAIL: 14km

TOTAL LIFTS: 28 - 1 Gondola, 1 cable, 9 chairs, 17 drags

ANNUAL SNOWFALL: 5m **SNOWMAKING: 5% of pistes**

CAR Via Geneva, head south on A40 & take exit 19 to Cluses & then take the N205 towards Sallanches for 2km then take the D106 road on the left up to Flaine. 44miles FLY to Geneva 90km, which is about 1 hours transfer to

Flaine. Annecy 80km. Lyon 190km

TRAIN services go to Cluses which is 30km away

BUS Alpbus runs between Cluses and Flaine 22euros return tel: +33 (0)450037009.Contact +33 (0)450347408 for other options.

TAXI: Tel. +33 (0)4 50 90 83 35

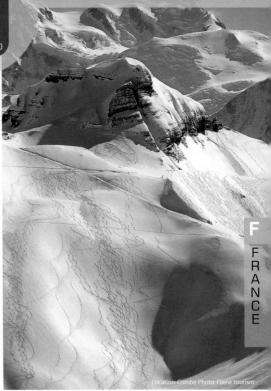

one). To get the best off-piste riding, hire a guide, which will cost about 60 euros for two hours. Heli-boarding is also possible here.

FREESTYLERS may at first feel they are invading a Euro-carver's hangout, but air heads have a good two mile long fun-park area. The Jampark is set up on the Calcédoine run over the Aujon ski area it's loaded with big hits to get high. There's even a kid's halfpipe called the Fantasurf. The park is supported by a reduced lift pass, so check at the ticket office for the latest deals.

THE PISTES are well maintained and hard booters are certainly at home here: Flaine was one of the first carving capitals in France and France as we all know is home to the hard booter. Like most of the country, there are many good areas for Alpiners to show off, which makes for some real fast areas.

BEGINNERS have a number of very easy flat runs which are serviced by a free lift located a short walk from the village area. However, to progress, you will need to buy a pass and head up to the more interesting runs. There are a couple of long blues leading away from the top of Les Grandes Platieres cable car, that will allow novices to find out what linking turns are like.

OFF THE SLOPES

Flaine is not a massive or happening village, nor is it the most expensive, but it's hell on earth in terms of the way it is presented as a holiday camp on a mountain. Lodging is basic, and apartments are the main accommodation with most either next to the slopes, or within a short walk. Evenings are noisy with Brits and lots of apres-ski

USQ www.worldsnowboardguide.com 139

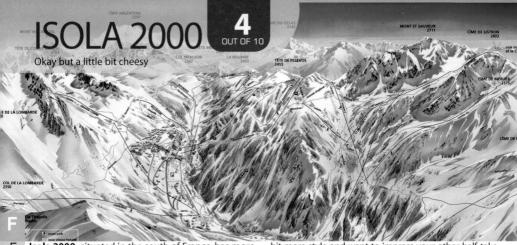

Isola 2000, situated in the south of France, has more to offer than you'd expect. A calculated and very purpose-built resort, the French seem to have got their sums a bit wrong in the early days when they built this rather cheesy and tacky mess, whose original plan was to pack in hordes of cheap package tour groups. However, things have changed a little, and the place is losing its poor reputation and gaining a lot of respect. The resort has easy access to lifts, and the area offers plenty of varied terrain to keep even the most adventurous rider busy for a week or two, a season here would be pushing it.

FREERIDERS scoping the land will touch the piste only to hop between tree runs, or to get back on the lift. Isola has ample tree coverage over the mid to lower areas. Natural gullies can be hit near **Melezes**, plus look out for the drop offs in the trees as you're going up the chair lift - they're all over the place. Turn to the north-facing slope when conditions are good, above **Grand Tour**, as it is well worth hiking the ridge for freshies. Do watch your run out though as you come to a severe drop off onto a flat piste below.

FREESTYLERS Isola 2000 is home to the Back to Back Snowboard Club, and a dedicated and maintained snowboard park. They don't have a residential Pipe Dragon yet, but with the experienced locals, you can be sure of a park with table-tops, spined tombstones and gaps. The locals are good to watch and know how to take a good line

PISTES. The whole area was planned to make runs long, well groomed and easy to return to base, with good cruising and smooth pistes on both sides of the mountain. You can pick up some good speed and lay over your turns.

BEGINNERS have a massive designated area near the base lift station. This keeps them out of trouble on a good area for progression, before they take on the higher grade runs, allowing quick learners the chance to ride the whole resort.

OFF THE SLOPES The easiest option with accommodation would be to stay in one of the apartment blocks - comfortable, unfussy and just a stone's throw away from the lift station and amenities. If you're after a

bit more style and want to impress your other half, take up space in one of the chalets available. For food, why not try the *Crocodile Bar*, which serves up some decent Tex-Mex. It's also a good local snowboard hangout and stays open long into the early hours, with good measures and good sounds.

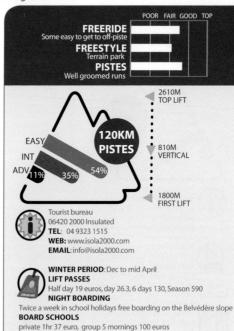

NUMBER PISTES/TRAILS: 45
LONGEST RUN: 6km
TOTAL LIFTS: 1 funicular, 2 Gondola, 10 chairs, 9 drags

TOTAL LIFTS: 1 Turnicular, 2 Goridola, 10 Chairs, 9 di

ANNUAL SNOWFALL: unknown SNOWMAKING: 15% of pistes

CAR Via Nice, head north on the N202, then the D2205 to Isola turning left on to the D97 for Isola 2000.90mins FLY to Nice, 50 miles away.

TRAIN to Nice

BUS daily from Nice bus station at 9:15 and tales 2hrs. 17.80 euros one way tel 0033 (0)493859260

Limited terrain and can get very busy

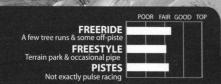

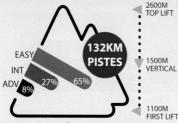

Tourist Office, 74220 LA CLUSAZ **TELEPHONE:** +33 (0) 450 32 65 00

WEB: www.laclusaz.com EMAIL: infos@laclusaz.com

WINTER PERIOD: mid Dec to mid April LIFT PASSES

Half-day 22.50 euros, Day pass 28,6 Days 146.5, Season 580
NIGHT BOARDING

Piste de la télécabine de la patinoire open once a week from 20h30 to 22h30

TOTAL PISTES/TRAILS: 83 LONGEST TRAIL: 3km

TOTAL LIFTS: 55 - 4 Gondola, 2 cable-cars, 14 chairs, 35 drags

ANNUAL SNOWFALL: 5m SNOWMAKING: 10% of pistes

CAR Via Geneva 50 km, head south on the A40 and exit at Bonneville on to the D12 via Borne to La Clusaz FLY to Geneva (50km), which has around a 1.5 hour

transfer time. Lyon airport 150km away, nearest airport is Annecy, 30km away.

TRAIN Train services go to Annecy which is 30km away. More info www.sncf.com

BUS 3 coaches /day from Geneva airport (8am, 1pm, 5pm). Takes 1hr 45, from 50 euros return.

La Clusaz is located in the distant shadow of Mont Blanc and is only an hour-and-a-half from Geneva. La Clusaz is a cluster of five low-level rideable areas, linked by a series of lifts. The two very noticeable problems with La Clusaz are a) the low altitude, which can mean poor snow levels, and b) the French disease of overpopulation by ski-tour groups. Collectively, snowboarding can be described as poor. It lacks anything of great interest, unless you're a carver who likes to pose alongside lift lines on blue runs. Advanced riders will have this place licked in a few days, with the only decent

challenge being a long black on the **Massif de Balme** area. You can ride four of the five areas via a network of connecting lifts, while the fifth, the Massif de Balme, can be reached by road or chair lift. Here you ride down a red or black before taking the gondola back up.

FREERIDERS will like the less crowded area of the **Massif de Balme**, where a series of red runs and a long black lead to open slopes which allow you to ride off-piste, hitting some powder stashes. **The Combe du Fernuy** is the area that descends a red section, down a tree line onto a cool run, en route to the Massif de Balme area. There are lots of trees, but no great challenges.

FREESTYLERS have a halfpipe and park on the Massif de Balme slopes, but neither are shit hot or particularly big. The way the area is spread out means that there is a lot of okay natural terrain for catching air, but this is not a great freestyle place.

THE PISTE'S are very well mantained in all five areas. The slopes allow for some good wide arcs on intermediate terrain; the longest run is on the Balme slopes, whilst on **Massif de Beauregard**, there's an interesting long run to tackle at speed.

BEGINNERS can achieve a lot here, with slopes that are excellent for finding out what snowboarding is like at the early stages. The Beauregard and L'Etale areas have good, easy slopes; the only potential problem is that they are mostly serviced by drag lifts.

OFF THE SLOPES the village has everything you would expect from a tourist trap. There's a good selection of beds ranging from expensive chalets to cheap, shared apartments, set in a traditional French-style village. Accommodation, shops, and restaurants are located within easy reach of the slopes, with many slope side hangouts. Evenings are dull and uneventful, unless you're a apres-ski fan

LA GRAVE

8OUT OF 10

With the right conditions, awesome & deadly

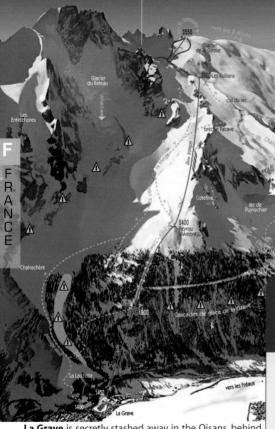

La Grave is secretly stashed away in the Oisans, behind the back of Les Deux Alps. When the snow falls, this mountain has 7,100 continuous vertical feet of drops, couloirs, cliffs, gullies, chutes, steeps, trees and crevices. This mountain isn't child's play so never ride alone. This is basically home to only die-hard extremists, with a few snowboarders who can hold their own. Still, the lack of skiing tourists simply guarantees 'no battle of the freshies' with untracked powder for days

FREERIDERS will find above the only gondola, two T-bars that lead to the **Glacier de la Girose**. If La Grave hasn't seen snow in weeks, this mountain gets mogul madness. Therefore, the 15 minute hike over the top to Les Deux Alpes should entice the pipe and park enthusiast. If it does dump snow, cruise down the glacier, but be pre-warned of the numerous, unmarked crevasses. Have a chat with the patrouilleur sat in the hut next to the cable-car station, who will give you the current whats what. Guides are essential to get the most out of the place, or even sometimes, just to get out of the place.

Further down Glacier de la Girose, lies many steep cliffs and unavoidable gullies. Once past these gullies, stay on the traverse to the skier's right and keep an eye out for the gondola station at P1. Do not become bewitched by the untracked powder through the trees and river beds, or you will find yourself plummeting off 100m cliffs. Ruillans, spread out like curtains, are four couloirs to be explored. This gives you the chance to ride top to bottom. Further down, are some great natural quarter-pipes and tree runs. Take warning of the cliffs and the river near the bottom.

This side of La Meije has held the legendary Derby for the past 17 years. In the world of snow racing, The Derby has the largest vertical drop of 2,150 metres on snowboard, ski, monoski or telemark and is held at the end of March and lasts for 5 days. For details visit www. derbydelameije.com

OFF THE SLOPES. Local facilities at La Grave are pretty basic. There are a few shops, 5 hotels and a couple of campsites. Riders spending a season here will find that rent and a season's lift pass is cheap. On the social scene its not exactly kicking. The *pub le Bois des fees* runs some DJ nights, but party animals should head over to Les Deux Alps or Serre Chevalier

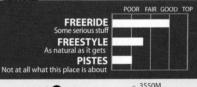

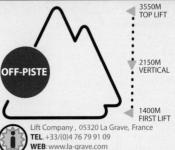

Tourist Office, 05320 La Grave - France **TEL**. +33/(0)4 76 79 90 05 **WEB** www.lagrave-lameije.com

TOTAL LIFTS: 4 - 2 Gondola, 2 drags LIFT TIMES: 9am-4:30pm

WINTER PERIOD: mid Dec to early May LIFT PASSES 1 Day Pass 33euros 3 Days 90euros, 6 Day Pass - 160euros GUIDES Tel. +33/(0)4 76 79 90 21

CAR motorway A 48 to Grenoble, then RN 91 to Bourg d'Oisans and Col du Lautaret. **FLY** Lyon Satolas or Grenoble Saint-Geoirs airport and

from there by VFD coach or taxi to La Grave. **TRAIN** to Briangon and from there by VFD coach or taxi to La

Grave.

TAXI Tel: 06 79 53 45 67 www.taxidelameije.com

LA PLAGNE

A bit tacky but good fun and easy riding

There are 10 resorts that compose the La Plagne boarding area, ranging from traditional villages to modern purpose high altitude purpose built resorts, some of which are horrible such as Aime la Plagne;, a great big apartment block. La Plagne is mainly suited to intermediate boarders as there is not that much steep terrain and few challenging runs. There are some good wooded areas which can be a blessing in white outs, especially around the areas of Les Coches and Champagny en Vanoise. This resort is ideally suited to people who stick to the piste with mile after mile of motorway cruising. 2003 saw the opening of the Vanoise Express which links La Plagne with Les Arcs, thereby creating the Paradski ski area and giving you access to 238 runs totally 425km.

FREERIDING. Guides can be hired through ESF and will take you to some of the many off piste areas that are not accessible by lift. Most of these

POOR FAIR GOOD TOP FREERIDE A few tree & some good off-piste **FREESTYLE** The Capella & half-pipe area kicks arse **PISTES** Some wide easy slopes

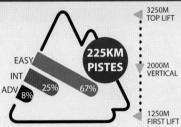

Office de Tourisme de la Plagne 73211Aime Cedex TEL 33(0)4 79 09 79 79

WEB: www.la-plagne.com EMAIL: bienvenue@la-plagne.com

WINTER PERIOD: Dec to April

LIFT PASSES 1 Day 39 euros, 2 Days 74 euros 6 Days 186, Season 650 euros

HIRE Loads of local shops to choose from BOARD SCHOOLS 17 schools to take your pick from

NUMBER OF RUNS: 134 LONGEST RUN: 15km

TOTAL LIFTS: 86 - 7 Gondola, 2 cable-cars, 35 chairs, 61 drags, 2 carpets

CAPACITY (PEOPLE/HOUR): 120,899 LIFT TIMES: 8.30am to 4.00pm

ANNUAL SNOWFALL: 5.2m SNOWMAKING: 250 acres

CAR From Lyon/Albertville (196km) take Motorway A43 and A430.

FLY to Lyon which is 2 hours away. Others: Geneva, Chambery, Grenoble & Annecy

TRAIN Daily from Paris (4hrs 15min) to Aime, 10 minutes transfer. From UK take Eurostar direct on saturdays to Aime. BUS services available from most towns. Tel: 04 79097227

USQ www.worldsnowboardguide.com 143

places involve some hiking so be prepared, and make sure you take all the necessary avalanche equipment and know how to use it. Just think size of ski area 10000 ha, with only 730 ha covered by mark pistes that's a lot of offpiste to discover. Overall La Plagne is not particulary steep but it is very open and easy to navigate with lots of fun riding to be had. There's guite a lot of flats, but this just gives you the opportunity to tuck up those balls and straight line as fast as your nerves will let you. Make sure you pay attention because these flats creep up on you and if you don't start high enough you will be walking. Les Arc is much steeper and more challenging but if you are staying in La plagne it is a distance to keep travelling between the two resorts. So pick one that suits you best, board there, and visit the other once or twice if it suits.

FREESTYLE. The Capella snowpark right in the heart of La Plagne is well served by ski lifts and well maintained by 6 full time staff. The piste is 900m long made up of a good selection of rails, boxes, waves and rainbows. There are hits of various sizes from scary, to manageable with a few small ones to start on before moving up to the bigger hits. There's a great sound system that keeps the tunes booming out all day. In all this is a good park for advanced riders due to its length and range of objects, giving the rider a real opportunity to find a line that suits and hit various objects on the way down in true slope style. It also has a good mix of smaller objects for beginners to find their freestyle legs.

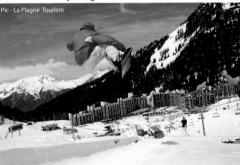

PISTES. Good area easy to navigate and nice and open. It's a well maintained ski area with a good selection of pistes for people of all standards.

BEGINNERS. This is a good resort to learn in, with 12 lifts free for beginners and a lot of good wide blues to get your teeth into once you have found you feet. But be prepared, pick the wrong run and if you don't have the confidence to straight line, you will be walking. There are a good variety of board schools to choose from, so pick one, strap on your board and have fun.

OFF THE SLOPES. Now not the prettiest alpine village it dose have some good qualities and there's avery good bus service connecting all the smaller resorts. There is a good selection of all the usual apartments, Hotels, Chalets, all catered and un-catered. So take your pick. There are plenty of local tasty Savoyard specialities, but not so good for the veggies. Now this is not the most stylish of nightspots but lets be honest if there's alcohol, and ladies for the fellas, and fellas for the ladies then who really cares. It is not cheap but it is cheaper than many other resorts in the French Alps, so drink up don't be shy and make some new friends.

La Tania is an off shoot of the Albertville Olympics built to house the spectators, it's steadily grown ever since, popular with the Dutch and Brits. The resort built in between Courchevel and Meribel has good access to the Trois Vallees. It's got a couple of drags, one just for total beginners and a big bubble with bench seats

that aren't big enough to get half your arse on. At the top of the bubble you've got two choices, take the Praz Juget drag to access Courchevel or the Dou Des Lanches chair for Meribel, if you don't do drags you can get to Courchevel off the Dou Des Lanches but the runs flat and you'll be walking. If heading for Meribel make sure you've got a Trois Vallees pass, and best to endure the flattish path to reach Meribel proper as if you drop down to soon you'll end up at the altiport and the only way out is a flat track or a slow drag.

FREERIDERS have got two great runs down, the blue Folyeres a rolling run through the trees with some great drop off hits or the red Moretta Blanche good for a full speed hack. Off Piste access is good the trees are ok at the top but they get real tight as you near the resort. Under the Dou Des Lanches can be fantastic but don't go near it without a transceiver as it's prone to sliding. Also good is between Loze and Dent de Burgin chairs.

FREESTYLERS will find lots of natural hits and loads of areas up high to build a big kicker. If you want pre made then head for Courchevel or Meribels fun parks.

PISTES. For those who want just the piste, will enjoy the two main rolling runs into resort or you could head down towards the altiport in Meribel as the pitch is good and the width wide

BEGINNERS will find a short drag lift out of resort, but not the best place to learn. Beginners will find the best slopes link with Courchevel.

OFF THE SLOPES

basically a collection of chalets and a couple of blocks of flats, in typical French purpose built style, but its a good place to sit, look up the hill and have a beer. Other than a few French bars Le Pub gives all there is to give, affordable filling lunches on a big sun terrace, live music a few times a week and doesn't mind a loud piss up. Which is a good job as it's all there is to do, and the Dutch do it all. Food wise its Pizza, cheese and meat, savoie style. 144 USQ WWW.WORLDSNOWBOARDGUIDE.COM

Photo:La TaniaTourism POOR FAIR GOOD TOP FREERIDE Tree runs & some good off-piste **FREESTYLE** Just natural hits **PISTES** Big open pistes 2738M TOP LIFT **50KM** 1338M VERTICAL 1400M FIRST LIFT La Tania Tourist Office 73125 Courchevel, France TEL: +33 (0)4 79 08 40 40 WEB: www.latania.com EMAIL:info@latania.com WINTER PERIOD: mid Dec to end April LIFT PASSES

3 Valleys: Half-day 34.5 euros, day 43, 6 Days 215, Season 935 Local: Half-day 28 euros, Day 36.5, 6 Days 174

NUMBER PISTES/TRAILS: 275 LONGEST RUN: 4km

TOTAL LIFTS: 65 - 10 Gondola, 1 cable-car, 16 chairs, 38

ANNUAL SNOWFALL: unknown SNOWMAKING: 15% of pistes

CAR take A43N to Albertville, N90 to Moutiers follow direction Courchevel

FLY to Lyon and Geneve 2 hours away. St Etienne and Chambery also close

TRAIN to Moutiers access by Euro Star and Paris BUS from Moutiers 30 mins www.altibus.com tel: 33 (0)4 79 24 21 58.

TAXIS: 06 09 03 87 20

LES ARCS

9 OUT OF 10

Lots of off-piste, powder & natural hits

Most people delight in telling you that **Les Arcs** is a massive, concrete carbuncle on the arse of the French Alps - but these people probably haven't been here, let alone spent any sort of time in the place. Ignore such comments, come with an open mind, and ride one of the best sets of mountains in the world. Les Arcs itself is split into five distinctive resorts - 1600, 1800, 1950, 2000 and **Bourg-St-Maurice**. Each place has a different feel to it, so choose wisely. 1600, where most of the chalets are situated, is quite chilled out with loads of trees. 1800 is the party place, while 2000 is a bit hideous and isolated, but has good access to some amazing terrain. The latest village is 1950, next to a 60m

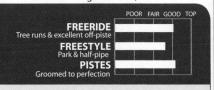

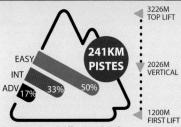

Tourist Office Courchevel La Croisette - Bp 37,73122 Courchevel. **TEL**: ++33 (0) 4 79 08 00 9

WEB: www.courchevel.com EMAIL: pro@courchevel.com

WINTER PERIOD: mid Dec to end April LIFT PASSES Les Arcs: 1 Day pass 38 euros, 6 Days 181 Paradiski: 6 Day pass 220 euros

NIGHTBOARDING 3 slopes lit, and its free!!

Arc 1600 - tue & thurs on the Combettes chair till 7pm Arc 1800 - tue & thurs on the Carreley & Chantel chairs till 7pm Arc 1950-Arc 2000 tues & thurs on the Marmottes chairlift until 9 pm.

NUMBER OF RUNS: 121 LONGEST RUN: 7km

TOTAL LIFTS: 76 - 1 Funicular, 3 Gondolas, 1 cable-car, 30 chairs, 40 drags, 1 Telebenne

CAPACITY (PEOPLE/HOUR): 68,000
LIFT TIMES: 8.30am to 4.30pm
MOUNTAIN CAFES: 14

ANNUAL SNOWFALL: 5m SNOWMAKING: 25% of slopes

CAR via Lyon to Les Arcs, 210 km (130 miles), approx 2 hours. Take motorway to Albertville, dual carriageway to Moûtiers then the RN 90 to Bourg Saint Maurice

FLY to Lyon international Transfer time to resort is 2 hours. Contact Satobus Alpes on +33 (0)4 37 255 255 to arrange transfer. Chambéry-Aix & Geneva airports available.

TRAIN to Bourg-St-Maurice, then funicular or bus to Les Arcs. Eurostar snowtrain takes 8hrs from London Waterloo. **BUS** from Lyon airport, are available on a daily basis via Bourg St Maurice to Les Arcs. Bus from Bourg to resort tel: +33 (0)4 7907 0449

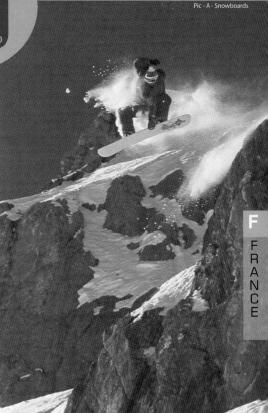

waterfall which opened in 2003 and has been created by those Intrawest people. Despite having a huge riding area, Les Arcs has managed to retain a cosy feel as its dead easy to get from one area to another and you are only likely to run into heavy lift queues during the height of the French holidays. On the mountain, Les Arcs has it all, from mellow beginner slopes to some of the most challenging runs anywhere in France, with hardly any moguls. What Les Arcs does have however, is a lot of punters as this is a very popular resort, but with such a vast expanse of snow to explore, the slopes are left fairly quite. The Vanoise Express opened in Dec 2003 and now links the resort up with La Plagne creating the Paradiski area.

FREERIDERS it's all here and it's all good! If there is fresh snow on the ground, you can be guaranteed an amazing day through trees in Peisey or above 1600, off cornices in 2000, or just straight lining anything all day long. The area off the Trans Arc cable car gives access to some great off-piste riding

FREESTYLERS might not see a lot of jumps on first arrival, and in truth, there aren't many natural jumps, but the best area is in Peisey, 2000 and high above 1800. The hits on an area known as Les Clocherets are also worth a visit. If you're into man-made jumps, then you should head to the Apocalypse Park which has green, red or black runs. It also has a good selection of rails and a strange boardcross thing called the boarder gliss. However, it's true to say that the park is not well main-

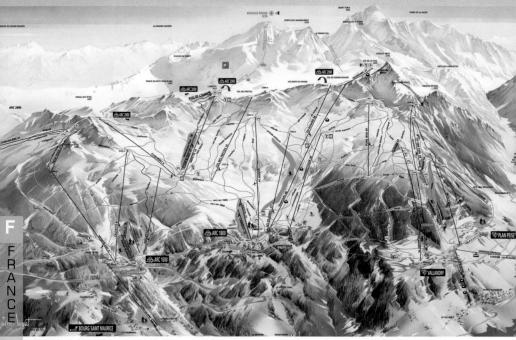

tained, but things are getting better.

PISTES. If you like to stick to the piste then you're in luck. Les Arcs is blessed with amazingly well groomed, wide open pistes. There generally crowd free, well most of the time, especially the higher grade runs. Les Arcs piste lends itself perfectly for big slashing turns. The Mont Blanc piste on 1600 is ideal for intermediate carvers, and the Belette and Myrtille runs are good for advanced riders who can handle a board at speed.

BEGINNERS are sorted here and it shouldn't be long before you're riding all over the place aided by the quality of the piste and the fact that most areas are connected by fairly easy trails and lifts. There are a lot

of drag lifts, so expect a bit of embarrassment as you fall off after the first two yards.

OFF THE SLOPES. The five areas of Les Arcs are somewhat spread out, although they link up by both lift and road. Each area has quick access to the slopes, making riding back to your accommodation the norm at the end of the day. 1800 is the most popular place to stay, where there is a good selection of apartment blocks and hotels. The best thing about all the areas is that prices for accommodation, eating out and partying are largely the same throughout, with something to appeal to everyone. The general feel to the whole area is one of a gigantic, spread-out holiday

camp that rocks 'til late, looks tacky, but has heaps going on with all manner of sporting facilities and shopping. Many operators run package holidays using chalets, hotels and apartments throughout the resort. Prices vary however - you can rent an apartment for four people for a week from 400 euros, loading in at least four more bodies, and then split the cost. Most lodging is next to the slopes, with nothing involving a long trek. No matter what area you base yourself in, you will be able to find somewhere that serves up food to your liking. The place is littered with restaurants with cheap and chearful offerings being the favoured selection. 1800 has the best offerings with places like Mountain Cafe, where they serve huge portions of everything including Tex-Mex. The Red Rock Bar is also noted for grills etc.

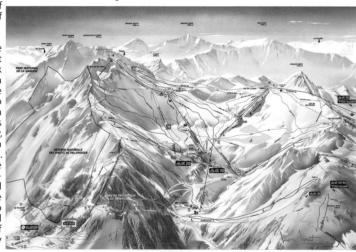

LES DEUX ALPS

7 OUT OF 10

Rowdy, full of Brits & Maybe the best park in France

Les Deux Alpes ranks amongst France's biggest and most friendly resorts. Not just friendly, but snowboard-friendly. The resort has plenty of testing and rider-friendly terrain, and an excellent terrain park. The pistes are big and wide, pretty featureless, but great for beginners and intermediates. As a glacial resort, when other areas are suffering from a lack of the white stuff, Les Deux Alpes has no such problem although the lower slopes can get pretty icy. Once freeriders have exhausted the local area,

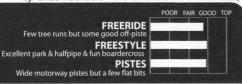

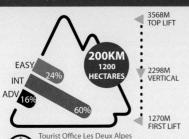

A

TEL +33 (0) 4 7679 2200 WEB: www.les2alpes.com EMAIL:les2alp@les2alpes.com

BP 7-38860, Les Deux Alpes

WINTER PERIOD: mid Dec to end April
AUTUMN PERIOD: end Oct to mid Dec (glacier)
SUMMER PERIOD: Mid June to end of August (glacier)
LIFT PASSES Day pass 35.5 euros, 6 Days pass 168.50 +

free la Grave access, Season 750 euros. **Ski Sympa area** (21 lifts): 1 day only 17.50 euros, 2 Alps + La Grave day 45

BOARD SCHOOL 120 euro 5 days for 3hrs

GUIDES The Maison des 2 Alpes offer off-piste guiding days, 60 euros per person, inc bleepers. Contact guides2alpes@yahoo.fr tel: 04 7611 3629

HIRE Atelier du Snowboard charge Board & Boots 28 euros per day, 108 for 6 days.

NUMBER OF RUNS: 102 LONGEST RUN: 12km TOTAL LIFTS: 58 - 1 Funicular, 4 Gondolas, 2 cable-cars, 20 chairs, 30 drags

CAPACITY (PEOPLE/HOUR): 61,000 LIFT TIMES: 8.30am to 4.30pm MOUNTAIN CAFES: 6

ANNUAL SNOWFALL: Unkown SNOWMAKING: 20% of slopes

CAR From Lyon take the E70/A48 motorway to Grenoble. Take Exit 8 (Briançon) onto the RN91, take the D213, exit at Chambon dam to Deux Alps. Drive time is about 2 1/2 hours, 170km

FLY Lyon international 160km away, transfer time roughly 2 1/2hrs. Grenoble is 120km away, Geneva 220km

TRAIN to Grenoble an hour away.

BUS Satobus runs from Lyon airport via Grenoble to 2 alps, tel: + 33 (0)4 7687 9031.

TAXIS: +33 (0)4 7680 0697

and if you've got the guts, you can hike or snowcat and drop into neighbouring resort **La Grave**. A great time to visit this place is summer, as the glacier allows for some fine summer riding in T-shirts and there's a huge array of jumps and rails not to mention 2 half-pipes. A lot of camps are held here in June and July, with camp programmes mainly aimed at freestylers.

FREERIDERS While skiers with poor imagination brand it a motorway resort, the same is not true for boarders. When there is a fresh dump, you can ride almost everywhere you can see - the off-piste is huge and challenging. The only terrain missing is that of trees, but with a free day on the lift pass in nearby Serre Chevalier, tree huggers should feel catered for. Check out the Dome for a powdergasm, and routes off the 6-man chair, La Fee, for steep, deep and testing riding. There's some hardcore off-piste around the Clot de Chalance accessed from the Serre Pallas run but you need to have a guide to show you the routes. From the bottom of the Super Diable you can head left out of the area for some cool riding and pick up the Diable piste much further down. The resort of La Grave is connected via the Dôme de la Lauze ski tow, and it's a renowned freeride wilderness. After a good dump of the snow the other side of the valley from the top of Pied Moutet provides some easy freeriding and tree shredding. Ask in the tourist information about the free off-piste chats and mini-tours.

FREESTYLERS can pipe and park ride all year round. Winter sees the park located at the Toura area with an immaculate 120m earth shaped halfpipe, loads of jumps and rails and 2 boardercross runs. The main boardercross sites underneath the lifts that run up from the restaurant. It's very freestyle orientated with plenty of jumps, a gap, some whoops, and some right banks, unfortunately its also full off skiers stopping and clogging it up, making it tricky to really go for it. There's also beginners boardercross to the left of the chairlift. From the top of these chairs you access the halfpipe and there's a big kicker on the way to the pipe and an advanced slopestyle runs parallel to it, the other side of the ridge, featuring some large kickers and rails. Serviced by a short drag below the pipe are a number of beginner and intermediate jumps, rails and boxes. In summer the Soreiller green run on the glacier becomes a big park with huge pro-jumps, a huge array of rails, 2 halfpipes and plenty of smaller kickers for mere mortals.

PISTES. This is an piste lovers dream retreat, with nicely pisted runs like the Roch-Mantel and the Signal for a warm up. The glacier itself is great for ballistic speed. The Sandri run at the foot of the glacier to the mid-station is a warp factor 9, if you adhere to the essential turn only rule. So, for those of you who think turning is to admit defeat, tuck em away and go for it. At the end of the day

USQ www.worldsnowboardguide.com 147

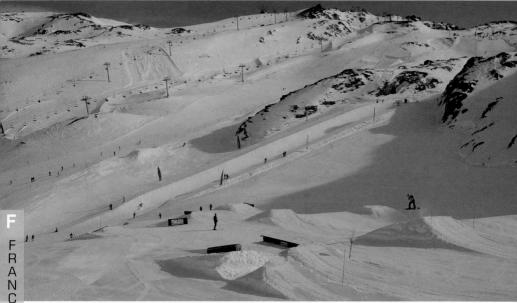

things do get a bit clogged up on the way down with a couple of narrow flat paths bottle-necking every-one. The valentine run to the base can be an absolute nightmare, its very steep and often sheet ice but it can be a right laugh watching people sliding backwards all the way down taking out others. You can take the windy narrow green run as an alternative but if you're a beginner don't lose your days confidence and take the gondola back.

BEGINNERS starting out couldn't ask for a better place to make steady progress. The gentlest terrain is at the very top of the resort on the glacier, where is also where you'll find the best snow. Due to the layout of the lift system, other than your first morning on the beginner's slope, you need never take a drag for the remainder of your stay. The chairlifts, gondolas and other lifts make the whole uplift problem easier to sort out than a wonderbra.

OFF THE SLOPES and at the base of the runs, Les Deux Alpes sits conveniently for most local services, but being a large town, not everything is within walking distance. The resort is a mix of old school and purpose-building but things aren't particularly subtle. There are loads of off-slope services, including a cinema, bowling alley, sports complex and an outdoor climbing wall. It is a busy package tour destination so expect a lot of tourist junk shops, but there are a couple of decent boarders shops.

ACCOMMODATION: There's something like 30,000 beds available, from standard grade apartment blocks, modern hotels but only a couple of traditional-style chalets. Prices are pretty reasonable and there's a hostel in town if your budgets real tight.

FOOD-wise, this place caters well for people on a budget, as well as those who want to splash out. There are a good number of reasonably priced pizza and burger bars along the main road. For a Tex-Mex, visit *Smokey Joes* or *Saxo* - also home to some of France's loveliest bar staff (top french tottie).

NIGHT-LIFE goes off seven nights a week, things start early and finish late. *Smokey Joes* near the main gondola station is good for a beer after a long day, and has a big screen for the football games. There's the obligatory *Yeti bar*, *Smithy's* gets messy late on, the *Red Frog* is a friendly Brit haunt, and *Pub Le Windsor* is a great little bar with a massive Whiskey menu. *L'Avalanche* and *L'Opéra* are the places to head for later if you can still stand.

MERIBEL

6OUT OF 10

Over hyped resort. Good park though.

Meribel at 1450m is a favourite for the Brits. Set in the middle of the **Trio Vallees** it's a good base to explore this massive area. So good in fact the French want it back. The Brit's have been slowly buying this resort and you can spend a week here without the need to speak a word of French, which is a good job as most of the bar staff wouldn't understand you anyway. This resort has enough varied terrain to keep everyone in a mixed ability group happy. Because of it's altitude the runs into resort can suffer from lack of snow and are often rock hard ice. They do have good snow making capabilities but as we all know its no replacement for the real thing. Meribel can be busy it's over priced and full of British skiers but has some great boarding.

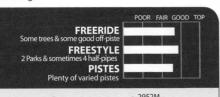

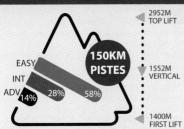

Office du Tourisme de Méribel - B.P. 1 73551 Méribel Cedex, France Tel :**TELEPHONE**: +33 04 79 08 60 01

WEB: www.meribel.net
EMAIL: accueil@meribel.net

WINTER PERIOD: mid Dec to mid April
LIFT PASSES
Meribel: Half-day 28 euros, Day pass 36.5, 6 Days 174 euros

3 Valleys: Half-day 34.5 euros, Day pass 43, 6 Days 215
HELIBOARD/GUIDES Héliski from 155 per person on the France/
Italy border. Tel/Fax 04 79 00 30 38. Guides available for 320 euros for

BOARD SCHOOL Around 150 euros for 5 days of 3hr HIRE Board & Boots 120-170 euros a week.

TOTAL PISTES/TRAILS: 74 LONGEST TRAIL: 4km

TOTAL LIFTS: 53 - 16 Gondolas, 18 chairs, 17 drags

ANNUAL SNOWFALL: 5m SNOWMAKING: 28% of pistes

CAR From Lyon, go south via A432, A43 to Albertville, RN90 to Moûtiers and then D90, 18km to Meribel. 200km total

FLY to Lyon 185km, Geneva 135km. Nearest airport is in Chambéry 95km away.

TRAIN services go to Moutiers which is 20 minutes away, 18km away.

BUS Alp-ski bus from Geneva takes 3hrs Tel: 04 5043 6002, 111 euros
return. Satobus from Lyon takes 2 1/2hrs and costs 86 euros return.

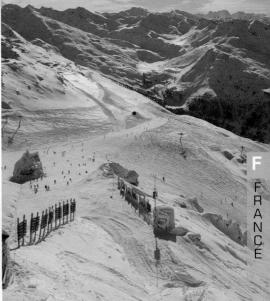

FREERIDERS have a massive area to explore with well maintained pistes and lots of powder faces. From the **Saulire** are some long reds down to **Mottaret** which it turn will allow you to gain access to the **Mont Vallon** area the highest point in the Meribel Valley. Under the Plan de Homme chair are some well spaced trees with an easy pitch but a lot of rocks. Get off the Olympic Express chair and keep going straight and you drop into a 845 meter decent towards St Martin de Belleville, keep left as you may run out of snow early or late season. A short walk between two peaks off the Mont Vallon bubble will lead you to a huge bowl with some big drop offs, take care avalanche is a real possibility here. If you do leave the valley don't miss the last lift home as taxis are ridiculously expensive.

FREESTYLERS have a good fun park which is reached by the Plattieres bubble get of at the second stage. There are 2 pipes one of which was used one year for the British championships, following the pipe are a number of graded hits which could do with steeper and longer run outs but are fine. Serviced by the Arpasson chair is the Moonpark (www.moonparc.net) which has a

good wide Pipe, and a new boardercross. A pass just for the Moonpark are available at 50euros for 3 days which don't have to be consecutive.

PISTES. On the piste there's some really sweet runs. The pistes are not

Coach & Air packages to Chamonix & the 3 Valleys

www.boardbreaks.com

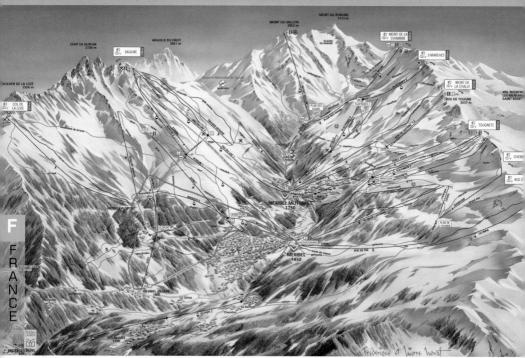

as well maintained as in Courchevel but are plentiful and wide. Meribel has red runs with a vertical drop of almost 1300m if you cant find somewhere to crank it over on a run that long give up.

BEGINNERS have lots of opportunities to master those linked turns around the Altiport area, although some of the lifts are very old and slow. If heading for the Mont Vallon area be prepared for some flat spots on the way home.

THE TOWN

Meribel is tainted by the Brit's, the bars have imaginative names like Le Pub. It's a big spread out resort as they sensibly won't allow high rise developments so

its grown out rather than up. The two main streets are full of bad clothes shops, board/ski hire, bars and restaurants. On the slopes away from the board you can take a tandem paraglide or ride a snow-mobile. Just up from Meribel is the village of Mottaret which is more of a purpose built village but is better placed for access to Mont Vallon the main fun park and Val Thorens.

Meribel is package deal central, and as such the bars are full of pissed Brit's in silly hats waiting for dinner, or chalet dinner. Before the days

board is over you can sink a few in the lively Rond Point. The Pub has pool and a few tv's, opposite is La Taverne which is often mobbed and of course where there's Brit's there's a Dicks Tea Bar. All the bars are way over priced so if you are in a chalet ask them to chill the red wine so you don't have to hold your nose to get it down your throat.

All the big tour operators come here. You should be able to get a deal as there's chalet after chalet to choose from. Don't stay in Brides-les-Bains however cheap it is (see trio vallees)

Tex-mex, pizza and burgers to be had in the pubs. As for the restaurants The Tremplins good and if you want it there's a Michelin star at the Cassiopee.

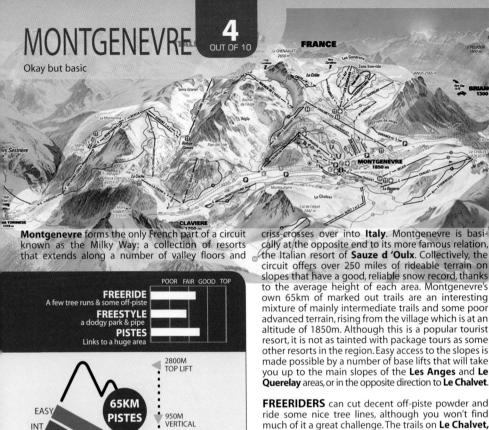

1850M TOURISM OFFICE, Route d'Italie

05100 MONTGENEVRE Tel: TELEPHONE: +33 (0)4.92.21.52.52

WEB: www.montgenevre.com

EMAIL: office.tourisme.montgenevre@wanadoo.fr

WINTER PERIOD: early Dec to end April LIFT PASSES

Just local area. Day pass 24 euros Montgenevre/La Lune, Day pass 26.5, 6 days 126 euros

HELIBOARD/GUIDES Ecole du Ski Français run Heliski trips that leave from Montgenèvre and head for Italy and the Dormillouse, Terra Nera and Clausi peaks

BOARD SCHOOL Private lesson 35 euros per hour visit www.a-peak.

TOTAL PISTES/TRAILS: 60 LONGEST TRAIL: 7km

TOTAL LIFTS: 38 - 2 gondolas, 16 chairs, 19 t-bars/tows, 1 magic carpet

ANNUAL SNOWFALL: unknown **SNOWMAKING: 28% of pistes**

CAR From Turin head west along the A21 and the E70, turning off at signs for Oulx and precede down the B24 to Montgenevre.

FLY to Turin in Italy which is 1 hour away.

Grenoble is 145km away

TRAIN services are possible all the way to Briancon, which is a 20 minutes transfer (12km) or taxi 06 0706 7998

cally at the opposite end to its more famous relation, the Italian resort of Sauze d 'Oulx. Collectively, the circuit offers over 250 miles of rideable terrain on slopes that have a good, reliable snow record, thanks to the average height of each area. Montgenevre's own 65km of marked out trails are an interesting mixture of mainly intermediate trails and some poor advanced terrain, rising from the village which is at an altitude of 1850m. Although this is a popular tourist resort, it is not as tainted with package tours as some other resorts in the region. Easy access to the slopes is made possible by a number of base lifts that will take you up to the main slopes of the Les Anges and Le Querelay areas, or in the opposite direction to Le Chalvet.

FREERIDERS can cut decent off-piste powder and ride some nice tree lines, although you won't find much of it a great challenge. The trails on Le Chalvet, located in what tends to be the quietest area to ride, give access to some cool freeride terrain and has a nice big powder bowl. There are some good value heliboarding options that drop you in nearby Italy once you've exhausted everything locally.

FREESTYLERS are presented with what they call a fun-park, but in truth it is a dire pipe, with only a few man-made hits. The best options for air are to seek out the natural terrain features.

PISTES. You'll find some good carving trails on Les Anges and Le Querelay, which are both popular and easy. The two blacks down the Pian del Sole en route to the village of Claviere, are a little more interesting and worth a blast.

BEGINNERS are well catered for here, with a host of easy trails that can be reached without needing to ride a drag lift. Fast learners will soon be able to ride from the summit of Les Anges to the base, via a mixture of blue and green trails.

THE TOWN. Services are based conveniently for the slopes with a mixture of apartment blocks, chalets, shops, sporting facilities and restaurants, styled in a sober manner but aimed at the package tour ski groups. The village is okay, although there isn't a great deal to get excited about. Lodging is very affordable. Evenings can be very lively, with a number of bars that have young crowds partying every night all night.

MORZINE

Low, lively & part of the huge Portes du Soleil

Morzine is a long established Alpine town witch is surrounded by tall mountains on all sides. Morzine is directly below the popular resort of **Avoriaz**. Unlike many purpose built French resorts it still holds an alpine charm, unlike Avoriaz. Its location at 1,000 metres (3,300 feet) can turn snow to rain fairly quickly, so temperature is crucial to this resort. With a good snow fall, however, Morzine and the nearby resort of Les Gets, can suffice for the snowboarder. The terrain varies from the long, tree lined, wide slopes of Morzine, to a board park in Les Gets, to the more challenging slopes of Mont Cherry and Chammossiere.

FREERIDERS. These mountains can be less busy than the slopes on the Avoriaz and Swiss side. Hence, beginners and intermediates will find more room to get the confidence up before heading for the Portes du soleil more challenging areas. There are plenty of tree-lined slopes, and many gentle pistes. Most riders particularly advanced riders will find they head up to the slopes above Avoriaz.

FREESTYLERS. Off the main chair in Morzine there is a small park with beginner level jumps and a rail or two. There is another beginner to intermediate park located at the top of Super Morzine Gondola and chair. It features a row of 5-7m kickers which are great for learning on. There is also a beginner box and an easy rail. There is a short drag lift that services this park so it's ideal for getting lots of runs in without having to take long chair lift rides.

THE PISTES are well maintained but a little dull. Fine for beginners and intermediates but advanced riders will soon be looking outside of the immediate Morzine area.

BEGINNERS will be glad to hear that it's mainly chair lifts on these slopes, so the dreaded poma or t-bars don't have to be tackled. The green slopes will be too flat for the snowboarder, but there are some easy blues and reds in Morzine for the beginner. The Pleney slope, which heads back to the town, is a steep red.

OFF THE SLOPES For those who need to take a break from the slopes there is plenty of shopping available in the town ranging from equipment to fashion. There is a swimming pool, bowling alley, pool tables, cinema, ice skating and ice hockey games.

Accommodation. There is plenty of accommodation in Morzine in every price bracket. Chalet Nanteque offer dorms with communal breakfast, tv rooms etc. They regularly have backyard jams in the garden with small rails, a quarter pipe and a bbg. This place is wicked for those on a budget. Chill Chalet & Rude Chalets also offer good value and quality. The Farmhouse Hotel inside the oldest building in Morzine offer fine dining, roll top baths and four poster beds.

Food. Providing you are not allergic to cheese, Morzine has plenty of restaurants at reasonable prices. The Panini hut in the centre of town offers a variety of snacks and is an ideal stop on the way home. L'Etal is a very reasonably

priced restaurant also in the centre, with a sun terrace for daytime dining and a cosy atmosphere inside in the evening.

Nightlife. The town has a good selection of bars with everything on offer. The Dixie Bar is good to go and watch the football & open until 2am. The Cavern is another central bar, which also has a mainly English cliental. It's open until 2am and there's live music or DJs most nights. A trendy hangout is the new English run bar and hotel 'The Ridge' just outside the centre, For a quieter option chill in the low lit Buddha Bar. The Opera is located just next door so if things liven up there is a big dance floor and a dancers cage! It's open until 4am . The *Paradis* is also open until 4am and takes you straight back to the 80's with it's red and black tiger striped couches and disco balls.

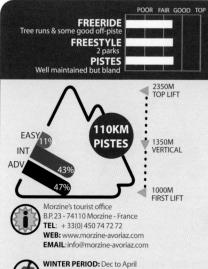

1/2 Day Pass 20.20 euros, Day 26.8 euros, 6 Day Pass - 134.4 Portes du Soleil: Day 37,6 days 179

BOARD SCHOOLS ESPA charge 40 euros for 2hrs lesson, 6x2hrs 115 euros. Visit www.morzineski.fr

NIGHT BOARDING On Boule de Gomme & Stade slopes

NUMBER PISTES/TRAILS: 66 LONGEST RUN: 6km

TOTAL LIFTS: 48 - 2 funiculars, 3 cable-cars, 22 chairs, 18 drags

ANNUAL SNOWFALL: 9m **SNOWMAKING:**some

CAR Head towards Cluses (A40), 35 km from Morzine FLY to Geneva 1 hour away, 80km

TRAIN Stations of Cluses (35km away) or Thonon-les-Bains - Daily TGV links with Cluses, Saturday and Sunday with Thonon

BUS SAT buses go from the airport to Morzine and take about 2 and 1/2 hours, Tel: 0033 (0) 450 791569

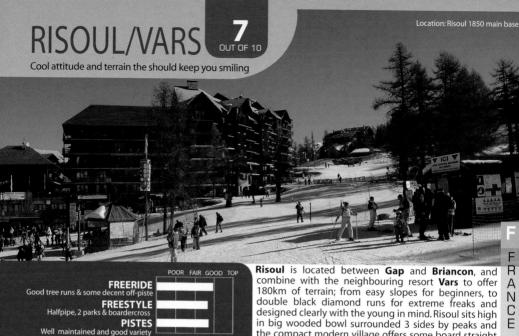

2750M TOPLIFT 80KM 1100M VERTICAL 1650M FIRST LIFT

Risoul TOURISM OFFICE, 05600 Risoul 1850

TEL:: 04 92 46 02 60 Vars Tourist Office, 5560 VARS

TEL: ++04 92 46 51 31 **AVALANCHE: 08 9268 1020**

WEB: www.risoul.com / www.vars-ski.com EMAIL: infol@risoul.com

WINTER PERIOD: early Dec to end April LIFT PASSES Half-day 22 euros Day just SURFLAND terrain park 22 euros

Full Day pass 27.50 euros, 6 Days pass 143.5 euros BOARD SCHOOLS ESI run a 6 day snowboard school HIRE Board & Boots 120 euros for 6 days NIGHT BOARDING Yes & pipe is somtimes lit

NUMBER OF RUNS: 104 LONGEST RUN: 8km

TOTAL LIFTS: 53 - 1 Gondola, 13 chairs, 41 drags CAPACITY (PEOPLE/HOUR): 53.000

LIFT TIMES: 8.30am to 4.30pm Mountain Cafes: 5

ANNUAL SNOWFALL: unknown **SNOWMAKING:** 50% of slopes

TRAIN to Montdauphin, 20 minutes away. (15km) CAR From Grenoble take the N85 to Gap then Briançon. Take the RN94 to Guillestre FLY to Grenoble, 2 1/4 hours transfer time or Turin

TAXI tel: 04 9245 2202 or 04 9245 2210

the compact modern village offers some board straight to your door opportunities. The lifts fan out in all directions from the base and most runs end back to the same point making this one of the easiest resorts to navigate around. The lower slopes cut through a larch tree forest, and off the slopes the trees are nicely spaced out affording some good tree shredding. Higher up the trees clear and that's where you'll find the big wide slopes and big open powder fields. From the top of Razi peak you can board into the resort of Vars, which is included in your lift pass. Vars offers a different experience with very few trees on its main slopes which again funnel down to the main village of Vars les Claux.

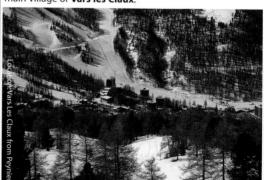

FREERIDERS tend to show up here around New Year in search of decent terrain, which they can find on Pic de Razis, Melezet and Plate De La Nonne, or Pic De La Mayt. Ride in these big powder bowl areas, and you can forget about sex being the best thing in the world. There's a fun circuit you can do by taking the Valon run from the top of Razis down to neighbouring Vars Sainte Marie, walking up to the Peynier t-bar (which is French for nut crusher) and then from the top of Peynier, more tree shredding into Vars Les Claux.

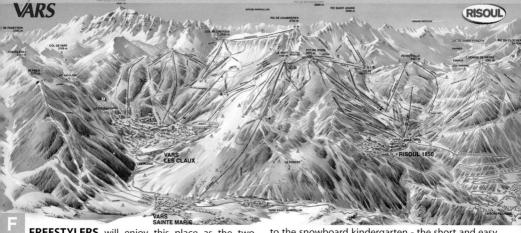

FREESTYLERS will enjoy this place as the two resorts between them offer something for all styles and abilities. In Risoul take the De Cezier chair to reach **Surfland**. Depending on the conditions you should find a quarter-pipe, small practice kickers, and some rails but more importantly you'll find the 140m long, 20m wide half-pipe, and this bad boys' earth formed so there's no excuse if it's not open. There's also sometimes a few rails towards the bottom the Melezet t-bars. Over in Vars head over to the Crevoux area, where you'll find a good boardercross that holds FIS events and a pro-line of huge kickers. In the same area there are usually some rails and boxes and maybe a few smaller kickers depending on the conditions. Away from the park there are plenty of places to launch skyward.

PISTES. Both resorts are impeccably groomed and offer some genuine diverse terrain to tackle. The runs from the top of the **Razis** into Risoul are great for speed freaks, and then narrow and twist and turn through the undulating forest offering a different challenge. The runs from the top of Peyrefolle and L'homme de Pierre follow a similar if less extreme fashion. In Vars its mainly wide open cruising runs.

BEGINNERS can take the bizarre cabin lift, **Accueil**,

to the snowboard kindergarten - the short and easy run is perfect for your first try on a board, but you'll soon want to explore, so take the **Clos Du Vallon** chair to find the best easy runs. There are a few t-bars around but you can navigate without having to ever use one, and none of the lifts have any scary offload slopes so it's very much a resort that you'll find comfortable finding your first turns.

OFF THE SLOPES. Risoul is a small village where the inhabitants still treat you as a guest and everything is within easy walking distance. The resort caters mainly for the French, and unlike a lot of French resorts, English isn't widely spoken. The majority of the accommodation is self catering apartments and there are only a few hotels. The Saturday change over day can be a nightmare with huge queues of people trying to pick up their keys and huge queues of people gridlocked in their cars as they try and get out of the one way system. In Vars there's none of these issues and plenty of Hotels and chalets. In Risoul there's a good variety of places to eat and Snack Attack do good takeaways and it's a similar same story in Vars but they have a lot more on takeaway front. Nightlife doesn't kick off till after 10pm but there's enough good places to get wasted in and of course they each have a Grotte du Yetti bar.

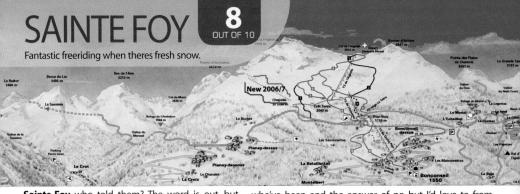

Sainte-Fov who told them? The word is out, but there's still time. Ten years ago if you asked someone about Sainte-Foy a blank look would greet you. If you'd driven there you would've missed it, if it hadn't of been for the fact the road ended. The home of mushroom loving David Vincent has changed, ask now and a gleam will light up the eyes of those

POOR FAIR GOOD TOP

who've been and the answer of no but I'd love to from those unlucky others. Towards Val d'Isere and Tignes from Bourg St Maurice there's a small turning to the left. Up it's 8km of once potholed tarmac lies the hamlet of Saint Foy. Not a place to spend a weeks holiday but if you're nearby, have use of a car and it's just dumped GO. This place with good snow has a hallucinatory feel, you won't be asking your mates to pinch you, you're going to need a twat round the head with their board to believe what you're seeing. A boarders dream, but who knows for how much longer? The road in is smooth, the building of chalets is changing the vibe from ramshackle farm house to modern resort. Gone are the days of being greeted by goats looking at you from their barns, lets hope they leave the slopes alone.

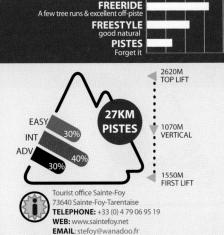

FREERIDERS, its what snowboards were invented for. There are basically 3 slow lifts, they run one after the other to take you from 1550m to the Col de L'Aiguille at 2612m. From here you have a myriad of choices but be careful each brow you come over leads to another untouched field and the next thing you know your ollieing your way over fences and the bottom lift will be a hitch hike away. On the way up you can look for the line you want to take. Be it wide open face, rock shoots or into the trees this place is a wide open mountain with only a few runs winding their way down under the lifts. If you can handle a walk and a long flattish path then you can drop down over the back side of **Rocher** d'Arbine. WARNING to get the best of this place get a guide; not just to show you the way, but to advise about safe routes and snow conditions.

FREESTYLERS need to discover how to seek out natural hits, since that's all you're going to get - but that's all you're going to need! Why bother making pipes in a natural heaven - they're better left to the tourist traps. Riding will never be as free or as natural as in this place. There's loads of drop offs and plenty of banked walls just waiting to be hit, but novice air heads must take care and ride only with a competent rider who can pre-spot for you, as who knows what may lie under that

WINTER PERIOD: Dec to April

LIFT PASSES

Half-day 16 euros, Day pass 19,6 Days 105, Season 330 HIRE 2 small shops best to take your own

ESF run off-piste groups to Le Monal, Les Pigettes, Fogliettaz. Visit www.esf-saintefoy.com tel: +33 (0)4 79 06 96 76

GUIDES Off-piste guide Jean-Noël Gaidet tel: +33 (0)6 14 62 90 24

TOTAL PISTES/TRAILS: 8

LONGEST TRAIL: 7km TOTAL LIFTS: 6-3 chairs, 2 t-bars/tows

TRAIN Euro star, snow train and tgv go to Bourg-St-Maurice, 20 minutes away.

CAR Via Bourg-St-Maurice, take the N90 direction Tignes/Val d'Isere for saint -Foy.

FLY to Geneva, 2 1/2 hours transfer time. Same from Lyon. BUS Ski bus from Sainte-Foy to resort, and local bus runs from Bourg-Saint-Maurice to Sainte-Foy

TAXI +33 (0)6 07 41 11 53

NEW FOR 2006/7: Marquises chair creating 2 new pistes and easier access to some off-piste. They've also bought a shaper so expect a small park

BEGINNERS have some fine rolling runs under the first 2 chairs and won't have the crowds of bigger resorts to contend, and cheaper lift passes.

flat blanket of soft looking snow.

OFF THE SLOPES On the slopes are some great little mountain restaurants, off the slopes, you will find a resort with little to offer. There are chalets, but they are spread out with no connections to night-life or eateries. But then, if you stay here it's for the riding not for anything else. Nightlife is a beer in the British run pub or a glass of wine in your chalet. Sainte-Foy is small and let's hope it stays that way.

USQ www.worldsnowboardguide.com 155

The main village of Saint Lary lies at 630 metres in the Aure Valley; above here there are two small villages, Saint Lary La Cabane at 1,600 metres, and Saint Lary Pla D'Adret at 1,700 metres. All three are connected by a series of lifts, with the upper villages reachable by road, or from Saint Lary by the cable car which takes you to the slopes. This relatively small resort lies in the French Pyranees and goes back to the 1950's. If you think that French ski resorts are massive purpose-built shams, this place will make you think again. What you get is a resort that is very snowboard-friendly, with good terrain that can be tackled by novices and riders with only a few days under their belts. However, this is also a popular resort which results in a number of long lift queues, especially at weekends.

FREERIDERS looking for vast powder bowls are not going to get them here. Advanced and hardcore riders wanting major long steeps are going to find this place a bit easy without too many challenges. The cluster of black runs off the **Tortes chair** offers some opportunities for freeriders to excel on fairly featureless terrain. Alternatively, the area known as **Bassia** is pretty cool, and will suit riders looking for trees to shred.

FREESTYLERS will find the Quicksilver Snowpark interesting, with its long boardercross circuit, an improved pipe, and a series of decent hits. The parks split into 3 definite areas the family park, which is great for beginners the slide park which is full of rails and the snowskatepark which is a slope style run

PISTES. Riders looking for fast, wide piste to lay out big turns on will find the few reds that are basic but okay. They should also provide novices who are getting to grips with steeper terrain some early learning opportunities

BEGINNERS will certainly find the easy blues spread out across the resort perfect for learning, with a mixture of chair lifts and drags to ferry you around. The short easy stuff reached from Saint Lary Pla **D'Adret** will sort you out, before taking the runs over on Vallon Du Portet. The **Corniche** is a long, easy blue that freeriding novices will soon be able to handle.

OFF THE SLOPES An old Pyrenean village, St Lary is laid out along a main street where you'll find chalets and hotels. Services are extremely good here, without 156 way www.worldsnowboardguide.com

the hustle and bustle of tourist traps. Although somewhat limited, most facilities are found in Saint Lary, rather than the other two villages. Eating and night-time hangouts are okay: quiet and tame, and inexpensive.

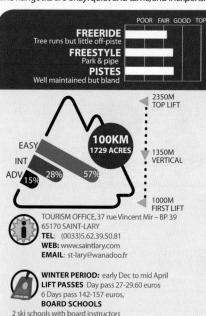

NUMBER PISTES/TRAILS: 53

HIRE hire shops at all elevations

LONGEST RUN: 3.6km
TOTAL LIFTS: 32 - 2 cable-cars, 9 chairs, 22 drags
CAPACITY (PEOPLE/HOUR): 25,000

LIFT TIMES: 8.30am to 4.30pm MOUNTAIN CAFES: 3

ANNUAL SNOWFALL: unknown SNOWMAKING: 10% of pistes

TRAIN to Lannemezan, 20 minutes transfer. CAR Via Tarbes, head south on the D935 and D929 towards the Spannish Border to Reach St Lary. FLY to Tarbes airport in Spain 2 hours away.

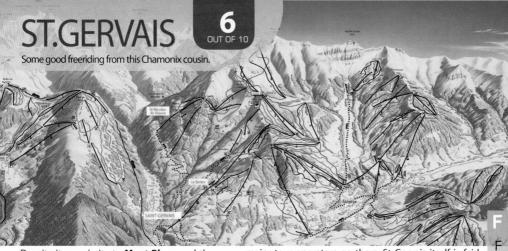

Despite its proximity to Mont Blanc and the ever popular Chamonix, St Gervais is not a very well known resort, probably due to the fact that no major tour operators go there. St Gervais itself is fairly small, but the lift pass (Evasion Mont-Blanc) covers 6 ski areas comprising of over 450km of slopes and some easily accessible off piste areas. It is also one of the areas covered on the Ski Pass Mont Blanc which allows access to the whole of the Mont Blanc region, (12 areas).

POOR FAIR GOOD TOP FREERIDE A few tree runs & some good off-piste **PISTES** Some good wide slopes

2353M **30KM** 1543M VERTICAL 810M FIRST LIFT

Tourist office St Gervais 115 av. du Mont-Paccard. F-74170 St Gervais

TELEPHONE: +33 (0) 450 47 76 08 WEB: www.st-gervais.net EMAIL: welcome@st-gervais.net

WINTER PERIOD: mid Dec to mid April LIFT PASSES

Local area: Half-day 24 euros, Full Day 30.50 EVASION MONT-BLANC (445km slopes)

1 Day pass -33 euros, 6 Days 159

HELIBOARDING On the Glacier of Trient / Pigne d'Arolla / Ruitor / Mont Rose. From 150 euros per /person

GUIDES COMPAGNIE DES GUIDES Tel: +33 (0)4 50 47 76 55 GUIDES DES CIMES +33 (0)4 50 93 52 29

TOTAL PISTES/TRAILS: 71 LONGEST TRAIL: 7km

TOTAL LIFTS: 36 - 2 Gondolas, 13 chairs, 20 drags, 1 tram

ANNUAL SNOWFALL: unknown **SNOWMAKING**: 20 snow cannons

TRAIN services are possible all the way to Le Fayet, just 2 minutes away

TAXI Tel: 04 5047 1753

FLY to Geneva airport 50 minutes away.

BUS SAT Bus from Geneva airport daily, tel: +33 (0)4 5078 0533 CAR Via Paris, take the A6 to Macon then take the A40 to St Gervais. **FREERIDERS** should check out the huge wide open bowls at Les Contamines, where there is varied off piste riding almost everywhere you look. It's best when visibility and snow are good though, as if it is cloudy you will just get frustrated that you are missing all the best lines and hitting all the hidden cat-tracks. Mont-Joy has some good steep off-piste riding. It is possible to ride right down to Les Contamines, but taking a guide to avoid accidental cliff drops is highly recommended.

FREESTYLERS have a fun park at Mont Joux, although it is not very impressive and seems to be rather neglected, particularly the halfpipe. The few jumps range from a small table top to a 30ft gap jump. It also gets very busy at times, especially weekends.

PISTES. Riders will find plenty of wide pistes, although some of them do tend to get chopped up by the end of the day. There are slalom courses at Mont Joux and across Megeve at Rochebrune.

BEGINNERS can save money by getting a lift pass for just the **Bettex** area, which has a few nursery slopes, including one chairlift. However, the slopes on the other side of the mountain tend to get more sun and are less icy. The areas around the Mont d'Arbois and Ideal lifts are recommended as there are a variety of easy runs as well as some easily reached harder ones for when you start feeling brave. The low points for beginners are the flat bits on the runs back down to Bettex.

OFF THE SLOPES

Local services are good and include ice skating, ice climbing, a cinema, loads of shops and a large number of restaurants. Around the mountain there is a good choice of accommodation in St. Gervais, with over 30 hotels, chalets, lodges and apartments. A lot of these are located below the St. Gervais-Bettex gondola, so theoretically you can ride to your door, snow permitting. Night life, however, is tame and limited to one club which is crap, plays dull French music and is expensive.

Great tree riding & one of France's best resorts

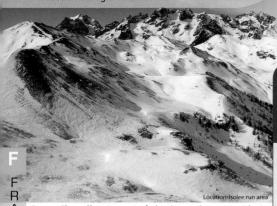

Serre Chevalier is one of the best places to ride in France. This great resort has heaps of major terrain, tight, open trees to weave, extreme drop offs to get the adrenaline going, big bowls, countless banks and gullies, super-fast flats to push the hair back, hits everywhere, and a giant, natural fun-park - all located next to a few unassuming, old-fashioned French villages (with a hint of the new here and there). As one local rider once put it 'who needs fun-parks, when this place is a complete funpark at every level and distinction!' It's not the highest resort in the world, so snow cover can sometimes suffer but things are usually pretty dam fine. The boarding area runs along the Le Grand Serre Chevalier range with the large town of **Briancon** at one end and the old village of **Le Monetier** at the other end. In between the villages of Chantemerle and Villeneuve provide the most convenient access to the slopes and are the most popular with holiday makers. The slopes around Briancon get a huge amount of sunshine but don't get the snow cover of the other areas. Chantemerle and Villeneuve areas are the most popular and extensive areas, but you can always find some untracked spots in the less popular Le Monetier. The resort was purchased a couple of years ago by the Compagnie des Alpes who own Tignes, Saasfee, Chamonix amongst others and a lot of cash is set to be invested over the next 5 years to improve the already good lift system. Once you've shredded all the trees you can head to La Grave in 30 minutes and Montgenevre isn't far from Briancon.

FREERIDERS get to shred plenty of open, tight trees, gullies and deep bowls, as well as some long steeps, where advanced riders can busy themselves for weeks on end. Serre Chevalier is perfect soft boot territory, and those riders wanting wide expanses of powder without having to hike, should check out the stuff off the Balme chair lift. When it's open the L'Eychauda t-bar is the place to head for with plenty of powder spots off the Isolee black run and some huge cliffs. In Le Monetier there's some challenging terrain under the Yret chair that you can access off the Col du Vent black but watch for slides.

FREESTYLERS should basically session the whole mountain as there are too many hits to mention - it will take most riders at least a season to hit each jump only 158 USQ www.worldsnowboardguide.com

once. The place is a super-big, natural funpark, with lots of logs to grind, and loads of big jumps everywhere. There's a terrain park and icy half-pipe located in Villeneuve, the halfpipe is located at the foot of the mountain on the Mickey run and above the Yeti bar. The terrain park is squeezed in to the plateau de la Rouge, but has been move higher and expanded for the 2006/7 season. They've earth shaped the big booters and the basic layout for the boardercross, so you can expect a perma-

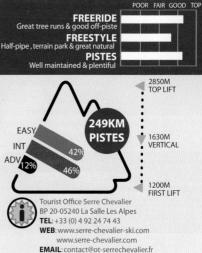

WINTER PERIOD: mid Dec to end April LIFT PASSES Grand Serre Che linked area:

1 Day 38 euros, 6 Days 173

Just Serre Chevalier: 1 Day 34 euros, 6 days 153 NIGHT BOARDING In Briancon from 7:30-10:30pm the Vauban run is open thursdays & fridays. 10 euros/free for Grand Serre Passes. The Mickey run & halfpipe in Villeneuve is open 5-9pm tues & fri BOARD SCHOOL A number of board schools. Private lessons from 31 euros an hour. Group 4hrs for 6 days 102 euros.

HIRE Krakatoa in Briançon are good & Outland in Chantemerle GUIDES: 33 (0)4 9224 7590 Full day 260 euros

NUMBER OF RUNS: 115 LONGEST RUN: 10km

TOTAL LIFTS: 68 - 3 cable-cars, 6 Gondolas, 20 chairs,

39 drags

CAPACITY (PEOPLE/HOUR): 68,000 LIFT TIMES: 8.30am to 4.30pm

ANNUAL SNOWFALL: 6m SNOWMAKING: 18% of slopes

CAR From Grenoble, Lyon or Paris take Motorway A51, exit Pont de Claix at 80 km from the resort via Lautaret Pass. Or drive via Alpe D'Huez & La Grave

FLY to Lyon (200km) airport 3 hour transfer. Nearest airport is Turin (108km), Marseille (250km) has a free bus saturdays 2pm to the resort

TRAIN The nearest train station is in Briancon, 10 minutes away. Daily night trains from Paris gare Austerlitz to Briancon dep 10.05pm arr 8.37am

BUS available from Lyon airport. Shuttles run from Briancon train station to Serre Chev every 20mins from 8.30-6 pm TAXI (SC1350) - Tel: 06 0932 2281, (SC1400) Tel: 06 8782 2121

NEW FOR 06/07 SEASON: new boardercross course and expanded terrain park. Main features of both are earth formed and should be available all season

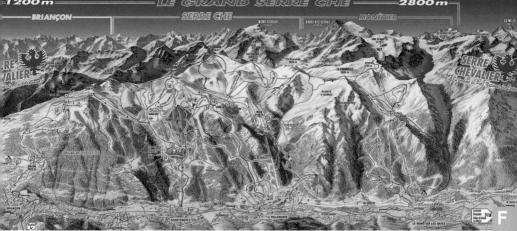

nent intermediate and pro-line of kickers running alongside the **Grand Serre chairlift** and they'll be adding the beginner jumps and rails depending on conditions.

PISTES. Riders are presented with as much alpine terrain as they could possibly need. There's plenty of top to bottom runs that can be taken a mach-1 speed. The black **Olympique** trail that runs to the base of Chantemerle is a full-on eye waterer when taken at speed.

BEGINNERS should find the runs around **Frejus** more suited to their needs, with a number of long, easy runs that bring you back down the mountain into the village of Villeneuve, via some tree-lined trails. Serre Chevalier has some super fast drag lifts, often travelling a long way at speeds more suited to riding down, not up. Watch out for the sharp turns that some of the drag lifts make through the trees. If you can master Serre Chevalier's drag lifts, you shouldn't have any trouble in the rest of the world although there are plans to slowly remove them and they can easily be avoided.

OFF THE SLOPES. Serre Chevalier provides a number of options for lodging and other local services. These are situated along a stretched-out valley road, set back from the base lifts. Briancon is the largest place to stay, but is not so convenient for the main slopes and is the first area to suffer in poor conditions. Chantemerle and Villeneuve (a few miles apart, linked on the slopes and by road), offer the best facilities nearer the slopes, and Le Monetier Les Bains is a beautiful old village but dead in the evenings.

ACCOMMODATION: 30,000 visitors can be bedded around here. The choices range from a bunk house and modern apartment blocks for groups on the

cheap, to classy hotels but a lot of the accommodation needs a good lick of paint.

FOOD. Your dietary needs are well sorted here, with a vast selection of restaurants and fast-food outlets to choose from, including a number of creperies. In Chantemerle, Le Petit Chalet serves top food but at a top price but there's a few cafes that serve good value pizzas. The Grotte Du Yeti in Villeneuve will serve you French delicacies like egg & chips, Le Bidule is highly recommened for fish lovers, and Nocthambule and Le Refuge are pretty decent.

NIGHT-LIFE is not exactly kicking but things do pick up later on in the evening. In Chantemerle the *x-treme* bar is the place to head for but not until after 10pm, and the *Karaoke* clubs stays open till the early hours. The Irish bar in the mall is good for an après beer, *Kitzbuel Café* only good for a pizza, but there is a cool lounge bar in the old town. In Villeneuve most people head to the *Grotte Du Yeti* (little England), *Le Frog* is okay, then it's on to *Le Bam Bam* nightclub. Le Monetier is very quiet but the *Alpin bar* is probably the pick.

WS9 www.worldsnowboardguide.com 159

TIGNES

Snow sure, true boarders moonscape

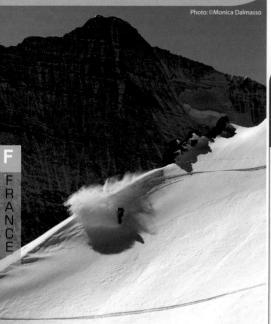

Tignes is very snowboard friendly; long before the other French resorts welcomed snowboarders, Tignes opened it's arms wide and said come here and slide down that, jump over that, and listen to this while your at it. If Carlsberg made snowboard resorts they would have made Tignes. Set at 2100 meters and part of the 290km of pistes that is the **Espace Killy**, it has a very good snow record, a glacier, a lake and a lot of varying terrain; Tignes can almost guarantee everyone leaves satisfied. You drive up to the resort on the same road towards Val D'Isere from Bourg Saint Maurice accessible by euro star and the snow train. A painting of Hercules holding back the water greets you as you cross over the high dam, and as you pass a church on your right you can see Jesus, who has freed his arms from the crucifix pointing towards the old submerged village, eerie man eerie. Tignes is one of the major resorts in France, and has long been hosting national and international events, their web site even has a Japanese translation. BASI runs some of it's snowboard instructors courses here. Snowboard teams and manufacturers also use Tignes to host training camps and events. The main lifts open early September and close late May and with summer boarding on the Grande Motte Glacier from mid June

to September you can almost board every day of the year. This year they even had a summer fun park. If you are up for it you can dive under the ice of Tignes-Le-Lac and look up at the ice distorted mountains.

FREERIDERS have loads of choice, there are some really long off piste runs some great reds and blacks and the wide Grande Motte Glacier. If you are lucky with the snow there's the 1200 meter decent from Aiguille Percee to Tignes Les Brevieres on a

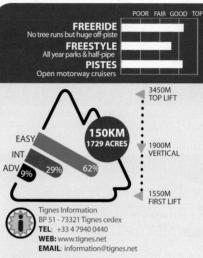

AUTUM PERIOD: early Oct to end Nov WINTER PERIOD: end Nov to May **SUMMER PERIOD:** June Nov to Sept

LIFT PASSES Autumn day pass 33 euros Espace Killy: 1 day pass 40,6 days 192.5

Tignes only: Half-day 26, day 34, 6 days 165 **BOARD SCHOOLS**

Huge (too many) number of ski & board schools in the resort HIRE loads of hire shops, all over priced. Board and boots start around 150 euros for 6 days.

HELIBOARDING

from nearby Italian resort; 2 drops Miravidi-Ruitor (3300 vertical drop) 225 euros. Contact Snocool.com, tel: 06 1534 5463

NUMBER OF RUNS: 67

LONGEST RUN: 6km

TOTAL LIFTS: 47 - 1 funicular, 1 cable-cars, 2 Gondolas, 24 chairs, 19 drags

LIFT TIMES: 8.30am to 4.30pm

ANNUAL SNOWFALL: 5m SNOWMAKING: 40% of slopes

CAR via Lyon to Tignes via Bourg St. Maurice, 102 miles (165 km). Drive time is about 2 hours. Watch out for the officious traffic wardens who will tow your car at any given opportunity.

FLY to Lyon or Geneva international, 2 1/2 hour transfer to resort. Local airport is Chambery.

TRAIN to Bourg-St-maurice, 30 min drive away

BUS services from Lyon airport, are available on a daily basis direct to Tignes. Ski bus runs 24hrs around the resort.

TAXI:+33(0)6 07 05 84 85

NEW FOR SEASON 2006/7: The 2 chair lifts at Palafour replaced with a 6-seater. Replacement of Bored Needle chairlift, new beginner lift at Boisses, snowmaking on Palafour.

2008/9: Replace Marsh & Tuffs chairlift with removable chairs. Snowmaking on Rhododendron and Cornflowers pistes.

160 USQ www.worldsnowboardguide.com

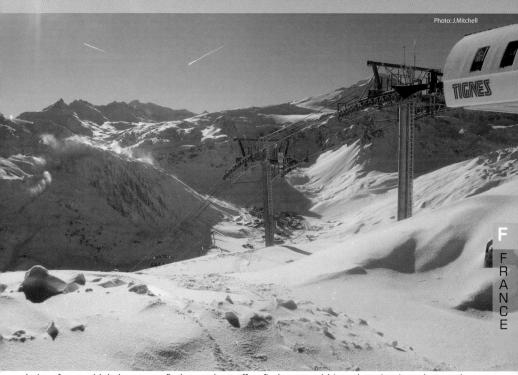

choice of runs, with help you can find a very long off piste route. To the sides of Les Lanches you can find good little rock shoots and bowls. Tignes is set in a wide open valley so you can see all the lines you'd love to take, it's just working out how to get to them. From the **Toviere** area there's some great spots of snow between the runs and two long blues into Val Claret. The Funiculaire and Cable Car take you to the Glacier at 3456 meters for more or less guaranteed good snow. From the top a choice of Reds and off piste routes await you, but watch out for crevasses. Always a good side trip is the Vallee Perdue in the Val D'Isere valley just make sure you have a espace killy lift pass and you make the last lift home. Take it easy in Tignes especially after a fresh dump, as it doesn't take much to trigger off avalanches and it's no fun stuck in an upside down world of blue light. If you want to go off piste take a guide, Snocool offer freeride and freestyle lessons. If you've got the cash and a group of four they'll drop you and a guide out of a Helicopter in Italy, 2 drops cost around 200 Euros.

FREESTYLERS will love the newly moved fun park which has two pipes some rails, a boardcross, and a number of hits ranging from spines to kickers and of course the grosse table pro, a big mother off a table top. There's always a bit of French hip-hop blasting from the bottom of the pipe and when the locals are there it realy goes off. Tignes has a very high standard of freestyle boarders, even the purest Freerider will be impressed, but don't be put off just get down there check out the small hits and move on up in size as your confidence improves. Don't go to the park and wipe out on a huge kicker probably chopping up the hit at the same time as putting an end to your holiday. If you've never jumped before build a small hit somewhere soft before hitting the park, or

find a natural hit and session it, and remember no silly hats ever they just aren't funny. The new park is next to the Les Lanches chair lift and walkable from Val Claret.

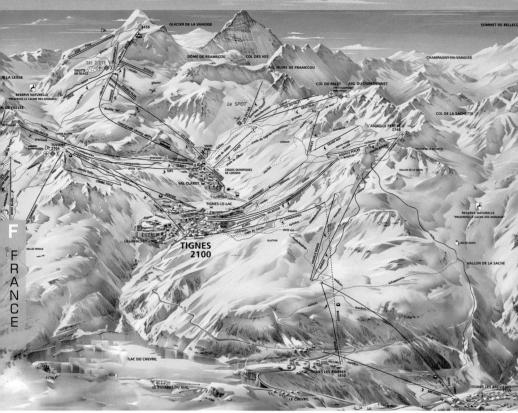

PISTES. Riders of all abilities are provided with slopes of all widths and pitch. The Grande Motte Glacier although sometime wind swept and cold is normally pisted flat. It's great for cranking it over at full speed it's long enough to give even the hardest boarder leg burn.

BEGINNERS have plenty of blue runs and loads of schools to choose from. Although not as good for the complete novice as Val D'Isere for someone on week 2 or 3 it's fine and you can always head out of the valley to ride the runs under the Marmottes chair. Kebra Surfing in Le Lac, which is Tignes oldest snowboard shop and school, and Surf Feeling in Val Claret offer a number of teaching programmes for freestyle or freeriding. It's around 150 euros for a weeks lesson.

OFF THE SLOPES. Tignes is a relatively ugly place it consists of two main areas Le Lac which is the main hub and Val Claret a split level town joined by a urine stinking lift, both joined by a free bus. Le Lac is strangely enough next to a lake which is normally frozen over. The areas mobbed with apartment blocks, hotels, and an array of bars, restaurants and shops all of which are expensive. At the head of the valley within an easy walk of the funicular is Val Claret smaller than Le Lac but of a similar ilk. It has better slope access and good parking next to the slopes, if you're on a day trip and has a few piste side cheep eats. Wherever you choose to stay, prices are much the same in both high. Tignes is an expensive resort whether you visit in winter, or come for summer snowboarding. Summer is actually a great time to visit as so much goes on, from snowboarding to water sports on the lake there's even a skate park.

ACCOMODATION. With over 28,000 visitor beds, this place has something for everyone, although there is not a wide selection of cheap accommodation. However, there are plenty of apartments for self-catering groups. The Tignes web site has a good listing of accommodation. Tour companies use this place big style, which means last minute package deals are always available at budget prices.

EATING. French food is full fat all butter croissants followed by melted cheese. If you're on a diet when you arrive, then this place will kill it dead and you'll go home fatter than ever. Every type of fast-food is available along with a large selection of restaurants serving expensive French dishes with heaps of garlic. None of it comes cheep so it's probably best to sort out catered accommodation before arriving.

NIGHTLIFE starts early and ends late - in fact, for some it never ends. This is a major party resort, with a wide choice of English and French bars, but you will never have enough funds to keep going in the bars or clubs as beer prices are shocking, at around 6 euros a pint. The best thing to do is tank up on supermarket carry-outs or the cheep plonk they give out with your chalet dinner. Minesweepers will be able to compare their pint nicking skills with some of the best in the industry. Le loop and the Angel bar in Le Lac are pretty good bars to get you started.

162 USQ WWW.WORLDSNOWBOARDGUIDE.COM

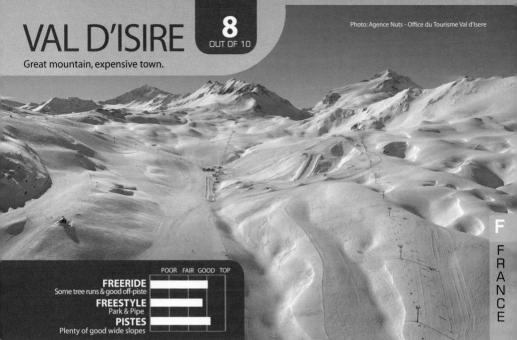

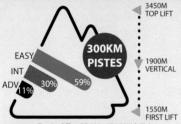

Tourist Office, BP 228 - 73 155 Val d'Isère
TELEPHONE: + 33 4 79 06 06 60
WEB: www.valdisere.com
EMAIL: info@valdesere.com

WINTER PERIOD: end Dec to early May SUMMER PERIOD: June to August LIFT PASSES

Half-day 30 euros, Day pass 41,6 days 197.5, Season 957 **HELIBOARDING** In Italy but can fly out of val d'isere

NUMBER OF RUNS: 140 LONGEST RUN: 5.5km

TOTAL LIFTS: 97 - 2 funiculars, 4 Gondolas, 4 cable-cars, 46 chairs, 41 drags

LIFT TIMES: 8.30am to 4.30pm

ANNUAL SNOWFALL: 6m SNOWMAKING: 15% of pistes

CAR From Lyon take the A43 to Albertville, then onto Moutiers, then the D902 to Bourg-St-Maurice continue to Tignes and then on to Val d'Isere. Total 220km FLY to Geneva (180km) 2 1/2 hours transfer time.

Chambéry nearest airport 130km away.

TRAIN TGV & Eurostar train services go to Bourg-St-Maurice, 40minutes away.

BUS Autocars Martin run a bus service from Bourg-St-Maurice to Val d'isire about 10 times a day and costs 11.70 euros. Tel: 04.7907.0449 www.autocars-martin.com.

TAXI:+33 4 7906 0250

Val d'Isere as a place to go snowboarding is amongst the best in France. However the most essential piece of kit you will need with you is your black Amex. It's got a great lift system a reliable snow depth and some fantastic riding with loads of off piste only a short hop from the lifts. They are trying a little harder to make snowboarders welcome holding events like The Big Day Out, and have built a snow park which is now much better than Tignes which together make up Espace Killy. The resort is set along one road starting with La Daille a few ugly blocks of flats that won a hat full of French architecture awards in the 70's. You may find you'll start or finish your day here as it's only a short free bus ride from the resort proper and home of the Funival funicular which will whip you to the top of the mountain faster than Bush could invade any oil producing state. The main village has been tastefully developed using a lot of the local stone. The main street is full of designer shops, restaurants and British bars, set back from the road are loads of hotels and chalets ranging from affordable to ridiculous.

FREERIDERS will want to come back again and again; there are miles of piste 200 in fact (inc Tignes) and more off piste than you'll be able to do in a week. There's terrain here for all, from motorways like Ok and Orange to the steep and tight of piste 5. After a dump it's an off piste playground with fresh tracks to be had all day on the les Marmottes face or try the Vallee Perdue which is a mad track only a few feet wide in places with blind bends and a couple of board off scrambles. In bad visibility head for the trees of Le Fornet. Warning you want to be on that flight home so follow resort advice on Avalanche risk and if your not sure don't do it. Worth mentioning are the guides who are excellent and very affordable between a group of 4 or 5. The better your ability the more you will get out of them.

FREESTYLERS can find endless natural hits. The fun

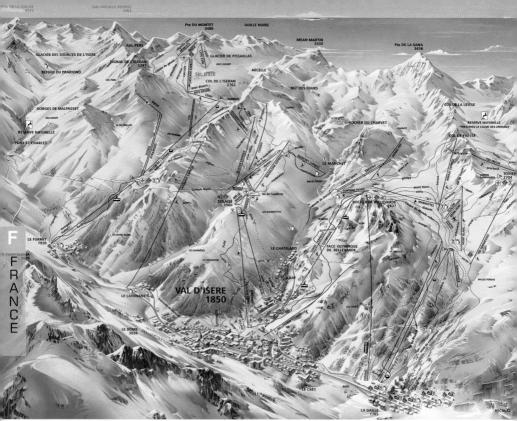

park under the **Mout Blanc chair** is smaller but now far superior to the one in Tigne, well worth a visit. Although there are clear influences from our American friends there is still a long way to. To begin with a lift dedicated to the snow park would make things easier.

PISTES. Riders who dig the piste can tear the place up in-between hits, and those of you in hards will be well in with the French euro cavers who lay it over when ever they can.

BEGINNERS on their first ever day will find the two free slopes, located in the centre of the village, perfect. Once confident of putting together a few turns, there are plenty of easy slopes and you can always get the bubble down at the end of the day. As most of the runs into resort are steep

OFF THE SLOPES

and at the end of the day packed.

Off the board, there's husky dog sledging, ice climbing, ice karting, Snowmobiles, paragliding, cinemas and loads of bars full of merchant bankers and red faced blonde haired Swedes and maybe a few French. Like many top French resorts the main draw back is the cost.

ACCOMMODATION. Most of the accommodation is of a good standard and situated close to the slopes. This inevitable means cold walks home after you have had a skin full, there is a free bus service which becomes less frequent

has the night goes on.

NIGHT-LIFE. Val d'isere is like the St Tropez of the French Alps, Full of good looking people spending a lot of money (most of it daddy's). *Cafe Face* oozes cool and *sheik*, this is a poser's paradise, sipping champagne listening to live music being mixed with silky house tunes. *Bananas* has a good vibe but can get packed, if you are on the pull check their id before leaving. Lowering the tone is *The Pacific* which is great for watching all premiership games, you can imagine the rest. For a fry up breakfast go to the Billabong café, if you want a meal in the evening take a stroll with the fur clad poseurs along the main street and choose from sausage to sushi or try some of the exclusive hotel restaurants.

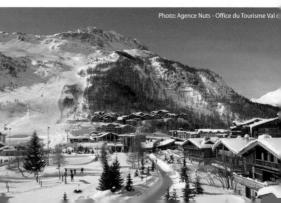

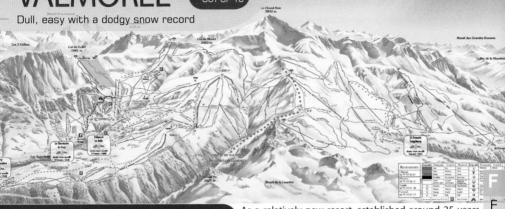

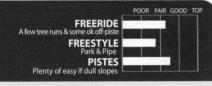

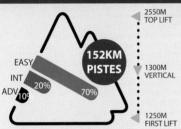

Tourist office Valmorel la maison de Valmore, Bourg-Morel, F-73260

TELEPHONE: +33 (0) 4 7909 8555 WEB: www.valmorel.com EMAIL: info@valmorel.com

WINTER PERIOD: late Dec to late April LIFT PASSES Just Valmorel: Half-Day 24, Day 31.50, 3 days 88.50 Grand Domaine: Half-day 25, Day 33, 6 Days 167, snowpark 16 euros /day

LONGEST RUN: 4km
TOTAL LIFTS: 54 - 2 Gondolas, 15 chairs, 37 drags
LIFT TIMES: 8.30am to 5pm

ANNUAL SNOWFALL: 4m SNOWMAKING: 10% of pistes

NUMBER OF RUNS: 83

CAR Drive via Albertville, take the N90 and take exit 37 on to the D95 to reach Valmorel FLY to Lyon (180km) or Geneva (125km) . Nearest

airport is Chambéry, 125km away.

TRAIN Train services are possible all the way to Moutiers/Brides

TRAIN Train services are possible all the way to Moutiers/Brides les Bains, about 10 minutes away. You can get a bus or taxi: +33 4 7924 1007 to resort.

BUS Bus from Lyon airport, tel: +33 4 37 255 255, Geneva airport tel: +41 22 798 2000

As a relatively new resort, established around 25 years ago, Valmorel has grown into a family/group ski-centre. This is by no means an adventurous place - indeed it's best described as dull. Nevertheless, it is a well planned and well set out resort, with slopes that are ideal for simple piste-riding. Valmorel, on its own, boasts 50 or so pistes which are not always that well maintained. When linked to St Francois Longchamp, the ride able terrain increases to a respectable 100 miles (152km) spread over 3600 hectates. Getting around the slopes should pose no problems, although you might have to queue for lengthy periods of time with skiers who sing nursery rhymes to their offspring. Valmorel is not noted for having the best snow record, especially on the lower slopes. Still, once you do get away from the idiots in the lift lines and hit the slopes, things only get better. Keep an eye open, however, for ski-classes cluttering up certain slopes

FREERIDERS are not going to get too excited with what's on offer here, but there is some alright off-piste riding around the **Mottet** area. Although Valmorel is a tame resort, some challenging riding is possible on a couple of black trails, though a good rider would rate them more as red runs.

FREESTYLERS are going to be most disappointed. There is a so-called fun-park and a halfpipe, but it's not often shaped properly. Any resort of any worth should have some natural freestyle terrain, but this place doesn't not even a sniff of a jump. The best thing to do is take a shovel and build your own kicker.

PISTES. Snowboarders who don't manage to hold an edge here, should give it up immediately and become a skier. Valmorel is a perfect resort for edging a board over at speed, or for general riding on intermediate trails it a good resort for first times but anyone else will soon be bored.

BEGINNERS, this area is littered with easy trails, but novices need to learn quickly to avoid sharing the same slopes with so many novice skiers.

OFF THE SLOPES Valmorel's village is dull, boring, expensive and full of some of the worst ski groups around (families). Accommodation options are good, but evenings aren't. Nothing happens, and there aren't any good bars of note, or come to that, places to eat. Well, there is *Pizzaria du Bourg* which serves up great slices.

USQ WWW.WORLDSNOWBOARDGUIDE.COM 165

VAL THORENS

Tacky with lots of skiers, but access to great terrain

High, high, high: **Val Thorens** is the highest resort in Europe, it's a load of purpose built block of ugly flats, a few shops and a line of bars with nothing to do at night but drink and at a height of 2300m it's painfully cold when walking for that drink. Who cares with a lift system that whisks you up to 3200m, north facing slopes, a 900cm average snow fall and a connection to the Trois Vallees you can stick the bad points where the sun don't shine. Furthermore, although not noted as a summer resort, you can still ride here right up until early August. Like the rest of the Trois Vallees it's full of package deal holiday makers. Lots of Brit's but not as many as Meribel or Couchevel, it's also popular with the Dutch and Swedes. Many of the apartments will give you instant slope access; some have a high rise chair going past your window so keep an eye out when leaving the shower. They've made Val Thornes a car free zone so at least you don't have to look out for motors when running for the pub, but you will have to make parking arrangements if driving. It's a rip off 53 Euros a week if you book on the tinternet otherwise its 62.5 if you just turn up. It's a board friendly place with a Fun Park and without the stuck up attitude of some of the Trois Vallees resorts.

FREERIDERS have much choice, take a trip up to the Cime de Caron for the best view in the Trois Vallees and then drop down the back side or follow the long sweeping red or black down. Intermediates should try the long, wide red runs around Fond 1, Boismint or the Peclet Glacier. The expert will relish the sheer volume of challenges on offer, from powder snow on the glaciers of Peclet and Chaviere, to world class, mogul-bashing on the long, steep Cime de Caron black run. If you have a head for heights, then visit Le Plein Sud, where you can cut some nice couloir descents. If you can handle a walk get a guide and head up left from the top of the Col Chair, over the col de Gebroulaz and ride the Glacier de Gebroulaz down into the Meribel Valley a truly amazing run. The resort height gives good snow but no trees so if you want to pretend to be James Bond head for Meribel.

FREESTYLERS have a dedicated snowboard park serviced by the 2 Lac lift, which has a boardercross circuit and a 110 meter long halfpipe. However, these are only kept in tip-top condition during a competition, rather than on a regular basis. There are some good natural hits but mainly drop offs. Look out for the Val Thorens board week in early December

PISTES. Riders have a stupid amount of pistes to fly down. The Cime de Caron is a well-established black run that tests the best speed-freaks and race heads. it's also possible to have snowboard slalom training with poles ask at the tourist info.

BEGINNERS have a variety of easy runs leading into the resort, which allow for easy access and steady progression. You don't have to travel far from the resort base before getting to a novice trail, but be advised there are heaps of little kids in bash hats that take up space while snaking down behind their

166 USQ WWW.WORLDSNOWBOARDGUIDE.COM

all in one red suited ESF instructor. If you want lessons try one of the independent ski schools which should have a board specialist if they don't go elsewhere.

OFF THE SLOPES

Val Thorens is the archetypical purpose built resort. No one would have built a thing here if it wasn't for alpine sports, not even a cow shed. A sheltered valley and an almost flattish spot have turned into high rise central. The obvious remit when planning this place

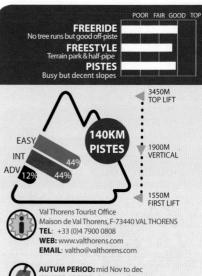

WINTER PERIOD: Dec to early May LIFT PASSES Local area:

Half-day 27.5, Day 34.5, 6 Days 166

3 Valleys: Half-day 34.5, Day 43, 6 Days 215, Season 935 **BOARD SCHOOLS** ski schools with snowboard sections Hire lots of choice

SNOWMOBILES alone 70 euros an hour, 2 people 80 euros **GUIDES:** Val Thorens mountain guides office:

Tel: 33 (0)6 89 29 23 36, 270 euros to hire a guide for the day or 60 euros per person

NUMBER OF RUNS: 67

LONGEST RUN: 3km

TOTAL LIFTS: 47 - 2 cable-cars, 3 Gondolas, 16 chairs, 8

LIFT TIMES: 8.30am to 4.30pm

ANNUAL SNOWFALL: 10m SNOWMAKING: 25% of slopes

CAR From Lyon drive via Albertville. Val Thorens is 130 miles (209 km). Drive time is about 2 hours.

NOTE: There is no street parking at the resort, you must use one of the dedicated car-parks, then a shuttle. Costs

12.80/64 euros per day/week.

FLY Lyon 193km away, Geneva 159km, Chambery 112km away, Bus services available to resort.

TRAIN TGV run services from Lyon, Geneva, Paris to Moutiers. Resort

BUS Altibus run services from Lyon, Geneva, Chambery airport, on a daily basis direct to Val Thorens. Altibus run service from Moutiers to resort, tel: +33(0) 820 320 368

TAXIS: 04 7900 6954

NEW FOR SEASON 2006/7: Improvement to the Laudzin, NEW Christine and Tête Ronde pistes. Snowmaking on Blanchot and Laudzin pistes

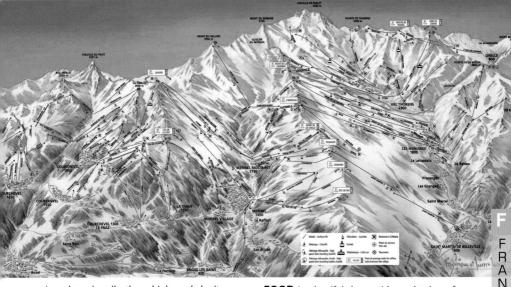

was, 'get them in, pile them high, and don't worry about how the place looks or feels. The outcome is a place that looks dire, but serves its purpose which is beer shelter and food in that order. Around the resort, you'll find a number of shopping complexes and places to eat. There is also a comprehensive sports centre, with a swimming pool and artificial climbing wall.

ACCOMMODATION: 20,000 visitors can sleep soundly here, all within spitting distance of the slopes. There are loads of self-catering apartment blocks, sleeping up to eight people, and a number of good hotels and serviced chalets, many actually on the slopes and next to a lift.

FOOD is plentiful here with a selection of restaurants more than 45 ranging from the normal selection of resort-style, expensive French restaurants, dodgy fast-food stands, to the normal offerings of a supermarket. For a cheap slap-up meal, try El Gringo's, or for something more classy, Chalet Glaciers. The Scapin Pub is also noted for its quick and affordable dishes which include pizza and garlic overdose food.

NIGHT-LIFE comes in the form of drunken Dutch après skiers. There are some ok bars at the top of town. Check out The Frog, The Malaysia, or The Underground. It's a great place for New Years Eve with fire works and music in the streets, even the firemen get in on it.

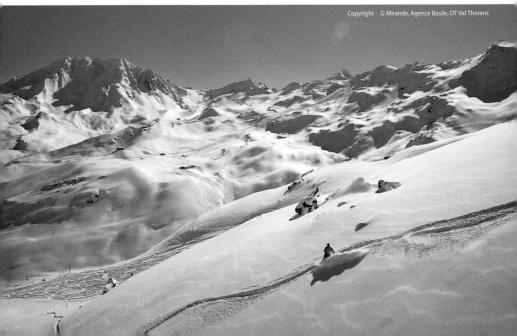

ROUND-UP

ALPE DU GRAND SERRE

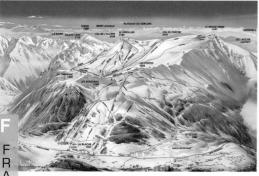

Good riding here, 2 hours from Lyon airport Runs: 35, Total Lifts:20

AURON

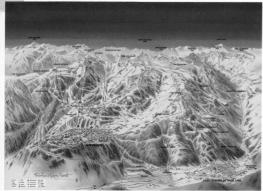

Some thick wood, 1 hour from Nice airport Runs: 70, Total Lifts: 21

BAREGES

Okay for novices, 45 minutes from Lourdes airport. Has a terrain park Number of Runs: 18

GOURETTE

Ride area: 30.5km/716 acres

Runs: 25 Easy 48% Intermediate 48% Advanced 4%

Total Lifts:16 - 6 chairs, 7 drags, 3 Magic carpets

Freestyle: terrain park

Contact: www.gourette.com

How to get there: Fly or get train to Pau-Pyrénées 60km away, then get

a bus, Tel: 33 15 5927 2222.

Drive: From Bayonne take the A64 Motorway, Exit no 9 Artix then follow directions to Pau

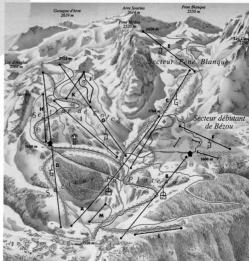

Taxi: 33 15 5905 4114

LA FOUX D'ALLOS

La Foux d'Allos, a purpose-built resort, is located way down in the southern section of the French Alps, 50 miles from the village of Digne. On its own, La Foux d'Allos offers a ride area of 70 miles, but linked with nearby resorts, the combined range gives freeriders of all levels 150 miles of terrain, with a good selection of advanced and novice runs. Local services are slopeside and very affordable, if only a tad dull

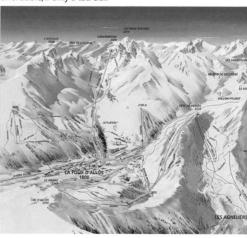

Ride area: 12km Top Lift: 2600m Bottom Lift: 1800m Total Lifts:22 How to get there: Fly to: Nice 2 hours away Contact: www.valdallos.com

LA JOUE DU LOUP

South of Grenoble and a stone's throw for the Veynes, lies the almost unheard of resort of La Joue du Loup, a tiny place place providing a mere half dozen trails. However, when linked with the resort of Superdevoluy, there's a more respectable 60+ miles to ride and explore. If you're an adventure seeker,

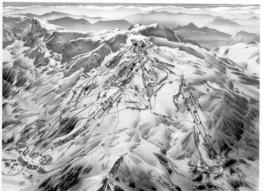

nothing here is really that daunting. Great for first timers on a family outing

Ride area: 97km Top Lift: 2750m Vertical Drop: 1040m Total Lifts:32 Night Boarding:13 slopes and halfpipes illuminated

How to get there: By air: 126 km from the airport of Grenoble-Saint Geoirs. By train: 28 km from the train station of Veynes-Divoluy. By car: Superdivolue is located 640 km from Paris, 216 km from Marseille and 190 km from Lyon

LA NORMA

La Norma is yet another unspolit tourist spot, although it does get its fair share of weekenders. They who are attracted to the open trails that offer some steep and fast, although rather limited, riding with only a couple of black graded trails and nothing that will require many turns before you're back in a lift line. In truth this is a novices retreat where first timers can learn to ride without all the hassles associated with the big tourist resorts. Affordable slopeside services are available but are best described as dull

Ride area: 97km Runs: 27 Top Lift: 2750m Bottom Lift: 1350m Total Lifts:18

How to get there: Air: Lyon or Geneva Airports - 2 hrs 30 mins transfer by hire car . Train: Modane station (overnight train from Paris), then 6km by bus or taxi to resort. Car: To Chambery (A43) and on to St. Jean de Maurienne, then take the N6 to Modane (direction of Torino - Tunnel of Freius).

Contact: www.la-norma.com

LA ROSIERE

On its own, La Rosiere is a tiny outpost, with an even balance of terrain that any rider worth their salt will have licked in a day or two. However, as La Rosiere crosses the border with Italy and is lift linked to La Thuile, the 80+ miles poses a different question. Add the 900+ miles of the Aosta Valley, and suddenly we are into a whole new ball game, which will take the best of the best years to conquer.

Ride area: 55km Runs: 32 Top Lift: 2642m Bottom Lift: 1850m Total Lifts:19

How to get there: Fly to: Geneva 2 hours away.

LES ANGLES

Les Angles is definitely not one of your normal ski tourist traps. Located in the Pyranees, it shares a non-lift linked pass with a few neighbouring resorts, with 200 miles of average rideable terrain for all styles. It is, however, crowd-free, and an alternative

to the massly populated areas further north. There's a pipe for air heads, but in truth most runs are for novices. There are plenty of slopeside services but most things around here are boring and dull and not the cheapest.

Ride area: 40km Top Lift: 2400m Total Lifts:20 How to get there: Fly to: Perpigan 1 1/2 hours away. Contact: www.les-angles.com

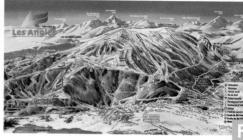

LES GETS

Linked to the 450kms of the Port du Soleil, Les Gets sits at 1172 meters to the south of Morzine. It's a small Savoyard village escaping the all too typical high rise developments that blight Avoriaz across the valley. It's possible to buy a Les Gets/Morzine pass which includes Le Mont-Chery, les Chavannes, Nyon and Le Pleney this adds up to 110km of red and blue pistes, which is fine for a weekend but if you're here for a week you should stump up the cash for the Port du Soleil Pass. It's an annoying walk across Morzine Village or a ridiculous mini train ride to access the

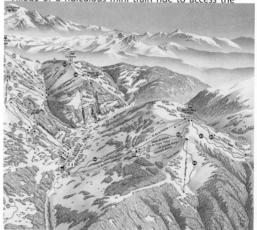

lifts up to Avoriaz, but well worth it to both freeriders and freestylers as it opens up not only a great fun park but also another 340km of piste. Les Gets has spent more than 24 million Euros over the last two summers upgrading the lift system and creating a new access point outside the village, with a huge car park so as to keep the traditional vide to the village. Freeriders will enjoy the slopes around Chamossiere and Le Ranfolly as they lead to some little gullies and tree runs. Freestylers will be best off heading for Avoriaz although there's a good little park on Mount-Chery's with hits and rails, accessible with the Les Gets/Morzine pass. Carvers have a lot of well suited

terrain if fact almost all of it. Off the slopes there's not much in the way of lively night life with only a few bars. There is Bowling and a Cinema

METABLEF

Metabief is slap bang on the border with Switzerland, which is probably why it is a cool and very friendly snowboard hangout. Although there are only 26 miles of piste and just a couple of black runs to entice hardcore freeriders, the place is still worth a visit. Laid back, unpopulated, with good slopes for all, and plenty of lodging and night-time action, although hangouts are some distance from the slopes.

Ride area: 40km Runs: 23

Top Lift: 1430m Bottom Lift: 880m Total Lifts:22

How to get there: Fly to: Geneva 1 hour away

MONTCHAVIN

Linked to the tourist trap of La Plagne, and next to the cable-car that links to Les Arcs this small resort suddenly seems a better option. On its own slopes, Montchavin has nothing to offer advanced riders, but plenty to entertain intermediate carvers and total beginners - they will find the place seemingly designed for them by Mother Nature. Freestylers are also presented with a park and pipe, but they are crap. Slopeside lodging is plentiful and okay

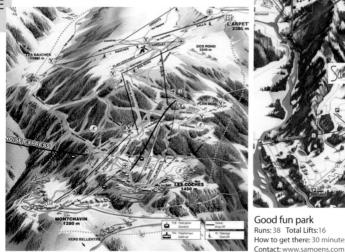

Ride area: 200km Runs: 16 Top Lift: 3250m Vertical Drop: 2000m Total Lifts: 22 How to get there: Fly to: Geneva 2 hours away Contact:www.montchavin-lescoches.com

PRA LOUP

Spread over two areas, Pra Loup and Molanes are not that bad to try, although being popular with weekenders and package tours, means clogged-up blues and busy lift lines. Par Loup is more or less a beginner's and intermediate piste-lover's hangout. Advanced riders will want more than what's on offer. Accommodation is provided in a selection of affordable, tacky apartment blocks

Ride area: 80km Top Lift: 2500m Total Lifts:31 How to get there: Fly to: Toulouse 2 1/2 hours away. Contact www.praloup.com

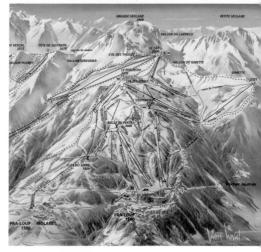

SAMOENS

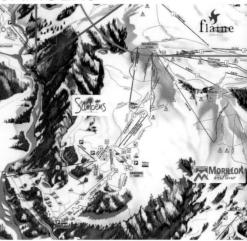

Good fun park Runs: 38 Total Lifts:16 How to get there: 30 minutes from Geneva airport

ARD DE LANS

Linked resort with Correncon en Vencours. Okay advanced runs.

Ride area: 130km Runs: 32 Total Lifts:27

How to get there: 40 minutes from Grenoble airport.

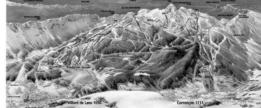

GERMANY

Not many people think of Germany as a snowboard destination and although it's no match for its close alpine neighbours, Germany can still boast plenty of rideable terrain. The dozen or so resorts are all located in the southernmost parts of the country, with some crossing over into Austria. The thing that seems to be consistent amongst about German resorts is the efficient way things are set out and how you're looked after. Most places are expensive and often stupidly overcrowded at weekends.

Travelling by car is a good idea, with resorts reached on one of the best road systems in the world. Unlike many other European destinations, there are no road tolls so you aren't hit with extra costs

Munich is the most convenient gateway airport for all the resorts with good onward travel facilities. It is possible to take a train across Austrian, Swiss and French borders direct to many resorts making train travel a good option.

For those thinking about doing a season in Germany, work is possible but you will need to speak the language (or have a good grasp of it). EU nationals can stay as long as they want without a work permit.

Accommodation is similar to that in Austria, from affordable pensions to way overpriced hotels. It's often cheaper to stay in a nearby town. Night life in Germany is pretty cool, Germans like to party hard and the beer is pure nectar. Clubs and discos are not bad, although far too many bars allow Euro pop. Overall, Germany is not the cheapest place, but is highly recommended.

CAPITAL CITY: Berlin

POPULATION: 82.4 million HIGHEST PEAK: Zugspitze 2963 LANGUAGE: German

LEGAL DRINK AGE: 16 beer, 18 spirits DRUG LAWS: Cannabis is illegal and frowned upon

AGE OF CONSENT: 16 ELECTRICITY: 240 Volts AC 2-pin INTERNATIONAL DIALING CODE: +49

CURRENCY: Euro EXCHANGE RATE:

UK£1 = 1.5 US\$1 = 0.8 AU\$1 = 0.6 CAN\$1=0.6

DRIVING GUIDE

All vehicles drive on the right hand side of the road

SPEED LIMITS:

50kph (31mph) Towns 81kph (62mph) Highways 130kph (recommended) Autobahns. Certain motorways have no speed limit, you'll recognise them!

EMERGENCY

Fire - 112, Police and Ambulance - 110 **TOLLS**

None **DOCUMENTATION**

A driving licence must be carried as well as insurance.

TIME ZONE UTC/GMT +1 hours Daylight saving time: +1 hour

GERMAN SNOWBOARD ASSOCIATION

Zizelsbergerstrasse 3. 81476 Munchen Tel - ++49 (0) 89 7544 7320 Web: www.gsahome.de

GERMAN NATIONAL TOURIST BOARD

Beethovenstraße 69, 60325 Frankfurt/Main Tel: +49 (0) 69/75 19 03 E-mail: info@d-z-t.com www.germany-tourism.de

USEFULL LINKS Munich airport www.munich-airport.de/EN/ Railways www.bahn.de tel: + 49 1805 - 996633

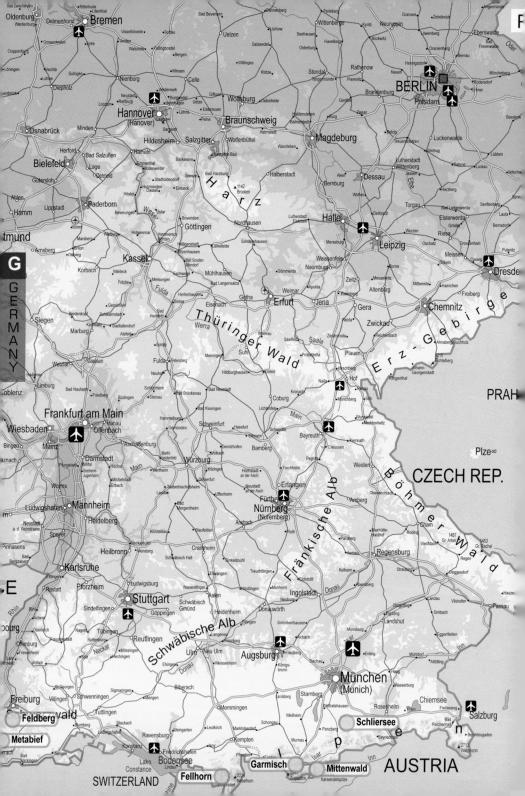

FELDBERG

Okay beginners resort

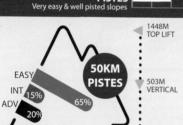

A few trees & some off-piste

FREESTYLE

PISTES

A small terrain park

945M FIRST LIFT Feldberg Tourist Information

Kirchgasse 1, 79868 Feldberg TEL - +49 (0) 7655 / 8019

WEB:www.liftverbund-feldberg.de EMAIL:info@liftverbund-feldberg.de

WINTER PERIOD: Dec to April LIFT PASSES: Half-day 20 euros, Day Pass 23 euros 2 Day Pass 44 euros, 6 Day Pass 104 euros

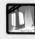

NUMBER OF PISTES/TRAILS: 36 LONGEST RUN: 2.8km TOTAL LIFTS: 29 - 4 chairs, 25 drags LIFT CAPACITY (PEOPLE/HOUR): 24,000 LIFT TIMES: 8.30am to 4.00pm

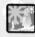

ANNUAL SNOWFALL: unknown SNOWMAKING: 10% of slopes

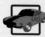

TRAIN services go direct to Feldberg. CAR From Zurich head north along the B315 and travel via Schaffhausen. FLY to Stuttgart, Basel and Zurich airports approx 1hr

drive away.

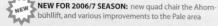

FREERIDERS who want for a simple day's riding and are not too adventurous, will find Feldberg an ideal place to spend some time at. There is an okay mixture of terrain with the best and most challenging freeriding to be found off the letter K drag lift.

FREESTYLERS should stick to riding in the terrain park located under the 6-seater chair on Seebuck. This is the only place to get any air time. There's usually 2 kickers and 3 rails there.

PISTES. Riders have a good resort for just cruising around with a number of well groomed trails to check out, especially those on the Seebuck.

BEGINNERS have a mountain that is perfect for learning on with a number of easy blue trails that cover all the areas, but note that all the easy runs are served by drag lifts.

OFF THE SLOPES. Feldberg is a large town with a very good choice of local services that include hotels, pension homes and chalets. There is also a good choice of bars and restaurants, the only draw back being that this is an expensive resort.

GARMISCH

A tale of 2 mountains

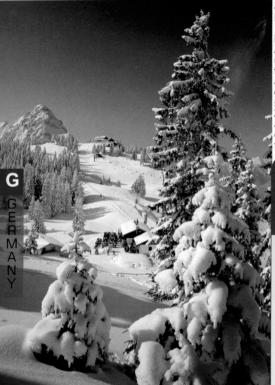

Garmisch is Germany's most popular, highest, and glitziest resort and is situated a stones through from Austria in the south of the country. It is an all-year resort and one of the countries premier health spa spots, but it's definitely a skiers resort, but worth a quick visit for snowboarders. The town has all the trappings of decent size town, complete with art galleries, a theatre, and plenty of places to stay and eat, but things do come with a hefty price tag. Throughout the winter the resort holds various ski events in town and on the mountain, and it is due to hold the 2011 FIS Alpine Ski World Championship. Garmisch even played host to the 1936 Winter Olympics, but the less said about that probably the better. There are 3 separate areas which make up the ski region. The classic area is made up of the Alpspitze, Kreuzeck, and Hausberg peaks and offers the most pistes, but with many flat spots and narrow paths its best left to the skiers. Zugspitz is the highest mountain in Germany and also home to the best and most snow sure area. It's a rocky outpost resembling a giant molar tooth; impossible to board down from, but has a large bowl that collects all the snow and is also home to the resorts terrain park. The final area is the unfortunately named Wank, It's a freeride only area, which can be excellent when the snow conditions are right.

Before deciding which area to visit, it's worth checking

out the screens at the station to see the conditions; often if the conditions in town are cloudy the Zugspitz can be clear and sunny. From the main station take the Zugspitzbahn and jump off wherever takes your fancy, it's a

5-10 minute train journey to the classic area, but it's 45minutes to Eibsee and a further 40minutes on the Eisbeeseilbahn to reach the top of the Zugspitz.

FREERIDE. In the classic area, from the top of the Alpspitzseilbahn cable-car you can head off-piste under the Hochalmbahn which will avoid the very flat run 15. Then as you head over to Kreuzeck and Hausberg it's a case of learning where you can drop into the tight trees to avoid some of the slow narrow paths that litter this area. Up on the Zugspitzplatt, some easy hiking from the t-bars will afford you some good virgin snow but do be aware of the avalanche risk. On the way down, don't take the train all the way, instead get off after the tunnel

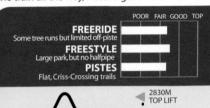

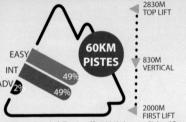

Garmisch Tourist office, Verkehrsamt, Richard Strauss-Platz 2 D-82467 Garmisch-Partenkirchen

TEL - +49 (0) 8821-180-700

WEB: www.garmisch-partenkirchen.de / www.zugspitze.de EMAIL: tourist-info@garmisch-partenkirchen.de

WINTER PERIOD: Dec to April SUMMER PERIOD: May to June

LIFT PASSES: Whole area: day pass 36 euros Just Classic (ie, shit) area: Half-day 23.5 euros, Day pass

BOARD SCHOOLS 6 days with 3 hour lessons from 110 euros HIRE Board & boots 20 euros a day

NUMBER OF PISTES/TRAILS: 34

LONGEST RUN: 3km

TOTAL LIFTS: 36 - 1 Track Railway, 6 cable-cars, 1 Gondolas, 5 chairs, 24 drags

CAPACITY (PEOPLE/HOUR): 50,000 LIFT TIMES: 8.30am to 4.30pm **MOUNTAIN CAFES: 12**

ANNUAL SNOWFALL: unknown **SNOWMAKING:** 15% of slopes

CAR From Munich, head south on the A95 Autobahn and then route 23 direct to Garmisch (140km)

FLY to Munich airport about 120km (1 1/2 hours) away or Innsbruck (Tyrol) 60km.

TRAIN services are possible all the way to the centre of Garmisch.

NEW FOR 2006/7 SEASON: the new Hausberg cable car replaces the old one and the cog-wheel train to Zugspitze is getting a refurbishment and will be able to handle more nunters

174 USQ www.worldsnowboardguide.com

and either take the 5km run, or you can drop into the tight trees and pick up the trail later on. Things do get narrow & flat later so tuck 'em in and go for it.

FREESTYLE. There's a terrain park situated on the Zugspitz, running parallel to the two number one. t-bars. The lack of snow over the past few seasons means there is no longer a half-pipe up there, but there is a decent long regular & pro line containing various kickers and rails, which is also used be the GAP1328 summer camp. Away from the park there's little natural freestyle terrain, but you'll often see the locals building small jumps around the extremely picturesque Kreuzalm.

PISTES. Garmisch is famous for its notorious Kandahar descent, a 3.5km black run starting from the top of Kreuzeck. It's a testing run, but blighted by the number of trails that cross over it at the top section and can often be bullet ice the further down you head, but 2mins is the time to aim for. Most of the trails in the classic area are narrow skier paths which boarders will struggle on for speed. Contrast this to the Zugspitz area, where wide treeless, non-icy pistes are the norm.

BEGINNERS. Around the top of the Hausberg area is most suited for beginners with some wide slopes serviced by a chair and some pomo lifts, but this isn't a good beginners resort and you may be best heading to nearby Mittenwald or Seefeld.

OFF THE SLOPES. Garmisch is an all year-round holiday destination which caters extremely well for its visitors. There is a huge selection of places to stay with services spread out over a wide area, but you may struggle to find a bargain. Numerous events are held in the town all year round, so not only is this a very expensive town, it can also be very busy. The area also has loads of sporting attractions and if you are feeling lucky there is even a casino to try your hand in. For a town the size of Garmish, its surprising

there are only 3 snowboard shops, and none that great.

ACCOMODATION. The area can accommodate over 20,000 visitors with a number of places in the main town area or spread out into the countryside. Prices are not cheap and no real budget options exist even though there is a large number of pension's and self catering places. Still one thing is for sure, most places are of a very high standard and hotels come loaded with restaurants, bars, pools, and sporting centres. The tourist information office is located in the centre of Garmisch and does an excellent job trying to locate a place to stay.

RESTAURANTS are plentiful and cater for all tastes, if not all budgets. Most places serve up a variety of disgusting sausages and potato dishes; however, you can find almost every international cuisine. Veggies

should pay a visit to the Grand Cafe.

NIGHTLIFE here is okay and set to a Bavarian theme. excellent choice of German beers are available in a number of bars where the booze flows fast and well into the early morning hours, mind you, the music in most places is enough to make you want to leave. Check out the Irish Bar or the Rose and Crown. There's little in the way of Apres-ski bars but there are a few small umbrella bars dotted around the centre.

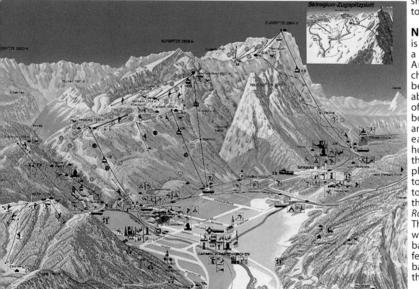

SCHLIERSEE ...

Rather basic but okay

Frequented Munich's highsociety kiddies and some cool riders, Schliersee is also home to the living snowboard legend Peter Bauer (you may still meet him riding here). What you get are two areas. interconnected by a free shuttle-bus: the Taubenstein is less crowded and is the place to be on a

POOR FAIR GOOD TOP
FREERIDE

fresh powder day but you'll get bored pretty quickly in the days in-between! Most of the runs are intermediate and nothing will keep you excited for long. At the parking lot you jump on the shuttle that takes you to the **Stumpfling-an-Sutten** area at the other side of the **Spitzingsee**, where the whole area lies in front of you, waiting to be ridden

FREERIDERS if there's enough snow, take the Brecherspitz lift, opposite the Firstam, to gain access to a freerider's paradise: long, steep tree-runs that remind you of Canada. On this mission you should follow the locals because there's a 25 metre cliff, with a flat and rocky landing hidden in the trees.

FREESTYLERS have a good mountain to practice getting air at various points around the slopes. The Osthanglift T-bar takes you to a good freestyle area. If you stay on the slope-side of the lift on the way down, you'll find some good natural hits and spines decorated with some nice rollers. The **Firstalm** is where the funpark is but it doesn't get shaped too often.

PISTES. Riders have a very good mountain to ride, with well groomed runs that will intrigue the hopeless novice, but bore the tits off most advanced riders. However, the pistes are open enough to allow for some wide carves and to be fair, a decent amount of speed can be achieved. The longest run is the 3200m Sutten, which is good for screaming down in under 3 minutes.

BEGINNERS have a cool first timer's resort, although there's a limited amount of slopes and a lot of weekend ski crowds cluttering up the place. Easy access is possible to all the beginner trails.

OFF THE SLOPES. Local facilities are located in two areas, **Schliersee** in the east and **Rottach-Egern** in the west which has the best night-life and some cheap B & B's. Both places offer good local services but be prepared to pay for it because this is not a cheap hangout, no matter what you're after.

Eating spots are good and evenings begin at the *Braustuberl Bar*, but watch out for the big waitresses who eat snowboarders for supper. Later, head for the *Moon-Club* where you are bound to find a nice fraulein.

176 USQ www.worldsnowboardguide.com

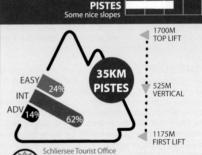

With the right conditions

An occasional park but fun natural

FREESTYLE

Schliersberg Alm, D-83727 Schliersee TEL: +49/+8026/6722

WEB: www.schliersbergalm.de EMAIL: info@schliersbergalm.de

WINTER PERIOD: Dec to April LIFT PASSES 1 Day 37 euros, 3 Days 105, 6 days 175

NUMBER OF PISTES/TRAILS: 31

LONGEST RUN: 3.2km
TOTAL LIFTS: 19 - 1 Gondola, 2 chairs, 16 drags
LIFT CAPACITY (PEOPLE/HOUR): 13,500

LIFT TIMES: 8.30am to 4.00pm

ANNUAL SNOWFALL: 3m SNOWMAKING: none

TRAIN services possible to the centre of Schliersee. **CAR** Via Munich, head south on the A8/E45 Autobahn and turn off at Kolbermoor on to route 472 via Hausham & the 307 to Schliersee

FLY to Munich airport, 1 1/2 hours away.

ROUND-UP

BALDERSCHWANG

Intermediate's place. Overall this is a boring place with a small and badly kept halfpipe.

How to get there:120 minutes from Munich airport

FELLHORN

Fellhorn is the mountain, Obersdorf is the town that serves it and together they are rated by many nationals as the best on offer in Germany. What you get is a mountain area that has a series of open trails with a few tree lines and a couple of decent steeps They regularly stage top events in the competition standard halfpipe. Whereever you ride here, expect to bump into a lot of skiers as it's a popular hang out.; Freeriders, check out the Kanzelwand trail for a good ride. Freestylers have a well maintained funpark to play in. Carvers, have a good series of pisted trails from top to bottom.4 Beginners this place is perfect for all your needs. There are good facilities 10 minutes from the slopes.

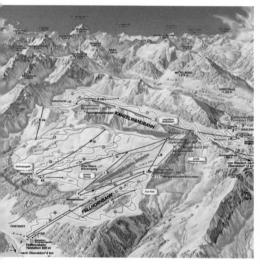

Ride area: 44km Top Lift: 1967m Total Lifts:30 How to get there: Fly to: Munich 11/2 hours away. www.fellhorn.de

MITTENWALD

Mittenwald is located in the Isar Valley and is an okay freeriders destination. It is famous for its steep Dammkar run which is served by a cable car that climbs 1311 vertical metres with only one tower (sufferers of vertigo take note). Freestylers have a halfpipe. Beginners have plenty of easy slopes. Local services are convenient but not cheap

Ride area: 22km Top Lift:2244m Total Lifts:8 How to get there: Fly to: Munich 11/2 hours away

METABLEF

Metabief is slap bang on the border with Switzerland, which is probably why it is a cool and very friendly snowboard hangout. Although there are only 26 miles of piste and just a couple of black runs to entice hardcore freeriders, the place is still worth a visit, Laid back, unpopulated, with good slopes for all, and plenty of lodging and night-time action, although hangouts are some distance from the slopes.

Ride area: 40km Runs: 23 Top Lift: 1430m Bottom Lift: 880m Total Lifts: 22 How to get there: Fly to: Geneva 1 hour away

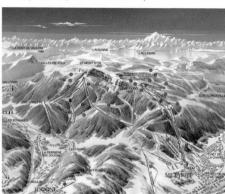

OBERAMMERGAU

Oberammergau is a happy go lucky sort of place but certainly not the most adventurous of resorts. On the Laberjoch area the runs offer more testing and challenging terrain. For those freestylers wanting to get big air, the halfpipe is your best option, but it's not the best nor well kept. The west side of the valley, on the Kolben. is the place for novices and intermediate riders looking for gentle and simple terrain to shred. Okay expensive local services exist, but not near the slopes

Ride area: 10km Top Lift:1700m Total Lifts:10 How to get there: Fly to: Munich 1 1/2 hours away

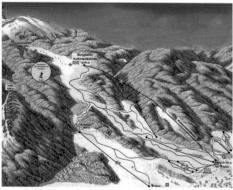

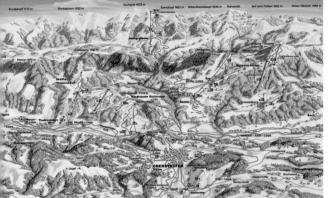

WINTERBERG

Winterberg, is situated southwest of Dortmond in the Sauerland mountain range which not many snowusers have heard of. The runs are spread over 5 hills with 25 slopes, but nothing too testing, the longest barely making 2 miles.Freeriders have lots of trees to weave through and with many runs interlinking, there are a few nice freeride spots to check out. Freestylers don't have a pipe or park but many of the runs have natural hits formed en route at the sides and there's also a number of ski jumps that you can air off. Carvers could do worse, but if you know how to carve at speed then you won't

BERSTAUFEN

Oberstaufen is a collection of seven small rideable areas. The main offerings are to be found on the Hochgrat mountain which offers some good off-piste and challenging runs. Intermediate carvers will also find the slopes worth the effort while beginners have access to some okay areas. Off the slopes, this place is by no means cheap as it is a very popular German tourists town.

Ride area: 20km Top Lift: 1340m Total Lifts:12 How to get there: Fly to: Munich 2 hours away

Willingen is a northern low key resort which is virtually unheard

of. The area is spread over two large hills with mainly nursery slopes. The main hill has some decent runs with the option of cutting through the trees but lacks

any great length. Note also that this place inhabited by lots of skiers (the older generation) and sledgers, so the few slopes that there are, are often very, very crowded, especially at weekends. Freeriders have very little to keep them interested beyond an hour, but there are a few trees to drop through. Freestylers haven't got a chance here unless you dig your own hit. Carvers will find the number 11 trail about the only thing of worth. Beginners aged 1 or 100 will love it here as the slopes are so slow and easy you'll be able to change your nappy as you ride. There are lots of small villages close by but they're all pricey

Top Lift: 830m Total Lifts:14 How to get there: Fly to: Munich 1 hour away

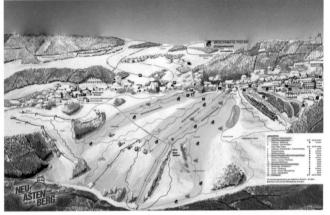

want a week here. Beginners, this place is great for you, however, only for a one off trip before going to Austria for your next snowboard holiday. Very good and lively

Ride area: 40km Top Lift: 809m Total Lifts:11 How to get there: Fly to: Dortmund 1 hour away

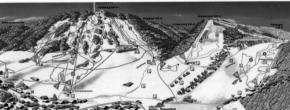

GREECE

Greece, the hot spot where bodies bare all on countless sun drenched beaches, scattered around numerous islands, also has a winter sports industry! Its not well known, and come to think of it not even thought of by most. Nevertheless, you can snowboard at one of fifteen recognised ski resorts, though some are very dubious. There are a number of mountain ranges where enough snow falls on an annual basis for shredding. Athens may be the historic home of the Olympics but just 2 1/2 hours away is the resort of Parnassos, where you can ride some 20 runs. Although the Greeks allow snowboarders on to the slopes they're not totally sure about the whole scene yet, and sometimes seem a bit stand-offish but they're cool enough. Greece is definitely not a freestyler's playground; forget about half-pipes or fun-parks. Some areas may have stupidly short runs and be only equipped with an antique single lift system located alongside the resort's only building, and often the terrain is not that great. It's generally flat, not well groomed and not very adventurous, but what the heck, you're riding in Greece!

If you fancy giving Greece a try, remember to contact the resort prior to leaving, to check if the place is actually open and the latest snow forecasts. The resorts are unbelievably basic, many without any facilities. You won't find many places to eat, sleep or drink in, and as for hard-core partying: forget it - this is walkman and duty free territory! Getting to the resort is best done by driving yourself as public transport is also poor.

KAIMAKTSALAN

2050m -2480m RUNS: 13, LIFTS: 6 www.kaimaktsalan.gr Kaimaktsalan has the highest lifts in Greece and is located 45km outside Edessa. It has a terrain park. that has 2 kicker lines and a separate rail line, on a good day featuring 15 obstacles.

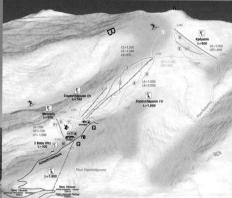

KALAVRITA SKI CENTER

The newest resort in Greece opening in 1988 and offers 12 runs suited for beginners and easily please intermediates. The 7 modern lifts include 2 chairs serving some okay terrain, but nothing too steep and

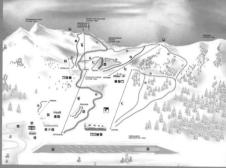

only a few trees to shred. The main town Kalavrita is 14km from the resort and only 32 Kilometers from the beaches of North Peloponnese www.kalavrita-ski.gr

PARNASSOS SKI CENTER This is the largest resort in Greece with a total of

20 runs covering 2 linked areas; Fterolakka and

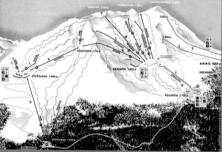

Kellaria. Although its the biggest don't expect to find anything in the way of a terrain park. The resort was built in the mid 70's and can get quite busy with Athenians escaping the city for the weekend. www.parnassos-ski.gr

SELI&TRIA-PENTE PIGADIA

SELI - TOP 1500m RUNS: 16 LIFTS: 9 - 1 chair, 5 t-bars, & 3 magic carpets TRIA RUNS LONGEST TO LIFTS A Lebel of the Conference and Seli was the first proper resort to open in Greece and sit with nearby Tria-pente Pigadia resort on Mary Vermio. Its a fairly quiet place which offe eeriding

This Country has 12 resorts which allow snowboarding both in the winter and summer months. None of the resorts are big or offer extensive mountain services, instead there are basic low level mountains with poor road access to them. On the slopes, runs tend to be short and not that well kept. However, Iceland is a very snowboard friendly country and resorts are more than happy to provide hits for freestylers to get air off. Visitors to Iceland will notice that apart from the short day light hours, it is a very expensive country. Visa requirements for entry in to the Country are very liberal but you do need to have return flight tickets on arrival.

BLAFJOLL Runs:20

Lifts: 11 - 2 chair, 9 drags

Lift times: Monday - Friday from 14:00-21:00. Weekends and public holidays from 10:00-18:00

Night Boarding: Yes

Contact: www.skidasvaedi.is tel: +354 561 8400 Location: 20 minutes from Reykjavik. Buses run from

most towns to resort

HLIDARFJALL

Top:1000m

Terrain park and pipe. Runs:14

Lifts: 4 - 1 chair, 3 drags (2930 ph)

Lift pass: Day 1000/1400 ISK weekday/weekend Season pass 14,000 ISK

Hire: Board & Boots 2,500 ISK per day from resort Board School: Lesson, lift & rental 3000 ISK per day Private lesson 5000 ISK for 3hrs

Contact: www.hlidarfiall.is tel: 462-2280

Location: 10 minute drive from the town of Akurevri

Terrain park and pipe. Lifts: 5 - 1 chair, 4 drags Night Boarding: Yes

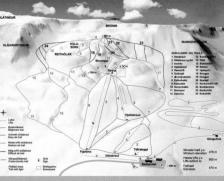

is no longer in operation and has been dismantled, but boarders are still welcome whenever there is

SKÁLAFELI

Okay beginners resort located close to the capital Reykjavík. 4 lifts serve some easy but snowsure terrain, including an occasional half-pipe.

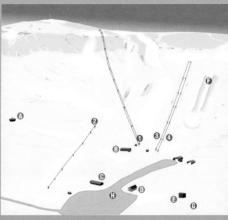

ITALY

Italy is often over looked by the British snowboarder, which is a big error. It's cheaper than France, the foods better than Austria, and the terrain is just as good, well almost. What you don't get in Italy is huge inter linked areas, most of the time the resorts don't link to their neighbors. The exception to this is the Dolomite Super Ski which has one pass that links 12 areas, but not all by piste. All the resorts of note, stretch across the north of the country, with some linking across into the neighboring countries. Make sure that your lift pass works, in the resort over the boarder, or you could find yourself stuck in Switzerland without the correct currency, no passport and a very long taxi ride. The main airports are Milan and Turin but Venice or Verona could be closer. Trains and busses are surprisingly cheap and efficient, but don't always link up well with resorts. Having said that, a few days in Venice followed by a few in the mountains could keep the girlfriend happy, while sneaking in a few extra days in on the slopes, making up for the slight hassle of the busses.

The Italians are famed for stylish dress, food, wine and fast cars. Anyone who's walked through an Italian ski resort, as the lifts are closing, will see some of the worse dressed people this side of a charity shop. The food is fantastic, and the wine you drink in Italy is far better than the plonk they export. As for the cars, well anyone who's driven a fiat, over five years old, will know the doors drop faster than an Italian mans midlife pasta filled belly, and they need more tender love than a young Italian beauty, to get up a steep mountain road. Ok so Ferrari and Lamborghinis are cool, but most of us would be lucky to own a matchbox one. Italy also has one of Europe's worse car accident rate, something to think about when offered that extra insurance at the car rental office.

Riders looking to work should have no real problems, lots of UK winter tour operators include Italy in their laugh and if partying isn't your thing there's loads of Via ta to scare you shitles

CAPITAL CITY: Rome POPULATION: 58 million

HIGHEST PEAK: Mont Blanc de Courmaveur 4,748m

LANGUAGE: Italian **LEGAL DRINK AGE: 18**

DRUG LAWS: Cannabis is illegal and frowned upon

INTERNATIONAL DIALING CODE: +39

AGE OF CONSENT: 16 ELECTRICITY: 240 Volts AC 2-pin

CURRENCY: Euro

EXCHANGE RATE: UK£1 = 1.5 US\$1 = 0.8 AU\$1 = 0.6 CAN\$1=0.6

DRIVING GUIDE All vehicles drive on the right hand side

SPEED LIMITS: 50kph (31mph) Towns

90kph (55mph) Highways 130kph (80mph) Motorways

EMERGENCY

Fire - 115 Police - 113 Ambulance - 118

TOLLS Payable on motorways using the Autostrada system Mont Blanc tunnel charges approx 20 euros each way

DOCUMENTATION

A driving lisence must be carried as well as insurance.

UTC/GMT +1 hours Daylight saving time: +1 hour

ITALIAN SNOWBOARD ASSOCIATION

Piazza Regina Elena, 12 - 38027 MALE. Tel 045 8303277 Web: www.fsi.it Email: fsi@iol.it

ITALIAN TOURIST BOARD

World-wide website - www.enit.it 1. PRINCES STREET, W1B 2AY LONDON Tel. 0044 207 408 1254 www.italiantouristboard.co.uk

USEFULL LINKS

Torino airport - www.aeroportoditorino.it Milan airport - www.sea-aeroportimilano.it Trains - www.trenitalia.com/en tel: 89 20 21 Airport transfers - www.savda.it

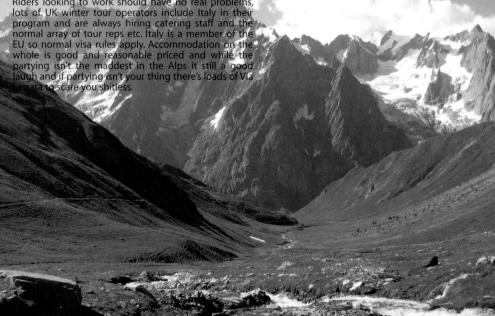

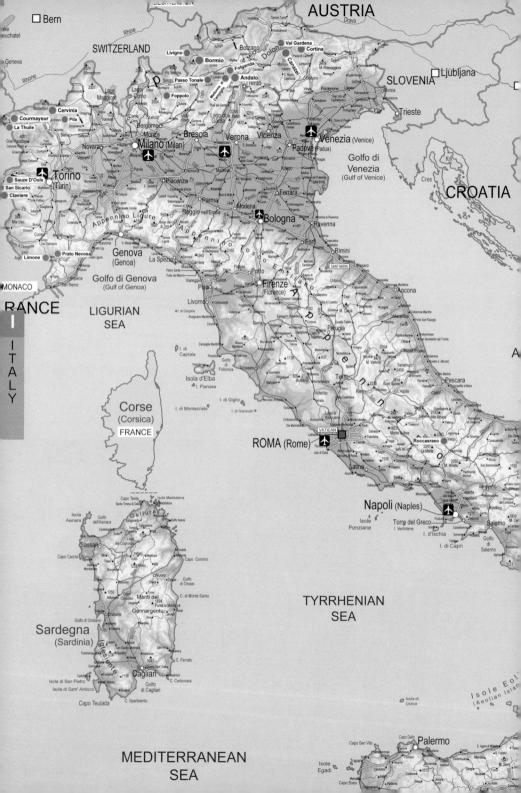

ANDALC

No hype, just a relaxed place to ride

Andalo lies at the base of the Brenta Dolomite mountain range just north of the city of Verona, which is also the gateway city for air transfer being only an hour and a half away. The towns of Andalo, Fai della Paganella and Molveno, form the Paganella ski area with over the 60 kilometres of marked out runs. It may not have the greatest annual snow record when the snow does fall; it provides a mountain that allows for some fine off-piste riding which includes lots of tight tree runs. Should the real snow not fall, then the resort boasts at least 90% snowmaking coverage on its pistes. The fact that this place is not the most famous resort may be its saving grace, because while some of the bigger

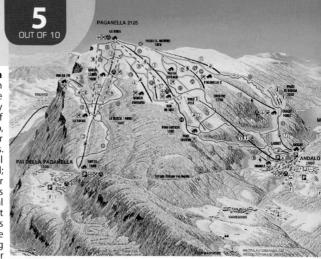

POOR FAIR GOOD TOP **FREERIDE** Trees & some off-piste **FREESTYLE** A terrain park **PISTES** Some good wide slopes

Andalo Tourism Piazza Paganella, 2, Andalo, 138010 TEL: ++39 (461) 585836

WEB: www.paganella.net EMAIL: info@paganella.net

NUMBER OF RUNS: 24

WINTER PERIOD: Dec to April LIFT PASSES: Skipass for Paganella-Brenta area: Day pass 30 euros, 2 Days 53.5 euros, 6 Days 141 euros **BOARD SCHOOLS**

Altopiano ski schools has snowboard lessons

LONGEST RUN: 5km TOTAL LIFTS: 18 - 2 Gondola, 15 chairs, 1 drags CAPACITY (PEOPLE/HOUR): 25,000 LIFT TIMES: 8.30am to 4.00pm **MOUNTAIN CAFES: 10**

ANNUAL SNOWFALL: 3m SNOWMAKING: 95% of slopes

BUS Trento (32 km) or Mezzocorona (17 km) TRAIN Take the Brennero line to Trento (40 km) or Mezzocorona (17 km)

CAR Highway A 22 - Brennero Modena, take San Michele All'Adige exit. Take SS43 to Mezzolombardo, then SP64 21km to Andalo

FLY 90 minutes (130km) from Verona airport, 170km from Brescia airport

and more popular destinations attract hordes of piste lovers, Andalo is left relatively crowd free and un-spoilt. The resorts history dates back many years yet this place is not an old fashioned out dated dump, on the contrary. the resorts management are constantly spending large sums of money keeping the mountain facilities up to date. In general the resort is split between being good for novices and intermediate riders. Advanced riders are not blessed with to many steep sections but that said. there are a number of hair raising descents to test the best. All the slopes are easily reached from the village via the main gondola. Once up the slopes you will be able to get around with ease, and for those who hate drag lifts, you'll find most of the runs are reached by chair lifts with a chair possible to the top section at 2125m.

FREERIDERS will be pleased to find that Andalo is actually a good place to ride with a number of riding options on offer. There are lots of tight trees to shred as well as a number of scary drops and fast steeps.

FREESTYLERS will also find Andalo a cool place. There is a halfpipe on occasions but its not always maintained. Local riders often construct their own hits and session them before moving on to try out some of the natural air terrain which is in abundance all over the mountain.

PISTES. Riders have lots of wide open spots where it is possible to lay out some big turns on runs that are well pisted on a daily basis.

BEGINNERS can start out on the easy slopes around the village area before heading up the mountain where you will find some excellent novice trails from the top station down to the mid section. The local ski school offer snowboard lessons and board hire is available in the village.

OFF THE SLOPES Andalo is a basic and simple village that offers its visitors a high standard of good facilities. There are a number of good hotels with accommodation available next to the slopes. Around the village you will find shops, a sports centre, an ice ring and a swimming pool. There is a night-club and a couple of bars but don't expect a lot of action as night times are relaxed and basic.

Bardonecchia is not only a small fashionable mountain town or a popular all year round holiday destination, but also rated in the top ten of Italy's resorts. Skiers have been flocking to these slopes for many years bringing with them all the razzle dazzle of the Italian ski world, indeed one of Italy's past Kings was said to be a regular visitor to this part of the Susa valley. In 2006 Bardonecchia played host to all the snowboarding events during the Turin Winter Olympics, so its a great opportunity to try out that crazy boardercross course they built. As a town, this place has been around since the time of the Romans and although a lot of what you find here is old, clapped out and in need of immediate repair, the place can still cut the mustard with a well set out series of mountain slopes that are connected by some twenty nine lifts. The 140 kilometres of marked out pistes cover a series of mountain faces that are split either side of the valley floor, and take in the hamlets of Campo Smith, Melezet and Jafferau. The main runs on the slopes of Bardonecchia will suit all levels but in the main are best for intermediates. Campo Smith and Melezet are pretty evenly split between beginners and intermediates, but one thing that is common with all the areas are the lift queues, which at weekends and over holidays can be stupidly long.

FREERIDERS will find that this is a fairly ordinary place to ride with nothing much to entice you back. However, up on the Jafferau area, which is only five minutes bus shuttle bus from Bardonecchia, you will find a nice big snow bowl and some cool backcountry spots along with some fast steeps.

FREESTYLERS. First impressions of the terrain and the opportunities for getting air, will not be good. There is a halfpipe and park at the base which holds the competitions but traditionally it's not well particularly well maintained outside the event dates.

PISTES. Carvers are the ones who should be most at home here, especially if you are only looking for gently descents on which to lay out some easy lines. Most of the slopes are well pisted and make for good carving, some of which can be done at speed.

BEGINNERS have a resort that is well suited to their needs. At Campo Smith and Melezet there are two large nursery areas but be warned, they do get very busy with novice skiers. Note also that this area operates a lot of old drag lifts.

OFF THE SLOPES. Bardonecchia is a mount town that provides a high level of good servialthough not a cheap place. There is a good cho of hotels, apartments, chalets and B&B's to choo from with rates that are mostly on the high si Around the town, or within close proximity, the are varying attractions from skating to bowli the town also has a good selection of shops a banks. Restaurants are also plentiful but night is some what lame.

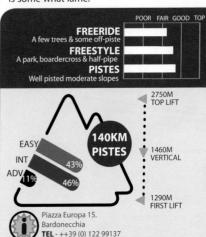

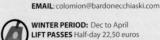

WINTER PERIOD: Dec to April LIFT PASSES Half-day 22,50 euros 1 Day 29 euros, 2 Days 48.5 euros, 6 Days 123 euros

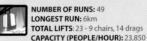

NUMBER OF RUNS: 49 LONGEST RUN: 6km TOTAL LIFTS: 23 - 9 chairs, 14 drags

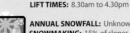

ANNUAL SNOWFALL: Unknown **SNOWMAKING:** 15% of slopes

WEB: www.bardonecchiaski.com

TRAIN Take the Torino-Bardonecchia-Modane line straight to Bardonecchia station

CAR From Torino take the A32 via the Frejus tunnel. Take the Oulx exit, follow directions to Bardonecchia FLY Turin 1 1/4 hours away 90km.

184 USQ www.worldsnowboardguide.com

BORMIO

Basic but okay

Bormio dates back hundreds of years and it's quite possible that the Romans who built an ancient spa town near here could have actually been the first to shred the slopes in their tin hats. However, Bormio as we know it today is rated very highly in Italy, with it's modern roots going back to the early sixties when the resort started dragging punters up its mainly intermediate all-round terrain. Bormio is a fairly busy place, with overkill in some very sad all in one ski suits. The ski world does a lot of racing on the slopes here; Bormio hosted the 2005 World Championships which suggests that there must be something on offer. Italian skiers like this place a lot, as do Germans and quite a lot of Brits. This means the slopes do become very clogged up at weekends and over holiday periods. Lift passes

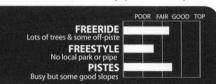

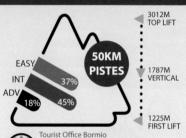

Via Roma 131-B. Bormio 123032 TEL: ++39 (0) 349 903 300 WEB: www.bormioonline.com

EMAIL: info@bormioonline.com

WINTER PERIOD: Dec to April LIFT PASSES: Lift passes for Alta Valtellina ski area, comprising of Bormio, Santa Caterina and San Colombano areas. Day pass 32 euros, 2 Day pass 61 euros, 5 Day pass 146 euros, Season pass 495 euros

NUMBER OF RUNS: 11 LONGEST RUN: 6km

TOTAL LIFTS: 14 - 1 Cable-car, 7 chairs, 4 drags, 2 Magic carpet

CAPACITY (PEOPLE/HOUR): 13,500 LIFT TIMES: 8.30am to 4.30pm

ANNUAL SNOWFALL: 3m SNOWMAKING: 40% of slopes

BUS From Millan take the A801 bus operate by Società Trasporti Pubblici Sondrio, tel: 0342/511212. Takes 4

TRAIN services are possible to Tirano which is 20 minutes away.

CAR via Milan, head north via the towns of Lecco, Sondrio and Tirano, along the A38 to Bormio.

FLY to Milan airport, 4 hours away. Ryanair have flights to Bergamo, 170km away (its 50km from Milan, but its sold as Milan)

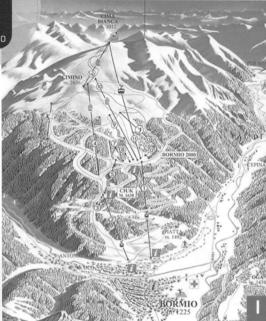

also provide access to the resorts of Santa Caterina (40km pistes) and San Colombano (30km pistes) creating the Alta Valtellina ski area, but the areas are only linked via ski-buses.

FREERIDERS have a mountain that is not extensive especially for advanced riders. There is some good off piste freeriding with powder bowls and trees to check out. The best stuff reached from the Cima Bianca, where the runs start off steep and mellow out to test the best. Don't bother hitting this stuff in hards, you'll regret it as this section is soft boot only terrain.

FREESTYLERS wanting to get big air will not find a great deal, but there are plenty of natural hits. The resort doesn't have a pipe or park, the nearest is 10 minutes away at Passo Dello Stelvio (linked by a shuttle bus). The Stelvio glacier, the largest in Europe, offers the opportunity to snowboard during the summer.

PISTES. Riders will find that Bormio is an excellent place for any level and the 6km run from the top station down to the village provides plenty of time to get those big carves in. It's perfect for riders who want to see what it's like linking turns and by the time you hit the bottom, you'll know for sure.

BEGINNERS will find the slopes at Bormio ideal for basics and excellent for progression. What's more, all the easy stuff can be reached without tackling a drag lift.

OFF THE SLOPES

Bormio is a rather strange affair, but nevertheless a very rustic and Italian place. Accommodation is offered in a range of locations, with the choice of staying on or near the slopes. Around town, you soon notice how glitzy things are however, staying here can be done on a tight budget if you leave out dining in fancy restaurants: seek out one of the cheap pizza joints. Night-life is nothing to get excited about; in fact it's pretty dull but still boozy.

Big linked area in Fassa Valley.

Canazei forms part of what is know as the **Dolomiti** Superski, which is said to the largest ski area in the world providing over 1200 kilometres of ridable terrain. What ever the merits of this claim one thing is for sure, and that is this place has got a lot going for it and will make a two weeks stay well worth the effort. Located along the Fassa Valley, of the Sella Ronda, Canazei is the largest of the cluster of villages that make up this area, with lifts that link it to Campitello, Mazzin, Alba to name but a few. Canazei, which is a sizeable town, sits at the base of the mountain with access up to the slopes having to be made by gondola and then on up by a large cable car. The first gondola ride up is often only possible after a long wait, as it's the only lift out of the town up to the slopes, unless you are in Campitello where they have a cable car to take you up. Generally this is a place that suits intermediate riders but, with such a vast area to explore, every level of rider should find something to test them. The terrain features are a mixture of rugged gullies to wide berth carving slopes on a mountain that has a fairly average annual snow record and at a resort the operates between December and April, which is a tad short when one thinks of the vast size of the area in general.

FREERIDERS are in for a bit of a treat here simply by the very fact that there is so much terrain to explore. If you can't have a good time here you should think about becoming a monk. The area is riddled with interesting terrain from chutes to trees to powder stashes. However, one major disappointment is the lack of challenging steeps for expert riders to perform on.

FREESYLERS should be able to enjoy this place as much as any other style of rider. There a lots of big drop off's and plenty of natural hits for gaining maximum air. The resort also builds a halfpipe, but it's not very well maintained nor is there a decent terrain park to play in.

PISTES. Boarders have acres and acres of well groomed tracks to speed down with some sizeable runs that allow for carving from the top to the bottom. The longest run in the area is over six and a half miles long (11km) which will get the thighs pumping.

BEGINNERS can't fail here, the place has lots of good nursery slopes and plenty of easy to negotiate intermediate runs to try out once you have mastered the basics. Note though that Canazei may only have a few drag lifts, but the Dolomiti Superski area has over a 130.

OFF THE SLOPES. Canazei is town that has over 10,000 tourist beds with loads of hotels and apartments to choose from, and although there is plenty of lodging close to the slopes, this is not a cheap place. However, the town has loads of restaurants and bars offering some very lively nightlife.

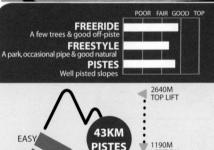

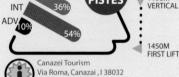

TEL: +39 (462) 601 145 WEB: www.fassaski.com EMAIL: info@fassaski.com

WINTER PERIOD: Dec to April LIFT PASSES 1 day 34 euros, 6 days 171 euros 6 Day pass for the entire Dolomite ski area 194 euros

TOTAL LIFTS: 29 - 4 Gondolas, 4 cable-cars, 14 chairs, 7 drags

LIFT TIMES: 9am to 4.30pm

ANNUAL SNOWFALL: 2.2m SNOWMAKING: 60% of slopes

BUS daily bus from train station

TRAIN to Trento, Bolzano and Ora are the nearest Car Main road to resort is the A22

FLY 3 hours from Munich airport. also close is Verona

CERVINIA

Amazing views but can frustrate

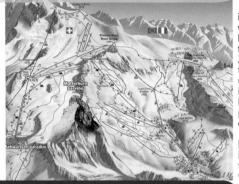

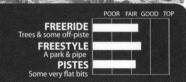

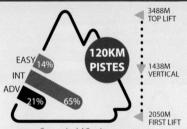

Consorzio del Cervino Via Guido Rey, I11021, Breuil-Cervinia. Asota TEL: ++39 (0) 166 9409 86

WEB: www.cervinia.it EMAIL: info@sportepromozione.it

WINTER PERIOD: Mid Dec to end April LIFT PASSES: one day 32 euros, 6 days 74 euros including Zermatt 42 (day) and 211 euros (6 days) **BOARD SCHOOL** Private around 30 euros hour

HIRE Board & Boots around 150 euros a week HELIBOARDING www.heliskicervinia.com run day trips for 360 euros for 3 drops. They also do 1 drop tasters for 100 euros.

NUMBER OF RUNS: 129 LONGEST RUN: 8km

TOTAL LIFTS: 20 - 2 Gondolas, 2 Cable-cars, 10 chairs, 6

CAPACITY (PEOPLE/HOUR): 28,500 LIFT TIMES: 8.30am to 4.30pm

ANNUAL SNOWFALL: 10m **SNOWMAKING:** 25% of slopes

TRAIN to Chatillon, which is 20 minutes away. BUS service from Milan Malpensa airport to Cervinia. www.savda.it run services from Turin aiport to Aosta twice a day, 6.3 euros.

CAR via Geneva, head south on the A40, via the Mont Blanc Tunnel. Then take the A5 for 27km and turn off at Chatillon on to 406 for 28km up to the resort

FLY to Geneva airport, 2 1/2 hours away. Milan Linate is 180 km. Turin Casselle is 118km away. Taxi services available from all airports.

Cervinia is set under the 4478 meters that is the Matterhorn. Truly one off the worlds most beautiful mountains, and if you can handle a walk you can board on its flanks. The town has a pleasant feel with a few poseurs mincing up a

down the main street but nothing too bad. The resort is placed near the top of the Aosta Valley, and links up with the extortionate resort of **Zermatt**, so if you want to board an exclusive resort without the cost then Cervinia's for you. One thing which is a real pain is the first run into Zermatt from Cervinia. It's flat, full of skiers poling along trying to take each others eyes out, and if the wind gets up the only way back is two long t-bar drag lifts. Although it's never been anti board it has been slow in making boarders feel at home, two year ago they opened a new park designed by Daniele Milano, and even sell a cheaper day pass just to access the park area 21 euros.

FREERIDERS. Cervinia is a fine place to board for the intermediate, it's a little flat in places to get the heart thumping of an advanced rider, and the novice may find themselves hopping along the flat a little to much to put up with. Seeing your mates disappear over that rise while you come to a halt is a quick way to piss off even the calmest of beginners. The pistes are well maintained and are easily viewed, so you can see the best spots from the, sometimes slow lifts. If you want off-piste then get your thinking head on and you can find some good routes. There's some great little spots and if you can't find them ask a local. If you get bored head over to Zermatt, or if you have the cash get a Helicopter.

FREESTYLERS will find the new Indian Park good for some big hits, the pipes ok and there's a few small hits to learn on. If you have a good look round you will find some good rock drops, find the right one and you could get a photo of you flying across the Matterhorn.

PISTES. Euro carvers will be get a little moist when they sit in their first chair over these slopes. There mostly wide and well groomed. The 22 km red run, Valtournenche, is the place to carve long and hard, while the blacks down into the village are cool. The pistes are never packed although they are busy during holidays.

BEGINNERS. The place to get your first bruises is up at the Plan Maison, which is reached by a cable-car. Once up be prepared to tackle some drag lifts in order to get to the easy flats, which also come with a heavy dose of ski schools. The runs rise up from the village at three main points and apart from a few areas, the lower sections are not beginner friendly, although there is a blue that leads down giving novices the chance to ride home.

OFF THE SLOPES. With fresh snow it almost feels like a real alpine town but as the snow melts so does its charm. There are some really uninspired concrete blobs which they call hotels but on the whole it's a pleasant enough place to stay.

The resort has some lively bars and a few reasonable piste side café bars, check out the Dragon for a beer or the dodge L'Etoile disco to check out the rich Italian skirt. Large tour groups do stay here, and are getting more common, but it has a good mix of nationalities so never feels mobbed.

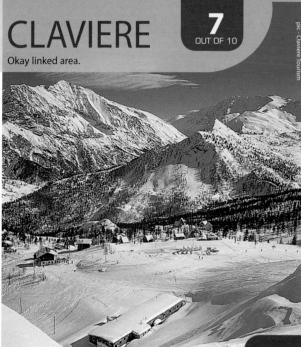

PISTES. Riders looking for long and wide open slopes will be happy to find that this place has lots of them. With the vast majority of the runs graded red or blue, carvers who like to glide around at a leisurely pace will love both Claviere and the rest of the Milky Way. But note, there are a lot of flat spots and some traversing is called for between runs, so expect some thigh burning moments.

BEGINNERS will have no problem coping with this place. Blue runs stretch from the summit's to the base areas allowing for some fine easy riding. But with seven drag lifts to contend with, getting around can be a bit tricky for drag lift virgins.

OFF THE SLOPES the resort is full of character and duty free shops. The village is not big and getting around the place is easy. The choice of lodgings is rather small, but options to sleep near the slopes are plentiful. Nightlife is very tame with only a few restaurants and bars to chose from.

Claviere is said to be Italy's oldest resort, and judging by its appearance its easy to see why, not that is look is a mark of what is on offer here. Because this happens to be a decent and popular resort that is just ten minutes away from the French resort of **Montgenevre**. Both resorts also form part of the ski circuit known as the Milky Way which offers over 400km of marked out pistes and takes in the resorts of Sauze D'Oulx, Sansicario, Sestriere and Cesana all of which are linked by an array of lifts totalling some 91, with a lift access height of over 2820 metres possible at Sestriere. Claviere has long been a popular resort and one that attracts a large number of skiers from all over Italy and from neighbouring France. This often makes the place very busy, especially at weekends, however, don't let that put you off, because once you get up on to the slopes, time spent in lift queues are generally minimal. Claviere, and its French neighbour Montgenevre, are just minutes apart and you can easily board between the two resorts on the same lift pass, which can also be used for the rest of the Milky Way circuit. The type of terrain is much the same where ever you choose to ride and in the main will favour intermediate freeriders the most.

FREERIDERS would be hard pushed to ride all of the terrain on offer here during a weeks visit. The slopes offer a good mixture of trees, off-piste powder and pisted runs. Advanced riders may only find a few decent black runs at Claviere, however, within the Milky Way circuit, there is an abundance of expert level terrain to try out.

FREESTYLERS Theres no park or pipe, so you'll need to head over the Sansicario. The area boast lots of good natural freestyle terrain where air heads can go high off banks and rollers dotted all over the place.

POOR FAIR GOOD TOP **FREERIDE** Some tight trees & good off-piste **FREESTYLE** No park or pipe but some good natural **PISTES** Lots of wide slopes 2300M TOP LIFT **50KM** PISTES 950M VERTICAL 1350M FIRST LIFT Claviere Tourism Claviere I 10050 TEL: +39 (122) 878 856 WEB: www.claviere.it / www.vialattea.it/en/

WINTER PERIOD: Dec to April

LIFT PASSES Day pass 32 euros, 6 days 125 euros
BOARD SCHOOLS Private lessons 1hr 34 euros
Group lessons 2hrs day for 6 days 100 euros

HIRE Board & Boots from 18 euros a day

NUMBER OF RUNS: 19 LONGEST RUN: 6km

TOTAL LIFTS: 11 - 4 chairs, 7 drags

ANNUAL SNOWFALL: 8m SNOWMAKING: 10% of slopes

BUS Everyday from Turin to Claviere and during weekends to Briancon

TRAIN Oulx station is near resort but you will need a bus from there which will take around 30 minutes

CAR A32 Turin to Bardonecchia to Frejus exit Oulx FLY 90 minutes from Turin airport, 97 km

ORTINA

Okay but dull village

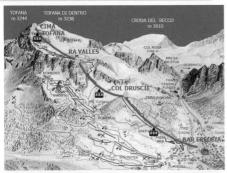

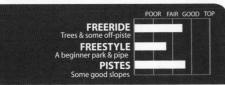

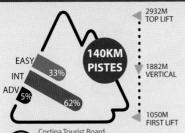

Pizza San Francesso, 8 Cortina d'Ampezzo TEL: +39 (0) 436 3231

WEB: www.dolomitisuperski.com/cortina www.dolomiti.org/dengl/cortina/

EMAIL: cortina@dolomiti.org

WINTER PERIOD: Dec to April LIFT PASSES:

Local area: 1 Day pass 37 euros, 6 Days 187 euros Dolomite Superpass: 1 Day 40 euros, 6 Days 202 euros

BOARD SCHOOL private from 36 euros/hr, 6 morning lessons from

NUMBER OF RUNS: 52 LONGEST RUN: 9km

TOTAL LIFTS: 51 - 6 Cable-cars, 29 chairs, 16 drags CAPACITY (PEOPLE/HOUR): 60,000

LIFT TIMES: 8.30am to 4.30pm

ANNUAL SNOWFALL: 4m SNOWMAKING: 90% of slopes

TRAIN to Calalzo di Cadore, which is 20 minutes away and served by a bus or taxi (041 936222) BUS Service from Venice Airport to Cortina run by www.atvo.it costs 10 euros and takes about 3hrs

CAR From the South take the A27 from Mestre to Pian di Vedoja (Belluno), take National Road 51 via Alemagna to resort From the north, from A22 Exit at Bressanone, take the road to Dobbiaco. From Bressanone exit to Cortina it takes about 1 hour. FLY to Venice airport 2 hours away 162km. 35min Helicopter to resort available www.heliair.it

Cortina D'Ampezzo is one of Italy's premier ski resorts. Situated just 2 hours drive north of Venice, Cortina is a popular weekend destination - try to avoid weekends here if at all possible. During the Christmas and New Year holidays it is overrun with the most fabulous of Italian glitterati.

When visited in early March however, Cortina was just a charming and friendly, if slightly dull, old school European mountain village turned ski resort, and a ski resort it certainly is as you won't find many other snowboarders on the mountain

The main problem with Cortina is the time spent on the lifts compared to the time spent riding. There was a new 6 man, high speed lift installed for the 2006 season, which carries an extra 1200 riders per hour, and speeds things up significantly. The best part of riding here (after the scenery) is the uncluttered slopes – get up to the top early and you have the slopes to yourselves. The early morning view from the top to the east down the Ampezzo valley is incredible - worth the visit in itself. Cortina is definitely not the motorway skiing of the big French resorts, but it can be fun, with well groomed slopes to suit all levels of rider.

FREERIDERS will find that the most challenging runs are located down from the **Tofana**, which rises to 3243m and is accessed by cable car. From the summit you'll find plenty of stuff to check out, offering some good powder riding. The terrain is varied, with steep pitches and nice rollers to jump off, but not many natural kickers. Tree runs abound at the lower elevations, and there are some good gullies to play in. Hire a guide if you want to snowboard off-piste here as the Dolomites are scraggy and craggy, the cliffs are big and are not signposted. Rugged doesn't begin to describe these mountains. That said, you could have a lot of fun off piste boarding here as there is a lot of terrain accessible from the lifts.

FREESTYLERS may not get man-made hits, but not to worry as there are plenty of natural ones with some cool drop offs and big banks to catch air from on both mountain sections. The Tofana area has the best stuff though. Cortina is not the resort to go to if you are looking for some freestyle action - the park is small with a small shallow pipe, one tabletop kicker and three rails. A good beginner park, but not much else going for the place freestyle wise.

PISTES: the Sella Ronda trail is definitely worth a visit, as is the Canellone which is a two planker's race run and the area to cut the snow in style, but not for wimps. The slopes in Cortina are well maintained, smooth and easy to follow. Some very steep sections, no flat "get out and push" sections which is a major plus.

BEGINNERS can progress here on good easy slopes, with the best stuff around the mid section of the Tofana. These can be reached by chair (rather than drag) lifts.

OFF THE SLOPES Cortina reflects its superstar status in the designer shops (Cartier, Prada and others), and accordingly it is very expensive, although some deals can be found. Eating in the centre of town is over priced with shoddy food and surly service, but get away from the centre and everything improves. The evenings are pretty boring here and the rich only make it very glitzy. However, it's not all gloom as you can spend the evening mocking the rich and mine sweeping their drinks: they won't even notice because they're too busy posing. Après ski seemed to consist of ski instuctors with bad tans drinking espressos - best avoided.

Great resort if you're not an adventurous boarder

Courmayeur lies on the opposite side of the Mont Blanc valley and only a stone's throw away from the top French resort of Chamonix which is a short drive back up through the Mont Blanc Tunnel. Courmayeur, a high level resort gives access to slopes that can be ridden by all and generally, this is a good place to spend a week or two. However, with its mixture of traditional Italian architecture and its modern resort offerings, Courmayeur is a destination that attracts millions of British skiers and other foreign nationals every year. They then copy their Italian counterparts by cladding themselves in horrid expensive ski wear and clogging up the slopes to often bursting point. The village is well spread out, but there is no real chance of leaping out of the nest, ollieing over a balcony and landing in a lift queue: you are going to have to do a bit of walking in order to take the cable car up to the slopes. The terrain will please intermediate carvers, but bore advanced freeriders. Be warned, every man and his dog hits the slopes at weekends and holidays. The main thing you notice is the amount of plate bindings and ski boots that there are about, as this is a carver's pose place, although many don't know what to pose in (ski boots are a no-no people). Top Italian female pro Martina Magenta hails from Courmayeur and can often be seen carving up the slopes.

FREERIDING here is pretty damn good, with some cool terrain to hit and the possibility of some trees to cut at the lower section. If it's powder and off piste riding you want, then Courmayeur is not the mega outlet like it's close French neighbour, but there is some good stuff to be had on steeps and trees down from the Cresta D'Arp. If you take the Mont Blanc cable car, you can gain access to the Vallee Blanche and ride into Chamonix. Although you will need to get the bus back, it'll be worth it.

FREESTYLERS here make do with the natural hits as there is no park or pipe to ride. You can however, get big

POOR FAIR GOOD TOP **FREERIDE** Some tree runs & good off-piste **FREESTYLE PISTES** Lots of wide slopes

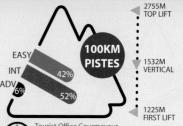

Tourist Office Courmayeur Monte Bianco, Pizzale 3, Courmayeur. I11013 TEL: +39 (0) 165 842 060

WEB: www.courmayeur.net / www.courmayeur-montblanc com

EMAIL: info@courmayeur.net

WINTER PERIOD: Dec to April

LIFT PASSES Half-day pass 28 euros, 1 Day pass 32 euros 6 Days 182 euros

BOARD SCHOOLS 5 days of lessons 110 euros HIRE Board & Boots from 25 euros a day

HELIBOARDING Contact Societa delle Guide de Courmayeur www.guidecourmayeur.com

NUMBER OF RUNS: 22 LONGEST RUN: 10km

TOTAL LIFTS: 18 - 1 Gondola, 4 cable-cars, 8 chairs, 3 drags, 2 magic carpets

LIFT TIMES: 8.30am to 4.30pm **MOUNTAIN CAFES: 10**

ANNUAL SNOWFALL: 7m **SNOWMAKING:** 15% of slopes

CAR Drive to Geneva via Mont Blanc Tunnel. Courmayeur 65 miles (104 km). Drive time is about 2 hours, *From Calais 563 miles (905 Km), Drive time is around 9 1/2 hours.

FLY to Geneva international or Turin which is also close.

TRAIN to Aosta then bus

BUS services from Geneva airport are available on a daily basis as well as from Milan and Turin.

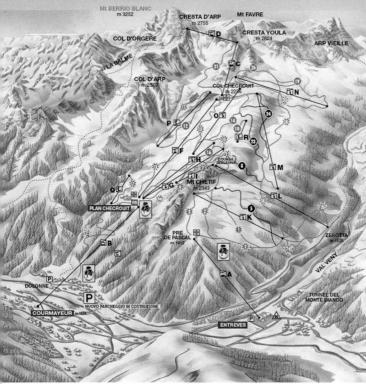

air and find enough to jib off, eg snow cannons, logs, stair rails, ski instructors, there's plenty. You'll also find plenty snow built up in lumps pushed to the side of runs or covering small trees and small mounts etc.

PISTES. Boarders who like to stay on the pistes will find loads of well pisted runs to content themselves with, especially the areas under the Bertolini chair lift.

BEGINNERS who decide to give Courmayeur a try won't be disappointed; it's a perfect place to learn, although the slopes can often be far too busy, leading to a few collisions. Novices should head for the runs off the Checrouit cable car, where you'll find some nice easy slopes to try out your first toe and heel side turns amongst the ski crowds, taking out the stragglers as you go.

OFF THE SLOPES, Courmayeur is a busy, stretched out place, with a lot going on. Most of the time the village plays host to package tour groups and although this helps to keep prices realistic, it does mean you have to rub shoulders with a lot of idiots. The village has a host of sporting attractions with the usual resort style swimming pools, ice rinks and fitness outlets. There is also an overdose of Italian style boutiques, selling expensive designer wear, but alas, there are no decent snowboard shops.

ACCOMMODATION is very good here. The town can sleep 20,000 visitors with lodging close to the slopes and in the town centre. You can choose to bed down in one of the hotels, or stay in one of the self catering apartment blocks which can accommodate large groups of riders. There is also a number of reasonably priced bed and breakfast homes to choose from

FOOD WISE, Courmayeur does a good job fattening up its visitors with the usual option to pig out in a few pizza restaurants. There are also a number of basic holiday tourist style eateries offering funny sounding traditional Italian dishes. However, you can eat reasonably if you stick to the lower end pizza joints such as La Boite, but if you're feeling flush and want to dine, check out Pierre Alexis.

NIGHT LIFE Courmayeur is late, loud and very boozy. Italians party hard here, but unfortunately so do a lot of apres skiers, who give the place a rowdy and low life feel to it. Popular places to check out are the Popas Pup, Bar

Roma or The Red Lion, all of which are lively watering holes with a young party style crowd.

SUMMARY

Not a bad place, with some good carving but basic freeriding. Great for beginners apart from over crowded novice slopes. Good local services. Overall this is an expensive resort but also a good value one.

FOLGARIDA ...

Okay alpine style resort

Folgarida is a fairly ordinary purpose built resort that links closely with the more famous resort of Madonna di Campiglio and the less famous resort of Marilleva. Collectively the area boasts 120 kilometres of lift linked piste, however, on its own Folgarida accounts for a small portion of the total area. Unlike many purpose built resorts in France and Italy, this place is not an ugly sham crammed with mountain tower blocks. What you get here is a well

pic -Folgarida Tour

balanced alpine style retreat nestled between trees and great scenery. This is also a place that attracts riders who like things easy and with out the hustle and bustle of the rather more stuck up neighbour of Madonna di Campiglio. Folgarida doesn't have a great choice of runs with only a few north facing easy slopes and almost nothing for expert riders apart from one black trail that runs down from the main gondola at the mid section. However, what this resort does have is a very good modern lift system that is able to whisk thousands of visitors up to its slopes and onto the neighbouring areas, all of which share a joint lift pass. This resort on its own, would only take two days of your time, but as the place links nicely with its neighbours, a two week stay would be well worth it.

FREERIDERS don't have a great deal of adventurous terrain to explore directly at Folgarida, however, close by there is plenty of scope for shredding in and out trees or for riding across good off-piste powder fields and down some bumpy slopes. Unfortunately expert riders are the ones who are mostly let down the most here with only a few of the slopes graded as black or difficult. Intermediates on the other hand have the largest share of runs to ride, with an array of red runs that crisscross all over the slopes of Folgarida and Madonna di Campiglio and a couple of long ones on Marilleva area.

FREESTYLERS. There's a pretty good half-pipe over at Marilleva in the Val Panciana area, otherwise you'll have to content with just natural hits dotted around the place.

BEGINNERS can come here knowing that they won't be disappointed. The resort is ideal for novices with an excellent selection of easy runs to try out, including good nursery areas that can be easily reached but are serviced by drag lifts.

OFF THE SLOPES

Folgarida is low key alpine resort with a good choice of local facilities all within walking distance of the slopes. There are affordable hotels, apartment blocks and chalets as well a few shops and an outdoor ice rink. Eating out and night life are both very low key but enjoyable none the less.

192 US www.worldsnowboardguide.com

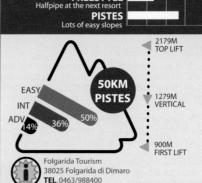

Trees, but very little locally

FREESTYLE

WINTER PERIOD: Dec to April

LIFT PASSES Half-day 22.5 euros, 1 day 27.5 euros 6 days from 134 euros

BOARD SCHOOLS 2 ski schools will give boarding lessons

HIRE a few shops, arond 20 euros a day

NUMBER OF RUNS: 31 LONGEST RUN: 3km

WEB:www.ski.it

TOTAL LIFTS: 26 - 6 Gondolas, 5 chairs, 15 drags LIFT TIMES: 8.30 to 4.30

ANNUAL SNOWFALL: Unknown SNOWMAKING: 90% of slopes

BUS Dolomitibus tel 0039 437217111

TRAIN Trento 28 km Rovereto 18 km both with bus conections

CAR A22 Brennero Motorway exit Trento Centro, then along Fricca ss349
FLY 2hrs minutes from Verona airport. North is Bolzano airport.

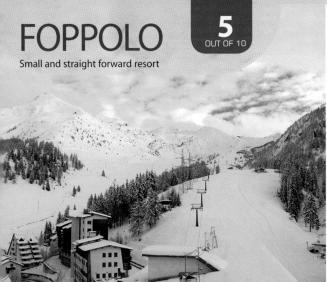

POOR FAIR GOOD TOP

Foppolo is a simple resort that will appeal to visitors who like crowd free slopes but slopes with good annual snow fall. Like many purpose built resorts, Foppolo, which dates back as a ski resort many many years, is located at the foot of the mountain. As a purpose built resort, access to the slopes is easy and convenient with riding spread out over a number of connecting mountain areas with riding up to the summit of Montebello at 2100m and down to the small hamlet of Carona at 1100m. Much of the terrain on offer here is rated evenly between beginners and intermediates with only small amount of black advanced grade slopes. Despite the lack of challenging terrain, this is still a cool Italian hangout with out to many ski crowds messing up the slopes. Foppolo, has some 20 pisted runs serviced by a dozen lifts which are mainly drag lifts. The resort also links up with that of San Simone, but you need to take the 15 minute shuttle

bus to reach its slopes as it doesn't link directly on snow. However, all the areas share a lift pass. Where ever you ride, what you will notice is the simplicity of the place and the ease in which to get around. You will also notice that the resort staff work hard at keeping the slopes well pisted and covered in artificial snow, when its needed, which is quite often.

FREERIDERS should be advised that this is not the most interesting place in terms of the diversity of terrain features. Much of the riding is set well above the tree line, however, there are some really nice bowls to shred through and a few okay off-piste spots to try out. From the summit point of Montebello, which is reached after a long drag lift ride, you can ride down a number of fast black trails that wind down a steep mountain face and are not to be taken lightly or you will end up in pain. At the bottom you can either elect to go back towards Montebello, or head on up in the opposite direction to the slopes of Carona where you will be able to try out a few more black runs.

FREESTYLERS won't enjoy this place that much. With no park or pipe air heads are left to either make their own hits or finding natural ones.

PISTES. Riders who like long and wide open runs will find a number to keep them occupied with a few nice reds to check out and some long easy blues.

BEGINNERS have lots of easy runs to learn on starting with the nursery slopes which rise up directly from the resort centre. The first main cluster of blue runs are reached via a long chair lift which can be used to reach most of Foppolo easy runs. Access to Carona on snow is not possible for total novices.

OFF THE SLOPES Accommodation in the resort is basic but convenient with lodging close to the slopes. The resort has a few shops, an ice rink, a few restaurants and a splattering of bars, but don't expect any happening nightlife.

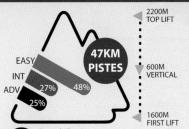

FREERIDE

FREESTYLE

no park or pipe

Some easy slopes

PISTES

A few trees & some off-piste

Foppolo Tourism
TEL +39 345 74315
WEB: www.foppoloski.it
EMAIL: info@bremboski.it

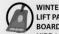

WINTER PERIOD: Dec to April LIFT PASSES: 1 day 23 euros, 2 days 37,6 days 95 BOARD SCHOOLS 4 ski schools in town HIRE Available in town

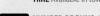

NUMBER OF RUNS: 23 LONGEST RUN: 2km TOTAL LIFTS: 12 - 4 cha CAPACITY (PEOPLE/H

TOTAL LIFTS: 12 - 4 chairs, 8 drags CAPACITY (PEOPLE/HOUR): 10,000 LIFT TIMES: 8.30am to 4.30pm

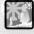

ANNUAL SNOWFALL: Unknown SNOWMAKING: 25% of slopes

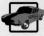

BUS Services available from Bergamo and Milan. CAR From Bergamo (58Km) head to Valle Brembana, then head towards Piazza Brembana untill you reach a crossroad. Turn right and follow to Foppolo.

108km from Milano **FLY** 2hrs from Verona or Milan airport.

LA THUILE

7 OUT OF 10

Okay freeriders resort with some nice powder spots

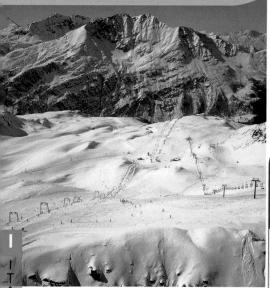

La Thuile links up with the French resort of La Rosiere to create the Espace San Bernardo, which together make up 150km of piste. The town of La Thuile sits at the head of the Aosta valley just down the road from its more famous cousin Courmayeur, but unlike its neighbour, it is a far quieter resort. The most annoying thing about La Thuile is its piste grading, reds should be blues and blue really means uphill. The longest run in the resort is No 7 which is graded red and starts at Chaz Dura 2579m. The run winds it's way down a secluded picturesque valley and is great if you want to get away from everyone, the last half of the run is on a road and you end up boarding past crossing cow signs, but a red you've having a laugh, you have to walk a good 2 of it's 11KM.

The village is a mix of old and new, the old part straddles a small river and has a few good bars and some cheep eats, while the new part is a bit soulless, the locals are friendly and really welcoming and there's also one or two hotels open to the public with their own sporting facilities, such as a swimming pool, gym and saunas.

Although La Thuile is only at 1441m a fast cable car takes you up to the Les Sucres area at 2200m, from here down to resort are some very steep blacks, while above are a number of runs which mostly lead back to the same place, via a long flat run out, which will infuriate people with only a few weeks under their belts. La Thuile looks after its pistes well, which are wide and flat - often too flat, the lift system is modern and efficient which makes waiting in line extremely rare. La Thuile is fine for a cheap week with a group of friends of mixed abilities, but don't head here if you want a week of hard core boarding.

FREERIDERS have some good black runs to try out: the **Diretta** (which runs through the trees) is full on and will test those who think they know it all. There's also some

cool freeriding to be had on the La Rosiere side, while those looking for off-piste will find it off the San Bernardo chair. However the real off-piste is best tackled by going heliboarding so dig deep into those pockets and take to the skies.

FREESTYLERS will find an abundance of natural hits dotted around both La Thuile and La Rosiere, but you will have to look for them. There's also plenty of space to build jumps so take a shovel. There is neither park nor pipe, so if that's you thing you maybe best off holidaying elsewhere.

PISTES. Riders have a variety of great pisted slopes for laying out big carves on and most can be tackled at speed without having to negotiate too many sightseeing skiers.

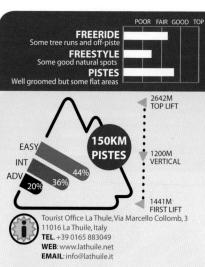

WINTER PERIOD: Dec to April

LIFT PASSES 1 Day pass 33 euros, 6 Days pass 182 euros Season 640 euros

BOARD SCHOOLS 1 hour private lesson from 35 euros

5 day snowboard course 125 euros (2 1/2hrs per day)

2 1/2hr group lesson 36 euros

HIRE Board & Boots 15 euros a day

or 65 euros 6 days

HELIBOARDING Scuola di la Thuile 4-7 people you go to Testa del Rutor @ 3486 meters and board down to 1200 meters

NUMBER OF RUNS: 74 LONGEST RUN: 11km

TOTAL LIFTS: 37 - 1 cable-cars, 17 chairs, 17 drags, 2

magic carpets

CAPACITY (PEOPLE/HOUR): 53,000 LIFT TIMES: 8.30am to 4.30pm MOUNTAIN CAFES: 9

ANNUAL SNOWFALL: 5m SNOWMAKING: 23% of slopes

CAR to Geneva via Mont Blanc Tunnel. La Thule is 76 miles (122 km). Drive time is about 2 1/4 hours. FLY to Turin and take a bus. Geneva international. Transfer time to resort 2 1/4 hours.

TRAIN to Pre-St-Didier (3 miles).

BUS services from Geneva airport are available on a daily basis. Check out www.savda.it, services run twice daily to/from Milano Malpensa and take 3hrs

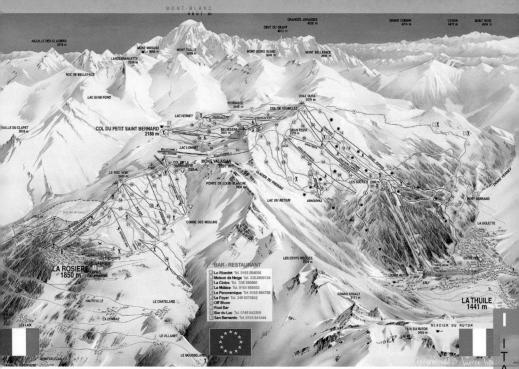

BEGINNERS need to know that apart from a couple of small nursery slopes at the base, the main easy runs are located above the Les Suches area, which is served by chairlifts rather than all drags. Learners will not be riding back into the village as it involves too much steep, but you can get the cable car back down. There are many board schools but try to find a BASI trained one as the local lads spend more time looking good than helping you get to grips with your first turns.

OFF THE SLOPES. La Thuile is finally reached after a short drive up twisting and winding mountain road. On arrival, you are presented with a scenic and old Italian village with a hint of the new here and there. The main happenings are conveniently at the base of the slopes and straddle a large river. Visitors are made very welcome in La Thuile and local services cater very well for all your needs. Around the village you will find a few shops, places to pig out and one or two

hotels with their own sporting facilities, such as a hotel swimming pool, gym and saunas. But other than that there is nothing major going on. Snowboard hire is best done from Ornella Sports +39 (0) 165 844 154.

ACCOMMODATION. La Thuile is a relatively small resort with around 3000 beds, bunks or other things on which to kip on. However, what is there is quite sufficient for a weeks stay with the option to lie out horizontally in a bed on the slopes or within a short walk of the first lifts. A number of tour operators offer full holiday packages here, so some

good package deals are available.

FOOD. As for eats, you can get all the usual Italian dishes here along with a selection of standard grade euro nosh. However, your choice of where to eat out is a bit limited on the whole. Still that said, what is offered is good and you can eat very well here on a low budget. Restaurants of note are that of *La Rascards* for a choice of local dishes, or *La Grotta* which is known for its slices of pizza and pasta, although not the cheapest of places and the Mexican's not bad.

NIGHT LIFE in La Thuile is very tame by Italian standards, so if you're the sort that likes to party hard all night long, this is not your resort. La Thuile is a very relaxed place and there is nothing much going on. Any so called action seems to be as the lifts close. Still you can enjoy a beer in the *La Bricole bar*.

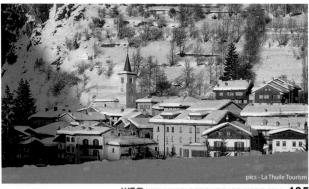

LIMONE

Quiet resort, some good freeriding when it snows.

Limone is located south of Turin and only a short distance from the French and Italian border, Limone is a traditional Italian town with a past that involves the railways. Today however, this relatively unknown holiday destination is a simple place that attracts summer and winter tourists all year round to sample its holiday attractions which include great mountains. The old sprawling town sits at the base of an impressive set of high peaks, with the 2344 metre summit of the Cima Pepino Mountain well within sight. The place is not widely known as a ski or snowboard destination outside of Italy which can be a bit of a blessing as the place is not tainted with mass package ski tour groups. But on the down side, not being the most popular of places can often mean a lack of on-going resort development. Still, this may not be a big fancy resort boasting loads of steep

challenging slopes, but you can nevertheless have a great time riding on slopes that can fill up with weekend visitors but are empty during the mid week periods. This is a simple resort that is suited to intermediate riders with very little to offer expert riders. Advanced riders will find some interesting terrain, but it won't take more than a few days to ride-out. The one big draw back about Limone is its annual snow record. Its fairly close proximity to the Mediterranean Sea means that this is not a resort blessed with heaps of regular snow.

FREERIDERS have a cool mountain to explore and should find Limone a pleasant surprise. There is a good choice of areas to ride that offers, tree riding, lots of gullies and uneven trails to descend down. Expert riders will find the Olimpica run a pleaser.

FREESTYLERS will be pleased to hear a small park was built a couple of seasons ago in **Limonetto** next to the San Lorenzo piste. On a good day and when theres enough snow you'll find a couple of kickers and some rails.

PISTES riders who usually prefer miles of perfect well groomed trails may be a bit disappointed. Most of the main runs are a bit choppy and not great cruising trails; that said you can still carve here.`

BEGINNERS might well find that this resort is not for them. There are some good novice slopes but they are very limited and serviced by a host of drag lifts.

OFF THE SLOPES, Limone is an old town located within easy reach of the slopes. The town offers basic but affordable facilities with a good choice of hotels, apartment blocks and some bed and breakfast homes.

POOR FAIR GOOD TOP FREERIDE A few trees & some off-piste **FREESTYLE** small terrain park **PISTES** Not well groomed but still okay 2085M TOP LIFT **80KM** PISTES 1075M VERTICAL 1010M FIRST LIFT Assessorato al Turismo Comune di Limone Piemonte, Via Roma 30 TEL, 0171 92.95.15 WEB: www.limonepiemonte.it EMAIL: iat@limonepiemonte.it

WINTER PERIOD: Dec to April LIFT PASSES Half-day 22.50 euros 1 Day 29, 3 days 76, 5 days 111, Season 590

LONGEST RUN: 6km TOTAL LIFTS: 20 - 9 chairs, 11 drags LIFT TIMES: 8.30 to 4.30

NUMBER OF RUNS: 46

ANNUAL SNOWFALL: Unknown SNOWMAKING: 15% of slopes

TRAIN services are possible to Limone Piemonte on the Torino-Cuneo-Ventimiglia (Nizza) line www.trenitalia.it CAR From Turin take the A6 towards Savona for 62km, then take the Fossano exit and continue for another 50km

FLY to Turin airport which is 1 1/2 hours away.

LIVIGNO

amazing park, open terrain, cheap - an excellent Italian job.

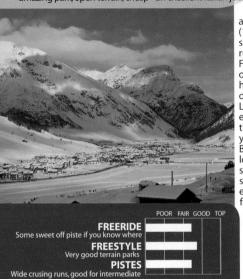

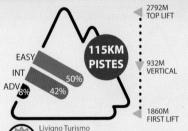

Via Dala Gesa 407a, I-23030 Livigno (Sondrio)

TEL. +39-0342-05.22.00 WEB: www.livignoweb.com EMAIL: info@aptlivigno.it

WINTER PERIOD: Dec to April LIFT PASSES Half-day pass 24 euros 1 Day 33 euros, 6 days 163 euros, Season 515 euros

NUMBER OF RUNS: 73 LONGEST RUN: 3.5km

TOTAL LIFTS: 33 - 3 Gondolas, 14 chairs, 16 drags LIFT CAPACITY (PEOPLE PER HOUR): 46,460

LIFT TIMES: 8.30 to 4.30

ANNUAL SNOWFALL: 2.5m SNOWMAKING: 15% of slopes

BUS from Tirano to resort via Bormio visit www. busperego.com for more info. Can also take a bus from the train station at Zernez www.silvestribus.it

TRAIN from Milan to Tirano-Ferrovie dello Stato, www. trenitalia.com. From the North take the Rhätischer towards

Kloisters and get off at Zurigo and take a bus

CAR via Milan, head north via the towns of Lecco, Sondrio and then heading up the A29

and turning of left at La Rosa and on up to Livingo. 220km total FLY to Milan airport 3 1/2 hours away.

Bergamo Oria Al Serio Airport is 45 km from Milan

Pissed off paying £5 + for a post boarding beer? Want to escape the fur coat brigade? Want to ride decent terrain without breaking the bank? If you answered YES to these questions, than Livigno is the place to head this season. Situated in the northern Italian Alps,

Livigno is a great place for snowboarders of all levels and disciplines. The town is essentially one long road (10km) running through a valley, with pistes on either side. The pisted terrain is very open, with wide motorway runs making it perfect for beginners and intermediates. For more advanced freeriders there are easily accessible off piste areas, and if you are willing to break sweat and hike for half and hour or so, you can reach some beautiful open powder fields, on both sides of the valley. Cost wise, Livigno is dirt cheap. Being a duty free zone means that everything from booze to boards is cheaper here than the rest of Europe. A 1L bottle of Smirnoff Vodka will set you back a measly £3, a half litre bottle of beer just 40p. BUT, don't be fooled, Livigno's low prices doesn't mean low quality; far from it, this is a top notch location. The lift system is modern, with high speed guads and gondolas servicing the majority of slopes, the passes are the new electronic style, which means there's no wasting time fumbling around in pockets, and frequent free ski buses run up and down the length of the town every fifteen minutes or so, connecting the valley together.

FREERIDERS with some history are not going to be too tested here, although the black down from the Della Neve is worth a go and should appeal. There's some nice bowls to ride if you're prepared to hike for a little while, but some areas may take you a long way from the resort so if you want to find the best spots hire a guide. The trees here are not the best either as a lot of the area is above the tree line.

FRRESTYLE. For the freestyling park monkey, Livigno should already be on your radar. The Burton European Freestyle Open competitions have been held here in the past, and as a result the parks are awesome. There is an expert park, with monster sized cheese wedges, and for those slightly less insane in the membrane, the intermediate park sits right next to it. Complete with a boarder cross track, a half pipe, several table tops, a fun box, and over ten rails of varying shapes, lengths and difficulties, this place is a jib monkey's dream play ground. Well maintained with a great atmosphere, freestylers can happily ride here until they're back in hospital nurturing broken bones. There is a small park entrance fee (5 Euors for 3 days), but if you just ride in confidently, you can get away without coughing up.

PISTES. The total pisted terrain is not huge and intermediates can cover it all in about three days, however there is plenty of wide motorway runs, perfect for cruising.

BEGINNERS will find this resort perfect for learning, with wide gentle runs located at lower sections which are easy to reach. However, slow learners may struggle with the numerous drags.

OFF THE SLOPES. The architecture of the town is beautiful; no ugly concrete apartment blocks here, everything is built chalet style. Plenty of cheap pizza and pasta joints, and on-slope fodder is great value too with a burger, sandwich or panini costing around just £2 a pop. The great value of Livigno attracts a young crowd who come to party, so during high season expect a rowdy time in the various bars and clubs.

Good overall resort

Madonna Di Campiglio is one of the best resorts in the Dolomites and thankfully not tainted with too many cheap ski package tour groups, which helps to keep lift queues to almost zero. The pistes are relatively crowd free, although should be said that Madonna does attract some of Italy's finest clientele. This well established ski haunt has now become a snowboarder's favourite, one that is trying really hard to satisfy boarders and it has to be said that it does a fairly good job. The old International Snowboard Federation used to stage a number of top

ALL BRINE VAL D AGOLA

MENTE SPINALE

VAL D AGOLA

MANDEN TO MENTE SPINALE

VAL D AGOLA

MANDEN AD CAMPICETO

13

MADDAN AD I CAMPICETO

13

MONTE WOO

MONTE SPINALE

10

10

12

13

MADDAN AD I CAMPICETO

13

MONTE WOO

MONTE W

events in Madonna, attracting many top riders. It's not just the snowboarding they come for, the parties go off as well, with top bands and DJ's playing at the side of the half-pipe. The ride area, which rises up around the resort, is linked with Folgarida and Marillea, giving a combined coverage of over 100 miles of extremely well groomed trails and some good off-piste. Much of the terrain will suit riders who are just getting to grips with their style and ability, but advanced riders with a few years under their belts will find it a little unchallenging in places, but still okay.

FREERIDERS should check out the areas at Spinale, where you'll find some good powder spots and some nice tree sections to blast through lower down. Fortini also offers a testing time.

FREESTYLERS like this place a lot and not just for the mega halfpipe (when an event is on) or the Ursus park located in the **Groste area**. For those who like their hits natural, there are plenty of snow walls and steep hits to get air from. Having said that though the Ursus park is usually well maintained by the crew and features a few massive kickers as well as a beginners area with some smaller jumps, rollers, and rails.

PISTES. The race run normally set aside for ski races, is the place for competent riders who want to show skiers how a mountain should be tackled at speed and with only two edges.

BEGINNERS will find Madonna is one of the best first timers resorts around, with lots of well set out easy runs, allowing for easy access and quick progression to more difficult terrain.

OFF THE SLOPES. The town has plenty of eating and sleeping options, with affordable places to sleep close to the slopes. Around the town, there are heaps of things to do with a whole manner of attractions such as ice speedway circuit and waterfall climbs. At night, things can get very lively, going off big style and lasting well into the early hours of the morning. There is a good choice of bars and clubs but they are all a bit pricey.

198 WSG WWW.WORLDSNOWBOARDGUIDE.COM

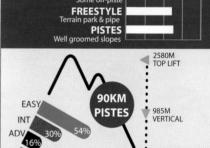

FREERIDE

A vi

Azienda per il Turismo S.p.A. via Pradalago, 4, 38084 Madonna di Campiglio (TN) TEL: +39.0465.442000

1520M FIRST LIFT

WEB: www.campiglio.to EMAIL: info@campiglio.net

WINTER PERIOD: Dec to April LIFT PASSES Half-day 27 euros 1 Day pass 35 euros, 6 days 170 euro

1 Day pass 35 euros, 6 days 170 euros NIGHT BOARDING 1 illuminated run NUMBER OF RUNS: 35

LONGEST RUN: 3.7km

TOTAL LIFTS: 20 - 4 Gondolas, 1 Cable-car, 12 chairs, 3

LIFT CAPACITY (PEOPLE PER HOUR): 31,000 LIFT TIMES: 8.30 to 4.30

ANNUAL SNOWFALL: Unknown SNOWMAKING: 50% of slopes

BUS For bus services from Trento visit www.ttspa.it **TRAIN** services are possible to Trento which is around a 25 minute transfer.

CAR via Verona, go north on the A22 to the Mezzocorona Jct. Then take the A43 north and A42 south turning off at Dimaro and on to Madonna along the A239.

FLY to Verona airport 2 1/2 hours away 150km.

PASSOTONALE

Some fine terrain but limited for expert riders

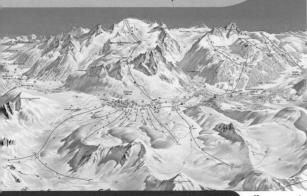

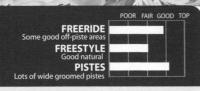

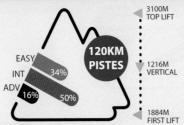

Passo Tonal Tourist Office -38020

TEL: 64 903 838 WEB: www.passotonale.it / Ski area: www.adamelloski.

EMAIL: tonale@valdisole.net

WINTER PERIOD: Dec to April LIFT PASSES Adamello linked area Half-day 24 euros, 1 Day 37 euros, 6 days 188 euros, season 550 euros

LESSONS Scuola Italiana run a 5 day course (2hrs per day) 87 euros. Private lesson 30 euros per hour

NUMBER OF RUNS: 41 LONGEST RUN: 4.5km

TOTAL LIFTS: 30 - 3 Gondolas, 19 chairs, 8 drags

LIFT TIMES: 8.30 to 4.30

ANNUAL SNOWFALL: Unknown **SNOWMAKING:** 40% of slopes

TRAIN to Male of the Trento-Mali Electric Railway, Passo Tonale can be easily reached by regular bus service. The nearest station of the State Railways is Mezzocorona. CAR A22 super highway then SS43

From Milan or Turin A4 exit at Seriate then follow signs Verona 163km 3 hours away. Milan 250 km 4.5 hours

Tonale is a high altitude resort perched in a wide open expanse that is both snow sure and sunny. Without doubt this a cool place to visit, a resort that is both old and new in terms of the village and its development. The resort is constantly improving and subsequently becoming more and more popular. However that popularity isn't a problem, lift queues are almost non existent and the pistes never become cluttered up , leaving lots of wide open runs to free of crowds. During the winter months Tonale gets a good share of snow and should the real stuff be lacking then the resorts snowmaking facilities can cover over 60% of the marked out pistes. Should you want to do some summer riding then this place can also accommodate you with good riding possible up on the nearby Presena Glacier in the summer months. You can reach the glacier from Tonale by cable car, but the glacier only opens in the winter if the snow on the lower areas is lacking. Tonale

offers great intermediate and beginner level riding with options to ride a long tree lined run between Tonale and the nearby resort of Ponte di Legno, although note that you can ride to Ponte di Legno, but you have to get a ski bus back. Both resorts share a joint lift pass, which is a modern hands free system whereby you pass through the lift gates with your pass still in your pocket. The lifts themselves are equally split between chair and drag lifts along with a cable car. All the lifts link well and even novices can get around with out having to use too many drag lifts.

FREERIDERS who like wide open pistes with long sweeping runs will love this place, but for those who crave steep gullies and like tight trees you will not be so impressed, but what ever your into, this is a good freeriders resort. There are excellent freeriding opportunities from the top of the gondola. There is a great backcountry valley to ride and a lovely reasonably steep couloir if you don't mind a bit of hiking. The locals say that you need a guide, but all you really need is a bit of mountain sense and some basic backcountry kit.

FREESTYLERS will need to make do with hitting natural jumps or building their own. There are however, lots of cool jumps including a number of drop-ins of rock sections and lots of cool snow banks to fly high off.

CARVERS have a mountain that is simply fantastic. The wide open motorway style piste will let you ride fast and wide across runs that make carving a total joy. The 4 km trail to Ponte di Legno is a cool trail while the 3 km race runs will test the best.

BEGINNERS who are unable to learn how to ride here can only be described as stupid because this place is one of the best resorts in Italy for novices. There are loads of easy to negotiate blue runs spread out over wide pisted areas with lots of nursery slopes all located close to the village centre.

OFF THE SLOPES. Tonale is a laid back resort with good hotels and apartment blocks. Around the village you will be able to get a cheap bed, a decent meal in one of the many restaurants, and have a simple but cheap night out.

PILA

Great for intermediates and mixed groups

Set in the **Aosta valley, Pila** is a great if little place. The Aosta valley in the north of Italy has the Chamonix tunnel at its head. As you drive towards France up the valley from Turin you pass a load of resorts of which Pila is the gem, well maybe the precious stone. Pila is set at 1800 meters amongst a large pine forest, all the runs are separated by trees and most are wide, giving you the feeling of having the mountain to yourself. If you're driving your own car, on a day trip, park in Aosta town and catch a very long gondola up to the purpose built village of Pila. If you want to drive right into resort,

be ready for a long slow climb, full of hairpin bends. The resort is often full of British school groups taking advantage of Italy's cheep prices (in comparison to France) and wide un-crowded piste's. The school groups can clog up the mountain cafes at lunch time with young girls trying to impress their ski instructor, but once on the slopes they soon blend in with everyone else. This resort offers fantastically varied terrain, great for intermediates and fine for both beginners and advanced riders. One problem with the resort is you keep finding yourself returning to the same Gorraz- G Grimod cable car area, which in high season can lead to long queues.

FREERIDERS. If you want to have it down the piste at full speed laying down some fat carves then this is the resort for you. Most of the piste's are wide and well groomed No 14 (Pre Noir) has a great pitch with a couple of drop offs leading to a few tight bends and No2 (Du Bois) good if you like it a little steeper. From the Couis 2 chair there are lots of places to drop in on an off piste face. If you don't mind a long walk then get your transceivers on and head off on one suggested Ski Mountaineering routes on the piste map. The trees are tightly packed but if you don't mind a few false starts you'll eventually find a route to hack it through the forests.

FREESTYLE. A short hop from the top of the La Nouva chair is what's described as a fun park. There's a small half pipe and a couple of rails but it's not well maintained. Pila is full of natural hits and ample space to build a kicker or two also the top right hand side of No15 (Grimod) has a natural half pipe which you can fly out of rather than back into.

BEGINNERS. After the first few bruises you pick up on the blue to the right of the cable car serviced by a comfortable chair Pila is you're oyster. With only one drag lift Pila's lift system is easy to negotiate and the runs wide and well groomed. There are many English speaking instructors.

OFF THE SLOPES. The Town has no real centre and the night life's of your own making it aint no party town. The resort is purpose built but done well and although not pretty it doesn't impose itself to much on the mountain. Accommodation is often piste-side and mostly contracted to travel firms.

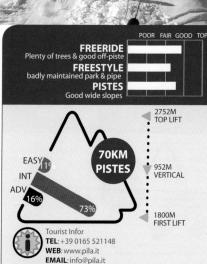

pic Pietro Celesia / Pila Tourism

From the dola in P

NUMBER OF RUNS: 21 LONGEST RUN: 4.3km TOTAL LIFTS: 14 - 3 Gondolas, 1 Cable-car, 9 chairs, 1 drag LIFT TIMES: 8.30 to 4.30

LIFT PASSES Half-day 20 euros, 1 day 29, 6 days 162

PILA SKI SCHOOL: 5 day snowboarding lessons (20hrs

RENTAL Board & boots 18 euros per day Lessons

ANNUAL SNOWFALL: Unknown SNOWMAKING: 30% of slopes

WINTER PERIOD: Dec to April

total) 145 euros. Private lessons 30 euros per hr

GUIDE 100 euros per day

BUS Take the autostrada coach from Turin or Milan to Aosta. The 'Freccia delle nevi' service runs weekdays during winter from Bergamo, Milan and Genoa TRAIN From Turin or Milan to Aosta via Chivasso

From the railway station: 5 minutes on foot from station to gondola in Pila (20mins)

CAR From Turin take motorway A5 towards Aosta (99km) Exit Aosta Est, then follow the regional road in the direction Pollein-Charvensod-Pila.

FLY Turin 3 hours away. There is a small airport at Aosta

Prato Nevoso is a relatively unknown resort, yet this small and very friendly place has been operating as a ski resort since 1965, although not by any stretch of the imagination a big or adventurous hangout. Although Prato Nevoso is not a big or adventurous hangout, it is still good with some nice terrain that will please intermediate carvers and bring a smile to the face of all novices. Prato Nevoso is located close to the French border, only a stones throw from the Mediterranean sea in the southern part of the

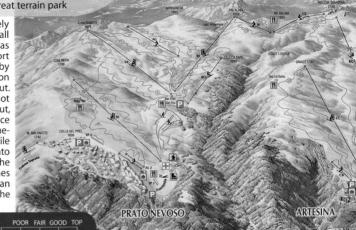

FREERIDE A few trees and some off-piste **FREESTYLE** Terrain park & pipe **PISTES** Well groomed slopes

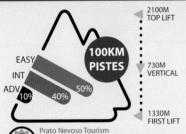

Piazza Mirtilli 25-12083, Prato Nevoso

TEL: +39 (0) 174 334 130

WEB:www.pratonevoso.com / www.pratonevososki.it EMAIL: associazione turistica @pratonevoso.com

WINTER PERIOD: Dec to April LIFT PASSES Half-day 18.5 euros 1 Day 26 euros, 6 Day pass 126 euros NIGHT BOARDING Open until 11pm, terrain park and

BOARD SCHOOLS Private 30 euros per hour, Group 2hr/6 days 120 euros

NUMBER OF RUNS: 16 LONGEST RUN: 4.5km TOTAL LIFTS: 30 - 10 chairs, 20 drags LIFTS CAPACITY (PEOPLE PER HOUR): 9,500 LIFT TIMES: 8.30am to 4.30pm

ANNUAL SNOWFALL: 6m **SNOWMAKING:** 7 Snow Cannons

BUS Weekends from Mondovi, 09.00 & 15.15 to Prato FLY to Turin airport which is 1 hour away. TRAIN to Mondovi, 30 minutes from resort.

www.trenitalia.com

CAR via Turin, head south on the auto route A6 and turn off at signs for Mondovi. From here follow the signs to the resort. Total distance 62 miles (100km).

Alps. Despite its proximity to warm areas, this is an area with a good annual snow record with heavy snowfalls throughout the winter months. Since its birth the resort has constantly improved its facilities and is currently working on plans for new lifts which will greatly improve access and acreage of rideable snow. On its own, Prato Nevoso is tiny with only 30km of piste, however, being linked with the resort of Aresina, the rideable acreage rises to a respectable 100km plus. Lifts join to two resorts to form an area know as the 'Mondole Ski' which offer a splattering of trees, some nice powder and wide open slopes.

FREERIDERS are presented with an area that will please those who like their mountains hassle free. There is option of going off piste by hiking with a pair of snow shoes and the resort publishes a 'Free Ride' map to help you find the best spots. You can get further advice from the local snowboard club (details available from the Surf Shop Prato Nevoso).

FREESTYLERS are well catered for with a good floodlit terrain park of the Seggiovia lift, which packs in not only a series of killer hits, but also a halfpipe and a permanent boardercross circuit.

PISTES are well maintained, wide and sweeping, free of any rocks and uneven obstacles.

BEGINNERS have a resort that is perfect for them in every way with a good number of easy to reach novice runs.

OFF THE SLOPES. Lodging and local services are based around the mountain with a number of hotels offering direct slope access. Overall, this is not an expensive resort unless you want it to be. You can bed down in the pricey Hotel Galassia or flake out in one of the inexpensive apartments. The village has an array of amenities from a pharmacy, to a mini golf course. There is also a number of okay restaurants, bars and nightclubs to check out.

ROCCARASSO

5 OUT OF 10

Overall okay, but basic

East of Rome in the region of Abruzzo, lies mountain range of the Apennines. This range is home a number small areas collectively titled Roccaraso which was moulded into a ski resort in the 1950s and has

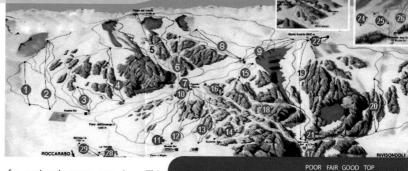

been something of a national secret ever since. This place doesn't show up in your average travel brochure and due to this you don't find many foreigners here. In fact, during the week you might find it very quiet on the slopes, but at the weekend, expect a deluge of Romans and Neapolitans sporting the most lurid all in one ski suits and large lift queues. There is nothing really challenging here, especially if the lack of altitude results in a lack of snow. However, the pistes are well maintained, and anyone who does find themselves in a lift queue can at least have fun mocking skiers in an array of sad outfits.

FREERIDERS will find a range of terrain to cover. Pistes are varied but will suffice more for those in the beginner or intermediate category than for advanced riders. There's little in the way of natural hits or off piste powder fields, but the low altitude means there are plenty of trees around (ie; Monte Pratello). Many of these are tightly packed though, and as such, inaccessible to many.

FREESTYLERS are blessed with two parks (off lifts 1 and 22) if there is enough snow out of which to build them or if the pisteurs can be arsed, whichever comes sooner. Otherwise take your shovel and build yourself a kicker or two.

PISTES. Speed heads will revel in the knowledge that the pistes are kept well groomed and that there's not a mogul in sight. There are a few steep runs available and many of these are pretty wide.

BEGINNERS will find this a great place to get started. Plenty of easy runs on the lower slopes mean that you don't have to take the lift to the top to find what you need. There are gentle runs down from most of the lifts, however, the majority of the reds aren't over threatening so these will be handy as you progress.

OFF THE SLOPES. The good news is that it is not over expensive here. There is lift-side accommodation at Aremogna, but the town of Roccaraso, a short drive down the hill, is where most of the visitors stay. This is also where the very limited nightlife occurs. Italians are not big drinkers and this reflects in the town's social scene. There are a couple of nightclubs, *Bilba* and *Jambo*, but most of the activity goes on within the confines of the hotels.

FREERIDE

FREESTYLE

Lots of too tight trees & no real off-piste

TEL: +39 (0) 864 62210
WEB:www.roccaraso.net

WINTER PERIOD: Dec to March LIFT PASSES Half-day pass 18-20 euros 1 Day pass 26-30 euros, 6 days 154 euros BOARD SCHOOLS Private Jessons 30 euros an hour

NUMBER OF RUNS: 50 LONGEST RUN: 3km TOTAL LIFTS: 29 - 2 cable-cars, 10 chairs, 17 drags LIFT CAPACITY (PEOPLE PER HOUR): 33,940 LIFT TIMES: 8.30am to 4.30pm

ANNUAL SNOWFALL: 1m SNOWMAKING: 5% of slopes

TRAIN direct to Roccaraso from Rome.
CAR Via Rome, take the A24 towards Aquila, then the
A25 towards Sulmona. Once past Sulmona, follow the
signs for Roccaraso. Journey time 2 hours.
FLY to Rome airport, 2 hours away.

SAN SICARIO

Modern resort with some good off-piste

Sansicario is a low level and modern purpose built resort that forms part of the vast Vialattea area which includes the neighbouring Italian resorts of Sauze D'Oux, Sestriere, Cesana, Claviere and the popular neighbouring French resort of Montgenevre. All these resorts link fairly well on the slopes by lifts and via the pistes, they also share a joint lift pass should you want to venture farther a field rather than staying on the local slopes. Sansicario was one of the resorts used in the Winter Olympics in 2006 . In general what you have here is a popular resort which attracts a lot of Italians to its slopes through out the winter season period. And they are attracted to this place because of the diverse terrain, the sunny slopes good choice of challenging runs that includes some excellent off-piste riding much of which in and out of trees and across big powder bowls. Sansicario boast some 40 marked out trails which are mainly

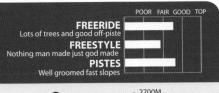

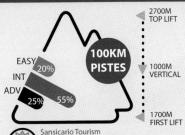

Cesana Sansicario, I-10056 TEL: +39 (122) 831 596

WEB: www.vialattea.it / www.sansicario.it EMAIL: ufficio.sportivo@vialattea.it

WINTER PERIOD: Dec to April LIFT PASSES 2 days 50 euros 6 days 145-163 euros

NIGHT BOARDING Wednesday nights in Sestriere until

9pm, 1.4km piste, 10 euros

BOARD SCHOOLS Private lessons 32 euros an hour HIRE 2 local board shops

NUMBER OF RUNS: 40

LONGEST RUN: 8km TOTAL LIFTS: 10 - 6 chairs, 4 drags LIFT TIMES: 8.30am to 4.30pm

ANNUAL SNOWFALL: Unknown SNOWMAKING: 15 Snow Cannons

BUS run from Oulx to the resort. FLY The nearest international airport is at Turin 1 1/2 hours away, 2 1/2 hrs are Milan and Geneva

TRAIN Oulx, 14Km away, is the closest station fast trains stop here from Paris Turin Rome and Lyon

CAR From Turin take the motorway towards Frejus. Take the exit after Oulx and continue to Turinese Cesana. Follow road towards Sestriere, then take Sansicario exit at crossroads. 80km total distance. 200km from Milan, 240km from Geneva

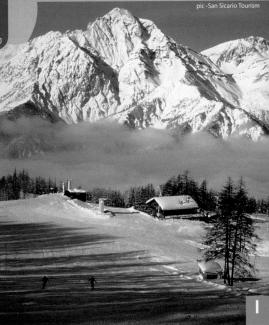

rated as red runs for intermediate riders. However, the Vialattea has hundreds of runs for all levels, so no one is going to feel left out here. You can ride with some ease from the top station all the way back down to the resort base, although total novices won't find it an easy thing to do, as the top runs are mainly all intermediate slopes with a couple of black trails here and there.

FREERIDERS will be able to come here knowing that this place will put them to the test in many ways, with a great choice of different terrain features to choose from. They will also be able to arrive knowing that a weeks visit here and across the Vialattea will not be enough to see all and ride out all the terrain laid out for you. If you're into trees and off-piste terrain then you will be well satisfied here.

FREESTYLERS may find the initially offerings around Sansicario a little tame. But first impressions can be deceiving, because if you look out you will find loads of good natural spots for getting big airs. There are some cool gullies to check out and loads of hits formed by some of the un-even terrain features that make up this mountain. The nearest terrain park is in Sestriere

PISTES. The abundance of fast and well pisted red runs that make up Sansicario slopes are idea for laying out big turns on.

BEGINNERS are the one group that may find this place a little off putting, as only a small percentage of the runs are rated for novices, and those runs that are grade blue for beginners are limited to a few sections at the lower areas off the dreaded drag lifts.

OFF THE SLOPES

Sansicario is a good winter holiday destination with well appointed hotels and guest houses good restaurants and shops but alas rather dull night life

SAUZE D'OULX

6

pic -Sauze D'Oux

Okay resort for all

Sauze d'Oulx is a resort that clubs together with a host of other areas to form one of the biggest rideable areas in Europe, known as the Milky Way. The resort played host to the freestyle skiing competions during the 2006 Winter Olympics. Located in the north west of Italy, Sauze doesn't have the greatest snow record, but does have a long history as a holiday camp style resort, the sort of place where certain low lifes come to get drunk near

the snow. In truth, things aren't quite as bad as they sound and nowadays the place is inhabited by more Italians than package groups from afar. At one end of the Milky way is Sauze d' Oulx, perched at 1500m and at the other end is Montgeneve in France, which together offer over 285 miles of rideable terrain, linked by a hectic lift system covered by a single pass. This vast area that takes in the slopes of Sauze, Sansicario, Borgata, Sestrieres, Claviere and Montgenevre provides an area of mostly intermediate and beginner terrain, with enough stuff for advanced riders to take on. There are a few black graded knuckle rides up on the Borgata and Sestrieres area to test the best, particularly freeriders. The biggest cluster of runs are found on Sauze d'Oulx' own slopes, where intermediate freeriders will find loads of interconnecting red runs that weave through tight trees.

FREERIDERS looking for good off-piste won't be disappointed, with many runs leading through dense trees. The Rio Nero is a long favourite off piste trail that bases out at the road between Oulx and Cesana, but does entail a bus ride back to the lifts.

FREESTYLERS have loads of natural hits to get air from, but you wouldn't call this a freestyler's hangout.

PISTES. You will find a staggering amount of good carving runs to ride in Sauze, making this a particularly good alpine resort.

BEGINNERS will get on well, but note that there are dozens of drag lifts and instruction is nothing to shout about.

OFF THE SLOPES. Resorts don't come much more basic than Sauze, although in a strange way, it all adds to the place and if you are out for a cheap time, this is where you'll get it. Lodging here is cheap in apartments and evenings are very lively, with pub upon pub and loads of good eating haunts making this place not so much a tacky hole but rather an okay place to visit. For a beer, check out the likes of *Paddy McGinty*'s (full on Italian name or what!) or the *Banditos* disco for a late night drink, dance and some holiday skirt!

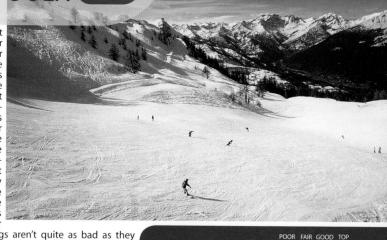

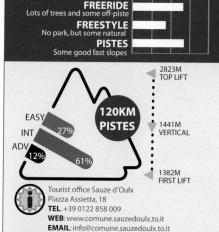

WINTER PERIOD: Dec to April LIFT PASSES 1 Day 29 euros, 2 Days 55 euros, 6 days 150

NUMBER OF RUNS: 40 LONGEST RUN: 4km TOTAL LIFTS: 22 - 11 ch

TOTAL LIFTS: 22 - 11 chairs, 11 drags LIFT CAPACITY (PEOPLE PER HOUR): 18,000

LIFT TIMES: 8.30am to 4.30pm

ANNUAL SNOWFALL: Unknown SNOWMAKING: 40% of slopes

TRAIN to Oulx which is 5 minutes away. **BUS** Regular bus service from Oulx train station. Coach

services on www.sapav.it

CAR via Turin, head north west on the A32 towards Bardonecchia-Frejus. At tollgate at Oulx take the road to Sauze d'Oulx

FLY to Turin, 1hr away. Local airport is Torino

VAL GARDENA

Good mix of terrain to suit most

Val Gardena is located in the northern area of the **Dolomites** and forms a collection of resorts and mountain slopes that is said to be the largest snowboarding area in the world. There is a staggering 600 miles of marked trails and are serviced by some 460 lifts of all shapes and styles these can be utilised by the Dolomiti Superski pass. A limited pass called the Val Gardena still covers 175km

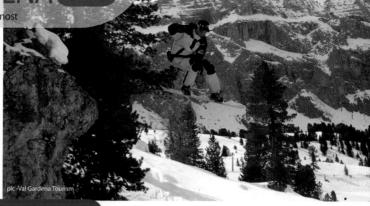

POOR FAIR GOOD TOP **FREERIDE** Some good off-piste areas **FREESTYLE** Park & pipe **PISTES** Lots of well groomed slopes

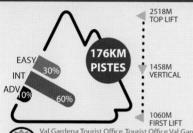

Val Gardena Tourist Office, Tourist Office Val Gardena Str. Dursan 80 c. 1 - 39047 S. Cristina

TEL +39 0471 792277

WEB: www.val-gardena.com / www.valgardena.it

EMAIL:info@valgardena.it

WINTER PERIOD: Dec to April LIFT PASSES

1 day pass: 30/37 euros 6 day pass: 165/188 euros

HIRE board from 16 euros /day, boots from 7 euros/day

NUMBER OF RUNS: 70 LONGEST RUN: 10km

TOTAL LIFTS: 84 - 7 Gondolas, 2 cable-cars, 45 chairs, 29

LIFTS CAPACITY (PEOPLE PER HOUR): 109,300 LIFT TIMES: 8.30am to 4.30pm

ANNUAL SNOWFALL: 2.5m **SNOWMAKING:** 95% of slopes

FLY to Verona airport 2 hours away. TRAIN to Bolzano which is 60 minutes away. CAR From Bolzano, head north on the A22 and turn off at Bressanone taking the E66 towards Brunico and

turning off on to the B244 to the resort area

NEW FOR 2006/7 SEASON: New halfpipe in Plan de Gralba area. New 6 person chairlift replaces 2 person chairlift in Paradiso/Goldknopf Seiser Alm area. New 4 persons detachable chairlift in place of drag. New detachable 4 person chairlift in placec of drag

of piste with 82 lifts. Val Gardena has the unfortunate history of being the place where a particularly sad Brit with a Russian name achieved a so called top ski result (who gives a toss). However, this is not a sad place to snowboard, it's actually very good, with something for everyone. Val Gardena is a huge valley, housing three main villages and a handful of satellite hamlets. And truly, if you can't ride here and enjoy yourself, then you must be a closeted synchronised swimmer or worse, a downhill skier with a nice shiny medal! The main villages here are Ortisei (the biggest town in the area), Oritsei and Selva .Wherever you choose to stay, you can move around the resort via a regular shuttle bus service. The well set out mass of lifts don't connect up everywhere, but with a piste map you can get around a very large portion of it without too many problems. Try the circuit ride known as the Sella Ronda, which takes you around 15 miles of lift connected runs.

FREERIDERS on the whole find Val Gardena a cool place to ride, with a good mixture of terrain features from trees to banks and wind lips. The best off-piste riding can be had in areas like Passo Pordoi, but its best tackled with the services of a local guide.

FREESTYLERS will find that the okay fun park and half-pipe, located on Alpe di Siusi is the place to hang out and get some air. If you're there at the right time you could also be riding to tunes by top DJ's. Theres also 2 boardcross circuits at Passo Sella and Comici/Piz Sella

PISTES. Riders of all levels will find millions of well pisted trails to get their fix from. Runs criss cross all over the area and no rider will see all of them in a week's trip, or even two.

BEGINNERS who can't learn to snowboard here must be clueless idiots; this place is a first timer's heaven. The runs up above Ortisei are full-on, perfect nappy territory.

OFF THE SLOPES. Accommodation and evenings are very Italian, with loads of good options in the main villages or at one of the smaller hamlets, which will have cheaper places to sleep and hang out. Eating and other local happenings are much the same wherever you are: all are laid back and okay.

ROUND-UP

ALAGNA VALSESIA

Small resort with directly only 5 lifts but backs onto the Monterosa Ski area (see Gressony). From the top of the Punta Indren back into the village gives you access to 2000m of vertical bad-ass off-piste terrain with some steep decents and couliors. A guide will set you back 240 euros for a day but is essential if you want to find some of the best areas (www.lyskammviaggi.com)

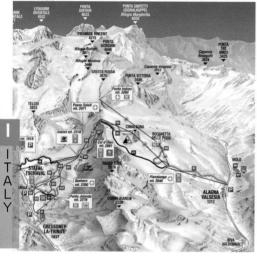

Top Lift: 3260m

List pass: Half day pass 23 euros, Day pass 32 euros, 6 days 170 euros Contact: www.alagna.it

How to get there: Fly to: 90 minutes from Milan airport, 110km Drive: From Milan, leave motorway at Novara Ovest or the A26 junction at Biandrate for Gravellona Toce and follow the signs for Romagnano-Ghemme. Then follow the main road \$5299 to Alagna.

CORNO ALLE SCALE

This is not a resort that many people would have heard of, but its worth a mention and even a visit, especially if you fancy a night out in the nearby town of Bologna. Corno Alle Scale has plenty of terrain to suit all standards with some gnarly off-piste for freeriders to bury themselves in. This is not a place for novices who like everything on hand, likewise freestylers looking for a host of man made hits will be disappointed. The only draw back about this place is that accommodation is located way back down the road (about 10 km) and with no local bus service, you must have your own transport. What is on offer is very basic but at least affordable. There is also a cheesy disco bar and a number of small drinking holes.

Contact: Corno alle Scale Tourist Office, P.zza Marconi, 6 -40042-Lizzano in Belvedere (Bo) Tel - 0534 50105

How to get there: Fly to: Bologna 1 hour away

GRESSONEY

Located in the Aosta Valley, Gressony is the neighbour to nearby Champoluc, with heaps of pisted terrain between the two resorts. The large amount of off-piste terrain here, offers a lot of big drop-ins, gullies and wide open bowls to please all freeriders. For carvers, there are ample wide spaces. Beginners have loads of easy flats to get hold of. Local facilities are very good and close to the slopes with some cheap options for lodging, eating and partying late at night.

Ride area: 200km Top Lift: 2661m Total Lifts:46 Contact: Tel - +39 (125) 307113 www.gressoney.com Get there:Fly to:Turin 1 hour away

MERAN 2000

Resort in the South Tirol area of Italy, 7 lifts accessing 40km of pistes

www.meran2000.net

OBEREGGEN

20 minutes from Bozen in the South Tirol lies the resort of Obereggen. 17 modern lifts provide access to 40km of mainly intermediate pistes which forms part of the Dolmite Superski area. Theres a park next to the Pampeago piste comprising of 3 kickers and a

variety of rails. Off the Toler piste is also a 80m halfpipe. Tues, thur, fri theres night boarding until 10pm. www.obereggen.com

PINZOLO

Linked with Madonna Di Campiglio, this small resort has 9 lifts servicing 11 pistes. There is a very small terrain park. A day pass is 23 euros

www.pinzolo.it

PIANCAVALLO

Piancavallo is a tiny purpose built resort and not unsightly. There is only a handful of runs that are split between beginner and intermediate level and nothing for advanced riders apart form a single graded black trail. Freestylers have a pipe. This is a simple piste loving carvers place through and through. Chalet accommodation and good services are slope side

Ride area: 24km Top Lift: 1829m Total Lifts:18

Contact: Tourist Office, Piazzale, Della Puppa, Loc Piancavallo, 33081 Aviano

Tel: 0434655191 www.piancavallo.com

How to get there: Fly to: Venice 3 hours away

ANTA CATERIN*A*

Santa Caterina is a resort that will appeal to sedate riders. The resort is linked to Bormio as part of the Alta Valtellina ski area and gives you access to over 100km of pistes, 40km of them locally. The resort was improved for the 2005 season, with a new slope, Edelweiss developed especially for the FIS Alpine World Ski Championships in January. Freeriders may be able to find some okay backcountry riding but its very limited and will only please intermediate riders. Freestylers have a half-pipe, but its not always looked after. Carvers just out for a simple day's piste riding will be at home, even granny could have a go. Fine for beginners but not a great choice of runs. Slope side services are good and affordable

Ride area: 40km Heights: 1738-2800mTotal Lifts:18 Lift pass: Day pass 29 euros, 6 days 143 Contact: www.santacaterina.it

SELLA NEVA

Sella Neva is a small resort in the north eastern corner of Italy bordering Slovenia and Austria. This is a popular carvers resort as well as offering some excellent freeriding and natural freestyle terrain. You can shred some trees at speed, go waste deep in powder or fly off endless cliffs. The fun park contains a half-pipe and is located off the Gilberti lift. This is also a good beginners resort. Sella Nevea is a good cheap resort with basic services.

SESTRIERE

Sestriere offers the potential for some great advanced riding both on and off piste, with a vast amount of terrain to explore in this part of the Milky Way. Freeriders will find a good choice of challenging runs and some excellent off piste. Freestylers are not well catered for but you will still find some interesting natural hits. Carvers have acres of good terrain. Beginners should not want for much more than you

get here. Off piste services are affordable and close to the slopes

This high altitude resort reaches up to 3250m from the village base at 1900m. For your 27.5 euros a day you get access to 40km of pistes including an 11km top to bottom run, when theres enough snow theres also a halfpipe

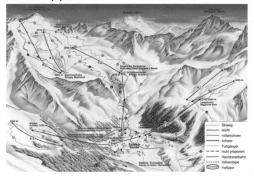

Ride area: 40km Heights: 1900-3250m Total Lifts:11 - 1 gondola, 5 chairs, 5 drags

Contact: Solda Office: ,Hauptstraße 72 ,I - 39029 Sulden (BZ) Tel. +39 0473 737060 www.sulden.com

How to get there: 150km from Innsbruck, nearest railway station is Landeck or Merano with local buses taking you the remainder

Large linked area of four skiing resorts, Folgarida, Marilleva, Pejo and Passo Tonale

VAL SENALES

Val Senales is situated 20km from the town of Naturns in Italys South Tirol. The Schnals Valley Glacier guarantees snow year-round with 8km of slopes open in the summer months and a good park. In the winter the area extends to 13 lifts servicing 15 runs (35km of pistes in total). The Roter Kofel and Teufelsegg chairs provide access to some steep black runs back into the village, alternatively take the Hochjochferner gondola, and cruise back down on the 8km run. In the summer theres a good park on the top of the glacier

www.valsenales.com

How to get there: From Innsbruck take the brenner pass follow the A22 to Sterzing, continue and take the Bozen Süd exit and take the Meran turn off. Continue to Naturns then take the valley road through Schnalstal to resort

WSQ www.worldsnowboardguide.com 207

NORWAY

Norway is famous for it's cross country skiing which is reflected in the fact that although there are over 160 resorts dotted around the country, 80% are simply not ridable. The terrain in the suitable areas is best for novices and intermediates, with little long term interest for advanced riders due to the lack of steep terrain.

Travelling around Norway is made easy by the country's excellent road and rail network, connecting well with international airports. The main gateway airport with regular international flights is Oslo, but onward travel usually means an extra 2 to 3 hours of travel.

If you're visiting Norway by car, you can take ferry crossings via ports in the UK, or short crossings from northern ports in Germany and Denmark. Driving in Norway is easy, but snow chains are a must in remote resorts.

The one common factor is Norway is its costs (super expensive in fact). Accommodation is pretty good with the most affordable type being cabins, which cater for groups. Hotels will burn a massive hole in your pocket. Beer prices are so high that evenings in the average bar are out of the question. The best advice is to bring heaps of duty free, or buy your drinks at the off licenses, but note, you have to be 18 to drink beer and 20 to buy or drink spirits.

Overall, Norway is really good but it does have some major drawbacks, like its total lack of music talent, stupidly expensive booze and the world's worst knitwear. On the other hand, the women in this part of the world are to die for.

A LONG

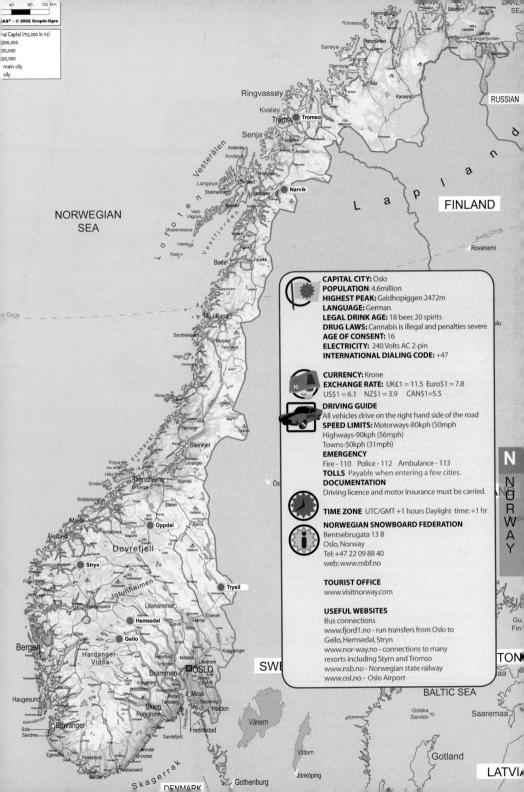

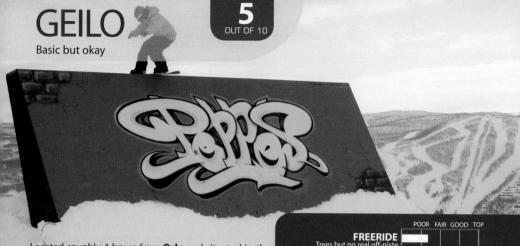

Located roughly 4 hours from **Oslo** and situated in the **Hallingdal Valley**, the largest mountain area in Europe, Geilo is the oldest resort in Norway. The well laid out town is easy to get around and lies close to the slopes, making for an easy attack of the runs first thing in the morning. The slopes rise up on two sides of the valley, with terrain that is well maintained, leaving lots of corduroy tracks to mess up in the early hours.

Geilo's slopes will suit intermediate and novice riders mostly, with little to set the heart racing for advanced or even competent riders, although there are a few black graded runs. The two separate areas (which aren't connected) rise up to give a maximum lift height of 1173 metres. If you want to ride both places, you'll have to take a snow taxi, which is not included in your lift pass. The Vestila area, which is actually the smaller of the two, has the longer runs, with a mixture of blues, reds and a couple of blacks.

FREERIDERS who pick a resort for powder and fast long adventurous trails, will not be satisfied here. There is no great adrenaline rush if you're a competent rider, just a couple of challenging runs to tackle and only a small amount of good powder terrain to seek out, but there are some trees to shred off the **Heissen** lift.

FREESTYLERS Theres a huge 150m Super Pipe at **Fugleleiken**; Northern Europe's largest. They spent NK1.2million in 2005 upgrading the park and getting all the toys needed to maintain it, so expect a well cut pipe and plenty of booters.

BEGINNERS are presented with an excellent choice of easy slopes to tackle, starting out at the base area with good flats higher up and easy runs back into the village

OFF THE SLOPES

Geilo also offers loads of things to do, you can try ice climbing, snow rafting or if you fancy reducing your balls to the size of two peas, you can sign up for a night in a snow hole. Geilo is a sprawling affair with good accommodation, but nothing comes cheap. Eating here is simple but even a basic pizza will set you back 70Kr. Night life will sting you if you plan to drink heavily or chat up a good looking Norwegian lass. Hos John's, Laverb and the Bardola are the places to try your luck.

210 USG WWW.WORLDSNOWBOARDGUIDE.COM

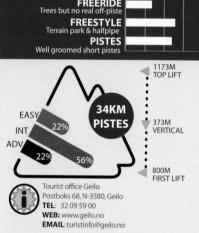

WINTER PERIOD: end Nov to mid April LIFT PASSES

Afternoon pass 270, Day pass 310, 2 Day pass 605 6 Day pass 1285, Season 3745

BOARD SCHOOL

Private lesson (55 min): 1Day-390 2Days-275 3Days-220

Geilo Skiutleie is the most central skihire in Geilo.

Located under the ski lift Taubanen

NIGHT BOARDING

4 slopes open, 5 days a week until 8pm from January-April.

NUMBER PISTES/TRAILS: 39

LONGEST RUN: 2km

TOTAL LIFTS: 20 - 6 chairs, 14 drags, 6 Children's lifts **LIFT TIMES:** 9:30 - 16:00

MOUNTAIN CAFES: 7

ANNUAL SNOWFALL: 1.25m SNOWMAKING:50% of pistes

TRAIN: services are possible direct to Geilo from Oslo and take around 3 1/2 hours. Bergen is 3hrs by train.

FLY: to Oslo airport, which is 4 hours away.

CAR: Via Oslo , head north on highway 7 via Honefos, Gol and Hol to reach Geilo. The distance is aound 150 miles (240 km) and will take 2 hours .

BUS: transfer from Oslo airport every Friday and Sunday, visit www. fjord1.no

HEMSEDAL

Norways best

Hemsedal has the claim of being the most photographed resort by the snowboarding press, and is no stranger to snowboardhaving hosted major events for years. The Artic Challenge was held here in 2001, and Mads Jonsson flew in the record books with a 57m jump off a

mssive 40m table top built in Hemsedal's backcountry. Its height, location and use of snow cannons all help to ensure a good snow record and a long season. The slopes lie about 3 kilometres from the main town and are reached by a free shuttle bus. The terrain will appeal to all

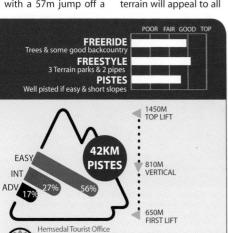

WINTER PERIOD: mid Nov to end April/May LIFT PASSES

Post box 3, N-3561 Hemsedal

WEB: www.hemsedal.com

EMAIL: info@hemsedal.com

TEL: +47 32 05 50 30

Half-day 285, Day pass 320, 2 Day pass 640 6 Day pass 1320, Season 4295

HIRE Several companies in town. Hemsedal Sport Skiservice charge 310 per day for board and boots

BOARD SCHOOL 90 min lesson 420 (weekend), 5x90mins lesson 595 (week), Private lesson 430 for 50mins

NIGHT BOARDING Tuesday-friday until 9pm. 5 slopes lit.

LONGEST RUN: 6km TOTAL LIFTS: 17 - 6 chairs, 11 drags LIFT CAPACITY: 22,600 people per hour LIFT TIMES: 9.30am to 9.30pm **MOUNTAIN CAFES: 6**

ANNUAL SNOWFALL: 3m **SNOWMAKING:** 15% of pistes

CAR Via Oslo, head north on highway 7 via Honefos and Gol and on to Hemsedal. Oslo to resort is 137 miles

FLY to Oslo airport, about 2 1/4 hours away. Direct sunday service from/to hemsedal NOK 375 return contact resort

TRAIN services are possible to Gol from Oslo and Bergen take around

BUS Direct from Oslo & Bergen, www.nor-way.no and www. bergenekspressen.no. Local bus services from Gol

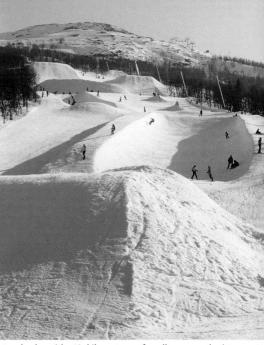

standards, with 40 kilometres of well prepared piste for freeriders to carve up as well as being ideal for beginners. Freestylers will get to enjoy one of the best parks in Europe, and there's a load of good accessible back country routes. The runs are serviced by a good lift system which, unlike some neighbouring resorts, is not all drag lifts. Theres also night riding for most of the season during the week until 9pm, useful if you're trying to avoid the expensive bars.

FREERIDERS. Theres a healthy attitude towards going off piste; it's your responsibility plain and simple. So with that in mind, grab a guide or a local and head off to the **Totten** or **Røgjin** Summits. From the back of the Totten Summit, you're treated to some excellent cliffs and powder, which will test even the advanced rider. Make a bee-line for the run known locally as the Annus, a long, steep couloir that should be treated with respect. From the top of Røgjin take the sign for 13 but head for the back of the mountain and follow round, for a run known as the rubber forest. You'll start off in a great powder field, but guickly heading into the trees, and they're thick and deep. These runs should lead you straight to main roads, where those canny Norwegian taxi drivers are ready to take you back to the base. Staying within the boundary line, if you like trees you'll have no complaints here. Theres some concealed tree rails in the woods off run 7.

FREESTYLERS. There's 2 terrain parks and small beginner/kids park. The intermediate park on run 33 consists

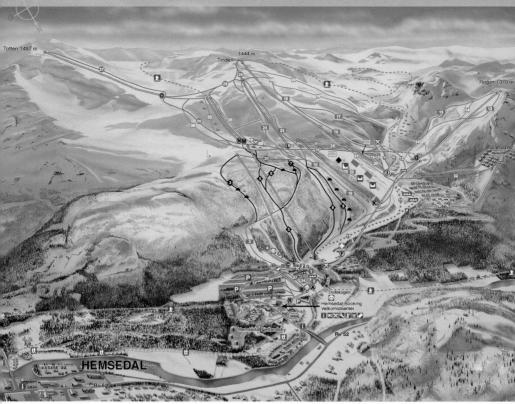

of series of jumps, and a good variety of rails once you turn the corner. The main park's built well and high with a great selection of jumps, quarter pipes, rails and boxes catering for good intermediates to experts. There's 2 half pipes including a well cut super pipe. Freestylers looking for some natural hits, should take the Holdeskarheisen and Roniheisen chairs to reach some cool terrain, including a tight gully to pull air in.

PISTES. Any carvers will find the runs known as the Hemsedalsloypa and Kuleloyas the place to lay out turns. These may not be the longest runs in the world, but they're not for wimps. The Sahaugloypa is also a decent run on which to get some speed together. In many of Norway's resorts the runs are usually very short, so it comes as a big relief to find a trail that lasts more than two seconds. The Turistloypa is the longest descent and although it's easy (even for novices still in nappies), it's worth a blast if only to avoid being on a lift again.

BEGINNERS seem to fare well wherever they go in Norway. Hemsedal is no exception; the only difference is that at least there is something worth progressing onto after mastering the easy flats at the base and those higher up. Instructors tend to avoid the intimidating drags at the bottom, and head up lift F, where theres a nice green all the way back down, it can get a bit busy though. Instructors do speak good english, group and 50 minute private lessons are available. Last season saw the expansion of the beginners/family area. Theres waves, a mini quarter

pipe, jumps, rails, self timer slope, and a path in the forest with animals made of wood all serviced by 2 platter lifts.

OFF THE SLOPES. If you plan to put Hemsedal on your calling card, only do so if you have a bank balance akin to that of Richard Branson. Put simply, Hemsedal is very expensive; however it is possible to do it on a budget, just watch the alcohol and taxis and the rest is surprisingly affordable. If you need to check your email then head for the Hemsedal Cafe in town, or the restaurant at the base near the Holvinheisen lift, and its free!

Accommodation can be had near the slopes, either at Veslestølen or Skarsnuten thats serviced by its own lift. The only trouble being that you're left with an expensive taxi if you want to get to/from the main town as buses to the resort finish early, but you can easily get quality apartment for a week for about £150 based on 8 sharing. Alternativley theres plenty of accomodation in town, or if the budgets really tight then opt for a cabin or the campsite. Hemsedal Cafe does some good food at lunch, enormous portions.

Night life. Things kick off at the outside bar at the base where they'll often have live music from 4pm, then its after ski in the village. A beer will set you back at least UK£5, so hold on to it tightly. The main snowboard hang out for evening madness is the *Hemsedal Cafe*, which is expensive, cool, and full of gorgeous Norwegians. *The skogstad hotel* has a nightclub open late.

OFFPISTE

FAGERNESTOPPEN 1003 m.o.h

NARVIK

Ghost town with good terrain if prepared to hike

About 1 hour west of the Swedish resort of Riksgransen lies Narvik, a hidden treasure in snowboard circles. With only 5 lifts and a summit that only just gets over 1000 metres, Narvik isn't your typical holiday resort: it's a small-town situated at the foot of a superb mountain, with lifts only opening in the afternoons on weekdays and all day on weekends and holidays. The busiest times are in

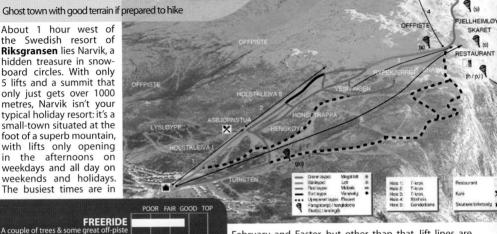

What there is is ok 1002M TOP LIFT 16KM 886M **VERTICAL** 125M FIRST LIFT

FREESTYLE

PISTES

Nothing laid on, but some natural

Narvik Tourist Office Kongens 66 Box 318, 8500 Narvik TEL: +47 (0) 471 795 122

WEB: www.narvikinfo.no

EMAIL: post@destinationnarvik.com

WINTER PERIOD: end Nov to end April/May LIFT PASSES 1 Day 230, 2 Day 410, 6 Day 890

HIRE Board & boots 210 per day

BOARD SCHOOL

Group lessons from 150 for 90mins. Private lesson 235 for 60 mins **NIGHT BOARDING** Yes

NUMBER OF PISTES/TRAILS: 8

LONGEST RUN: 1.8km TOTAL LIFTS: 5 - 1 gondola, 2 chairs, 2 drags LIFT CAPACITY: 23,000 people per hour LIFT TIMES: 10.00am to 9.00pm

ANNUAL SNOWFALL: unknown SNOWMAKING: 30% of pistes

Direct buses available from Tromso

TRAIN to Narvik from Oslo will take 20 hrs.

Drive via Oslo, head north on E6 all the way up to Narvik, which is at least a 20 hour drive.

to Oslo airport and then to Evenes which is 50 miles on.

February and Easter, but other than that, lift lines are practically non-existent and being located so far north, tour groups have never heard of this place. This helps to keep the slopes free of sad two plank numpties.

FREERIDERS should get the most out of this area. Much of the riding terrain is above the tree-line, but the lack of tree runs is fully compensated by plenty of natural pipes, bowls, cornices and cliffs to fly off. For fat lazy riders or those who prefer not to exhaust themselves with hiking, you'll be able to have a good blast within the lift covered area. The area known as Fagernesfiellet is a paradise for relatively advanced freeriders. The lifts only cover a small percentage of actual terrain available and as heli-boarding is forbidden in Norway, heaven is waiting if you're prepared to hike. There are no rules regarding where you can board, but before you take off, it's advisable to hook up with one of the locals who will show you the secret spots. In addition to Morkolla, with its enormous amount of snow, Narvik's backcountry offers wicked extreme terrain.

FREESTYLERS don't have a fun park, although one is planned for the future. There is, however, plenty of good natural terrain for getting air and the flat stuff allows for loads of ground spinning.

PISTES. Theres not much in the way of pisted trails on offer, the pistes of Fagernesfiellet are steep, wavy and suited to a bit of carving, but pistes aren't the reason to visit.

BEGINNERS will probably have a better time in Ankernes, a resort which is 3 miles away, rather than the main slopes of Narvik.

OFF THE SLOPES

Narvik is at the base of the slopes and everything is within walking distance. Expensive is the key word around here, but lodging in a cabin or a room at Breidablikk Inn is one of the easiest on the pocket. As for night life and partying, things happen at the Fossestua which has a pool table and is good for a beer and a late night session.

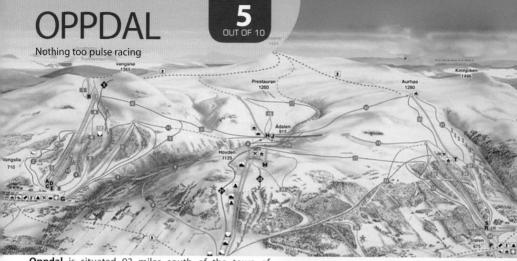

Oppdal is situated 93 miles south of the town of **Trondheim**, where three valleys (originating in different) parts of the country) meet. The resort is divided into four main areas, providing something for all riders with some of the best off-piste Norway has to offer. During the usual winter holiday period, the population doubles, so if you're not particularly fond of lines and crowds, try to stay clear. As one of Norway's biggest areas, Oppdal will appeal (as with much of this country) to easy going, piste loving freeriders. The 77 km of piste are for beginners mainly as there's nothing for advanced riders to get too excited about, and even intermediates will soon tire of the place. At the top of Vangslia there's a black run, but the mountain flattens out at the bottom making it a short and uneventful trail, unless you're a beginner joining at the top of lift A, where it becomes an excellent easy area.

FREERIDERS are kept interested with some particularly good freeride terrain to explore that includes trees, steeps and powder. The stuff found in Stolen Valley is pretty good, but due to avalanche danger, the area is often closed. However, the runs on the Vangslia mountain offer the best time, with some nice terrain features to ride, including steeps.

FREESTYLERS have a pipe (not a hot one, though) and a snowpark. The Adalen area is a natural snowpark which should keep air heads aroused for a day or two. Ground grommets will find the uneven slopes great for flatland tricks.

PISTES. Riders can experience what it's like to fly, by cutting some lines on the Downhill World Cup arena. What's more, Oppdal's longest run reaches a respectable 2.5 miles, offering a long ride.

BEGINNERS are well catered for, with loads of novice trails stretched across the 4 connected areas all accessed with one lift pass. Snowboard instruction is also very good.

OFF THE SLOPES

In the main, local services are varied but expensive. For a convenient place to sleep, stay at the Hellaugstol camp ground, about 100 metres from the slopes, or at Landsbytorget in Stolen where a group can share an apartment. At night, check out The Jaeger Pub or go skating.

214 USQ WWW.WORLDSNOWBOARDGUIDE.COM

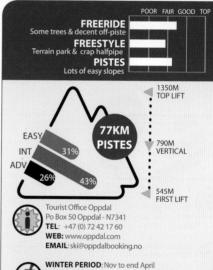

LIFT PASSES

1 Day pass 280, 2 Day pass 520, 6 Day pass 1190

NIGHT BOARDING

monday - friday until 9pm and costs NOK130

NUMBER PISTES/TRAILS: 27 LONGEST RUN: 4km

TOTAL LIFTS: 16 - 2 chairs, 14 drags LIFT TIMES: 9.30am to 9.00pm

MOUNTAIN CAFES: 4

ANNUAL SNOWFALL: unknown **SNOWMAKING:**45% of pistes

BUS services available from Bergen, Oslo, Trondheim, tel: +47 815 44 444

TAXI tel: +47 72 42 12 05

FLY to Oslo airport, about 4 hours away, nearest airport is

TRAIN services go direct to Oppdal from Trondheim, Oslo and Bodø. Night trains also available tel: +47 815 00 888

CAR via Oslo, head north on E6 all the way up to Oppdal (420km). 120km from Trondheim

NUKEN (1832 MOH STRYN Okay summer riding > 1 LETT MIDDELS EKSPERT SKILØYPE ٠ GROTLI 3 CATWALKE TURISTEN

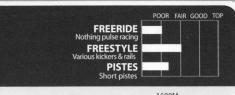

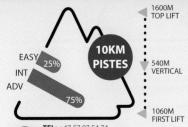

TEL: +47 57 87 54 74 WEB: www.strynefjellet.com EMAIL: info@strynefjellet.com

WINTER PERIOD: Feb to March **SUMMER PERIOD:** May to August LIFT PASSES

1 Day 280, 3 of 4 Days 780 6 of 7 Days 1200, Season pass 3000 HIRE Board & Boots 100NOK per day

BOARD SCHOOL

Nothing formal but availble for 295Nok per hour

NUMBER OF PISTES/TRAILS: 8 LONGEST RUN: 2km TOTAL LIFTS: 2 - 1 chairs, 1 drags

ANNUAL SNOWFALL: 5m SNOWMAKING: none

BUS available from Oslo and Sweden FLY to Oslo airport and then inland to Anda (45km) or Vigra

TRAIN services are possible to Trondheim from Oslo. CAR Drive via Oslo, head north on route 7 to Gol and then take the 52 to Signol onto the route 1 and route 60 via Olden to Stryn. Approx 480km

Stryn is located at the base of the Jostedalsbreen glacier and is Norway's most famous summer resort (in fact the only one of note). The glacier gets so much snow during the winter (five metres plus), that the lifts are usually totally buried and as they couldn't run them even if they wanted to. Although this is a popular snowboarder's hangout, it should be pointed out that Stryn is also very popular with skiers, resulting in fairly long lift queues. What's more, a number of ski teams spend time on the slopes doing training sessions, swelling the numbers further. Still, leaving the two plankers aside, what you have is a small glacier mountain offering some interesting and steep riding on slopes where snow holds its condition all day. A lot of Norwegians simply come up to strip off and sunbathe (an often enjoyable sight). However, for those wanting to snowboard, the 10 kilometres of terrain are serviced by just two lifts; a double chair and a drag lift. A lot of snowboard camps are held here each year with lots of pros on the teaching staff.

FREERIDERS coming here in search of big powder bowls, dense trees and limitless off piste should forget it, Stryn has none of that. In the main, you are presented with some steep, but featureless terrain.

FREESTYLERS are the ones who are going to benefit from a trip to Stryn the most, apart from the natural hits and the famous road jumps (as seen in many a video), the man made kickers are superb.

BEGINNERS that are easily intimidated may find this place a little daunting as the slopes are steep, but there are some areas to play about on if you really want to ride here.

OFF THE SLOPES

Stryn is located along a road that is littered with campsites offering cheap places to sleep. The main hangout is the village of **Hjelle**, 15 minutes from the slopes, where you can rent a shared cabin from 420 Kr. The main local pub is where the only action takes place with numerous late night drinking sessions happening place on a daily basis (although it costs).

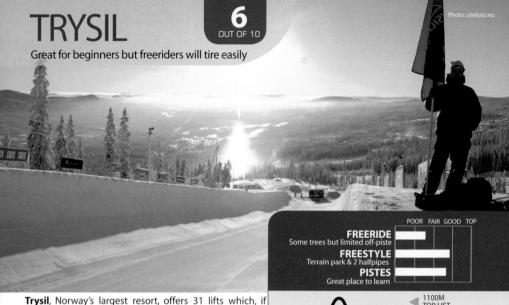

Irysii, Norways largest resort, offers 31 lifts which, if you follow the sun around the 70km of piste, you can snowboard 360 degrees around the Trysilfjellet mountain. Situated just over two hours from **Oslo**, Trysil is a resort that caters well for its visitors, no matter what time of year. This is a perfect resort for both families and beginning or intermediate riders. Advanced riders will be disappointed with Trysil's black runs, as they are predominately clustered together in one area, and are similar to good red runs in Europe.

Two thirds of the mountain is a picturesque tree lined winter wonderland, but the top third is bare and feature-less. Currently no chairlifts take you to the top, so unfortunately it's a series of excruiating T-bars, but this is where you can get away from the perfectly groomed pistes. A new 6 person chair lift from **Fagerasen** is set to change that however. Ski-Star, who also own Hemsedal, Are & Salen, have recently taken over Trysil and big expansion plans are afoot.

FREERIDERS who venture here will find it hard pushed to find any good tree runs, as the trees are all so tightly knitted together. The place where it is perfect for tree runs is unfortunately flat, so if you do try the piste lined trees, make sure you're wearing a helmet before you pinball your way out! The black runs which run up from **Hogegga** offer the best boarding for good intermediates and advanced riders. Good steeps and numerous jumps present themselves on the sides of the pistes, especially when you criss-cross the seemingly unused mogul run in this area.

FREESTYLE. The park is impressive and many proboarders come to train, film and get ready for their next big competition. As well as offering qualifying rounds to the Artic Challenge, they have been home to Burton's Slopestyle, Sweet Rumble in 2006 and the Norwegian halfpipe Championship. If the whole park thing just reminds you of banging your shin against a metal rail & falling on your ass, then Trysil can help out. Like any good decent resort, the park here offers something for the beginner whether it's an easy on flat box or nicely carved

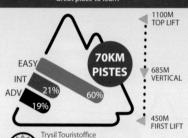

Trysil Storve

Storvegen 3, NO-2420 Trysil, TEL: (+47) 62 45 10 00 WEB: www.trysil.com

EMAIL: trysilfjellet@trysil.com

WINTER PERIOD: Dec to end April
LIFT PASSES

Half-day 280, 1 Day pass 320 2 Day pass 620, 5 Day pass 1280, Season 4200

NIGHT BOARDING
Night pass 220. On Turistsenteret: tuesdays (8pm) and fridays (9pm).

On Høyfjellssenteret: wednesdays (8pm) and fridays (9pm) BOARD SCHOOL Normal group & private lessons available including special park tuition

RENTAL Board & Boots 295 per day

NUMBER PISTES/TRAILS: 65 LONGEST RUN: 5.4km

TOTAL LIFTS: 31 -6 chairs, 16 drags, 9 Childrens lifts LIFT TIMES: 9:00am to 4:30pm

MOUNTAIN CAFES: 6

ANNUAL SNOWFALL: 2m SNOWMAKING: 45% of pistes

BUS services from Gothenburg, Stockholm and Olso to

FLY to Oslo which is around 140 miles away.

TRAIN Elverum train station is 7 miles away, bus connection

to Trysil runs 8 times daily

CAR via Oslo, take E6 to Hamar then route 25

NEW FOR 2006/7 SEASON: new heated 6-seater chairlift at Fageråsen, improved snowmaking

216 US www.worldsnowboardguide.com

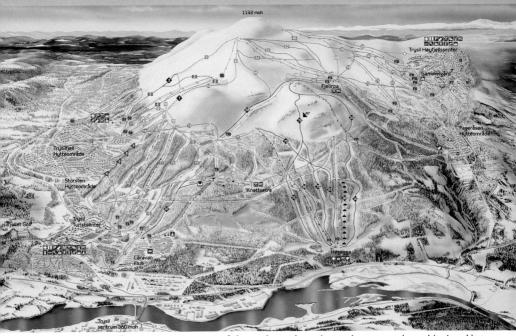

basic jump. Although, if you've just come out of the Knettsetra for lunch and sampled the expensive alcohol, you might as well go large and take it all on!

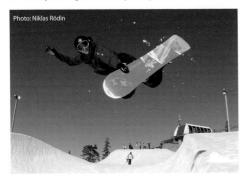

PISTES.The pistes at the bottom two thirds of the mountain are tree lined, wide, well groomed and easy to navigate and the pistes on the top third are featureless but more expansive, natural and offer great views of the surrounding area.

BEGINNERS. there are two types of orgasm, one with a good looking Norwegian chick and the other is learning to snowboard at Trysil. The place is learner heaven, with a mass of easy slopes that are well linked and well serviced by the lift system. The only problem is the fact that there are only 5 chairlifts out of the 30 in total.

For the complete newbie however, the Fjellekspressen and Liekspressen chairlifts can take you up to some nice meandering blue runs enabling you to practise that perfect technique. Unless it's your first week, you may get bored of the area after more than a day and may choose to be more adventurous and venture onto

those t-bars - just make sure you buy a bionic ankle to get you through the t-bar madness before you go!

OFF THE SLOPES

The village of Trysil is 2 km from the slopes and offers good local facilities, although what is on offer is stupidly expensive and would make a weeks stay a struggle with funds, and impossible on a low budget. Most people don't venture into the town much, only for supplies (3 of Norway's largest grocery stores have outlets here), as the majority of the accommodation and the partying is to be found slopeside.

Acommodation is mainly slope side as over 80% of the cabins, apartments & hotels are based on the pistes or next to the lifts. Go with a group, and ensure you have some friendly Norwegians with you and it becomes more affordable.

If your **nightlife** starts with a good apres session then Trysil gives you a flying headstart. Knettsetra, an easily accessible mid station bar, kicks off the apres ski with food and the usual expensive Norwegian beer. At the end of a tipsy trip down the mountain (and via the park!)you find Laaven, which is usually jam packed on weekends and during holidays, so get there early to avoid queuing (probably around 10 minutes after you leave Knettsetra!). Other watering holes include Sindrestua and Ski Puben - a more grown up English style pub, both located at the bottom of the Fjellheisen chairlift. Bakgarden is a hangout for youngsters - strictly non-alcoholic - which offers youngster type things like a pool table, films and Playstation consoles (which are probably playing SSX). Later in the evening bars/pubs/restaurants can be found in town, but most Norwegians tend to gather in their chalets consuming their own supplies, and sometimes the lethal Norwegian moonshine.

ROUND-UP

FILEFJELL SKIHEISER

This is one of Norways smallest resorts and also one of the most boring. There is very little on offer, other than a few over rated intermediate and beginner runs. There is a small terrain park with a line consisting of a couple of jumps and 3 or 4 rails. The nearby village offers very basic lodging and other services all of which come at a high price.

RIDE AREA: 8km TOP LIFT: 1125m TOTAL LIFTS:3 CONTACT: Tel +47 (0) 613 675 75 www.tyin-filefjell.no Tyin-Filefjell Skisenter, N-2985 Tyinkrysset HOW TO GET THERE: Fly to: Fagerness 2 hours away

GAUSDAL

A bit dull, but okay. 9 lifts, 20 runs. www.gausdal.com

GAUSTABLIKK

A few okay runs, 7 lifts serving 20km of pistes. www.gaustablikk.no

Total waste of time for boarders, about 20mins from Hemsedal. www.golinfo.no

GRONG

Forget it altogther, 6 lifts, 10 runs. www.grongfri.no

HOVEN

Okay night riding, 4 lifts & 12 runs and a small park & halfpipe. www.hovden.com

HAFJELL/LILLEHAMMER This is Norway's famous resort if for know other reason

other than it once hosted the winter Olympics. However, just because they flew the '5 rings', doesn't mean that its a good measure of what's on offer. What you get here is a narrow cluster of runs with an okay mixture of all ability terrain that includes a long black run from almost the top to the bottom. Freestylers have 2 good

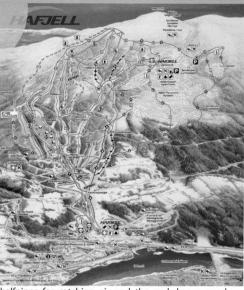

halfpipes for catching air and the park has a good variety of jumps including some big ones and rails for all levels. Beginners have a few easy to reach novice slopes although crowded

RIDE AREA: 33km RUNS: 29

Easy 30% Intermediate 41% Advanced 18% Expert 11%

LONGEST RUN: 7km TOP LIFT: 1050m VERTICAL DROP: 830m

TOTAL LIFTS: 22 - 3 chairs, 18 drags, 1 Magic Carpet

LIFTS OPEN: 9.30am to 3.30pm 9.30am to 4.30pm (floodlit slopes)

CONTACT: Hafjell Alpinsenter ,AS 2636 Øver Norway

Tel.: +47 61 27 47 00 www.hafjell.no

HOW TO GET THERE: FLY: Fly to: Oslo 2 hours away.

BUS: Free shuttle bus from Lillehammer, and good local bus service www.

opplandstrafikk.no

DRIVING: 15km from Lillehammer, follow exit to Hafjell. 200 km (2.55 hrs) from Oslo, follow E6 north.

Has a good halfpipe and 3 or 4 jumps and rails, 7 lifts and 18km of runs including a decent 3.5km run, 60 minutes from Oslo. www.kvitfjell.no

SJUSJOEN

Only good for no hopers, 4 lifts & 9 runs 80mins from Oslo. www.sjusjoen-skisenter.no

Okay for slow beginners, 5 lifts, 2hrs from Oslo

TROMSO

Famous for holding the finale of the TTR series, the Artic Challenge. Very basic resort, miles from anywhere, but they have the capacity to build a good park & pipe.

www.tromsoalpinsenter.com / www.ttrprosnowboarding.com

Valdres is a small unassuming typical Norwegian resort with a good reputation amongst Norway's snowboard population. The tree lined runs will suit intermediate freeriders and air heads. There is some

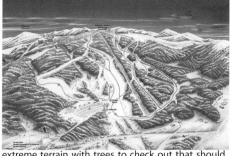

extreme terrain with trees to check out that should keep the average freerider happy for a day or two.

Grommets will find enough logs to slide down. The fun park and pipe are also good and offer the best chance of pulling some good air. Carvers looking for lots of wide open flats will be disappointed, as will advanced riders looking for major hits or deep gullies.

First timers should have no problem here, the flats at the base area are full-on for collecting the first bruises with ease. Lodging is the usual Norwegian offerings, with a number of decent chalets or apartments to choose from. Night wise, simply crank up the walkman and down your duty free booze.

RIDE AREA: 10km LONGEST RUN: 2km TOP LIFT: 1050m LIFTS: 4 CONTACT: Valdres Tourist Office, P.O.Box 203, N-2901 Fagernes Tel - (+47) 61 35 94 10 Fax - (+47) 61 35 94 15 www.valdresalpin.com HOW TO GET THERE: Fly to: Oslo 2 hours away

VASSFJELLET

Vassfjellet is not a tourist resort perched way up high on a mountain and boasting millions of square miles of ridabe piste backed up with a modern base complex decked out with purpose built hotels and other tourist traps. No, this is a locals place and serves the masses from neighbouring towns and the city of Trondheim a few miles away. If you're on a road trip and fancy something different then check this place out, it's pretty cool and very snowboard friendly, with a large number of student riders from Trondheim's University. They are given student concessions on lift passes, so if you're doing the college or Uni number,

be sure to carry your student card. The terrain is fairly well matched in terms of level and styles and although the slopes here can be described as dull, most riders will find something to keep them content for an hour. By most standards this is a very small resort with only around 6 miles of piste (half of which is flood lit for night riding). This place is by no means going to hold the attention of advanced riders for too long, especially if you're looking for big powder bowls and large cliff drops. Still there is a 2 mile run to keep you occupied for a few minutes, (which offers the opportunity to ride at speed and take out a few skiers en route). If you really want to find out where the best ride areas are, contact the guys at the local snowboard club, there are no guides here but they will give you a few pointers. Freeriders have

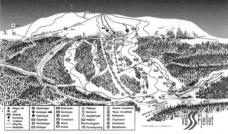

a few wooded sections to cut through, but they won't take long to ride through. **Freestylers** roaming around will find some banked walls to check out, as well as a well kept pipe and 2 parks, the Øvre terreng and Radio 1, littered with kickers, rails and a quarter pipe. **Carvers** who can will have the whole area done in five minutes. **Beginners** will find this place more than adequate with a good selection of easy runs.

At the end of the day, every one heads off back to Trondheim by a regular bus service. There's a good selection of places to sleep, eat and drink at almost affordable prices. Night-life is also pretty good but booze will cost you dearly.

RIDE AREA: 10km

Easy 25% Intermediate 25% Advanced 30% Expert 20%

LONGEST RUN: 3.5km

TOP LIFT: 670m VERTICAL DROP: 460m TOTAL LIFTS:6 CONTACT: Vassfiellet Skiheiser AS, P.b. 6079, 7003 Trondheim

Tel: ++47 (0) 72830200 www.vassfjellet.com **HOW TO GET THERE:** Flv to: Oslo 3 hours away

VOSS

Voss is a very popular resort with over 40km of well groomed trails that will please carvers and basic freeriders. The limited off-piste on offer is not bad and allows the chance to go steep and deep above and below the tree line in a number of spots. Freestylers should avoid trying to catch air out of the permanent ski jump here, as you're not allowed too. Instead check out the pipe or the numerous natural hits dotted around the whole area.

RIDE AREA: 40km TOP LIFT: 945m TOTAL LIFTS:10
CONTACT: www.voss-fjellheisar.no ++47 (0) 56 51 12 12
HOW TO GET THERE: Fly to: Bergen 21/2 hours hours away

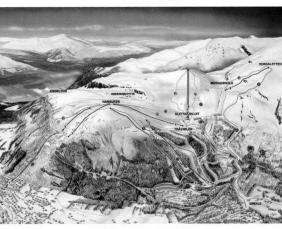

transport is not so hot.

Portugal, believe it or not, has a mountain winter sports resort where you can snowboard, complete with uphill lift services. Although Sierra de Estrela is no match for the main European Alps, it's still has real snow and is cheap to visit. It's worth noting that the summit is over 2000m, which is higher than anything in Scotland and many Scandinavian resorts. Portugal has a good snowboard following that stems from its influences and links with the big surf scene here. The riding styles favour mostly freeride and freestyle with only a few Alpine/Carvers around. The people are really friendly and if you do decide to do a road trip for a two day visit in winter, remember that even if the snow is miserable, at least the people are not. They are warm and friendly and will show you a cool time, partying and chasing gorgeous women, while waiting for the white stuff to fall. Getting around in winter is best done with your own vehicle as local

Sierra de Estrela

Sierra de Estrela, located in the mid-northern region of the Country. Despite the area's altitude, conditions are not always that favourable. The warm winds that blow in from the Atlantic coast also make it impossible to have snowmaking facilities. Most riders only check the place out at weekends and if the locals want to ride any longer they tend to visit Sierra Nevada in Spain and Val D'isere or Isola 2000 in France. At present it only gives 10 hectares of lift serviced terrain, though there is more to explore if you're willing to do some hiking.

FREERIDERS will find some amazing off-piste that will appeal as much to intermediate riders as it will to advanced. If you take the lengthy hike over to the area called Covado de Boi at the opposite side of the main area, you'll gain access to a good share of couloirs and some big hits to fly off. The only real draw back is that once at the bottom, if you don't have someone waiting with a car to take you back to the main area, you'll have to hike back. Still work hard, play hard! Another good place to check out is Lagoa Escura; a big slope where the best powder is, in a totally crowd free area that bases out at an amazing lake.

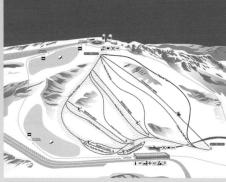

FREESTYLERS should also check out the Covado de Boi area, where there's a 300 metre natural half pipe which, on occasions, has 3 metre walls banked up.

PISTES, Riders who like to ride only long wide runs, forget it. This place is not for you. That said, there are some open areas that allow for a few signatures in the snow with your edges.

BEGINNERS this place is absolutely perfect for you, although hopelessly limited.

OFF THE SLOPES

Because Sierra de Estrela is an ecological natural park, there are a lot of development restrictions on and around the mountain. Although some accommodation is available close by, the best option is in Covilha, 12 miles away where you'll find hotels, restaurants, shops to hire snowboards, bars, discos and places to simply hang out, all at affordable prices.

SCOTLAND

You can choose one of the five real snow areas, the many artificial ski slopes dotted around the country, or the new indoor real-snow slope in Glasgow.

The Scottish resorts are similar; low level hills, with uneven trails that can get stupidly crowded. You won't find a halfpipe due to the weather conditions, but resorts will try and build a terrain park when there is snow and have a number of rails out, and do prepare yourself for some impeccable lift queuing.

Visually snowboarding in Scotland is reminiscent of New Zealand or Norway with the resorts overlooking green fields and villages. Like New Zealand & Australia every flake of snow is important so wooden fences are used to help farm snow and prevent it from blowing off the slopes.

There's been a lot of discussion whether Scotland will have a snow industry in ten, twenty years time, with the effects of global warming. Ask the locals and they'll not necessarily say that Scotland doesn't get the snow it used to, but it just doesn't seem to last as long as it did.

All of the resorts have had to change the way they operate in order to have a viable future and most now gain their income from summer activities and budget for a winter season of 4-6 good weeks.

The season starts as soon as there's snowfall in December and ends when the last bit of snow has gone. During that period most of the time conditions can be quite poor and the wind can blow so hard

that it hurts as it hits you at 70 miles an hour. There's little point booking too far in advance, so keep an eye on the weather forecasts and conditions and book up at short notice.

The last few seasons have seen some fantastic conditions very late on in April, with regular fresh dumps of snow and sunshine. Most people have given up the season by then so crowds are no problem.

Getting to the resorts should pose no problem with good air, rail and road links. Londoners can have a great weekend with overnight train services arriving in Fort William or Aviemore, a short distance from the slopes. You can fly into Glasgow or Edinburgh, with bus services linking to most resorts, but the easiest way to get around is by car.

Off the slopes there are plenty of small hotels and guest houses to stay in, nightlife isn't particularly rowdy and there's certainly very little in the way of après-ski but locals are exceptionally friendly.

Season riders will find employment and lodging easily. If you want to teach snowboarding, you can do it legally without an instructor's certificate. However, it may help you get work.

In short, Scotland is a great country for its scenery, natural beauty and history, due to the weather it's not always a great destination for boarding but it can surprise and offers a different experience from your normal alpine fayre.

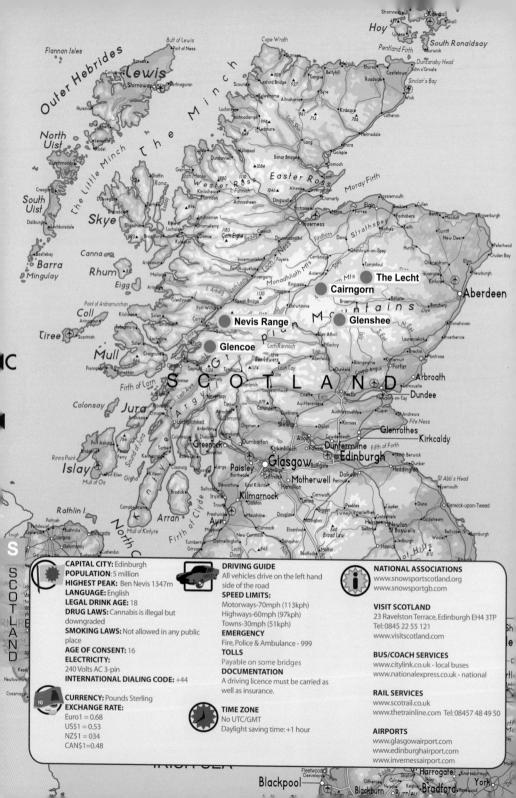

CAIRNGORM

Okay when theres snow

The CairnGorms is a unique place for all sorts of reasons. For some this is a great place to visit to see some of Scotland's wild life, while others venture to these hostile hills to walk along some of the well worn paths. But this is not a proper ski/board destination and doesn't even begin to compare with resorts on main land Europe. The Cairngorms will give locals, those who live close and the casual visitor the chance to have a few hours fun on snow.

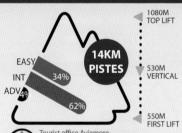

Tourist office Aviemore Grampian Road, Aviemore. Inverness-shire TELEPHONE: +44 (0) 1479 810 363 WEB: www.cairngormmountain.com

WINTER PERIOD: Jan to end April LIFT PASSES

Half day £20, 1 Day £26, 5 Days £106, Season £350 HIRE 1 day £15.50,5 days £50.50

BOARD SCHOOL

Group lessons £35/day (4hrs), half-day £31 Full day including 4hrs tuition, pass & rental £63 Private £135 full day, £75 for half

ANNUAL SNOWFALL: unknown

NUMBER OF RUNS: 28 LONGEST RUN: 2.9km TOTAL LIFTS: 17 - 1 Funicular Train, 2 chairs, 14 drags Lift capacity (people per hour): 12,000 LIFT TIMES: 8.30am to 4.30pm

SNOWMAKING: none FLY to Glasgow international. Transfer time to resort is 2 1/2 hours. Inverness airport is 30 miles (45 minutes) away TRAIN services are possible to the centre of Aviemore, 9

miles or 15 mins from the slopes, visit www.scotrail.co.uk BUS services from Glasgow airport are available on a daily basis to Aviemore

CAR from Inverness, head south on the A9 and travel to Aviemore. From London, head north via the M1, M6, A74, M8 to Perth and the A9 to Aviemore, 9 hours 535 miles.

If you live far away, check on conditions before leaving. This region has a poor annual snow record and suffers from very harsh winters which entail strong winds and ever changing weather patterns. The mountain layout also leaves a lot to be desired, however the introduction the funicular train makes getting around the runs a lot easier. However, its not all bad news on Cairngorm, and when it has snowed and the sun is out, you can have a great days riding. What's more, local boarders are very friendly and will be happy to show you were the best spots are to ride.

FREERIDERS won't find any trees, bowls or powder and experienced riders used to long testing steeps won't find anything to tackle apart from the West Wall, the only black run. The White Lady run can be good when it's not riddled with moguls.

FREESTYLERS who like to go big off natural hits, forget it. However, when the conditions are good there is a terrain park which has a series of big hits, and some rails.

BEGINNERS, this place is definitely not for you. There are hardly any nursery slopes, and the ones you do find are sandwiched between snow fences and choked up with ski classes. Beginners are far better off going to 'The Lecht', 40 minutes away.

OFF THE SLOPES. Spey Valley is home to a number of good local villages. For a small village Aviemore has a good choice of restaurants. The Cairngorm Hotel is very good, Harkai's restaurant does a great hangover breakfast. Nightlife in Aviemore is simple, there are no fancy clubs just a handful of bars, try the Mambo Cafe.

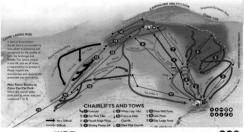

USQ www.worldsnowboardguide.com 223

NEVIS

Home to Scotland's most extreme terrain

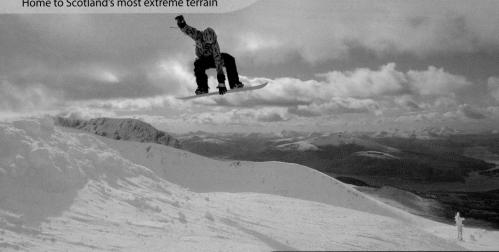

The **Nevis Range** opened in 1989 and has a modern lift system to rival any small resort in the Alps including Scotland's only gondola. The resort is situated about 6 miles from the town of Fort William, and its summit, Aonach Mor, is only 400 feet shorter than its close neighbour Ben Nevis, Scotland's highest mountain.

As with all the resorts in Scotland the weather is extremely changeable and is often a mixture of high winds, driving sleet ,rain and heavy blizzards. However, the people who run the place shrug off these problems and do their best to look after visitors. The main gondola takes you up from the carpark to the Snowgoose restaurant and the learner area. It's then the quad chair, the goose t-bar and the summit button to reach the top. As you would expect the better conditions can be found the higher you go, and there's usually a small terrain park at the summit.

There's not a tree in sight and wooden fences stretch down the mountain to prevent the snow from blowing off the main area. On a powder day the snow often drifts around the fences which provide some of the deepest snow to lay turns in, but they've nicely sharpened the ends of the fence posts so try not to impale yourself when trying to nab that last bit of powder.

With the exception of Duncans Drop and a few others the pistes are cut very narrow so you can't really open things up too much. They're kept in as good condition as they can be but if it hasn't snowed for a few days expect some brown stony patches.

FREESTYLERS . There's usually a park at the summit, depending on conditions there's usually at least some rails, and sometimes a couple of kickers. As soon as it snows the crew are out there building things and they often run big-air competitions. Away from the park, head out to the top of the corries for some serious air opportunities and dotted around the resort are plenty

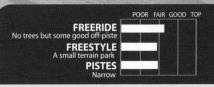

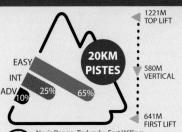

Nevis Range, Torlundy, Fort William Inverness-shire, PH33 6SW, Scotland TEL: (+44) 01397 705 825

WEB: www.nevis-range.co.uk EMAIL info@nevis-range.co.uk

WINTER PERIOD: Dec to end April LIFT PASSES

1/2 Day Pass £16, Full day £23, 5 days £85, Season £245 RENTAL board and boots £17.50,6 days £65 BOARD SCHOOL 4 Hour group lesson £20, private £22/hr

TOTAL NUMBER PISTES/TRAILS: 35

LONGEST RUN: 2km

TOTAL LIFTS: 12 - 1 Gondola, 3 chairs, 8 drags LIFT TIMES: 8.30am to 4.30pm

BUS: take a regualr CityLink or National Express bus to Fort William. Local bus available to resort, but not very frequent - timetable on www.rapsons.com

TRAIN: Train services to Fort William, 10 minutes away.

FLY: Glasgow 2 hours away.

CAR: From Glasgow, head north on the A82, via Dumbarton and Glencoe, approx 2.5hrs. Nevis Range is 7miles from Fort William. From London, use the M1, M6, A74, to Glasgow.

TAXI: Al's Taxis 01397 700 700

of lumps and bumps and fences to pull tricks off.

FREERIDERS. The Nevis range does have its own secret weapon known as the Back Corries. When they are open and conditions are right the Back Corries are probably Scotlands best freeriding terrain with some genuinely steeps, cornices and cliff drops. When they're not open and there's good enough coverage head to the top of the goose t-bar and head left and cut under the summit button, where you'll find a long gulley. Head the other way past the Sidewinder slope and head out the main area and there's some easy off-piste to be had, but watch out for rocks and aim to cut back to the bottom of the guad chair.

BEGINNERS have a number of easy slopes located at the lower areas not far from the top gondola station.

OFF THE SLOPES

The nearby town of Fort William on the shores of Loch Linnhe is set in a stunning location and has a big choice of accommodation and

eating spots. You can choose from a number of hotels or family guest houses are available from £20 per night. There is some accommodation near the slopes but it's limited and isolated. Evenings are not hot but there are plenty of pubs and restaurants to try out along the high street, the locals are very friendly and you can have a rowdy time.

ROUND-UP

GLENCOE

Glencoe is Scotland's oldest resort and the best place to ride in the country. Unlike other Scottish resorts, this is not a poor alpine imitation and okay, Glencoe may have very harsh weather patterns, but who cares, they do things the right way here and don't try and make out that they are something that they're not. This may not be a big place, but it is exactly what Scottish snowboarding should be about: simple, friendly and without an attitude. It also has the best natural terrain. In general, the runs will suit all levels, although not testing. Glencoe's remoteness means it is far less crowded than other resorts. People who come here do so because they don't want the bull of the other places.

FREERIDERS will find some okay terrain in the main basin off either the top T-bar or top button lift. Off the top button lift you will find a couple of reds and an interesting black trail that bases out into an easy green run.

FREESTYLERS have a cool natural freestyle area, but the weather prevents the building or lasting of a halfpipe. However, ask the management and they'll happily do what they can to build you a decent series of hits.

BEGINNERS should have no problems learning here as there are some excellent short runs to try out which are easily reached.

LOCAL SERVICES can be found in the small village of Glencoe, a 6 mile drive away. It offers limited, but

Creag Dubh SCO First Aid T Main Rasin T-bar Tow To Fort William

good, accommodation with a number of cheap B & B'. Alternatively, the village of **Onich** is 12 miles away and has a bigger selection of services, including a bunkhouse with a bar. Fort William is 30 miles away and has an even bigger offering.

AREA SIZE: 500 acres, 20km of pistes TOP: 1058m BOTTOM: 475m RUNS: total 19 - 53% easy, 37% intermediate, 10% advanced

TOTAL LIFTS: 7 - 2 chairs, 4 drags, 1 learner tow **HIRE:** Board and boots £15/18 per half/day

LESSONS: 2hr group lesson £16, 1hr private lesson £30 Beginner package - day rental, pass & lesson £40 LIFT PASSES: Half day £16, Day pass £24, Season £245 CONTACT: Tel:01855 851226 www.glencoemountain.com

GETTING THERE:

Fly to Glasgow airport 2 hours away. Prestwich & Inverness possible **Train** services are possible to Fort William & Bridge of Orchy 30 minutes from Glencoe.

Bus. Citylink run regular coaches from Glasgow to nearby Fort William, White Corries is the access road nearest to the resort. Tel. 08705 50 50 50 Car via Glasgow, head north on the A82, via Dumbarton and Tyndrun to Glencoe. From London, head north via the M1, M6, A74, to Glasgow.

GLENSHEE

With 2000 acres of terrain, **Glenshee** is Scotland's biggest resort. This place was first to use snow cannons, but in truth, they haven't really helped to improve what largely is a disappointment. The runs are spread out over varying slopes and on a good day, you will find some off-piste powder. The majority of runs are short novice trails with only two steep sections. Freeriders have no trees, but a bit of powder on **Glas Maol** area. Freestylers will find a small park when there's enough snow and there's a couple of natural hits to hunt out. Carvers, can crank a it down the **Cairnwell** but not for long. Beginners will hate the way the lifts are set out, however, the novice runs will provide some fun. Local facilities don't exist. Within a large area there are places to stay in and villages to get a meal but nothing near the slopes.

AREA SIZE: 2000 acres, 40km of pistes TOP: 1058m BOTTOM: 650m

RUNS: total 36 - 58% easy, 36% intermediate, 6% advanced

TOTAL LIFTS: 21 - 2 chairs, 19 drags/t-bars HIRE: Board and boots - £11/16 for half/full-day LESSONS: 90min lesson £15, 90min Private lesson £30 Beginner package - day hire, lift pass & lesson £35

LIFT PASSES: 1/2 Day £16.50, Day Pass £23, 5 Days £92, Season £250

CONTACT: Tel: 013397 41320 www.ski-glenshee.co.uk

GETTING THERE:

Fly to Aberdeen 1 1/2 hours away (69 miles). Edinburgh (84 miles) or

Glasgow (101 miles)

Train The nearest stations are Aberdeen, Perth, Dundee or Pitlochry.

Bus. from Dundee, Aberdeen or Perth to Braemar or Blairgowrie both

about 9miles from the resort. Tel: 08705 50 50 50

 $\textbf{Car} \ \text{situated on A93, 9} \\ \text{miles south of Braemar \& 25} \\ \text{miles north of Blairgowrie} \\ \text{}$

LECHT

The Lecht is by far the smallest resort in Scotland, however, this is also one of the friendliest and quite simply the best beginner's resort. This value for money area, only has a handful of runs that rise up from the car park allowing for good easy access by foot to the well maintained novice runs. This is not a place for those who want long testing steeps, but it is a place with a cool attitude towards snowboarding and a genuine and welcoming feel to it. Freeriders could have the whole place licked in an hour or two. Freestylers, they always try and build a park and pipe here, with locals from Aberdeen using this as a fun weekend hangout. Beginners, this place is perfect for novices, the best in Scotland. Basic but affordable local facilities can be found in Tomintoul. 15 minutes away.

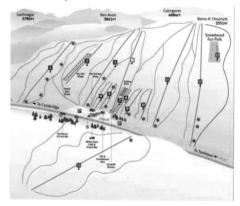

AREA SIZE: 6km of pistes **TOP:** 777m **BOTTOM:** 637m **RUNS:** total 20 - 70% easy, 25% intermediate, 5% advanced

TOTAL LIFTS: 11 - 1 chairs, 9 drags

HIRE: 1 day £17

LESSONS: 2days hire, pass and group lesson £75 **LIFT PASSES:** 1/2 Day £15,1 Day pass £20,5 Days pass £84

CONTACT: Tel: (01975) 651440 www.lecht.co.uk GETTING THERE: Fly Aberdeen 2 hours away.

Car On the A939 Cockbridge to Tomintoul Road. West of Aberdeen

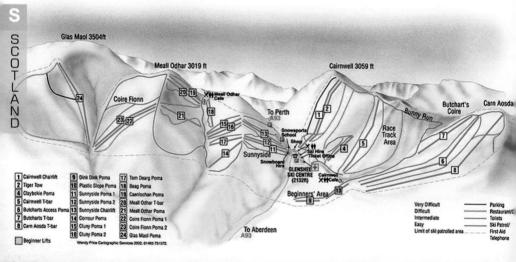

SPAIN

If you thought Spain was only about bull fighting and tacky seaside resorts inhabited by Europe's finest villains, then think again. Spain is also about snowboarding and while it's not as intense as other parts of Europe, it's certainly worth more than a mention as well as a visit.

Spain has some thirty resorts offering every type of terrain possible and to suit all style's of riding and abilities.

Spain hasn't always had the greatest snow record and with many of the resorts not being the most up to date, there's very little artificial snowmaking to help out when the real stuff is lacking. Resort facilities are not the greatest either, with little or no snowboard facilities, poor options for places to sleep and limited snowboard hire options.

However, this is generalising because the big areas like Sierra Nevada are an easy match for the rest of Europe, indeed it will put a lot of northern places to shame.

The Spanish tend to be a bit like their Italian cousins, they love to pose and in doing so end up looking stupid in designer ski suits. Snowboarding is, however, fairly well received throughout the country.

The majority of the resorts are situated in the north of the country and can prove tricky to reach with a hit and miss public transport service. Your best bet is to hire a car at airport and drive, this way you can leave quickly if you dislike a place.

One last point, Spanish snowboarding is not as cheap as you may think. Don't think of it as just a cheap alternative to France or Austria, although Spain is certainly cheaper than Switzerland.

CAPITAL CITY: Madrid

POPULATION: 40 Million HIGHEST PEAK: Mulhacen 3478m

LANGUAGE: Spanish LEGAL DRINK AGE: 18 DRUG LAWS: Cannabis is illegal

AGE OF CONSENT: 16 ELECTRICITY: 240 Volts AC 2-pin **INTERNATIONAL DIALING CODE: +34**

CURRENCY: Euro **EXCHANGE RATE:**

UK£1 = 1.5 US\$1 = 0.8 AU\$1 = 0.6 CAN\$1=0.6

DRIVING GUIDE

All vehicles drive on the right hand side of the road SPEED LIMITS:

Motorways 120kph (74mph) Highways 90kph (56mph) 50kph (31mph) Towns

EMERGENCY Fire - 080 Police - 091 Ambulance - 092

TOLLS Payable on a number of main roads DOCUMENTATION

Driving licence and motor insurance must be carried.

TIME ZONE UTC/GMT+1hrs Daylight saving time:+1 hr

SPANISH SNOWBOARD ASSOCIATION

Web: www.a-e-s.jazztel.es Email: infoaes@telefonica.net

OFFICIAL TOURIST WEBSITE www.spain.info RAIL SERVICES www.renfe.es **COACH SERVICES** www.eurolines.es

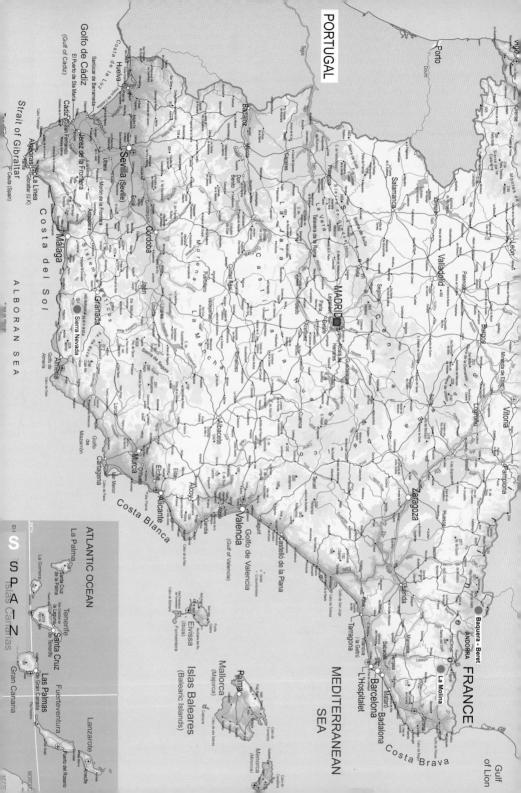

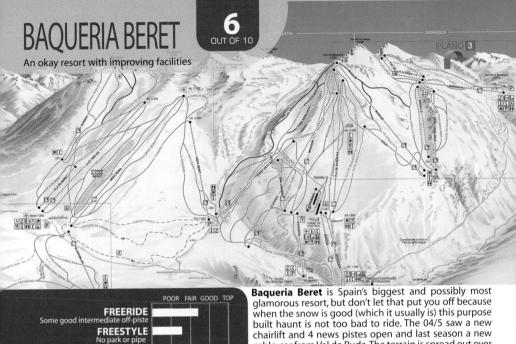

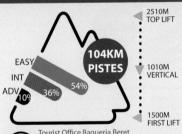

some good open slopes

PISTES

Tourist Office Baqueria Beret SA Apartado 60, Viela, E25530 TEL: ++34 (0) 73 645 062 WEB:www.baqueira.es

WEB:www.baqueira.es EMAIL:baqueira@baqueira.es

WINTER PERIOD: Dec to April

LIFT PASSES 1 Day 39 Euros, 6 Days 196, Season 810 HIRE Board and Boots week 75 euros

NUMBER OF RUNS: 73 LONGEST RUN: 4.8 km

TOTAL LIFTS: 31 - 20 chairs, 7 drags, 4 magic carpets LIFT CAPACITY (PEOPLE PER HOUR): 47,462

LIFT TIMES: 9.30am to 9.00pm

ANNUAL SNOWFALL: Unknown SNOWMAKING: 40% of slopes

FLY to Barcelona airport, 4 hours away (350km). Toulouse 166km, Zaragoza 290km away

TRAIN services via a transfer by bus from the French town of Montrejea (60km). In spain the nearest station

is Lleida ,184 km away

CAR from Barcelona take the AP2 motorway and turn off at Lleida

CAR from Barcelona take the AP2 motorway and turn off at Lielda onto N230 through Alfarràs, Benabarre , Pont de Suert , Val d'Aran to the resort. 340km total distance chairlift and 4 news pistes open and last season a new cable-car from Val de Ruda. The terrain is spread out over four connecting areas, all of which are easy to reach and will largely appeal to intermediate piste loving carvers.

FREERIDERS looking for some cool off-piste to ride will be pleasantly surprised, with some great powder riding to be had well away from the chicken sticks in bad

FREERIDERS looking for some cool off-piste to ride will be pleasantly surprised, with some great powder riding to be had well away from the chicken sticks in bad suits. Check out the areas on the Tuc De Dossal that are reached by chair lift, or hit the stuff up at La Bonaiqua. Advanced riders are the ones who will be most disappointed, apart from two black graded runs there's not a great deal of testing stuff.

FREESTYLERS have a rather limited amount of good natural freestyle terrain, but there is the odd good hit to get air from, plus a few drop offs to try out.

PISTES. Carvers take over on the slopes here with terrain that is ideal for hard alpine riding. The resort is mainly suited to intermediates with some nice red runs but not many expert trails. For the less talented edge merchants, there are some easy blue runs.

BEGINNERS will take kindly to this place as this is a good resort to start out on and progress steadily with. Much of the terrain is easily reached by chair lifts and if you don't like Pomas or T-Bars then you'll be happy to know that you can get around the whole area without having to use them.

OFF THE SLOPES. Accommodation is close to the slopes, but eating and entertainment is not of a snow-board related nature. Still there is a supermarket for food and loads of Tapas (bar snacks). Evenings are OK and drinks are cheap (well compared to say drinks in France) apart from in the clubs where drinks are a flat rate of 10 euros each). Check out *Lobo* first, then *Tiffany's*, where the music is as crap and old as the name, but when you're drunk at four in the morning, who cares?

AMOLINA 5 Okay fun resort La Molina is located at the end of the Moixero mountain range in the Pyrenees. Its slopes descend from the summit of the Tosa de Alp peak and connect to the neighbouring resort of Masella to form the ALP 2500 POOR FAIR GOOD TOP area providing access to 111km of pistes. These are both FREERIDE welcome alternatives to big resorts scattered around Trees and some good off-piste the northern alps simply because mid-week, lift queues **FREESTYLE** don't exist and the slopes are blissfully crowd free. The park over in nearby resort people of La Molina make you feel very welcome and **PISTES** coupled with neighbouring Masella, both areas have Well groomed quiet pistes great terrain to shred, with slopes that are covered by trees up to the midway point and then clear pistes up to 2445M TOPLIFT the summit. The terrain will capture the imagination of most intermediate riders, no matter what their style is,

FREERIDERS in search of extremes that require helmets should forget it, but for the rest, there's ample to search out. Off-piste opportunities present you with loads of trees, with some nice back bowls and good

FREESTYLERS you'll need to get over to Marsella as theres little laid on these days at La Molina. The park on La Pleta has beginner and advanced lines consisting of some kickers and rails.

PISTES. Riders get the chance to polish up their skills on well groomed pistes and because this place isn't busy, you can go completely balls out without the worry of running over small children.

BEGINNERS in La Molina or Marsella will find that the nursery slopes are wide and spacious. Instruction services are excellent, with foreign speaking instructors available (which helps).

OFF THE SLOPES, this is not a resort designed for package groups of clueless skiers without manners. No, La Molina is a laid back place with a simple appeal offering affordable accommodation with the chance of staying close to the slopes. Local services are very basic; however, there are enough good facilities to keep you amused with a further selection of amenities down in the village of **Puigcerda**, which is only 10 minutes away. The El Bodegon restaurant is the place to check out if you want to try some local dishes while night life in La Molina is what you make of it. There's no great action here but you can have a good rocking time in such places as the Sommy Bar.

230 USQ WWW.WORLDSNOWBOARDGUIDE.COM

50KM EASY 875M PISTES VERTICAL 1700M FIRST LIFT Information Central Offices La Molina

Building of the Cable Cabin, s/n 17537 La Molina TEL: 972 89 20 31

WEB:www.lamolina.com EMAIL:lamolina@lamolina.com

WINTER PERIOD: Dec to April LIFT PASSES

Half day pass 25 euros, 1 Day pass 33 euros 5 Days 122.5 euros, Season 460 euros HIRE Board and Boots 22 euros a day

NUMBER OF RUNS: 42 LONGEST RUN: 4km

TOTAL LIFTS: 16 - 1 Cable-car, 6 chairs, 7 drags, 2 baby lifts LIFT CAPACITY: (PEOPLE PER HOUR): 25,000 **MOUNTAIN CAFES: 6**

LIFT TIMES: 8.30am to 4.30pm

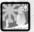

ANNUAL SNOWFALL: Unknown **SNOWMAKING:** 42% of slopes

FLY Barcelona airport 2 1/2 hrs away TRAIN Station at La Molina

BUS Eurolines run coaches from Barcelona which take 2 1/2hrs. Day trips from Barcelona possible leaving 06:15 returning 20:30 and costs 39.80 inc lift pass. Tel: 902 40 50 40. Local bus runs services run through town, and the train station. 1.9euro

CAR Drive via Barcelona, head north on the N152 via Granollers, Ripoli and Ribes de Freser.

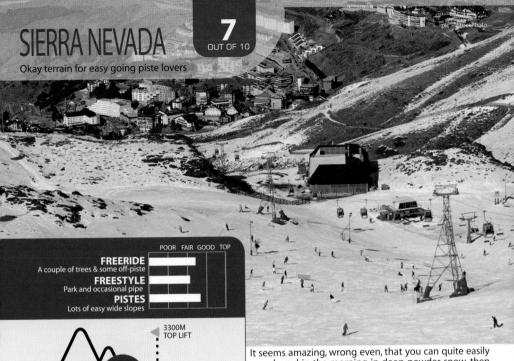

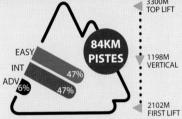

Sierra Nevada Mountain and Ski resort 4 Edif.Cetursa 18196. Sierra Nevada TEL: 902 70.80.90

WEB:www.sierranevadaski.com EMAIL:sierranevada@cetursa.es

WINTER PERIOD: Dec to April LIFT PASSES

Half day 29.5 euros, 1 Day pass 37 euros 5 days 157 euros, 5 eason 700 euros

HIRE Board & Boots 24 euros for a day, 70 euros 5 days BOARD SCHOOL weekend 4hr group lesson 39 euros Private lessons 30 euros per hour NIGHT BOARDING Saturdays 19.00 to 21.30

NUMBER OF RUNS: 79 LONGEST RUN: 6 km

TOTAL LIFTS: 19 - 2 Gondolas, 15 chairs, 2 drags, 2 Magic

LIFT CAPACITY (PEOPLE PER HOUR): 41,755 LIFT TIMES: 9.00am to 4.30pm MOUNTAIN CAFES: 2

ANNUAL SNOWFALL: Unknown SNOWMAKING: 31% of slopes

CAR Madrid to Sierra Nevada is 270 miles (435km), Drive time is about 6 1/2 hours.*From Calais, 1257 miles (2022Km), drive time is around 24 hours.

FLY Malaga airport is 90mins away. Granada airport is 48km away with connections from Barcelona and Madrid.

TRAIN to Granada 33km away.

BUS services from Madrid via a change over at Granada, on a daily basis. Bus services from Granada tel: +34 958 18 54 80

snowboard in the morning in deep powder snow, then pop down to the beach just over an hour away for a huge seafood meal, a swim in the Mediterranean sea and a relax on a sun soaked coast, but that's exactly what you can do from here in this most southern resort of Sierra Nevada, located a short distance form the town of Granada. It's possible from the high point of Veleta to see the Atlas Mountains of Morocco across the Mediterranean. Sierra Nevada is an OK place to ride and is particularly well suited to beginners and hard boot carvers, as well as offering some cool off-piste freeriding in powder bowls. The purpose built resort is well located for the slopes. These are first accessed by the main gondola which deposits you in Borreguilles, directly onto fantastic beginner's piste. Go up higher and you will be on slopes whose angles are great for free carving - just that perfect angle to really lay 'em out in perfect control. Night-riding is done on the Rio slope, a 2 mile run that provides one of the best lit night trails anywhere. The 04/05 seaspm saw some major improvements and piste extensions as well as more snowmaking facilties.

FREERIDERS should check out the stuff just below the peak of Veleta at 3398m. To do this, traverse to the Olimpica and where this crosses the Diagonal, kick hard to your left and travel off piste on an itinerary known as Tajos de la Virgen. The view above you is truly stunning, (a bowl edged with dramatic cliffs). The Dilar chair takes you towards the Radio Telescope, where after a walk along the ridge you can see below a huge expanse of off-piste which you have just travelled over on the chair. Take any line, the slope is a good safe angle with an easy traverse back to the Solana piste and the Dilar chair.

FREESTYLERS have to make do most of the time, with an array of unusual natural hits. They do build a pipe when snow conditions permit it. However, if you ride

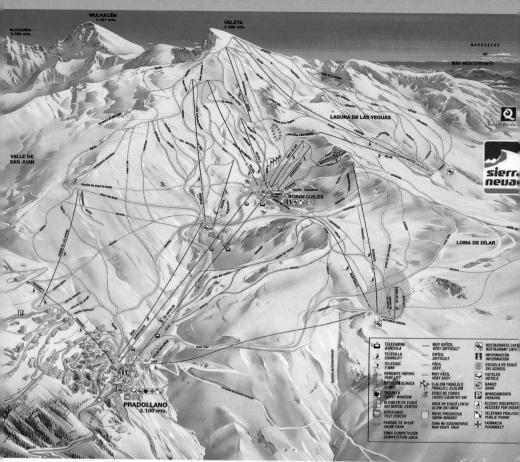

over to Tajos de la Virgen run, you'll find rolling jumps verging into vertical kickers. Kick back again towards the Cartujo piste and make use of the piste edge with it's many varied banked sides to gain more air time.

CARVERS are much in evidence here as the slopes lend themselves really well to edging a board over at speed, especially on the fast black trails. Particular good blacks for this are down from the Borreguilles.

BEGINNERS; the Borreguilles area is full on for learning the art of hurtling down a mountain on a board, but not the only place to go. Much of this resort is excellent for novices with good snowboard instruction facilities.

OFF THE SLOPES, Sierra Nevada is a cool place with a lot going on. Getting around the village, which is extremely steep, is pretty tough on foot though (especially once you have had a few beers). There is a bus service that runs until midnight, or alternatively, a chair lift that links the various levels to the centre of the village, for which you will need a valid lift pass to get on. The main set back for this place is the high cost of everything, which may have something to with the fact that the Sierra Nevada attracts a lot of the Spanish elite, and all the baggage that clings on to them. However, what is on offer is of a high stand-

ard with locals making you welcome.

ACCOMMODATION comes in all manner of styles and prices starting at super expensive. Most of the accommodation is located within easy reach of the base lifts and is pretty good, with some accommodation options at affordable prices. For budget riders, there's a hostel offering cheap beds with joint lift pass package rates.

FOOD. If you don't like Spanish food then don't fret, this place serves up all kinds of affordable grub from Chinese to Mexican. The main thing to watch out for, is that because this is a busy place, restaurants fill up early on in the evening and so a lot of waiting for a table is common place. Still, a meal, at a price, can be had in the likes of the *Ruta del Veleta*, (very posh and expensive but good). Tito Luigi is good for a cheap meal.

NIGHT LIFE. If you like hard, fast and drunken action, there is plenty of it here but nothing happens until late. Bars and clubs don't get going until at least midnight, then it rocks and you'll have no trouble staying out late, drinking until you drop at 5 in the morning. The *Soho Bar* and *La Chicle* are your main late hangouts, where Senorita's are in plentiful supply all night long.

ROUND-UP

ALTO CAMPOO

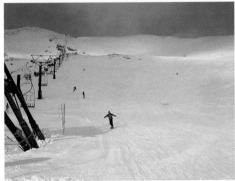

Very small resort located in the Cantabrian Mountains, in the far north of Spain. The area has a series of short trails mainly of intermediate level with nothing challenging for advanced riders. Overall, this is a simple retreat that will please carvers, bore freestylers but suit novices. Off the slopes there is a couple of small hotels and limited basic local services near the base area.

Ride area: 19km Number runs: 16 Total Lifts:13

Top Lift: 2175m Bottom Lift: 1650m

Contact: Alto Campoo Tourist Office, Codigo de pais, Spain (34)

Tel: ++34 (0) 942/77 92 23 www.altocampoo.com How to get there: Fly to: Madrid 3 hours away

Astun is a fairly decent resort which lies in the Astun Valley in the north of Spain. Although a rather featureless resort, Astun nevertheless has some interesting terrain that will keep freeriders of all levels happy for a few days and intermediates content for a week. Carvers have a number of long sweeping trails to do their thing on. Beginners have a good series of easy slopes. Local services at the base area are basic and affordable.

Number runs: 28 Top Lift: 2324m Total Lifts:14 Contact: Astun Tourist Office, 22889 Valle de Astun, Huesca Tel: ++34 (0) 34974373088 www.astun.com How to get there: Fly to: Pamplona 1-1/2 hours away

A resort in the far north that will bore the tits off you if you know how to ride and spend more than two days here. There is also the odd natural hit for freestylers to gain some air off. There is still a couple of

fast blacks for carvers to try out. Not to say this place is no good, its just that its a bit limited unless you're a total beginner. However, there are no convenient local services

Ride area: 1359 acres Runs: 41 Top Lift: 2750m Bottom Lift: 2020m Total Lifts: 15 - 6 chairs, 9 drags Contact: Amigs, 14-16, 08021 Barcelona, Tel: 902 40 66 40 www.boitaullresort.e How to get there: Fly to: Madrid 3 hours away

Although not a very big resort, with only 30km of marked piste, Cerler is one of Spain's best natural freeride/freestyle resorts, it is laid out above the ancient village of Benasque up in the Pinneos Mountains in the north of Spain. On the slopes, freeriders will find an abundance of fast trails both on and off the piste with numerous areas where its possible to shred through some tight trees and down some deep powder. Most of the runs are graded red and will appeal to intermediate riders, however advanced riders wanting an easy time with a bit of a challenge, will also like it here especially on the runs that descend from the Cogulla peak. Freestylers will find some nice hits. Beginners will find this place is perfect. Good local facilities are provided a short distance from the main base area, with hotels and shops

Number runs: 21 Top Lift: 2364m Total Lifts:13 Contact: Cerler Tourist Office, Estacion de Esqui de Cerler telesilla B-1, 22449 CERLER Tel: ++34 (0) 974 55 10 12 www.cerler.com How to get there: Fly to: Barcelona 2 hours away

FORMIGAI

Located way up in the north of the country on the French border, El Formigal is a modern purpose built affair. It offers some very good snowboarding on its wide open crowd frees slope that will appeal to piste loving carvers and beginners mostly. Fast riding freeriders and hard core freestylers are not going to be tested too much. There is no pipe or park but there is a lot of good natural freestyle terrain to get air from. Off the slopes you will find a good selection of affordable slopeside services

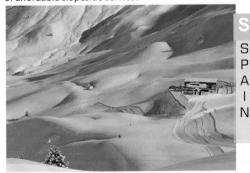

Number runs:48 - Easy 29% Intermediate 46% Advanced 25% Top Lift: 2200m Vertical Drop: 377m Total Lifts:21 - 1 Gondola, 5 chairs, 15 drags

Contact: Tel - ++34 (0) 974 490 000 www.formigal.com How to get there: Fly to: Barcelona 3 hours away

SWEDEN

Sweden emulates Norway in almost every aspect; cold climate, short winter days and expensive beer. Like Norway, Sweden has a lot of listed resorts - approximately 150. However, 80% cater just for cross country skiing, so most Swedes head down to France and Austria to ride, leaving their own resorts generally crowd free, which helps when you see the size of them.

In general, 99.9% of all resorts are small and at a low level. Terrain will suit mainly intermediate freeriders and freestylers with treeriding and excellent off piste opportunities. Many resorts have built decent terrain parks to try and lure the boarder in. Fast carvers won't be too impressed and advanced boarders may find things a bit limiting, but novices will have a good time on loads of easy slopes.

Getting around the country is easy, although you may have to do some travelling to reach some of the far flung resorts. Air, bus and rail services are damn good, but all are very expensive.

Sweden has the reputation of being very expensive, especially booze. Resort facilities and services are of a high standard. Accommodation is in the form of hotels, little wooden cabins or hostels. A basic Bed and Breakfast home costs from 350kr per night while a bunk in a hostel is around 150kr or a cabin from 170Kr a night.

Over all, Sweden may not be the most adventurous country in which to ride, but it's worth a road trip in June when you can still ride in T-shirts: What's more, Swedes are cool people and the girls are gorgeous and absolutely stunning.

CAPITAL CITY: Stockholm POPULATION: 9 million

HIGHEST PEAK: Kebnekaise 2111m

LANGUAGE: Swedish

LEGAL DRINK AGE: 18 beer, 20 spirits

DRUG LAWS: Cannabis is illegal and penalties severe

AGE OF CONSENT: 16

ELECTRICITY: 240 Volts AC 2-pin
INTERNATIONAL DIALING CODE: +46

CURRENCY: Krona

EXCHANGE RATE:

UK£1 = 13.6 Euro1 = 9.3 US\$1 = 7.2 NZ\$1 = 4.6

DRIVING GUIDE

All vehicles drive on the right hand side of the road **SPEED LIMITS:**

Motorways-110kph

Highways-90kph Towns-50kph

Towns-50kph

EMERGENCY Fire/Police/Ambulance - 112

TOLLS None, except bridge to Denmark
DOCUMENTATION

Driving licence, insurance certificate and vehicle registration, passport

TIME ZONE

UTC/GMT +1 hours / Daylight saving time: +1 hour

SWEDISH SNOWBOARD ASSOCIATION

www.svensksnowboard.net

SWEDEN TOURIST BOARD

Swedish Travel & Tourism Council, P O Box 3030 Kungsgatan 36, SE-103 61 Stockholm www.swetourism.se www.visit-sweden.com

TRAINS www.sj.se

BUSES www.ltnbd.se

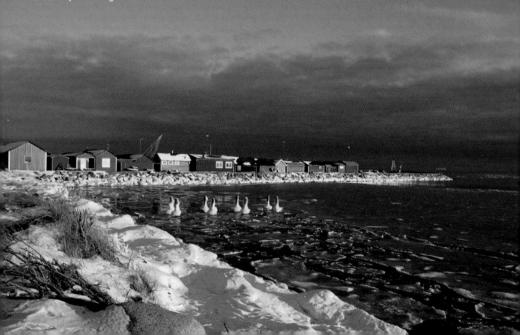

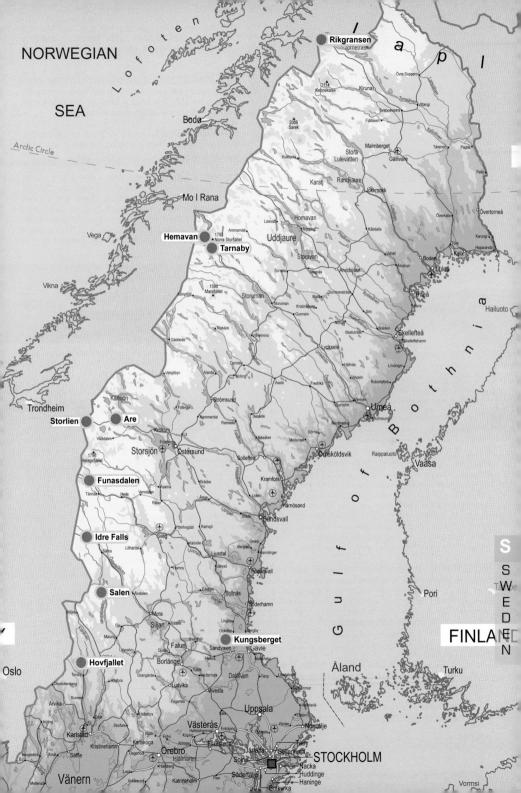

Åre is the biggest and most developed resort in the whole of Scandinavia and unlike many Swedish resorts, this isn't a poxy little hill! This is a good sized mountain that will give all rider levels a good time. It is situated in the middle of Sweden, near the town of Östersund. The runs here cover three main mountains all accessed by one lift pass, although the lifts themselves don't link up. Åre is the largest area with the most challenging terrain while runs on Duved and Bjornange are a lot shorter and will appeal mostly to novices and intermediates.

FREERIDERS will find a lot of varied terrain, from cornices and wind lips to steeps, as well as some cool tree runs. You can catch a lift on a piste basher or hike up 5mins up to the top of Åre's Areskuten 1400m summit. This allows you to descend some excellent terrain that goes off in different directions but still allows you to get back to the base (study a lift map first).

FREESTYLERS have a great funpark known as **The Snowboard Land Park**, which is next to the Bräcke lift and comes loaded with a number of big hits to gain maximum air from. There are 2 lines for beginners and experts. The pipe's pretty good and has 3 metre plus walls and is regularly used to host international competitions that attract the worlds top pros.

PISTES. Any riders who like laying out big arcs will find the well groomed pistes ideal for leaving a signature

in the snow. The long red run from the top of the Kabinbanan cable car that eventually takes you home via some wood, is perfect for this.

BEGINNERS should not feel left out here, there are plenty of easy slopes which run from the top lift to the base area. The of runs on the Duvedsomradet area are cool with varying terrain features.

OFF THE SLOPES, what you get here is similar to what you would find in any top resort in the Alps. However, this will hurt the wallet and you shouldn't bother trying to do a week here on a tight budget, you won't last. Still, you won't be disappointed with the level of services and convenience of the accommodation. For food, check out *Broken Dreams* for a burger and local grub or *Bykrogens* for a pizza. Night-life is very pricey, but don't hold back, spend and be merry as you can have a great night out here in places like the *Sundial* or the *Diplomats*.

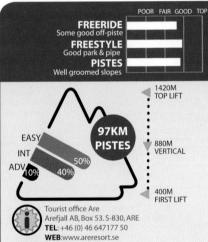

WINTER PERIOD: Nov to May LIFT PASSES Half-day 300SEK, 1 Day pass - 320 3 Day pass - 920, 5 Day pass - 1505

HIRE Board & Boots1 day 270SEK,5 Days - 890

BOARD SCHOOL range of instruction including freestyle, private and off piste.

NIGHT BOARDING There is a floodlight system covering 5 pistes including Gästrappet and Lundsrappet

NUMBER OF RUNS: 100 LONGEST RUN: 6.5km

TOTAL LIFTS: 40 - 1 Gondola, 1 cable-car, 6 chairs, 31 drags

LIFT CAPACITY: (PEOPLE PER HOUR): 47,390 LIFT TIMES: 9.00am to 4.30pm

ANNUAL SNOWFALL: Unknown SNOWMAKING: 25% of slopes

BU FLY (95

BUS Ski bus runs from Duved to Åre Björnen. **FLY** to Stockholm and then inland to Ostersund airport (95km away)

TRAIN services are possible direct to Are from Stockholm which takes around 10 hours.

CAR via Stockholm, take the E4 north to Gavle and then to Bergby at which point you head north west along the E14 via Ostersund to Are. (approx 7hrs)

RIKSGRANSEN

Midnight freeriding, beat that.

In the far north of Sweden close to the Norwegian border lies the remote resort of Riksgränsen. A place with one of the most unusual seasons in Europe and one that has become a snowboarder's favourite for summer road trips. In late May film crews and an abundance of pros flock here to do some last minute filming. Riksgränsen is located just 300km north of the Arctic Circle which would suggest that this is a cold place, but because of its proximity to the Gulf Stream and the Atlantic Ocean, riding in a T-shirt is guite normal in the latter months of the season. Un-like most resorts

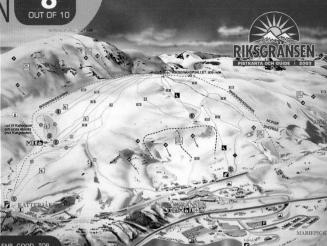

POOR FAIR GOOD TOP **FREERIDE** No trees but great off-piste **FREESTYLE** No park, but good natural **PISTES** Short & sweet

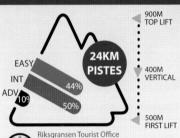

S-980 28 Riksgransen TEL: ++46 (0) 980 400 80 WEB:www.riksgransen.nu EMAIL:info@riksgransen.nu

WINTER PERIOD: Feb to late June LIFT PASSES Afternoon 30 euros 1 Day pass - 32.5 euros, 5 Day pass - 131 euros HIRE Board & Boots 35 euros per day, 109 for 5 days.

A Transceiver will cost 55 euros for 5 days NIGHT BOARDING In perfect daylight until midnight (midsumer)

NUMBER OF RUNS: 16+18 off-piste routes LONGEST RUN: 1.6 km TOTAL LIFTS: 6 - 2 chairs, 4 drags LIFT CAPACITY (PEOPLE PER HOUR): 7,500

ANNUAL SNOWFALL: 5m SNOWMAKING: none

LIFT TIMES: 9.30am to 11.59pm!

BUS from Narvik in Norway to Kiruna (www.nordtrafikk. no) or take the number 91 (www.ltnbd.se). Taxis available from Kiruna tel: 0980-12020

FLY to Stockholm then inland to Kiruna airport about

TRAIN services direct to Riksgransen which is a 20hr journey from Stockholm visit www.connex.info to book tickets

CAR located close to the Swedish/Norweigan border east of the Norweigan town of Narvik off the E6 and E10 routes.

in Europe, Riksgränsen doesn't open until mid February and stays open until late June, or as long as the snow allows the lifts to be used. You can ride all day in a T-shirt, and strangely enough you can still snowboard right up until midnight when there is still bright natural day light and the lift are sometimes still open. Although no one tends to hang out here for more than a week to ten days, you won't be too disappointed if you're a no-nonsense freerider, or a full on freestyler.

FREERIDERS will find some good off piste with steeps, windlips, and cool hits for getting air born. In addition to the 16 pistes, you'll find another 18 established off-piste runs. There's a huge number of serious routes which usually involve a small hike to start with but are well worth it, try the Lilla Ölturen run from the top of the mountain all the way down to Björnfjell railway station, or hike to the top of **Norddalsbranten** for some great steep runs. If you sign up for heli-boarding you get the chance to see the best of Lapland's backcountry terrain.

FREESTYLERS are attracted to Riksgränsen in big numbers. The Swedes love their hits and Riksgränsen has an abundance of natural terrain. Get your thinking hat on and search out some of the best freestyle terrain in Scandinavia, or try and claim a backcountry booter left by the pro's.

PISTES. The terrain is not really that good for laying out big turns on, however, via the Ovre lift you do get access to a decent red that joins up to a black.

BEGINNERS do make it up here, but in truth, it's a long way to come just for a couple of small easy flats.

OFF THE SLOPES. Riksaränsen Hotel is where it all happens off the slopes. Beds and food are offered at reasonable prices...Summer up here is for riders in a van, equipped with a tent, loads of duty free booze and a copy of Penthouse. There's no airport in Riksgränsen you should fly to Kiruna it's an hour from resort. You can also pig out at Lappis cafe. There's no night-life as such here. However, you can have a very good drinking session in the Riksgränsen Hotel which often last all night and après ski can kick off in Grönans

ROUND-UP

BJORKLIDEN

By any stretch of the imagination, Bjorkliden is a small resort with a mixture of basic beginner terrain to simple intermediate carving slopes. Still, overall it?s not a bad resort and offers a lot of interesting opportunities, just not of a very advanced level.

Freeriders who find the marked out runs a bit of a bore could sign up for a heli-board trip and enjoy some cool backcountry riding. Freestylers can make do with a decent sized terrain park with a good halfpipe and hits. Nothing local near the slopes but what is available a few miles away is okay but pricey.

BJORNRIKE

Small resort that offers the average rider an afternoons okay carving on a number of trails which include a couple of fast blacks. But in the main, this is a resort to please beginners with a low IQ. Slope side lodging and accommodation and other resort facilities are expensive but okay.

BYDALEN

Overall, this is not a bad place to spend a few days if you are beginner wanting nice and easy runs or a freerider looking for easy to negotiate tree runs. Riders who rate themselves can see if it's justified with a good selection of black runs to try out. Freestylers don't have too much to test them, but as with most Swedish resorts, locals build their own hits and session them all day long. There is also some fast carving runs to suit the carvers.

Ride area: 50km Top Lift: 1010m Total Lifts:11 Contact: Tel: +46 (0) 643 32011 How to get there: Fly to: Stockholm 51/4 hours away

FUNASDALEN

Fundasdalen is rated by many as one of Sweden's best resorts, offering a good level of varied terrain and with plenty to keep expert and beginner riders happy for a good few days. Riders who like to go fast can do so here on a series of black runs and a great selection of red intermediate trails. If back country riding without the hiking is your thing, heli-boarding is available to those with sufficient means. Freestylers don't need to go heli-boarding as they are provided with 2 halfpipes and a number of terrain parks that all house some mighty big hits with spines, gaps and quarter pipes. Beginners have an equally good number of basic trails. About town theres okay slope side lodging and services

Ride area: 90km Top Lift: 1200m Total Lifts: 34 Contact: S-840 95 Fundsdalen,

Tel: +46-(0)684-164 10 Fax: +46-(0)684-290 26 www.funasdalsfjall.se How to get there: Reach Funasdalen via Roros airport in Norway 1 hour away

HEMAVAN

Hemavan is a rather unusual resort that has a reason-

able marked out ride area and an even bigger unmarked backcountry terrain accessible by helicopter. For those freeriders who can't fly off to secret powder bowls, there are some nice reas close to the lifts including lots of trees at the

areas close to the lifts including lots of trees at the lower section of the slopes. This is not a resort noted for its advanced terrain, indeed there is only a couple of advanced graded runs, but for intermediates and first timers, this is a fine place to check out and spend a few days. If you do decide to visit this place then be prepared to put yourself out as there are no local facilities on the slopes and although accommodation and other amenities are not too far away, it's very spread out and will require a car.

Ride area: 30km Top Lift: 1135m Total Lifts:7

Contact: Hemavan-Vaxholm AB, Hemavans Hvgfjdllshotell, Box 162

S- 920 66 Hemavan

Tel: +46 (0)954-301 50 Fax: +46 (0)954-303 08 How to get there: Fly to: Stockholm 12 hours away

HOVFJALLETT

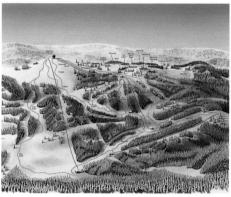

Hovfjallett is basically a waste of time unless you are aged 80, wearing a hearing aid and excel at speeds of one mile an hour. Although the area has a few black runs and half a dozen red trails, all can be licked by an average rider in the time it takes to have a curry induced crap. However, the place is friendly and provides a good halfpipe for air heads.

www.hovfiallet.se

IDRE FJALL

In the top ten ranking of Sweden's resorts Idre Fjall is a place that will suit all levels and rider styles. The area has a combination of easy runs and a number of testing black runs. Nothing here is all that long.

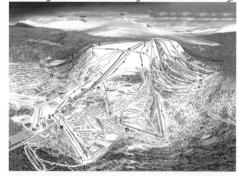

W

indeed the longest trail measures just under 3km, however, with 42 trails this is a place that can take a good few days to explore, especially if you sign up for a heli-board trip. Freestylers have a terrain park and a halfpipe which the locals take great pride in and keep in good condition. Off the slopes you will find a good choice of slope side lodging and places to eat and drink in. www.idrefjall.se

KUNGSBER-

Located 2 1/2hrs South of Stockholm and not far from Sweden's western coast lies the small resort of Kungsberget. With 17 runs,

the longest being 1.6km it would bore you stupid after a day or so if it wasn't for the excellent terrain park. Its loaded with some huge tables and kickers, and an array of rails and boxes including a wall ride. Theres night riding every Wednesday till 9pm

Lift Passes: Half day pass 200SEK, Day pass 240, 5 day 860, Season 995 Contact: www.kungsberget.se

How to get there: Fly to: Stockholm 2 1.2 hours away

Ski Bus leaves from Cityterminalen in Stockholm at 7am weekend and

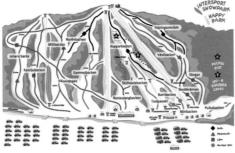

costs SEK 340 including lift pass Tel: +46-290-622 10. Pickups also from Uppsala & Gävle

Salen is about as big as they get in Sweden, with 108 pistes serviced by 77 lifts spread out over four areas; they offer every thing you could want both on the slopes and off. Of the four mountain areas Lindvallen and Högfjället are connected by lifts, as are Tandådalen and Hundfjället, so you'll need to take a ski bus to see the whole area.

The terrain is split evenly between all levels and with a host of advanced runs that will have the hardest of riders tested to the limits and needing a week to

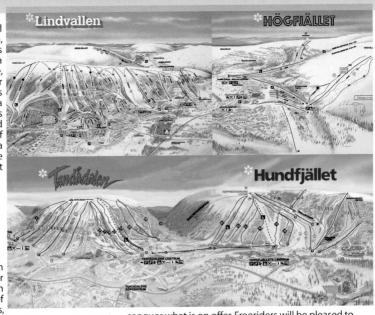

conquer what is on offer. Freeriders will be pleased to find lots of cool areas to get a fix with deep powder stashes and fast steeps off-piste.

For those wanting to go high off man made hits, then there is a host of terrain parks and halfpipes to satisfy your needs. In Tandådalen theres 2 terrain excellent parks with 2 halfpipes and various spines, kickers, rails and boxes. Theres another park at Lindvallen

Resort services are extreme with literally dozens of hotels, restaurants and night time hangouts much of which is either on the slopes or very close to them.

STORLIEN

Storlien is a small affair with nothing great to shout about unless you are a novice or intermediate rider who looks for simple slopes. There is nothing much here to please advanced riders, with only a couple of black runs. Freeriders will find that this place has some nice off-piste areas although very limited. Freestylers have numerous natural hits to get air from and a pipe. Basic lodging is available but none of it is that cheap

www.storlienfjallen.se

SWITZERLAND

The Swiss have gained their riches by shrewdness and getting in on the act early. So it's no wonder their resorts have been welcoming snowboarders for some time and providing them with a huge variety of services. It's never been a big deal for Swiss areas to build halfpipes and fun parks.

What you find in Switzerland is a decent mixture of the old and new. Many resorts are made up of old chalets that look the part, while others are sprawling modern affairs. Verbier is a huge and very impressive place, spoilt only by the fact that it's damn expensive and that it attracts Royalty and idiots on Big Foot

Travelling around the country is made easy with a good road network that links up well with the rest of Europe. To drive on Swiss motorways you need to buy a road tax called the Vignette, which costs around Sfr 30 and can be purchased from Automobile Associations or at border crossings. The tax disc must be shown in the window and fines are payable if you are caught without it.

Flying options are excellent in Switzerland, with most resorts reachable within a 3 hour transfer from the main gateway airports. For such a small country with so many high mountainous areas, it's amazing how good and how many direct train routes there are to resorts. Trains wind their way up to some of the smallest places, travelling up such steep inclines that you're left wondering just how good the brakes are! Few resorts don't have their own train station, or one more than 15 km from away. Bus services are also good, especially from airports, but although they're cheaper than the trains, the buses are slower and less frequent.

Switzerland is not a member of the EU, so all foreign required for many nationals, but you must obtain proper permits if you want to work, even as a kitchen porter. You can get cash in hand work with no questions asked, so long as you don't draw attention to yourself.

When it comes to money, Switzerland is costly budget riders be warned nothing is cheap, and this is not a country where you can scam your way around easily, although thankfully a lot of resorts have bunk houses and youth hostels that help to keep costs.

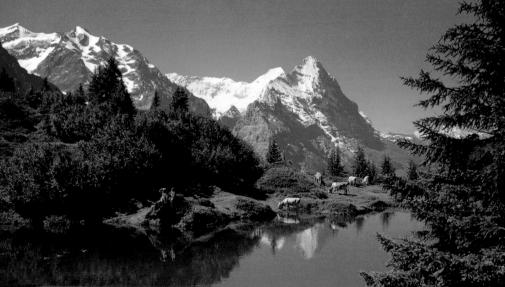

CAPITAL CITY: Bern POPULATION: 7.5 million HIGHEST PEAK:

Mont Rosa 4634m

LANGUAGE: German/French/Italian **LEGAL DRINK AGE: 18**

DRUG LAWS: Cannabis is illegal but laws are slack

AGE OF CONSENT: 16 **ELECTRICITY: 240 Volts AC 2-pin** INTERNATIONAL DIALING CODE: +41

CURRENCY: Swiss Franc (CHF) **EXCHANGE RATE:** UK£1 = 2.3 EURO = 1.5 US\$1 = 1.2

DRIVING GUIDE All vehicles drive on the right hand side of the road SPEED LIMITS:

Motorways-120kph (74mph) Highways-80kph (50mph) Towns-50kph (31mph)

EMERGENCY Fire 118, Police & Ambulance 117

TOLLS Drivers on motorways must have permit which costs CHF40 available from most garages. & service stations

DOCUMENTATION Driving licence, vehicle registration document and motor insurance must be carried. Passport will be needed for photo ID

TIME ZONE UTC/GMT+1 hours Daylight saving time: +1 hour

SWISS SNOWBOARD ASSOCIATION Webereistrasse 47, Postfach 8134 Adliswil 1, Switzerland Tel:+41 1 711 82 82

Web: www.swisssnowboard.ch Email: info@swisssnowboard.ch

RAILWAYS www.sbb.ch www.zentralbahn.ch www.tpc.ch (Bus & train) www.glacierexpress.ch - Glacier Express

www.rhone-express.ch - Rhone Express BUS SERVICES www.zvv.ch

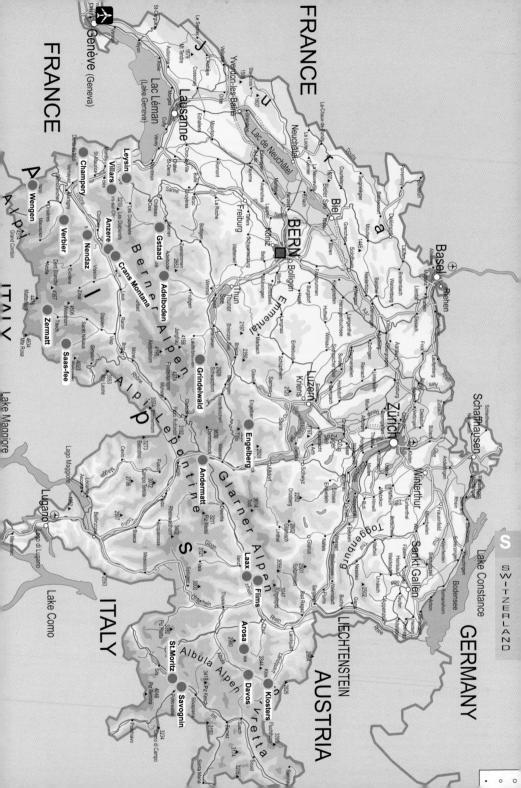

Adelboden, which links with Lenk, is a decent sized picture postcard swiss resort, located a short distance from the resort of Gstaad and close to the glitzy resorts of Wengen Grindelwald and Murren, However, unlike its neighbours, this is a less popular place making it that bit quieter with crowd free slopes. This is also not a resort favoured by tour operators, although a few do bus in the two plankers to mess things up. What you get to ride here is split into 6 areas all linked by lifts. Collectively, all the areas provide terrain that will keep novices and intermediates happy for a few weeks, while expert riders will have things sorted in a few days after tackling the blacks on the Geils area. The mountain has some nice diverse terrain that will bring a smile to most freeriders. It also has a good terrain park and some nice pisted areas.

FREERIDERS will find plenty to keep themselves occupied with here. The Geils area offers some good off-piste riding coupled with a series of black runs that will test the best and draw tears if you fail to respect the terrain. You can also find some fun terrain in the adjoining area called Engstligenalp.

FREESTYLERS are spoilt for choice here, with the option to ride the Gran Masta Park. The park has features for riders of all levels, with a selection of kickers from 3 to 18 metres and rails/boxes of all shapes and sizes, but no halfpipe though. Many of the locals here like to ride the natural hits and have a number of secret spring boards that are tucked away, so hitch up with a local and go big.

PISTES. Boarders who want to stick to the piste will find that Adelboden will suit their needs perfectly, although there are a lot of flat cat tracks that may catch out the less-accomplished rider.

BEGINNERS have a mountain that caters for them in every aspect, good novice areas with easy access from the village, excellent snowboard tuition at the local snowboard school and runs serviced by easy to use lifts, although many are drag lifts.

THE TOWN. Off the slopes, Adelboden offers plenty of slope side accommodation with various hotels and a number of chalets to choose from, all in a relaxed setting. Eating out here is mixed with affordable options coming from traditional swiss style restaurants. Night life is also okay, but on the whole, not rocking. Check out such bars as the Alpenrosli and Lohner.

242 USQ www.worldsnowboardguide.com

POOR FAIR GOOD TOP **FREERIDE** Some fun bowls and faces **FREESTYLE** Well-maintained terrain park **PISTES** Wide and mellow

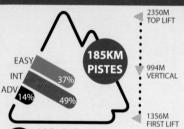

Adelboden Tourismus Dorfstrasse 23, CH-3715 Adelboden

TEL.+41 (0) 33 673 80 80

WEB: www.adelboden.ch / www.adelboden-lenk.ch EMAIL:info@adelboden.ch

WINTER PERIOD: LATE Nov to end April LIFT PASSES Afternoon 49CHF, 1 Day pass 55Chf 6 Days 245 Chf, Season 785

HIRE Many shops in the town around 50CHF for board &

BOARD SCHOOL Halfday 2 hr lesson 40 or 88 CHF inc equipment. Private 70 CHF per hour

NUMBER OF RUNS: 105 LONGEST RUN: 7km

TOTAL LIFTS: 58 - 7 Gondolas, 3 cable-cars, 10 chairs, 22 drags, 16 Children's lifts

LIFT CAPACITY: (PEOPLE PER HOUR): 33,000 LIFT TIMES: 8.30am to 4.30pm

ANNUAL SNOWFALL: Unknown **SNOWMAKING:** 32% of slopes

TAXIS: Tel. +41 (0)33 673 28 48 and +41 (0)33 673 15 15 FLY to Geneva airport, 3 hours away.

TRAIN services are possible to Frutigen station (15 minutes).

CAR From Austria/E.Switzerland take the A1 Zurich-Berne, motorway, A6 Berne-Spiez, then take main road for Frutigen-Adelboden

NEW FOR 06/07 SEASON: drag lift on Bühlberg is to be replaced with a 6 seated chairlift

ANDERMATT

Excellent small freeriders resort

Andermatt is a very small resort, located close to the St.Gotthard Pass tunnel with a reputation for excellent powder snow that other resorts can only dream about. This may not be a massive resort, but what it does have is a respectable 1500 metres of vertical with some damn fine steeps, lots of offpiste and crowd-free slopes that are generally also skier free (apart from major holiday times) making Andermatt a great place to snowboard There is excellent terrain for advanced riders in soft boots and is noted for its testing runs that also appeal to intermediates who are beginning to sort out their riding. The area is split into four areas with the most testing terrain to be found on the Gemsstock slopes, easily reached from Andermatt by a two stage cable ride. From the top, you get to ride down some serious open steep bowls that eventually make their way to the base. However, to guarantee that you do get back to the base, you are well advised to use the services of a local guide.

FREERIDERS have an excellent resort to explore,

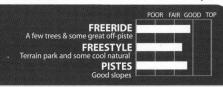

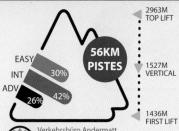

Verkehrsbüro Andermatt Gotthardstrasse 2, 6490 Andermatt

EMAIL:info@andermatt.ch

TEL: +41 (0) 41 887 14 54 WEB:www.andermatt.ch

WINTER PERIOD: Dec to April LIFT PASSES 1 Day pass - 54chf 2 Day pass - 95chf, 5 Day pass - 205chf

NUMBER OF RUNS: 24 LONGEST RUN: 5km

TOTAL LIFTS: 12 - 2 cable-cars, 4 chairs, 6 drags LIFT CAPACITY (PEOPLE PER HOUR): 33,000

LIFT TIMES: 8.30am to 4.30pm

ANNUAL SNOWFALL: 8.5m SNOWMAKING: none

FLY to Zurich airport 2 hours away. TRAIN services are possible direct in to Andermatt. Change at Göschenen to the Matterhorn Gotthard Bahn www.mgbahn.ch

CAR From Basel take the A2 for 90mins, take the Göschenen exit and drive for another 10mins

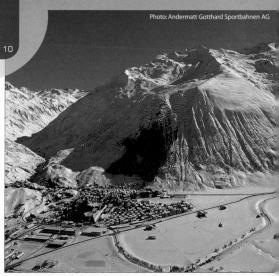

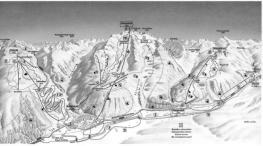

with great off-piste riding in big powder areas. If your thing is fast steeps and banked walls, Andermatt is a resort that will serve your needs well and will easily keep you interested for a week or so.

FREESTYLERS are provided with a fun park on the **Gemsstock** area, but its not particularly hot. There is also a boardercross course . However, there is plenty of good natural terrain to get from with big naturally formed banks and some cool drop offs.

PISTES. Riders who like to perform will be pleased to find that there's plenty of fast sections to really crank some big turns on. The Sonnenpiste is a decent run to try out before hitting some of the blacks on the Gemsstock area.

BEGINNERS usually head for the Natschen area, but if you're a slow learner this may not be your resort The slope graduation goes quickly from easy to very hard.

OFF THE SLOPES. Good accommodation can be found in chalets or in one of the hotels, with access to the slopes very easy by foot. The old village is as Swiss as they come: somewhat boring and somewhat basic. However, it's not as expensive as some other Swiss resorts and as you can ride hard all day, who needs major night-life? A few beers in a bar free of moaning package tour apres numpties should do the trick. Nights can rock and the locals help to make the action take off, but don't expect lots of it.

ANZERE

Good basic resort

Anzere is one of Switzerland's custom built resorts that dates back to the sixties. This small resort with a modest 25 miles of piste, sits at an altitude of 1500m. This has helped to ensure a good annual snow record of over 800 centimetres a season on slopes that get a lot of sun. This allows for plenty of tanning as you ride the slopes or sip a beer at a mountain bar Overall. Anzere is a fun. happy-go-lucky place

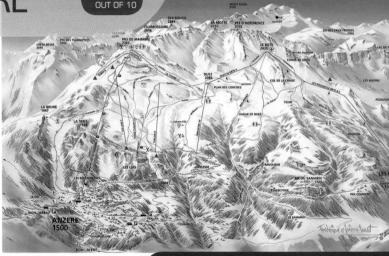

that will appeal to the laid back snowboarder. A lot of families and older skiers hang out here, but snowboarders can mingle with ease with both and riders are not ignored or snubbed. The 25 miles of runs are simple and all styles will find something to keep them happy, but it appeals mostly to novices and riders just getting things dialled. Anzere would be worth a visit for a few days if you're on a road trip, but a two week trip will prove to be a bit of a bore for those riders who rate themselves at an advanced level.

FREERIDERS in soft boots will fair well on the areas found off the **Les Rousses** and **Le Bate chair** lifts. The trees at the lower parts although not extensive, do offer some pine shredding. The Swiss don't particularly like the woods being cut up, so beware, you may encounter a few sharp tongues from the locals.

FREESTYLERS can spin off a number of natural hits and there are ample areas for practising your switch stance, especially on the runs frequented by the oldies who are leisurely sliding around on their two wooden planks. There's permanent boardercross on the Pâtres piste.

PISTES. Competent riders will find the black under the Pas-de-Maimbre gondola worth a visit. It should be said that this run could be a red, but it's OK and allows for a few quick turns.

BEGINNERS should achieve the most on the well matched and easy slopes which can be tackled by taking the Pralan-Tsalan chair lift and then by using the drags (hold on tight, wimps).

OFF THE SLOPES. Anzere is a well laid out village, with a good choice of accommodation (mostly expensive) but budget snowboarders will find affordable beds in a selection of apartments and chalets. *Village Camp* offers decent priced lodgings while the Avenir does the best pizza. For evenings, it's best to check out *La Grange* or the *Rendezvous*.

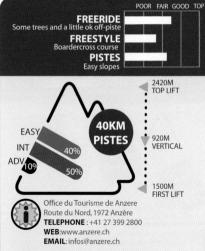

WINTER PERIOD: end Nov to April

LIFT PASSES Half day 32CHF Full Day pass 47 5 days 195 chf, Season 635

BOARD SCHOOL Private lessons 1hr 50CHF, day 260

Full day group 45CHF, 5 days 165 HIRE Board & Boots 38CHF, 6 days 136

NUMBER OF RUNS: 24 LONGEST RUN: 4km

TOTAL LIFTS: 11 - 1 Gondolas, 2 chairs, 8 drags LIFT CAPACITY: (PEOPLE PER HOUR): 9,000

LIFT TIMES: 8.30am to 4.30pm

ANNUAL SNOWFALL: 8m SNOWMAKING: 5% of slopes

TAXIS +41 27 398 3545 and +41 79 433 4815
FLY to Geneva airport, 3 hours away. Zurich also close
TRAIN to Sion station (15min.TGV from paris.
CAR via Geneva, east on the N1 and N9 to Sion and turn
left and then drive up the steep road to Anzere.

AROSA

Good freeriding & a decent halfpipe

Arosa is all Swiss, and a place that fits in perfectly in with how the Swiss marketing chiefs would have you see it. This is one of those cosy Swiss hamlets perched high above the tree drenched valley floor. This is a high altitude resort which sits above 1800 metres and is located in the eastern sector of the country not far from the town of **Chur** and the better known resort of **Davos**. However, unlike Davos, this is not a massive sprawling mountain town, Arosa is a quiet traditional swiss village loaded with all the charm you could hope for, although spoilt slightly by its glitzy stuck up image. Still, the area offers some good snowboarding opportunities and will make a week's trip a good one if you're a novice or intermediate rider. Advanced riders have very little to keep them interested beyond a day or so. The 40 plus miles of open wide trails are serviced by a modern and well appointed lift system that can shift over 22,000 people an hour uphill with just 16 lifts Although Arosa is not on the calling card of every tour operator, the few that do use this place help to cause a few lift lines and the odd bottle neck on certain slopes. The runs are spread out over two areas, that of Hornli and Weisshorn where the most challenging terrain is located.

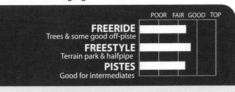

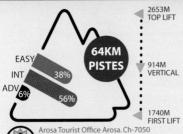

TEL: +41 81 378 70 20 WEB:www.arosa.ch

WINTER PERIOD: Dec to April LIFT PASSES 1 Day pass 56 chf, 5 days pass 230chf

NUMBER OF RUNS: 55 LONGEST RUN: 5.5km

TOTAL LIFTS: 16 - 3 cable-cars, 7 chairs, 6 drags LIFT CAPACITY (PEOPLE PER HOUR): 22,000

LIFT TIMES: 8.30am to 4.30pm

ANNUAL SNOWFALL: unknown **SNOWMAKING:** 10% of slopes

FLY to Zurich airport about 3 hours away. TRAIN services are possible direct into Arosa via Chur. CAR Drive via Zurich, head south on the N3 to Chur and

then take the winding road up to Arosa (30km), a total distance of around 100 miles (160km).

FREERIDERS who want to sample some tracks at speed, should check out the black on the Weisshorn. If you want to get into some freshies then take the off-piste track to the resort Lenzerheide via the Hornli slopes, but do so only with a guide.

FREESTYLERS have a good half-pipe located at **Carmennahue**. This is also the location for the fun park which is equipped with a standard series of hits including one or two nice kickers. However, this is also a place that offers some good natural freestyling, but you have to look for it.

PISTES. Riders who like to slide around on gentle well prepared slopes and without any surprises, will find Arosa ideal for their needs.

BEGINNERS in Arosa could do a lot worse. The slopes here provide novices an easy time and allow for some quick progression.

OFF THE SLOPES you will find a limited selection of facilities, but enough to get by with. Accommodation is well stationed for the lifts and comes in the standard grade Swiss hotel format. Warm, cosy, charming and costly. Eating out and night time action is not hot at all, but if you're only out for a quiet time away from the crowds, this place will do nicely.

CRANS MONTANA

Big snowboarders resort offering something for everyone

Photos CRANS-MONTANA TOURISME

One of Switzerland's top snowboard areas is made up of two linking towns, that of Crans and Montana. Both of which are pretty outstanding and make a totally fullon place with plenty of interest for all. Both areas fuse together to provide over 100 miles (160km) of all-level and all-rider style terrain. Snowboarders have been cutting up these slopes for years, which have lead to a resort with some of the best snowboard instruction and facilities anywhere in Europe. Unfortunately the popularity of this area does mean some stupidly long lift queues with skier cluttered slopes. A lot of tour operators throughout Europe come here with package groups (especially from the UK) so there's a lot of idiots messing up early morning runs. Still, for all the area has to offer, advanced riders are not always tested, with the terrain largely covering intermediate or novice levels. The hardest listed run is the black that runs down from the Toula chair, which is best tackled in softs as the unevenness in parts is better ridden in something where you can easily absorb the bumps at speed.

FREERIDERS in search of off-piste and fresh powder, need to hook up with a guide and set off to areas around the Plaine Morte Glacier, where you can make your way

to nearby Anzere. The route goes through some tunnels, which makes it well worth the effort. The area known as the Faverges is cool and for riders with some idea of what they're

doing, there are some decent steeps to tackle but watch out for the thigh burning traverse on the way back. For those who can afford it, you can do some cool heli-boarding on some major terrain.

FREESTYLERS are well catered for, with a good pipe on Pas du Loup, which can be reached by the Montana-Arnouvaz gondola. The fun park at Aminona is loaded with rails spines and gaps, so new schoolers will love it and for those who want to find out how to ride a pipe correctly or to get big air, there are a number of schools that will help out, all of which offer some of the highest levels of snowboard tuition in Europe (they practically invented snowboard instruction here).

PISTES. Riders wanting to draw some arcs have plenty of long reds to check out. In particular the red run that drops away from the Plaine Morte

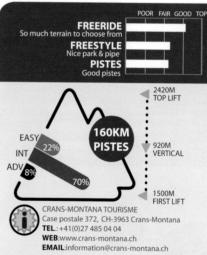

LIFT PASSES Half-day 47CHF, 1 Day 56chf, 5 Days 240 chf HIRE Board & Boots from 28 CHF BOARD SCHOOL Lesson, Lift & hire from 40 CHF a day

NIGHT BOARDING 3.5 km floodlit every friday 7-10pm, CHF15 **HELIBOARDING** in mont blanc area

NUMBER OF RUNS: 49 LONGEST RUN: 12km

TOTAL LIFTS: 33 - 1 Funicular, 7 Gondolas, 2 cable-cars, 10 chairs, 13 drags

LIFT CAPACITY: (PEOPLE PER HOUR): 36,520 LIFT TIMES: 8.30am to 4.30pm

MOUNTAIN CAFES: 12.

ANNUAL SNOWFALL: 7m SNOWMAKING: 10% of slopes

CAR: A9 to Sierre then 15 km to resort FLY: 2.5 hours from Geneva, Zurich 4hrs, Sion nearest airport, 40 mins away.

TRAIN: To Sierre then Funicular 12 mins or 30min drive BUS: Buses between Sierre-Montana-Crans via Chermignon or Mollens

246 USQ WWW.WORLDSNOWBOARDGUIDE.COM

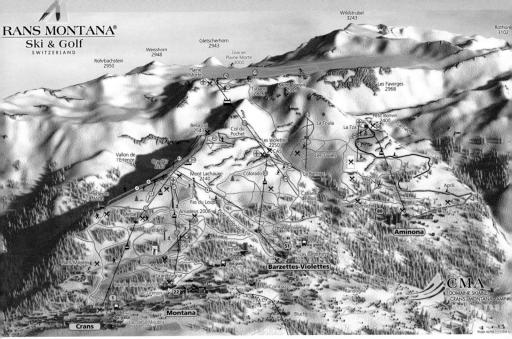

down to the village of **Les Barzettes**, is perfect to lay out some big lines and with a length of 7.5 miles, you have plenty of time to get it right.

BEGINNERS are treated to a variety of no nonsense blues which may require some navigation to avoid drag lifts. That said, this is a good novices resort, apart from the sometimes busy slopes. What really stands out is the superb level of snowboard tuition available, with a 3 hour group lesson costing from 40 CHF

OFF THE SLOPES.

As well as supposedly having the largest linked resort in Switzerland, Crans-Montana also said to have the largest number of hotels and accommodation options of any mountain resort in the country. However, you could actually be forgiven for not classing this place as resort at all, but rather a large bustling town which in effect is what it is. The whole

area is serviced by a regular bus service which is the best way to get around if you don't have a car (taxi prices are criminal). There are loads of sporting outlets, dozens of shops, (check out The Avalanche ++41 (0) 402 2424 for snowboard hire) a cinema and if you are feeling really lucky, a casino.

ACCOMMODATION: The 40,000 plus tourist beds are spread throughout a large area with the option to stay in either Crans or Montana Lodging options are fairly extensive with a good choice of slope side hotels or a large selection of self catering apartment blocks for groups, but on the whole nothing comes cheap wherever you stay.

FOOD. Around town you are spoilt for choice when it comes to restaurants with a selection of over 80 eateries no one need starve here. This place is blessed with simply loads of places to get a meal and even though this is an expensive resort, there are affordable joints such San Nick's, which offers some good pub grub or Mamamias for a slice of pizza or a bowl of pasta at just about affordable prices. If you wish to splash out, try Le Sportings.

NIGHT LIFE is pretty damn good here and well in tune with snowboard lifestyle, although it is carried out along side some very sad Swiss style après ski nonsense. Cool hangouts to have a beer in include The Amadeus Bar and Constellation, both with a party mood and loud music. The Memphis Bar is a good bar.

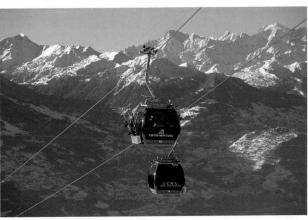

The further developement of Pischa is also excellent news.

FREESTYLERS also get delicious feeding. Jakobshorn has a park with kickers/tables/superpipe/rails at the top of Jutz chair and T-bar. There is also a monster pipe & kickers at the base outfront of Bolgen Plaza bar restaurant. The outside bar & decked area provides a full view. Night riding on Friday nights!! From late January Parsenn opens a park below Totalp chairlift with kickers, tables & Boardercross.

POOR FAIR GOOD TOP

810M

FIRST LIFT

FREERIDE Some tree runs & excellent off-piste **FREESTYLE PISTES** Good variety of long runs 2844M TOP LIFT 310KM PISTES 2034M VERTICAL

Davos Tourismus

Promenade 67 CH-7270 Dayos

TEL: +41 (0)81/415 21 21 WEB: www.davos.ch / www.davosklosters.ch EMAIL:davos@davos.ch

WINTER PERIOD: mid Nov to mid April LIFT PASSES Half day 48CHF, 1 Day pass - 65 Chf 5 Day pass - 248 Chf, Season pass (inc Laax) 897-1050CHF

HIRE Loads of hire shops in town, board and boots from 55Chf BOARD SCHOOL 3 x 2.5hrs 260Chf. Top Secret & Schweizer Schneesportschule run sbowboarding lessons inc backcountry & freestyle

NIGHT BOARDING Halfpipe illuminated fridays from 19.00

NUMBER OF RUNS: 110

LONGEST RUN: 12km

TOTAL LIFTS: 57 - 4 Gondolas, 11 cable-cars, 10 chairs, 29 drags

LIFT CAPACITY (PEOPLE PER HOUR): 64,400

LIFT TIMES: 8.30am to 4.30pm **MOUNTAIN CAFES: 15**

ANNUAL SNOWFALL: 5.5m SNOWMAKING: 10% of slopes

CAR From Zurich take motorway A3/A13 towards Chur, take the Landquart exit and continue to Davos. 145km total

FLY to Zurich international 155km away, transfer time to

resort is 2 1/2 hours. Friedrichshafen airport 145km away TRAIN to Davos centre. Train from Zürich via Landquart takes 2 1/2hrs. Train from Geneva will take 5hr20

BUS Kessler Carreisen AG run transfer from Zurich airport 4 times every saturday, 70 single, 120 return. Tel: +41 (0)81 417 07 07. Local bus service timetables on www.vbd.ch

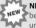

NEW FOR 06/07 SEASON: the Pischa ski region will be turned into more of a freeride area. 3 pistes will be unpisted

Davos is not just a major snowboard resort; it's also a massive town that offers just about all you need to have a cool time. This very happening place offers the lot; tons of deep powder, loads of trees, big natural hits, halfpipes, fun parks, a boardercross circuit and night riding. All this on 200 miles (320km) of fantastic snowboard terrain, on slopes that holds the snow well. Davos is located in an area that makes it ideal to check out many other resorts, including the famous retreat of Klosters (the place where Prince Charles and Prince Harry first tried snowboarding). However, back to Davos which is a resort that needs to be visited a number of times if one is to ride the whole area. Davos itself, has a bit of an attitude when it comes to money, but it's a working town and so far less snobby than other similar places, more importantly, Davos offers access to some major snowboarding terrain - there's enough stuff here to keep any rider busy for a long time. At the end of January It plays host the World Economic Conference where all the World leaders and billionaires gather to schmooze and pretend they care in front of the cameras; a security nightmare and certainly a week to avoid. The town sprawls along the bottom the Davos valley with the 5 mountain areas either side. The main Davos Dorf/Platz area services the Parsenn and Jakobshorn mountains. Nearby Klosters is next to the Madrisa and Parsenn mountains. The other 2 mountains Pischa and Rinerhorn will involve a 20 minute bus or a train to get to

FREERIDERS will wet themselves when they see the off-piste opportunities, which are mega and best checked out with the services of a guide. It is possible to find fresh tracks a week or two after snowfall. The run down to Teufi from Jakobshorn is pretty cool, but you will have to bus back to Davos. From the top station (which is well above the tree lines), advanced or intermediate freeriders will find a number of testing blacks which mellow out into reds as they lead straight back down to the **Ischalp** mid-section. From here you could carry on down through the trees to the base or if you want an easy final descent, there's an easy blue that snakes it's way home, ideal for novice freeriders. There are also routes down from Parsenn above Wolfgang.

248 USQ www.worldsnowboardguide.com

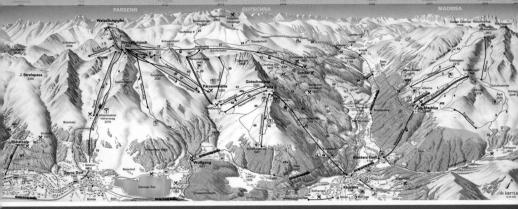

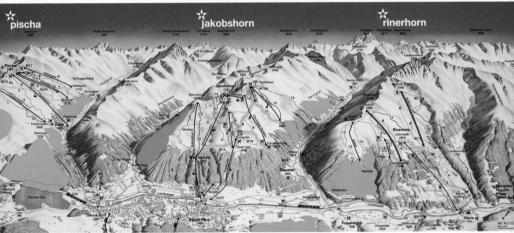

Pischa's park is next to the Mitteltali lift.

PISTES. Any headband wearing euro carvers won't be disappointed here, the 6 mile red run into the village of Serneus is full-on and you should be carving big style at the end of this one.

BEGINNERS wanting to get to grips with things should go see the guys at the 'Top Secret snowboard school, the instructors really know how to turn you from a side standing fool into a powder hound. At the top station of Jackobshorn, novices are treated to wide open easy flats which are serviced by drag lifts or a short cable car ride. Alternatively, there are plenty of very easy runs lower down on the Parsenn slopes

OFF THE SLOPES. If you're the sort of individual that wants to be housed, fed and watered in a charming sweet little village with cow bells hanging from rickety old sheds, don't bother with this place. Although better looking than it was, it is still a massive drab mountain town. It does have choice however and although generally expensive you can find some cheaper options and a solid slice of snowboard lifestyle. It attracts international conferences particularly at the end of January, but with this comes some excellent sports centres, lots of shops, and even a Casino!!

ACCOMMODATION in Davos is second to none. On top of there being loads of expensive hotels, Davos also has an affordable snowboarders hostel come hotel called the "The Bolgenschanze" which offers a number of "ride and stay" packages at reasonable prices (++41 81 43 70 01). The town also boast a host of bed and breakfast joints. You could also try Extreme holidays.

FOOD. Two words that don't go together in Davos, cheap and eating out (okay 3 words..) but if you have the cash then the options for dining high on the hog are excellent. There is a good choice of restaurants offering every type of cuisine, ranging from local dishes to Chinese (above casino £20-30). You will also find a few fast food joints: Try the Kebab (and Burger) place next to the main Coop. Great pizzas at Padrino and some Indian and Thai (Davos Dorf)

NIGHT LIFE in Davos rocks despite the wallet demolition. There is a good choice of bars and late night clubs, with live bands and artists playing seven nights a week. Most places pump out modern music but a few play sickening euro pop to please the apres skiing nerds. The Bolgenschanze Hotel is one of the best hangouts, providing the full snowboard lifestyle package and gets packed out with loads of chicks gagging for it. Check out www.davosbynight.ch for all the big nights.

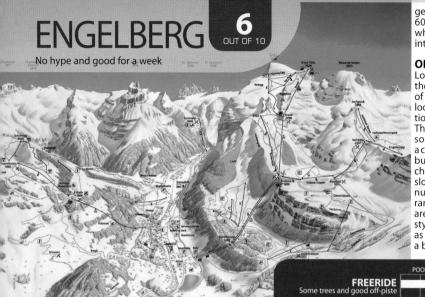

Engelberg is a cool resort located slap bang in the middle of the country, not far from the town of **Lucerne** or the resort of **Andermatt**. By any standards, Engelberg has a very impressive rideable vertical drop which is said to be the longest in Switzerland. The beauty of this place is that it's left alone by mass ski crowds so the place has a cool laid back feel about it, without the hype. The ride area is a bit unusual and spread out from the village area. This is a resort noted for its avalanches so lots of attention is called for before trying out any of the slopes. The main happenings are offered on the Titlis area noted for its intermediate terrain but somewhat lacking for those who like to shine. The **Gerschnialp** area is for those sucking on a dummy (beginners). Theres is some summer boarding and a terrain on the **Titlis glacier**.

FREERIDERS have a very good mountain here with some great off-piste to check out, but be warned, avalanches are common here. Some of the best off-piste terrain can be found having taken the Jochstock drag lift to reach the slopes on the Alpstublii, where you will find some amazing runs. Another easy to reach gem is the Laub area, which bases out conveniently to allow you to do it again. But this pleaser should not be tried out unless you know the score and can handle fast steeps, because this one will wipe your lights out for good if you balls up. Guide services are available here so use them, and stay alive.

FREESTYLERS who like it done for them will find the park on the **Jochpass area** (www.terrainpark.ch) the place to head for. Theres a some big kickers and a rail line that they usually keep nicely in shape. Dotted around the area are plenty of good natural hits to check out.

PISTES. Riders have a fair selection of well looked after pisted runs or some fine unpisted slopes. Check out the Jachpass trails for a burner.

BEGINNERS, 30% of the slopes are said to be easy terrain, but in truth if you're a fast learner, then you soon 250 WSQ www.worldsnowboardguide.com

get to ride a further 60% of slopes which are rated intermediate.

OFFTHE SLOPES.

Local services at the base area are of a high standard located in a traditional Swiss setting. The village offers affordable some accommodation but don't expect cheap digs near the slopes. There is a number of restaurants here which are all similar in style and price, but as for night life, it's a bit dull.

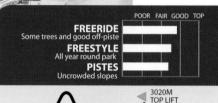

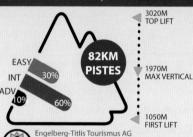

Tourist Center, Klosterstrasse 3, 6390 Engelberg
TEL: +41 (0)41 639 77 77

WEB:www.engelberg.ch / www.titlis.ch **EMAIL**:welcome@engelberg.ch

WINTER PERIOD: Nov to April SUMMER PERIOD: June to August LIFT PASSES Half day 42CHF, 1 Day 52 Chf 5 Days 219CHF, Season 1100CHF

BOARD SCHOOL Swiss Snowboard School (www.skischuleengelberg.ch)& boardlocal (lucerne@boardlocal.ch) run lessons HIRE board and boots from 45 Chf/day

NUMBER OF RUNS: 44 LONGEST RUN: 4km

TOTAL LIFTS: 27 - 1 Funicular train, 7 Gondolas, 7 chairs, 12 drags

LIFT CAPACITY: (PEOPLE PER HOUR): 23,000 LIFT TIMES: 8.30am to 4.30pm

ANNUAL SNOWFALL: 3m SNOWMAKING: 5% of slopes

TAXIS +41 (0)78 666 57 57 or 41 (0)41 637 33 88

FLY to Zurich airport, about 2 hours train away. **TRAIN** from Lucerne there is a direct hourly service to

Engelberg operated by the LSE. Direct trains available from Zurich to Lucerne.

 ${\bf CAR}$ Via Zurich, head south on the routes A123/N4a/N14/N2 to Stans and turn off at signs for Engelberg.

GRINDELWALD

Nice park & wide open slopes but busy & too easy

Grindelwald is one of the resorts that helps form the area more commonly known as the Jungfrau **Region**. The other resorts that make up this sector are **Wengen** (very posh and super up its arse attitude), and Murren the most laid back and snowboard friendly of the three. Grindelwald sits up at an altitude of some 1034 metres and scenically, is an impressive place. However, the same can't be said of the rideable terrain that is immediately on offer from the base village, for this is not an adventurous mountain resort and freeriders will soon get bored of the place, although it is a very good carvers resort. The 200 plus kilometres of marked piste stretch out across two large wide open plateaus that stretch up from both sides of the village, with the slopes on the Mannlichen and Kl.Scheidegg side linking up with the runs that descend back down into Wengen. You can also

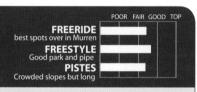

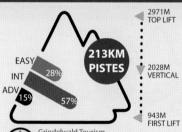

Grindelwald Tourism P.O. Box 124, CH-3818 Grindelwald PHONE +41 33 854 12 12

> WEB:www.grindelwald.ch / www.jungfrauwinter.ch EMAIL: touristcenter@grindelwald.ch

LIFT PASSES Half day 42 CHF, 1 day 58 CHF 5 day 220 CHF, 2 day for entire Jungfrau region 123 CHF, 6 days 295

BOARD SCHOOL Private lesson CHF 320 for full day Group 3 day 185 CHF, 1 week 255 HIRE 6 days Snowboard & boots 219

WINTER PERIOD: Dec to April

LONGEST RUN: 15km TOTAL LIFTS: 45 - 10 Gondolas, 6 cable-cars, 16 chairs, 13

LIFT CAPACITY: (PEOPLE PER HOUR): 42,000 LIFT TIMES: 8.30am to 4.30pm

ANNUAL SNOWFALL: 5.3m SNOWMAKING: 10% of slopes

FLY Zürich Kloten and Geneva Cointrin have rail services to Interlaken. Bern Belp have airport taxis available to take you to the train station.

TRAIN to Interlaken Ostthere, then train to Grindelwald (approx 35min)

CAR Motorway to Bâle, Geneva or Zürich to Spiez, then to Grindelwald via interlaken

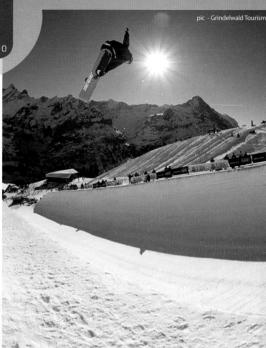

reach Murren via the slopes but in truth, it can be a bit of a pain the arse. Grindelwald is a large sprawling resort that attracts a lot of visitors, there is no such thing as a good time to visit to avoid crowds; the place is always packed. The main access lifts are not only slow but the queues for them can be hellish and can often mean a 50 minute wait in line. Still, once you do get up on the slopes and the conditions prove to be favourable, provided you don't wan to be particularly tested, you will be able to have a good time.

FREERIDERS who stick to Grindelwald are not going to find a great deal to keep them entertained, not because it's crap, there's just not that much to appeal. The best freeriding terrain is in Murren

FREESTYLERS Theres a terrain park at Bärgelegg featuring a number of kickers and various kinked, straight and rainbow rails and boxes as well as a wallride. There's a superpipe located on **Schreckfeld** and a boardercross at **Oberjoch**. Visit www.stoneland.ch for details.

PISTES. The slopes may be busy, but there is still plenty of piste to lay out lots of wide linked turns on if thats your thing.

BEGINNERS have a host of nice gentle open slopes to learn on, the only draw back being that the access to them is not convenient.

OFF THE SLOPES. The village at the base of the slopes has a number of hotels and chalets to choose from, but nothing comes cheap as this place is stupidly expensive. Not all the accommodation is close to the slopes so expect to do some hiking to and from the base lifts. The resort has a host of sporting attractions, a lot of hotel restaurants but little or no cheap fast food, the night-life also sucks.

GSTAAD

6

Okay but a bit snobish

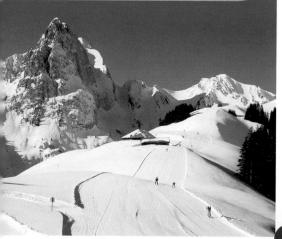

Gstaad is part of a massive slope linked area void of the mass holiday groups. What you get here is crowd free snowboarding with miles of backcountry adventures and over 150 well prepared pistes covered by a single lift pass. Welcome to Gstaad, a place where snowboarding comes as second nature and a place that despite its appeal for attracting far too many poncy image junkies with designer eye-wear, is a place that has a good snowboard feel to it and one where you can ride hard. Despite the sad gits that flock here, the area has long allowed snowboarders freedom to roam its slopes, which are split between a number of areas with Gstaad sitting mid-way between them. The areas most favoured by snowboarders are Saanenmoser and Schonried which can be reached without any hassle from Gstaad. Further a field is Les Diablerets which is a glacier that's open in the summer months.

FREERIDERS are somewhat spoilt for choice here with some notable freeriding terrain over on the **Saanen** area where with aid of a guide, you can ride out some great powder fields. Alternatively, for something a little more testing you should head up to the Les Diablerets

glacier.

FREESTYLERS have a number of terrain parks to choose from, with the best offering on the **Sanserloch** area (www.vanillaz.com), where you'll find some big jumps, gaps and rails. A bit of a trek away is a park on the **Glacier 3000** with various kicker and rail lines, and a halfpipe. However, constructed half-pipes are not always necessary here as there is a lot of diverse natural terrain with some notable cliffs and big wind lips. Check out the cliffs up at **Huhnerspiel**.

BEGINNERS have the biggest percentage of easy slopes around here much of which is not linked and spread out between the areas with some of the best runs on the Saanenmoser slopes.

OFF THE SLOPES. Gstaad is not for those with a weak stomach as on the snobbish, fur clad scale, this joint rates high and therefore is very expensive. Good affordable lodging can be had in places like the *Snoeb Hotel*, a specialist riders hangout. Night life here can also be good with an okay selection of bars that allow for some hard core drinking sessions.

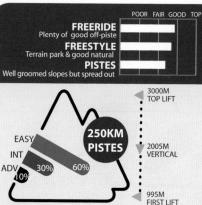

SKI GSTAAD Promenade CH-3780 Gstaad TEL: +41 (0)33 748 81 81

WEB:www.gstaad.ch / www.glacier3000.ch **EMAIL**:gst@gstaad.ch

WINTER PERIOD: Nov to April
LIFT PASSES Half day 47, 1 Day pass - 55Chf, 5 Days pass
- 232Chf

NUMBER OF RUNS: 150 LONGEST RUN: 15km

TOTAL LIFTS: 69 - 14 Gondolas, 3 cable-cars, 38 chairs, 14 drags

LIFT CAPACITY (PEOPLE PER HOUR): 42,000 LIFT TIMES: 8.30am to 4.30pm

ANNUAL SNOWFALL: Unknown SNOWMAKING: 5% of slopes

FLY to Geneva airport 2 1/2 hours away. Berne-Belp Airport 91 km away.

TRAIN services are possible to Gstaad/Vevey station.

CAR From Geneva, take the N1/N9 via Lusanne to Aigle at which point turn of on to the A11 to Gstaad just after the village of Saanen.

252 USQ www.worldsnowboardguide.com

pic - Laax Tourism

LAAX/FLIMS

World class halfpipe & some good freeriding

Laax and its smaller brother Flims are Swiss national treasures and pure snowboard heaven. This place is highly regarded by those snowboarders who know about it and what you have here is a full on snowboarder's resort that links up with the more sedate Flims. Together they form an area regarded as one of the most snowboard friendly

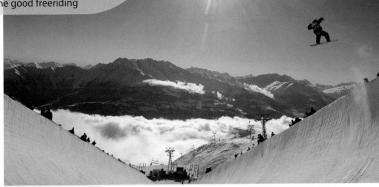

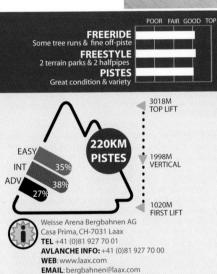

AUTUMN PERIOD (VORAB GLACIER): end Oct to mid Dec WINTER PERIOD: mid Dec to end April LIFT PASSES Half day 50CHF, 1 Day 63Chf, 6 Days 354Chf LESSONS Various group & private lessons as well as specialised freestyle and freeride courses contact: fahrschule@laax.com HIRE Plenty of hire shops, some allowing a try before you buy.

NUMBER OF RUNS: 58 LONGEST RUN: 14km TOTAL LIFTS: 29 - 7 Gondolas, 4 cable-cars, 8 chairs, 7 drags, 3 kids lifts

LIFT CAPACITY (PEOPLE PER HOUR): 42,000 LIFT TIMES: 8.30am to 4.30pm

ANNUAL SNOWFALL: 7.2m

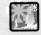

SNOWMAKING: 20% of slopes CAR Zurich via Chur to Laax is 90 miles (145 km). Drive

time is about 2 1/2 hours. FLY to Zurich about 3 hours away, Milan 3 1/2hr away TRAIN to Chur, 40 mins away.

BUS Bus services from Zurich take around 2 1/2 hours direct to Laax via Chur. Buses from Chur run 8 times a day from 06:49 until 22:15 visit www.zvv.ch/postauto for timetables. Ski buses run between Flims & Laax and run every 20mins until 6pm, takes about 15mins.

places in Switzerland. The resort bosses go out of their way to help snowboarders and it's no wonder that when there's a boarder event, the world pro's all seem to make it here. The Burton European Open has been held here for the past few seasons, and the Orange AIM series finals are also hosted here in mid March. When events are held here, it's not just the top riders that come to perform, some big name pop stars and DJ's also put in an appearance.

The Vorab Glacier opens in October with a decent terrain park and a halfpipe, however it can take up to an hour to get up from the base. When the season opens fully in December the park relocates to its main place under the **Crap Sogn Gion**, and the Vorab area becomes a great freeriding area.

It is notable that not many tour operators plague these slopes; if ever there was a mountain meant for snowboarders free of two plankers, this is it. Laax also has one of the best lift systems in Europe with lots of fast Gondolas whisking you up to the peaks, and you are seldom queuing for long. Beginners will also enjoy the fact that although there are some drag lifts, they can be easily avoided without restricting yourself too much.

FREERIDERS are tempted by some amazing off-piste opportunities with some cool tree riding and full-on powder. The ride down from La Siala summit is a real pleasure and can be tackled by most intermediates. Over in Flims for some easy to reach, classic off-piste riding, check out the Cassons area but it's not for the fainthearted. The cable-car only holds 20 people so you'll find yourself almost alone at the top. Below that the area from Naraus to Foppa is great after a good dump for beginner and intermediate freeriders.

Theres some good tree riding accessed from the Nagens Gondola by picking up the black 18 run. Its quite a narrow path as it snakes around the mountain, allowing you to hop off the side and (hopefully) pick the path up again after some tree shredding.

FREESTYLERS are coaxed here with an excellent park and pipe situated on the Crap Sogn Gion. The 140m earth shaped monsterpipe is impeccable and is usually joined by a 80m version. The terrain park has separate

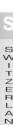

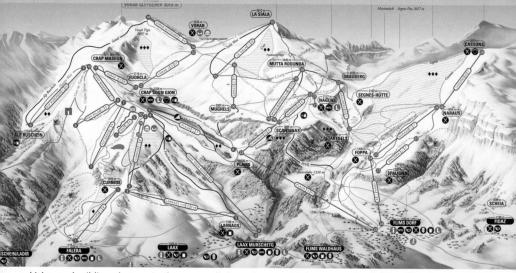

kicker and rail lines, but again they are well shaped and when the parks in full flow you'll find at least 6 kickers and up to 20 rails of various shapes and sizes. Early season you'll need to head onto the Vorab Glacier where they build a park during the Autumn months

PISTES. There's a good variety of pistes from open slopes at the top to the ones lower down that cut through the trees. They are all very open and wide, but there's nothing too testing but those with balls should try out the long black race run, Crap Sogn, back down to the base station of Murschetg.

BEGINNERS have a great mountain where learning the basics is a joy on simple, hassle free slopes, which are easy to reach from all parts of the resort. There's a well set out series of novice trails from the base area of Flims Dorf. The easy blues start out from the Narus and allow first timers a good choice of easy to negotiate descents back down to the base area.

OFF THE SLOPES. Both the villages of Laax and Flims (which are 10 minutes apart by road) sit at different levels and offer a host of good local facilities that will make a two weeks stay well worth the effort. Mind you, neither come cheaply and two weeks will burn a big hole in your wallet. Laax has a host of attractions from squash courts to an outdoor ice rink but is more spread out than Flims.

ACCOMODOATION. Some 6000 visitors are offered somewhere to sleep here, and although the choice of lodging and the prices are good, most places are a little spread out and for most, may entail a walk to the slopes. The trendy and well located Riders Palace near to Murschetg in Laax, (www.riderspalace.ch) has 5 bunk dorms at 70CHF per night (based on a week, peak season) or you can pay triple that for a room with a plasma TV and a playstation. They often do special packages including lift passes. Riders on a budget, book in at Gliders which is a cool backpackers place where a bed will cost around 45 CHF a night

FOOD is much the same as in any other high

mountain retreat, that is lots of hotel restaurants all serving up generally bland, traditional Swiss meals at very high prices. Still, there are a number of notable places to get a good meal including the odd pizza. try the Pomodoro and La Dolcha Vita in Flims. If you fancy a fish meal then look no further than Crap Ner restaurant in Laax, which is noted for its food (and its prices).

NIGHT-LIFE in either Laax or Flims is okay and fairly well suited to snowboard lifestyle (apart form the cost of a beer - approx 7CHF). Nothing here is of mega status but the bars on offer are good for getting messy in while listening to some good tunes. The Crap bar in Murschetg, Laax at the bottom of the slopes is easily the pick of the bunch for some après or late on. It's a cool place that plays some good tunes, and luckily you'll find most of the skiers Oompah'ing up in the Umbrella bar opposite. The Riders palace in Laax has a bar that's open till 4am and they always have some boarding films showing on the big screen. There's a huge club underneath that's lively when the big stars are out. Around the Murschetg area is also the Casa Veglia nightclub that's open till the early hours. In Flims The Iglu at Flims Dort is open till 1am, as is the Stenna bar oppositite. There's a nightclub open till 6am in Flims Waldhaus towards Laax.

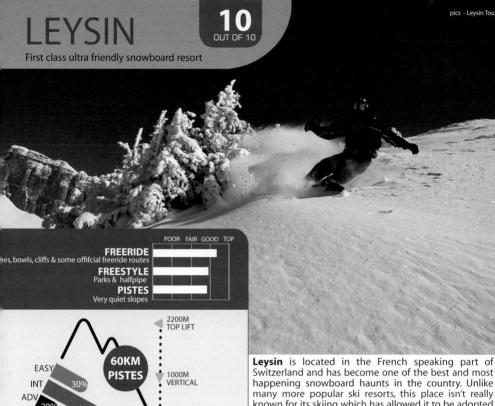

Tourist Office Leysin Place Large, CH-1854 Levsin TEL: +41 (0) 24 494 2244 WEB: www.leysin.ch EMAIL: tourism@leysin.ch

WINTER PERIOD: Dec to April LIFT PASSES just Leysin Half day 37, Day pass 43 Chf Linked area - 215km pistes

1 Day pass 55 CHF, 5 Day pass - 225 CHF, Season 930 BOARD SCHOOLS Snow sports Leysin charge 45CHF for half-day lessons, 205 for 6 half days. Private lessons 60 CHF per 60 CHF **HELIBOARDING** on one of the four Glaciers

1200M

FIRST LIFT

NUMBER OF RUNS: 16 LONGEST RUN: 4km TOTAL LIFTS: 13 - 1 Gondolas, 7 chairs, 5 drags LIFT CAPACITY (PEOPLE PER HOUR): 18,000 LIFT TIMES: 8.30am to 4.30pm **MOUNTAIN CAFES: 6**

ANNUAL SNOWFALL: Unknown **SNOWMAKING:** 20% of slopes

CAR Take the A9 from Geneva, take the Aigle exit to Levsin. 100km. Drive time is about 2 hours. FLY to Geneva international. Transfer time to resort is 2 3/4 hours, 100km away. Nearest airport is Sion, 50km

TRAIN Take a train to Aigle then change for Leysin. Takes 35mins and departs every hour. TGV from Paris takes 4:25hs BUS services from Geneva take around 2 hours direct to Leysin via Aigle. Taxis 024 493 22 93 or 024 494 25 55

Switzerland and has become one of the best and most happening snowboard haunts in the country. Unlike many more popular ski resorts, this place isn't really known for its skiing which has allowed it to be adopted by snowboarders. This has helped to ensure that the place has a low key friendly appeal about it with- out any bull or hype. Leysin connects with the two alpine villages of Villars and Les Diablerets to create a very acceptable 60 km of piste.

This resort has gone out of its way to be snowboard friendly for years, back in 92 it played host an ISF tour event, and these days the TTR Nescafe Camps Open is held here (www.nescafechamps.ch) where the world's top riders fight it out in the pipe & park.

Leysin is in fact an old and rather large sprawling mountain town and not a modern purpose built resort like some found nearby. What you get here is a high up mountain that in a good winter, offers everything to keep adventure seeking advanced riders happy, while also appealing to first timers who don't want to use a drag lift straight away. A notable point about Leysin is that it's not a popular resort with holiday companies, which is a good thing as the slopes don't get clogged up although weekends can still be a bit busy with locals and punters from Geneva. However, once you do get up on the slopes, you can roam freely over acres of great terrain without seeing another soul for hours

FREERIDERS have plenty of great terrain to explore. with tree runs down to the village, or extreme terrain with bowls and cliffs which you can reach by dropping in to your right on the Berneuse. You should also check out the official off-piste runs that give you the feeling of backcountry riding, for example try the route behind

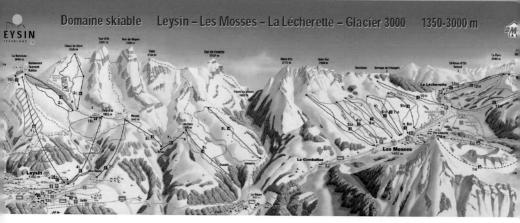

Tour D' Ai, starting at the top of Chaux de Mont.

FREESTYLERS will be able to spin huge airs in the huge pipe, which is normally maintained, but don't be shy to ask for a shovel at the nearby lift hut. As well as the pipe, the fun park (located between Berneuse and Mayen) has quarter pipes and gaps to ride. Mind you, it's not usually built until the end of February.

PISTES. Riders will enjoy The Berneuse which is a good place to lay out some big turns.

BEGINNERS can get going at the nursery slopes which have easy to use rope tows, before venturing up to slopes on the Berneuse. The drag lift at the Chaux de Mont will be difficult for first timer and beginners should not use this lift, even for the lower section, as the exit point is on a very steep piece of terrain. The local ski schools handle all the snow-board tuition here.

OFF THE SLOPES

Being such a spread out place means that depending on where you're booked into, you could end up doing a lot of hard walking, unless you have a

car. Around the town, life is very easy going with a lot of Americans hanging around due to the American colleges based here. Local services are basic but acceptable, offering a well located sports centre equipped with a swimming pool and indoor tennis and squash courts. If you happen to speak the language (French and German) you could even while away your evening at the cinema. Anyone who fancies a skate can check out the ramps down in Aigle. about 40 minutes away, however there's plenty of street in Leysin which the locals will happily share with you.

ACCOMODATION. The options for a bed range from

a classy hotel to the normal array of pensions along the main high street. One of the best options is the really cool bunk house called The Vagabond, which offers cheap nightly rates and has a cool bar. Alternatively, Chalet Ermina is a really good bed and breakfast place and great value.

FOOD. Plenty of restaurants to choose from, but a few of them are tucked away so you will need to study your tourist guide to search them all out. Generally, prices are in the middle to high bracket but affordable food is available, especially if you check out the offerings at the cool bunk house called Club Vagabound which is located away up on the back road. The town also has a couple of cheap pizza restaurants.

NIGHT-LIFE in Leysin is just as it should be nothing major but plenty going down with a lively crowd that's always ready to party. The partying is aided by a lot of young American students (none of whom can drink anything like the amounts the Europeans sup). The main spots are Club Vagabound, although on Saturday nights it gets way too busy, and Top Pub which is much quieter.

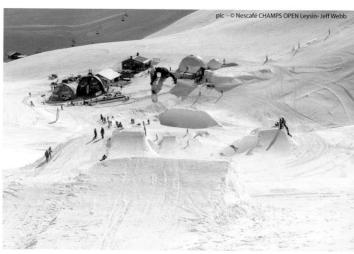

pic - @ francois panchard

NENDAZ

Great ride area

Being in the shadow of a big brother can often have its draw-backs, and the little guy may get left out and dismissed as not worth the effort. Not in this case. Nendaz is the lesser known relation of Verbier and along with a number of other resorts, forms the collective 425km 'Les 4 Vallees', located 2 1/2 hours east of Geneva just up from the town of **Sion**. Although linked by lift with

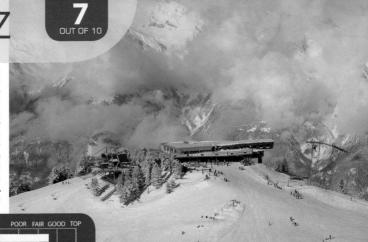

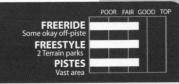

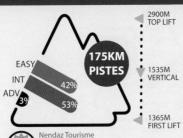

1997 Nendaz TÉL. +41 (0)27 289 55 89

WEB:www.nendaz.ch / www.telenendaz.ch EMAIL:info@nendaz.ch

WINTER PERIOD: Nov to April LIFT PASSES 4 Valleys area: Half day 52CHF 1 Day 62, 5 Days 274, Season 820 Local area: Half day 40CHF, Day pass 48,5 Days 211

BOARD SCHOOL 3 schools offering the usual group & private lessons. Ski Nendez offers half day lessons (3hrs) for 39 CHF. 5 full days 340 CHF. 90min privcate lesson 85 CHF. Freeride & Freestyle lessons available

HELIBOARDING Available through Ski Nendez

NUMBER OF RUNS: 45 LONGEST RUN: 15km

TOTAL LIFTS:22 - 3 Gondolas, 1 cable-cars, 5 chairs, 13 drags, 3 Magic Carpets

LIFT CAPACITY: (PEOPLE PER HOUR): 22,190 LIFT TIMES: 8.30am to 4.30pm

ANNUAL SNOWFALL: 5.3m **SNOWMAKING:** 15% of slopes

FLY to Geneva airport, about 1 1/2 hours away 165km. Zürich, 2 1/2 hrs. Bâle 2 1/2 hrs. Nearest airport is Sion, 15km from resort

TRAIN services possible to Sion (15 minutes). Direct services available from Geneva & Zurich.

CAR Motorway A9 to Sion, exit Sion-Ouest in the direction of Nendaz. Then 15 minutes drive (15km) up to the center of the resort. BUS from Sion Airport to Nendaz. Taxis, Taxi Praz tel: +41 (0)79 409 32 15

Verbier, Nendaz offers an entirely different experience and is a lot less formal and populated. What you have here is a resort with a selection of runs starting right from it's base. It then connects up with the neighbouring hamlets and slopes of Veysonnaz, Thyon and Siviez. What's more, with the Mont Fort area offering some great summer snowboarding, this place becomes a bit of an all year round treasure. Apart from Nendaz's unique piste markings and the fact that they have installed snowmaking facilities all the way to the top, this place is one of only a few locations in Europe to offer Heli-boarding with passenger collection and mountain guides. You can fly to the heart of the Rosablanche glacier to ride major backcountry powder spots.

FREERIDERS will be pleasantly surprised when they arrive and see what this area has to offer both on and off-piste. Both advanced and timed riders will find a weeks stay a pleasure while thrill seekers can test themselves to the limits.

FREESTYLERS are provided with loads of possibilities for gaining air (and not just in a helicopter). There are loads of banks, gullies and cool areas with logs to grind. Park wise you'll have to head over to Thyon. The Jean Pierre parks for beginners and the Tracouet is the expert park, they're located either side of the Theytaz drag. There are various kickers and rails, and they burried a car there last season.

PISTES. Carvers have as much here as any other style of rider, particularly on the series of red trails above Siviez and on Veysonnaz slopes where you can shine on your edges at speed.

BEGINNERS should leave after a week's visit at a new level. The gentle slopes directly above Nendaz will suit you're every need.

OFF THE SLOPES, Nendaz offers a quality selection of places to sleep, eat and drink in at prices to suit everyone, not just the elite, as is often the case in many resorts. Furthermore, basic local services are well appointed and you can sleep close to the slopes. Locals make you very welcome which helps to give this place a good snowboard vibe and these are some good night posts to check out.

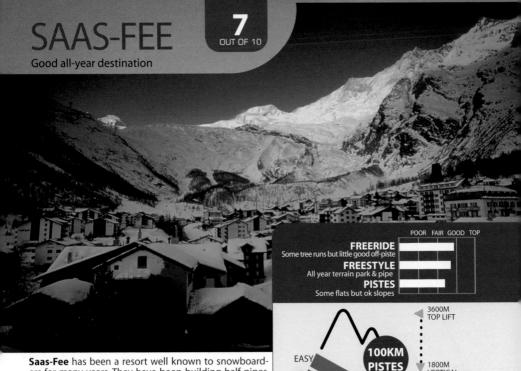

ers for many years. They have been building half-pipes, parks and other obstacles since way back and before many others areas had even heard of snowboarding. With its high altitude glacier, Saas-Fee also provides a mountain where you can ride fast and hard in the summer months, indeed for some, this is the only time worth visiting. Winter or summer, this is still a cool place that stages numerous competitions in both seasons and snowboard manufactures do a lot of product testing. Saas Fee is a resort with two faces. In summer the small glacier area has a snowboard park which boasts two half pipes, a boardercross course, and various hits. However, in winter the snowboard park relocates and the resort focuses itself more on family skiers. Most of the mountain is geared to skiers and possibly hard-booters. There's a variety of red and black runs, as well as nursery slopes and top to bottom blue runs, but nothing to really test you (although the runs off the Hinterallalin - when open - are supposed to be more challenging). Pisting is somewhat haphazard away from the main stations at the mid point and top glacier, so expect moguls on red and black runs

FREERIDERS will be disappointed to find that the off-piste is limited by crevasse danger around the glacier - but there are some nice tree runs off **Platjen**. Alternatively, the runs off the Hinterallalin drag lift will sort out the wimps, with some cool freeriding to be had and some fast steep sections to try out.

FREESTYLERS. There's a park on Morenia which has a pro and normal kicker line and a few rails. The halfpipe's located up there as well. Away from the park you may find some hits off the Mittaghorn and Langfluh lifts, but they are far between. You will find a few drop offs near the Langfluh and Platjen areas.

has a pipe's i may

WINTER PERIOD end Nov to end April
SUMMER PERIOD July to Oct
LIFT PASSES 1/2 day 52 CHF, 1 day 63 CHF, 5 days 273
BOARD SCHOOL Several options. www.skischule-saasfee.ch runs group lessons for 44 CHF per day and private for 59
CHF per hour
NIGHT BOARDING Thursdays 8 to 10pm in Saas-Balen
Tuesdays 7 to 9:45pm in Furggstalden

VERTICAL

1800M

FIRST LIFT

NUMBER OF RUNS: 40 LONGEST RUN: 9km

Saas-Fee Tourismus

Postfach, 3906 Saas-Fee

TEL. +41 27 958 18 58

WEB:www.saas-fee.ch

EMAIL:to@saas-fee.ch

TOTAL LIFTS: 22 - 1 Cable Railway, 7 cable-cars, 1 chairs, 13 drags

LIFT CAPACITY (PEOPLE PER HOUR): 22,400 LIFT TIMES: 8.30am to 4.30pm MOUNTAIN CAFES: 10

ANNUAL SNOWFALL: Unknown SNOWMAKING: 10% of slopes

cAR Geneva via Aigle, Saas Fee is 145 miles (235 km, drive time is about 3 hours. Travelling from the east you'll need to take the Furka pass or jump on a car-train. Resort is car free so you'll park up (CHF 8 per day) and get an electric shuttle to your hotel.

FLY to Geneva international, Transfer time to resort 2 hours.
TRAIN to Brigg or Visp (20 minutes) then take the post bus.
BUS services from Geneva take 3 hrs direct to Saas-Fee via Brigg.
Buses from Brigg and Visp run hourly until 8 pm

258 US9 www.worldsnowboardguide.com

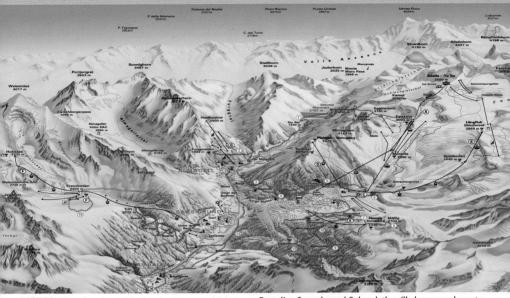

PISTES. There's a host of pisted runs on which to lay out some wide tracks. No matter what your level, you'll soon be weaving in and out of the two plankers in style on graded runs from steep blacks to tame blues. The runs under the Mittelallalin restaurant are a great area for carvers.

BEGINNERS are not left out, Saas Fee has plenty of novice runs, but some of the blue pistes have long flat sections to catch you out, resulting in a fair bit of skating along. You'll also get really used to T-bars by the time you leave this place. The lower runs have a reputation for rocks and worn patches, so take care when you first head out. However, the best way to find out what's what, is to call in on the boys at the

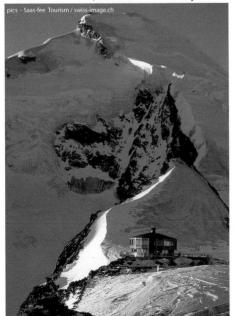

Paradise Snowboard School, they'll show you how to get around any obstructions

OFF THE SLOPES

Saas Fee is a car-free place where you get around by either electric vehicles or on foot. However, everything is located close to each other and the slopes. The town is a cool place, with options to sleep close to the slopes in hotels or chalets. Money wise, Saas-Fee can be very expensive if you're staying in a hotel and eating out in restaurants, but on the other hand, you can do things cheaply by staying in an apartment and feasting on supermarket produce. The resort crams in loads of amenities, from swimming pools, a cinema, a museum, an ice rink to heaps of shops, including a couple of cool snowboard shops centrally located: Popcorn +41 (0) 958 19 14 and Powder Tools +41 (0) 89 220 7792.

ACCOMMODATION: 7500 visitors can be housed here. Hotels come as one would expect, standard Swiss and expensive. However, with this place comes a good number of affordable bed and breakfast places apartment and chalets for those wanting to go self catering. Whereever you stay, nothing is too far from the slopes.

FOOD. Being a modern and popular resort, Saas Fee is well equipped to feed all its visitors no matter what their chosen diet is. There are well over 50 restaurants here many based in hotels but also a good number of independent ones. Notable places to pig out in are the Boccalino for pizza or the Lavern for traditional Swiss food. Hotel Allalin is a good restaurant with affordable meals set in a rustic style.

NIGHT LIFE is very good here despite there being a few places offering the ski après crap. Snowboard life-style centres around the Popcorn bar and snowboard shop, but the Happy bar is cheaper (especially at happy hour 7:30 - 8:30 daily). There are a few other bars worth checking out. If you decide to stay in and party, watch out for the 'hush police' - too much noise after 10pm and you'll get fined around 120 Sfr.

SAVOGNIN

Good for a few easy days

Two hours south of Zurich lies the relatively unknown resort of Savognin that is fast becoming a magnet for snowboarders out for a good time and for riders who want to steer clear of the big resorts because they don't want to get caught up in the hustle and bustle of large ski crowds. Fortunately the ski press don't mention Savognin, which helps to keep this gem a small secret for snowboarders to do as they please with. The natives are super friendly and happy to have snowboarders on their slopes. The

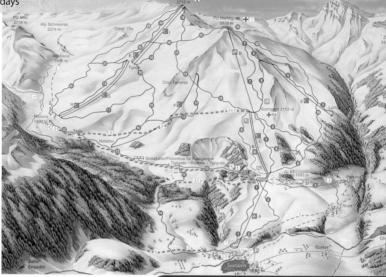

local snowboard scene is cool with its own riders club where you can find out all there is to know about this place, such as the best hits or runs and where to get messy in the evenings when the lifts are closed. The 50 miles of piste will make a weeks stay well worth it, appealing to novice carvers

FREERIDERS of an advanced level are going to be disappointed if its testing stuff you crave for, there is none really. You can have a bit of excitement on the black run known as the Pro Spinatsch, running down from the Tiggignas chair lift, it is also the location of Savognin's fun park. It doesn't take too long to conquer if you know what you're doing on your edges.

FREESTYLERS will find the best air to be had is either off the nicely shaped walls in the 90m half-pipe or in the fun park which is tooled up with fun boxes, gaps, spines, rails and a quarter pipe. For some natural hits there are a few cliff drops and some air to be had on the area called Tiem.

PISTES. Riders have some particularly well groomed runs A good piste to suit all levels whether you're in soft or hard boots, is the Cresta Ota, which runs down from the Piz Cartas summit and makes for a good time.

BEGINNERS are looked after with a number of easy blues and the option of being able to slide back to base at the end of the day on easy to handle runs. However, uplift is mainly via drag lifts.

OFF THE SLOPES. Savognin is a small village with nothing major going on, although it's affordable and doesn't come infested with apres ski crowds. Accommodation is a mixture of Swiss pensions and hotels, all of which are well located for the slopes. There are one or two good evening haunts, with the best place to get a beer being the Zerbratent Paulin.

260 USQ www.worldsnowboardguide.com

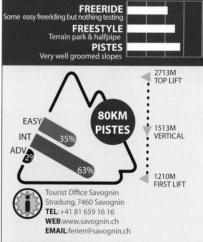

POOR FAIR GOOD TOP

WINTER PERIOD: Dec to April LIFT PASSES Half Day 41CHF, 1 Day pass - 50Chf 5 Day pass - 216Chf, Season 705

LONGEST RUN: 7km TOTAL LIFTS: 10 - 3 chairs, 7 drags, 3 magic carpets, 1 cat LIFT CAPACITY (PEOPLE PER HOUR): 16,000 LIFT TIMES: 8.30am to 4.30pm

ANNUAL SNOWFALL: 4m SNOWMAKING: 10% of slopes

FLY to Zurich airport, 2 hours away. TRAIN to Chur then take the local bus to Savognin CAR Via Zurich, head south on the N3 to Chur and take the A3 via Tiefencastelt to Savognin.

ST.MORITZ

8OUT OF 10

Way too poncy but great freeriding

St Moritz has two classic distinctions, on the one hand this has to be one of the finest natural backcountry freeride places to ride in Switzerland, but on the other hand. St Moritz happens to be top of the league when it comes to snobbery. Without doubt this is one of the most expensive resorts on the planet, and not with-standing the outrageous costs here, the place attracts so many stuck-up rich idiots, that you can smell the fur clad sods a mile away. St Moritz is a high altitude resort that along with the areas of Pontresina and Diavolezza, form the Upper Engadine region. Diavolezza is a glacier mountain that used to host summer snowboarding. St Moritz, which gives access to the slopes on the Corviglia and Marguns, is an area that is largely made up of intermediate pisted runs which get

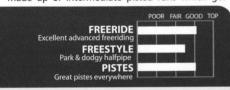

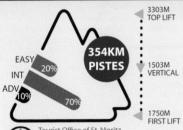

Tourist Office of St. Moritz
Via Maistra 12, 7500 St. Moritz
TEL. +41 (0)81 837 33 33

WEB:www.stmoritz.ch / www.bergbahnenengadin.ch **EMAIL**:information@stmoritz.ch

WINTER PERIOD: end Nov to end April LIFT PASSES Half-day 59CHF, 1 Day Pass 70Chf 6 Day Pass 339Chf

BOARD SCHOOL group 1/2 day lesson from 45CHF 6 half-day lessons from 230CHF. Private half-day 180CHF NIGHT BOARDING Every friday 19pm till 2am!

NUMBER OF RUNS: 88 LONGEST RUN: 8km

ANNUAL SNOWFALL: 3.5m

TOTAL LIFTS: 56 - 3 Funiculars, 1 cable railway, 6 Gondolas, 7 cable-cars, 18 chairs, 27 drags

Gondolas, 7 cable-cars, 16 chairs,27 drags LIFT CAPACITY (PEOPLE PER HOUR): 65,000 LIFT TIMES: 8.30am to 4.30pm MOUNTAIN CAFES: 37

SNOWMAKING: 15% of slopes **CAR** From Zurich, head south on the N3. Turn off at

the R-28 down to St mortiz (200km)

Calais the journey is 9 1/2 hours. 516 miles (830 km)

Landquart on to the route 28 to Zernez and then take

FLY to Zurich/Milan airport, 3 hours drive away. Munic h/Basel, 4 hrs away. Local airport is Samedan - St. Moritz, most airports offer connecting flights

TRAIN take a train to Chur, then take Rhätische Bahn direct to resort, www.rhb.ch for more info

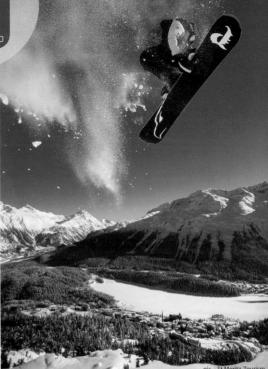

stupidly busy on most days and unfortunately there are not too many expert pisted trails to escape the hordes of learning skiers. However, there is heaps of adventurous off piste terrain to check out, but only do so with the advice and services of a local guide.

FREERIDERS have a huge amount of great back-country terrain which will blow your mind, with lots of steeps, gullies, cliffs and virgin powder to seek out. Some of the best freeriding can be found up on the **Diavolezza** glacier, which is for serious riders only. St Moritz's number steep is the slope that drops down from the **Piz Nair** summit of the top cable car.

FREESTYLERS have a good park, but the pipe sucks. There are heaps of natural hits far better of getting big air.

PISTES. Riders will find lots of fairly easy and ordinary well pisted runs to cruise down. But really you should freeride only at this place.

BEGINNERS may not have the best selection of novice trails to start out with, but what is on offer is superb if only too busy.

OFF THE SLOPES St Moritz can easily be summed up as an over priced, over hyped ugly sham that seems like a real rip off. Accommodation, which is provided by an array of hotels and chalets, is available in a spread out area. There are plenty of places to get a meal, but you have to look hard to find an inexpensive burger bar. The nightlife is full on, although very poncy! They have night skiing every Friday from 9pm until 2am and provide onmountain bars with DJs and bands playing throughout the night.

WOW WWW.WORLDSNOWBOARDGUIDE.COM 261

VERBIFR

Some of the best extreme terrain in Switzerland

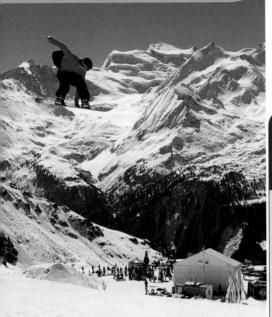

pic - Verbier Tourism

Verbier is a big resort in more ways than one: Big slope area, big mountain and big on extreme terrain. However, Verbier is also big on the stuck and poncy scale being a resort that goes out of its way to attract the rich. Despite its great terrain this is also a resort where snowboarding is still fairly small but don't fret, the attitude is pretty cool and snowboarders are welcome everywhere. The snow record here is good and even in a poor season, it's still possible to ride to the resort in April. Generally, the terrain gives over to all levels, offering every rider something to get their teeth into.

However, Verbier is essentially a freerider's resort, with easily accessible powder, trees, hard-pack, cliffs, hits and extremes, some of which necessitate a hike first. Verbier joins with Nendaz, Veysonnaz, La Tzoumaz and Val de Bagnas to create the 4 Vallees with 94 lifts and over 400km of piste, which can be serviced by one lift pass.

FREERIDERS who know just what snowboarding is all about will be very impressed with Verbier. The O'Neil Xtreme competition is held here on the North face of the Bec des Rosses which should give you an idea of what awesome terrain is on offer. The Mont Gele cable car serves no piste, just a series of off-piste runs and couloirs of varying extremity; tuck your balls (or equivalent) away before you get up here. The less squeamish should check out the areas round the back of Lac des Vaux! The Col des Mines, and Vallon d'Arbi routes steer you towards wide

open powder fields with the words 'session me' written all over them. If trees are your thing. Verbier has loads of them, especially in the Bruson area, but remember, Switzerland is the one country that protects its forests, so shredding the spruce is not always appreciated.

FREESTYLERS have an okay park located up on La Chaux, it features 3 separate lines and a number of kickers and rails. The natural stuff around La Chaux is pretty good too and around the Lac des Vaux lifts, are the places to get air.

PISTES. Riders who enjoy hacking it down the pistes will enjoy things here but the best is undoubtedly the long, wide red piste that goes

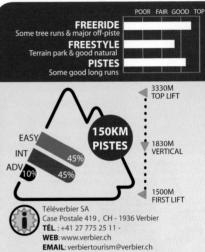

4 Valleys (400km): Day 63, 5 days 279, Season 1486

WINTER PERIOD: late Nov to end April LIFT PASSES Verbier only: Half day 45CHF 1 Day pass - 54Chf, 5 Day pass - 240Chf, Season 1275

BOARD SCHOOL La Fantastique have Mountain Guides available 440 CHF per day, Full day private lesson 370 CHF per day HIRE Board & Boots froom 43CHF per day (verbier.com)

HELIBOARDING www.lafantastique.com offer heliboarding from 360 CHF each based on 4 people

NIGHT BOARDING Yes

NUMBER OF RUNS: 56 LONGEST RUN: 15km

TOTAL LIFTS: 38 - 8 Gondolas, 2 cable-cars, 18 chairs, 10

LIFT CAPACITY (PEOPLE PER HOUR): 26,000

LIFT TIMES: 8.30am to 4.30pm **MOUNTAIN CAFES: 10**

ANNUAL SNOWFALL: 3.5m **SNOWMAKING:** 5% of slopes

CAR Geneva via Martigny to Verbier = 104 miles (167 km) Drive time is about 2 hours.

FLY to Geneva international, 3hr transfer to resort. Local airport is Sion

TRAIN to Le Chable (10 minutes). More info www.rail.ch BUS services from Geneva take around 3 hours direct to Verbier via Martigny. and cost 55CHF, its 95CHF and 4 1/2 hours from Zurich. Taxis +41 (0)27/776.16.33

NEW FOR 06/07 SEASON: chairlift Attelas 3 and the gondola Attelas 2 to be replaced with a 6-seater detachable chairlift

262 USQ WWW.WORLDSNOWBOARDGUIDE.COM

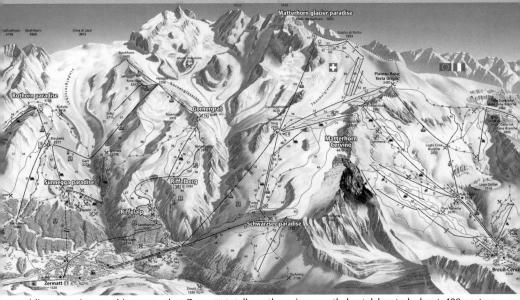

riding trees is your thing, note that Zermatt totally restricts riding through the forest areas. If you have the money, you can also take a day's heli-boarding. Air Zermatt, but it is very expensive: two flights over the Monte Rosa will cost you around 440 Chf.

FREESTYLERS are provided with 2 ever improving half-pipes, but as there is so much good natural terrain, it's not that important. Two fun parks have been built in recent years.

PISTES. Carvers are still in evidence here, preferring to cut up the number of good and long testing runs that descend en-route to the village via some extremely crowded lower novice trails.

BEGINNERS may find Zermatt a bit tricky but not a big problem, just a bit tainted with too many first timers on skis clogging up the easy trails, particularly on the long blue run into Cervinia. However, you can ride easily higher up the mountain, certainly on the glacier, making for some long, easy runs to progress on.

OFF THE SLOPES, Zermatt is a large, car free town that can be pricey which may call for some major scamming to get by. A useful tip when travelling here from abroad is, if you fly in to Geneva and plan to take the train down to Zermatt, buy your train ticket at a Swiss Tourist office in your home country before you enter Switzerland, as it can be cheaper. Around the town you are presented with loads of shops, various sporting centres and other visitor attractions. Getting around the main part of town is easy, but in parts you will find that a lot of walking is required. Cars are banned to protect Zermatt's environment and microclimate, so there are free electric buses and more costly taxis (tuk tuks) to shuttle you around. Do be aware that the buses are silent so take a good look left before you cross any roads.

ACCOMMODATION can be expensive. However,

there is a youth hostel located about 400 metres from the main lifts in the centre of town, which is cheap and offers half board accommodation.

FOOD. The supermarket located near the train station offers cheap eateries and for many a diet of crisps, biscuits, mars bar and cheap beer is enough. There is a McDonalds for a cheap Mac attack

NIGHT LIFE varies from the après ski of the rich there are some exclusive and expensive bars, to more casual bars and cafes. There is a cool snowboarder's bar located on the bridge en-route to the Matterhorn lift in the Swartzee area. Around town there is a large selection of bars offering different themes and some being quite lively. There are also a number of late night discos such as the Pink Elephant, Grampis or Le Broken

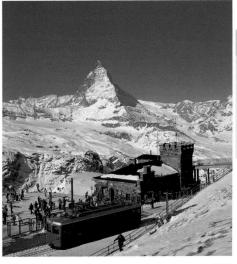

DZPLBENH-50

ROUND-UP

BEATENBERG

Beatenberg is a blip of a place not far from Interlarken and above Lake Thun. The 10 miles of beginner friendly, intermediate dull and advanced crap terrain is spread out over a slope area unspoilt by mass crowds. In truth this is not a snowboarders destination unless you're recovering from piles and need somewhere out of the way to convalesce in peace.

Local services are very basic but at the same time offer more than what is on the slopes.

Ride area: 16km Top Lift: 1905m Total Lifts:5 Contact: www.beatenberg.ch +41 (0) 33 841 1818 How to get there: Fly to: Zurich 2 hours away.

BETTMERALP

On its own, Bettmeralp offers a mere 20 miles of basic carving terrain, but by linking with the Aletsch area, you suddenly have a more respectable 60 plus miles of okay freeride terrain in an area that also has a number half-pipes and a couple of fun parks for big air possibilities. Generally, the slopes here will

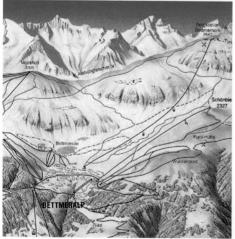

suit beginners and mid way merchants as well as giving advanced riders something to look forward too. Okay local services but costly

Ride area: 32km Top Lift: 2710m Total Lifts:12 Contact: Tel: +41 (0)27 928 60 60 How to get there: Fly to: Zurich 2 1/2 hours away

RRAUNWALD

Braunwald is located two hours from Zurich. This small place has gained a reputation as a friendly freestyle outpost where locals and those in the know spend the weekend getting air.t The terrain itself is nothing to shout about but is still cool and rarely attracts more than a 5 minute lift gueue. They reqularly build decent half-pipes and parks here for which they stage various events in. Off the slopes things are laid back, good but basic.

Ride area: 24km Top Lift: 1900m Total Lifts:8 Contact: Tel: +41 (0)55 643 30 30 How to get there: Fly to: Zurich 1 hour away

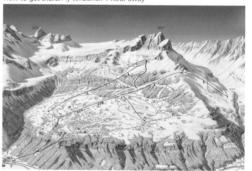

HAMPERY

Champery is a resort that forms part of the massive Portes du Soleil area, which boast a lift linked area of over 400 miles. Champery itself has 62 miles of terrain, with something for all but nothing that outstanding. An intermediate freerider will like this place although the slopes do get busy. They have a good sized park and half-pipe here. (www.superpark. ch) . Local services are very good in a village full of character.

Ride area: 99km Top Lift: 2277m Total Lifts:35 Contact: www.champery.ch Tel: +41 (0) 24 479 20 20 How to get there: Fly to: Geneva 1 1/2 hours away

Champoussin is yet another resort that helps to make up the Portes du Soleil area. This is a major plus because you would by no means want to get stuck with what's on offer here. A rider who knows what?s will have this place done and dusted in an hour, even a quick learning novice could lick the place in a day or two. This a resort that old timers wanting to find their youth will like, but any- one else will find it dull. Local services near the slopes

Ride area: 24km Top Lift: 2150m Total Lifts:8 Contact: Tel - +41 24 477 20 77 How to get there: Fly to: Geneva 1 1/2 hours away

CHATEAU D'OEX

Chateau d'Oex is a place that is relatively unknown by the masses. When you see what's on offer its soon clear to see why. Famed more for balloon races, the slopes here are very ordinary and won't take a good rider that long to conquer. However with a further 150 miles of terrain in the area to check out, a week's visit here will be worth the effort. Freestylers get to ride a pipe and beginners have some good slopes. Good slope side services

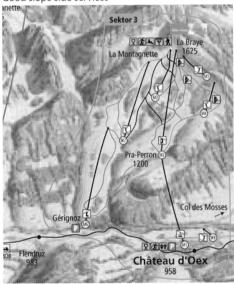

Ride area: 48km Top Lift: 1800m Total Lifts:10 Contact: Chateau-d'Oex Tourist Office Tel:+41 (0) 26 924 25 25 How to get there: Fly to: Geneva 2 hours away

KLOSTERS

Forget the reason for Klosters fame, this resort offers any rider a challenging time with good off-piste that will please freeriders. Carvers have some excellent runs to try out and freestylers have a fun park (not hot mind, better to use the one at nearby Davos). Great also for beginners. The biggest let down here is the brown nosed ski snobs from the UK, hoping to be seen with a royal. Okay local services but pricey

Ride area: 160km Top Lift: 2844m Total Lifts:12

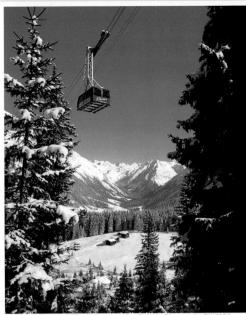

Contact: Tourist Office Klosters, Alte Bahnhofstrasse 6, CH-7250 Klosters

Tel:+41 (0) 81 410 20 20

How to get there: Fly to: Zurich 2 hours away

I FN7FRHEIDE

Lenzerheide is a big place that covers two mountain slopes, offering some really nice open riding with tree line trails to the base area. Intermediate freeriders and carvers are in for a treat here, with the biggest cluster of runs to be found on the Statzerhorn slopes. Freestylers have an okay half-pipe and park on the Rothorn slopes. Beginners should love this place with easy trails all over the place high and low. Good laid back local services slope side.

Ride area: 152km Easy 46% Intermediate 41% Advanced 13% Top Lift: 2865m Total Lifts:35 Contact: www.lenzerheide.ch Tel: +41 (0)81 385 11 20 Lenzerheid Tourist Office, CH-7078 Lenzerheide How to get there: Fly to: Zurich 2 hours away

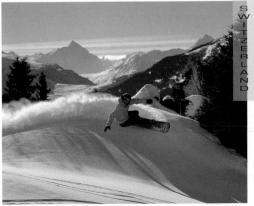

WSQ www.worldsnowboardguide.com 269

S

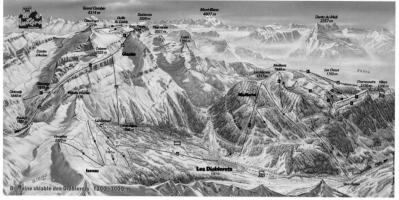

boarders out back close to the Jungfrau Region. There's no hype here, no mass holiday crowds, just a cool mountain with something for everyone. There are wide powder fields. gullies and big cliffs on a mountain that is majorly snowboard friendly providing a very decent park and good beginner areas. Visit freestylepark.ch for info on the terrain park.

Good lodging and local services close by.

LES DIABLERETS

Les Diablerets is a cool snowboarders hangout that offers summer riding on the glacier. This is not a place for piste loving carvers, no, this is a freeriders retreat offering some great backcountry riding in deep powder, but not for the fainthearted, some of this stuff will take you out quick style if you balls up. Although not a big place, this is a good unspoilt haunt that caters well for freestylers and novices. Good slope side services.

Ride area: 125km Runs: 77 Easy 50% Intermediate 42% Advanced 8% Top Lift: 3000m Bottom Lift: 1200m Vertical: 1800m

Total Lifts: 46 - 3 Cable Cars, 3 Gondolas, 11 Chair Lifts & 28 Drags Lift Pass: 1 day 39 euros for Isenau 1 day 46 euros Diablerets 1 day 54 euros Glacier 920 euros season

Board School: 1 morning (adult) 35 CHF 4 mornings 120 CHF private lesson 60/250 per hour/day

Contact: Les Diablerets Tourist Office, 1865 Les Diablerets Tel: +41(0)24-492.33.58

How to get there: FLY: Geneva: 120 km Zürich: 250 km Bâle: 200 km TRAIN: direct trains to Aigle and then a mountain train to Les Diablerets. Lausanne - Aigle : 30 min Aigle - Les Diablerets : 50 min

DRIVING: Motorway A9, direction Grand St Bernard, exit Aigle. Then, road Aigle - Les Diablerets (20 km).

MEIRINGEN-HASLIBERG

Meiringen-Hasliberg has a history related to Sherlock Holmes, but today what you have is great snow-

Hasliberg Meiringen

Ride area: 64km Top Lift: 3000m Total Lifts:28 Contact: www.meiringen-hasliberg.ch Tel: +41 (0)33 972 50 50 Meiringen Haslital Tourism, CH-3860, Meiringen How to get there: Fly to: Zurich 1 1/2 hours away

MORGINS

Morgins, on the Swiss side, is yet another resort that forms part of the massive Portes du Soleil area which crosses into France. On the Swiss side, Morgins is the highest resort and not a modern imitation of some of its cousins. What this place has to offer is easy access to over 40 miles of direct terrain and a further 360 miles of linked terrain. Collectively, there is something for everyone. Good slope side local services

Ride area: 67km Top Lift: 2000m Total Lifts:16 Contact: www.morgins.ch Morgins Tourist Office, Tel - +41 24 477 23 61 How to get there: Fly to: Geneva 11/2 hours away

Rougemont is a tiny place that links indirectly with its bigger and more famous cousin Gstaad. This helps boost the 12 miles of terrain on offer here to a respectable 150 miles plus. Rougemont on its own is not a place that you would book a week's holiday at, indeed only a rider so stoned that an inch

> seems like a mile will enjoy this place. However, there is a small half-pipe and an 80 year old beginner will fair well. There are slope side facilities, but over all, this place is very dull.

> Ride area: 19km Top Lift: 2156m Total

Contact: Website: www.rougemont.ch Email:info@rougemont.ch Rougemont Tourist Office, Batiment

Communal, CH - 1838 Rougemont Tel: +41 (0)26 925-83-33

How to get there: Fly to: Geneva 21/2 hours away

ROUND-UP

BELGIUM

SNOW VALLEY

has a half pipe a nursery slope and a 235 meter slope all in doors and all pumped full of the fake stuff. It's in the town of Deusterstraat and costs 16 euros per hour. This place is a good modern indoor slope and has a good vibe going on.

SKIBAAN CASABLANCA 365

this place is open and yep the Belgians love it. It's been run by the same family since the 70's it's in the town of Gravenwezel in the province of Antwerp. Check out for some classic photos www.skicasablanca.be

HOLLAND

Reputedly has 51 dry slopes and a number of indoor real snow slopes, including Europe's longest.

SNOWPLANET

is about 45 mins outside Amsterdam, and features a 230m and a 100m real snow slope. SnowPlanet Spaarnwoude
Heuvelweg 6-8,
1981 LV Velsen-Zuid,
phone: +31 (0)255-545848,
fax: +31 (0)255-545840,

SNOWWORLD

www.snowplanet.nl

is part owned by the Austrian resort, Sölden, and is in 2 different locations. SnowWorld Landgraaf hosts the World's largest indoor slopes at 500m and 520m. It is located in the Strijthagen Nature Park. SnowWorld Zoetermeer has 3 slopes and 8 lifts, and is in the Buytenpark Nature Park. For more info see www. snowworld.nl. Prices are around 15 euros an hour.

LIECHTENSTEIN

This tiny country is situated between the borders of Switzerland and Austria. The main resort is Malbun which is just over 2 hours from Zurich airport. The resort is not particularly big, with 20km of pistes and 6 lifts

MAI BUN

This is pretty small but does have a terrain park with a few rails & kickers

Lifts: 6 - 2 chair, 4 drags (6800 ph)

Lift pass: Day pass 37 CHF 6 Days 155 CHF, Season 380 CHF

Board School: Ski school Malbun offer 3 day beginners course 120 CHF (2hrs lesson per day), 5 day 170 CHF.

Private lessons CHF 60 per hour

Contact:

Mountain Railways, P.O. Box 1063 9497 Triesenberg Malbun Tel: + 423,265 40 00

Web: www.bergbahnen.li

Location: From Zurich (110 km) head to Valduz via Coffin, approx 1 1/2 hours. Munich, 250km, Innsbruck 170KM. nearest airport is Zurich Kloten, 1 1/2 hr transfer

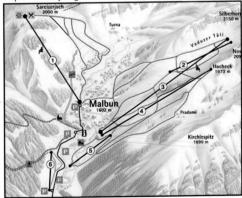

EASTERN EUROPE

Bosnia Herzegovina 294
Bulgaria 273
Croatia 294
Czech Republic 278
Kosovo 279
Latvia 280
Macedonia 281
Poland 282
Romania 294
Slovakia 286
Slovenia 290
Ukraine 295

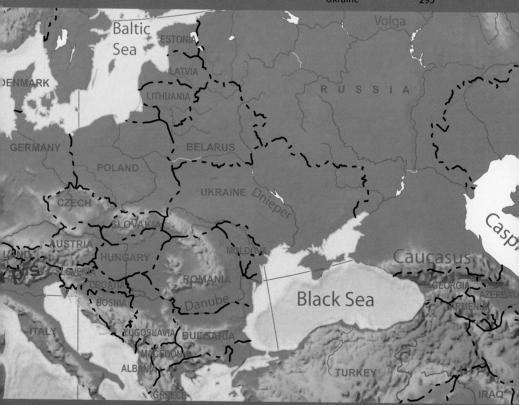

BULGARIA

Bulgaria is ahead of its neighbours in attracting westerners to sample its winter hospitality with a number of resorts which provide a good and a far cheaper alternative to many of the resorts in the Western Europe. Travelling to Bulgaria should pose no real problems with international flights arriving at the capital of Sofia. Note for entering Bulgaria visitors from EU member countries don't need a visa Another point, forget about credit cards, although there are not widely accepted, you're better off with hard cash, US Dollars are the best currency for changing into Lev's. On the slopes, piste preparation is not hot and mountain facilities are primitive but prices are very low and the pistes are un-crowded. A number of tour operators offer package tours to Bulgaria with great budget deals available.

Freeriders will enjoy the unpredictable and uneven terrain features found in most rideable places but freestylers will be left a little disappointed if big pipes and man made terrain parks are your thing. Such things are almost none existent however lots of natural freestyle terrain is available along with some very big cliff jump areas.

The best way of travelling in Eastern Europe, is to hire a car or bring your own reliable vehicle. Always check with the national embassy to get the latest facts about travel in Bulgaria or any other part of Eastern Europe. Overall, resort's services are very basic with low key primitive accommodation, restaurants and amenities. Locals on the whole are very friendly and will look

after you, especially if

you flash a few dollars.

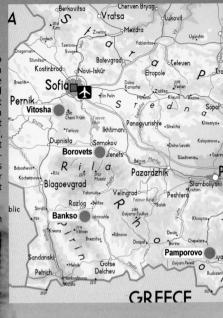

CAPITAL CITY: Sofia POPULATION: 7.3 million **HIGHEST PEAK:**

Musala 2925m

LANGUAGE: Bulgarian **LEGAL DRINK AGE: 18**

DRUG LAWS: Cannabis is illegal and frowned upon

INTERNATIONAL DIAL CODE: +359

AGE OF CONSENT: 16 ELECTRICITY: 240 Volts AC 2-pin

CURRENCY: Lev (BGL)

EXCHANGE RATE: UK£1 = 2.9, EURO = 2, US\$1 = 1.5

DRIVING GUIDE

All vehicles drive on the right hand side of the road

SPEED LIMITS:

60 kph - towns 80kph - main roads 120kph - motorways

tion, along with your passport.

TOLLS

DOCUMENTATION Driving license, insurance and vehicle registra-

BULGARIA SNOWBOARD FEDERATION

Daylight saving time: +1 hour

Sofia 1606 51 Skobelev blvd.

TIME ZONE

UTC/GMT +2 hours

Phone / Fax:++359 2 9522 015 Web: http://bgsf.dir.bg/dynamic.html Email: bgsf@mail.orbitel.bg

USEFUL WEB LINKS

www.bulgariatravel.org

BANKSO

7 DUT OF 10

Bulgaria's new booming resort

Forget your ideas of the Communist blocks and Russian gangsters, Bansko is shaping up to be the next "undiscovered" resort and with over 30million euros invested in the ski lifts & facilities, and another 50mil invested in the surrounding area, its easy to see why there's numerous articles in the UK's national press saying it's the next big thing. It is situated at the foothills of the Pirin mountains and is listed as a UNESCO world Heritage site. You fly into Sofia which is the nearest airport and then a 2 hour taxi ride will get you to the hill. In the coming months a road is being finished that will cut this down to under and hour and a half.

The mountain itself, all though not the biggest in the world, is growing and there is talk of linking it with some smaller local resort as well as adding new lifts onto the surrounding mountains. Two lifts have already been added for the 2006/07 season and more are planned. Sofia/ Bansko just missed the short-list to host the 2014 Olympics but it clearly shows its ambition.

FREERIDE. A new gondola takes you from the base station in the town to the halfway station up the mountain. From there you can choose where to go. But don't think it's just a beginners resort. Some of the terrain is awesome and untouched. With good snow the tree open up

giving you some interesting runs, further a field you can hike to get some great off piste. If you're planning to venture into it get a guide and take the proper equipment.

FREESTYLE. Park wise, Bansko shapes up. They have a brand new pipe dragon and shapers from some of the bigger European resorts. The park is well designed and has good progression for everybody. A good mixture of kickers ranging in size from beginner to advanced, and some good rails from ride on wide bars to gap flat downs.

PISTES. Two chairs will then take you up to the highest run just under Todurka peak which is at 2,600m. From there you have a good choice of pisted runs to get you back down to the halfway station depending on your ability. It's best not to go lower than that until the end of the day as it can be a bit hard to keep your speed up if you're a beginner boarder. The resort owns 20 piste bashers so all the runs are well looked after.

BEGINNERS. Bansko's a good beginners resort as it's cheap and the instruction is good. Method Snowschool are a new British run board school offering all level of tuition & courses. They'll help you out as well as giving you a bit of local knowledge.

OFF THE SLOPES. The old town is about 5 mins walk from the lifts and has all the the charm of a traditional working town. Plenty of pubs are starting to appear thanks to the amount of tourists that are popping up, which makes for a wicked night out. With beer from as little as 30p a pint and food from £2, a night out hardly breaks the bank. Food is mainly local, served in traditional Bulgarian taverns complete with chimneys and wooden interiors and offer delicious home made traditional Bulgarian cuisine. The wine and rakiia spirits are loved as much by the locals as by the tourists and help create a friendly atmosphere and there's often live music from local Bulgarian bands. Also don't be scared to go into a Mehana, this is not a Mexican restaurant, but a local "tapas" style affair serving up small plates of speciality food.

274 USQ WWW.WORLDSNOWBOARDGUIDE.COM

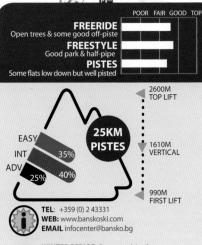

WINTER PERIOD: Dec to end April

LIFT PASSES 1 day 50L, 6 days 280L, Season 1340lv

NIGHT BOARDING 1 run lit

RENTAL Board & boots 40/2001v per day/6-days BOARD SCHOOL

4hr group snowboard lesson 63lv. Private 4hr lesson 135lv

NUMBER PISTES/TRAILS: 17 LONGEST RUN: 16km

TOTAL LIFTS: 12 - 1 Gondolas, 6 chairs, 5 drags + 10 magic carpets

ANNUAL SNOWFALL: unknown SNOWMAKING:50% of pistes

FLY: Sofia 3 hours drive to Bansko **BUS:** Buses direct from Sofia run several times daily but can take up to 4hrs.

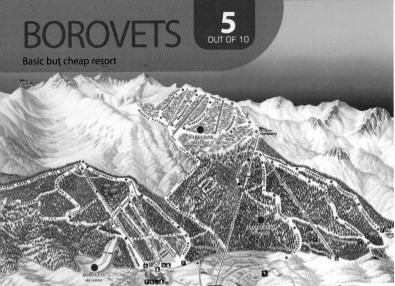

Borovets best known of the Bulgarian resorts. with a wide range of facilities on one of the highest rideable areas in Eastern Europe. Locals say that the season comes late Borovets: mid-February often sees only half the runs open, but riders in the know say that April has the best snow. Between 2004 and 2006 the resort saw some major upgrades to its lift system. 3 new lifts were added, the gondola and another lift were refurbished and a new huge 12km created.

The terrain is mainly suited to intermediate carvers, with nothing too challenging for the experienced. The 58km of piste is split into three areas, offering open runs and lines through trees. Hard packed snow and ice frequently make the runs tough work and with small rocks sticking out when there's poor snow cover; a little vigilance is essential. Some of the best riding can be found on the runs above the 2500m point. The 6 person gondola ride to the top station takes about 25 minutes and to avoid queues avoid the period between 9am and 11am. A tip for those on a package trip is to buy your lift ticket before you arrive, it could save you \$20.

FREERIDER'S favourite spot is an off-piste run down under the gondola pylons. The small cluster of trails off the **Sitnyakovska** chairlift are ideal for intermediate riders but they are a bit short.

FREESTYLERS will be glad to know that it's not frowned upon if you want to build kickers. The Rotata halfpipe is located off the **Martinovi Baraki** 4 chairlift, there is a portable drag lift that sometimes services the area.

PISTES. Carvers will find enough wide areas to put in a few turns, but overall this is not a very good carving resort.

BEGINNERS have only one official blue marked run, but you should soon master some of the reds. Take note, the French designed lift system caters well for skiers, but it's not hot for novice boarders. The main problem is some of the lift take-offs are quick with deep rutted tracks that will throw you off with ease. One particular lift is so bad that it's not uncommon to see bodies dropping like flies.

OFF THE SLOPES

Borovets is a is a small place set around 1400 metres. The main hotels are the *Rila*, *Samokov* and the *Olympic*. Everything here is cheap. Evenings can be very boozy, with cheap beer available every where. It's worth noting that most places don't accept credit cards or travellers cheques. Food is basic, filling and mainly based on pork early hours of the morning and with booze so cheap be prepared for serious drinking and wicked hangovers.

FREERIDE
FREESTYLE
An occassional half-pipe
PISTES
Variety but be patient

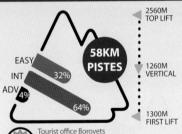

Balkantourist, Borovets 2010, Bulgaria TELEPHONE: +359 (0) 2 835 219

WEB: www.borovets-bg.com EMAIL: rila@borovets-bg.com

WINTER PERIOD: end Nov to end April/May LIFT PASSES

Half day 25/20BGL weekday/weekend, Day pass 50/30 6 Day pass 260bgl

NIGHT BOARDING 4 runs are open every day 5pm to 9pm costs 20/15 weekday/weekend

HIRE Board & boots 10/55 per day/6-days

TOTAL NUMBER PISTES/TRAILS: 20

LONGEST RUN: 12km

TOTAL LIFTS: 14 - 1 Gondolas, 3 chairs, 10 drags

ANNUAL SNOWFALL: unknown SNOWMAKING: 20% of pistes

FLY: to Plovdiv airport 71 miles (115 km) or Sofia 72km

BUS: Take a local bus from the airport to Sam kov Bus Station (30mins) then a van to Borovets.

CAR: Via Sofia, take the route 82 south out of the city via the town of Pancharevo and Samokov to reach Borovets.

PAMPOROVO

Small and basic

Pamporovo is a small un-assuming resort that is set amongst the Rhodope Mountains which are located in the south of Bulgaria. This is also a resort that claims to be the sunniest in Europe and the home to the mythical singer 'Orpheus'. Pamporovo is only an hour or so away from Bulgaria's second city **Plovdiv** which makes this a popular destination for weekend city dwellers. The mild winters in this part of the country give rise to two distinctions, great sunny mountain but not always great snow capped slopes, due mainly to the weather patterns coming from the nearby Aegean sea. However when the mountain is covered in snow Pamporovo becomes the ideal place for beginners with a nice selection of easy slopes, along with a number okay trails to please intermediate riders. But this is not a resort for hard-core freestylers or riders of an advanced level, although fast carvers will find a number of cool runs to take at speed, notably the area of The Wall which is often used for major ski events. But the dominating feature at this the 500 ft giant TV tower and restaurant which sits on the Ploydly summit of Snezhanka at 1926m

OUT OF 10

Stoudenys Pandrama
Pandrama
Hotel

Garakt Kanton
Hotel

Ploydiv Hotel

Ministration Office
Prespa Hotel

Prespa Hotel

Ministration Office
Prespa Hotel

Prespa

FREERIDERS have a mountain that doesn't offer a great deal in terms of exciting or varied terrain if you like to ride hard and fast. But that said there are some tight trees to check out and a few natural uneven spots to hit.

FREESTYLERS who crave natural wind lips and big cliff jumps will be disappointed, however, the guys from the Smolyan snowboard club occassionally build a halfpipe.

PISTES. There's a couple of good carving runs to check out but note, piste grooming is not hot here, resulting in runs being left rutted and often uneven.

BEGINNERS are the ones who will like Pamporovo the most. The terrain is ideally suited to novices with a selection of easy to reach green and blue runs serviced by drag and chair lifts. Snowboard hire and instruction is available on the slopes.

OFF THE SLOPES Pamporovo is a purpose built but relaxed resort with a good level of resort facilities located close to the slopes. There is a shopping complex, hotel swimming pool, sauna, a number of bars and the odd disco all within easy reach of the slopes and all with a common theme, cheap. Every thing is affordable and booze is almost a give away. Around the resort there are a number of well appointed hotels offering cheap nightly room rates and good weekly packages. Hotels *Perelik* and *Mourgavets* are both popular place to stay and have pools, bars, restaurants and even a bowling alley. For those wanting self catering then the *Malina Village* is the place to stay with a number of well equipped chalets for hire.

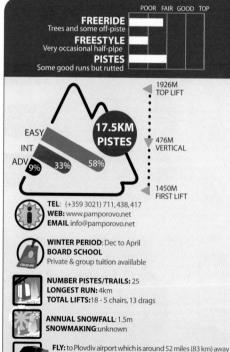

with a 2 hour transfer time. Sofia airport is 260km away. **BUS:** services from either Plovdiv or Sofia are possible.

TOSHA

OUT OF 10

Okay for a few days

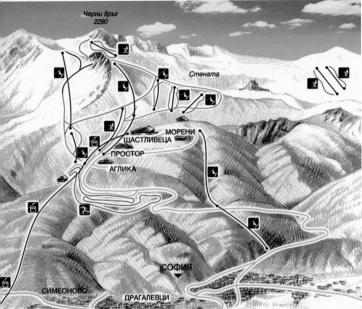

Vitosha is Bulgaria's highest resort and one that boasts a long season, is located just half an hour from the capital of city Sofia and set amid the Vitosha National Park. This is a small resort that attracts hordes of punters form the nearby capital especially at weekends. The village is

perched high up at a level of 1800 metres with lifts travelling up to a top station of over 2290 metres. The season here generally runs from December to mid April with the mountain best described as suiting beginners and slow learning intermediates. The 20 or so marked out trails are serviced by 11 lifts, which is almost one lift to two runs, thus helping to keep lift lines to a minimum. Overall Vitosha is a simple place resort that should keep you amused for a couple of days if you are an advanced rider or entertained for a week should you be a novice. The mountain boasts a number of interesting slopes, a long 5km run and some nice wooded areas. But if you are the sort of rider who looks for something different at every turn and doesn't like riding the same runs more that twice, then you won't enjoy this place.

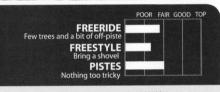

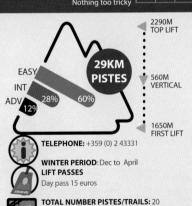

LONGEST RUN: 5km TOTAL LIFTS: 9 - 1 Cable car, 2 chairs, 6 t-bars LIFT TIMES: 8.30am to 4.00pm

ANNUAL SNOWFALL: 1.5m SNOWMAKING: none

FLY to Sofia airport which is around 22 miles away BUS services from either Ploydiv or Sofia are possible. CAR Its 22 miles from Sofia

FREERIDERS will be pleasantly surprised with some of the slopes especially if you head up the highest point of the Cherni Vrah peak. From here you will be able to gain access to a number of challenging runs which includes the Vitoshko Lale area which has a mixture of un-even red and black runs but one thing this place is not noted for is off-piste or backcountry riding. Although there are some trees to check out, there's no back bowls of deep powder spots.

FREESTYLERS won't fall in love with Vitosha as this is not a place for getting big natural airs. Yes there are a few natural hits, and local are always building kickers, but there isn't any big launch pads or permanent terrain parks or halfpipes to ride.

PISTES. Riders have a mountain that on one hand provides some decent fast spots, but on the other hand the choice of good wide carving sections are limited to iust a few runs.

BEGINNERS have the best of things here with 10 out of the 20 runs graded as easy, with the largest cluster of novice runs found around the Stenata area. The long green off the Romanski chair is a nice easy run.

OFF THE SLOPES you will find that Vitosha is a bit low key with not a lot going on. The resort has a number of convenient hotels with cheap rates. Around the resort you will find a few night spots, but in truth this sleepy place is not a hot spot. The best night spot is the Hotel Prostor. For a far greater selection of locals services you should visit the city of Sofia which is 23 km away reach.

CZECH REPUBLIC

HARRACHOV

Harrachov in the far east of the republic centres on the Certova Mountain which has snow making facilities. The resort is limited to low pitch rolling slopes. Its main boast is the array of ski jumps and cross county trails so its best suited to our two plank brothers.

LIFTS: 3 chairs 1 drag. PISTES: 5 runs. TOTAL: 6.3 km, LONGEST 2.2km.

HERLIKOVICE & BUBAKOV

are resorts with linked runs and lift passes and are close to the major resort of Spindleruv Mlyn. There is a 1.5km cable car and 8 drag lifts. The longest run is 3km, there is good snow making facilities and the chance to board a 2.5km night run. Most impressively there's a terrain park but don't expect too much.

JANSKE LAZNE

is a spa town and has had some recent investment which includes snow making. If you get bored of the small slope area there is always the 3.5km sledging piste.

LIFTS: 12 -1 Cable Car: 1. Chair: 1.10 Drags RUNS: 14 LONGEST: 3.5km. TOTAL 13km

SPICAK

In the far west of the country near the German boarder in amongst the Bohemian Forest is the resort of Spicak. Its a small resort with only 5.5km of pistes and two snow cats but its a good beginners resort and an intermediate could have fun here for a day or two. It offers night boarding and has snow making facilities and when there's been a dump there are plenty of trees to shred. Open from 8.30 till 16.00 and 18.30 to 21.00. 560czk for a day+night, 200czk for night boarding only.

SPINDLERUV MLYN

Spindleruv Mlyn is one of the best known resorts in the area and its easy to get to as there are plenty of public buses from Prague which take 3 hours. Its located just south of the Polish boarder, and consists

of a strip of soviet style concrete hotels set near woods at 780metres. Medvedin to the north west is the highest peak at 1235m while Plan to the south at 1196m sometimes has the better snow as it doesn't get so much sun. The resort does have a terrain park and a half-pipe and regularly hold competitions. A chairlift ascends Snezka (1602 m), the Czech Republic's highest mountain, but no runs lead down to the valley. Overall this is a basic freerider's haunt, but by no means testing

LIFTS: 11 - Chairs: 5 Drags: 6 RUNS: 21 RIDE AREA: 26km pistes LONGEST RUN: 2.7km. LIFT PASSES: Half-day 600, Day pass 750 NIGHT BOARDING: The Hromovka I, 1.1km slope is open every day from 6-9pm

GETTING THERE: From Prague head to Mlada Boleslav on the D11 or E65. Take road 16 to Jicin, onto 22 to Vrchlabi then take the 296 to Spindleruv Mlyn, 160km total distance.

www.skiarealspindl.cz

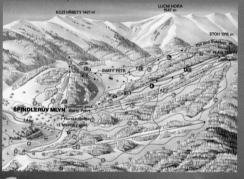

KOSOVO

Imagine you're a young Kosovan Albanian, which is around 90% of the population. The country has just one resort; you go riding on the mountain on a regular basis, then war breaks out. After the war, part of the country divides into little sectors; this is due to different religions, Serbian 10% (Catholic), Albanian 90% (Muslims). It just so happens that your local/only resort is in the middle of a Serbian area, you can't travel through or enter this area because military checkpoints prevent this. You can't leave the country to go riding at any other resorts; you haven't got a passport (Most Kosovans destroyed their Yugoslavian passports during the troubles in 1999)!

FREERIDE Riding the 2 man chair can take you to the highest point and some good freeriding, but watch out for the power cuts (not funny). There is some good terrain on the left with a nice open bowl and a good tree run to finish off with. It will take you a good few days to explore the whole area and if you want some decent terrain go hiking. The areas the lifts were running at are great. Later in the season watch out for the bears.

BEGINNERS The lower part of the mountain is ideal to learn. This is where the T bar is located.

OFF THE SLOPES. Accommodation there are a number of small B&B/locals who are happy to give you a roof over your head for a few Euros. These are

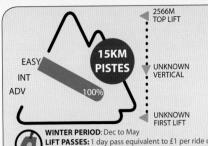

LIFT PASSES: 1 day pass equivalent to £1 per ride on the chair lift and 33p on the T bar. The purchasing of the lift tickets was an interesting process. You buy a ticket of the guy at the lift, you then give the said ticket straight back to the same guy who rips the ticket up and throws it on the floor.

TOTAL PISTES/TRAILS: 3 (more available) LONGEST RUN: 3km TOTAL LIFTS: 2 - 1 chairs, 1 drags (in heyday 9 lifts) LIFT TIMES: 9am to 4pm

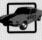

FLY: Grab a flight to Skopje or Pristina the journey time from the airport is approx an hour. Check with the embassy to see if travel is safe. This is a little hard unless you're in the military, UN or a charity organisation working in Kosovo. Because the number of checks and road blocks, passport might not wash. But give it time, who knows

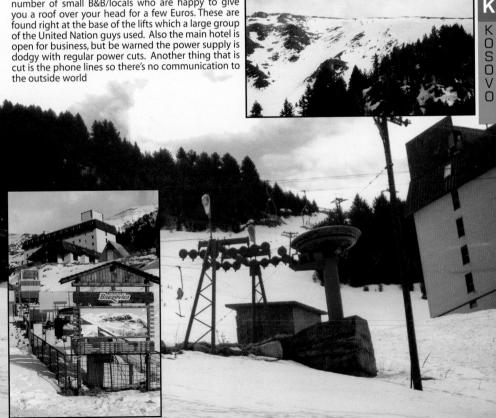

LATVIA

The former Soviet state, Latvia gained independence in 1991 and in April 2004 became full members of the EU along with Greece and Poland.

There are around 30 resorts in Latvia, all within 100 miles of the capital Riga. However only 6 of those have more than 1 lift and the longest run in any resort is a paltry 350m. Valmiera is the biggest and best resort in the country.

Snowboarding in Latvia has taken off and most of the resorts have a terrain park, and there are many national snowboard events held annually. The Latvian Snowboard Association was started back in 1996 and now has over 120 members.

Expect snow quality to be poor, however most resorts posess some snowmaking equipment.

VALMIERA

Valmiera is the main snowboarder's hangout in Latvia, and is located 80 miles (130km) north of the Latvian capital Riga. There are two slopes, the longest measuring a mere 170 metres, serviced by two basic lifts and a snow-cannon. You couldn't split this place into styles or levels. Suffice to say that novices alone will have half an hour's fun. The winter allows for some limited riding on real snow while the summer sees an influx of boarders to ride the only sliding carpet, (better known as a 'Dry Slope'), in the Baltics. During the summer a lot of BMX riders also turn up to ride the BMX dirt track, while others simply come to chill out and take the occasional boat trip on the river Gauja.

There's a terrain park that is floodlit, which provides a decent number of kickers and rails, although theres no half-pipe. You can hire snowboards and boots at the base and snowboard instruction is also available on request.

Lodging and other local services at the slopes are not for wimps or for those looking for all the creature comforts of an Alpine resort. You can choose to stay in one of the small camping style houses located behind the slopes, which use old wood stoves for heating. Alternatively in the town of Valmiera you will find ore and other basic cheap lodgings.

Night-life is a Do-It-Yourself job with a Walkman, or check out Multi Klubs, Tirgus iela 5, ph 42 32114 for a party.

Fly to Riga International airport 80 miles away. Bus: A transfer takes 2 /2 hours. Trains: via Riga take 2 /2 hours.

Driving: via Riga, head north on the A2 for 50 miles travelling via Sigulda and turning north via Cesis to reach Valmiera.

RAMKALNI

A tiny hill with a ride area of 400m and only 2 runs. The longest is 200m, and there are 2 drags.

REINA TRASE

is another dinky place with 10 or so very short runs. However, there is a terrain park with a fair number of hits and some rails. It is serviced by 4 drag lifts and a rope tow.

MILZKALNS

60km east from the capital Riga, lies the resort of Milzkalns. There nothing to get exited about here. It's just a small hill with a few pomos and runs that never exceed 300 metres. There are only 5 drag lifts and 8 runs.

ZAGARKALNS is yet another small hill.

Photo: Zagarkalns resort

Popava Shapka is a complete eye opener, this place is not a wipe my arse package tour location where you have everything on a plate. You're on your own, everything takes time, from finding the lift pass office, there's no neon lights just a A4 piece of paper in a hotel window. The hiring option is an old Nidedecker or you go without. Getting hold of a little map is like getting a smile on the London underground. The lift queues are mad. If you jump the line you are looking at a good thecking from the lifties, these boys don't mess about. A young lad jumped in to hook up with his dad; this wasn't an option, he was kicked straight to the back and his dad was nearly done over in a nose to nose argument.

FREERIDER The upper most part of the area has the best freeride terrain but don't expect too much. The whole mountain is good to go if you can dodge the Sunday walkers and the locals selling bottles of beer and cigarettes at the side of the piste. The resort has some good riding options with a few gullies and trees within easy reach. Riding the 2 man chair can take you to the highest point and some good freeriding, but beware there's no piste markers so you'll need to know your route.

FREESTYLE None at all, you will be lucky to find anyone else on a snowboard.

BEGINNERS The lower part of the mountain is ideal to learn but can get crowded with none snow sports users. You'll also need to be careful of the litter.

OFF THE SLOPES. Accommodation There are a number of hotels on the door step (one of them named *Wankal*). They all seem mighty fine or you could try the city which is cheaper and enjoy the white knuckle ride on the bus or the gondola on a daily basis. The eating options are ok but I'm sure the environmental health would have a field day. A strict diet of mars bars, crisps and coca cola. Night life the city of **Tetevo** has a large number of bars and night clubs.

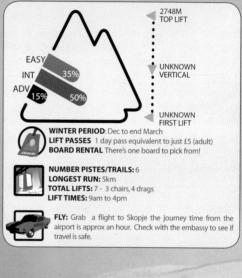

DACHIOOZ-A

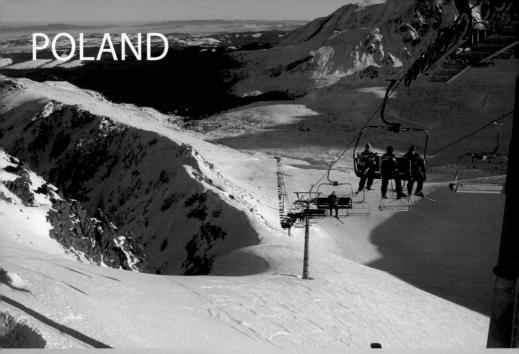

These people have had some shit, the Second World War started there and ended with twenty years of Communist Russian rule, followed by a puppet Polish Government for another twenty. When you arrive in Warsaw or Krakow its grey even when the sun shines its grey and the taxi drivers will try to rip you off by about 1000%. But look a little deeper past the unsmiling faces and the bastard taxi drivers and what you'll find is real wild spot.

Renaissance buildings, cheap beer, beautiful people and enough vodka and gherkins to see out any post nuclear war. In the High Tatras the bushes are full of wolfs and bears, in the city there full of suit wearing vodka heads, who just couldn't make it home. There are many resorts in Poland but most are tiny, with only one or two lifts. The best is the resort town of Zakopane, which is directly south of Krakow on the Slovakian boarder.

The last few years has seen much cash invested jn Poland, with Krakow being high on the list for Brit's trying to make a few quid in the property market. This has seen a large investment in the surrounding resorts, with high speed six man chairs taking the place of knackered old drags.

OUT OF 10

Full of out of control nutters on skis

30min drive from Zakopane, and can make for an enjoyable day. It's owned by the same company who own Kasprowy, the best area in Zakopane. Lets hope Kasprowy sees the level of investment that this place has. The car park's full of nice cars, the base area has a few new bars, with people outside grilling lumps of cheese that look like bars of soap, and the slopes are serviced by modern lifts and full

Bialka pronounced be-ow-ka, is about a

In true Polish style the resort is little more than a hillsid and the piste map's a joke, as there aren't really any pistes. It's just a wide open area serviced by spaced out parallel running chair and drag lifts, which more or less all arrive at the same place. The resort is open late every day, and around 4pm they close the sloves while they piste bash it ready both evening

of the Polish elite.

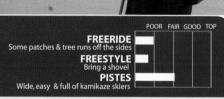

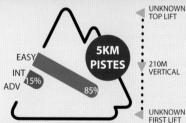

ul.rodkowa 181, 34-405 Białka Tatrzanska

GENERAL INFO: 018 2654133 WEB: www.bialkatatrzanska.com EMAIL: kotelnica@bialkatatrzanska.com

WINTER PERIOD: Dec to April NIGHT BOARDING

All slopes lit and open till 10pm

TOTAL PISTES/TRAILS: 6 LONGEST RUN: 1.4km TOTAL LIFTS: 7 - 2 chairs, 5 drags MOUNTAIN CAFES: 2

ANNUAL SNOWFALL: unknown SNOWMAKING: 50% of pistes

FLY: 4 hours from Krakow BUS: local transit vans run between Zakopane & Bialka and cost almost nothing. They leave when they are full CAR: 30min from Zakopane

One of the cool things, to make up for the completely out of control nutters on skis, is that no one seems to want to leave the piste. Now the runs are short, and certainly not steep, but you can lick it down the powder at the resorts edges all day without anyone else joining in, leaving you all day to get fresh tracks. There are plans to build 3 new chairs to service the peak between the main areas of Kotelnica and Kaniowka which at the moment is a hike to get to, however it was due to be completed for the 2005/6 season but there was no sign of it.

FREERIDING. The best run by far is a few worth while steps up from the main chair no7. Just drop off into the clear area and then left along a flat path into the woods. Keep your speed up then just follow the footpath through the woods which then opens out onto a steep and wide, unfortunately short, slope. Cut right at the bottom and another short walk will take you to the base of the mad little inflatable ring track. Also of note is the powder to the left of the drag on the far left of the resort.

FREESTYLE. If you don't have a spade then I'd buy one if you want to get any air. The idea of a park just hasn't got to Poland yet.

BEGINNERS will like this place as the pitch of the slope is even and there are good chair lifts, so no need for drags. What you wont like are the afore mentioned out of control skiers, this is not an anti ski rant it's just no one here knows how to ski or they've just had too much local schnapps.

OFF THE SLOPES The restaurant at the bottom of the slopes serves some of the cheapest Pierogi & burgers around. There are a couple of hotels and restaurants situated in the main town a short distance away but nothing of note. The resort is best done as a day trip from Zakopane. A taxi will cost about £20 and a shared minibus costs about a £1 pp.

s answer to Chamonix, France. Tounded in the Seventeenth century Zakopane is now a collection of wooder chalets, soviet lats and western branded shops. Like Chamonix it's a town which services a collection of small resorts; Kasprowy Wierch, Polana Szymoszkowa, Nosal and nearby Bialka. Unlike Chamonix most of these resorts are just hill sides covered with snow ploughing Poles, straight lining, out of control at breakneck speed.

The two main downside to Zakopane are accessing the slopes and the lift passes. There is a tourist bus but it's infrequent and you need a logarithms book to decode the timetable. It's best to take Taxis to the slopes, but make sure the meters on tariff one. Mini bus taxis are cheaper. As for the lift pass's, each little area has it's own pass and many sell single rides, half days or full days, some have hand free cards which you put credits on and different lifts deduct different values. It's absolutely ridiculous and can lead you to needing different coloured passes for different lifts in the same area. At the end of a week your pockets are full of cards, some which have a deposit on, paper passes and a head that wonders what the Russians have done to these people's minds.

Put all that put to one side, and if you like it old school, don't mind a walk for your powder, or are a complete beginner, then Poland's just great. It's cold as, which keeps its plentiful snow in tip-top condition, it's cheap with a pint never reaching over the £1 mark, and the women are just fine, just fine.

The town has a centralised pedestrian street which in the day has cheap eats and more silly hat stalls than you would think possible. This is also the place to head at night for a few beers. Roosters have: burgers, beer and waitresses in tight t-shirts and red hot-pants. Krakorviacy I Gorale restaurant is a meat feast with huge bits of meat cooked on an open grill, there's also a mad Polish band playing most nights, which goes down with most locals downing their cutlery and giving it up on the dance floor. The bars close around midnight and then the underground clubs open until the very early hours. Expect to pay a small cover charge to enter the clubs, and the memory erasing vodka's always free-poured and served straight at room temperature.

For lodging, www.sunshineworld.co.uk a British based company, run Holidays for all budgets and include transfers and instruction, or for more info check out www. zakopane-life.com .The Hotel Belvedere is Zakopane's top five star hotel it's cheap compared to its western equivalents.

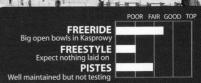

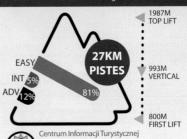

ul. Ko ciuszki 17

TEL: (+48) (18) 20-122-11 WEB: www.zakopane.pl / www.pkl.pl

EMAIL: info@um.zakopane.pl

WINTER PERIOD: Dec to April

LIFT PASSES Around £10 a day, depends on where you are and how many runs you do.

NIGHT BOARDING Every area except Kasprowy Wierch BOARD RENTAL from 35 zloty/day but its crap gear

NUMBER PISTES/TRAILS: 21

LONGEST RUN: 7km

TOTAL LIFTS: 19 - 1 cablecar, 1 funniclar, 6 chairs, 10 drags LIFT TIMES: 9.00 till 20.00

MOUNTAIN CAFES: 2

ANNUAL SNOWFALL: unknown SNOWMAKING:some

TRAIN: Many trains daily between Zalopane and Krakow. It takes 4 hours and watch out for pic-pockets.

FLY: Krakow 100km is the closest airport in Poland, the drive to resort can take anything from two to four hours

depending on the traffic. Poprad 70km in Slovakia is the closest airport but what with the hassle of taking a car through the boarder crossings you're better off flying into Krakow

CAR: What a shit road. There's one road in from the north and at weekends and holidays it's packed. There's a new four lane road being built with EU money but it wont be finished until 2008/9.

BUS: Regular bus services run from Krakow

NEW FOR 2006/7 SEASON: The cable-car in Kasprowy is due to be replaced with a much faster one.

284 USQ www.worldsnowboardguide.com

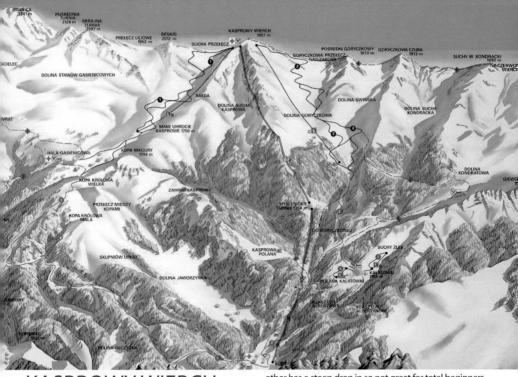

KASPROWY WIERCH

Kasprowy Wierch, set in a national park is the by far the best area. An old cable car, built in the 30's, takes you in two stages up to the largest and steepest pistes in the area. The cable car can be mobbed in the mornings, leading to long queues. There is the option if you really hate gueues to pre book a timed ascent; but it must be done two or three days in advance. A new cable car is due to be built in the summer, but if progress of the new road from Krakow to Zakopane, paid for with EU money, is anything to go by don't hold your breath.

FREERIDING. Once away from the jammed cable car Kasprowy Wierch is a really great spot for the freerider. There's two chair lifts one on each side of the mountain. To the left is a black run that leads down to the shorter of the two lifts, which makes for a good warm up and some great views on the way back up. But the real place to head is mountains other side, after a 50 meter walk, from the cable car, you can strap your board on and head to a black run in the first bowl. If you stay high to the left and walk along a ridge you can access a further two off piste bowls, with some great big powder faces. If you don't fancy a walk then cut directly right under the longer chair and keep heading right, watch out for corniced cliffs at the top and rocks, this area has some real steep powder stashes and a few natural half pipe areas. You can shred it up through the trees, but remember to cut left or you'll end up below the chair.

BEGINNERS. Two pistes which are fine to progress onto after you've graduated from the nursery slopes of the other areas. One has a narrow path and the

other has a steep drop in so not great for total beginners.

DLANA SZYMOSZKOWA

You will never see such fantastic lifts gracing such a small area, but thank god they do or you'd be so pissed off with queuing you'll whack someone, which is a real bad idea as most of the Poles are huge and will easily rip your head off. A brand spanking six person high speed chair runs alongside an equally new 4 person one. Below is a frenzy of snow ploughing mayhem on two very short runs. The slopes are open till 10pm most nights but they close the lifts around 4pm to let the groomers loose for half an hour. The area is great for beginners, who don't want to experience a drag lift, but little else.

Nosal has a very steep narrow Black with a single seater chair, the run is often icy. The rest of the area is little more than a collection of very short green slopes accessed by drags, coved in little helmet wearing ski scools.

GUBALOWKA

Consists of a funicular train running from the base to the top with a couple of t-bars serving the same terrain. There's a long blue run and that's about it

No funicular this time, but a single chair serves the main slope with a couple of beginner tows. There's no real piste as such, just an open face of easy gradient.

SLOVAKIA

Slovakians drink more beer per capita than any other country in the World and at 50p a pint who can blame them? It's home to the High Tatras mountains, part of the Carpathian range (also see Poland). Its best known resort is Jasna in the Low Tatras. Slovakia, the eastern half of the former Czechoslovakia, is a beautiful place and is well cheap. The towns are made up of Renaissance architecture and grey Commie high-rise tower blocks.

Bratislava, the Capital, has an International airport, and makes a great place to start you trip. It's a fantastic 3 hour train ride from the capital to the mountains, through some breathtaking scenery. You can also fly to Kosice, or the closest airport to Jasna, Tatry-Poprad. Also flying into Krakow in Poland is an option with a road trip between the two countries's very possible. Make sure if you're hiring a car that you can take it out of Poland and smile at the boarder guards, as they're on a constant go slow.

As well as great beer, interesting food and beautiful women, it has some good riding. If you're an experienced rider and like a road trip then it's a cool place to tour but more importantly it's also a great place to

learn. The instruction standard is ok and board hire is available. Burton even has a hire shop and a LTR school in Jasna. If you're a complete beginner then why spend loads of money on a lift pass for a huge area when you're going to spend days on the same slope? A week's pass here is around £60 and will offer the beginner more than enough terrain to keep them happy. Most resorts will have a lot of drag lifts but you've got to learn to conquer them at some point, as there's nothing worse than seeing your mates heading off to that hidden spot, while you are on your belly being dragged up the hill holding on for dear life.

Most resorts have really old ski lifts and don't always believe the piste map, as there are often a few lifts closed when you get up the hill, and they look like they've been closed for years. The resorts are all boarder friendly and most have some rail slides and a few wonky hits. Slovakia is a great option for those sick of over paying for rude waiters in the more visited resorts of Western Europe.

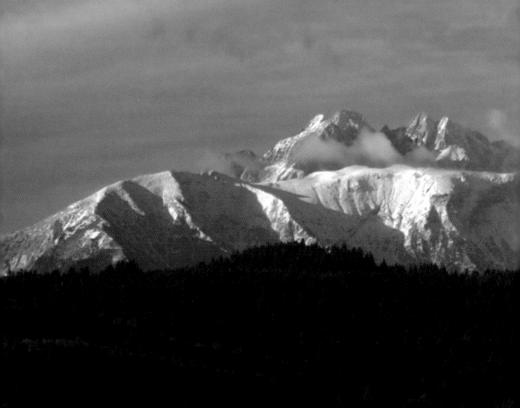

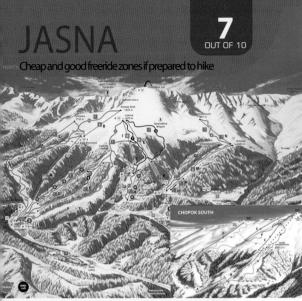

POOR FAIR GOOD TOP

FREERIDE Just take the time to find the chutes FREESTYLE Small park, good natural terrain **PISTES** Limited but varying 2024M TOP LIFT

1074M VERTICAL 950M FIRST LIFT TELEPHONE: tel: 421 44 5478 888 (9)

WEB: www.ski-jasna.sk

WINTER PERIOD: end Dec to end April LIFT PASSES

1 Day pass 450 Sk, 6 Day pass 3,500 Sk, Season pass 15,000 NIGHT BOARDING Every Thursday by the main Zaharadky

chairlift - one drag lift operating from 6pm - 9pm - Also next to Hotel Junior at same times, 1 drag lift

BOARD SCHOOL two schools one run by Burton

RENTAL Two shops one run by Burton, Located in the Hotel Grand near to Otupe area of resort

TOTAL NUMBER PISTES/TRAILS: 17 LONGEST RUN: 5km

TOTAL LIFTS: 17 - 1 Gondola, 4 chairs, 12 drags

LIFT TIMES: 8:30am to 4:30pm

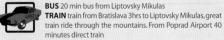

FLY 60 km from Poprad Airport. Good connections with Bratislava &

CAR 15 km away from Liptovsky Mikulas, 4 hours from Bratislava, 1 Hour from Poprad

Over the last few years Slovakia has built up a reputation as being the next big thing – and after spending a bit of time in Jasna you start to understand why. Following what seems almost a dead end road through the Demanovska Valley, you find yourself in the middle of Jasna, sometimes referred to as **Chopok** (highest peak in resort). The tree laden resort makes for picture postcard scenery, and at times you may think you've stepped out into the Chronicles of Narnia through some of the tree runs. At certain points in the season you find vourself overloaded with Ukrainian, Russian and Polish tourists on the school break, but a good mix of terrain for beginners and intermediates means this is spread over the resort - but you will find around the main lifts huge queues during peak holiday weeks which can be stressful. It's these times that you will find the "freeride zones" come into their own. Theres plenty of cheap eats on the hill, as long as you like goulash, corn or fried food, but for something more traditional head to Biosonova Chata for a good

feed. Two of the nursery slopes are open at night and frequented by one piece suits bent double, with arses pointed to the havens and eyes fixed on the tips of

there skis.

FREERIDE. There are three marked areas which have no lift access and require anything from 10mins to 2 hours walking to get your fresh fix; not exactly popular with your average tourist who try and avoid the queues by hiding in the many cafes. However, spend a little time getting there and you can experience the chutes and great terrain that these areas offer.

From the top of the **Royná Holá** - Konsky Grún chairlift you can take a 30 minutes walk over to the south side of Chopok, to Jasná Juh - a smaller resort then the north side, but still covered by your lift pass. At the peak you will also find one of the remotest cafes around - where for 300skk (£6) you can spend the night on top of Chopok with evening meal and breakfast included for fresh tracks the next morning.

FREESTYLE. The fun park which you can walk has the usual supply of rail slides, with a wall ride and a couple of kickers.

OFF THE SLOPES

The resort itself consists of a few hotels which will cost you aroun £18 a night for half board. The nightlife at the hotels is a bit suspect - so take a cab or jump on the bus down to Liptovsky Mikulas at the bottom of the valley where all nightlife and entertainment is centred. Look out for Route 66 & Ski Club for cheap beers with lively atmosphere into the early hours. Although you won't find many English speaking groups around - there are an increasing number setting up, so before you see the Crystal & First Choice clad reps walking around you should take advantage of the cheap prices and unique experience. Currently the only British operation are Propaganda Snowboards who have a chalet directly between the city and the resort, check out www.propagandasnowboards.com for more information

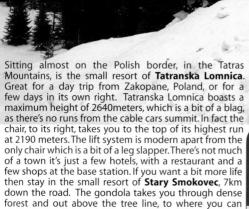

either board down a red and onto a blue back to the

base station, or take a short chair lift up to a steep and often icy black run. There are big plans to modernise and expand the resort but no firm timescales have been

FREERIDE. When you look at the piste map, this resort like many in Eastern Europe, makes you think there's more here than you think. Really its one long run from the top to the bottom, linked by a few narrow zig zaging paths. This is no bad thing as at least you get a good long run in, and there's never really a queue at the base station and the gondola is fast and takes four people at a time. From the top of the Black you can cut far right for a powder face, or left into a bowl which looks great, but beware the forest below closes out and it's a hike back to the piste. A few years ago a hurricane blew through here, taking out loads of trees and leaving some gaps in this incredibly dense forest, but again take care as the forest does close out and there are loads of tree stumps.

FREESTYLE. None of any note, best thing to do is take a spade and make your own. There are loads of fallen trees so you could take a saw, cut of the odd branch and make a great rail. If it's jumps and park you want, head to the nearby resort of **Jasna** 80km away.

BEGINNERS. Drags are the main draw back to the little Jamy area, where you can catch those edges on the first

few days. After that you can get the Gondola up to the aptly named Start area, which is a blue back to the resorts base. Not a bad place to begin but the blues really little more than a wide path and can be a little flat in parts.

OFF THE SLOPES. Locally there's a few modern hotel, with a couple of smaller family run guest houses buy you're better of staying down the road in Stary Smokovec.

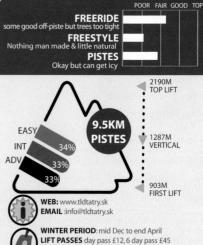

NIGHT BOARDING 17.30 to 20.30

TOTAL NUMBER PISTES/TRAILS: 6

LONGEST RUN: 3.2km
TOTAL LIFTS: 7 - 1 Cable-car, 2 Gondolas, 1 chair, 3 drags
LIFT TIMES: 8.30 to 20.30

TRAIN: local train station Zeleznicna stanica, one line so not to many trains a day. 4 1/2 hours from Bratislava BUS: bus from Poprad one at 8.00 returning 15.30

FLY: Poprad airport is only 20km away. Krakow in Poland is anything from 3 to 5 hours away depending on traffic and border quards.

CAR: Only 12 km from Poprad, 56km from Zakopane in Poland. From Bratislava Slovakias capital, E75 and E50 motorway/main road straight to resort

288 USQ www.worldsnowboardguide.com

set as yet.

ROUND-UP

DONOVALY

This small beginners resort doesn't have much to recommend it unless your a nappy wearing newbie, but to be fair the resort does wheel out a few rails and will build a kicker or two when conditions are ok. There are 17 very short and exceptionally easy runs, 11 of which are open for night boarding.

SKIPARK RUŽOMBEROK

This modern resort reaches a height of 1209m and does offer a couple of longish runs back down to the base to compensate for the majority of short runs. Don't expect a terrain park, but there is a small amount of tree-riding to be had, and most of the runs are backed up with artificial snowmaking.

TARY SMOKOVEC

Just 7km down the road from Tatranska Lomnica is Stary Smokovec. This tiny resort never makes it above the tree line, and proclaims a very short black, but it's really a few meandering blues. There's a long green which is lit at night and doubles as toboggan run, but the resorts best for leaving your beginner mates while you head off to Tatranska Lomnica. Stary means Old, but Stary Smokovec has a modern, if small, central area based around the train station,

consisting of: shops, a hire shop, and a few bars and restaurants. There are many hotels with the biggest being the huge imaginarily named Hotel Grand. On the slopes its fine to get those early turns licked, but not much else. The place is full of snow ploughing Slovaks with little if any control. If you've never seen a slope before

then great, if you have, then best to go somewhere else.

Is a small resort with 16km of marked down hill piste. There are 3 chair lifts including a new 6 person lift which links with an 8 seater cabin to take you to the resort's highest point 1050metres. You can get to 1236 metres but it's a walk. Under the main gondola they usually knock togther a couple of jumps and some rails. There is night boarding on one of the longer runs and a few bars and hotels at the resort, height 630metres. www.velkaraca.sk

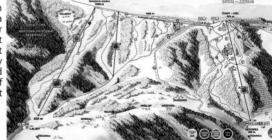

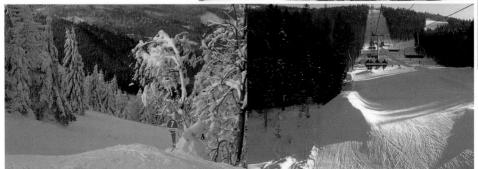

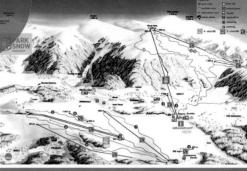

SLOVENIA

Slovenia is where east meets west. This former part of Yugoslavia has a heavy influence from the Austro-Hungarian Empire in the north, and a more chilled Venetian influence in the south. This tiny country, the size of Wales, has it all; the biggest subterranean canyon in the world (bull shit) at Skocjan caves, miles of vineyards, fine beaches along the Adriatic Sea, reputedly the most beautiful alpine lake in the world in Lake Bled, and last but by no means least great mountains, at affordable prices, in the Julian and Savinje Alps.

Offering western service at nearer eastern European price, Slovenia is truly a great place for the beginner and intermediate or the advanced rider who doesn't mind a hike. A night in a 4 star, piste side, hotel will only set you back 35euros half board, and the lift pass prices make a mockery of the swish French and Swiss resorts.

Gaining from its position, at the eastern end of the Alps, Slovenia has the first mountains that weather fronts from the east hit, thus giving it more than its fair share of snow, with many resorts receiving an averaging of around 4meters. With a country this small, Slovenia is one of the only places in Europe, where you can board in the morning, drive through vineyards and swim in the Mediterranean in the afternoon and party all night in the Capital Ljubljana.

What you wont find is huge interlinked resorts or great parks but thankfully you wont find huge lift queues or a hole in your wallet either. Most resorts will have all but the very beginner bored in a few days, so it's best to do a road trip around a few resorts. Most resorts are within an hour of the Capital, and a nine-seater minibus shouldn't set you back more than 90 euros if you don't want to drive.

1

KRANISKA GORA

Fools gold - 5* hotels, fast lifts but little substance

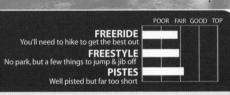

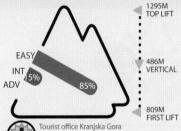

Ticarjeva ul. 2, 4280 Kranjska Gora TEL::+386 4 580 94 40

E-MAIL: tic@kraniska-gora.si WEB: www.kranjska-gora.si

WINTER PERIOD: Dec to April LIFT PASSES euro 25/day, euro 122/6days NIGHT BOARDING all slopes 6-10pm 17euros or free with 3day or more pass.

BOARD SCHOOL 2hr lesson 38euros RENTAL16 euros/day 18euros/day with boots

TOTAL NUMBER PISTES/TRAILS: 11 LONGEST RUN: 1.2km TOTAL LIFTS: 10 - 3 chairs, 7 drags LIFT TIMES: 8:30am to 4:30pm

ANNUAL SNOWFALL: Unknown **SNOWMAKING:** 90% of slopes

BUS from Jesenice 30-minute drive 20km TRAIN Nearest station Jesenice then bus FLYLjubljana airport is closest 2 hr drive CAR Ljubljana-Kranj-Jesenice-Kranjska Gora 2hr drive

Riders who think Slovenia is some back arsed eastern European hole should dig out an atlas and take a closer look. Kranjska Gora is flash

both on and off the slopes; five star hotels and a casino are right next to the brand new chair lifts in this former part of the old Yugoslavia. The thing which lets down the resort is the terrain. It's all very similar, with almost all the pistes being of the same length and the same pitch. Unfortunately, for Kranjska Gora, the piste lengths are too short for all but the beginner or rider in their first few weeks, with you returning to the same lift in only a couple of minutes tops. The pistes are very well groomed and some are opened for night boarding which is good for a laugh. The resort lacks any real freestyle terrain and off-piste riding, but all that said it's really cheap and offers western facilities at almost eastern prices and the fantastic back droop of the Julian Alps. If only some one would cut down a few more trees as a snow clad forest towers above the lift system.

FREERIDE. People who've just started linking turns will get the most out of this place. The lifts are fast and uncrowded and the pistes are as flat as the Dutch dykes. There are two 4 man high speed chairs from the base station. Number 7 takes you to a steep often icy run down to number 14 which takes you to the highest point 1295. From here you can hike up to the summit, but watch out for avalanches, or follow the run back down through the very tightly packed trees. Don't cut down to the left at the top unless you want to limbo under fallen trees, stop on top of a waterfall, and climb out via a steep snow/rock slope. Don't be encouraged by the piste map as lift 8 which goes to the summit 1570 only runs in the summer. If you want to get to some big powder faces you'll have to rent a guide and walk into the surrounding mountains. Call 00386 041 749 055 for local quide.

FREESTYLE. There's some small drop offs, under lift 7, and a few things to hit in amongst the trees, but this is not a freestyle resort. There's no park of any sort and not one planned in the near future. In fact the only man made hit is a ski jump round the corner in Planica which holds international events.

THE PISTES are groomed almost to perfection, and are good and wide so you can crank over your turns. Just as your legs are starting to burn you'll be at the lift again which in one ways good, but in another shite as you'll soon get board.

BEGINNERS. There's a great area at the base station serviced by t-bars and good slopes to progress to. If it's your first week then this is a great resort, it's cheap and its modern lift system makes it a great place to learn. The hire equipment's not great but it will do and again it's inexpensive. If you've done a bit before then you'll be happy here for a few days but not for a whole week.

OFF THE SLOPES. Not the most kicking place in the world. The five star hotels have laid back bars and there are a couple of bars in town with bar live music and painful karaoke. Beers around a pound a pint and spirits can be strangely expensive. The best thing about this place is above the urinals there's a pad on the wall, to rest your head against when you're pissed up and can't aim straight. Food is basically a mixture of Italian and Austrian so cabbage on your pizza is not unknown.

Great unkown resort, perfect for a few days

Want to stay in the Eagles Nest? Well Vogel's the place for you. This great little resort is accessed only by cable car or by a crack team of WWII nutters. High above the beautiful Lake Bohinj sits the little known resort of Vogel; which has varied terrain, good off piste access, a park with some stupidly massive hits, tree runs, mountain cafes, cheap accommodation, and some of the oldest chair lifts you'll ever see outside of Scotland. The newest, a 2003 cable car, takes you up the imposing cliffs from the small car park at the lake side. Other than a small bar, and a shop. there's nothing at the base of any interest. At the top of the cable car you have the Ski Hotel Vogel, which is amazingly perched on the cliffs edge (the eagles nest). From here there's access to some incredibly slow chair lifts to a central station which is where the fun starts. There's lots of scope here for off piste lovers and also plenty of good pisted terrain with a long run all the way back down to the cable car base.

FREERIDE. Most of the runs around the central station can be seen from the good little mountain café. The pistes are quite short and it's easy to see all the off-piste in this area so it gets tracked out fast. But there's a great long run down to cable car by cutting right off of the red piste 11, which can be increased in length by starting at the top of the resort off the number 7 chair. From the top of chair 8 you can walk up towards the cross and then drop back down onto piste 11 but it does slide here so take care, also off of chair 7 you can ridge walk and get into a wide bowl but again take care of avalanches.

FREESTYLE. There is a park with a couple of rails and some of the largest kickers you'll ever see. There's no progression system in place here, it's straight from a 2 foot kicker to the, clinically insane only, huge bastard. There is plenty of small rock drops to fly off all over the resort and some real large ones under chair 8.

PISTES. You can certainly let go in this resort and crank up some good speed. The pistes aren't the widest you'll ever ride but they're mainly uncrowded and well groomed. One thing which picks this resort out from other Slovenian resorts is the length of the pistes. From the top of chair 7 to the bottom of the cable car will take you a good 15min flat out.

BEGINNERS. As with all Slovenian resorts Vogels a winner for beginners. Cheap accommodation and lift pass's added to easy access to the well groomed piste by chair lifts makes for a beginner's paradise. There are a couple of t-bars and a very short slow button back to the cable car, but all but the most incompetent should be able to cope with them. Lessons can be arranged through the hotel, but they won't be the best you'll

OFF THE SLOPES. What town? There's a car park at the bottom of the cable car, and at the top there's a hotel and two bars. The Ski Hotel Vogel is a cool place to spend a few nights www.skihotelvogel.com with double rooms, half board, from 35euros/night per person. The Wild Boar Pub has dorm and private rooms and will do you a good lunch or dinner and is a great place for a

pint, with its log fires. www.bombagroup.com Ski Hotel Vogel and the Wild Boar which rent out the local cabins are your only options up the hill. At the bottom you'll have to drive to Ribcev Laz. If you're looking for night lift then just come here on a day trip. If you want to be first on the lift in the morning and you're happy drinking with the people you're travelling with or want to try your luck with the bar staff then Vogels for you.

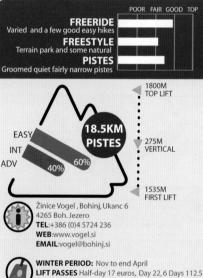

HIRE Board and Boots 14 euros a day

NUMBER OF RUNS: 14 LONGEST RUN: 6.8km

TOTAL LIFTS: 9 - 1 Cable-car, 4 chairs, 4 drags LIFT TIMES: 8.30am to 4.15pm

ANNUAL SNOWFALL: 3m in 2005/6 SNOWMAKING: none

FLY Ljubljana airport TAXI Ljubljana 031290420

BUS You can use local buses but their irregular and slow. If there's more than two of you it's cheaper to get a Taxi. TRAIN Again better to get a taxi as from the train station

you will need to get a bus from Kranj which is the nearest station. CAR 2hr drive from Ljubljana. North on A2 then west past Lake Bled.

ROUND-UP

KOBLA

Small resort located near the town of Bohinj not far from Vogel. There are 3 chairlifts running one after the other to reach the summit just shy of 1500m offering a few continuous 1000m vertical descents but theres little in the way of advanced terrain.

POHORJE AND AREH

The Pohorie Mountains, lie south of Maribor, which is one of the biggest cities in Slovenia. The town has its own airport and is easy to reach by car or train and is only 12 miles from the Austrian border. The snow fall is rather unpredictable, although there is a lot of snowmaking. The whole resort is within the treeline and there's often amazing freeriding after a fresh dump. Pohorje and Areh are separate summits, the top lift stations are interconnected with a free shuttle bus running every hour. There's also catwalks connecting the different lifts but they're very flat and can be a pain in the arse. The Areh area

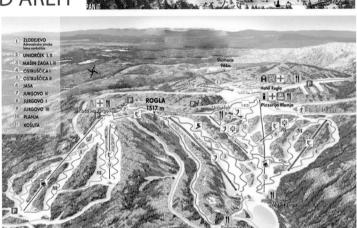

is higher so there's better snow and no snowmaking necessary, unfortunately there's only a few drag-lifts. Pohorje on the opposite has excessive snow-making, longer runs, the gondola and chair lifts, night riding, and it takes you down all the way to the city.

There's no pipe and the park consists of two hits, which are too icy to be fun. There are some rollers and the catwalks give you something to jump off, but nothing really big. Although this is not a place for advanced riders, it's perfectly okay for beginners and slow intermediate carvers. The hotel Bellevue, in the middle of the resort, is now a youth hostel costing from 2.000 sit a night but you'll need to reserve in advance.

Rogla is 25 miles from Ljubljana, Slovenia's capital and is easy to reach by car, taking the E59 highway, exit at Slov.Konjice, from there on you just follow the signs to the summit. Although Rogla recently hosted the Youth Snowboard World Championships, this is a very flat resort and not at all challenging. It's laid back and a family hang-out with only a few steep runs which still don't make it worth spending a whole day here. What does

make you want to come back though is the excellent good and cheap pizza place at the summit and the chance to go snowmobiling. You can rent snowmobiles for an hour or all day and go on tour with some friendly guides even at night which adds a special thrill.

Tiny beginners resort, only 35km from capital city. It only has one chair and 5 drags, it's also very low so the seasons short, but if you fancy a night board and you're in Ljubljana give it a go

BOSNIA HERZEGOVINA

BJELASNICA

the main resort, is a 20 minutes drive from Sarajevo. This is where the men's downhill, slalom and giant slalom were held in the 1984 Winter Olympics. The resort has loads of trees up to 1500 metres with the resort summit just over 2000 metres. Things are pretty basic here, as Sarajevo was under siege in the 1990's, and foreign investment is slow to stretch to the winter resorts.

INGMAN

is low in altitude at 1500 metres but can still boast the lowest ever temperature in the region of -43. Thanks to this, Ingman still gets an average snowfall which is enough for them to host the strange Olympic sport of wearing lycra and shooting at little round targets. Ingman is located south west of the Capital and is worth a visit if you're in the area.

TREBEVIO

is known more for fighting over the last decade than boarding. It is higher than it's neighbour Ingman, and offers some fun at 1630 metres. Trebevic hosted the Olympic bob sled in 1984 but due to its vantage point over the surrounding area, in the 1990s it instead hosted a lot of fighting. Although most of the land mines have thankfully been cleared, the infrastructure is still a long way off western European resorts. However, like Ingman, if you're in the area check it out.

CROATIA

SLJEME MOUNTAIN

Resort Sljeme Mountain Medvednica (1035 metres) has 6 runs, 4.5km of slopes, snow making and night boarding. A 1 day pass costs 70,00kn (about £7), lt's close to the capital Zagreb and is linked by a good road. Currency: Kuna 10 / £1

ROMANIA

POIANA BRASOV

was Founded in 1895, is part of the Carpathian range which spreads all over Eastern Europe. It first served as a tourist district for Brasov and the first construction there was in 1904, then in 1909 it hosted its first Romanian ski contest.

It is a small resort with just 9 miles of marked out terrain offering some limited advanced carving on the Valea Lupului trail to basic freeriding through trees up on the Postavarul area. Although the slopes are not noted for having long lift queues, some of the runs can be very busy, especially the beginner areas. Freestylers will have to make do with getting air by building hits and then hiking them as there is no halfpipe here or any good natural kickers.

Runs: 10 (12km of pistes) Longest 2.3km 34% EASY 34% INTERMEDIATE 33% ADVANCED

Lifts: 11 - 3 cable-cars, 8 drags

Board School: yes, 120 instructors. English spoken

Contact: www.poiana-brasov.com

Location: 13km from town of Brasov. Fly to Bucharest, 168km or 3 hours by car from resort.

Off the slopes the purpose built resort is suitable for a few days of hanging out with a few cheap hotels and lots of cheap night-life. There are a some night clubs here and lots of...erm..."Gentleman's Bars," if you know what I mean!

SERBIA KOPAONIK

1770M TO 2017M

Located on Mt Kopaonik, which is the biggest mountain of the central Serbia is the resort of the same name, which is the largest in the area. The most recent claim to fame is that NATO fired cruise missiles at transmitters on Mt Kopaonik in March 1999.

Runs: 23. 20% beginners,70% intermediate,10% advanced

Total runs 44km. Longest run: 3.5 km

Lifts: 22 lifts - 8 chairs, 14 drag

Getting there: 275 km from Belgrade 3hrs flight from London

UKRAINF

This is another ex-Soviet state to have a revolution in 2005, albeit a peaceful one. The streets of Kiev were full of protestors for weeks until a second election was held and the crowd got the result it wanted. So, if people needed to protest for a new government and industrial investment, you can imagine what the mountain resorts are like. Most were built in the 70's and need investment as does the hire kit, so bring you own.

BUKOVF

has seen some investment of late and has plans for more. It also claims to be the Country's up and coming resort. Theres 10 pistes served by 5 lifts, including one black run

www.bukovel.com

DRAGOBRAI

near the Romanian boarder has 2 longer lifts and a few short ones and claims the highest slopes in the country at 1400 metres

in the Carpathian Mountains to the west of the county near Poland, is a popular resort with the locals. Varied terrain on Mt Trostyan is between 900-1250metres.

near the resort of Slavsko, is a smaller resort that is ok for beginners. Other resorts to note are Yaremcha and Slavske.

Photo: Stefan Tordenmalm Landscape, The castle Swallow's Nest near Yalta, Ukraine

NORTH AMERICA

Canada USA

297 337

CANADA

Canada holds an almost mystical pull for the snowboarder. Masses of resorts, around 270, meters of annual snow fall and both natural and man made terrain that's the envy of many a European resort director. The best resorts are in the west of the country, in Alberta and British Columbia with the others being in the east and a few in the central states. A lot of money has been pumped into many of the western resorts, both on and off the slopes. Trees are being felled and pistes, flats and hotels are taking their place. This isn't as bad as it sounds as Canada's not short of trees and mostly the developments being done in good taste.

The two things that you'll notice in Canada, as apposed to Europe, is there's no lift gueues and if there are they are polite and organised; a stark contrast to having a badly dressed skier stomping all over your new board. The second thing is the off piste. In some resorts ski patrol can arrested if you go out of bounds or at least take your pass away. But within a resorts boundary there are huge areas of untouched snow, in other words monitored off piste areas.

The eastern resorts are similar to the east coast US resorts; cold, low and with plenty of trees. While the Western resorts have a little more altitude, but still with plenty of great tree runs. Vancouver, Calgary and Toronto are the main international airports. Many resorts have much closer domestic airports, so to avoid a long transfer search out the local ones.

Canadians treat their visitors with respect and provide a very high level of resort services. There are good slope facilities in most places, along with an abundance of places to eat and sleep close to the slopes. Prices are generally higher than those in the US but lower than in Europe. Canadians also like a beer and a good night out, so expect to party hard.

If you're not on a package deal the only real way to get around is with a car. Petrol's cheap but the speeding fines aren't. Greyhound busses are an option as is the

CAPITAL CITY: Ottawa POPULATION: 33 million HIGHEST PEAK: Mt Logan 6050m LANGUAGE: English & French

LEGAL DRINK AGE: 18/19

DRUG LAWS: Cannabis is illegal but attitudes are very

AGE OF CONSENT: 16

ELECTRICITY: 110 Volts AC 2-pin INTERNATIONAL DIALING CODE: +1

CURRENCY: Canadian Dollar (CAD)

EXCHANGE RATE: UK£1 = 2.1, EURO = 1.4, US\$1 = 1.1

CANADIAN SKI AND SNOWBOARD ASSOCIATION

Suite 200, 505 8th Avenue S.W. Calgary, AB T2P 1G2 Tel: (403) 265-8615 www.canadaskiandsnowboard.net

DRIVING GUIDE Drive on the right hand side of the road SPEED LIMITS: Motorways-100kph (62mph) Highways-90kph (55mph), Towns-50kph (31mph)

EMERGENCY 911 for police/ambulance/fire TOLLS Some tunnels & a few roads

DOCUMENTATION Must carry drivers license INFO Driver & Passengers must wear seatbelts. Frequent drink driving checks in place, and its illegal to have an opened alcohol container in your vehicle.

TIME ZONE 6 time zones in Canada, GMT+4 to +8

Accommodation facilities in Canada include condos and high quality hotels, as well as B&B's, lodges, hostels or dorms. Prices vary from place to place and are generally very high in resort. If you have a car you can stay in a nearby town for much less. Entry into Canada is liberal but you will need a passport and be advised, you can't work in Canada without a work permit as rules are strict. If you get caught scrubbing dishes in a hotel without the correct paper work, you'll soon be on your way home. If you wish to teach snowboarding in Canada, you will need the Canadian Association of Snowboard Instructors (C.A.S.I.) Level 1 certificate. contact C.A.S.I. on 001-514 748 2648 or visit www.casi-bc.com

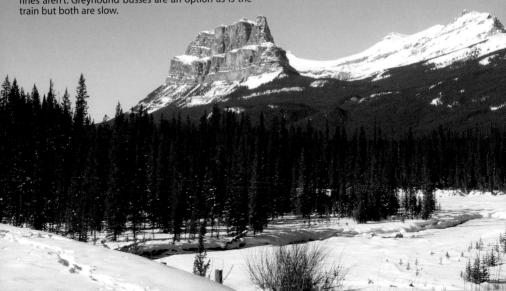

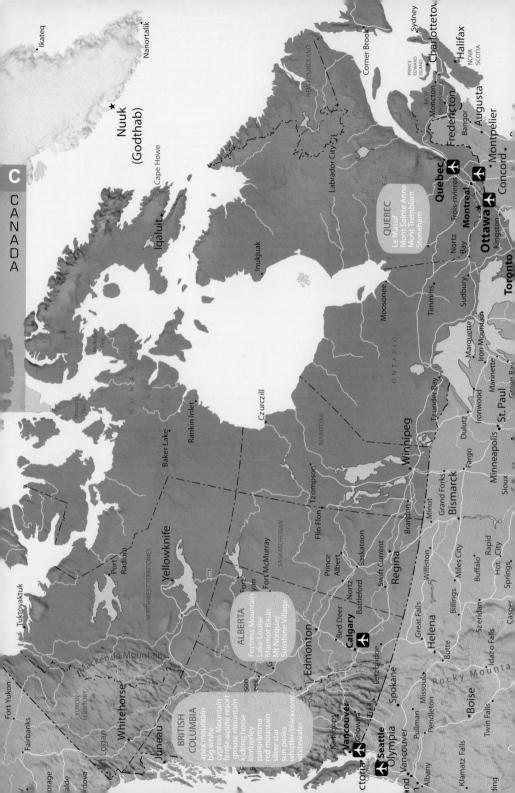

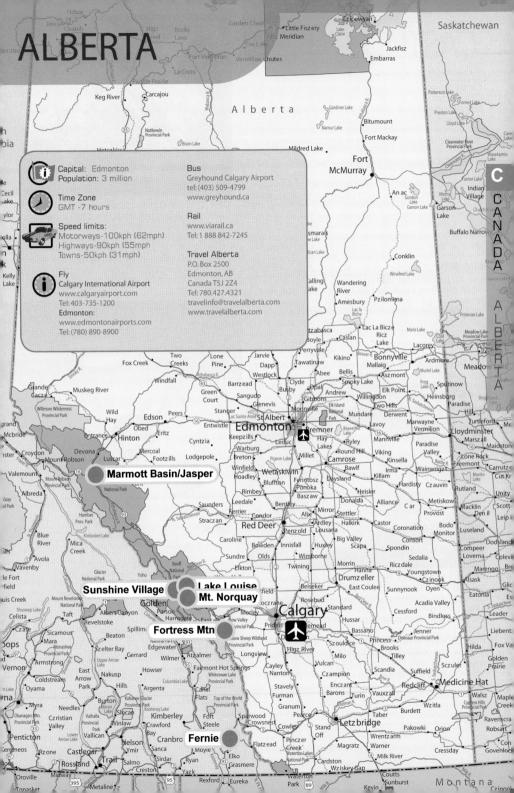

CASTLE MTN 8 OUT OF 10

What it's all about

Castle Mountain was saved from bankruptcy by a group of local families, and if I knew where they all lived I'd pop round and give them all a pat on the back. This tiny resort, only 2 ½ hours from Calgary, is rough. The car parks potholed the chair lifts will snap your legs in half if you don't time it right, there's only one pub, only one place to stay and there's only one thing to do, Snowboard. Castle is the kind of place where snowboarders who are pissed off with overcrowded and overpriced resorts dream of. If you're in the area and it's just snowed get in your car and head to Castle. Having said that however, development work has begun on **Haig Ridge** to add 6 new beginner & intermediate pistes, and the whole resort is set to benefit from some tlc over the next couple of years. In typical fashion though there'll be no fancy golf courses or heated seats, as they strive to keep things small and friendly.

FREERIDE. Castle has two main lifts which slowly take you to the Skyline Traverse; from here it's up to you. Right or left as far as you fancy then just drop into the powder. To the right you will find mostly steep tree areas with a few open easier descents like North Bowl. To the left is more of the same although the trees are wider spaced. Keep going left as far as you can and you pass through a wooden gate adorned with a hangman's noose. Beyond the gate is an area of Chutes with names like **Desperado** and **Lone Star**, all the chutes are steep and great for flying down at full speed, you have to take the **Cinch Traverse** back to the lifts, but the descents worth every meter of the traverse.

FREESTYLE. There's no park here and nor should there be. This is a freeride resort with enough natural hits to keep even the most park bound rider happy. In the Chutes there are loads of rock drops and if you look in the trees you'll find plenty of logs to side on.

PISTES. Some of the pistes are groomed but Castles not really about groomed runs. If you want to lay it over on hard packed pistes then head for Panorama and leave Castle to the powder hounds.

BEGINNERS. Complete beginners will save money on an expensive pass but may find the resort a little short on easy slopes. Second and third weekers will love it as it will push their riding to the limit. Watch you don't head too far into the trees or you may find yourself looking a little closer at the pines than you would have hoped.

OFF THE SLOPES. What town? The nearest town is **Pitcher Creek** which does has a few guest houses but no real life. The resort has a hostel which is fine; it has dorm and private rooms and is cheap at \$25/night www.castlemountainskilodge. com . There's a day centre offering great breakfasts and lunches, and there's the T-bar pub offering beer and pizza. It's a well laid back place, just like the whole resort.

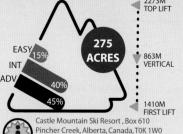

TEL: (403)627-5101

EMAIL: info@castlemountainresort.com WEB: www.castlemountainresort.com

BOARD SCHOOL Private lesson \$45 per hour Group lesson \$30 2hrs. Full day inc rental, lift pass & 2hr lesson \$91 RENTAL Board & Boots \$35 per day

NUMBER OF PISTES/TRAILS: 67 LONGEST RUN: 5km TOTAL LIFTS: 6 - 3 chairs, 3 drags

ANNUAL SNOWFALL: Unknown SNOWMAKING: none

CAR From Calgary take the Highway 22 towards Burmis, pick up the 774 to Beaver Mines then onto Castle FLY Calgary - 2-1/2 hours away.

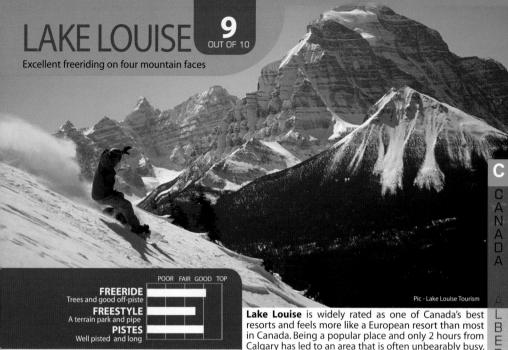

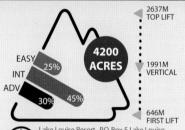

Lake Louise Resort, P.O. Box 5 Lake Louise Alberta. T01 1EO

TEL::001 (800) 258 7669 SNOWPHONE:001 (403) 244 6665

WEB:www.skilouise.com EMAIL:info@skilouise.com

WINTER PERIOD: Nov to May

LIFT PASSES 1 day lift pass: \$60 CDN

5-day pass: \$290 CDN, 7-day pass: \$406, Season Pass: \$729 BOARD SCHOOLS 2.5 hours group \$59,5.5hrs group \$89 HIRE board and boots \$39/day

NIGHT BOARDING No

HELIBOARDING full day 3 to 5 drops \$700, 20 Dec- 15 Apr

NUMBER OF PISTES/TRAILS: 51

LONGEST RUN: 8km TOTAL LIFTS: 10 - 1 Gondola, 8 chairs, 1 drag LIFT CAPACITY (PEOPLE/HOUR): 19,000

MOUNTAIN CAFES: 3

ANNUAL SNOWFALL: 3.8m SNOWMAKING: 40% of trails

CAR Calgary via Canmore/Banff. Lake Louise is 115 miles (185km). Drive time is about 2 1/4 hours.

FLY to Calgary International. Transfer time to resort is 2 1/4 hours.

BUS from Calgary takes 2 1/4 hours. Info: (403) 762 6700, a return is \$99, and buses run every other hour. A local shuttle bus runs daily to Lake Louise from Banff.

Lake Louise is widely rated as one of Canada's best resorts and feels more like a European resort than most in Canada. Being a popular place and only 2 hours from Calgary has led to an area that is often unbearably busy, both on the slopes and around town. In the past year or two, the resort has endeavoured to address this with a lot off changes on the slopes including the inclusion of the new Glacier Triple Chair and the Grizzly Express Gondola which both start from the base area. The resort has also done much to improve the slopes with extra piste groomers and a Super Pipe Grinder.

The terrain on offer here is spread out over four mountain faces, Front Side/South Face, the Ptarmigan, Paradise and Back Bowls and the Larch area that collectively provide slopes to suit all levels and styles of rider. The well-connected lift system includes a high speed quad that can whisk you to The Top of the World in under ten minutes, from where you can access the Back Bowls with unlimited long tree-lined powder runs lying in wait at every turn, and with new runs and lifts planned for the Wolvern and Richardsons Ridge areas, there's always new ground to explore. Lake Louise is also located close to the smaller resorts of Sunshine and Mt Norquay with all three sharing a joint lift pass.

FREERIDERS should note that it is illegal to ride in the marked out avalanche danger areas. If you're caught expect to be ejected from the hill with your pass confiscated, and even prosecuted. However, if you have the balls and fancy some out of bounds, the Purple Bowl in the Larch Area is a mega place to check out, offering a mixture of extreme and easy terrain. If you don't mind a knee-deep hike, trek up to the double black at Elevator Shaft where you'll find a host of black runs, cornice drops and rock jumps to try out. For those looking for easy to access powder, drop into the back bowls of the Summit Plater lift, the steep blacks here will test the best, but be warned: don't go outside the marked boundary into the West Bowl unless you know what you are doing.

FREESTYLERS have a superb fun park known as the

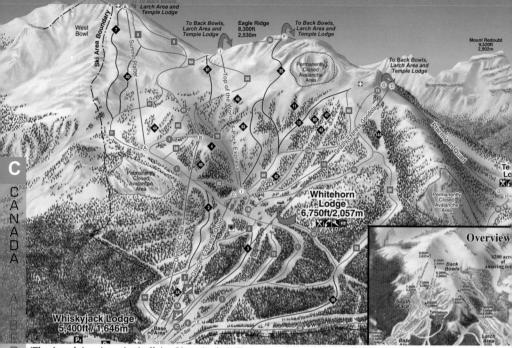

'The Jungle' and reached off the Olympic chair. First you hit the pipe and then ride through some well spaced rails before entering the jump area which has loads of options, some huge hits, a little closely placed together, which leads you back to the base area. For the complete freestyle novice there is a baby park above the magic carpet to the right of the base area. It's hidden enough that not to many people will laugh at you fall flat on your face.

PISTES.Corduroy lovers can opt to weave down a large number of well groomed pistes or try out. For a long easy run on the front side of the South facing slopes, turn a hard right off number 14 onto number 39 and have it down a well quite piste which, at 8 kms, is the longest run in the area. Alternatively, for less crowded riding, check out the Larch area.

BEGINNERS will find Louise a particularly good place to start out, with a host of easy to reach runs starting at the base area. The runs off Eagle chair are the best and allow you to have a long cruise home down trails such as 14 and 1, which are also in a speed restricted area. The Lake Louise Snowboard School is excellent and offers loads of beginner to advanced programmes. As learning at all big resorts if it's your first week you may find that you are paying top \$ for a large resort and only seeing a small part of it.

OFF THE SLOPES. Lake Louise's holiday complex is located a five minutes drive from the slopes and can be reached by local shuttle bus. The village, which is dominated by the *Chateau Lake Louise* has a good selection of local facilities and caters well for dot. com millionaires but not for budget conscious snow-boarders. The truth is, Lake Louise has become far too overcrowded with holiday punters and charges excessive prices for everything. Many visitors prefer to stay in **Banff** which is 45min drive but the free bus **302** WSQ WWW.WORLDSNOWBOARDGUIDE.COM

can be mobbed and can take over an hour.

NIGHTLIFE. Evenings in Louise are simply lame although *Charlie's* or *The Grill* are good for a beer and a game of pool.

ACCOMMODATION in Lake Louise is very expensive with a number of classy hotels and lodges to choose from. Self catering is also possible with some reasonable deals available for groups. If you have the cash, the Post Hotel is excellent.

FOOD. Around Lake Louise the choice of restaurants is excellent, but very pricey; The Chateau is criminally so. The licensed cafe at the youth hostel has the best value food.

BANFF Banff is loaded with accommodation, shops, bars and places to hang out. Hotels can be expensive but there are cheap alternatives, including the two youth hostels that costs from C\$20/night. The Blue Mountain has nightly rates from \$55 for B&B. The High Country Inn has rooms from \$75 a night

The Hard Rock Cafe sells good cheap food, while Bumper's has the biggest steaks you've ever seen. The licensed cafe at the youth hostel has the best value food. Alternatively there is a KFC, a McDonalds, etc. if you strive originality.

Night-life is what you make it, and most of the bars have pool tables and play loud music. The *Rose and Crown* is an English-style joint and worth a visit. Most of the pubs and bars have drink promotions on during the week so you can always find somewhere cheap to get smashed before you head off to one of the two local nightclubs that are usually packed out from 12am till closing at 2.30am most nights.

D

MARMOT BASIN

Great freeriding mountain

Marmot Basin, sometimes incorrectly called Jasper which is actually the local town, is an absolute gem of a resort and highly rated by those in the know. Just driving to this place through Jasper National Park in the Rockies is a pleasure in itself with some stunning scenery en-route. Marmot is a resort that attracts snowboard-

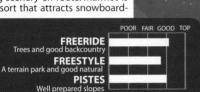

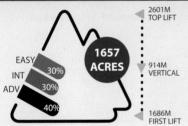

Marmot Basin, Box 1300 Jasper, Alberta, Canada, TOE 1E0 TEL: 1-(780)-852-3816

WEB:www.skimarmot.com EMAIL:info@skimarmot.com

WINTER PERIOD: late Nov to end April/May LIFT PASSES Half-day \$47.17, 1Day \$58.5 CDN (\$42.46 mid-end Jan). 3 Days \$171.70 CDN, Season Pass \$829

BOARD SCHOOLS \$69.00 CDN inc 2 hour beginners lesson, day pass & board. 2hr Group \$46.00 CDN

HIRE board and boots \$33.64/day

SNOWMOBILES Snow Farmers is a skidoo-ski operation about an hour west of Jasper

HELIBOARDING Wiegele's HeliSki, CMH, & Robson Helimagic all operate within 1-2 hrs drive of Jasper, on the BC side of the border.

NUMBER OF PISTES/TRAILS: 84

LONGEST RUN: 5.6km

TOTAL LIFTS: 9 - 6 chairs, 2 drags, 1 magic carpet

LIFT TIMES: 9.00am to 4.30pm

LIFT CAPACITY (PEOPLE/HOUR): 11,931

MOUNTAIN CAFES: 3

ANNUAL SNOWFALL: 4m **SNOWMAKING: 10%**

CAR Edmonton via Jasper. Marmot Basin is 270 miles. Drive time is about 4 1/2 hours.

FLY to Edmonton International, transfer time to resort is 4 1/2 hours. Local airport is Hinton 38 miles.

BUS A daily bus service run by Greyhound, operates 4 times a day from Edmonton to Jasper and takes around 5 hours.

TRAIN run direct into Jasper

NEW FOR 2006/7: \$1.8 million being spent on snowmaking on the lower part of the mountain covering 6 main runs.

ers and skiers who like their slopes hassle-free and despite being a popular haunt, no one spends more than a few minutes queuing in lift lines, the lifts here can shift over 10,000 people an hour uphill.

Recently Marmot, has opened up even more terrain with two new mountain faces known as the Eagle Ridge which provide a further 20 runs of steep double black diamond slopes and intermediate trails. Overall the terrain here is evenly split between all levels and styles of riding, with good backcountry areas to explore, nice bowls and trees to dip into and fast carving slopes.

FREERIDERS looking for powder should check out **Eagle East** where the bowls are full on. This area is avoided by the vast majority of punters, so the snow stays for days after a storm. The area is covered in trees but they are well spaced so you can let rip. Take the Kiefer T-Bar or the Paradise Chair to check out Caribou Ridge which offers an abundance of testing terrain with bumps and hits for both the freerider and freestyler. Intermediates who know what they are doing will also like this area and can ride most of the mountain one way or another. If you have the energy, advanced freeriders can hike up to Marmot Peak which yields an amazing ride down through powder bowls. The trees in the lower sections are pretty cool, but if you have the balls, check out **Knob Bowl** off Knob Chair for a taste of heaven.

FREESTYLERS have plenty of good natural terrain for catching air, but check out **Rock Garden** for some of the best hits. There are lots of trees here and if you look out, you will find the odd log to slide. You wouldn't come to Marmot just to ride the Terrain Park, however it's still fun. There's a couple of table tops, rails and a quarter pipe but nothing too scary. Here, grommets can catch air all day without bothering anyone else.

PISTE lovers have some good opportunities to lay out nice, big arcs on the kind of prepared piste that carvers delight in. For some demanding riding, Exhibition is the place to visit, while the more sedate rider will like Dromedary trail.

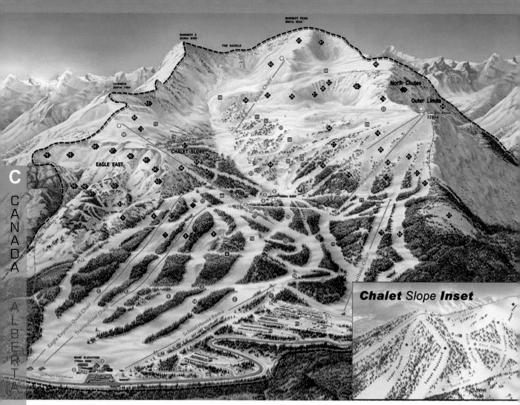

BEGINNERS will note one clear thing about Marmot Basin and that is how good it is for cutting their first tracks. The slopes are accessible with the easy stuff at the bottom and some good progression runs found higher up, which allows for long and gentle riding back to base. What's more, novices can get around the slopes without having to use any T-bars thanks to the way the chair lifts have been set out. Snowboard instruction services are good with a number of tuition packages available for all levels and styles of riding. There are even lessons available with video analysis to quicken your progression. A two hour group lesson costs from C\$50 with lift pass and full equipment hire.

OFF THE SLOPES

Marmot Basin doesn't offer any slopeside accommodation or full local services other than the new *Caribou Chalet* at the base of the slopes. However, the town of **Jasper** is only 10 miles away and although it isn't as big as its more famous cousin Banff, Jasper is less crowded and you shouldn't have any problem finding good quality lodging at prices to suit all. There is a regular ski bus that runs all day stopping at many of the hotels en-route from Jasper to the slopes.

NIGHT-LIFE in Jasper is best described as very low key and a bit boring. *Pete's Bar* seems to be the inplace to check out, where you can mix with a lively crowd boozing and playing pool. The *Whistle Stop* is also a cool hang out with pool and on screen sports

action. O'Shea's is a typical Irish pub, while the Atha-Bar is the place for live music and a dance

ACCOMMODATION in Jasper ranges from the usual selection of lodge-style hotels to B&B's or hostels which are widely spread out. Places like The *Amethyst Lodge* offer a selection of well equipped rooms with rates from C\$75/night per room, while *The Astoria*, located in central Jasper, has winter rates from C\$104/night per room. *The Marmot Lodge*, also centrally located, offers self catering style accommodation for groups or couples as well as having an indoor swimming pool and fitness centre.

EATING options in Jasper are much the same as in any of Alberta's towns. If you want a slap up feast, then dine at the expensive *Edith Cavell*, or the *Tonquin Rib Village* where you can get a damn fine steak. If you like pizza, then visit *Papa George*'s or *Jasper Pizza Place*. If you are in need of a fast food fix there's also a Pizza Hut, McDonald's and KFC.

SUMMARY. Great freeriding mountain with excellent challenging runs on crowed free slopes. However, the resort is let down by the lack of slope side facilities, although what is on offer in Jasper is first class.

MT.NORQUAY

Uncrowded varied slopes

Mount Norquay is the nearest boarding area to **Banff** and offers some great riding, including good night riding and flexible ticket options, such as hourly rates and a terrain park ticket. Norquay is a ten minute bus ride from Banff. With only 5 lifts it is the smallest resort in the area, but it's not without a lot of varied terrain to ride in fact some of the steepest in the area. Locals claim the terrain either side of the North American chair is superb after a heavy dump. Norquay often has the quietest slopes for miles around, people always head straight to the crowded slopes of Lake Louise and Sunshine

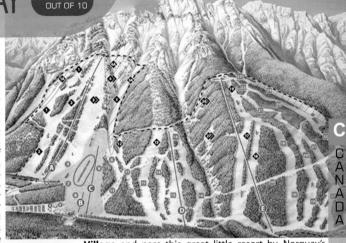

FREERIDE
Trees but no backcountry
FREESTYLE
A terrain park and halfpipe
PISTES
Short but well groomed

EASY 20% ACRES 503M VERTICAL ADV 36% 1636M FIRST LIFT

Mt Norquay, P.O. Box 1520 Banff, Alberta, Canada, T1L 1B4 **TEL**: (403) 762-4421

WEB: www.banffnorquay.com EMAIL:info@banffnorquay.com

WINTER PERIOD: Dec to April LIFT PASSES 1/2 Day \$41,1 Day pass \$52 5 Days \$221, Night \$24 NIGHT BOARDING fridays 5pm till 11pm

NUMBER OF PISTES/TRAILS: 28 LONGEST RUN: 1.16 miles TOTAL LIFTS: 5 - 4 chairs, 1 magic carpet

ANNUAL SNOWFALL: 3m SNOWMAKING: 85% of pistes

BUS services direct from Calgary & Edmonton via Banff. FLY to Calgary 1 1/2 hours transfer to Mount Norquay. DRIVE From Calgary, via Highway 1 head towards Banff via Canmore.Mt Norquay lies north of Banff and south of Lake Louise alongthe Norquay road. Calgary to resort is 68 miles.

Village and pass this great little resort by. Norquay's night riding is on Fridays 5pm till 11pm a night ride ticket costs \$24

FREERIDERS should take the high speed Mystic Express lift to ride the best boarding area on the mountain. It gives you access to six long blue runs through the trees, with Imp and Knight Flight being favourites. There are some steeper options from this lift, like Black Magic, and the interestingly named Ka-Poof, which can either be great after a heavy fall of snow, or awful with icy hardpack late in the season. For the real steep stuff take the North American chair and have it down the Gun Run, but make sure you know what you're doing or you maybe spending more time in Banff then on the hill.

FREESTYLERS have a good halfpipe and fun-park, both of which are shaped by the Rockies first magician Pipe Grinder. Next to the pipe is a full on fun-park with all types of hits, including a massive quarter-pipe, gap jumps and table-tops. The great thing is that it's nearly always deserted. A discounted lift pass is available for riders using the park via the Cascade lift at just \$33.

PISTES. Most of the pistes of Norquay are well groomed, and although not particularly long, they are great for having it down at high speed and as the rest of the resort often empty. The easy flats of the Spirit Quad chair is the place to head first before cranking it down Excalibur, a decent black run off the Mystic Quad.

BEGINNERS have very easy access to tame pistes from the base station. The green runs next to the Cascade chair are a great place to learn some linked turns. There's also a great little fenced area for complete beginners with a long magic carpet right at the base area.

OFF THE SLOPES. There are no local facilities at Norquay apart from Timberline Inn at the bottom of the ride-out (tel: (403) 762 2281). *The Timberline Inn* has a bar and restaurant with nightly rates from \$88 for a single. **Banff** is the better option; here you'll find all the local services that you could possibly want. Banff is only ten minutes away and is served by a regular bus that runs seven days a week to and from the slopes.

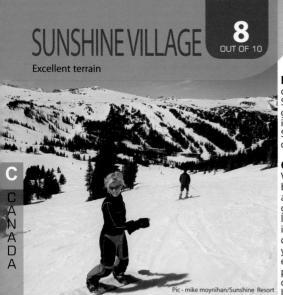

Sunshine and Goat's Eye Mountain are amongst the oldest resorts in Alberta and are the best places in the Banff area for deep snow. The area receives serious amounts of snowfall every year and is a good alternative to its neighbour, Lake Louise. From the car park the high speed 8 man Gondola takes you up to the Sunshine Village base area and offers you the chance to get out at Goat's Eye Mountain, which is where most of the hard core riding is, including some severely steep, double black diamond runs such as The Wild Side, Hell's Kitchen and Freefall. Two areas are accessed form Sunshine Village; Mt Standish and Lookout Mountain most of the runs on Mt Standish are annoyingly short especially when the resorts busy. Lookout Mountain has longer runs, the park and also the resorts highlight Delirium Dive great but for nutters only.

FREERIDERS with experience will head straight for **Delirium Dive** a short walk off the Continental Divide chair, this area is roped off and you access it through a little gate which only opens if you're wearing a Transceiver. What a great idea it keeps all those twats who know shit all about backcountry boarding out. The Dive is a steep open powder face with some insane shoots and drop offs at the top, it's a must. Away from the Dive, the best and most challenging areas can be found on Goat's Eye Mountain. On Lookout steep runs through the trees to check out include Little Angel, Ecstasy and Horot's Revenge where you may find powder. From the Wawa chair you can ride down a frozen waterfall on the aptly named Waterfall run.

FREESTYLERS have the usual offerings, but those who don't dig freeride and just want to ride the park should head to Lake Louise. There's a cool halfpipe under the Strawberry chair and a sizeable terrain park reached from the Continental Divide chair. You can also pull some big air and spin until you're dizzy, on the natural hits dotted all over the place. For a great drop off hit the entrance to the Head Wall run with speed.

PISTES. There's an array of pistes to have it down at speed, you will find lots of groomed runs to tackle all over resort, the best of which are on Lookout Mountain. With

306 USQ WWW.WORLDSNOWBOARDGUIDE.COM

a chose of lazy green down to the day lodge or some well maintained steeper blacks under the Angel Quad. You can also find some okay cruising trails on Sunshine Coast and Wild Fire, but make sure you have plenty of speed for the long traverse back to the lift station.

BEGINNERS and intermediate riders are well catered for on runs that include The Red 90. South Divide and Green Run. The Wawa chair gives access to some excellent novice freeriding, although short. The Dell Valley run off the Strawberry chair has some great banks to slow you down when trying to link those first few turns.

OFF THE SLOPES. You can stay in Sunshine Village, at the Sunshine Inn which is accessed only by the Gondola, offering the only ride-in, ride-out accommodation in the Banff area. The hotel has a great fire place to relax at, but there's no real night life although the Old Sunshine Lodge can kick off if it's the staff's payday. It's not cheap, although they do offer some good midweek deals, but remember you do get first tracks everyday while everyone else is waiting for the Gondola down at the car park. The cheaper option is to stay in Banff. It's only 15mins away along Route 93 and a regular local bus services operates to Sunshine.

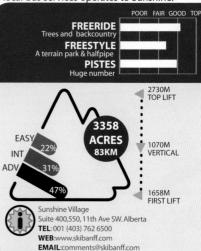

WINTER PERIOD: Nov to May LIFT PASSES Half-day pass \$53.27 CDN

1 Day pass - \$64.95 CDN, 5 of 7 day pass \$310.75 CDN BOARD SCHOOL Beginner lesson inc lift, rental & lesson. 1 day

\$130.84, 2/\$252, 3/\$350.47 Group full day \$116.82, Private full day (6rs) \$500 HIRE Board and Boots \$33.50/day. 5 Days \$137.35

NUMBER OF PISTES/TRAILS: 107 LONGEST RUN: 8km

TOTAL LIFTS: 12 - 1 Gondola, 9 chairs, 2 magic carpets LIFT CAPACITY (PEOPLE PER HOUR) 20,000 **MOUNTAIN CAFES:5**

ANNUAL SNOWFALL: 9m

BUS services direct from Calgary & Edmonton via Banff. FLY to Calgary, with a one hour transfer to Sunshine Village

DRIVE From Calgary, via Highway 1 head towards Banff via Canmore. Sunshine lies north of Banff and south of Lake Louise. Calgary to resort is 70 miles.

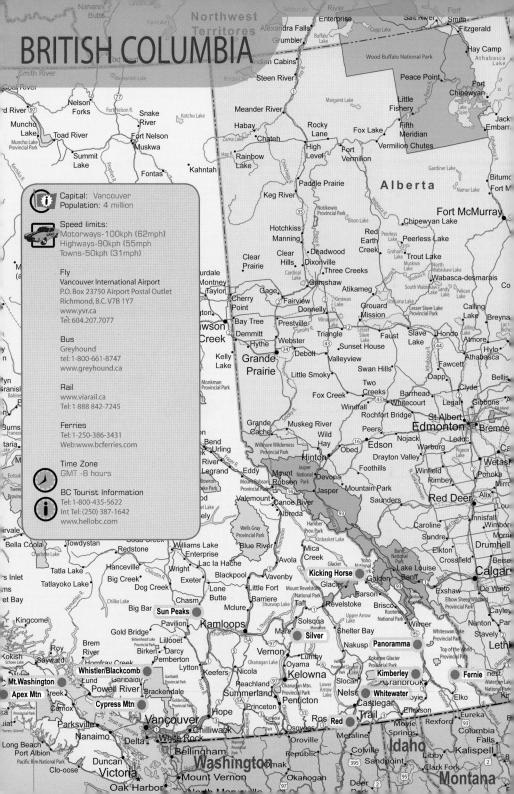

APEX MTN

Great riding

Apex Mountain may be a small resort, but with it's down-toearth atmosphere and great riding opportunities, it's no wonder that Apex is a popular place. Located in the Okanagan sunny Valley, Apex is known for its great natural terrain: bowls, gullies, glades and groomed cruising runs radiate from the rounded top of the resort's main peak, Mt Beaconsfield. If you're a novice or

POOR FAIR GOOD TOP **FREERIDE** Trees and some off-piste **FREESTYLE** A terrain park

intermediate, head for the wide boulevards off the Stocks Triple chair, where you'll find half a dozen nicely graded, rolling descents. Notice how the trail names evoke the area's mining history - Motherlode, Gambit and Sluice Box.

FREERIDERS looking for some decidedly 'darker blue' cruising should head on up to Mt Beaconsfield and try Ridge Run and Juniper where a search for more challenging terrain won't take long. Alternatively, check out the whole series of wicked runs plunging down Apex's North Side. Wind your way through the woods and, if you dare, peer down Gunbarrel, a chute that's just 'one turn wide, and drops straight down the fall-line for 366 double black diamond vertical metres (1,200 ft).

FREESTYLERS. There is a terrain park with a quarterpipe and and various rails on the Claim Jumperrun. With a bit of hunting you'll find some good natural gullies and hits on Mt Beaconsfield.

PISTES. Riders will fair well on Apex's short, but challenging trails. There are enough steep blacks for the advanced alpine rider to carve, while the novice can practice on some nice, flat blues.

BEGINNERS should find that Apex allows for an easy time, as in general, this is a good mountain to learn on and allows for quick progression. Grandfather's Trail is a nice green that allows you to ride from the summit to the base with ease. The local snowboard school offers various learn to ride packages with a one day lesson, lift and full hire costing form C\$57 per person.

OFF THE SLOPES

The New Inn at Apex offers ride-in accommodation and some good value bed and lift ticket deals, from C\$60/night mid-week. If you're planning on staying a while there are apartments available to rent, otherwise there are plenty of beds in the town of Penticton, forty minutes away. When the sun goes down on Apex Mountain, The Gunbarrel Saloon is the main place to eat and enjoy all sorts of entertainment. Other good food haunts are The Rusty Spur and Longshot Bar.

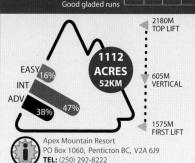

PISTES

WINTER PERIOD: Dec to April LIFT PASSES Half day \$38, 1 Day pass - \$53 5 Day pass - \$245, Season pass - \$649

BOARD SCHOOL Group \$60 for 3 hours Private \$65 for 1hr, all day (4rs) \$165

WEB:www.apexresort.com

EMAIL:info@apexresort.com

HIRE \$38/day additional days \$29 NIGHT BOARDING 4:30pm to 9:00pm, Fridays & Saturdays. Price \$12

NUMBER OF PISTES.TRAILS: 67

LONGEST RUN: 5km TOTAL LIFTS: 5 - 2 chairs, 1 t-bar, 1 platter tow, 1 tube tow LIFT CAPACITY (PEOPLE PER HOUR) 8700

LIFT TIMES: 9:00am to 3:30pm

ANNUAL SNOWFALL: 6m SNOWMAKING: 40% of pistes

BUS services direct from Vancouver takes around 5 hours. Bus Transfers from Penticton & Kelowna airports available tel: (250) 492 5555

FLY to Vancouver, 4 1/2hrs away. Domestic transfers possible to Penticon airport, 35min drive away. Kelowna airport 90mins from resort.

DRIVE From Vancouver, take highway 1 at Hope join Highway 3 to Keremeos, take highway 3A for 11.5 km take Green Mountain Rd for another 14km and take Apex Mountain Rd for further 11km to Apex village. About 4 1/2hrs drive

Big White! Where? Big White is the worlds best big unknown resort; it's a giant skate park covered in snow and trees. Recently bought by an Australian family along with Silver Star, they don't seem to be afraid to spend some cash, \$125 million last year with \$4 million on the Telus terrain park alone. Snowboarders in search of good mountains have been cruelly misled by the world's slack ski press for years and Big White is a prime example.

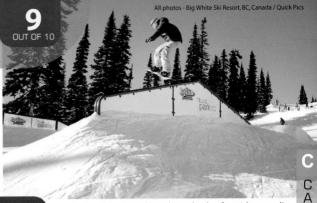

POOR FAIR GOOD TOP **FREERIDE** Trees and good backcountry **FREESTYLE** Impressive parks & pipes **PISTES** Well prepared slopes

2319M TOP LIFT 2765 CRES 777M VERTICAL 1755M FIRST LIFT

Big White resort, PO Box 2039 Stn. R Kelowna B.C. Canada, V1X4K5 TEL: (250) 765-3101

WEB:www.bigwhite.com EMAIL:bigwhite@bigwhite.com

WINTER PERIOD: late Nov to mid April LIFT PASSES Half-day \$50, Day pass \$65 Day pass inc nightboarding \$70 5 of 6 Days \$297, Season pass \$999

BOARD SCHOOLS 2hr Group \$42, Private 2 Hours \$157

HIRE Board & Boots, 1 day \$36 additional days \$27

SNOWMOBILES 1 to 4 hour tours

NIGHT RIDING 5:00 pm - 8:00 pm Tuesday to Saturday free with any multi-day pass otherwise \$24

NUMBER OF PISTES/TRAILS: 118

LONGEST RUN: 7.2km

TOTAL LIFTS: 16 - 1 Gondola, 9 chairs, 2 drags, 2 Magic carpet, 1 beginners tow, 2 Tube Lifts

LIFT TIMES: 8.45am to 8.00pm

LIFT CAPACITY (PEOPLE/HOUR): 25,400 **MOUNTAIN CAFES:**7

ANNUAL SNOWFALL: 7.5m SNOWMAKING: none

CAR Vancouver via Merrit & Kelowna. Big White is 278 miles (447km), drive time is about 5 hours.

FLY to Vancouver International. Transfer time to resort is 5 hours. Local airport is Kelowna 45 mins.

BUS A bus from Vancouver takes around 5 hours. Local buses run daily from Kelowna to Big White and take just 45 minutes.

NEW FOR 2006/7 SEASON: new the largest 6-person lift in Canada, the Snow Ghost Express cost \$7million. Happy Valley Beginner Area complete with magic carpet, some run improvements

Knowledgeable Canadians have had a freeride paradise with an annual 7.5 meters of champagne powder largely to themselves. Big White is located in the Okanagan Valley, 45 min from the large town of Kelowna.

N

AD

The recent large investment has resulted in an excellent lift system, good off slope facilities and a lot of marketing. The secret of Big White won't last much longer. Most of the mountain is covered in trees with rolling pistes, but never uphill enough to make you walk. Almost every piste is littered with hits, allowing for you to take air numerous times on every decent. The lift system allows the crowd to disperse around the mountain making for crowd free slopes even on the busiest of days. Big White is an ideal resort for mixed abilities groups, there are miles of easy slopes which can be enjoyed by the advanced rider hitting the rollers, while the beginner can learns to link there turns on the same pistes. The only thing missing here is wide open powder faces, with a max elevation of 2319 meters the trees cover most of the mountain leaving only small powder faces.

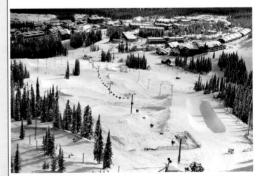

FREERIDERS get the chance to ride through trees, trees and more trees. From the Gem Lake Express chair you can access the Sun-Rype bowl area, one of the only powder faces, before dropping through the trees or onto the deserted rolling pistes below. Riders with balls (or equivalent) should take the Alpine T-bar and test their extreme riding on one of the double black diamond runs that are found on the Cliff, but only if you can ride and ride well. Likewise, the black runs off the Powder chair are not for the squeamish. For those not quite up to the same standard, the blue runs off the Ride Rocket chair are worth a blast, as is the Blue Ribbon over in the West Ridge area.

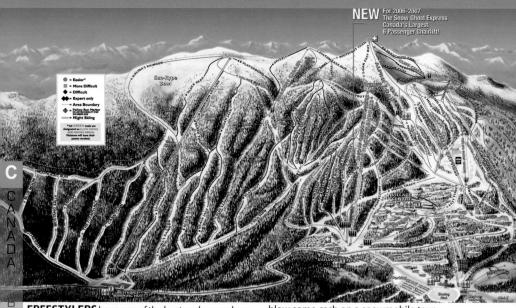

FREESTYLERS have one of the best parks anywhere. Flynn Seddon has designed a fantastic park which is permanently managed and repaired by a dedicated team. All the rails and hits are clearly graded allowing for the perfect progression form hopping of small hits all the way through to flying off huge ones. The park has its own lift going diagonally over the park, so you can check out other people's moves on the way up, it's also lit up during night riding night. There's a great Board cross and two well maintained pipes, often used for national events. Outside the park the mountain is full of natural hits. If you like rollers check out Black Jack and Black magic, if you want some small rock drops kickers and banks to turn on check out under the Rocket Ridge Express.

BEGINNERS will dig Big White, as it is totally accessible from top to bottom with a good selection of easy trails. If you can link your turns then you can explore the mountain, but study your lift map first. Instruction is good and well priced, with a one day lesson, equipment hire and lift pass costing from C\$55.

PISTE lovers will enjoy Big White as the terrain is perfect for laying out some big turns, although none of the runs are overly wide. By taking any of the main lifts, such as Ridge Rocket or Bullet, you gain access to some fast slopes. Cougar Alley is full on and for a long carve you should crank it from the summit of the Alpine T-Bar, down to the base.

OFF THE SLOPES, Big White is a friendly and affordable place, with lots of staff from around the world. Weekends usually see an influx of extra punters from surrounding towns and cities, but the place is never so busy as to be annoying - there is room for all. Local amenities are growing, offering everything you may need during your stay, with shops and other services being well located and within walking distance of each other. Riders with too much money can throw it away at the casino, whilst families can prance around on the 7500 sq,ft, ice rink. If that's not enough, then

blow some cash on a snowmobile tour.

EATING choices are numerous and of an extremely good standard. For a hearty breakfast, check out the Ridge Day Lodge which opens from 8.30am daily. Snowshoe Sam's is good for a beer and a game of pool, it also shows football and is good for a burger. Soup & a sandwich lunch is best in the Village Centre.

NIGHT-LIFE: By no means mad cap or hardcore drinking, but you can make it lively. The *Loose Moose* is the place to get on the dance floor, while Raakels is the place to chill and listen to some live music. For a bigger selection of night-life, check out the action in **Kelowna**. It is only 45 minutes away but you will need your own transport at night.

ACCOMMODATION in Big White is very good with much of it on, or close to the base slope areas, which allows you to ride straight to your door. There are a couple of classy hotels to choose from and a few chalets. For groups, there is a choice of condominiums with prices to suit most budgets. The *White Crystal Inn* is a quality hotel located close to the slopes. It has a bar, restaurant, and fitness room, but note, it's not cheap. For a hostel Same Sun Backpacker Ski Lodge is best.

ACCOMMODATIONS FROM BUIGET TO LUXURY

Big White • Silver Star • Sun Peaks

America TF: 1 877 765 9058 UK Tel: 020 8123 5861

SNOWEBB.com

Cypress Mountain is one of three local mountains in the Vancouver area (the other two being Grouse Mountain and Mt Seymour). Situated 30 minutes drive from Vancouver, Cypress Mountain caters largely for people living in the city. It's a relatively small resort with five chair lifts, 2 high speed guads, 1 guad and 2 doubles. The terrain on offer is very much beginner to intermediate level, but that doesn't deter the large number of 'Vancouverites' who flock here. Night-boarding is one of the biggest draws at Cypress, offering uncrowded riding for the true enthusiasts until 10pm every night.

FREERIDERS may find the best riding to be had on Mt Strachan in the east, which has two main chair lifts, Sunrise and Sky (plus Midway and Easy Rider for the beginners) that take you to the top of the best black runs. On a clear day,

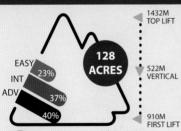

Cypress Mountain, P.O. Box 91252 West Vancouver, B.C. Canada, V7V 3N9 TEL: 604-926-5612

WEB:www.cypressmountain.com EMAIL:contact@cypressmountain.com

WINTER PERIOD: Dec to April LIFT PASSES 1 Day pass \$47.17 Evening \$34.91, Night \$28.30

NIGHT BOARDING from mid Dec to end March till 10pm on all main runs

HIRE Board and Boots \$37/41 Day

NUMBER OF PISTES/TRAILS: 38 LONGEST RUN: 2.1km

TOTAL LIFTS: 7 - 5 chairs, 1 magic carpet, 1 tube tow

ANNUAL SNOWFALL: 6.22m SNOWMAKING: 85% of pistes

BUS services direct from Vancouver takes around 30 minutes. \$15 return, \$8 one way

FLY to Vancouver 30 minutes transfer to Cypress Bowl DRIVE From Vancouver, use highway 1 westbound,

direction Horseshoe Bay. Leave at exit 8 for Cypress Bowl (13km)

NEW FOR 2006-2008: over the next 2 years they'll be gearing up for 2010 Olympics. 7 new advanced runs serviced by a new quad chairlift, in total 100 acres of new terrain. New day lodge

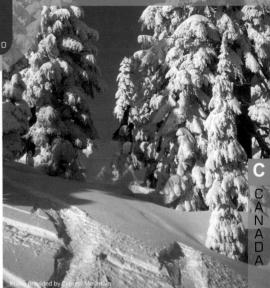

the view is absolutely stunning, with the enormous Mt Baker dominating the horizon down to Washington, USA. Snowboarding on this side of Cypress Mountain is better than anywhere else in the resort due to the steep and variable terrain, and because of the altitude, there is also more snow. There are some truly top class off-piste tree runs to contend with (although a little short by European standards), and some challenging black runs too.

FREESTYLERS have a snowboard park sponsored by 'Bell' one of the local mobile phone companies. It is well maintained by the owners, the instructors and a few local riders who are constantly changing the set-up. There is also a big halfpipe and if that's not enough, there are two awesome 12 foot quarter-pipes (snow permitting!)

PISTES. Carvers in search of loads of fast and extreme slopes will be a little disappointed but head for Horizon or Fork when the slopes are nicely groomed or Upper & Lower Collins when it's less busy.

BEGINNERS have it best at Cypress Mountain. The Eagle chair on Black Mountain gives access to some easy/intermediate winding runs; alternatively, the flats on Mt Strachan and the Sunrise chair are ideal for learning the basics. Cypress Mountain Snowboard School offers courses to suit all, with a one week course that includes full equipment hire, costing from C\$290.

OFF THE SLOPES. There is no accommodation on the mountain as the city of Vancouver is so close. In downtown Vancouver, there is an excellent hostel which has friendly staff, awesome facilities and runs daytrips to the mountain. Alternatively there are all the normal types of hotels that any large city can offer down town and on the North Shore itself.

There is plenty happening in Vancouver at night, on the North Shore head for the 'Rusty Gull' on 2nd or 'The Shore' on 3rd just off Lonsdale. Downtown on Granville Street, watch out for 'Fred's Tavern' or 'Roxys'. For incredibly rich but incredibly fit women head for the 'SkyBar' downtown, but make sure you got the cash to keep the ladies in bubbly! USQ www.worldsnowboardguide.com 311

Fernie Alpine Resort deservedly has reputation for being a powder paradise. With an average annual snowfall of 875cm and enough steep gladed terrain to keep vou entertained for the longest of stays, it is not surprising that it has become so popular, especially with the Antipodean snowboarding contingent. Since the take over by Resorts of the Canadian Rockies (owners of Lake Louise) the ski area has doubled in size. The two new chairs have opened the doors to

POOR FAIR GOOD TOP **FREERIDE** Trees and great off-piste **FREESTYLE** A terrain park & great natural **PISTES**

three bowls, Timber, Currie and Siberia that offer some of the mountains most challenging terrain. Beginners, intermediate and advanced riders will feel equally at home on the slopes and if for some reason you decide to leave your board at home for the day, there are a number of activities from dog sledding to snowmobiling that will entertain you.

FREERIDERS, this is what Fernie is all about. Advanced riders looking for steep tree runs could do worse than heading up to White Pass, then traversing around Currie Bowl to Stag's Leap and the surrounding area. Or, at the top of the Timber Quad, a quick two-minute walk will take you to the top of **Siberia Ridge**, where you can pick your line and charge through the well spaced trees. Unfortunately due to its increasing popularity you may have to fight for your fresh lines.

Once the ski area is tracked out, there are a number of 30-40 minute hikes that are worth every lung-bursting step. Make sure that you are not the one to put the boot pack in. Head to Mongolia Ridge for more trees, Polar **Peak** for stunning panoramic views, top of the **Face Lift** for short powder fields or traverse around to the Currie and Lizard Bowl ridges for some serious double black diamond chutes like Corner Pocket or Lone Fir. Also worth checking out, if the avalanche danger is low, is Fish Bowl which is located just outside the area boundary just past Cedar Bowl. Make sure you have your avy gear!

FREESTYLERS, you may be a little disappointed as Fernie no longer has a halfpipe, however management has put more money into developing the terrain park. The park has been kept in much better shape than in previous years. There are now a few more rails, more booters (huge ones at that!) and even a sweet Wall Ride. The terrain park is now located on Falling Star.

You don't have to hang out in the terrain park to jib; there are plenty of natural hits all around the mountain. In fact

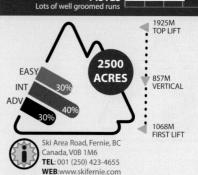

WINTER PERIOD: Nov to April LIFT PASSES 1 day lift pass: \$62 CDN

5-day pass: \$300 , 7-day pass: \$420, Season Pass: \$749 BOARD SCHOOLS Lesson, lift and equipment - \$43 HIRE Board and boots - \$25 (Kids - \$20)

NUMBER OF PISTES/TRAILS: 107 LONGEST RUN: 5.1km

TOTAL LIFTS: 10 - 6 chairs, 4 drags LIFT TIMES: 8.30am to 3.30pm LIFT CAPACITY (PEOPLE/HOUR): 13,716

MOUNTAIN CAFES: 8

ANNUAL SNOWFALL: 8.75m **SNOWMAKING:** none

CAR From Calgary drive to Okotoks & then Sparwood. Calgary to resort is 188 miles (300km). 5 3/4 hours drive time

FLY to Calgary International. Transfer time to resort is 3 hours. Local airport is Cranbrook (Air Canada fly into) about

1hr away BUS from Calgary twice daily, operated by Greyhound Bus Lines. (3 1/2 hours). Shuttle bus around town \$3 one way. TRAIN run by Amtrax only go as far as Whitefish, Montana USA.

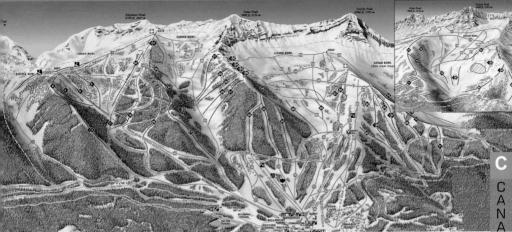

Fernie is one big terrain park! If you and your mates feel like getting away from everyone why not head to Lost Boys in Siberia Bowl or the area below the Face Lift traverse and build your own kickers to huck yourself off into deep, soft powder.

PISTES. For those of you who like to stay on piste, Fernie has plenty of wide open runs that are groomed regularly. After a fresh dump of snow, what is better than laying out some big carves on that packed powder corduroy. Try the Bear, North Ridge or Falling Star.

BEGINNERS will enjoy learning to ride at Fernie. Instructors are of high standard and will have you up and going in no time. Once you have enough confidence to leave the confines of the Mighty Moose beginner area you will find plenty of empty, tame runs off the Deer Chair, before trying the Bear and Elk runs which link together to give a long ride down to the Day Lodge.

OFF THE SLOPES. The town of Fernie has developed from the coal and lumber trade and is situated on the banks of the Elk River and beneath the impressive Lizard Range on which the ski area lies. Accommodation and local services can be found a few minutes down the valley in the old town of Fernie. Here plenty of affordable places to eat, sleep and drink are offered with a bit of a Wild West feel. Lodging is available at the resort base, but it is more expensive. There is a shuttle bus service that operates to and from the mountain on a daily basis, costing around \$6CAD for a return trip. Fernie offers a high level of services with a host of attractions which include ice skating, a cinema, swimming pools and other sporting facilities. Fernie is also a top summer destination with plenty of fly-fishing, hiking and mountain biking. Mountain biking is huge here with several lifts running during the summer so people can ride down the snow free runs!

NIGHT-LIFE in Fernie is rather tame but still enjoyable. There are a number of bars but they all seem much the same. Check out Eldorados for live music, The Central or the imaginatively named The Pub which has pool tables and table football.

ACCOMODATION. There is plenty of budget accommodation to choose from. The Raging Elk and the SameSun are two conveniently located hostels downtown and there is any number of hotels and motels. On the mountain hotels and self catering apartments include The Wolf's Den (cheapish) and Lizard Creek Lodge (more expensive) but offer

ride-to-your-doorstep

convenience.

FOOD. The choices for eating out are extensive and cater for every pallet and every price range. If you wish to dine out in style then you should check the Lizard Creek dining room. Lodge Gabriella's is the place for Italian dishes while Rip & Richard's is noted for its local cuisine. Smitty's Restaurant is noted for its pancakes, breakfasts and light lunches. By far the best down in town is the Currie Bowl but get there early.

SnowValleyLodge.com

Seasonal and short-stay accommodation based in the heart of Fernie, powder capital of British Columbia, Canada

Seasons starting from £1800, include:

- hot tub
- cable TV
- free broadband internet
- · pool table, PS2, games
- board maintenance area
- · access to our van

email: info@snowvalleylodge.com call: Wendy 07866 498385

GROUSE MTN

A nice day out

Grouse Mountain is the smallest resort out of the three (Cypress, Grouse, Seymour) located on the North Shore of BC's capital Vancouver. Along with a mountain top multi-media theatre, Grouse Mountain has a good selection of trails that will keep the average grade snowboarder content for a day or two, amuse an expert rider for an afternoon and totally please a beginner for a 5 day period. Regular night riding on Grouse's flood lit slopes is very popular with townies from Vancouver, who

facts about Vancouver.

townies from Vancouver, who take to the slopes in the evenings after a day in the office. However, Grouse doesn't attract mass crowds due largely to the poor and unreliable snow conditions. Still, when the 25 well marked trails are covered in snow then this is a mountain that provides some good fun riding with a little for everyone. Apart from a couple of double black diamond extreme runs, however, much of the terrain is rated intermediate and overall is tame. Grouse Mountain is best known for its truly amazing views of the North Shore and downtown Vancouver, the guide will tell you this in the cable car, along with many other 'interesting'

FREERIDERS will find that much of what is on offer here at will suit them so long as they are not looking for major long steeps covered in knee deep powder. There are however, some areas where the average rider can show off on runs such as the **Devil's Advocate**. This is a short but fast steep trail that winds its way down through some tress before linking up with a long intermediate run known as the **Inferno**. With all or most of the runs carved out of trees, there are ample opportunities to slice through the trees and grind the odd fallen log.

FREESTYLERS. There are 3 terrain parks at Grouse. The Rookie Park, below the Screaming Eagle lift, the Advanced Park on Side Cut and the Paradise Jib Park in Paradise Bowl. On a good day there's up to 30 rails and boxes in the parks and a number of jumps for all abilities. There's no pipe anymore though.

PISTES. Carvers have a reasonable selection of trails to choose from with some excellent wide carving to found off the Peak Patio and Peak chair lifts. Both lifts give access to some basic runs.

BEGINNERS may not have dozens of novice trails to choose from, but nevertheless, the easy runs are well appointed and most first timers should have no bother negotiating the nursery areas before progressing on up to more challenging terrain. The local ski school offers a number of snowboard programmes.

OFF THE SLOPES the place to stay is in **Vancouver**, where you will be able to find just about anything to suite you're fancy.

314 USQ WWW.WORLDSNOWBOARDGUIDE.COM

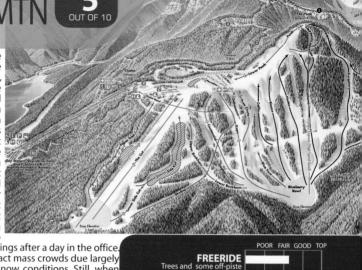

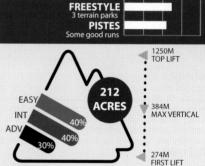

Grouse Mountain Resorts Ltd. 6400 Nancy Greene Way, North Vancouver, BC, V7R 4K9 TEL: 604.984.0661

WEB:www.grousemountain.com EMAIL:info@grousemtn.com

WINTER PERIOD: Nov to April

LIFT PASSES 1 Day Pass \$42, Night Pass after 4pm \$33 Season Pass \$700, Season Night \$415

BOARD SCHOOL Group \$38.

Park Clinic 5hours \$89,5 day park clinic \$420 HIRE Board and Boots \$39/day,5 Days \$166 NIGHT BOARDING 13 runs 113 acres

NUMBER OF PISTES/TRAILS: 25

TOTAL LIFTS: 5 - 2 chairs, 2 tows, 1 magic carpet **LIFT TIMES:** 9:00am to 10pm

ANNUAL SNOWFALL: 3m SNOWMAKING: 75% of pistes

BUS regular services to the base of Grouse Mountain every half hour. (Bus 232 from Phibbs Exchange/Bus 236 from Lonsdale Quay) http://www.bctranslink.com

FLY to Vancouver

DRIVE 15 minutes from downtown Vancouver. Follow Georgia Street westbound through Stanley Park and across the Lion's Gate Bridge. Take the North Vancouver exit to Marine Drive, then left up Capilano Road for 5 km (3.1 miles).

KICKING HORSE

Freeride paradise

Three hours west of Calgary and close to the town of Golden lies the resort of Kicking Horse. With large sums of dollars being spent on development, the resort is staking its claim as one of the biggest resorts around trying to be a match for the likes of Fernie and Lake Louise. A swift new gondola which takes you up to the very flash Eagle's eye Restaurant and a whole load of boarding options, is certainly helping to stake this claim. They are also hoping to open up some new extreme terrain in the Super Bowl area below Terminator ridge, and some new gladded beginners terrain near the base area; positions been granted so it should be soon. All the lower trails are hacked out between thick lines of ferns and suit novices, although there are a couple of notable advanced runs such as Pioneer and Grizzly. The top half of the mountain is of more

POOR FAIR GOOD TOP **FREERIDE** Trees & small off-piste FREESTYLE No park or pipe **PISTES** Huge array of slopes

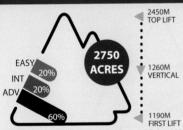

Kicking Horse Mountain Resort, P.O. Box 839, 1500 Kicking Horse Trail, Golden BC, VOA 1H0 TEL: 250-439-5400

WEB:www.kickinghorseresort.com EMAIL: questservices@kickinghorseresort.com

WINTER PERIOD: mid Dec to mid April LIFT PASSES Half-day pass \$44, 1 Day pass - \$59 6 Day pass - \$321, Season pass - \$799

BOARD SCHOOL Private lesson \$459 (6rs), Group \$50 (2hrs). Beginner package \$80 full day inc equipment, lesson & lift pass

HIRE Board & Boots \$31 per day, performance stuff \$47 **HELIBOARDING** See client services at the base lodge

NUMBER OF PISTES/TRAILS: 106 LONGEST RUN: 10km

TOTAL LIFTS: 5 - 1 Gondola, 3 chairs, 1 drags **MOUNTAIN CAFES: 2**

ANNUAL SNOWFALL: 7.6m SNOWMAKING: none

BUS services to Golden from Calgary, takes around 3 hours. Snow shuttles run from Golden to Kicking Horse (15mins)

FLY to Calgary, transfer time to is 3 hours. DRIVE From Calgary take Trans-Canada Highway 1 west to Golden, 9 miles from highway, Goldens 15 mins. 164 miles, 3 3/4 hours. 1.5 hours west of Banff via the Trans Canada Highway

interest to the better boarder with some decent black runs and a couple of double-diamonds to get your ticker going.

FREERIDERS Will love it: it's one of a few BC resorts with wide open powder faces. The trail marked out as **Porcupine** is a cool run that can be done at speed, but only if you know what you're doing. For the intermediate freerider, check out Kicking Horse, which starts out

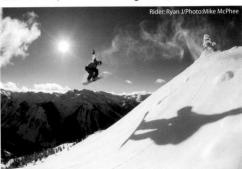

fairly mellow before dropping away more steeply midway down. For the advanced, go straight up the gondola to the top of the mountain and drop into either of the bowls off the ridge. If you fancy some hard core riding then take the Stairway to Heaven chair and take a short walk up to your left into the Feuz Bowl, or stay high and keep walking above Feuz Bowl leaving resort and access another huge bowl. If you've got a spare \$4000 then take a 3 day Heliboarding trip, www.canadianheli-skiing. com based in Golden, Or \$600 for a 3 decent day trip Purcellhelicopterskiing.com

FREESTYLERS may be forgiven for thinking that kicking horse is not for them. Freestyles not what Kicking Horse is about. It's splattering of natural hits and the occasional log won't keep your attention for long. There's no park although there's talk of one in the future.

PISTES. People who love the piste will enjoy the treelined trails which run in a straight line down to the base area. Pioneer and Grizzly are notable carvers' trails where you can lay out some fast lines at speed, but this is an advanced rated run so be warned.

BEGINNERS might look at the piste map and think that the place is made up of runs not suited to their ability, but on the ground it's a different story. You should head up Catamount chair where you'll be able to choose a number of well groomed very wide runs. If you can handle a short path then head up to the top and check out the Crystal bowl area.

OFF THE SLOPES there is little to offer. At the base there is a small hire shop and a few places to get a bite to eat. There's new condo development going up with good position next to the base area but there not cheap. Vagabond lodge is the cheapest and has rooms from \$160pppn and offer a good menu. Lodging and other local facilities can be found 2 miles away in the town of Golden. Although not the most happening place, it's free of marauding crowds, very affordable and is still okay. The Kicking Horse Hostel (www.kickinghorsehostel.com) Station Avenue, tel (250) 344-5071 has beds for \$25.

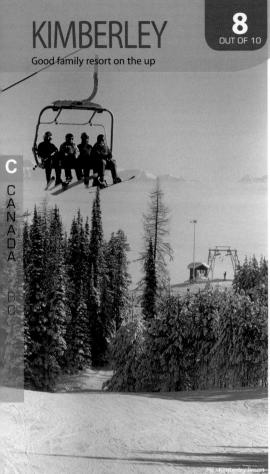

Kimberley Alpine Resort, to give the place its full title, is on the up and up and is currently in the middle of a multi million dollar expansion plan that has incorporated new mountain facilities as well as a new slope side village Kimberley's history, like many old Canadian towns, stems from the days of mining. However, you would be forgiven for not knowing this when you arrive as the area has been developed into an all year round quality outdoor recreation centre. First impressions of the place are not one of a sleepy old mining town; instead you are left feeling like you've just landed in a sausage-munching Bavarian town. Still, this strange fusion of Canada and Germany seems to work well as Kimberley is growing rapidly and is presently the fourth largest resort in British Columbia. Kimberley is owned by the same company that owns Lake Louise in Alberta, but that's about the only connection between two. Located 3 hours from Lake Louise, Kimberley is a resort that will appeal to everybody with a good selection of all level trails. The large percentage of easy and intermediate runs may be one reason that the slopes here attract a lot of skiers, however, snowboarders in the know are not left short changed with a good choice of fast black runs.

The runs are spread out over two faces and cut through

a lot of thick spruce trees providing some great tree-riding. Although advanced riders are not going to be pushed much here, there are a couple of notable double black diamond runs that deserve full attention in order to avoid a broken collar bone.

FREERIDERS will find that Kimberley offers them some really cool tree-riding and some fairly good powder days. The runs off Buckhorn chair take you to some nice terrain, while the Easter triple chair lends access to the double black Flush run, which descends through trees that will either make or break you.

FREESTYLERS will be please to know that the park, the Mambo Terrain Park and the halfpipe have improved greatly since we last reviewed the resort. There are quiet a few unusual but really cool rails for all abilities. There are also a few good natural hits located off the Rosa chair, which also gives access to some gentle terrain interspersed with wooded sections where you can practice some grinding skills on downed logs.

POOR FAIR GOOD TOP

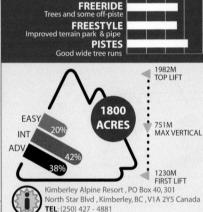

WINTER PERIOD: early Dec to mid April LIFT PASSES 1/2 Day Pass \$39, Full day \$50 BOARD SCHOOL Private lesson \$55 per hour

Group lesson \$30 2hrs, Beginner package lift pass, lesson & hire \$49 HIRE Board and boots - \$39/day

NIGHT BOARDING North Star Express High Speed Quad open from 5.30 to 9pm, \$19

NUMBER OF PISTES/TRAILS: 68 LONGEST RUN: 6.4km

WEB:www.skikimberley.com

EMAIL:info@skikimberlev.com

TOTAL LIFTS: 10 - 5 chairs, 4 drags, 1 magic carpet

LIFT TIMES: 9.00am to 9.00pm LIFT CAPACITY (PEOPLE/HOUR): 10,012

ANNUAL SNOWFALL: 4m SNOWMAKING: 65% of pistes

CAR From Calgary, travel via Memoral Drive and the P2 / P3 and P95A routes all the way to Kimberley. Calgary to resort is 281 miles, 8 hours drive time.

FLY to Calgary/Vancouver with daily domestic flights to Cranbrook (15 mins away).

BUS Greyhound bus leaves Calgary at 6:15 pm and arrives 12:15 am, tel 1-800-661-8747

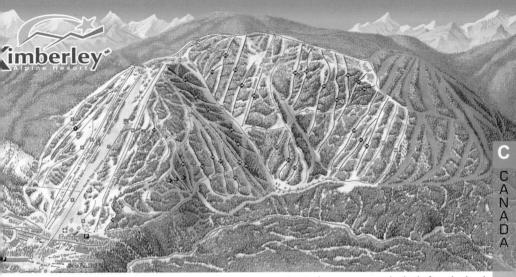

PISTE lovers get the best look-in on Kimberley's slopes with some decent wide open runs allowing for big arcs. The run marked Main is a fast long burner which brings you out at the main base area, while Flapper is a shorter but faster pleaser.

BEGINNERS who plan to spend a week here should leave far more competent than when they arrived. This is a particularly good resort for beginners with some excellent novice trails that cover the whole mountain and some nice long green runs that allow easy riding from the top to bottom.

OFF THE SLOPES. Downtown Kimberley is only five minutes from the slopes and offers a very good selection of facilities as well as what is said to be Canada's biggest cuckoo clock. Overall Kimberley is not a cheap resort in terms of accommodation and general local services. However, what is not in

question is the way you are looked after; the locals are very friendly. Kimberley is also an all year round holiday destination offering a host of sporting attractions form golf to white-water rafting and water skiing.

NIGHT WISE, Kimberley is a bit dull and definitely not a hot action town. Nothing really stands out or captures your attention. The place has a number of bland bars that all seem to go in for far too much stupid après ski rubbish. Still, you can get very messy and drink on until the early morning hours.

ACCOMMODATION in Kimberley is very good with easy access slope side lodging in condo units or chalets. The Rocky Mountain Condo and Hotel centre is located at the very base of the slopes just a short walk from the North Star Express chair lit. The hotel offers everything you could want during your stay with units sleeping up to 14 people. Downtown

Kimberley has the biggest selection of lodging with cheap B&B's and motels.

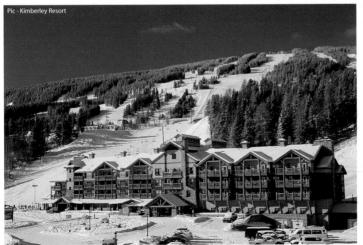

FOOD. Around Kimberley you will find a good mix of eateries with something for everyone to sample whether on the mountain or in the village. The Day Lodge Cafeteria serves up a good breakfast while Mingles' Grill specialise in killer grills. Kelsey's Restaurant and the Steamwinder Pub offer a good selection of bar food, although both are a bit cheesy going in for après ski.

BEGINNERS have lots of good blues and greens straight off the base chair. The designated beginner's area has a surface lift and there's a magic carpet for the complete For those getting novice. around the mountains who don't mind a pathway check out the Sun Bowl Trail.

OFF THE SLOPES. There's loads of slope side accommodation, but none cheap. If you're on a budget and have your own transport stay in Invermere, a 15 min drive away. The best place to rent a board or get your's serviced is Lusti's. Not much happens in Panorama at night unless you want to dress as a sailor and jump around on a bouncy castle and if that's your thing then get yourself off to the doctors, weirdo.

Panorama has some cash and is spending it. In the last few years they've replaced 2 drag lifts with high speed guads, built some new accommodation, beefed up their snowmaking capabilities and opened up a great double diamond area called **Taynton Bowl.** Snowmaking! Snowmaking? Panorama has more sunshine days than any other resort in western Canada, great for the goggle marks, but not so good for the white stuff. The marketing team of Panorama has aimed at the family market, which if you are single or don't have kids is a real shame. If you do have kids then the short transfer time (3 hours/ Calgary), the occasional fire work display, the hot pools and the kids party's make it a good chose. But and it's a big but, be prepared to pay through the nose for accommodation, it isn't cheap and there isn't a lot of choice. One of the other draws to Panorama is the Heliboarding in the Bugaboos area, which boasts over 2,000sq KM to ride so you'll always find freshies, but once again in true scamarama style, be ready to pay for it

FREERIDING. Trees, trees and more trees. There's a limitless amount of tree riding here; steep, shallow, wide, tight, long short you name it, they've got a tree run for you. For the advanced rider a short walk from the summit quad will lead you to Taynton Bowl which has a lot of steep treed shoots, but has a leg burning exit path. The Extreme Dream Zone has some shorter but still steep runs, with an easy out. Don't take your inexperienced mates into the Dream Zone as the trees are really tight and it'll be more of a nightmare zone.

FREESTYLE. The park is situated in the base area and has an ok pipe, a few hits and lots of rails. The park is fine but compared to some Canadian resorts Panoramas park is small and limited. The pistes don't offer too much in the way of hits or rollers but in Taynton Bowl there's loads of rock drops to fling yourself off.

PISTES. If you like it wide, well maintained and empty then this is the place. Most of the runs from the Champagne Express chair are well set up for you to crank out some full speed turns but with all that fake snow make sure you're edges are sharp.

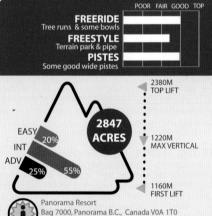

TEL: 001 (250) 342 6941 WEB:www.panoramaresort.com

EMAIL:paninfo@intrawest.com

WINTER PERIOD: end Nov to late April LIFT PASSES 1 Day pass \$60 5 days \$255 Season \$829

BOARD SCHOOL Group \$49/1.5hr, Private \$109/1.5hr

HIRE Board & Boots \$35 per day, 5 days \$140

SNOWMOBILES:2 hours \$110

HELIBOARDING: 930 square miles available! www.rkheliski.com NIGHT BOARDING Thu-Sun Till 9.00pm inc Terrain parks

NUMBER OF PISTES/TRAILS: 100 LONGEST RUN: 5.5km

TOTAL LIFTS: 9 - 1 Gondola, 5 chairs, 3 drags LIFT CAPACITY (PEOPLE PER HOUR): 8,500

ANNUAL SNOWFALL: 4.8m SNOWMAKING: 40% of slopes

BUS direct from Calgary takes around 2 hrs. FLY to Calgary, 2 hours transfer

DRIVE From Calgary, use highway 1 and P93 to Radium Hot Springs, then Hwy 95 to Invermere, which is 11 miles from Panorama. Calgary to resort is 184 miles. 4 3/4 hours drive

Great terrain, lots of new development

Red and the town of **Rossland**, which is a cool little town, go back in history to the days of the Canadian gold-rush of 1896. Founded by Scandinavian's looking for gold, Red is one of the oldest resorts in Canada. It's been operating as a ski resort since 1947 when its first chair lift was installed. As time has passed, so has Red's reputation, known for it's powder and some of the best extreme riding in Canada, Red has earned it's new found fame.

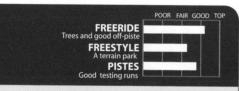

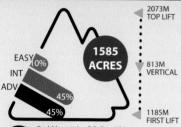

Red Mountain, P.O. Box 670, Rossland. VOG 1Y0. BC TEL: 001 (250) 362 7384 WEB:www.ski-red.com

EMAIL:info@ski-red.com

WINTER PERIOD: Dec to April LIFT PASSES Half-day £39, 1 Day pass \$52 6 of 7 Days pass - \$288, Season Pass - \$789 BOARD SCHOOL Private lesson \$55 per hour

Group lesson \$30 2hrs, Beginner package lift pass, lesson & hire \$49 HIRE Board and boots - \$39/day

NIGHT BOARDING North Star Express High Speed Quad open from 5.30 to 9pm, \$19

CAT BOARDING available from www.bigredcats.com (Tel: 1-877-969-7669). A Day will cost \$310-350 and give you access to 18,000 acres! Also www.valhallapow.com

NUMBER OF PISTES/TRAILS: 83 LONGEST RUN: 7km TOTAL LIFTS: 6 - 5 chairs, 1 drag LIFT TIMES: 8.45am to 3.30pm **MOUNTAIN CAFES: 2**

ANNUAL SNOWFALL: 7.6m SNOWMAKING: none

CAR From Vancouver take TRANSCANADA 1 eastbound to Hope. Then Hwy 3 through to Grand Forks. Continue another 45mins to Nancy Greene Lake, turn right onto Hwy 3B. Follow Hwy 3B until you

reach Red Mountain TRAIN to Spokane in the US

FLY to Vancouver International is 7hrs drive away. Spokane Airport is 2.5hrs drive away.

Castlegar airport is 30 mins.

BUS from Vancouver takes around 7 hours. A Local bus runs daily from Rossland to Red Mountain. Airport transfer available from Spokane airport \$C90 each way.

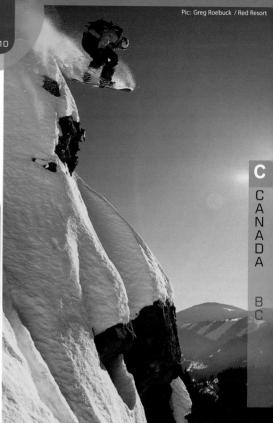

Freeriders will be stoked when they see what awaits them. Although this may not be in the super league of resorts, it nevertheless has a lot going for it with excellent, crowd-free runs and early powder untrashed by morning masses. This could change as the resort's growing off the slope annually, with the new owners planning to build 1,400 dwellings and 70,000 sq feet of commercial space in the next 15 years. Having said that it's one of the only resorts in Canada to develop with style, taking full advantage of the abundant natural building materials, let's hope that keep to that philosophy.

Granite Mountain and Red make up 1,585 acres of terrain, but are serviced by only three very slow chair lifts and a short drag which at weekends can lead to a bit of a wait. There are plans over the next two years to install new lifts and open up more terrain. Both mountains offer a variety of runs that mainly suit snowboarders who ride well. First timers are going to have their work cut out. The trail map lists many of its runs with a star to mean extreme, and that's exactly what the runs live up to. Grante is the bigger of the two areas and is easily accessed from the base lodge. Once at the top you can head off in a variety of directions, but note that most of the runs at the top are for advanced riders, although Ridge Road will take novices off to easier slopes.

FREERIDERS should check out Buffalo Ridge which takes you down one side of Grante into bowls, natural hits and lots of trees. Sara's Chute, a double black, takes you down steeps, through trees and eventually brings

USQ WWW.WORLDSNOWBOARDGUIDE.COM 319

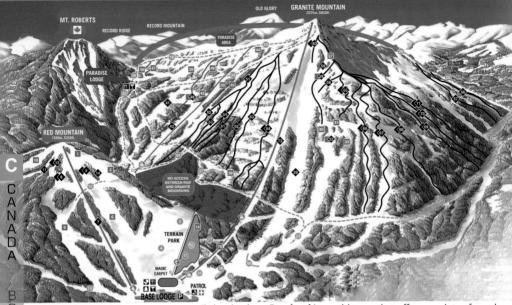

you out onto **Long Squaw,** a green trail that leads back to the base area.

FREESTYLERS will find Red's new 6 acre park next to the drag lift at the base station. It's full of kickers and rails but no pipe. The local geeky kids will show you how to do it, watching an 8 year old in specs and all tucked in by his mother getting massive air is a regular occurrence. Alternatively, there are plenty of natural hits, especially on Grante Mountain.

PISTES huggers will find loads of good runs although not all are regularly groomed. On the Paradise side of the mountain, the terrain will suit those wanting tamer stuff and carvers can lay out big lines on runs such as Southern Comfort. Other notable trails to check out are Doug's Run and Maggie's Farm.

BEGINNERS may be a bit put off when they first see the terrain level ratings and although the slopes are rated intermediate/advanced, it doesn't mean novices can't ride here. There is ample terrain to play on at the Upper and Lower Back trails, before riding the Long Squaw trail that runs back to the base lodge. The local snowboard school caters well for all your first time needs by offering a number of tuition program's that will soon have you shredding Red Mountain with ease. They have a very helpful new 225 foot Magic Carpet lift at the base for first timers.

OFF THE SLOPES Red Mountain has a good selection of lodging properties and facilities at the base of the slopes. Prices vary but staying close to the slopes is generally more expensive than staying down the road in the town of Rossland. If you have some cash and want to live it up, check out the Lofts, there fantastic high spec chalets with hot tubs, TV's bigger than a car and great views of the mountains. Red Robs are a good bet if you don't have the cash for the Lofts, *Mountain Gypsy* restaurant underneath serves great food. The base lodge does a good burger at lunch time.

Rossland is an old town that offers a variety of good local services from cheap eating haunts to boozy late night hangouts. Board and boot hire is available next to the slopes or in Rossland, check out Powder Hounds for all your needs.

NIGHT-LIFE in Rossland is not exactly the most happening, but it's still cool. It offers a number of good night-time hangouts where you can drink to jazz music or boogie to pop. Most bars play decent tunes and have pool tables. The Flying Steamshovel is bar, as are *The Powder Keg* and *Rafter's*.

ACCOMMODATION is as you'd expect from any resort. At the slopes there is a selection of Lodges, Chalets and Condo's. Places such as the *Red Mountain Cabins*, a short walk from the slopes, is pricey but very good as are the lofts. However, the best option is to stay in the town of Rossland which is only 2 miles from the slopes. The options include cheap B&B's and a hostel which are all close to the night-time action. Check the web site for accommodation and the latest prices.

FOOD. Rossland is not noted for its restaurants, but what you find is very good, and at prices to suit all pockets. Sunshine Cafe has a good menu while Elmer's serves great veggie food. The Flying Shovel dishes up good pub grub. Mountain Gypsy is the spot for pizzas and pasta.

Good all-round resort

Take a trip to Silver Star and you'll feel like you've taken a trip. When you walk down the high street, which is part of a piste, you walk through a purpose built fake mining village.

ACCOMMODATIONS FROM

Big White • Silver Star • Sun Peaks

America TF: 1877 765 9058 UK Tel: 020 8123 5861

Visit us at

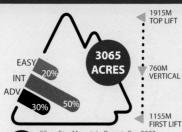

Silver Star Mountain Resort, Box 3002 Silver Star Mountain, BC, Canada V1B 3M1 TEL: (250) 542-0224 WEB:www.silverstarmtn.com

EMAIL:guestservices@skisilverstar.com

WINTER PERIOD: late Nov to mid April LIFT PASSES Half Day \$50, 1 Day \$65 Day/Night \$70, Night \$25, 5 of 6 Days \$297

BOARD SCHOOL Group \$69 4hours , Private \$99/hour Full day \$399

HIRE One day \$36, Five days \$186

NIGHT BOARDING Thu to Sat 3.30pm - 8.00pm

NUMBER OF PISTES/TRAILS: 112 LONGEST RUN: 8km

TOTAL LIFTS: 10-5 chairs, 2 drags, 2 magic carpets, Tube Lift

ANNUAL SNOWFALL: 7m SNOWMAKING: none

BUS services from Kelowna, can be arranged on request. Daily Ski bus runs from nearby town Vernon FLY to Vancouver, and then onto Kelowna airport. A 1hr bus shuttle service will take you to the resort

DRIVE from Vancouver, use as a map reference the town of Vernon, which is 12 miles from Silver Star along Hwy 97.

NEW FOR 06/07 SEASON: new quad chairlift to replace the Mid T-Bar

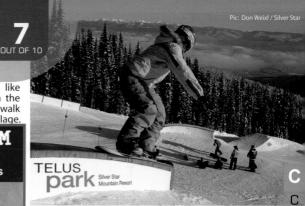

The shops are painted bright colours and have a raised wooden walkway outside. If you look up you expect to see a mock cowboy shootout around each corner you expect to bump into Mickey Mouse. That said Silver Star has an average snow fall of over 6 meters, a front side of well groomed pistes, and a backside of hard core shoots. Silver Star won't disappoint riders, and you won't see Mickey. Beginners will also appreciate Silver Star with its well connected green and blue runs. The local snowboard school runs daily programmes as well as weekly camps which offer video analysis.

FREERIDERS who start in the town and should head down to the 6 man Comet Express which takes you to the top of the Vance Creek area, from here you can head down Big Dipper over a few rollers to the park or back down one of the many groomed pistes to the chair. After warming up, take the flat Bergerstrasse green run to the hard core Putnam Creek Area. The double diamonds in this area are steep tree lined shoots which will test the best. Check out Where's Bob and after 50 meters drop left into a hidden shoot which will join up with the bottom of **Stardust**. All the runs on the Putnam creek area are only serviced by the Powder Gulch Express chair, so on a fresh snow day get there early.

FREESTYLERS looking for air will be pleasantly surprised with the natural hits. However, with a two acre fun-park, you don't need to look far to find places to hit. The park is located below Big Dipper trail.

PISTE lovers will find this a challenging resort. The Milky Way is an excellent open area where big arcs can be accomplished with ease. However, the steepest carvable pistes are on the North Face slopes where you'll be put to the test. Most of the Vance Creek area is well maintained but is always the busiest part of the resort.

BEGINNERS will find that Silver Star has a good selection of progressive runs easily accessed by chair lifts, although you will find you'll have to negotiate some pathways to make the most of the resort.

OFF THE SLOPES, Silver Star's old-fashioned Victorian theme is by far the maddest village you'll ever board from, but it does have a good range of accommodation and a few bars fine for a drink and a bite to eat. The best bar is Long Johns pub, which often has live music. Those on a budget should stay at the hostel where many of the resort staff hang out. The town of **Vernon** is located only a short distance away and is the place to go for a lively Saturday night out and to eye up some local skirt.

A

C

SUN PEAKS OUT OF 10
A really good resort

Sun Peaks is a resort situated about 40 miles from **Kamloops**, in the interior of the Rockies, this is a resort that has come of age. Over the past few years, huge expansion plans have been put into operation with fast modern lifts and massive changes to the layout and structure of the village. The overall results mean a damn fine mountain to ride that is not overpopulated with holiday masses. Sun Peaks is a large resort with a large vertical descent. The marked-out terrain isn't super-varied, but what is on offer is still good and well prepared with riding to suit all levels and styles.

FREERIDERS looking for long, wide straights with trees galore will find this mountain ideal, keeping you well occupied for a week or more. Take the long Burfield Quad to the top and you can gain access to some great terrain. If you plan to go outside the marked boundary, you are required to register with the ski-patrol. For some cool in-boundary riding, **Head Wall** is the place to bust a gut, with a series of short but demanding double diamond blacks. For something a little less daunting, try out the long and sweeping 5 mile trail off the Ridge, which can be tackled by intermediate riders.

FREESTYLERS have a massive 30 acre fun park area located off the Sunrise chair, which is loaded with hits and a pipe. Around the slopes you also find numerous natural hits to launch off.

PISTES. Sun Peaks appeals to carvers and fast riders in a big way; some of the runs here are superb, and just right for laying the board over an edge at speed. If you have the balls, try the steep Expo; if not, try your luck down **Spillway**.

BEGINNERS who don't appreciate the novice slopes here or manage to progress with style should give up snowboarding and take up train spotting. This is an excellent beginner's resort with some perfect novice tracks off Sundance.

OFF THE SLOPES. Accommodation and all other amenities can be found in Sun Peaks or in the small hamlet of Burfield. It should be pointed out that this is not a budget rider's destination as it can get expensive. There's a good choice of restaurants, bars and shops to choose from, but night-life is very tame with *Masa*'s the favoured evening hangout for booze, music and meeting the locals.

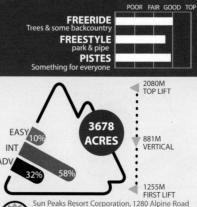

WEB:www.sunpeaksresort.com EMAIL:info@sunpeaksresort.com

WINTER PERIOD: mid Nov to mid April LIFT PASSES 1/2 Day \$51,1 Day \$60, Season pass \$899 BOARD SCHOOLS 2Hours Group \$49/69, Private \$52/hr

NUMBER OF PISTES/TRAILS: 117

LONGEST RUN: 8km TOTAL LIFTS: 11 - 5 chairs, 3 drags, 2 tows, 1 magic carpet

ANNUAL SNOWFALL: 5.59m SNOWMAKING: 65% of slopes

BUS services from Vancouver takes 5 1/2 hours. Sunstar run a Shuttle service from Kamloops airport to resort, \$34 visit www.sunstarshuttle.com

FLY to Vancouver with domestic flights to Kamloops

DRIVE From Vancouver, take Hwy 1 east via Kamloops, then via Hwy 5 exit to Jasper for Sun Peaks.

, NEW FOR 2006/7 SEASON: \$4million in total being spent. ▶New Quad Chairlift on Tod Mountain, New Umbrella Bar, ⁴ new runs on lower Orient Ridge. Expanpsion of Terrain Parks adding more easy features, new Park Bully Basic but still cool

Just off the west coast of Canada and floating in the Pacific Ocean is Vancouver Island, which is home to a number of resorts. The most notable and indeed the biggest is Mt Washington, which is located in the middle of the island. Over recent years large amounts of money has been spent on upgrading the whole area to make it modern and more fashionable. The amount of terrain available here is pretty cool offering a good mixture of off-piste, powder, trees and well groomed runs.

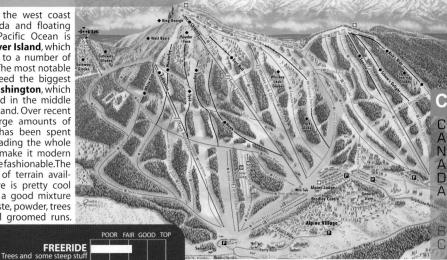

Some good runs 1588M TOP LIFT 1000 ACRES 505M VERTICAL 1083M FIRST LIFT

FREESTYLE

PISTES

A terrain park & pipe & good natural

Mount Washington Resort P.O. Box 3069, Courtenay, BC V9N 5N3

TEL: 001 (250) 338-1386

WEB: www.mtwashington.bc.ca EMAIL:ski@mtwashington.bc.ca

WINTER PERIOD: Dec to May

LIFT PASSES 1/2 Day \$39 1 Day \$50, 5 Days \$215 BOARD SCHOOL Group \$25/1.5hrs, Private \$45/hour HIRE Board & Boots \$37 per day

NIGHT BOARDING Fri/Sat 4.30pm-9.00pm, \$10

NUMBER OF PISTES/TRAILS: 50 LONGEST RUN: 2.5km

TOTAL LIFTS: 7 - 5 chairs, 2 drags

LIFT CAPACITY (PEOPLE PER HOUR): 11,000 LIFT TIMES: 8.30am to 4.00pm

ANNUAL SNOWFALL: 9m SNOWMAKING: none

BUS services from Vancouver are available to the

FLY to Vancouver

DRIVE From Vancouver, you will need to drive to Horseshoe Bay and take a ferry over to Nanimo or Comox.

From Nanimo, travel north on Hwys 1 &19. Mt Washingtonis 15 miles west of Strathcona Parkway.

As Mt Washington grows, so do the crowds, therefore be warned that the slopes can get busy at peak times.

FREERIDERS up to advanced status have a good selection of steep blacks reachable off the top of the Eagle Express chair. Here you can head down trails like **Hawk**, a fast run that starts out wide before dropping down through trees. Less adventurous but still as good is the cluster of runs off The Gully, such as Scum's Delight.

FREESTYLERS head here en-masse to ride some great natural terrain and take advantage of the clean hits in the park. Located by the Coaster run off the Whiskey Jack chair, the park is loaded with table-tops, gaps, hits and a good halfpipe.

PISTES. Riders who only want a series of straight, fast slopes to cut up, will not be disappointed. If you're up to the grade, check out **Chimney** - it will prove whether you are a man or a mouse. Alternatively, Whisky Jack is a gentle but excellent carver's run, especially if you are still mastering the art.

BEGINNERS will have to do introductory courses on how to cope with bruises on the lower slopes, before heading up higher. Based at the lower sections, the Green chair and Discovery lift gives rise to some easy novice terrain.

OFF THE SLOPES. In resorts that are constantly growing and developing, one is bound to find differences each time you visit. Local facilities are a bit sparse but what is on offer is good. If you can't find what you're after, then check out the offerings in Courtney, 25 minutes away. This is where you will also get the best night-life. Accommodation options are fairly extensive with 4,000 tourist beds available in a variety of condos and chalets, many of which are on, or very close to, the slopes. Lodging is not overpriced here - you can get a decent condo for C\$70/night or a chalet from C\$100.

Major riding for all styles but can get busy

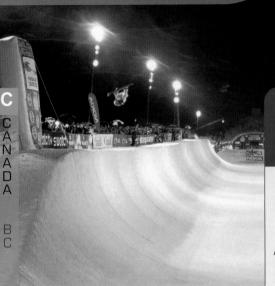

Whistler/Blackcomb. Where to begin? Repeatedly rated as the No. 1 resort in North America and not without reason, Whistler will host the 2010 Winter Olympics and is without doubt one of the best resorts in the world. A combination of absolutely unbelievable terrain combined with Intrawest ownership has shunted Whistler to super-resort status, but glitz aside, experience the riding here for yourself to see why.

Two monstrous mountains cradle the purpose built village of Whistler itself - year round population 10,000, swelling to 5 times that peak season - beware school holidays. Now almost as famous for it's amazing mountain biking as it's snowboarding (freestyle adrenaline seekers checkout the downhill park if in summer camp!), Whistler is a magical encounter for all ability levels. You really can ride here for years without becoming bored. Whistler has it all - 33 lifts accessing over 7000 acres of varied and challenging terrain, amazing backcountry access, bowls, steeps, trees, 2 terrain parks and 3 pipes, 2 of them superpipes. The downside of having it all is crowding - avoid Christmas and Easter at all costs. Early Dec. or Jan. are often good for a local vibe with no crowds and lots of pow. The village throngs with restaurants, bars and clubs. Doing a season here is an excellent choice to do both the vast mountain and social scenes justice. Brits under 35 (and now non-students) can obtain a 1 year BUNAC work permit and as a result may soon be competing with droves of Aussies seeking beds in Intrawest staff housing for the winter.

Party hounds should check out the annual World Ski and Snowboard Festival held every April, with pipe and big air comps, live bands and DJ's. Powder hounds - go for 'Fresh Trax' tickets to access the mountain before the crowds at 7am - if any sense leave the breakfast to the

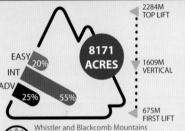

4545 Blackcomb Way, Whistler, B.C. VON 1B4, Canada TEL: 604.932.3434

WEB:www.whistler-blackcomb.com EMAIL:wbres@intrawest.com

SUMMER PERIOD: June to July LIFT PASSES 1 Day \$70,6 Days \$378, Season pass \$1639

BOARD SCHOOLS Half day Group \$135 Full day \$205

Private Half day \$399 Full day \$599

HIRE Board & Boots 1 Day \$36,5 Days \$150

HELIBOARDING 3 runs of 1400/2300M \$640pp

6 runs of 2700/4600M \$940pp

SNOWMOBILES \$99 for begginers trip, full day @\$229

NIGHT BOARDING Thursday, Friday and Saturday the Super Pipe is open \$15 5-9pm

NUMBER OF PISTES/TRAILS: 230

LONGEST RUN: 11km

TOTAL LIFTS: 33 - 3 Gondolas, 18 chairs, 12 drag

LIFT TIMES: 7.00am to 3.30pm

LIFT CAPACITY PEOPLE PER HOUR): 59,000

MOUNTAIN CAFES:17

ANNUAL SNOWFALL: 9.14m SNOWMAKING: 35% of pistes

CAR Vancouver via Squamish on Hwy 99. Whistler is 115km, drive time is about 2 1/4 hours.

TRAIN direct to Whistler

FLY to Vancouver International. Transfer time to resort is 2 hours. If you have the cash, you can take a HeliJet straight to the resort in 30mins

BUS from Vancouver takes around 2 hours.

Take the Perimeters Whistler express from the airport straight to Whistler, its \$65 each way, \$130 return and leaves every couple of hours. Geryhound and Snowbus run daily services from Vancouver city. A local bus runs daily around Whistler and Blackcomb.

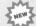

NEW FOR 2006/7 SEASON: new Piccolo Express quad Lift will run to Piccolo peak from the bottom of Flute Bowl

skiers and go ride those pillows lines!

Blackcomb Glacier is home to a handful of snowboard camps in summer, including Camp of Champions and Whistler Summer Snowboard Camp. Open to all levels they can be pricey but what a way to parallel superkid Shaun White! The summer scene up there is spectacular with tons to do in the evenings - Whistler has it's own skatepark, dirt jumps and downhill park, a must for the still hungry adrenaline seeker.

FREERIDERS. The resort is sheer powder heaven when it dumps, which is often with its Pacific Northwest climate. Natural hits spring up all over both mountains which both have amazing tree runs, both marked and unmarked. On Whistler try Peak to Creek via the Peak Chair and Bagel or West Bowl. Even better, get a local to point you to CBC trees and Khybers for a 'Clearcut' BC forest experience. The whole Harmony area is awesome, with open bowls, cornices, shutes and pillow lines galore. Blackcomb Glacier is a must - access it via Spanky's Ladder to drop into Ruby, Diamond, Sapphire and Garnet bowls or the Showcase T Bar to encounter the infamous wind-lip. Seventh Heaven and Crystal Chair offer pillows, cliffs, tight trees and more. Remember, if it's raining in the village it's often puking up top - don't let the sometimes damp village conditions put you off.

FREESTYLERS. Both mountains have pristine terrain parks, with Blackcmb's beauty continually rated no. 1 in Transworld Snowboarding alongside Mammoth, CA (also Intrawest owned). The park is split into 3 levels - pay an extra \$15 for unlimited use of the Advanced park and remember the mandatory helmet - most of the booters are an average of 40-60 ft. DJ's blast an eclectic mixture of tunes from a booth on the legendary shack booter, the first in a

series of similar monstrosities which take you either to Catskinner Chair or continue through the superpiupe to Solar Coaster. The park also features a wide variety of technical rails, spine jumps, a gap jump and quarterpipe with alterations throughout the season. 90% of Canada's pro-riders reside in Whistler so watch out for cutting edge action and lots of filming. The Intermediate park on skiers right has the same features on a smaller scale and beginners can try the Terrain Garden (off Easy Out) or Habitat Park on Whistler. Newly opened last season as part of the FIS Snowboard World Championships was the Night Superpipe located at Base 2, in conjunction with the 'King of the Rail' competition held weekly under Magic Chair lights.

PISTES. Carvers and speed freaks will love the deliciously long, wide open groomers of both mountains, On Blackcomb, Springboard, Rock and Roll and Ridgerunner are a must and Panorama on 7th Heaven features a set of natural, groomed rollers that will boot you to the gods. On Whistler, cruise down to Creekside via the Dave Murray downhill. The Saddle, Tokum and Bear Paw are also immaculate groomers, ripe for early morning ripping but always check the grooming maps to avoid running into mogul fields!

BEGINNERS. The enormous and expertly staffed Snowboard School caters for riders from 6 upwards - Super Sliders (6-8), Super Riders (9-12), Ride Tribe (13-17) and Adult. Group (up to 8 people), private and other tailored lessons leave from all 3 bases, Whistler, Blackcomb and Creekside, and cater for every level. Beginners are well looked after on the Magic Chair (Blackcomb base) or Olympic Chair (Whistler midstation). Whistler has the most green (novice) trails so it is best for practising riders. Freestyle programmes focusing purely on park and pipe are also available. Contact www.whistler-blackcomb.com

OFF THE SLOPES. Whistler is a paradoxical paradise with extreme being the word, attracting anything from the likes of Timberlake and Diaz to hoards of Kokanee swigging Aussies living the dream and 'doing a season'. On the surface it appears hellishly expensive, and can be so, but dig deeper and the friendly locals will point you to the good spots to ride, eat, party and purchase. There are dozens of high profile shops and some cool local establishments, Showcase, Evolution and the Circle are thriving snowboard shops with knowledgeable, easy going staff. Whistler is also home to dozens of bars and restaurants, 2 movie theatres, ice skating and swimming at Meadow Park, and an indoor climbing wall and tennis courts. All amenities are within easy walking distance including the lifts accessing both mountains.

NIGHTLIFE begins at Apres. Worth checking out in the village are GLC featuring chilled live DJ's, vaulted windows overlooking the slopes and a huge log fire. Amsterdam Cafe caters for a funky young crowd and Citta and Crystal Lounge are cool places to chill back with some Nachos and the odd Hockey game. The Longhorn and Merlins can be a laugh, often housing fur clad skiers in ridiculous head-gear playing party games under instruction of local character and musician 'Guitar Doug'. In the Creek, Dusty's is the place to go. After dark the options are varied; again GLC rates highly, with local and international DJ's spinning music such as hip hop and drum 'n' bass. Local hip hop legend Mat the Alien (from Bury no less!) plays weekly at Moe Joe's, a locals favourite night. Try Thursday's at Garfinkels for an evening of cheesy drunken debauchery or Tommy's for a young, clubby dance crowd or hideous 80's night on a Monday.

Buffalo Bills is where the over 30's head, a notorious cougar hangout, watch out boys!

ACCOMMODATION in general is expensive but top quality, with outdoor pools and hot tubs the norm even at mid price places. Whistler has the most ski in-ski out accommodation of any resort in North America, ranging from the royally expensive *Chateau Whistler* and recently opened 5 star *Four Seasons*, to Hostelling International on Alta Lake and the Shoestring Lodge at Nesters. With over 2 million annual visitors a year, rooms in all areas fill early so book early to avoid disappointment. Decent mid price hotels include the Coast Whistler and Blackcomb Lodge. Most places offer deals late and early season - take advantage of this to experience the World Ski and Snowboard Festival in April and often surprisingly good snow conditions.

FOOD. Locals frequent cafes such as *Ingrid's*, *Gone* Bakery and Behind the Grind for hearty, homemade soups and snacks. Java and Samaurai Sushi at Nesters Mall are great local hangouts if you have wheels (or are staying at the Shoestring Lodge). On the cheap but nasty side, Whistler hides McDonald's and KFC in its Marketplace, alternatively, meat eaters should pop around the corner to Splitz Grill for the best burger in town. Higher on the price ladder do not leave Whistler without a visit to Sushi Village, eternal local favourite and as famous for it's strawberry sake margs as scrumptious menu. La Bocca is funky and fresh with a great patio and expensive but amazing extremes are Araxi and Bearfoot Bistro. When riding. avoid the ludicrously overpriced junk on-mountain and ride to the village for lower cost and way better quality.

It's all about the powder!

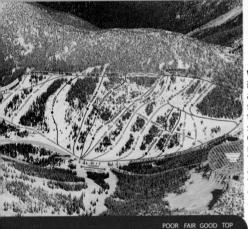

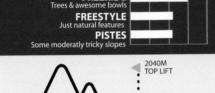

FREERIDE

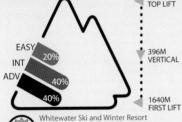

P.O Box 60. Nelson, BC, Canada. V1L 5P7
TEL: (250) 354-4944

TEL: (250) 354-4944
WEB:www.skiwhitewater.com
EMAIL: info@skiwhitewater.com

WINTER PERIOD: Nov to April LIFT PASSES 1/2 Day pass \$34.5 Full day \$46, Season \$645

BOARD SCHOOLS \$49 2 hour lesson, pass, board hire Halof day \$29, Full day \$45

NUMBER OF PISTES/TRAILS: 24 LONGEST RUN: 8km

LONGEST RUN: 8km

TOTAL LIFTS: 3 - 2 chairs,1 drag magic carpet LIFT TIMES: 9.00am to 3.30pm

ANNUAL SNOWFALL: 12m SNOWMAKING: none

BUS services from Vancouver, go to the town of Nelson.

FLY Fly to Vancouver, with a transfer time of around 12 hours. Castlegar Airport is 41km from the resort

DRIVE From Vancouver, use as a map reference the town of Nelson along Hwy3 of Hwy 6, 394 miles. From Nelson head south on Highway 6 towards Salmo for 12km until you see the turn off for resort. Calgary to resort is 374 miles

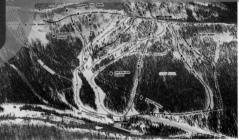

Whitewater is located close to the town of Nelson and is a very good bet for riding even when other resorts are begging for snow. Whitewater receives 1,200cm of snow each winter and due to the areas stable winter temperatures, the snow lasts and lasts. The lifts access some of the best high altitude in-bounds terrain in Canada. Whitewater is a huge bowl, contained by two ridges that join at the apex to form the 2,440m (800 ft) Ymir Peak. Ymir (pronounced 'why-mur') is named after a Norse legend and traps any westerly storm. Water vapour sucked off nearby Kootenay Lake is turned into consistently dry champagne powder that fills the bowl. Admittedly a 'high end' resort, with a majority of expert and intermediate terrain, Whitewater still has a lot of room for those lovers of groomed run cruising with long, easy beginner runs off the Silver King lift.

FREERIDERS should take the Summit chair to access the opposite ridge which offers steeper, groomed, intermediate runs and the most challenging off-piste through bowls and trees. Try Dynamite, Catch Basin and Glory Basin, and lay down one powder track next to another. Get up early to challenge Blast, a steep fall-line under the chair lift. There are many, many awesome areas filled with powder at Whitewater, however, we think they should remain secret...sorry! But if you are up for a walk and you have a look around you'll find them.

FREESTYLERS need to roam over the whole area to find places to get air, as there is no permanent pipe or park. However, there is plenty of great natural freestyle terrain.

PISTES. Riders wanting fast groomed terrain will enjoy Whitewater's trails which offer every level of hard booter something to tackle. But, c'mon, you are at Whitewater... enjoy the pow!

BEGINNERS will find that Whitewater is the kind of area that doesn't really have beginners - just learners who progress in powder by riding steeper and deeper lines. A beginner park called The Hunter has been created near the day lodge. However most people who have mastered the basics choose to head for the hills and carve up snow where groomers never reach.

OFF THE SLOPES

There is no in-resort accommodation available at present, but there is a wide range of places to sleep in the town of Nelson. **Nelson** has good local facilities and is very affordable, if only a bit dull and basic. *Coal Oil Jonny's* offers Nelson brewed beer on tap. The *Dancing Bear Inn* and *Flying Squirrel International Hostel* have Stay and Ride specials. During the day there is great food in Shucky's Eatery (even the soups are made with wine), and offers everything from fries to a full course lunch. This is NOT your standard resort food; it's more like that cosy, quaint little mom and pops type food. Yum!

WSQ WWW.WORLDSNOWBOARDGUIDE.COM 327

FAIRMONT SPRINGS

Small family resort, about 40 miles from Banf

Number of Runs: 13 Longest run:1mile (1.6km) Info: Has a terrain park (nothing big) & beginners pipe Top 1585m Bottom 1280m Vertical: 304m Total Lifts:2 - 1 chairs, 1 drags Lift pass: 1/2 Day Pass - \$25, Day Pass - \$34 Lift times: 4.00pm to 10.00pm Hire: Board & Boots \$20 School: 1 Hour lesson - \$44 Contact: Fairmont Hot Springs Resort Box 10, Fairmont Hot Springs, British Columbia, Canada, VOB 1L0 Phone:1-800-663-4979 or Tel: 250-345-6311 www.fairmontresort.com

HEMLOCK VALLEY

(seriously!), if you've a spare US\$4 million it can all be yours ... Number of Runs: 34 Info: Has a terrain park Top: 1524m Bottom: 975m Vertical: 397m Total Lifts:4 - 3 chairs, 1 drags Lift pass: 1/2 Day Pass - \$32, Day Pass - \$39 Night Pass - \$15 Lift times: 9.30am to 10.00pm Hire: Board & Boots \$36 a day School: Beginners all in day lesson, lift, hire \$59.00. Private lesson \$56 per hour Contact: 20955 Hemlock valley road. Agassiz B.C. Canada V0M-1A1 Phone: (604) 797-4411 Fax: (604) 797-4440 www.hemlockvalleyresort.com

Slight problem with this place its currently up for sale on ebay

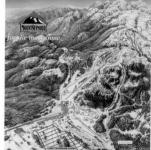

www.mountseymour.com questservices@mountsevmour.com Location: 30 minutes from downtown Vancouver, Heading west on Hwy #1, cross the Second Narrows Bridge, take the 3rd exit (#22) on to Mount Seymour Parkway and follow the signs to the Provincial Park. Turn left at Mount Seymour Road (at MohawkStation) and arrive at the base area in 15 minutes

POWDER KING Easy 34% Intermediate 33% Advanced 33%

Average snowfall: 12.52m Top: 1829m Bottom: 935m Vertical: 640m Total Lifts:3 - 1 chairs, 2 drags

Lift pass: Day pass \$40, half day \$33 Adult Season passes \$574-804 depending on when bought.

Lift times: Thursday to Sunday. Usually 9 or 9:30AM till 3 or 3:30PM Hire: Board & boots \$25 per day, half-day \$20. Demo boards \$30 per day

School: Group lesson, 2hrs \$16.05 Private lessson \$23,99 first hour, then \$14,99

Contact: Powder King Mountain Resort Inc. P.O. Box 22023 Pine Centre Postal Station

Prince George, B.C. V2N 478 Tel/Fax: (250) 962-5899

Web: www.powderking.com

Fly to Prince George, 195 km from resort Drive: From Vancouver, head north on Highway 97 to Prince George, then head north 195 km (122mi) to the mountain. From Edmonton head north to Dawson Creek, and then come south to Powder King approximately 210km (131mi)

HARPFR MOUNTAIN

info@fairmonthotsprings.com

A decent size family resort, near Kamloops.

Location: Hwy. 93/95, 3 hours west of Calgary

Ride Area: 400 acres Number of Runs: 15 Easy 25% Intermediate 50% Advanced 25% Info: Has a terrain park

Top:1524m Bottom:1097m Vertical:427m Total Lifts:3 - 1 chairs, 2 drags Lift pass: 1/2 Day Pass - \$21 Day Pass - \$29 Lift times: 9.30am to 10.00pm

Hire: Board & Boots \$34 a day School: Full day inc hire, lift pass & lessons

Contact: Snow Phone 250-573-4616 Office 250-372-2119 www.harpermountain.com info@harpermountain.com

MOUNT **SEYMOUR** RESORT

info@hemlockvallevresort.com

30 minutes from Vancouver with 3 terrain parks & a halfpipe

Ride Area: 60 acres Number of Runs: 21 Longest run:1.6km Info: Well setup up for freestylers with 3 terrain parks and a halfpipe

Snowfall: 17m Top: 1265m Bottom: 1020m Vertical: 330m Total Lifts:5 - 2 chairs, 2 magic carpets Lift pass: Day pass \$34

Lift times: 8.30am to 10.00pm Night Boarding: 11 slopes lit, pass \$15

Hire: Board & Boots \$37 a day School: Day lesson, lift & hire \$45 Contact: Mount Seymour Resort 1700 Mt Seymour Rd, North Vancouver, BC V7G 1L3 General Information 604.986.2261 24-Hour Snow Phone 604.718.7771

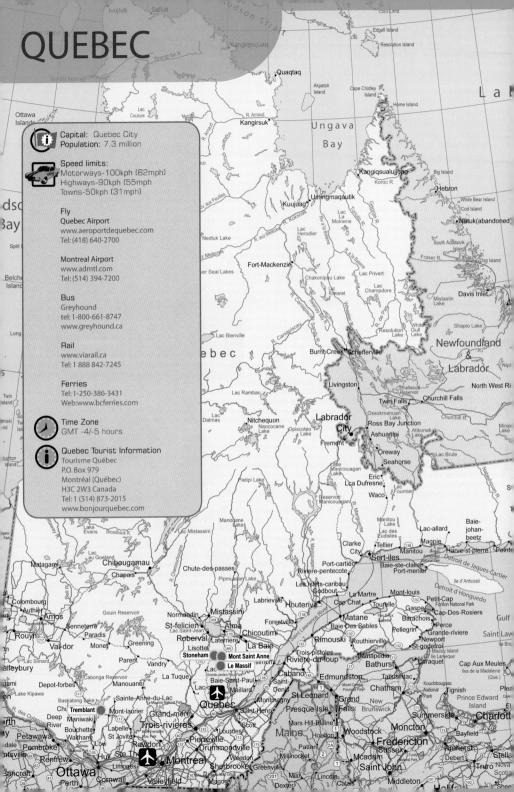

LE MASSIF

Okay but nothing demanding

Le Massif is an unassuming and rather un-adventurous small mountain resort that lies just 45 minutes north of Quebec City. In recent years the resort has undergone a number of major re-developments spending in excess of 25 million dollars on facilities that will greatly improve not only the number and type of mountain runs, but also access to the resort and local facilities. It was also taken over in 2004 and its new owners spent a further \$5million on improvements.You can now travel from Quebec City along route 138 to the top of the slopes, as well as the base. What you will find on your arrival is a mountain that offers most grades something to try out although it has to be said that a week here

would become very boring after a few days. Still the resort can now boast up to 36 marked out trails which are tree lined up to the summit which is also the location of the new Day Lodge. All 36 runs are serviced by just 5 lifts including a new fast quad chair, which Le Massif boasts at being the longest high speed chair lift in Quebec Province. And that's not the only boast they make around here, as they also claim to have the most extensive snowmaking facilities on the east coast. What ever the legitimacy of such claims, Le Massif can claim to be an okay place to ride if you are a total beginner or basic intermediate rider.

FREERIDERS have a fairly ordinary mountain to ride that allows for some basic freeriding down mixed ability slopes which are sandwiched between lots of dense wooded sections. However, this place is not hard-core and forget about any decent back-country terrain or powder bowls.

FREESTYLERS should be able to have fun here. There are plenty of spots where you can pull some natural air with banks of snow lining many of the tree lined slopes. You will also find the odd log to grind over, (should you not mind wrecking your boards base). There is a terrain park under the Camp Boule Express.

PISTES. Riders who come to a resort looking for loads of super fast steeps, should go else where. That said Le Massif does have a number of nicely groomed carving trails to ride along.

BEGINNERS have the best chance to shine here with a good selection of easy runs to choose from which can all be reached with ease and with out needing to use drag lifts all the time.

OFF THE SLOPES Le Massif's local facilities are basic to the extreme. All your accommodation and eating needs can be found down in Quebec City which is 45 minutes away.

ALT. 750 m

ALT. 7

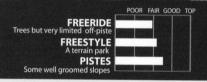

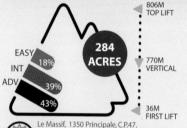

Le Massif, 1350 Principale, C.P.47. Petite-Riviere-Saint-Francois. Quebec. **WEB**: www.lemassif.com

WINTER PERIOD: Late Nov to early April LIFT PASSES Half day \$39.12,1 day \$50.42, 3 days \$139.10, Season \$839

BOARD SCHOOL Group \$49 for 2hr lesson, Private \$40/hour **HIRE** Board & Boots \$34 per day

NUMBER OF PISTES/TRAILS: 42 LONGEST RUN: 2.3miles

TOTAL LIFTS: 5 - 3 chairs, 2 drags LIFT CAPACITY (PEOPLE PER HOUR): 8700

LIFT TIMES:8.30am to 4.00pm

ANNUAL SNOWFALL: 6m SNOWMAKING: 60% of slopes

BUS services from Quebec City go Le Massif and take around 45 mins.

FLY to Montreal with a transfer time of 3.5 hours to the resort.

DRIVE from Quebec City, head north along hwy 138 past Mont-Sainte-Anne.

A bit tedious, but okay for a few days

Mont Sainte-Anne is a decent resort and will certainly keep an intermediate rider content for a few days and a beginner satisified for a week with ease. With its proximity to **Quebec City**, the tree lined slopes here attract hoards of city dwellers at weekends, making this a busy place to ride and while the resort can boast lots of rideable terrain, this is not the highest of resorts. Any resort close to a large city is often busy and suffers long lift queues, but thanks to the fast, high-tech lift system, these are greatly eliminated. Spread out it sud on three facing slopes, South, North and Side West, the trails cut through thick trees that stretch to the summit. The South Face offers the most challenging terrain, with a number of decent black and extreme runs, which will test both freeriders and carvers alike.

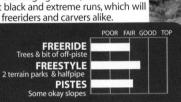

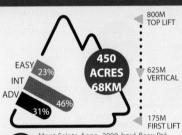

Mont-Sainte-Anne, 2000, boul. Beau Pré Beaupré (Québec) Canada, GOA 1EO

TEL: (418) 827-4561 WEB:www.mont-sainte-anne.com

EMAIL:info@mont-sainte-anne.com

WINTER PERIOD: Dec to May LIFT PASSES Half-day \$41, 1 Day pass - \$53 Night Pass \$25.5 of 6 days \$242. BOARD SCHOOLS 2hr \$43.45, 5 days \$199.95

HIRE board and boots \$29/day NIGHT BOARDING 4 p.m. - 9:45 p.m., 17 pistes lit

NUMBER OF PISTES/TRAILS: 63 LONGEST RUN: 5.7km TOTAL LIFTS: 13 - 1 Gondolas, 6 chairs, 6 drags LIFT CAPACITY (PEOPLE PER HOUR): 18,560 LIFT TIMES: 8:30am to 3:45pm

ANNUAL SNOWFALL: 4m SNOWMAKING: 80% of pistes

BUS services from Montreal, go to resort FLY to Montreal, 2 1/2hrs from the resort. DRIVE From Montreal, take Hwy 40 and drive north in the direction of Quebec. Exit at the junction for

route 138 and then take the R-360 to the resort. Montreal to resort is 180 miles. Quebec is 25 miles.

FREERIDERS of all levels should like Mont Saint-Anne, however, if you like to ride fast, you could get round this place in a day or two. All the slopes are carved out of closely knitted trees providing for some bumpy trails, but lacking in wide, open powder bowls. The south side slopes offer the most challenging runs with a cluster of fast double black diamond runs down the middle, one of which runs from the top all the way to the base and will burn up your thighs or make your eyes water if you bail. They've recently opened up the Black Forest area proving access to 20 acres of steep terrain.

OT TO

FREESTYLERS are free to roam the whole mountain, but may wish occupy any of the 2 terrain parks or the halfpipe. The main park is on La Grande Allee trail where there is a good series of man made hits and a well shaped 75 metre halfpipe with walls cut by Quebec's first Pipe Dragon. You'll find the other park located under the La Tourmente chair

PISTES. The pisted runs are well-suited to cranking over at speed. The most testing trails, including double black diamond runs, can be found on South Face.

BEGINNERS are provided with gentle green runs that allow riding from top to bottom on some very tame descents. If you stay here for a week, you should be very competent by the time you leave (a two-week trip might be a bit much, even for a novice).

OFF THE SLOPES. Mont Sainte Anne offers a very good selection of local services both at the base of the slopes or 25 miles away in down town Quebec City. Local lodging options are extensive with some 3000 visitor beds within a 3 mile stretch of the slopes. The main village is well set out and pleseant place to stay. There are a number of shops to serve your needs from boutiques to basic snowboard shops all mainly geared towards the casual visitor. The area also offers loads of other sporting attractions.

STONEHAM ...

Okay resort all round

Stoneham is one of the largest resorts in Quebec which forms part of the 'Resorts of the Canadian Rockies Group' who also own the likes of Lake Louse, Fernie and Kimberley amongst others. With such a pedigree one would expect Stoneham to have something good to offer, and indeed it does, as well as playing host to the FIS Snowboard World Cup. The 30 plus trails are spread out over a group of mountain faces with the slopes carved out of tightly knitted trees that grow over the whole area form the base up to the summits of each mountain area. Initial access to Stoneham is via route 73 from

Quebec City, which is only 20 minutes away. As you drive into the resort you are presented with a series of mountains peaks set out in a horse shoe like fashion that all base out together. In general Stoneham offers mostly simple slopes to suite beginners and intermediates. However, expert and advanced riders will find some okay terrain with a least six double diamond black trails to ride down. The 326 acres of terrain is serviced by 9 lifts with the highest area achieved by a quad chair up to 630 metres. The mountain faces are not exactly lift linked but you can easily travel around all the areas by the series of interconnecting trails. 183 acres of terrain, which equals 16 runs, is also used for night riding.

FREERIDERS will find that Stoneham offers a number of decent challenges making a weekend stay worth while. There are a series of double black runs that will provided a few white knuckle rides with trees and other obstacles to negotiate en-route down. However, Stoneham is not a powder mountain.

FREESTYLERS should note that Stoneham is not a mountain paved with loads of natural freestyle terrain however, the management have decided to address the balance by building a host of features which includes four large terrain parks loaded with all sorts of toys, including a boarder-cross run. The resort also has a Super-Pipe with 17 foot walls, located down a steep black slope on mountain 4.

PISTES. Riders have a resort that should appeal with a good selection of well groomed trails to choose from.

BEGINNERS will find that this is a good place to learn the basics of snowboarding. There are a number of novice runs that run from the highest points down to the base area.

OFF THE SLOPES. Stoneham offers a choice of condos and hotels beds at the base of the slopes. The Stoneham Hotel has double bed rooms from \$83 per night and comes with a bar and restaurant. As for night life, forget it. Although there are half a dozen good restaurants and a couple of okay bars, none are that hot and nothing rocks. For a full range of services you will need to stay down in Quebec City.

332 USQ WWW.WORLDSNOWBOARDGUIDE.COM

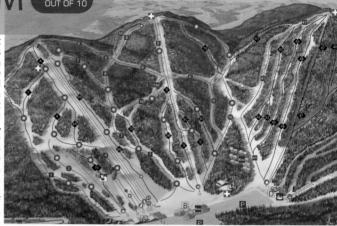

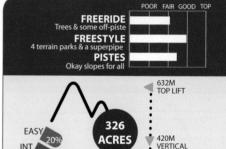

Stoneham Mountain Resort 1420, Hibou Road, Stoneham (Québec), Canada GOA 4PO TEL: (418) 848-2411

> WEB:www.ski-stoneham.com EMAIL:info@ski-stoneham.com

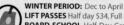

LIFT PASSES Half day \$34, Full day \$43, 5 of 6 days \$191 BOARD SCHOOL Half Day Group lesson \$36,51, Full Day \$56,51, Specialist park & pipe 3 day courses

212M

HIRE Board & Boots \$29
NIGHT BOARDING

16 trails, 184 acres, 15.6km of pistes open till 10pm, \$25

NUMBER OF PISTES/TRAILS: 32 LONGEST RUN: 3.2km

TOTAL LIFTS: 9 - 4 chairs, 4 drags, 1 Tubing Lift LIFT CAPACITY (PEOPLE PER HOUR): 14,200 LIFT TIMES: 8.30am to 4.00pm

ANNUAL SNOWFALL: 3.5m SNOWMAKING: 86% of pistes

exit at Stoneham. Follow road signs to the resort (6 km)

BUS routes to Québec City. Then, a shuttle service links up Québec City to the resort.

FLY to Montreal with a transfer time of 3 hours to the resort. You can also fly to Quebec City from Montreal.

DRIVE 20 minutes from Québec City. Take Highway 73 North and

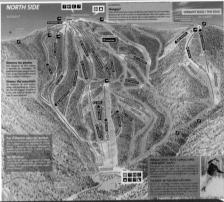

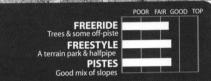

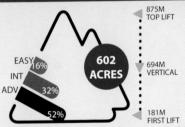

Mont Tremblant Resort, PO Box 240, 2001 ch. Principal Mont-Tremblant, Quebec, Canada J0T 1Z0

TEL: 001 (819) 425-8681 WEB:www.tremblant.com EMAIL:info@tremblant.com

WINTER PERIOD: Nov to April

LIFT PASSES Half-day \$47.75, Full-Day \$55.85 BOARD SCHOOLS 90 minute group lesson, morning

lesson \$50, afternoon \$57

HIRE Board & Boots \$32 per day, \$45 for top stuff SNOWMOBILES 3 hour tour \$149+\$49 for passenger

NUMBER OF PISTES/TRAILS: 94 LONGEST RUN: 6km

TOTAL LIFTS: 12 - 2 Gondolas, 9 chairs, 1 drags LIFT CAPACITY (PEOPLE PER HOUR): 27,230

LIFT TIMES: 8.30am to 4.00pm

ANNUAL SNOWFALL: 3.82m SNOWMAKING: 70% of pistes

BUS services from Montreal, go to the town of Tremblant.

FLY to Montreal, with a transfer time of around 2

DRIVE From Montreal, travel north along Hwys 15 &117, direction Ste Jovite, turning of at signs for Mont Tremblant. Montreal to resort is 91 miles, 2 hours drive time.

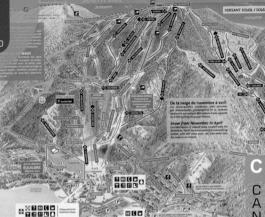

Tremblant is one of the largest boarding areas in east Canada and forms part of what is believed to be one of the oldest mountain ranges on the planet. Tremblant's organisational connections with Blackcomb, Panorama and also mighty Stratton in the US, helps them lay on a good time. The mountain's layout is excellent and extremely well planned, covering two sides, the South and the North which also has a new beginner slope running from the top to the bottom. The South side gives initial access to the runs which are all carved out of thick forest. The North side is a little smaller, but offers the same degree of cool riding. Both sides make up an area suited to carvers and freeriders, especially intermediate and advanced riders.

FREERIDERS have a really good mountain to explore, with plenty of white knuckle trails with drop offs, trees and powder. For some excellent tree-riding, go to Emotion. This area is graded a double black diamond trail, so it's not for the weak-kneed.

FREESTYLERS have a decent size halfpipe and park, located under the Express Flying Mile chair on the South side, and only takes a few minutes to reach. The park is well looked after and you also get to listen to some tunes blasting out of the P.A.

PISTES. Buckle up tight as you'll be able to show off in style on well-pisted trails with 'carve me up' written all over them. Geant, a long wide black run on the North side, is really fun, while Zag-Zag on the South side is a killer double black that tames out lower down.

BEGINNERS Tremblant offers more than enough for first timers, with easy green and blue runs on the South side. Take the Express Tremblant chair and novices can ride from top to bottom, via La Crette and Nansen green trails. If you're a late (in the day) starter then you may wish to have a late lesson; for around C\$20 you can have an evening instruction session.

OFF THE SLOPES. The village of **Tremblant** is only a few minutes from the slopes, although there are some slopeside facilities with a good selection of condos and hotels to choose from. Getting around is easy on foot, alternatively there is a daily local bus service. Food and drinking options are okay and night-time can be pretty rowdy, rocking 'til the late hours. But note this is not the cheapest of places, so expect to notch up some credits on your card.

ROUND-UP

BELLE NEIGE

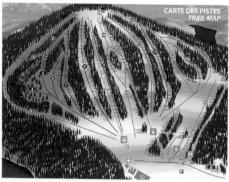

Number of Runs: 19 Easy 29% Intermediate 28% Advanced 43% Top Lift: 305m Bottom Lift: 150m Vertical: 115m

Total Lifts:4 - 2 chairs, 2 drags

Lift pass: Day pass \$28

Contact: Nos coordonnées, 6820, Route 117, Val-Morin (Qc) JOT 2R0

Tel: (819) 322-3311 www.belleneige.com info@belleneige.com

Ride Area: 202 acres Number of Runs: 52 Easy 25% Intermediate 23% Advanced 23% Expert 20% Info: Has 3 terrain parks Top Lift: 565m Bottom Lift: 180m Vertical: 385m

Total Lifts:5 - 4 chairs, 1 magic carpet Lift pass: 1/2 Day Pass - \$36, Day Pass - \$44

Night Boarding: 30 trails open Hire: Board & Boots \$33 per day

Contact:

150, Champlain, Bromont (Quebec), 1866 BROMONT • [450] 534-2200

www.skibromont.com operations@skibromont.com Location: From Montreal. On Highway 10, take Exit 78 towards bromont. Cross the traffic light on Boulevard Bromont and turn right on Champlain to SkiBromon, takes 45 minutes

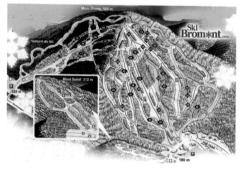

CAMP FORTUNE

Number of Runs: 17 Total Lifts:5

Contact: Camp Fortune, 300 ch. Dunlop, Chelsea, QC J9B 2N3 Tel - 819.827.1717 Fax - 819.827.3893

CLUB TOBO

Number of Runs: 6 Total Lifts:2 Contact: Tel: (418) 679 5243

COTES 40-80

Number of Runs: 6 Total Lifts:2 Contact: Tel: (514) 229 2921

EDELWEISS VALLEY

Has a terrain park & night boarding

Ride Area: 150 acres piste, 1300 acres total

Number of Runs: 18

Easy 33% Intermediate 48% Advanced 17% Expert 2%

Longest run: 1mile (1.6km) Night Borading: 12 out of 18 trails

Top Lift: 343m Bottom Lift: 152m Vertical: 191m

Total Lifts:5 - 4 chairs, 2 drags, 1 Magic carpet

Lift pass: Weekday Pass - \$32 Weekend Pass - \$34 Night \$23

Lift times: 8.00am to 10.00pm

Board School: Private lesson (1hr), lift pass & rental \$65 for day

Hire: Board & Boots \$28 per day

Contact: Mont Saint-Sauveur 350 Saint-Denis Saint-Sauveur,

Québec, JOR 1R3

Telephone: (450)227-4671 www.edelweissvalley.com

Directions: From Ottowa-Hull - 5-15 miles via routes 105, 307, & 366 to Edelweiss Valley.

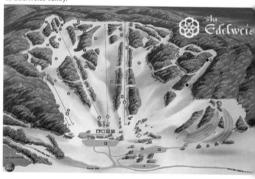

GRAY ROCKS

Number of Runs: 22 Easy 19% Intermediate 45% Advanced 36%

Vertical: 189m Annual Snowfall: 4.2m Total Lifts:5 - 4 chairs, 1 Magic carpet

Lift pass: 1/2 Weekday Pass - \$20 Weekday Pass - \$25 1/2 Day

Weekend Pass - \$25 Weekend Pass - \$35

Lift times: 8.00am to 10.00pm

Board School: weekend lessons \$105 for 2 days inc 6hrs lessons, lift &

hire 1/2-day (2hrs) lesson \$40, full day (4hrs) \$60

Hire: Board & Boots \$30 per day

Contact: Gray Rocks Resort & Convention Center, Mont Tremblant,

Tel - 1-800-567-6767 www.grayrocks.com

FLY: Fly to Montreal 1 1/2hrs away

BUS: Shuttles from Montreal Airport, tel: 1-800-471-1155

From Montreal (by car : 90 minutes / 120km / 75 miles) Take Autoroute 15 North until it merges with route 117 North at Ste-Agathe. Continue along route 117 and take the first exit for St-Jovite. At the first traffic light in St-Jovite, turn right on route 327 North for 5 km to Gray Rocks (on your right).

ROUND-UP

BLACKSTRAP

Blackstrap has just 8 runs with only 88 metres of vert with the longest run just making 450m., This small mountain is best for novices and slow intermediates. The resort also, provides a cool fun park with a few table tops and a halfpipe. . No slope side lodgings exist, the nearest accommodation and services can be found at Dundurn, Hanly and Saskatoon.

Location: DRIVING: Located 32km south of Saskatoon via Hwy 11 and Hwv 211

Contact:

Blackstrap Winter Sports Park Blackstrap Provincial Park Box 612 Mailing Address:

Dundurn Phone: (306) 492-2400

Fax: (306) 492-2401

BLUE MOUNTAIN

Located 32km south of Battleford, Blue; Mountain is a very small retreat that offers a host of sporting activities including some limited snowboarding. There is some basic accommodation on site as well as other basic amenities.

Location: DRIVING: 1 1/2 hours west from Saskatoon via Highway #16 and Grid # 687 north at the town of Denholm (which eventually turns into Highway # 378).

Contact:

Blue Mountain Outdoor Adventure Center R.R.

#1 North Battleford

Saskatchewan CANADA S9A 2X3 Phone (306) 445-4941

CUDWORTH SKI AREA

Located south on 6th Ave, Cudworth consists of just one 230 metre trail with just 24 metres of vertical with one tow. Accommodation and other facilities are available in Cudworth.

Contact:

tel- (306) 256 3281

LITTLE RED RIVER PARK

Located 3km east of Prince Albert via Hwy 5, Little Red River Park consists of just two runs and two lifts. One slope is of beginner level while the other is an intermediate trail. The are also ski patrol, snowboard Instruction and a halfpipe. Accommodation and other facilities are available in Prince Albert

1084 Central Ave, Prince Albert SK tel- (306) 953

MISSION RIDGE SKI AREA

Located 2km south east of downtown Fort Qu'Appelie

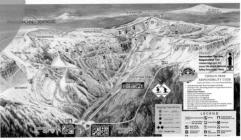

Mission Ridge, is a mountain with 8 runs, 92 metres of vert and 4 lifts. This small resort is a popular destination and can get busy. The area boasts a funpark and also provides night riding with special rates. Freestylers will find a 3.5 acre park featuring hip jumps, rails. Accommodation and other facilities are available close by in Fort Qu'Appelie

Number of Runs: 35

Easy 10%

Intermediate 60%

Advanced 30% Top Lift: 6.770 ft

Bottom Lift: 4,570 ft

Vertical: 2,200 ft

Annual Snowfall: 4.2m

Total Lifts:6 - 4 chairs, 2 drags Lift pass: Day pass \$40 Night Pass \$10

Lift times: 9 AM to 4 PM (4PM to -9PM select days in Jan & feb)

Location: FLY: Fly to seatle (140 miles away), local airport is Pangborn Memorial Airport

TRAIN: Amtrak serves Wenatchee, 12 miles away

DRIVING: From Seattle, Take U.S. Hwy. 2 east to Wenatchee and follow the signs to Mission Ridge, 138 miles.

Contact:

Mission Ridge P.O. 1668, Wenatchee, WA 98807-1668 Phone (509) 663-6543

PASQUIA SKI SLOPE

Located 12km south east of Zenon. Pasquia is a tiny hangout with 4 slopes, 1 tow and only opens for afternoon riding with private bookings. Accommodation and other facilities are available in Zenon.

RR Tisdaie, SK tel- (306) 767 2682

SKI TIMBER RIDGE

Located 5km south of Big River on Hwy 55, Ski Timber Ridge provides 5 trails, with the longest run at 800 metres and the max vert at 90 metres. You can also get snowboard hire and instruction at the slope with daily lessons and privates. Main accommodation and other local facilities are available in Big River which is only 2 km away and has a number of okay lodging options, good places to eat as well as a host of sporting activities

Number of Runs: 6 Total Lifts:2 Top Lift: 2600ft Bottom Lift: 1400ft

Hire:Boards available from rental shop on slopes

Board School:Board instruction available

Location: DRIVING: Located 32km south of Saskatoon via Hwy 11 and Hwy 211

Contact:

Ski Timber Ridge, Box 741 Big River, Saskatchewan (Canada) SOJ 0E0

STURGIS ASSINIBOINE

Located 1km south of Sturgis off Hwy 49, Tiny area offers five trails with a maximum vert of 36 metres and one drag lift. Very basic and limited local facilities are available in Sturgis 1 km away

TABLE MOUNTAIN PARK

Located 29km west of Battleford off Hwy 40. Eight trails. 107 metres of vert and 4 lifts make up this small hangout that also has night riding and a fun park. Local services and lodging available in North Battleford and Cut Knife

Contact: Box 343, North Battleford, SK tel. (306) 937 2920

TWIN TOWERS SKI AREA

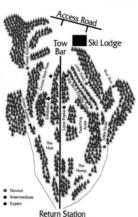

Only 3km south of Stranraer off Hwy 31. Twin Towers has six slopes, the longest being 853 metres. 91 metres of vertical and 2 lifts with a snowboard area and rentals on site. All local services availible in Herschel, Rosetown (58km), Kindersley and Plenty.

Number of Runs: 9 Lift pass: Day pass \$20 Half Day \$17 Season \$£240 Lift times: 10:00 am - 4:30

Total Lifts:1

Hire:Board & boots \$27 Location:

DRIVING:

Located 3kms South Of Stranraer on Highway 31 . 45 minutes from Biggar, Rosetown, Kindersley & Kerrobert

WAPITI VALLEY

Wapiti Valley is located 47 kms north of the City of Melfort and 24 kms south of Choiceland on Highway #6 to Codette Lake and the Saskatchewan River Valley.

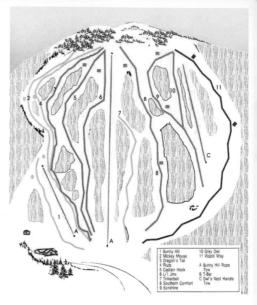

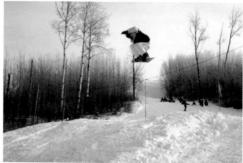

Number of Runs: 11 Easy 36% Intermediate 55% Advanced 9% Longest run: 0.7miles (1.2km) Verical Drop: 90m Total Lifts:3 - 1 chair, 2 drags Lift times: 9:00 am - 4:30 Lift Pass: Day Pass - \$20 1/2 Day Pass - \$15 Season \$199 Hire:Board & Boots \$25 per day

Board School: Private lesson 1hr \$25 Group lesson 1hr \$12-16 Location: DRIVING: Wapiti Valley is located 47 kms north of the City of Melfort and 24 kms south of Choiceland on Highway #6 to Codette Lake and the Saskatchewan River Valley.

Contact: Wapiti Valley Regional Park, P.O. Box 181 Gronlid, Saskatchewan, Canada, SOE 0W0

Telephone: (306) 862-5621 Fax: (306) 862-5621

WHITE TRACK

Located 27km from Moose Jaw in Buffalo. Its nine slopes are evenly split between 3 drag lifts and a maximum vert of 70m. All local services available in Moose Jaw, Chamberlain and Regina

Contact:

Box 702, Moose Jaw. SK Tel (306) 691 0100

USA

There are hundreds of resorts in the US spread out over the northern eastern states, the central Rockie states and the north western states, however, many are no more than a backyard affair operated by a dollar-hungry hillbilly.

The usual season lasts from November until mid-April, with a few northern areas staying open until mid-May. US resorts are generally much smaller than ones in Europe. However, the Rockies do have peaks that rise up to 3,000 metres.

Flights to US cities are frequent, with many having transfer flights to resorts. From various airports you can reach the resorts by bus (sometimes a free shuttle service), or by hire car. If you're touring around the US, you can fly very cheaply using an Air Pass costing from \$375.

Travel to a resort by train is limited in terms of direct routes. In most cases you will need to take a train to the nearest city and then transfer by bus. East coast resorts are the easiest to reach by train from international airports. A 30 day rail pass for unlimited travel costs from \$400.

Greyhound Buses operate the largest cross-country network of routes, with dozens of options. Like trains, it may be necessary to take a Greyhound bus to a city and then transfer by a local bus. A 30-day adult Ameripass costs from \$450.

Visa requirements vary, but generally, Europeans can enter without a visa and stay for 90 days. All foreigners need a valid passport. If you want to work in the US, you will need to obtain a work visa, which is difficult. If you are caught working without a visa, you will be deported.

CAPITAL CITY: Washington D.C. POPULATION: 298 million

LANGUAGE: English

LEGAL DRINK AGE: 21 (most states) DRUG LAWS: Cannabis is illegal AGE OF CONSENT: 16

HIGHEST PEAK: Mt.Mckinley 6194m

AGE OF CONSENT: 16
ELECTRICITY: 110 Volts AC 2-pin
INTERNATIONAL DIALING CODE: +1

CURRENCY: US Dollar (US\$)

EXCHANGE RATE: UK£1 = 1.9, EURO = 1.3,

NZ\$1 = 0.64, CD\$ = 0.9

DRIVING GUIDE All vehicles drive on the right hand side of the road

SPEED LIMITS: Varies per state

EMERGENCY Police/Fire/Ambulance - 911

General police enquiries 625-5011

TOLLS Called Turnpikes and payable on many highways **DOCUMENTATION** Driving licence and motor insurance must be carried.

TIME ZONE 5 time zones (see states) UTC/GMT -5 to -10 hours

USA SNOWBOARD ASSOCIATION

PO Box 3927, Truckee, CA 96160 Tel: (800)404-9213 email: karen@usasa.org web: www.usasa.org

TRAINS www.amtrak.com Tel: 1-800-872-7245
BUS/COACH www.greyhound.com Tel: 1-800-231-2222

Accommodation comes in the form of hotels, motels, guest houses and condominiums (apartments), which are reasonably priced and usually of a very high standards. A low cost option would be to stay in a youth hostel or a ski dorm.

Restaurants vary considerably in price from cheap to ridiculous, and remember that you are expected to tip in restaurants.

Proof of age is constantly required when buying alcohol, so keep some form of ID on you wherever you go. Baby-faced snowboarders forget it.

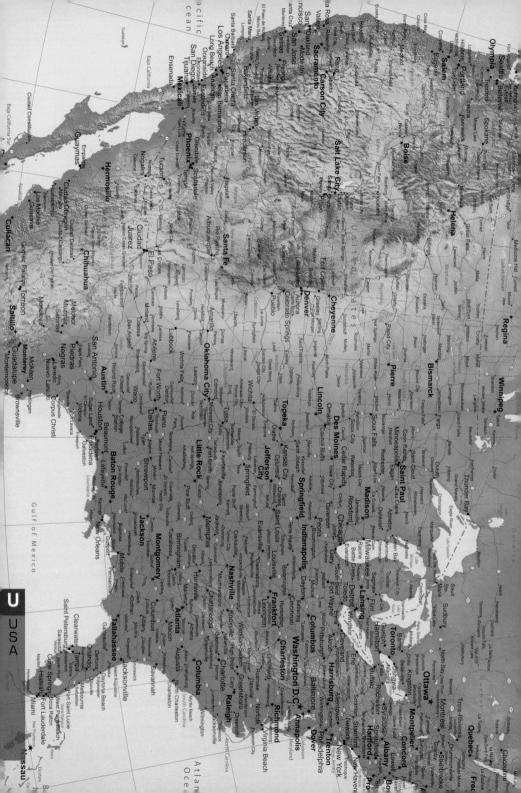

ALASKA

If you mention the name Alaska to most people, they will shiver with the thought of huge icebergs, wild snow cape mountain ranges and ridiculously cold temperatures.

In terms of terrain for snowboarding, most believe that the only people who can snowboard in Alaska are expert riders who know how to ride high altitude, steep, extreme back- country areas. While much of this is true with some 90% of the ridable terrain only accessible via a helicopter or by long hikes form barren and remote out-posts, Alaska is infact not just for a select few of big headed sponsored riders doing a video shoot, its a place that welcomes all riders no matter what you're ability, and although this is a very cold state with recorded low temperatures of -70°C, don't be put of. Alaska has all the modern resort facilities found in any other US snowboard/ski resort. The only

can ride, and two, you only ride in a group and with a local guide and are properly equipped with backcountry clothing and safety equipment.

Lots of companies run trips out of Valdez with day trips to week long holidays on offer. Blade Runner Adventures www.heliskiworld.com have some great prices with lower end accommodation keeping the cost down. 7 night and 5 days with the helicopter start at \$3300 with 6 drops /day. A day with 6000 metres of vertical decent is \$600. www.valdezhelicamps.com offer day trips at around \$700, up to \$4900 for a 6 day, 7 night package, with 80,000 vertical feet per six-day package guaranteed. It's lots of cash but it's not actually that expensive in the grand scheme of things. If cash is short you can mix the helicopter in with some snowcat boarding at \$200/day and if the weather is bad at least there are snowcats to get you up the hill. If you're in the UK you can book similar deals through www.

difference is that what Alaska offering are a lot more limited with infact only one major developed resort, Alyeska which is a fully developed resort with some 62 runs and many purpose built facilities at the base of the slopes (see next page). As well as Alyeska, there are a number of smaller ridable areas, but the remainder are very basic and are not resorts as we know them. They are more or less for locals and run by clubs and private companies. One thing to put a big smile on your face is the 20 metres of snow most of the resorts get on average.

VALDEZ

Where you won't get any of the standard resort set up style of services is in Valdez, which lies some 300 miles east of Anchorage. Valdez, which is actually a busy oil port, is the snow-boarders heaven and for the place for purist only. This is where backcountry, means 'Backcountry'. There are no lifts with lines of skiers in sad clothing and headbands moaning about snowboarders, no groups of ski classes getting in the way all over the place, no ski patrols, no marked runs, no pisted runs. Nothing other than pure virgin terrain that should only be ridden if one, you

eaheliskiing.com ensuring you can talk to someone on the phone who knows their stuff before departure. Trips run from Feb to April.

As for local amenities, accommodation and restaurants, Valdez is a hard town that is home to oil workers who can drink stupid amounts of alcohol and who don't give a shit what snowboard you ride. The town has a number of lodges and bed and breakfast homes with affordable rates. The Totem Inn is one of the main places to hang out in the evenings, where you can get a decent meal, shoot some pool or drink yourself stupid well into the night trying to keep up with the locals.

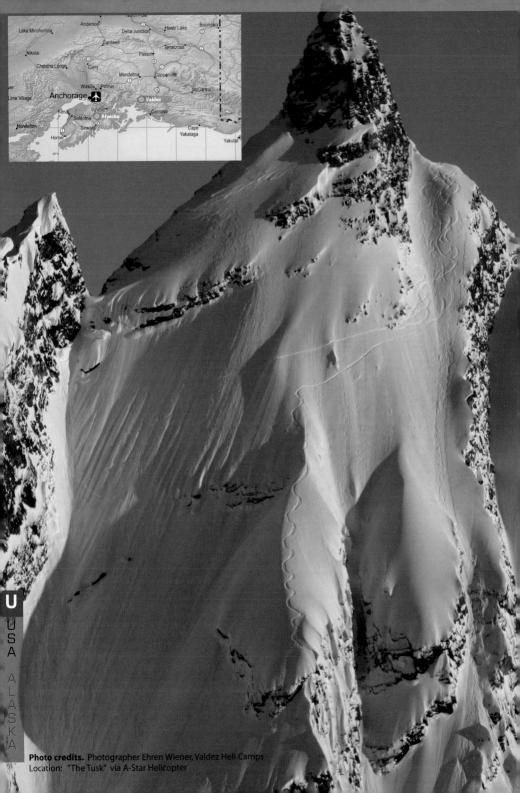

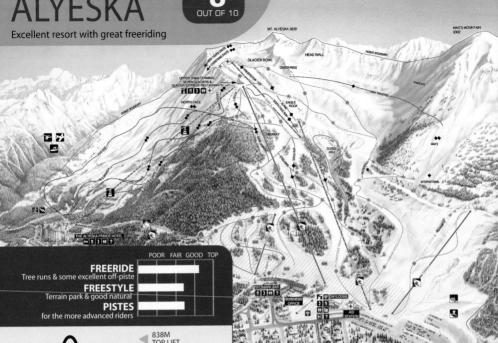

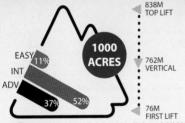

Alyeska Resort, P.O. Box 249, Girdwood, AK 99587 TELEPHONE: 907.754.1111

WEB:www.alyeskaresort.com

EMAIL: guestservices@alyeskaresort.com

WINTER PERIOD: late Nov to end April LIFT PASSES 1 day \$52, 1/2day \$37, 1/2 day & night \$45, Season \$1029

BOARD SCHOOLS 2hr group \$35, 1 hour private \$60 BOARD HIRE board and boots \$32-35day

NIGHT BOARDING Friday & Saturday 27 trails lit from 4:30 to 9:30 SNOWMOBILES 1/2 day to all day trip starts at \$150

HELIBOARDING 6/7 drops a day from Feb 14 to April 12 \$650pp

TOTAL PISTES/TRAILS: 68 LONGEST TRAIL: 2.4km

TOTAL LIFTS: 9 - 1 Tram, 6 chairs, 2 drags LIFT TIMES: 10.30am 9.30pm

ANNUAL SNOWFALL: 20m SNOWMAKING: 42% of pistes

CAR from Anchorage take New Seward Highway, take left to Alyeska Highway at mile 90 (after approx 40miles) and continue for another 3 miles until you see the sign. Total distance 45 miles, 50 minutes.

FLY to Anchorage Int (64km), transfer time to resort is 50 mins. TRAIN direct to Girdwood (Alyeska)

BUS There is a daily bus service between Alyeska and Anchorage run by Gray Line Buses. A return ticket cost from \$12 or \$8 single. Travel 40 miles south west of Anchorage and you will eventually arrive at the somewhat unusual, but interesting resort of Alyeska. It happens to be Alaska's only traditional purpose-built resort which, now celebrating its 40th year and has a lot going for it. Forget the impression of severe weather conditions and ice slabs that one normally associates with Alaska. What you find here is a great mountain, with excellent terrain serviced by a modern lift system and is spread out over a series of slopes that begin at almost sea-level. Over the years, places like Alyeska have been largely left alone by the mass holiday crowds. Hardly any ski guides or magazines feature this resort, which is a shame because despite its location in the far northern reaches of the US and Canada, Alyeska has as much to offer, if not more, than many Rocky Mountain-based resorts. A huge plus for this resort is not only its excellent snow record, with average yearly dumps of 20m, but also the fact that you can ride deep powder in early and late spring. The 1000 acres are excellent and offer something for every style and ability, especially advanced riders. The double black diamond runs on the North Face are a match for anything found anywhere else in the US. There's plenty of diverse terrain with a number of damn good bowls and gullies. Across the lower slopes are glades, while higher up you will find nice open slopes and well groomed trails.

FREERIDERS who know the score, have a damn fine mountain to check out with some very challenging terrain on offer. The double blacks on North Face will give you the chance to go wild at speed, as will the double black listed as Max's. There is also plenty of intermediate freeride terrain with lots of okay red and blue

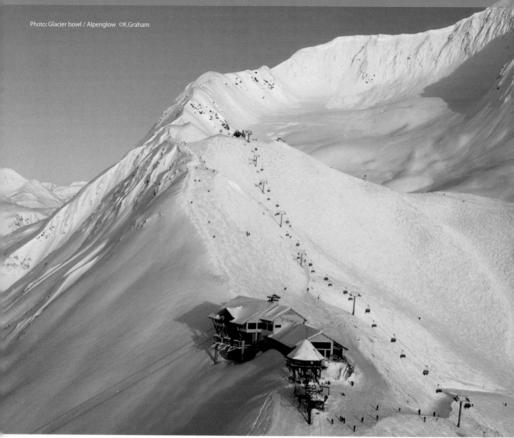

trails both on and off-piste. If you hike to the summit, you can gain access to the **Glacier Bowl** which has a superb descent down a wide, open expanse of deep snow. For those not content with the easy access slopes there is heli-boarding and snowcats tours in the **Chugach** mountain range, where you will get to see Alaska as it should be, wild, un-tamed, spectacular, orgasmic.

FREESTYLERS are well catered for here with an abundance of natural hits to get air, such as the nice banks on the **Mambo**. The resort also has a good terrain park located on the **Prince Run** which is furnished with a a few kickers and an arrary of rails and boxes. The park is floodlit.

BEGINNERS don't have a vast area of novice slopes but what is on offer is not bad especially on the lower areas off Lift 3. Avoid this area at the end of the day as it becomes the busy homebound route for everyone coming down off the mountain.

OFF THE SLOPES

You will find all the creature comforts required to make your stay a pleasant one and although not extensive, local services are very good. There is a good choice of lodging and eating joints conveniently located either at the base of the slopes or in the small town of Gridwood, a few minutes away by shuttle bus. The area also boasts an array of local 342 USQ www.worldsnowboardguide.com

activities ranging from river rafting, to para -gliding on skis or a board. You can even do a cruise around some of the glaciers or try your hand at salmon fishing.

ACCOMODATION. You can lodge at the base of the slopes, most notably in the **Westin Alyeska Prince Hotel** which is located just yards from the cable car's base station. Around **Gridwood** there's a good selection of condos and B&B's, but it's not the cheapest place to stay. The cheaper option is to lodge in Anchorage, which has a far bigger selection.

FOOD. Alaska my not be world renowned for its culinary skills, however, the choice and quality of restaurants along with fast-food outlets is particularly good in and around the resort. You can pig out on fine Cajun food at *Double Dusky's Inn*, or sample some well-prepared sea food at *Simon's Saloon*. The *Bake Shop* is a local's favourite for quick snacks, whilst the *Teppanyaki Katsura* offers traditional Japanese nosh, but at a price.

NIGHT-LIFE around **Gridwood** is somewhat tame, but nevertheless not bad. There is a decent selection of laid back hangouts. The *Sitzmark* and *Aurora* bars are well visited and lively spots. But if you want some real late night action, check out what's going down 40 miles away in **Anchorage**, where you are able to party hard.

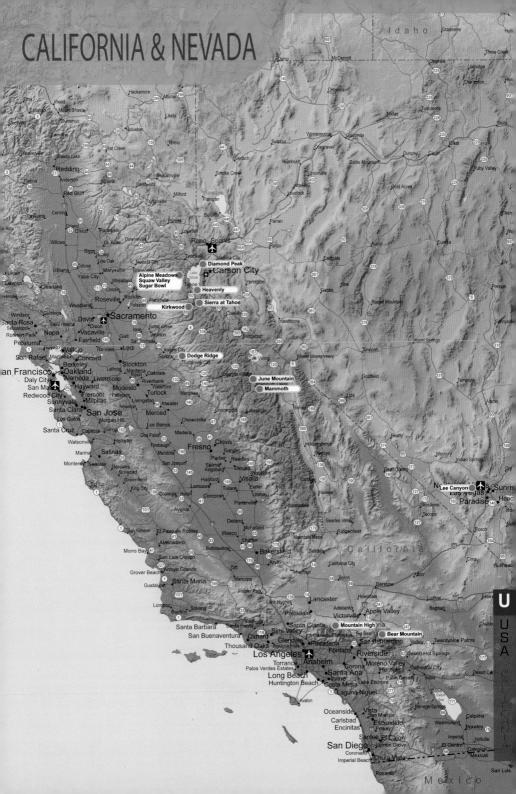

Alpine Meadows has some of North Tahoe's best terrain and should be an essential stop when ever you visit Tahoe. This is a no frills resort with only a car park, a restaurant and lots of high speed lifts, but what more do you need. Terrain is a big thing here and they have it big time, and what's even better, is they run an open boundary policy which is hard to find in North America.

Alpine Meadows has all sorts of natural terrain that lends itself to the specific needs of snowboarders. There is a wide variety of trails from beginner to expert, lots of tree runs, great off-piste with amazing views of Lake Tahoe, if you care to stand and stare. On a week-day, you will hardly ever stand in line for the lifts, giving maximum riding time and ample reason to rest and chill at one of the mountain restaurants. Combine all this with a very snowboard-friendly and generally mellow attitude, and you've got simply a magic place for all snowboarders.

FREERIDERS look no further this resort has everything to keep you smiling for many days. The summit six chair takes you to over 70% of the mountains terrain in just six minutes and also access to the back bowl which offers some nice hiking to some black diamond chutes. Alpine Meadows is also home of some of the best open tree runs in the area with some nice cliff drops if it takes your fancy. On powder days check out some awesome off-piste available from Scott chair and Lake View. Unlike other nearby resorts, Alpine has an 'open boundary' policy, meaning that providing the area boundary is marked 'OPEN', you can ride wherever you desire. However, you must observe all 'CLOSED' signs, or

risk riding in dangerous areas and losing both your lift pass and your life. If you are prepared to explore at Alpine you will find some excellent powder, long after a storm - it's worth hiring a guide for the day. Intermediates can enjoy long cruises from the Roundhouse detachable quad, and also over the back of Alpine on Sherwood, where the best early sun can be found.

FREESTYLE Alpine has two terrain parks which are well maintained by the mountain and the local boys who are super friendly. The super pipe is also well looked after with a daily cut. The rails are all standard orientated with a long C rail for the big boys. For those who like their hits spread naturally across the mountain, you may need to ask a local where the best ones are located as they are not always obvious but are in abundance. Be sure to use a spotter for reasons of safety.

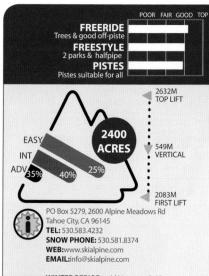

WINTER PERIOD: mid Nov to early May LIFT PASSES Half-day £39,1 Day pass \$41, Holiday dates \$49. Season \$1240 BOARD SCHOOLS

BOARD SCHOOLS

2hr 15min group lesson \$42, Full day pass, lesson & hire equipment \$99, Private lesson 1hr \$90

HIRE Standard package 1day \$38, Premium \$48

NUMBER PISTES/TRAILS: 100 LONGEST RUN: 4km

TOTAL LIFTS: 14 - 11 chairs,2 drags, 1 magic carpet LIFT CAPACITY (PEOPLE PER HOUR): 15,000

LIFT TIMES: 9.00am to 4.00pm MOUNTAIN CAFES: 3

ANNUAL SNOWFALL: 11.6m SNOWMAKING: 80% of pistes

CAR From Reno take Interstate 80-West to Truckee (45 miles) then 5tate Route 89-South exit (10 miles), then right onto Alpine Meadows Road (3 miles). Drive time is about 11/2 hours.

FLY to Reno International, transfer time to resort 1 1/2 hours. 4 hrs from San Francisco

TRAIN to Truckee, 6 miles away

BUS from Reno takes around 1 hour. A Grey Hound bus from San Francisco takes 5 hours via Tahoe City, 6 miles away. Free Ski shuttle buses run from most Tahoe towns (tel 530.581.8341.)

344 USQ www.worldsnowboardguide.com

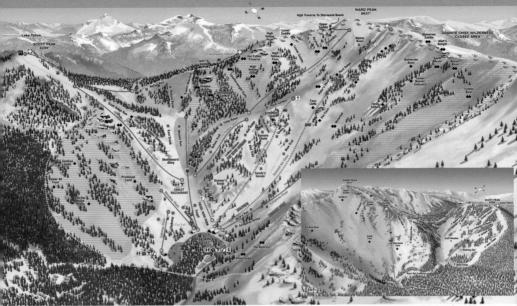

THE PISTES are just great with super smooth corduroy slopes all over the mountain. The best advanced and intermediate stuff is off the Summit chair lift, where you will find some nice blacks that mellow out into blue trails for some real fast descents.

BEGINNERS once you've managed to link your turns you have a good area to take things that little bit further. The hot wheels chair takes you to some easy going terrain. The beginner's slopes are found at the base station which is handy to grab a quick a beer on the massive balcony if you need a break. The local ski-school offers a high level of tuition, with a full day's package costing from \$56. Novice's can even have freestyle lessons

OFF THE SLOPES. Alpine Meadows, doesn't have any real slope side services. However, just about anything you need can be found in nearby Tahoe City. Tahoe City has a surplus of accommodation, eating out and sporting facilities. There are loads of

shops, including loads of souvenir outlets so beloved by tourists and skiers. With the Tahoe area being so popular, it is quite possible that you could be hanging out, on or off the slopes, with some of the biggest names in snowboarding as a number of pros live in the area.

ACCOMMODATION can be found in Truckee and Tahoe City, 6 miles away. It's a bit of a trek but you can often get great deals in Reno also known as the "mini Vegas". Cal-Nev resort at \$79 per person is quite expensive, but this place has history and used to be owned by old blue eyes himself. You also get great views over lake

Tahoe www.calnevaresort.com . In Reno, the Circus Hotel (www.circusreno.com) and Harrah's (www. harrahs.com) are good. Many hotels offer excellent room & lift pass deals, especially mid-week.

FOOD.If you can't find anywhere in this area to suit your taste buds, then you have a serious medical problem. There are loads of eating outlets in every price range - the choice and range are excellent. For a decent breakfast before hitting the slopes, check out The Alpine Riverside Cafe. For good food at reasonable prices, check out Bridgetender or the Mandrian Villa in Tahoe City. Jasons Saloon also serves up some decent nosh.

NIGHT-LIFE here is pretty cool with lots of night spots in the area. Partying options are great, with excessive drinking and chatting up of local birds made easy. Some of the best talent can be found in places such as Naughty Dog, Pierce St Annex, or Humpty's. The River Ranch, which is en-route to Alpine, is also noted for being a lively place.

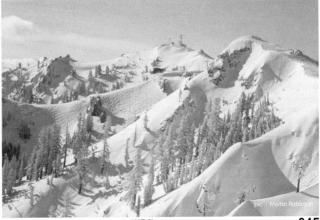

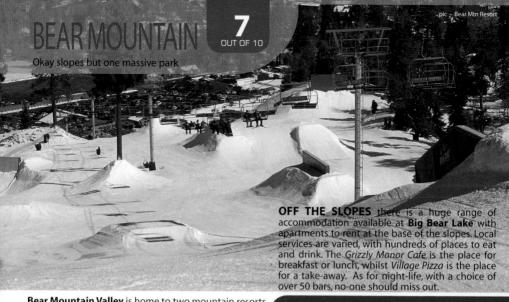

Bear Mountain Valley is home to two mountain resorts, Big Bear and Snow Summit. Both play host to numerous top snowboarding events including the Annual Board Aid Festival at Snow Summit. As a rule, resorts' marketing slogans are trite and meaningless, but Bear Mountain's billing as a 'Good Time' place is quite accurate. Anyone who has ridden the parks or pipes, and afterwards sat in the sun on the outdoor deck for lunch. would be hard-pressed to dispute this claim. Part of the deck's inherent allure is the fact that riders need a place to kick back after spending time on Bear's slopes, where vertical is the name of the game. The high speed quad, Big Bear Express, reaches the top of Goldmine Mountain in about seven minutes, where you can ride the Claim Jumper trail to notch up over 500 vertical metres. Bear Mountain offers riding for all abilities, from carving to freestyle and all species in-between. Big Bear is a black diamond bliss but also okay for intermediates.

FREERIDERS have a good choice of areas to ride. The double black diamond Geronimo run is a real tester. however Gambler, a nugget most riders never find off the top of Showdown Mountain, is also super cool.

FREESTYLERS are in their element as almost every run features a jump or rail. The entire 195 acre Bear mountain has become one big park with up to 150 jumps and 80 jib objects littered around. The halfpipe and superpipe sit alongside each other and are located near the base and Big Mountain Express chair.

PISTES. Lovers of the groomed slopes have a number of good trails to cruise, although in fairness the resorts not the best for super fast cranking it over trails. For a quick burst plus a show-off, check out Grizzly, a short but steep trail.

BEGINNERS, Bear is an excellent place to learn. The local snowboard school offers an introduction to Snowboarding scheme, and a Vertical Improvement Program for riders who want to enhance their carving and jumping skills. Kids under 9 can also sign up for the magic Minors Snowboard Camp.

POOR FAIR GOOD TOP **FREERIDE** Some trees but little off-piste **FREESTYLE** 198 acre park & 2 halfpipes **PISTES** Short and sweet 2685M TOP LIFT EAS 507M VERTICAL 2177M FIRST LIFT Bear Mountain Resort P.O. Box 6812, Big Bear Lake, CA 92315 TEL::909.585.2519 WEB: www.bearmtn.com EMAIL: info@bearmtn.com WINTER PERIOD: Dec to April LIFT PASSES

full day \$49/62

BOARD SCHOOL 2 hours \$30 group, 1 hour private \$85 RENTAL board and boots \$30/day **NIGHT BOARDING**

1/2 Day Pass\$39/50 low/high season

Westridge terrain park open Friday & Saturday nights until 9:30pm

NUMBER OF RUNS: 32 LONGEST RUN: 3km TOTAL LIFTS:12 - 9 chairs,3 drags LIFT TIMES: 8.30am to 4.00pm

ANNUAL SNOWFALL: 2.54m SNOWMAKING: 100% of slopes

FLY to Los Angeles, with a transfer time of around 2 hours. BUS services from Los Angeles can be taken to the resort. CAR From Los Angeles, use Interstate 10 east to Redlands. Then Hwy 15 north to San Bernardino and west on route 18..Los Angles to resort, 99 miles., 2 hrs drive.

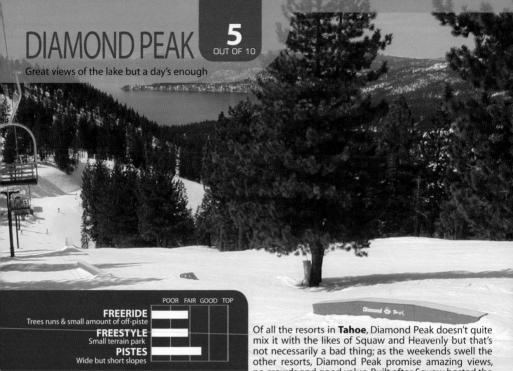

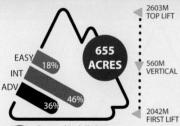

Diamond Peak Ski Resort 1210 Ski Way, Incline Village, NV 89451

TEL: - (775) 832-1177 WEB:www.diamondpeak.com EMAIL:info@diamondpeak.com

WINTER PERIOD: Dec to April LIFT PASSES Half day \$35, \$46 adult day, \$535 adult season, \$58 family day ticket **BOARD SCHOOL**

Private lessons from \$75ph, groups \$55 - \$72 for 1.45hrs. HIRE Rossignol step-in bindings. 34S per day for full kit

NUMBER OF RUNS: 30 LONGEST RUN: 4km TOTAL LIFTS: 6 - all chairs LIFT TIMES: 9.00am to 4.00pm **MOUNTAIN CAFES: 2**

ANNUAL SNOWFALL: 7.5m **SNOWMAKING:** 75% of slopes

BUS Ski buses pick up from many locations around

FLY 35 miles from Reno/Tahoe Airport

CAR From San Francisco or Sacramento - Take I-80 East to Truckee. Take HWY 267 exit to North Shore Lake Tahoe. At HWY 28 junction, turn east to Incline Village. Turn left on Country Club Drive. Take Ski Way to the top.

no crowds and good value. Built after Squaw hosted the Winter Olympics in 1960, and extended to its current size in the 80's. Diamond Peak is a resort that places a strong emphasis on fun, families and snow, and they succeed in many ways as this is a cool hang-out that attracts all ages with the slopes getting a good annual snow covering. The slopes are set out in a simple manner with a good mixture of runs spread out over the whole mountain. Being a guiet resort, the trails don't get busy and there aren't long lift lines, but most of the lifts are painfully slow, but does give you plenty of opportunity to sample the amazing views of Tahoe.

FREERIDERS who can cut the mustard, will find the longest and most challenging terrain up in the area known as the Solitude Canyon, which is reached off the Crystal Express chair. But note you are not allowed to go past the marked boundary and if you do you will be prosecuted, so study your lift map.

FREESTYLERS head for the terrain park located half way along **Spillway**. Its a small park with around 4 kickers, but they're removing the halfpipe for the 2007 season to provide more space for jumps. Its not fenced off so you get a lot of idiot skiers ruining your approach. Up at Lakeview theres a rail park, again nothing too taxing.

BEGINNERS, the **school yard** run the obvious place to start. There is a special lift pass available that only covers the 2 beginner lifts and will save you a lot of money. Some of the other lifts have such as Ridge have a nice steep exit as you leave the lift, so its worth spending a while watching the beginners clatter into each other while you do up your bindings.

OFF THE SLOPES there's no accommodation at the resort but Incline village has the closest hotels or there's plenty around Tahoe.

this relatively new resort be of much interest? After all. it's only been going for 15 years. Well Dodge Ridge has some 60 trails with 12 lifts which take you over a mountain that has a lot to offer, especially advanced riders, with a good series of double black diamond runs such as the trails that can be found off of lift 3. The slopes are well maintained and well set out offering something for all levels with a good mixture of trails.

FREERIDERS who like to experience rough, hard core and fast terrain will like what they find here. There is a good selection of expert runs to take on with the most interesting being the Six Shooter and the Sonora Glades, which is a tricky steep section with heaps of trees. Little more sedate trails to try out are the Sunrise or the Exhibition while the **Gentle Ben** is even easier.

FREESTYLERS have had a halfpipe and terrain park here for years. The Discovery way park is set up for beginners located just off chair 6 while half pipe at Center Bowl off of Chair 5 is 300 foot long. For jibbing head to Rockys road top of chair 7 and if board cross is your thing then Ry's Run under chair 3 will tickle your fancy. All the hardend freestyles hang out at the Sunrise park off chair 8 where there's some mean arse hits.

PISTES. Fast riders have a couple of cracking trails to let loose on, namely the Sunrise if you have the balls or the Quicksilver which is a nice long blue trail off lift 8. Fools Gold is another cool fast trail.

BEGINNERS will find the best areas to take on are located at the lower sections of lifts 2 and 1. Please note that these are novice areas and although tame, should not be at speed.

OFF THE SLOPES things suddenly change and become a little different as well as very basic indeed. Local services, provided in nearby town of Pinecrest are very good with good rates for accommodation

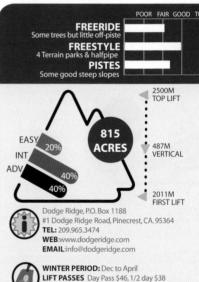

HIRE board and boots from \$35/day, helmet \$10/day

LONGEST RUN: 3.2km TOTAL LIFTS:11 - 9 chairs, 2 drags LIFT CAPACITY (PEOPLE PER HOUR): 15,700 LIFT TIMES: 9.00am to 4.00pm

ANNUAL SNOWFALL: 7.5m-12m SNOWMAKING: unknown

NUMBER OF RUNS: 59

FLY to San Francisco, transfer is 2 1/2 hrs BUS services from San Francisco available.

CAR 30 minutes from Sonora: 90 minutes from the Central Valley; 3 hours from the Bay Area. Directions: 580 East to

the 205 East past I-5 and 99. At Manteca take 120 East toward Sonora. Stay on the 120/108 through Escalon to Oakdale. At Oakdale turn left on 108 East to Sonora. Stay on 108 East through Sonora to Pinecrest (30 miles). Turn right on Dodge Ridge Road.

Great all-round resort with some excellent steeps

This is an over hyped resort, but its the only one where you jump on a Gondola straight from town without need for any transport. The gondola that runs from downtown South Lake Tahoe makes access to the mountain so much easier, but you still can't board back down . Heavenly is a large resort that stretches across the two states of California and Nevada. Heavenly has over 40 years of operation under its belt, as well as some of the largest snowboard/ski acreage in the US, and by far the biggest vertical out of the Lake Tahoe resorts. Snowboarders are drawn from afar, especially at weekends and during holidays. In the past, the International Snowboard Federation has held world cup events that have attracted riders from around the world, who came for the challenge of a big mountain with

POOR FAIR GOOD TOP FREERIDE Trees & good off-piste **FREESTYLE** 4 Terrain parks & halfpipe **PISTES** Huge number of excellent slopes

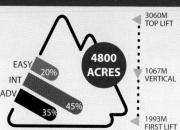

Heavenly Mountain Resort P.O. Box 2180, Stateline, NV 89449 TEL: (775) 586-7000

WEB: www.skiheavenly.com EMAIL: info@skiheavenly.com

WINTER PERIOD Nov to April LIFT PASSES 1 Day \$44,3 Days \$120,6 Days \$192 BOARD SCHOOLS 2 hour group \$35, 1 hour private \$60 HIRE from \$32/day

SNOWMOBILES Yes

NUMBER OF RUNS: 86 LONGEST RUN: 8.8km TOTAL LIFTS: 29 - 1 Aerial Tram, 1 gondola, 18 chairs, 8

LIFT TIMES: 8.30am to 4.00pm **MOUNTAIN CAFES:** 7

ANNUAL SNOWFALL: 8.64m SNOWMAKING: 69% of slopes

CAR From Reno take highway 395 to Carson City, then highway 50 & follow the signs (58 miles) From San Francisco take highway 80 through Sacramento, then highway 50 to tahoe

FLY to Reno via Carson City, Heavenly = 58 miles (93). Drive time is

TRAIN Nearest station at Reno

BUS A bus from Reno takes 1 1/2 hours. A Grey Hound bus from San Francisco takes 6 hours via South Lake Tahoe, 6 miles away. Ski buses do a morning pick-up from many towns & hotels around Tahoe area.

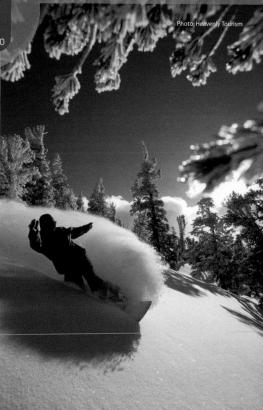

hardcore terrain. However, Heavenly is not just for the pro's - there is something here for everyone - but the slopes do favour riders of intermediate and advanced levels, with steeps and big air possibilities on double black diamond runs, like those of Mott & Killebrew Canyons and the Gunbarrel.

FREERIDERS will find the most challenging terrain is located on the Nevada side of the resort in the Milky Way bowl. However, it does become tracked out very quickly and would be best left until just after a fresh dump. Still, the Milky Way Bowl is major and offers some great powder. Advanced riders who like their slopes steep and covered with trees should check out the North Bowl. But for those who really want to fill their pants should make for the white-knuckle rides on the Mott & Killebrew Canyon area. Here you will find a series of expert double black diamond runs through a series of chutes. For something a little less intimidating try the blues off **Tamarack** and **Sky** chairs.

FREESTYLERS. Well kick my free style arse into space , freestylers are not only provided for but are welcomed with a big hug. Four claimed to be new but really just improved parks where opened last year. Spreading out across both sides of the mountain the parks can offer all level of riders a place to hang out and progress slowly. The Groove Terrain Park is the perfect stomping grounds to learn the basics. Cascade Terrain Park is the intermediate park the stepping stone between the Groove park and the high flying hits of the High Roller

USQ www.worldsnowboardguide.com 349

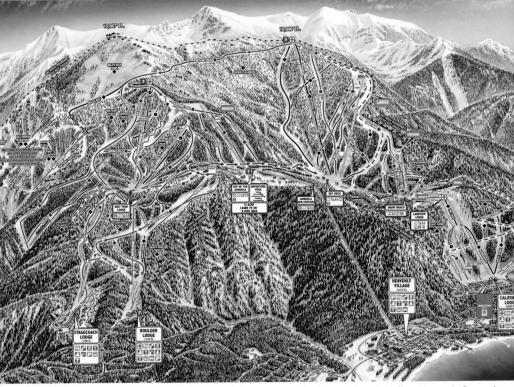

Terrain Park, Jibbers have there own hang out in the Rail Yard Terrain Park which evolves as the season progress's

PISTES. Riders of the piste are not to be outdone, since Heavenly is a highly rated as a groomed resort. There are plenty of well prepared pistes for laying out big tracks on, such as Liz's and Big Dipper

BEGINNERS may at first feel a little left out with the lack of green runs. However, there are plenty of excellent blue trails to check out. Be aware that in various areas there are a number of blacks that turn off and drop away from some of the easier trails, so check your piste map. The cluster of greens off the Waterfall lift, on runs like Mombo Meadows, are good for whetting the appetite before trying the blues off Ridge and Canyon lifts.

OFF THE SLOPES, local action is lively and plentiful. The choice of accommodation, eating and booze joints is massive and many within easy reach of the slopes. However, local services are a bit spread out and having a car here is a must. Locals make you feel at home and services are of a very high standard. However, the popularity of the area does mean that the place can be excessively busy, especially at weekends. South Lake Tahoe has heaps of shops and loads of sporting facilities

ACCOMMODATION: Although there is lodging within walking distance of the slopes, it is very expensive. South Lake Tahoe is heaving with hotels and motels from very cheap to very expensive. If you are on a budget try 'Doug's Mellow Mountain Retreat' (916) 544 8065 at \$13-\$15 per night for a small dormitory. The Blu Zu Hostel 4140 Pine Park (916) 541 9502 \$15 per night for a bed in the dormitory.

RESTAURANTS are plentiful and at prices to please everyone, there are also various fast-food joints. Every type of food is available here from Chinese, Italian, Mexican to standard American fair. It's all on offer. The list of good eating places is too long to mention in this short journal, but loadls will point you in the right direction if you ask for some recommendations. In the meantime Red Hutt or Chris's are both good.

NIGHTLIFE in Heavenly is dull. However in South **Lake Tahoe** there is plenty of gambling if that is your thing and many of the casinos have nightclubs. Some of the better ones are Club Z and Nero's. Hoss Hogs host some great band nights and Mulligans Irish bar is always a favourite for late night drinking.

often not found in even in many larger resorts. It's as though some of the best mountain features have been selectively picked and welded together to form a neat package that is user-friendly to a multitude of disciplines. This place has something to offer carvers, freestylers or freeriders of any level. There is a welcome blend of energy-sapping steeps and mellower stuff perfect for cruising. Because of the small size of June it doesn't have package tour status and it has a minimal number of ski schools, making the place a bit of a secret for those in the know and leaving you without lift queues even in peak periods. This all makes the place sound a bit like something resembling heaven, and in many respects it is, especially if there's been a dump and if the park and pipe have been recently re-shaped. Having said that, June can't offer the variety of the decent larger resorts. Nevertheless, if you don't mind riding the odd run more than once and having to take one foot out along some of the flat green runs, you will get a lot out of the relaxed attitude here, away from the big resort experience.

FREERIDERS can feel free to use any of the perfectly good pistes if they wish, but when there's trees-a-plenty to circumnavigate like there is here, you'd be mad to limit yourself. At June Mountain Summit are some steep natural chutes and bowls. From the June Meadows Chalet those who can should be sure to drop off blind in to Gull Ridge for a tasty black run or two back down to June Lake.

FREESTYLERS fortunate enough to find themselves at June have at their disposal a world class half pipe in front of June Meadows Chalet and the Boarder Town Snowboard Park located on Gunsmoke off of lift J4. This fantastic board park is out of bounds to bi-plankers, a testament to June's snowboard policy, and consists of about 20 hits, tabletops and banks of all sizes plus another half pipe upon which those skills can be honed. Mambo park is good for the beginner while Sunrise park is a mile and a quarter of mid sized hits and rails. In total we're talking 40 acres of dedicated freestyle terrain.

PISTES. The resort has a lot of well-groomed slopes to take advantage of, suiting an array of styles. The selection of black rated slopes from June Mountain Summit are great for the speed freaks to let loose, while the green and blue runs down from Rainbow Summit offer something far less daunting. Beware of some very flat green sections around the middle elevations.

BEGINNER freeriders can take their time on a few gentle, un-crowded slopes. This can be attempted alone or under the laid back tuition of the instructors available. For those novice freestylers who wish to learn the art of the pipe there are also instructors around to teach you what you need to know. In fact, not just the novices need benefit from their guidance as upper level tuition is offered too.

OFF THE SLOPES June Mountain resort; the population is a mere 600. It's a very relaxed community and there are a number of cabins and motels at which to stay, as well as plenty of fine eateries.

Small but perfectly formed

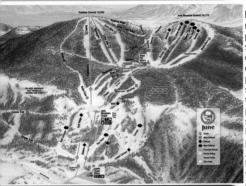

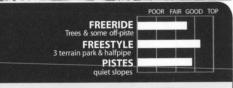

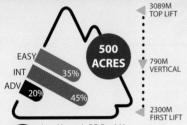

June Mountain.P.O. Box 146. June Lake, California 93529 TEL: 760.648.7733

WEB: www.iunemountain.com EMAIL: junemtn@gnet.com

WINTER PERIOD: mid Dec to April

LIFT PASSES 1/2 Day Pass \$41, Day Pass \$53, 5 of 6 Day

Pass \$182, Season Pass \$650

BOARD SCHOOL

Beginner package lesson, pass & rental \$140 a day. Lesson only \$80. Private lessons \$75 per hr HIRE Board & Boots \$30 per day

NUMBER OF RUNS: 35 LONGEST RUN: 4km TOTAL LIFTS: 7 - 6 chairs. 1 drag

LIFT TIMES: 8.30am to 4.00pm

LIFT CAPACITY (PEOPLE PER HOUR): 10,000 **MOUNTAIN CAFES: 2**

ANNUAL SNOWFALL: 5.3m SNOWMAKING: 10% of slopes

FLY to Reno, a 3 1/2hr trip south. Mammoth has a small airport.

San Francisco/Vegas about 7hrs drive.

CAR From Los Angeles: Hwy 14 to Hwy 395 north to Hwy 158; 327 miles. From San Francisco & Sacramento: Interstate 80 to Hwy 50 to the Kingsbury Grade cutoff to Hwy 395 south to Hwy 158: 300 miles

Kirkwood has the reputation of being an advanced rider's mountain, as proved by their hosting of the North American Freeride Championship, In 2005 Kirkwood (and most of Tahoe's resorts) boasted having "The biggest snow base in the WORLD"!: a truly epic season with over 20m of snowfall. With an array of double-black diamond trails, good back country access gates, and the highest base elevation in the area, this resort is a 'powder hounds' dream. Although Kirkwood has some rather long, slow chair lifts, it is far less crowded than any other resort in Tahoe, leaving fresh lines to be had all day long. In addition to its amazing 'fill-ya-pants' freeriding, Kirkwood has excellent pistes and some full-on freestyle terrain. It is located a little south of Lake Tahoe. along Highways 88 and 89, and is about a half-hour drive from the resort of Heavenly.

FREERIDERS in particular will get stoked with the natural terrain Kirkwood has to offer. Areas like The **Wall** and **The Sisters** reachable from Chair 10, accessing some very serious drops and chutes, in addition to an abundance of other black and double black diamond runs, will make those hardcore freeriders feel like a kid in a candy store. If it's big open bowls you enjoy the most, head out towards **The Wave** and **Larry's Lip** accessible from Chair 4. And if that's not enough to get your whistle wet Kirkwood now offer back country Powder Cat Riding tours at very reasonable prices. Do be careful not to venture into these areas if you're not up to the mark as they are strictly for experienced riders only.

FREESTYLERS will be more than happy with Kirkwood's Stomping Grounds terrain park. Accessible from Chairs 5 and 6, here you will find a range of advanced features with different jump and jib lines continuing on to the **Sierra Mist Super Pipe**. There is also a good beginner's terrain park found off of Chair 7, called the **Terrain Garden**. Those freestylers that like to explore will discover plenty of natural hits and drops all over the place.

PISTE riders are presented with some first class carving terrain that is a match for anywhere else in the Tahoe region. If you like long, steep groomers, runs like **Zachary** and **Olympic** from Chair 6 will keep the heart pumping. For something a little less daunting check out some of the blue runs off of Chair 2.

BEGINNERS need to get their act together fast if they want to appreciate Kirkwood's offerings to the full. Although Kirkwood only has a small percentage of easy trails, there are some good 'learn-to-turn' areas to be found over on Chair 9, like **Graduation** which has its own easy-to-use lift. If you're feeling up for a bit more of a challenge head up Chair 7 for some easy blue runs. When you make it back down to the Timber Creek Lodge have a killer hot-dog at the cafe whilst enjoying the view.

OFF THE SLOPES there isn't much in the Kirkwood Mountain Village itself, apart from a few quiet bars, small eateries and some rather expensive accommodation. Your best bet is to stay in South Lake Tahoe town, where you can find something to suit all holiday 352 USQ www.worldsnowboardguide.com

Photo: Cory Rich, Aurera Pfiotos

Set 30 (01) [25] 41 [3]

budgets, and rent a car to drive the short distance to Kirkwood, but don't get caught out in a snow storm as the road can close very quickly. They do also operate a daily \$5 bus service with pickup points around Tahoe.

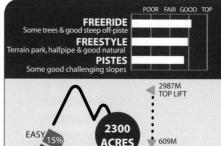

Ki Ki

1501 Kirkwood Meadows drive

Kirkwood, CA 95646 TEL: 209-258-6000 WEB www.kirkwood.com

EMAIL: info@kirkwood.com

WINTER PERIOD: Dec to April

LIFT PASSES \$65 Day, \$49 Half Day, \$469.00 Season Pass **BOARD SCHOOL** Beginners day package (pass, lesson,

VERTICAL

2377M FIRST LIFT

hire) \$80.2hr group \$40. Private \$90 per hour. Pipe & park lesson \$25 Backcountry clinics & specialist courses on tackling steeps available for \$100 per day

HIRE board and boots \$37, helmet \$5

BACKCOUNTRY

2.5hr CAT tours available to Martin Point and Red Cliffs for \$150 and \$100 respectively per person. Price includes beeper. Tel: 209.258.7360

NUMBER OF PISTES/TRAILS: 65 LONGEST PISTE: 4m

TOTAL LIFTS:12 - 10 chairs,2 drags LIFT CAPACITY: 17,905 people per hour LIFT TIMES: 9-3.30pm

ANNUAL SNOWFALL: 12m SNOWMAKING: 10% of pistes/trails

BUS Day trips from San Fran possible, shuttle buses run from Tahoe \$5

FLY to Reno, 70 miles from the resort BUS from Reno, takes 90 mins

CAR From Reno take the US route 395 south and then state route 88 west to Kirkwod. Reno to resort is 70 miles,

From S.Tahoe, take US50 (Lake Tahoe Blvd.) West. Turn left onto US50W/Hwy 895(Emerald Bay Rd) approx Smiles to Meyers. Continue Hwy 895outh for 11 miles then onto Hwy 88 West for 14 miles, then, turn Left onto Kirkwood Meadows Drive.

Not many people will know this or indeed will believe it, but yes it's true, it's a fact, it exists: a snow-capped mountain to ski and ride on just outside the world's gambling heaven Las Vegas. Lee Canyon is a tiny resort only 45 miles from the Las Vegas Strip. To give some perspective, its total

FREERIDE

FREESTYLE

PISTES

Trees but no decent off-piste

Basic Terrain park & halfpipe

POOR FAIR GOOD TOP

40 acres are about half the area of Mammoths terrain parks. It is weird to drive up from the heat of the desert to arrive in just 20 minutes at altitude with snowdrifts all around. The mountains get regular snow throughout the winter with an average of 3m a year, The resort can also cover 60% of the slopes with artificial snow should the real stuff be lacking. Set at 8500ft in the Spring Mountains to the north west of Las Vegas, what you actually get is a slope area offering a respectable 1000ft of vertical drop. There are three slow chairlifts, one on the nursery slopes accessing a total of 10 trails, one of them dotted with ramps and kickers (plus a sign that says "No aerial flips allowed" (most people seemed to ignore it!). All standards from beginner to snowgod would find something here to keep them amused for a while - if only an afternoon or two. What's more, this place never gets too crowded. The car park often seems full yet the slopes never seem to number more than 50 people at a time. At the slopes you can get full snowboard hire but like most hire kit the quality varies - getting there early gets you better equipment. There is also a shop, bar and cafe for your standard burger hit.

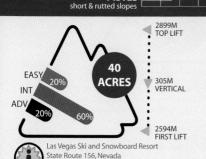

FREERIDERS should find the 4 black runs, which are not groomed and are basically mogul fields, a cool place to ride offering a fun challenge. Two of the blacks descend through some trees which only adds to the fun. There are a few bits where you can get off piste but the powder soon gets shredded out so don't expect any hardcore backcountry terrain.

TEL:001 (709) 593 9500 WEB: www.ridelasvegas.com EMAIL: ridenski@lvssr.com

> **FREESTYLERS** are best looking out for natural hits as the man made offerings are a bit lame. The snowboard park, which is designed as a long trail, has a pretty mundane halfpipe but money has been spent to improve things.

PISTES. Riders who stick to the piste will find that this is not a place for them due to the lack of well maintained

LIFT PASSES 1/2 day \$29, Day pass \$39, Season \$319-499 **BOARD SCHOOLS** Group lessons \$25 for 1 1/2 hours. Private lessons \$70 ph

HIRE Boards & Boots \$25 per day

LIFT CAPACITY (PEOPLE PER HOUR): 2,500

WINTER PERIOD: Dec to April

NUMBER OF PISTES/TRAILS: 11

trails. The terrain is often too bumpy to hold a good edge and the runs are short.

BEGINNERS only have a few rather dull areas to slide around on.A new 150' Magic Carpet will help increase uphill capacity and make learning easier.

MOUNTAIN CAFES: 1 ANNUAL SNOWFALL: 3m

> **OFF THE SLOPES**. To find out what's going on off the slopes, get yourself a guide book on Las Vegas as there is no way that we can even begin to tell you all that is on offer in this massive gambling city.

SNOWMAKING: 75% of slopes BUS from Las Vegas take around 1 hour.

FLY to Reno or Las Vegas International CAR Route 95 out of Las Vegas towards Reno. After 30 miles turn left onto Route 156, then 15 miles or so to Lee Canvon.

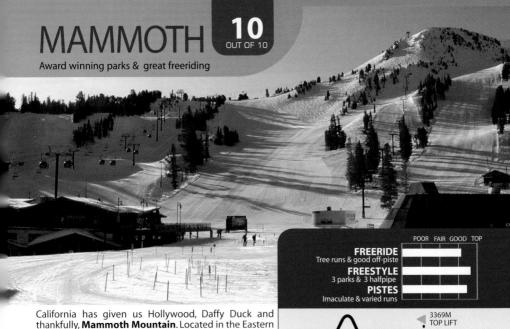

The resort was purchased by the Starwood Capital Group in December 2005 and has undergone huge improvements in the years leading up to the sale and the building of the new Village. Mammoth's slopes can often get busy at weekends when the place fills up with California's city dwellers, but during the week the place is very quiet. Mammoth is a pretty big place with over 150 trails set out on a long-since dead volcano; no matter what your style or ability, there's plenty to do. Mammoth's terrain parks have achieved legendary status, for the third year running picking up Transworlds best pipe award, and runner up to Whistler for best terrain park. Its not just for the pro's either, there's parks and pipes designed for every ability. Overall Mammoth is a great resort for boarders, there's good variety in terrain from trees to open bowls, an efficient lift system; the last drag lift was removed last season. One gripe is the piste markings which are a bit of a nightmare as they

Sierra region, Mammoth has welcomed snowboarders onto its slopes for many years, and has a great snow record that seems to improve every year, meaning riding

is often possible into June.

seem to just disappear.

FREERIDERS have a great mountain to ride with trees, big bowls and loads of natural hits to catch air, especially in areas such as Huevos Grande and Hangman's Hollow. Experienced riders normally head up to the ridge reached by Gondola 2 Here there is a host of chutes that lead into a wide bowl, perfect for freeriders to show what they're made of. The Cornice run is the one to go for - it's awesome and will give you a major buzz. If you really have the balls, check out Wipe Out, a double black run off Chair 23. If you emulate the name of this run, not only will it make your eyes water, but everyone on the chair lift above will be able to watch and laugh as you wipe out in style (give them two fingers and then get on your way).

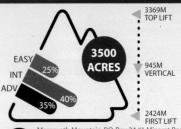

Mammoth Mountain, P.O. Box 24,#1 Minaret Road Mammoth Lake, California 93546 TEL: 001 760.934.0745

WEB: www.mammothmountain.com EMAIL: info@mammoth-mtn.com

WINTER PERIOD: early Nov to early June LIFT PASSES

Half day \$52,1 Day pass \$64,4 Day pass \$225, Season Pass \$1500

BOARD SCHOOLS Group lessons \$60 for 3 hrs

Private lesson \$75 per hour, half-day \$225, \$450 per day

HIRE Board & boots \$30 per day, \$25 half-day

SNOWMOBILES Yes

NUMBER OF PISTES/TRAILS: 150 LONGEST PISTE/TRAIL: 4.8km TOTAL LIFTS: 27 - 3 gondolas, 24 chairs LIFT CAPACITY (PEOPLE PER HOUR): 50,000 LIFT TIMES: 8.30am to 4.00pm

LIFT TIMES: 8.30am to 4.00pm MOUNTAIN CAFES: 9

ANNUAL SNOWFALL: 11m SNOWMAKING: 33% of slopes

CAR From LA follow US 395 north to Hwy. 203 (at Mammoth Lakes Junction) - 307 miles. Reno - US 395 south, to Hwy. 203 - 168 miles.

San Francisco Area - Interstate 80 or Interstate 50 to US 395 south, to Hwy. 203 - 320 miles.

FLY to Reno International, transfer time to resort is 4 hours, Local

airport is Mammoth Lakes, 20 miles away. There are plans to upgrade airport to handle larger planes.

BUS from Reno takes 3 1/2 hours. CREST bus service from Reno/

Tahoe 3 days a week, call (800) 922-1930 for info.

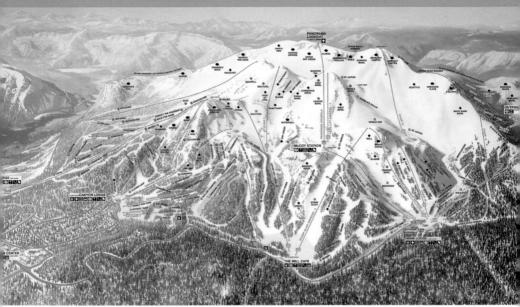

FREESTYLERS have a resort that is well in tune with their needs, whether you're after natural hits or purpose built jumps. A good spot to check out is the area known as Lower Dry Creek which is a natural halfpipe. Alternatively, the Dragon's Back gives the advanced freestyler plenty of air time. Theres 3 terrain parks suitable for all levels. The family park near Canyon Lodge has a beginner's half-pipe (10ft walls) and a few boxes, but the real fun starts on the unbound parks. The unbound team keep the parks & pipes maintained perfectly all season. Depending on the snow conditions there's a huge number and variety of rails and the awesome 16'x36' wall ride. **Unbound south** is a great long park full of intermediate to advanced jumps, rails and boxes with lifts to take you straight back up. The **main unbound** park is across by the main lodge with great views of the park as you ascend on the lifts crossing it. Here you'll find the super pipe with its 15ft walls and next to it the massive super duper pipe. They try and open the pipes as soon as the resort opens, and when things start getting slushy in April, they build a spring pipe in the **saddle bowl** off the face lift express. You'll also find some huge table tops, and jumps up to 80 foot in length. To the side of the main unbound is a good run through the trees full of easy jumps on the right and tables to the left. Jump straight back on the lift and you can easily get up and down in 10 minutes. For complete beginners check out the area under the lift between the sesame street runs. There are some bumps to get some credit card air on, and some boxes. If you're still not happy then June Mountain is only a 30 drive away.

PISTES. The runs are super-well pisted and make for good terrain, both for those wanting to go at speed or for the more sedate carver. Check out the trail known as the Saddle Bowl, where you will find a nice, tame, long blue run.

BEGINNERS, if you can't learn or improve at Mammoth, then you're into the wrong sport. The area is perfect for novices, with plenty of green and easy progression blue runs at the lower sections and excellent snowboard tuition available. Sesame **Street** run off chair 11 near the main lodge is perfect for beginners, theres no pistes joining it so you won't get flustered by other riders, and under the chairlift are a series of bumps and boxes to try if you're not bruised enough already. Special beginner packages including lesson, lift and gear start from \$87 and are well worth the money and the local snowboard school has a good reputation.

OFF THE SLOPES

At the base area you will find some accommodation and basic facilities. However, the best value is to stay down in the town of Mammoth Lakes which is 4 miles from the mountain. Mammoth Lakes has a huge selection of good local services and although the area is not noted for being affordable, riders on a budget will still be able to swing it with a number of cheap supermarkets and low priced dorms to lodge at. For all your snowboard needs, Mammoth has a number of snowboard shops, such as Stormriders tel (760) 934 2471 and Mountain Riders, tel (760) 934 0679.

ACCOMMODATION. There's plenty of accommodation to be found in the town of Mammoth Lakes which is about 4 miles from the main lodge, but note on the whole most are very expensive. You will find condo-overload plus a few B&B joints and a hostel. The Ullr Lodge on Minaret Rd is a reasonable priced hostel with beds from \$20 a night. The new village on the edge of town has various apartments available and means you can practically ski-in/out every day, but at a cost. The Mammoth Mountain Inn is situated near the main lodge and offers some good room and lift deals, but the development work going on nearer town however leaves it feeling increasingly isolated. The rooms have been refurbished and a free night bus now runs into town, so it's not a bad choice if you want to be one of the first on the slopes.

FOOD. You can get almost any type of food here, ranging from expensive to mega bucks. There are a number of cheaper food-stops such as Berger's, where you can dine on chicken or burgers. The Breakfast Club is the place for early starters, while Roberto's serves hot Mexican nosh. If pizzas are your thing, then try a slice at Nik-N-Willie's which is noted for its food. Grumpy's is noted for chicken served up in a sporting setting. Hennessey's in the new village is ok, but if you fancy something that's not in breadcrumbs then take a look along the old Mammoth road, the Alpenrose comes highly recommended. For a great coffee and to check your email go to Looney Beans, 3280 Main Street.

NIGHT-LIFE hits off in Mammoth Lakes and while not fantastic; it is still pretty good with bars playing up-to-date sounds. Amongst the more popular hangouts are Whiskey Creek and the Stonehouse Brewery. Grumpy's is a cool place that serves booze and burgers, set to a back drop of TV screens showing the latest slope action. In the new village Dublins does the beer/TV thing well, and has a nightclub called Fever next door, but pick of the bunch is Lakanuki's. The Innsbruck near the main lodge is good for a beer after a long day.

S

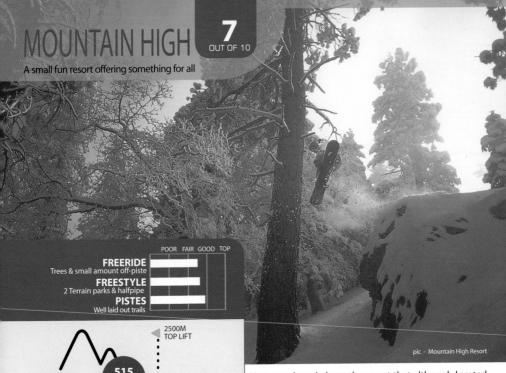

Have you heard about the resort that although located in the southern reaches of California and only ninety minutes from Los Angeles, boasts at having five terrain parks, two half pipes, fifty-nine named trails, twelve lifts and night riding seven days a week over seventeen flood lit slopes? No? Well let me introduce to you Mountain High, a no nonsense resort with riding over two mountain areas with a summit of over 2499 metres. By no means is this a big resort, indeed Mountain High is relatively small when compared to the likes of its more northern neighbour Mammoth Mountain. However, unlike Mammoth Mountain this place is far less overhyped, far less crowded and a lot more affordable. There may only be just over 500 acres of ridable terrain, but as the saying goes, 'size doesn't always matter, it's what you do with the size that counts. And to be fair, Mountain High does very nicely with what it has with tow mountain areas covered in tight trees and offering a good selection of well laid out trails. The East Resort mountain has the highest summit elevation of 2499 metres but the smallest selection of trails, while the West **Resort** has the largest selection of trails. Both mountain areas have terrain parks and halfpipes however, the two areas are not connected by mountain lifts and you can't ride between the two, instead you will need to take the resort shuttle bus to reach either. They have been doing things here on the mountains since 1937 so in that time the management have learnt a thing or two. Along with standard tickets they operate lift ticket schemes such as the Flexi ticket system where you buy a pass for a certain number of hours or the Point system which is a system where you buy points that let you ride whenever you want throughout the season. You can even transfer the points to a friend.

FREERIDERS will no doubt find the slopes on the East

WINTER PERIOD early Nov to late April

CRES

LIFT PASSES 1/2 day \$43, Day \$48, \$499 (\$249 early bird) BOARD SCHOOL Beginner lesson includes pass, lesson & hire \$55. Standard lesson & day pass \$75, Private \$75per hour

PO Box 3010,24510 Highway 2, Wrightwood, CA 92397

671M

1829M

FIRST LIFT

VERTICAL

HIRE Board & Boots \$30 per day

NIGHT BOARDING Till 10pm every day. Night pass \$30

Mountain High Resort

TELEPHONE: (760) 249-5808

NUMBER OF PISTES/TRAILS: 59 LONGEST PISTE/TRAIL: 2.6km

TOTAL LIFTS: 16 - 11 chairs, 3 drag, 2 magic carpets

LIFT TIMES: 8.30 am- 10.00 pm **MOUNTAIN CAFES: 7**

ANNUAL SNOWFALL: 4.5m **SNOWMAKING:** 95% of slopes

CAR From LA, take Interstate 10, Freeway 60 or 210 freeway south. Exit Highway 138 West, take left onto Highway 2, resort 3 miles past Wrightwood. Approx 90mins total

FLY to Ontario airport with a transfer time to the resort of 45 minutes, also 90mins from LA

BUS from Ontario airport takes around 45 mins to Mountain High. Buses from Los Angeles take around 90 hours and from Orange County the time is 75 minutes.

2006/7 SEASON: \$2million base expansion - relocation of Coyote and Roadrunner chairlifts, new beginner lift

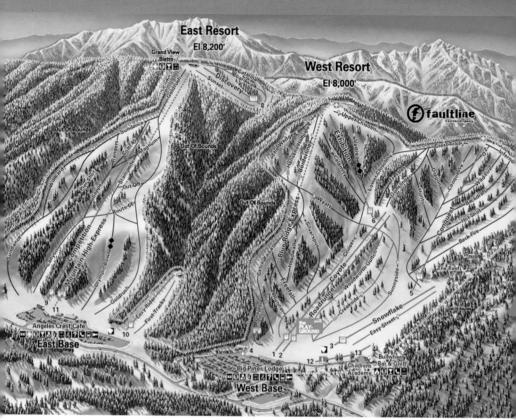

Resort to there liking, especially the Olympic Bowl which is a double black diamond stretch. On the West Resort there are a number of nice trails to check out with lots of trees and some fine steeps. The runs off the Inferno Ridge are particularly good as is the Vertigo. For those who like to take it easy then the Upper and Lower Chisolm trails are first class trails.

FREESTYLERS are extremely well looked after here with choice of five terrain parks and two halfpipes as well as loads of natural hits from which to get air from. The terrain parks, which are sponsored by Vans are spread across both mountains and known as the **Faultline**. Two of the parks are for beginners while both half pipes have their own drags lifts.

PISTES. Riders will find that the East Resort offers some of the best cruising with a good selection of runs from the top.

BEGINNERS should like Mountain High with a nice selection of gentle slopes laid out at the base areas with the best runs on the West Mountain off the Coyote and Roadrunner lifts.

OFF THE SLOPES things are somewhat different and not what you would totally expect. The resort itself, doesn't own or provide any slope linking accommodation or provide a multi complex resort with all the normal holiday attractions. Around the base areas are a few sport shops and snow-board hire outlets and cafeterias, but that's about

it. However, Mountain High is located next to the town of **Wrightwood** which provides a host of local facilities from lodges to bed and breakfast joints. **Los Angeles** is only 90 minutes away so you could **Los Angeles** is only 90 minutes away so you could **Los Angeles** is only 90 minutes away so you could **Los** base yourself there or at any one of the many towns en route. Where you eat depends basically on where you decided to stay. Most lodges and hotels in the area have restaurants or are close to one. There are also loads of fast food joints to seek out all the way back to Los Angeles. Nightlife and other evening entertainments vary from place to place, but basically things in Wrightwood are laid back and not very exciting while Los Angeles rocks big style and offers millions of things to do.

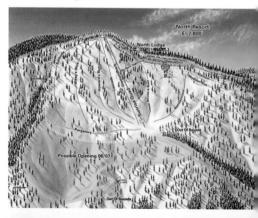

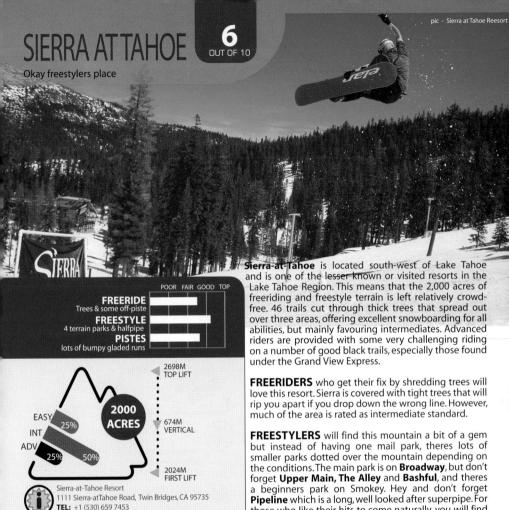

WEB: www.sierratahoe.com EMAIL: sierra@boothcreek.com WINTER PERIOD: early Nov to end April LIFT PASSES Half day \$50, 1 Day pass - \$59, 3 Day pass

\$117. Season pass - \$699 (unlimited Northstar & Sierra) BOARD SCHOOLS Burton LTR centre - \$74 for 2hr lesson package or \$40 for just the 2hr lesson. Private \$90/285 hour/day HIRE board and boots \$34 per day

BACKCOUNTRY Backcountry tour 3 1/2hrs for \$25

NUMBER OF PISTES/TRAILS: 46 LONGEST PISTE/TRAIL: 4km TOTAL LIFTS: 10 - 9 Chairs, 1 magic carpet LIFT TIMES: 8.30am to 4.00pm LIFT CAPACITY (PEOPLE PER HOUR): 14,920

MOUNTAIN CAFES: 2

ANNUAL SNOWFALL: 10.6m SNOWMAKING: 20% of slopes

BUS from Reno to South Lake Tahoe. FLY to Reno, with a transfer time of around 2hrs. San Francisco airport approx 3 1/2hrs away. DRIVE From Reno, take I-395 south through Carson

City to US Highway 50 west over Echo Summit and turn left onto Sierra-at-Tahoe Road. 1 3/4hrs, 78miles

FREERIDERS who get their fix by shredding trees will love this resort. Sierra is covered with tight trees that will rip you apart if you drop down the wrong line. However,

FREESTYLERS will find this mountain a bit of a gem but instead of having one mail park, theres lots of smaller parks dotted over the mountain depending on the conditions. The main park is on **Broadway**, but don't forget Upper Main, The Alley and Bashful, and theres a beginners park on Smokey. Hey and don't forget Pipeline which is a long, well looked after superpipe. For those who like their hits to come naturally, you will find plenty of banks and big walls to ride, especially where snow banks up alongside the trees.

PISTES. Riders who look only for perfectly flat, bump less slopes may not be too impressed. This is not a resort that can lay claim to having lots of great piste on which to lay some fast turns. In general the terrain is a little unforgiving. However, there is some quite good riding to be had on the West Bowl Slopes where carvers can show off in style and at speed.

BEGINNERS will find plenty of easy slopes, with the chance of riding from the summit down the green Sugar 'n' Spice trail. Other cool novice trails are off Rock Garden and Nob Hill lifts. Broadway, located at the base area, is good for the total beginner and it even has its own beginner chair so you won't have to suffer the embarrassment of continually falling off a drag lift.

OFF THE SLOPES there is some basic slopeside accommodation, but for the best local happenings and night-life, head back down to the South Lake Tahoe area, only 12 miles away. Get the free shuttle bus if you don't have car. WSQ www.worldsnowboardguide.com 359

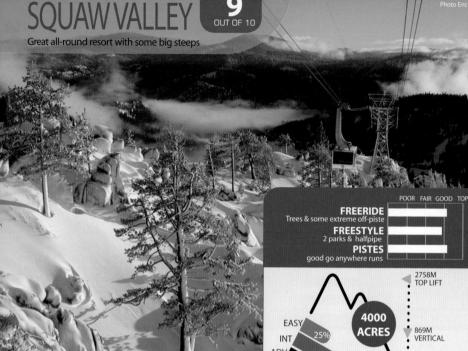

Squaw Valley is full-on and has been snowboardfriendly for many years. Squaw is a total snowboarder's resort in every sense and is one of the best known in the Tahoe area. With its European-alpine feel, and its history in hosting the 1960 Winter Olympics, Squaw is well used to looking after its visitors, with a substantial mountain on which to do so. 4000 acres of open bowl riding, 6 peaks, 30 lifts, a total capacity of 49,500 people per hour, 3 fun-parks and a halfpipe, combined with an average of 450 inches of snow a year (with massive amounts of snowmaking too), makes Squaw a great riders' hangout. Countless snowboard action videos feature the slopes of Squaw and it's easy to see why. Located a stone's throw from its neighbour Alpine Meadows, Squaw has heaps of terrain for all styles of rider to conquer - steeps, trees, long chutes, as well as easy flats for novices. Like many of the resorts in the Tahoé region, Squaw serves the weekend city dweller. Don't despair though as the slopes can still be fairly quiet during the week-days leaving plenty of powder and open runs to shred.

FREESTYLERS have been able to ride Squaw's excellent halfpipes and parks for a good number of years. The Central Park fun-park features many obstacles to catch air and is one the best kept terrain parks in the US. The halfpipe is shaped with a Pipe Dragon and has perfectly cut walls that most resorts only dream about. You can also ride the park and pipe at night until 9 pm. Squaw also has a fast Boarder Cross circuit. Belmont Park is the place for novice freestylers while the Ford Freestyle Superpipe & Terrain Park has hits and a 550foot pipe!

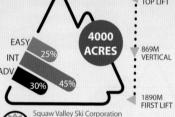

P.O. Box 2007, Olympic Valley CA 96146

TEL: 001 (530) 583-6985 SNOWPHONE: 001 (530)583-6955

WEB: www.squaw.com EMAIL: squaw@squaw.com

WINTER PERIOD: mid Nov to early May Lift Passes

1 Day pass \$64, 1/2 day \$50, 2 Day pass \$113,5 of 7 Days \$267 Season \$1,495

BOARD SCHOOLS group \$43/2hr, private \$90/hr

HIRE board & boots \$37/day, 5 days/\$148

NIGHT BOARDING 3.2 mile Mountain Run open and terrain park open every night until 9pm. Free for day pass holders otherwise \$20

NUMBER OF PISTES/TRAILS: 100 LONGEST PISTE/TRAIL: 4.8km

TOTAL LIFTS: 33 - 2 Gondolas, 1 cable-car, 35 chairs, 4 drags, 1 Magic carpet

LIFT CAPACITY (PEOPLE PER HOUR): 49,500

LIFT TIMES: 8.30am to 9.00pm **MOUNTAIN CAFES: 3**

ANNUAL SNOWFALL: 11m SNOWMAKING: 50% of slopes

CAR 42 miles from Reno, NV, 96 miles from Sacramento. and 196 miles from San Francisco via Interstate 80. Resort is 8 miles from Truckee and 6 miles from Tahoe City and the North Shore of Lake Tahoe, on Hwy 89

FLY to Reno International (42miles), transfer time to resort is 1 hour TRAIN Amtrak to Truckee, 6 miles away

BUS from Reno takes around 1 hour (tel: 866-769-4653). A Grey Hound bus from San Francisco takes 5 hours via Tahoe City, 6 miles away. Free service runs between S.Shore Tahoe and Squaw, Call 866-769-4653 and another from N.Shore tel: 530-581-7181

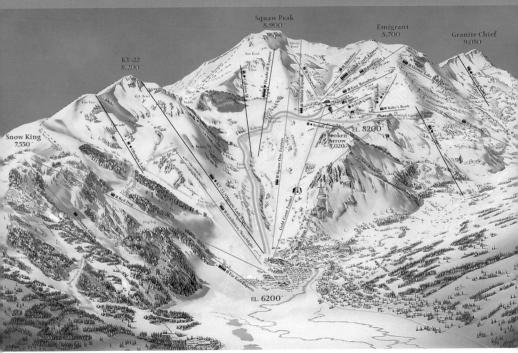

FREERIDERS wanting an adrenalin rush will be able to get it in an area known as the KT22. This particular area is rated double expert, and it's for no mean reason. Lose it up here and its all over - your own dear mother wouldn't even recognise your body, so be warned. Powder-seekers will find some nice offerings around Headwall, or over at Granite Chief which is a black graded area (not for wimps) with well spread out trees

PISTE loving freeriders, will not want to leave the amazingly well groomed slopes at Squaw. The runs off Squaw and **Siberia Express** are superb for laying big edged turns and can be tackled by all levels. **Gold Coast** is a long trail that will leave you breathless if do it in one.

BEGINNERS have a great resort to start mastering the art of staying upright. Much of the novice terrain is to be found at the base area, while the bulk of easy trails are located further up the slopes and reached off Super Gondola or the cable car. Once up, the smattering of greens and blues are serviced by a number of chair lifts, so you can avoid the T-bars during the early stages of snowboarding.

OFF THE SLOPES

Away from the slopes, Squaw has gained a reputation of being both expensive and a bit snobbish, and in both cases, it's true. But don't be put off as the place has a good buzz about it, and the locals are really friendly. Lodging, feeding, partying and all other local services are convenient for the slopes. The village packs in a raft of activities with ice skating, climbing walls and a games hall. Getting around is easy, although having a car would allow you to travel around at your own leisure.

ACCOMMODATION is offered with a number of places close to the slopes. But it will cost you. Condo's are plentiful and well equipped, but not all affordable. For a cheap and comfortable place to stay, check out the Youth Hostel - it has bunks at happy prices but bring your own sleeping bag. Check Squaws web site for the latest deals.

FOOD. Like any dollar-hungry mountain resort, expect to notch up some mileage on the credit card. Even a burger can set you back a small fortune. But as there are so many eating options, even the tightest of tight riders will be able to grab some affordable scram.

NIGHT-LIFE is aimed at the rich, so if you find that Squaw's local offerings are not your style, then try out the far more extensive facilities on offer in nearby **Truckee** or **Tahoe City** where you'll find the best night spots and local talent. You can either drive down, or catch a bus or taxi. Check out *Red Dog* or *Naughty bar*.

Sugar Bowl has numerous points that it likes to draw to people's attention, such as the fact that it is one of the oldest resorts in California and was fathered by no less than Walt Disney 60 years ago. However, don't be alarmed: Donald Duck and Mickey Mouse are nowhere to be seen, although many of the skiers here are a right bunch of Dumbos. Sugar Bowl is a nice little gem of a place that should keep you amused for a few days, but it should be pointed out that this place can become little crowded over holiday periods etc. The terrain is evenly split over

three main areas that are connected, Lincoln, Mt Judah, and Mt Disney. Lincoln and Mt Disney offer some of the most testing runs with a cool selection of black trails and a couple of double black diamonds. Mt Judah has the most sedate terrain and best for beginners and intermediates. The resort offers base facilities where you can get snowboard hire.

FREERIDERS will be pleased with Sugar's nice offering of trees, back bowls and morning powder trails. The black runs on Mt Disney will sort out the wimps from the men, with some very challenging trails especially the area off the Silver Belt chair lift where you will find a steep cliff section.

FREESTYLERS are more than welcome here and have full access to all three areas. From the top of the Mt. Judah lift you can access the Coldstream Terrain Park then the huge Golden Gate park. They are littered with tables, quarters, kickers and numerous rails and boxes for the jibbers. The Nob Hill Park is great for beginners and has a few rollers and boxes. The x-games/FIS standard superpipe's located at the bottom the Lincoln express, and is usually in fine condition.

PISTES. Most of the runs are fairly short and can be a little uneven, but that said Sugar Bowl is still okay with a few good cruising trails.

BEGINNERS will find that the best laid out easy terrain is available on **Mt Judah**, which has a particularly good easy section for novices to shine on. The section of the Christmas tree chair is also noted for being a good easy area.

OFF THE SLOPES there is some very limited accommodation in the base lodge, which houses a hotel and can be reached via the gondola. However, the best option and biggest choice of local services can be found in the nearby town of **Truckee** which is only 10 miles

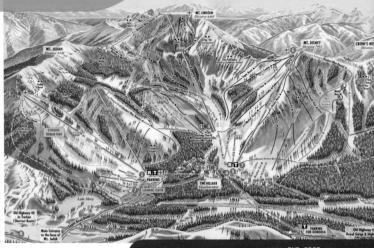

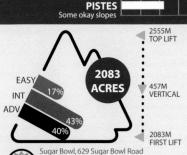

FREERIDE Trees & some good off-piste

FREESTYLE

3 Terrain parks & halfpipe

Norden, CA 95724 PHONE: (530) 426-9000

WEB: www.skisugarbowl.com EMAIL: info@sugarbowl.com

WINTER PERIOD: Nov to April LIFT PASSES 1/2 Day Pass \$39, \$49 Holidays Day Pass \$46, \$59 Holidays, Season Pass - \$900 BOARD SCHOOLS private \$90/hr

HIRE Boards & Boots from \$39/day

NUMBER OF PISTES/TRAILS: 80 LONGEST PISTE/TRAIL: 3 miles TOTAL LIFTS: 13 - 1 gondola, 10 chairs, 2 drags LIFT TIMES: 9am - 4pm

ANNUAL SNOWFALL: 12.7m **SNOWMAKING:** 13% of slopes

BUS from Reno to the resort. Bus pickups from San Fran area \$99 inc lift pass visit www.bayareaskibus.com Shuttles from Truckee to resort run every hour FLY to Reno, transfer time is 40 minutes.

DRIVE From San Francisco - Take Bay Bridge to Interstate 80, head east toward Sacramento/Reno. exit at the Norden/Soda Springs off ramp. Turn right on Highway 40 eastbound, continue 3 miles

ROUND-UP

BORFAL

Small resort, but has 5 terrain parks and a halfpipe. One of the parks is floodlit and open till 9pm every night

RIDE AREA: 380 acres NUMBER RUNS: 41

30% easy, 55% intermediate, 15% advanced

TOTAL LIFTS:9 chairs, 1 magic carpet LIFT PASS:1/2 Day, \$22 Day \$36

CONTACT: Tel: (530) 426-3666 www.borealski.com

HOW TO GET THERE: Truckee 8 miles, San Francisco 175 miles Reno 45 miles On the 1-80 take the Boreal / Castle Peak exit

HOMEWOOD

NUMBER RUNS: 56 - 15% easy, 50% intermediate, 35% advanced

TOTAL LIFTS:8 LIFT PASS:1/2 Day, \$32 Day \$42

CONTACT: www.skihomewood.com EMAIL:smile@skihomewood.com HOW TO GET THERE: Nearest airport is the South Lake Tahoe airport that services Tahoe Air. The Reno Tahoe International airport has just a 1hr drive time

MT.ROSE

The nearest resort to the lively gambling den that is Reno. The ski-bus from Reno will have you on the slopes within an hour. There's been a lot of money put into this resort of late and there's now 2 good size terrain parks and 60 runs. They get around 10m of snow in a season, and theres a whole line of double D shoots to drop into.

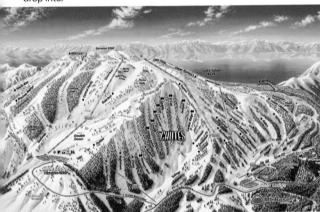

NUMBER RUNS: 60 - 20% easy, 30% intermediate, 50% advanced TOP LIFT: 2956m BOTTOM LIFT: 2408m VERT: 549m

TOTAL LIFTS:7 - 6 chairs, 1 drag LIFT PASS:1/2 Day, \$42 Day \$62

CONTACT: Tel: (775) 849-0704 www.skirose.com

HOW TO GET THERE: Fly to Reno, 25mins away by car, Located on Mt. Rose Hwy SR431 22 miles from Reno.

NORTH STAR

Northstar opened its slopes to snowboarders in 1997 and its quickly become one of the most boarder friendly resorts. The terrain is awesome the amount of rails on offer is beyond. The vibe is so mellow it

has been remarked as a little Whistler village. The resort is found on the north side of the lake and a few minutes from the old cowboy trading post Truckee. The resort is under going a big development project which will be complete very soon. Check out "Totally Board snowboard shop" for some bargains, you'll find the shop in truckee. Northstar is a resort not to be missed.

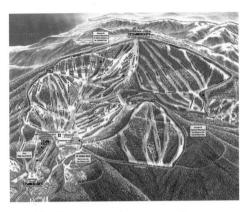

Freerider it's going to take you some time to cover all the 70 recognised routes. All the trails are cut through the trees so tree runs are a must. Don't expect any cliff drops or wide open bowls to bang in some big powder turns. The whole area is well

covered with obstacles to please all

standards.

Freestyle Northstar has a team of park staff who keep the 6 terrain parks in good order. The parks cater for everyone what ever the standard. So if you are planning to expand your book of trips into the rail chapter then head to Northstar, I lost count the amount of rails on offer. If you are into pipe riding the northstar has a well maintained 400 ft super pipe.

Beginners Northstar has an excellent starters pack with everything included in the price. The area also has some gentle terrain if you are starting out or shaking off the cob webs. If you ability is intermediate or advanced why not hook up to a free

75 min lesson which are held in the afternoon

Accommodation with the new development accommodation can be found, dead centre of the lifts or a few minutes away in Truckee

RIDE AREA: 2420 acres NUMBER RUNS: 70 25% easy, 50% intermediate, 25% advanced

TOP LIFT: 2624m BOTTOM LIFT: 1929m VERT: 695m TOTAL LIFTS: 17 - 10 chairs, 6 drags, 1 tubing lift

LIFT PASS:1/2 Day, \$47 Day \$61

CONTACT: www.skinorthstar.com

HOW TO GET THERE: Fly to Reno, 45mins away

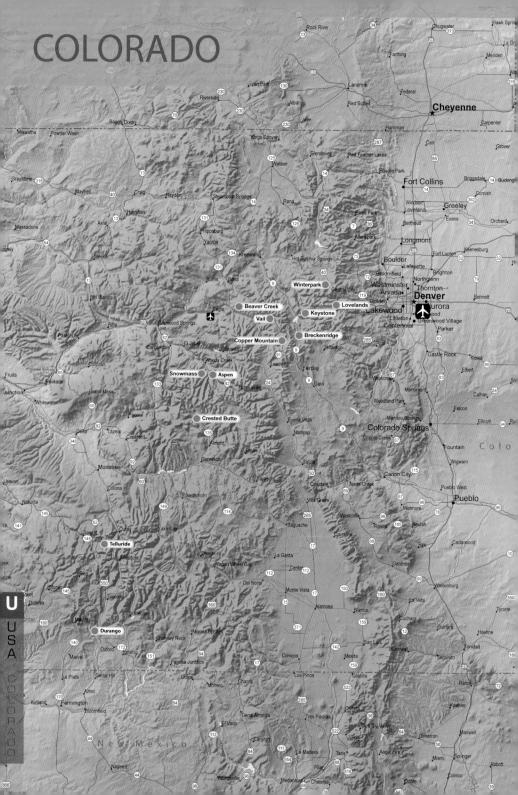

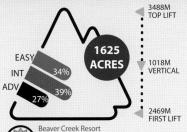

Bea P.O TEL

Beaver Creek Resort PO Box 915 Avon, CO 81620 TELEPHONE: 001 (970) 949 5750 WEB: www.beavercreek.com EMAIL: bcinfo@vailresorts.com

WINTER PERIOD Late Nov to mid April LIFT PASSES 1 Day pass \$81, 4 of 6 days \$324 BOARD SCHOOLS

Day of lessons \$120 with lift pass \$175 Beginner day - lesson, hire, pass \$193, Full day private \$595 NIGHT BOARDING No

NUMBER OF PISTES/TRAILS: 146 LONGEST PISTE/TRAIL: 5.56M TOTAL LIFTS: 14 - 13 chairs, 1 drags LIFT CAPACITY (PEOPLE PER HOUR): 24,700 LIFT TIMES: 8.30am to 4.00pm MOUNTAIN CAFES: 7

ANNUAL SNOWFALL: 8.38m SNOWMAKING: 50% of slopes

CAR Denver via Interstate 70. Beaver Creek = 120 miles. Drive time is about 2 1/4 hours. Exit Avon FLY to Denver International, Transfer time to resort is 2

1/4 hours. Local airport is Eagle County, 10 miles away.

BUS There are daily bus services from both Denver and Vail/Eagle
County airports direct to Beaver Creek. Tel: (970) 328-3520

TAXI: (877) 829-8294

cousin Vail, has a classy and expensive reputation - an ex-US President even has a house here. But don't let that put you off as this is a resort that has come of age with a really healthy attitude towards snowboarding, as seen by the provision of so many snowboard services. Even some of the local riders give up their time to form what they call the Snowboard Courtesy Patrol, which is a group of snowboarders that patrol the area's slopes to offer assistance and keep everyone in check. Beaver Creek is a relatively new resort, but unlike some old timers, it has managed to get things right. The well set out lift system is located on four areas, with runs that favour intermediate riders for the most part. The trails, which are cut through thick wooded areas, are shaped in a way that allows you to get around with ease, making riding here an ideal experience

FREERIDERS are presented with a series of slopes, covered in trees from top to bottom. If you like to ride hard and fast, then the double black diamonds on Grouse Mountain off the Grouse chair will satisfy you. Here you can drop down a line of four steep trails, where the longest, Royal Elk, sweeps in an arc through trees, whilst Osprey is the shorter of the four. Alternatively, the Half Hitch and single black trails found off the Centennial chair are less daunting, but just as much fun. If you prefer tree runs, make sure to check out the areas in the Bachelor Gulch & Arrowhead Villages. Enjoy established runs such as Coyote Glade and Renegade, or carve your own runs through the powder-filled trees in both Villages. To ride the best spots, hook up with a local snowboard guide.

FREESTYLERS will find plenty of big natural hits to float air. If you're a park rider, then head for any of the three parks Beaver Creek has to offer depending on your ability. There are three parks of varying levels, beginning with **Park 101** for those new to the park that features rollers, dots and other terrain features that will allow lower level riders of all ages to learn. For intermediate park riders, **Zoom Room** features small rollers, tables and rails, and moves to progressively larger features and rails throughout. The most advanced park, **Moonshine**, is designed to be user friendly for intermediate to expert riders looking to improve their skills on a wide variety of

WSQ www.worldsnowboardguide.com 365

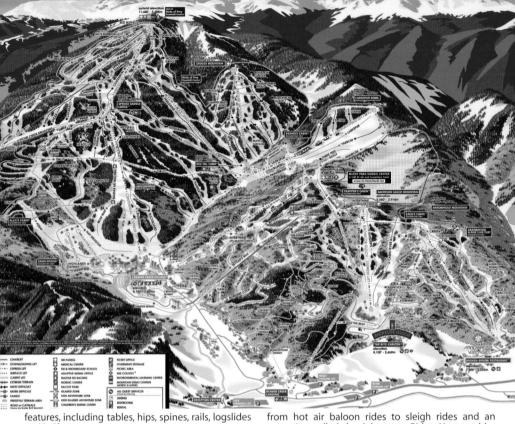

features, including tables, hips, spines, rails, logslides and half-pipe.

PISTE riders are well catered for here with many good trails. Edge-to-edge stylers are attracted by the extremely well groomed trails that descend from all areas of the resort, which twist and wind their way through the tree-lined trails. The Centennial trail is an extremely popular run that starts off at the top of the Centennial lift. Starting as a black run and descending into a more sedate blue down to the base area, it can be done in a short space of time if you can hang on at the start.

BEGINNERS will find the best easy trails are to be found at the top of the Cinch Express Lift. To get down from the beginner area, take the Cinch green run back to the village. A nice touch at Beaver Creek is the kid's fun-park, Chaos Canyon Adventure Zone, which has a series of small hits. Riders who have never been on a snowboard will learn quickly if they visit the local snowboard school, which has a high reputation. Burton runs a learn to ride Method Center here.

OFF THE SLOPES Beaver Creek is a major in terms of dullness. However, the village is a laid back place and locals are very friendly. Beaver is a much quieter hangout than nearby Vail, which may be why the place attracts nice family groups that walk around holding hands and smiling as they go. The resort offers all the normal Colorado tourist attractions

from hot air baloon rides to sleigh rides and an attraction called the Adventure Ridge. You can hire full snowboard equipment at Beaver or in Vail with prices much the same wherever you go, from around \$35 a day. Check out the Otherside Snowboard Shop at 001 (970) 845-8969

ACCOMODATION. There are no real cheap options for lodging in Beaver - in short, prices start at silly and go up to downright criminal. There are plenty of beds with many close to the slopes, but for budget riders, you are better looking for somewhere to kip in the small, nearby hamlet of **Avon**.

FOOD. If your sole reason for visiting Beaver is the food, you will find a variety of mostly costly, but good restaurants to choose from. Vegetarians, vegans, or monster meat lovers will find their every desire well catered for from one end of the village to the other. The *Coyote Cafe*, which is near the lift ticket office, is noted for good food at okay prices. Other good eateries to try, are *The Saddleridge*, the *Mirabelle* or *On The Fly* for great sandwiches.

NIGHT-LIFE: put simply, is dull and basically nonexistent. The bars cater in the main for rich ski-types in expensive cowboy boots, who prefer to sit around log fires talking bull. However, the *Coyote Cafe* is good and worth a visit for a few beers. The best thing to do is head for **Vail** - but remember to have plenty of dollars on you.

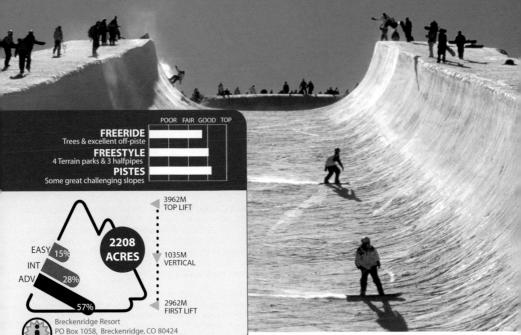

EMAIL: breckguest@vailresorts.com WINTER PERIOD End Nov to end April LIFT PASSES

SNOW REPORT: (970) 453-6118

WEB: www.breckenridge.com

Day pass - \$45-75 (low to high season) 3 Day pass - \$135-225, 5 of 8 days \$225-375

BOARD SCHOOLS

TEL: (970) 453-5000

3 days of lessons from \$165 with beginers lift pass for \$11/day park and pipe lasson \$60/75

NIGHT BOARDING No

NUMBER OF PISTES/TRAILS: 146 LONGEST PISTE/TRAIL: 5.6km

TOTAL LIFTS: 27 - 15 chairs, 5 drags, 7 Magic carpet LIFT CAPACITY (PEOPLE PER HOUR): 36,680

LIFT TIMES: 8.30am to 4.00pm **MOUNTAIN CAFES: 9**

ANNUAL SNOWFALL: 7.5m SNOWMAKING: 25% of slopes

CAR Denver via Interstate 70 & Hwy 9. Breckenridge is 81 miles, Drive time is about 1 1/2 hours. FLY to Denver International, Transfer time to resort

is 1 1/2 hours. Local airport is Eagle Airport (Vail). 63

BUS Colorado Mountain Express run bus services from both Denver and Vail/Eagle County airports direct to Breckenridge. Taxis - (970) 468-2266

NEW FOR 2006/7 SEASON: new 3000 p/h capacity gondola from base to Peaks 7 and 8. Beware though for those 7 minutes you'll probably going to be piped some speil in 'capsule museum' as they're calling it ..

Breckenridge is a true snowboard classic, and has been for many years, having played a leading role in the development of snowboarding in the US. The resort is constantly improving by adding new features to the mountain and around town. Located off Interstate 70, to the west of **Denver** and part of the Ten Mile Range, Breckenridge is a big and impressive area with terrain that spreads over four excellent snowboarding peaks, all offering something different for everyone. Some say that the 'new school' style of snowboarding started here, but whether you're from the new or the old, you should have no problems cutting big turns on the mainly wide, open flats

FREERIDERS with their powder-searching heads on will not have to hunt for long when they see what's available in the Back Bowls off Peak 8 and off Peak 9's North Face. Here you'll find plenty of terrain for riders who know how to snowboard. At the top of Chair 6, you'll find loads of good hits and drop offs, while lower down there are some wicked tree runs. You'll find good powder here, even after everywhere else has been tracked out. The Imperial Bowl on Peak 8 has over 1,000 metres of vert to tackle, and new for this season is a chair that'll take you to the top.

FREESTYLERS should have no reason to complain as apart from having some fantastic natural freestyle terrain, there are also four terrain parks and four pipes of competition standard. The latest addition to Breckenridge is what they call a 'Super Pipe Dragon', the

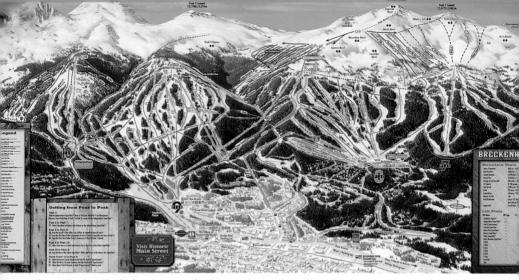

only one in the US which can cut perfectly smooth deep walls. The Lechman trail is known for being one of the best natural freestyle runs on the mountain, with loads of hits formed from big wind-lips running down the sides of certain sections. Head for Peak 9 and you'll find the Gold King fun-park which is pretty awesome and well-maintained: there are some big, big jumps to go for and thankfully it's groomed at least twice a week, although it does gets icy. There is also a halfpipe, located just above the park, which is shaped with the Pipe Dragon every Thursday and is therefore closed on that day. However, when it's re-opened on Friday mornings, it's perfect - but get up early, because everyone wants to get there first. Peak 8 is home to another park and pipe on the Fairway area.

PISTES. Riders have a mountain here that will allow for some very fast and challenging riding on well groomed alpine trails. Speed-freaks should try out the Centennial trail, which is a long flat and perfect for cranking out some big turns. Intermediates will find the runs off Peak 10 the place to be, in particular the **Crystal**.

BEGINNERS have plenty of easy runs, many of which can be found on Peaks 8 and 9. The fact that novice trails like **Silverthorne** are wide enough for all newcomers helps to make this a great beginners' resort, especially around the Quicksilver lift.

OFF THE SLOPES

As with many of Colorado's resorts, Breckenridge can be uncomfortably expensive. However, for riders on a tight budget, providing you shop around for accommodation and other local services, you will be able to stay here. The town is spread out, and has a rustic wild west feel about it. You can spend until you drop here with a staggering 225 plus shops, including a number of good outlets for snowboard hire with the option to rent demo boards and step-in set. Other attractions include a new 5 million dollar ice ring and a cool area for skateboarders to do their thing.

368 USQ WWW.WORLDSNOWBOARDGUIDE.COM

ACCOMMODATION options are vast with some 23,000 visitor beds up for grabs. Those on a tight budget will manage to find a cheap B&B, while those wanting some luxury will be able to chill out in lodge or classy hotel. *Breckenridge Mountain Lodge* is an okay and affordable place. *The Great Divide Lodge* is an expensive alternative.

FOOD, Around town you will find a massive selection of good restaurants and fast food joints ranging from cheap to steep with over 100 places to choose from. Breakfast is dished up in numerous places. The Prospect does a nice sunny side up as does the *Mountain Lodge Cafe*. Veggies should head to Noodle & Bean for the very same, while meat lovers may want to try a grill at 'Breckenridge Cattle Co' which is also noted for its fish food.

NIGHT-LIFE is pretty good and rocks until late. There's plenty of beer, dancing and fine local talent to check out, including four main nightclubs and some 80 ood bars. Head to the *Underworld Club*, or *Jake T Pounders* which is young, trendy, fun and one of the main hangouts that has darts, football and pool tables. *Eric's* is another cool hangout.

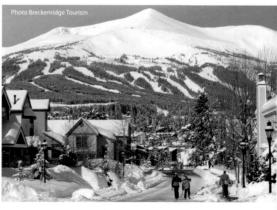

Copper Mountain is considered by many to be one of the best mountains in the USA and since being bought by Intrawest Resorts, the whole place has seen heavy investment to greatly improve a place that was good before. Copper's crowd free slopes with long trails and few traverses appeal to tree-riding fans, and those looking for something interesting to tackle. Powder is in abundance here with four big bowls holding massive amounts of it. Most of the main chairs take around ten minutes to reach their drop off points, although it seems double that time when you're dangling hundreds of feet in the air, with wind driving snow up your nose and down your neck. Still, the lifts are modern and connect well with the runs. Once you get to the

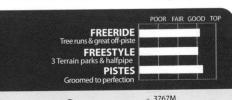

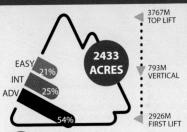

Copper Mountain Resort, 209 Ten Mile Circle, Copper Mountain, CO 80443

TEL: 866-841-2481

WEB: www.ride-copper.com

WINTER PERIOD Nov to April LIFT PASSES

Day pass - \$50-70 (early to regular season) Half-day \$45-\$51, 5 Day pass - \$230, Season pass \$1000 **BOARD SCHOOLS** Various beginner, progression, park &

freeride lesson packages available HIRE Board & Boots package \$37/day

NIGHT BOARDING

Friday & Saturdays open till 9pm, the jib park is floodlit

NUMBER OF PISTES/TRAILS: 125 LONGEST PISTE/TRAIL: 5km

TOTAL LIFTS: 22 - 15 chairs, 2 drags, 4 magic carpets, 1 tubing lift

LIFT CAPACITY (PEOPLE PER HOUR): 30,600 LIFT TIMES: 8.30am to 3:30pm MOUNTAIN CAFES: 2

ANNUAL SNOWFALL: 7.1m SNOWMAKING: 380 acres / 15% of area

CAR from Denver via Interstate 70, Copper Mountain is 78 miles, drive time is about 1 1/2 hours. FLY to Denver International Transfer time to resort 1

1/2 hours. Local airport is Eagle County, 20 miles away. BUS Colorado Mountain Express run transfers from Denver airport

to resort every 90 minutes. Price is \$108 return and takes 2 hours. Call 970-241-1822 for details

pics - Copper Mtn Resort

top of each run, you will not regret the chair ride as you are presented with a mountain that is lovingly pisted, and well marked out and will make for a great time.

FREERIDERS, welcome to sex on snow! Copper has it all for you. Powder, deep bowls and trees all on offer from expert double blacks to tame piste trails. Take the Flyer chair to reach the Flyer area where you will find a series of blue runs that cut through trees. Alternatively ride the Sierra lift to get a powder fix. More advanced riders should take Lift E to take on a cluster of short blacks. These are perfect for freeriders, especially the Union Bowl. If you keep right off the E-lift, you hit some decent trees. Intermediate freeriders will find plenty to interest them on the run known as Andy's Encore, reached off the B-1 chair.

FREESTYLERS have a great mountain to explore with great natural terrain and numerous parks that always make it onto the top ten lists of best parks in N.America. The main park Catalyst is located on the Loverly trail and features 3 separate ability lines. The beginner line has a series of rollers and simple rails, for the expert line we're talking huge tabletops, spines and a quarterpipe. At the bottom of the park is the competition 130m superpipe. Junior grommets have their own park and they've added a special floodlit jib park near the base. Natural terrain seekers should find Union and Spaulding Bowls the areas to check out for wind-lips, rock jumps and hits galore. Copper has a programme called the Team. If you volunteer to help look after the park and

USQ www.worldsnowboardguide.com 369

A

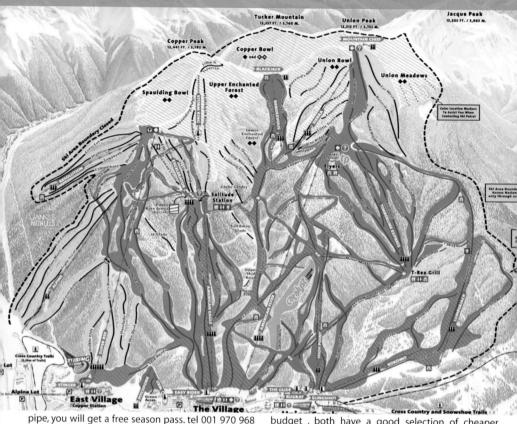

pipe, you will get a free season pass. tel 001 970 968 2318 for details.

PISTE riders will find that this is definitely a place for them, with plenty of advanced and intermediate wide open trails to choose from. Trails are groomed to perfection and runs like **Bittersweet** are a speed demons dream

BEGINNERS who come here won't be disappointed. Copper has more than sufficient areas for learning the basics and progressing onwards. There are plenty of easy green trails. The tree-lined runs of the **American Flyer Quad** are a real joy. The flats of K and L lifts are also perfect for first timers.

OFF THE SLOPES. Copper Mountain is very much a snowboard-friendly place and the locals will make your stay a good one. However, Copper has the usual pitfalls of many Colorado resorts - it can be painfullly expensive. But if you're a good scammer, you can stay here on a low budget if you put yourself about and get to know the locals. The resort facilities are very good and un-like many resorts, Copper isn't overloaded with dozens of soppy tourist shops, but rather a need to have selection. There is also a sports centre a swimming pool and gym.

ACCOMMODATION in Copper offers slopeside beds, but prices range enormously from \$20 up to \$800 a night. Staying in nearby **Dillon** or **Frisco** would be a good alternative if you're on a tight

budget , both have a good selection of cheaper accommodation. For all your lodging needs, contact Copper Mountain Lodging Services.

FOOD. The menus on offer here are perfect for the holiday crowds, but nothing comes cheap - a burger and a coke at Copper Commons is about \$6. Still, Farley's does do an affordable steak, while O'Shea's serves up killer breakfasts at very reasonable prices. Pesce Fresco's is another noted eatery with a big menu to choose from. However, for a burger and other light snacks, check out the *B-Lift Pub*, a favourite with locals and visitors alike.

NIGHT-LIFE around Copper is somewhat tame. The main hang outs being *B-Lift Pub*, *O'Shea's* and *Farleys*. However, the better option for a night out drinking or pulling a local bit of skirt, is in nearby **Breckenridge** or **Vail**. The choice of bars is much better, but unless you're 21+, and have ID to prove it, you're going to be seriously bored.

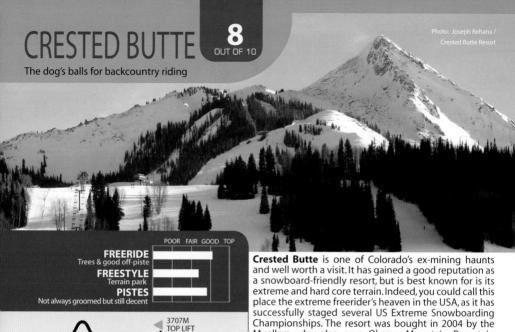

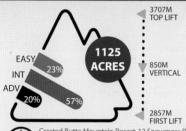

Crested Butte Mountain Resort, 12 Snowmass Road, P.O. Box 5700, Mt. Crested Butte, CO 81225

TEL: (800) 810-SNOW **SNOWLINE:** (888) 442-8883 WEB: www.skicb.com EMAIL: info@cbmr.com

WINTER PERIOD mid Nov to mid April

Half-day \$56, 1 day \$74, 5 of 7 days \$340, Season \$1,199 BOARD SCHOOLS Private lesson \$225 for 2hrs. Varrious

2hr group workshops around \$80 for beginners to advanced. Beginners day package inc lift pass & 5hr lesson \$115 HIRE Board & boots \$23.40 per day. Top demo kit available for \$32.40

NUMBER OF PISTES/TRAILS: 121 LONGEST PISTE/TRAIL: 4.2km

TOTAL LIFTS: 15 - 11 chairs, 2 drags, 2 magic carpet LIFT CAPACITY (PEOPLE PER HOUR): 19.850

LIFT TIMES: 9:00 a.m. - 4:00 p.m **MOUNTAIN CAFES:** 5

ANNUAL SNOWFALL: 6.1m SNOWMAKING: 80% of pistes/trails

CAR From Denver take Highway 285 south to Poncha Springs, Highway 50 west to Gunnison, then Highway 135 north into Crested Butte, total 233 miles, drive time is about 6 1/2 hours.

FLY to Denver International, transfer time to resort is 6 1/2 hours. Local airport is Gunnison/Crested Butte, 30 miles south with services from/to Denver

BUS Alpine Express run bus services from both Denver and Gunnison airports direct to Crested Butte.

Muellers who also own Okemo Mountain Resort in Vermont. They are planning some huge investments in the resort, with the long term aim to expand terrain to nearby Snodgrass Mountain. Crested Butte easily offers some of the most challenging snowboarding in America. What you get is a serious mountain for serious riders, and not your typical dollar-hungry Colorado destination. If you like your mountain high with steeps, couloirs, trees, major off-piste in big bowls, then Crested Butte is for you. With 100+ runs, spread over 1000 acres, no-one needs to feel left out, on crowd-free slopes, with a good average snow record.

FREERIDERS are in command here, with much of the terrain best suited to riders who know how to handle a board and prefer off-piste. Extreme Limits is a gnarly. un-pisted heaven for extreme lovers wanting big hits and steeps. Check out Headwall and North Face for some serious double black diamond trails, offering cliffs, couloirs and trees. In order to stay safe and appreciate Crested Butte's extreme terrain, you are strongly advised to get a copy of the Extreme Limits Guide, which is a separate lift and trail guide, pinpointing how and where to ride. Ignore its advice, and you may not live to regret it. However, don't simply read the guide and head off, you MUST also seek the services of a local snowboard or ski guide as well.

FREESTYLERS will find that a two week stay would still not be enough time to check out all the natural options for going airborn. Check out Crested Butte's gnarly fun-park, which has rails, logs, table-tops, quarterpipes and is also skier-free. To get to the park, take the Silver Queen or Keystone lift.

PISTES. Riders who choose a resort because of its motorway-wide, perfectly groomed slopes without a bump in sight, may feel a bit left out, but not too disappointed. You can still carve hard on a number of selected trails. For a fast trail, give **Ruby** a try, or check out the flats on the Paradise Bowl.

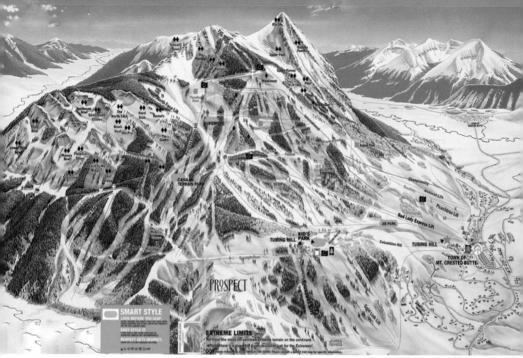

BEGINNERS cutting their first runs would do best to ride on the lower slopes near the village, before trying out **Poverty** or **Mineral Point** off the Keystone lift. There are a number of green runs to tackle before trying some of the easy connecting blues. The runs off **Gold Link** lift are pretty cool and worth a go. A beginners learn to snowboard programme with lift, lessons and hire, costs from around \$80.

OFF THE SLOPES

Visitors coming here expecting to find the all too often horrible Colorado-style, glitzy ski-tourist trap, will be pleased to note that Crested Butte is none of that. This is a friendly and welcoming place with services located at the base area or in the old town, a short bus journey away. Wherever you stay, there is plenty to keep you entertained at prices that don't always hurt. Local facilities include basic sporting outlets, a swimming pool, a gym, and an ice rink. There is also a cinema with the latest movies on show. But note, this is not a place loaded with attractions, but more of a place where you can sit back and relaw without being over pampered. Colorado Boarders Shop is the place for hire and snowboard sales.

ACCOMMODATION is available at the slopes or in the old town, and together they can sleep 5,000 visitors in a choice of condos, hotels and B&B's. Prices vary, with rates as low as \$25 a night in a B&B, or as high as \$300 in a fancy hotel. The nearer you stay to the slopes, the more costly things are, making the old town the cheapest option.

FOOD. Fatties on a mission to eat fast, hard and cheaply, welcome - you have arrived in heaven. This place is littered with eateries in every price range. For a hearty breakfast, there are a number of good places

to visit such as Forest Queen, The Woodstone Grill or the Timberline Cafe, all three open early. Later on in the day, check out Idle Spur where they serve damn fine steaks cooked exactly to the way you like it.

NIGHT-LIFE comes with a cowboy theme without the flashiness or bright lights. You can drink in a relaxed atmosphere at a number of joints that go on until the early hours. *Talk of the Town* has a punkish reputation and worth a visit. The *Idle Spur* is another cool hang which offers a good selection of beers and often has live music.

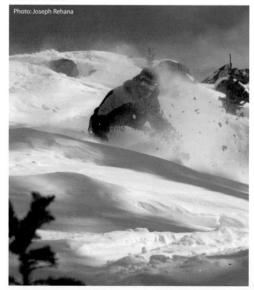

DURANGO

Good resort for all

Durango Mountain Resort was formerly known has Purgatory and changed its name when it was taken over in 2000. Its a fantastic place and one that doesn't come with all the razzamatazz and ponciness that many of Colorado's other resorts have. What's more, this place is not an over priced hunt designed for Dot.Com millionaires, this is a place where riders who like to ride hard and then relax with ease, can do so at resort that is friendly and extremely well set out. This can be said for both on and off the mountain and down town in Durango, which is 25 miles away. Although Durango is under new management, there has been a ski centre here for the past 36 years, and the future looks good for this place with a number of major developments taking place up on the slopes and down in the base

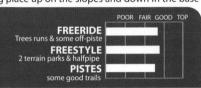

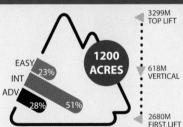

Durango Mountain Resort #1 Skier Place, Durango, Co 81301

TEL: 970,247,9000

WEB: www.durangomountainresort.com

WINTER PERIOD: Nov to April LIFT PASSES Day \$56/60 4 Days \$204/220 BOARD SCHOOLS Group \$40 2.5 hours Private lessons \$140 for 2hrs, \$300 all day. SNOWMOBILES \$50 1 hour, \$170 4 hours HIRE board & boots \$28/32 a day

LONGEST PISTE/TRAIL: 3.2km TOTAL LIFTS: 11 - 9 Chairs, 2 drags LIFT TIMES: 8.30am to 4.00pm LIFT CAPACITY (PEOPLE PER HOUR): 15,600 **MOUNTAIN CAFES: 3**

ANNUAL SNOWFALL: 6.6m SNOWMAKING: 21% of slopes

NUMBER OF PISTES/TRAILS: 86

BUS from Denver but not direct. FLY American Airlines offers daily nonstop jet service from Dallas to Durango which means a one-stop connection from most anywhere in the country.

Additionally, connecting flights into Durango are offered from Denver on United Express, from Phoenix on America West Express, and from Albuquerque on Rio Grande

DRIVE 30min drive from downtown Durango. Albuquerque is a 3 1/2 hour drive to the south, Denver is 6hrs northeast, and even Phoenix is an easy day's drive.

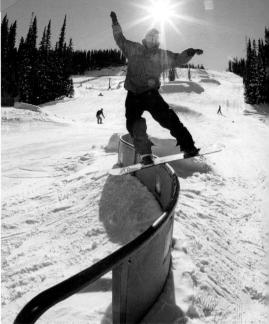

village of Purgatory. On the slopes you have a surprisingly well laid out selection of runs that provide something for everyone with a good choice of advanced and excellent intermediate slopes.

FREERIDERS have a wonderful mountain to play on. A weeks visit won't be wasted here with a good selection of runs to choose from with some very fast descents through trees and some fine powder stashes to seek out. The runs located under and around the Grizzly chair lift are cool and will offer the advanced rider a good time. The Bull Run is especially good but be warned, the lower section is not for the faint hearted. For some less daunting descents try the runs off the Hermosa Quad. Snowcat boarding is a good option to find some great untracked lines.

FREESTYLERS have plenty to do here with a choice of terrain parks and halfpipes. Paradise Terrain Park has a 450ft half-pipe, hits, rails & drops. Pitchfork Terrain Park features hips, rails, table tops, gaps, big air hit.

THE PISTES here are ok and you have a series of cool cruising trails but in truth this place is more of a freerider's resort. Still, runs like the Path of Peace is a good intermediate cruising trail.

BEGINNERS can almost ride from the top to the bottom on a nice cluster of easy green trails reached off the Hermosda lift.

OFF THE SLOPES If you wish to lodge close to the slopes, then theres 3,120 beds near the resort, but a cheaper bet is to head 25 miles over to **Durango**. Theres 7,000 beds there, as well as okay restaurants and bars.

Keystone has been a ski resort since 1970, but it was only in 1997 that the management finally allowed snowboarders to use their mountain. Since then Keystone seems to have embraced snowboarding whole-heartedly, with the recently revived terrain park (named Area-51 after its 51 different features) proving their commitment to the sport. Keystone is owned by Vail Resorts, who also own Vail, Beaver Creek, Breckenridge and Heavenly - all these resorts offer a multi-area pass allowing additional access to the smaller resort of Arapahoe Basin. Having the only gondola access (2 of them actually) in Summit County, in addition to offering the county's only night-boarding area (15 lit trails including the park and pipe) Keystone has started to attract boarders from all around.

FREERIDERS can roam freely over Keystone's three connected mountains: Keystone Mountain, North Peak and The Outback. Keystone is the front mountain and is laden with jib runs like Mozart and Spring Dipper. It's a good idea to have someone to spot your blind landings off the big rollers as it can get real busy. North Peak (the second mountain) offers some good steeps and open tree runs. However The Outback is the place to go with newly available Cat Riding Tours providing unique, guided services in the new expansion of Erickson Bowl and Bergman Bowl. Along with a shuttle service in the Outback Bowls and a bit of dry pow pow it makes Keystone a freeriders playground.

FREESTYLERS will not be disappointed with the perfectly crafted park known as A51, with a 400-foot Super Pipe and as many different rail features as the mind can imagine. Located in the Packsaddle Bowl, Keystone have just added a quarter of a million dollars of improvements tripling the parks size. Sitting on a perfect aspect allowing just the right amount of sun to both walls, the pipe is excellent, with walls reaching 5m in high season. They have a new snow-bowl feature (super fun to play in), wall ride and some really aggressive advanced rails including a 50 foot flat bar and a gigantic rainbow that they light on fire at night. There is now also a great beginner/intermediate freestyle area known as the Incubator Terrain Park on Freda's Way loaded with heaps of intro features, an intermediate fun box line and intermediate rail line.

PISTES lovers will be delighted to know that Keystone grooms some of their runs twice a day, leaving lots of terrain to lay out big turns. Check out runs like Wild Irishman and Frenchmans if you want to crank out some turns.

BEGINNERS are well catered for with two good ski schools and some reasonable learning areas and good long green runs like Schoolmarm. However you may find that there are a few too many flats.

OFF THE SLOPES. Keystone has recently completed a multi-million dollar redevelopment plan so theres a lot of expensive condos and a handfull of hotels. Eating and drinking options are plentiful, although night time action can be a bit lame to say the least. Head to the local towns of Silverthorne and Frisco for some cheap backpacker options. If you're after some good pub grub 374 USQ WWW.WORLDSNOWBOARDGUIDE.COM

pic - Tim Axe/Keystone Resort

head to the Great Northern Tavern for a good steak and a handcrafted microbrew. Piasano's does great Italian and Summit Seafood for 'quess what. Nothing really on the fast food end until you get closer to the town of Dillon. Party people will have a good variety of choice including some local haunts like Dos Locos, The Goat, Great Northern Tavern and nightclub Greenlight.

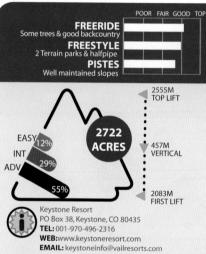

WINTER PERIOD: mid Nov to end April

LIFT PASSES 1 Day \$75, 2 of 3 Days \$150, 5 of 8 days \$375 BOARD SCHOOLS Burton LTR 2hr group lesson \$70+\$11

for lift pass. Terrain park lessons \$70 2hrs Private 2hrs \$205, full day \$430

HIRE board and boots \$28 per day

NIGHT BOARDING Until 8.00pm 15 trails, half pipe & park lit CAT BOARDING Into Erickson Bowl and Bergman Bowl but you'll need to be able handle youself. They run daily 10am-2pm \$75 . You can also pick up the Outback Shuttle CAT to save some hiking to get the the Outback bowls £5 per trip. Tel: 970-496-4386 (4FUN) to reserve a space

NUMBER OF RUNS: 116 LONGEST RUN: 5km

TOTAL LIFTS: 20 - 2 Gondolas, 12 Chairs, 2 drags

4 magic carnet

LIFT CAPACITY: 35,175

LIFT TIMES: 8.30am to 8.00pm

ANNUAL SNOWFALL: 5.84m SNOWMAKING: 35% of slopes

BUS Colorado Mountain Express run transfers from Denver airport and take 1 1/4 hours FLY to Denver Int which with a 1,3/4 hours transfer

time. Vail/Eagle airport is 65 miles away DRIVE From Denver, head west on 1-70 via the Eisenhower tunnel to Dillion. Exit at the junction 205 to Hwy 6 onto Keystone,

a further 6 miles.

Good compact resort

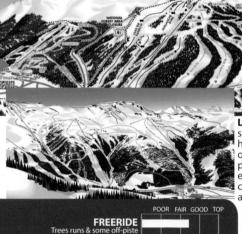

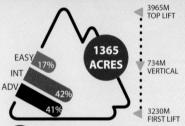

FREESTYLE

Terrain park
PISTES

Well laid out

(1)

Loveland Mountain Resort Po Box 899, Georgetown CO 80444 PHONE: 303-571-5580

WEB: www.skiloveland.com
EMAIL: loveland@skiloveland.com

WINTER PERIOD: Nov to April LIFT PASSES Day \$58 Late season day \$45 BOARD SCHOOLS Group lessons \$40 for 2 1/2 hrs, packages available that include hire & lift pass from \$63. Private lessons from \$70 per hour HIRE Board & Boots \$28 per day

NUMBER OF PISTES/TRAILS: 70 LONGEST RUN: 3.2km

TOTAL LIFTS: 11 - 9 Chairs, 2 drags LIFT TIMES: 9am - 4pm

ANNUAL SNOWFALL: 10m SNOWMAKING: 12% of area / 160 acres

LIFT CAPACITY (PEOPLE PER HOUR): 15,600

BUS from Denver available by arrangement. **FLY** to Denver, transfer time 1 hour.

DRIVE From Denver, head west on I-70 via Idaho Springs & turn left onto the route 6 past Georgetown,

to reach Loveland. The distance from Denver is 56 miles.

Lovelands is a resort that has a reputation for good snow, a long season, and a claim to have the world's highest quad chair lift which lets you off at an elevation of 3871 metres. Located close to **Denver**, is definitely a place that is worth a visit and a great one for day trippers, especially for the city slickers from Denver. Despite being close to Denver, however, overcrowding is not a problem and both the lift lines and pistes are often deserted. The resort has recently been investing a lot of dollars in expanding the terrain with the addition of another 400 acres of extreme slopes at the area known as the Ridge. A lot of money has also been spent on upgrading the snowmaking facilities to help boost the snow cover. Loveland is not the biggest hill in Colorado, but what you get is more than adequate and there are certainly smaller places than this one. What you have is a ridable area that stretches up from two points, Loveland Valley & Loveland Basin that are linked by chairlift and road. **Loveland Valley** is the smaller of the two areas with a cluster of runs that rise up through some thick wooded glade's that eventually thin out the further up you go. Loveland Basin, who's slopes stretched out around a high bowl above the entrance to the Eisenhower **Tunnel**, is the main area to ride with a good choice of runs from basic intermediate trails to some hardcore extreme runs with a few double black diamond extreme slopes.

FREERIDERS should grab the number 2 lift and head up to the **Ptarmigan area** where you will find lots of cool freeriding terrain. However, some of the best freeride terrain can be found off lift 8 in the **Zip Basin**. Here you will find some nice backcountry type terrain with a few gullies and bowls.

FREESTYLERS have an okay terrain park with a series of kickers and numerous rails, but in truth some of the natural features are better for air.

PISTES. The resort has a number of well maintained trails that are nicely laid out. Some of the best carving trails are off the number 6 lift.

BEGINNERS can take a lesson here to help then tackle what is largely not a beginner's resort. That's not to say novices should stay away, it's just that the resort is more of an intermediate level.

OFF THE SLOPES. While there area boasts a few shops and places to eat, this is not a resort as such. One okay option would be to stay down in **Denver** where you can't fail to find good local facilities.

USQ www.worldsnowboardguide.com 375

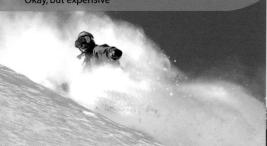

Snowmass is the biggest of the resorts that make up the Aspen area, and the second largest resort in Colorado. With its four separate peaks, Snowmass is an impressive resort with a lot going for it and warmly welcomes snowboarders. This has not always been the case within the Aspen group, where snobbish areas such as Aspen Mountain only recently allowed snowboarders. However, the 1,246 metres of vertical available here, means you don't have to go anywhere else. Snowmass is mainly an advanced/intermediate rider's retreat, with a good choice of double black diamond runs and trails through trees, steeps and awesome powder making this a place where everyone can get a fix.

FREERIDERS will go crazy here. Snowmass is a real pleasure and offers fantastic riding. Those wanting to cut some serious terrain should check out Hanging Valley and Cirque for some double black steeps and powder bowls. The run known as Baby Ruth is also where advanced riders will get a real buzz. Snowmass offers plenty of backcountry riding with organised tours: Aspen Powder Tours runs trips for riders wanting the ultimate thrill, from around \$230 a day.

FREESTYLERS have two halfpipes and a three terrain park, as well as a mountain riddled with natural hits. The main pipe is some 500ft long, with big walls and perfect transitions for getting massive amounts of air. The pipe was originally designed by pro Jimi Scott, and is easily reached off the Funnel lift. There is also a very good funpark reached off the Coney Glade chair lift.

PISTES. There's a good selection of wide, open motorway flats for putting in some big carves, with an array of all-level, well groomed trails set out across the area. Big Burn reached off Lift Number 4 is a good intermediate trail.

BEGINNERS cutting their first snow should start at the base area from the Fanny Hill chair lift, before trying out the steeper stuff on the Big Burn. The local ski-school has a 3 day beginner's programme that guarantees you will learn to ride: if you don't, you get an extra day's tuition free.

OFF THE SLOPES. The base village has dozens of lodging options, with beds within easy reach of the bottom runs. Evenings are not up to much, but there is a lot more going on in nearby Aspen. For a drink, check out the *Copper Street Pier*, or *Eric's* for a game of pool. Be aware that Aspen is super \$\$\$\$ dollar-hungry.

376 USQ WWW.WORLDSNOWBOARDGUIDE.COM

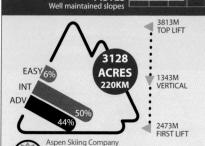

FREERIDE

FREESTYLE

PISTES

Trees & some good off-piste

3 Terrain parks & 2 halfpipes

Post Office Box 1248, Aspen, CO 81612 TEL: 800-308-6935 WEB: www.aspensnowmass.com

WEB: www.aspensnowmass.com

WINTER PERIOD: mid Nov to early April LIFT PASSES 1 day pass \$75, 6 days \$440, Season \$1,879 BOARD SCHOOLS Day private \$479, Day Group \$109 HIRE Number of hire shops on mountain

NUMBER OF PISTES/TRAILS: 88 LONGEST RUN: 8.5km

TOTAL LIFTS: 22 - 1 Gondola, 14 Chairs, 2 drags, 3 magic carpets, 2 beginner lifts

LIFT CAPACITY (PEOPLE/HR): 27,181 LIFT TIMES: 8.30am to 4.00pm

ANNUAL SNOWFALL: 7.62m SNOWMAKING: 5% of area

BUS journeys from Denver, take around 2 1/4 hours. Buses run between aspen and snowmass until 2am FLY to Denver, with a 3 1/2 hour transfer, local airport is Aspen, 3 miles

TRAIN Nearest station is Glenwood Springs about (64 km) from Aspen. www.amtrak.com

DRIVE Snowmass Village is located 5 miles off Colorado 82 via Brush Creek Road. Aspen is located 5 miles past Brush Creek road via Colorado 82

NEW FOR 2006/7 SEASON: Silver Queen Gondola gets a refurbishment with the cabins being replaced

STEAMBOAT

Excellent treeriding, but stuck up off the slopes

Steamboat is a curious place in more ways than one. What you get is an old mining town with a seemingly laid back approach coupled with a mountain that offers some great riding with over 2939 acres of terrain that is spread out over four tree-lined mountain peaks. Unfortunately, many will find Steamboat is certainly not the best place to spend a weeks vacation. Although this is not a bad place to visit in terms of the riding opportunities and the good annual snow record, its tacky dollar hungry, fur-clad ski-cowboy image will make most normal snowboarders want to throw up. However, Steamboat has a growing snowboard population and has made a

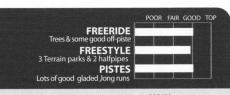

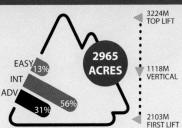

Steamboat Ski & Resort Corporation 2305 Mt. Werner Circle, Steamboat, CO 80487 TEL: 970-879-6111

WEB: www.steamboat.com EMAIL: info@steamboat.com

WINTER PERIOD end Nov to early April LIFT PASSES Half-day \$55-61, Day Pass - \$79-81 Season Pass - \$1499 (early bird \$935)

BOARD SCHOOLS group clinic all day \$27 private 2 hours \$235 all day \$475 HIRE board and boots \$33/day

SNOWMOBILES 2hr \$80,4hrs \$135, all day \$175

NUMBER OF PISTES/TRAIL:S: 164 LONGEST RUN: 4.8km

TOTAL LIFTS: 20 - 1 Gondola, 17 chairs, 2 drags LIFT CAPACITY (PEOPLE PER HOUR): 32,158 LIFT TIMES: 8.30am to 3:30pm

ANNUAL SNOWFALL: 8.19m SNOWMAKING: 15% of area / 438 acres

CAR From Denver, head west on 1-70 via the Eisenhower tunnel, leave the Silverthrone exit. Then head north along Hwy 9 and Hwy 40. Denver to resort is 167 miles

FLY to Denver, with a 4 hour transfer. Yampa Valley airport is 22miles from the resort, theres 5 flights daily from Denver & Houston BUS from Denver take around 3 hours 20 mins from Yampa.

NEW FOR 2006/7 SEASON: new Sunshine Express High-Speed Quad Chairlift powered By Solar/Wind Energy. New Sunshine Bowl Trail & Improved snowmaking. New Zaugg Pipe Cutter

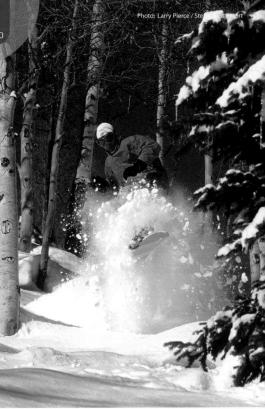

real effort to drag itself into the 21st century (although having live bands playing on the lower slopes on a Friday afternoon is hardly ground breaking stuff). Still, the resort has several things in its favour. The resort offers some fantastic tree-riding, there's ample deep powder and some great carving slopes. There is also a couple of double black diamond trails offering extreme slopes for advanced riders to tackle along with some over-rated blacks for intermediate riders to try out. What is most notable here, are the trees and the options for backcountry snowboarding, which can be explored by taking a snowcat trip organised locally.

FREERIDERS can have a good time at Steamboat. If you're up to the grade, try riding the steeps on the Meadows of Storm Peak, where Christmas Tree Bowl and the neighbouring chutes will give you a good challenge. Alternatively, try cutting some deep powder tracks in areas like Toutes.

FREESTYLERS can catch some decent natural air or sample the man-made hits in the Maverick terrain park on Big Meadow. The Maverick park claims to have the biggest park in North America 650 foot long ending in a 50foot 1/4pipe. There's also a great park, called the Sobe Park, with a 200 foot pipe and numerous rails and kickers. The Beehive, is a small fun-park with a series of mini-hits for kids only, located on the Spike trail reachable off the South Peak lift.

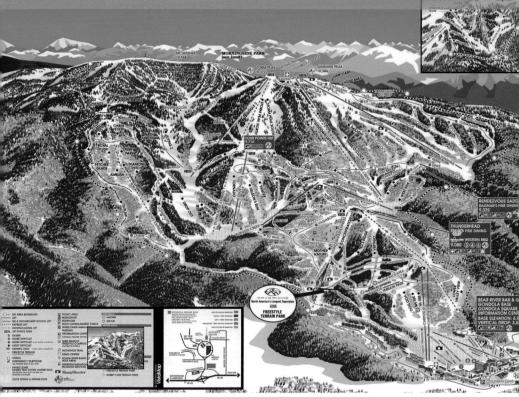

THE PISTES here are very good with good long descents on which to perfect their technique. Steamboat is also noted for its Olympic race runs, which can be used by snowboarders. Further more, this is also a place where speed skiers, and indeed extreme down hill mountain bikers, often come to practice their thing. Which means the mountain certainly has a number of very gnarly slopes where you can cut it at great speed, but don't go racing down fast runs in an out of control or dangerous manner, because not only will someone get seriously hurt, but the ski patrol will take a very dim view of your actions and throw you off the mountain.

Beginners and total novices will feel most left out here, for apart from some green runs snaking in and out of the higher grade trails, the easy stuff at the base area is often very tiresome. Steamboat has an excellent ski and snowboard school.

OFF THE SLOPES

Steamboat is a welcoming town even if it has a poncy feel about it. The town is loaded with all manner of attractions and is well equipped for making your stay a good one. You can choose to stay on or close to the slopes and the main resort facilities are well located to each other and for the slopes. However, being a dollar-hungry place, those of you on a tight budget may not be able to survive beyond a couple of days here. The cost of most things is unjustifiably high. Which is a shame (perhaps its a deliberate resort policy so they can attract dot.com millionaire's and keep low-lifes away). Around town you will find a host of things to do, from a climbing gym to an indoor ice rink. The town also has a number of shops,

with most now catering for snowboarders, some even offer good deals on board sales.

ACCOMODATION. Steamboat has a very good selection of accommodation with loads of lodges, chalets and condo's to choose from.

FOOD. Steamboat has a good selection of restaurants from fancy dining out joints to a number of fast food places, whether you have a steak or a burger, one thing is for sure, you can guarantee it will be top notch (mind you so will the price). You can eat out in style on the mountain at places like the *Bear River Bar & Grill* or the *Rendezvous Saddle* cafeteria.

NIGHT-LIFE in this over hyped town leaves a lot to be desired and can be best described as crap and aimed at middle-aged skiers with sad dress sense. They have way too much après-ski nonsense here. However, the *Cellar bar* has a good deal going. For \$12 you get to drink as much as you can for two hours.

TELLURIDE

Great no nonsense freeriders resort

Telluride sticks two fingers up to convention when it comes to the norm in Colorado! Why? Well it's simple, no tackiness, no bull, no hype, no snotty nose yuppies; none of it, what you have here is easily summed up as 'superb'. Telluride, which is said to have been robbed over a hundred years ago by Butch Cassady, is full on, but unlike other resorts in Colorado, this Wild West town won't rob you blind. Telluride, which is an old mining town, is set in the San Juan Mountains and is a skiers and snowboarders' heaven that offers every style and ability of rider something to saviour, especially beginners as this place has to be one of the best novices resort in the whole state. The Prospect Bowl area is great, accessed by three high speed quad lifts which lead you to varied runs and the **Ute Park**; It's really opened up this hill.

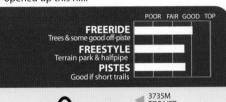

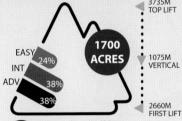

Telluride Ski and Golf Company 565 Mountain Village Boulevard, Telluride CO 81435

TFI • 970-728-6900

SNOW PHONE 970.728.7425 WEB: www.tellurideskiresort.com FMAII: info@tellurideskiresort.com

WINTER PERIOD: Nov to April LIFT PASSES Day \$75,6 days \$418, Season Pass \$1375 BOARD SCHOOLS

Beginners and various clinics available 800-801-4832 HIRE Board & Boots \$33 per day

NUMBER OF PISTES/TRAILS: 84

LONGEST RUN: 7.36km

TOTAL LIFTS: 16 - 2 Gondolas, 11 Chairs, 2 drags, 1 Magic Carpet

LIFT TIMES: 9am - 4pm

LIFT CAPACITY (PEOPLE PER HOUR): 21,186

SNOWMAKING: 15% of slopes FLY Montrose Airport is 65 miles away flights from Chicago, Dallas, Houston & Newark. Telluride Airport

is 6 miles away & connecting flights from Denver and

Phoenix DRIVE From Denver by way of Grand Junction - Take Interstate 70 West to Grand Junction, go South on Route 50 to Montrose. Continue South on Route 550 to Ridgway then turn right onto Route 62. Follow this to Route 145 and turn left. Follow the signs into Telluride. Travel time - 7 hours

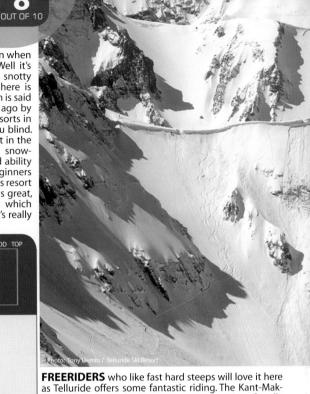

M, the Spiral and the Plunge runs are a series of really challenging steeps that will either leave you seriously bruised if you bail, or make you feel like a god if you complete them in style. These are serious double black diamond trails and not for wimps.

FREESTYLERS who are happy to roam around riding off natural hits are in for a pleasant surprise. The mountain has a number of natural pipes and banks. The West Drain slope offers some cool riding due in part to it being a natural half pipe. The Air Garden Terrain Park covers 10 acres and features a number of boxes, rails, kickers, table tops and a halfpipe designed for a variety of abilities. You'll find it on Lower See Forever area.

PISTES, This resort lends itself perfectly well to cruising at speed, although it should be said that many of the trails are a bit short. Note also that some runs are only pisted on oneside, which means one side being smooth and the other bumpy

BEGINNERS are probably the one group who will feel most pleased here and most at ease because Telluride not only has a good percentage of easy trails, they are also well set out and very easy to negotiate.

OFF THE SLOPES things are just as good as on them. There are two options to choose from for lodging and local facilities in either Telluride's main town or up in the Mountain Village. Which every you choose you wont be disappointed as both offer good accommodation, great places to dine and a number of cool bars.

USQ www.worldsnowboardguide.com 379

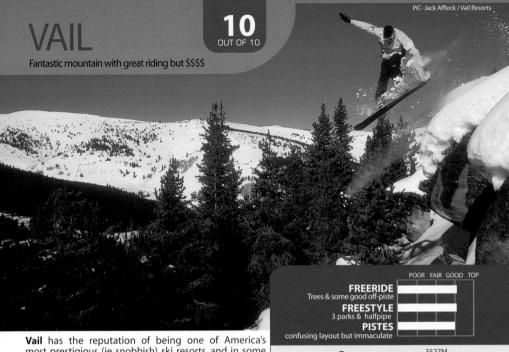

most prestigious (ie snobbish) ski resorts, and in some respects it's true. The town of Vail, a bizarre imitation of a 'typical' Swiss alpine village, is centred around the base of the resort and is hellishly expensive. However, there are loads of good reasons to visit Vail, which include the large amount of terrain on offer (over 4,000 acres) and Vail's extremely healthy and positive attitude towards snowboarding. The terrain park has 3 halfpipes and 12 runs, and is also open to skiers although thankfully, it's frequented almost exclusively by snowboarders. One major point regarding Vail is that it is a very popular resort resulting in some long lift queues throughout the season. But in terms of climate and cost, a good time to visit is late season when the snow is soft and the price of lift tickets drop dramatically.

FREESTYLERS are extremely well catered for on Vail's slopes. Vail also provides a major half pipe and terrain park known as the Golden Peak. Both park and pipe are groomed to perfection. The pipe has huge walls offering great transitions while the park is loaded with not only a major series of gaps, spines etc, but also a chill out area that has video screens, pumping music and drink vending services.

FREERIDERS will find this place heaven. Vail's Back Bowls will stoke you beyond belief when you see what is on offer. In order to find out where the best places are, you should pick up a copy of the free pocket-sized snowboard mountain map which will point you in the direction of the best boarding trails and hits. The most popular backcountry includes **Ptarmigan Ridge**, a 25ft cornice jump and Kengis Khan, another cornice not suitable for sufferers of vertigo. The cliffs under Chair 4 are easier to access, as long as you don't mind your slams being applauded by everyone on the lift. The tree run Cheeta Gully is marked as one of the special snowboard trails and will test the most proficient rider.

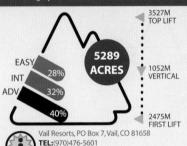

WINTER PERIOD: mid Nov to end April LIFT PASSES

Day pass \$81, 3 of 5 days \$243, 5 of 8 days \$405 BOARD SCHOOLS one day group \$90/100

Full day inc pass & rental \$190-202

WEB: www.vail.com

1 Hour Private Lesson \$110,3 hours park lesson \$80

EMAIL: vailinfo@vailresorts.com

HIRE board and boots \$27/day

SNOWMOBILES 1 hour from \$62

NUMBER OF PISTES/TRAILS: 193

LONGEST RUN: 5.4km

TOTAL LIFTS: 34 - 1 Gondola, 23 chairs, 10 drags LIFT CAPACITY (PEOPLE PER HOUR): 53,281 LIFT TIMES: 8.30am to 4.00pm

MOUNTAIN CAFES: 20

ANNUAL SNOWFALL: 8.5m SNOWMAKING: 5% of area

CAR Denver via Interstate 70, take Main Vail Exit (176), 97 miles (156km). Drive time is about 1 3/4 hours.

FLY to Denver International (110 miles), transfer time to resort is 2 hours. Local airport is Eagle County, 30 miles

y, 13 airports offer connection

BUS There are daily bus services from both Denver and Vail/Eagle County airports direct to Vail.

380 USQ www.worldsnowboardguide.com

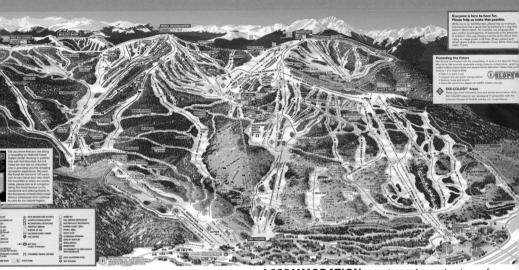

PISTES. Vail has some excellent blue trails and some challenging fast blacks. Many of the runs start out as one grade and then suddenly become another, so study a lift map in order to negotiate the best spots with ease. The Avanti lift gives access to some really good fast trails. The Mountain Top lift also allows you to ride in style on a number of extremely good trails.

BEGINNERS have a mountain with so many easy trails and excellent progression possibilities, that if you fail here, you must be a complete loser. The areas of Golden Peak are perfect for learning the basics, although it can become a little clustered around midday, especially at weekends and holidays. Vail's snowboard school is excellent and has a number of instruction programmes.

OFF THE SLOPES. If you reckon that Vail is just about the slopes, think again as there are heaps of things going on with an amazing amount of great local services. The area is huge, so use of the free shuttle bus may be necessary depending on where you base yourself. Recently, merchants & restaurant owners have taken a much-needed approach to offering lower priced options for visitors, including apres, dinner & drink specials. Do your homework before making a choice and you will save much more \$\$ than you thought. Locals know exactly what to do to make your stay a good one. They offer a high level of service whether you're buying a burger or checking in to a hotel.

ACCOMMODATION consists of a selection of some 30,000 visitor beds and providing you don't mind not being slopeside, you will find affordable lodging. Many opt to stay out in one of the nearby villages with cheaper housing and on average, only a 20 minute 'commute' to the slope. Check Vails web site for a full listing of accommodation.

FOOD. Eating in the resort or around the main area may destroy your bank balance or father's credit card if you don't choose carefully. Some prices are silly, but there are plenty of semi-affordable, fast-food ioints to check out. To tickle your taste buds, why not check out Pazzo's, which serves a good helping of cheap pasta or where you can have a 'do it yourself pizza'. The Red Lion also features good, cheap burgers, sandwiches & fries in one of the most convenient, frequently visited village locations (On Bridge Street, in the heart of all the action).

NIGHT-LIFE, as you'd hope, is extremely good. The offerings are excellent, with good bars and okay places to boogie well into the early hours. Contrary to popular belief, you CAN find cheap drink specials in the heart of the village. Two frequented stops this season included Fubar and 8150, which both featured a \$10(US \$) all-you-can-drink special on Sunday & Monday nights (we hope to see the return of this unbelievable deal in the 04/05 season). You can also checkout the many après specials, which include \$3 beers and discounted appetizers.

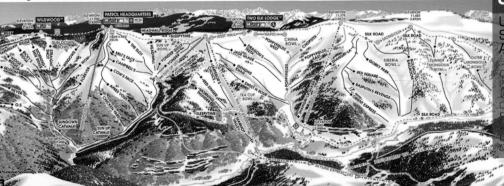

Winter Park - a mere 67 miles from Denver, nestling at the base of **Berthoud Pass** at an altitude of 2,743 feet, is said to be the fifth largest resort in the USA, with over 2886 acres of terrain. The old saying that 'size always matters' doesn't ring true at winter, since although this place is vast, it is not as great as the hype dictates. However, Colorado is famous for its powder snow and in fairness; Winter Park snags more than its fair share, with an average annual snowfall of 350 inches and plenty of blue sky days. The high tree line of Winter Park means that even when there is low cloud, visibility is still good. Winter Park is actually two mountains, Winter Park and Mary Jane. Winter Park has trails for all standards of rider and is well groomed. What makes this place somewhat dull is that it is really tame, with hardly any fast, challenging terrain. The best runs (if such exist) are on the Mary Jane slopes and are mostly black trails. There have been some big improvements in the terrain parks over the past few seasons.

FREERIDERS will find plenty of okay tree runs around both mountains with near perfect spaced trees. However, don't expect to ride all the ferns at any great speed. There is some good riding to be had in Parsenn Bowl on **June Mountain**, and on the runs of the **Challenger**.

FREESTYLERS are presented with three fun-parks. The Rail yard is the big one designed for the advnaced rider. Conditions depending it has 25 rails, 16 jumps and a super-pipe organised into various lines. The Jack **Kendrick park** is set-up for more intermediate riders it has a number of rails and kickers and a less intemidating halfpipe.

Kendrick is designed for the Freerider looking to hone their skills before going to **Rail Yard.** Apparently Kendrick's jumps have more flow than the Mississippi River. The **Discovery Park** is the place to learn how to navigate rollers, catch air, and slide on foreign surfaces! This beginner terrain park is designed to be a great place to learn skills for the first time.

PISTES. Riders looking for wide pistes where they can pose doing big arcs, will find Winter Park right up their street. Much of what you find on Winter Park mountain will suit piste lovers.

BEGINNERS also fair well here. The easy trails, and indeed some of those classed as intermediate, can be ridden within a few days if you put your mind to it.

OFF THE SLOPES Winter Park's lodging is 6 miles down the valley, where you can find a good selection of places to stay at affordable prices. The evenings are not too hectic, but you can party. Check out Lord Gore Arms which shows videos every night with DJ's and bands, or The Pub for Sunday night disco mayhem.

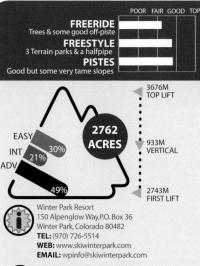

WINTER PERIOD: Nov to April LIFT PASSES Half-day \$49-50, Day pass - \$65-70 BOARD SCHOOLS Beginners package lift, hire & 2 1/2hr

lesson \$89/99 per day. Various group lessons 2 1/2hrs \$49/59 HIRE Beginners Board & Boots \$28/32, Demo Board & Boots \$40/44

NUMBER OF PISTES/TRAILS: 134 LONGEST RUN: 8.2km

TOTAL LIFTS:21 - 18 chairs, 2 Magic Carpets, 1 Rope tow

LIFT CAPACITY (PEOPLE/HR): 35,030 LIFT TIMES: 8.30am to 4.00pm

ANNUAL SNOWFALL: 9.1m SNOWMAKING: 20% of slopes

BUS journeys from Denver take 1 hour. FLY to Denver Int, transfer 1 1/2 hours DRIVE From Denver, head west on 1-70 via the Eisenhower tunnel to exit 232 on Hwy 40 direction

Granby.. 67 miles. 1 1/2 hours drive time.

TRAIN Amtrak's California Zephyr goes to Winter Park daily from Chicago & LA. Ski train weekends from Denver

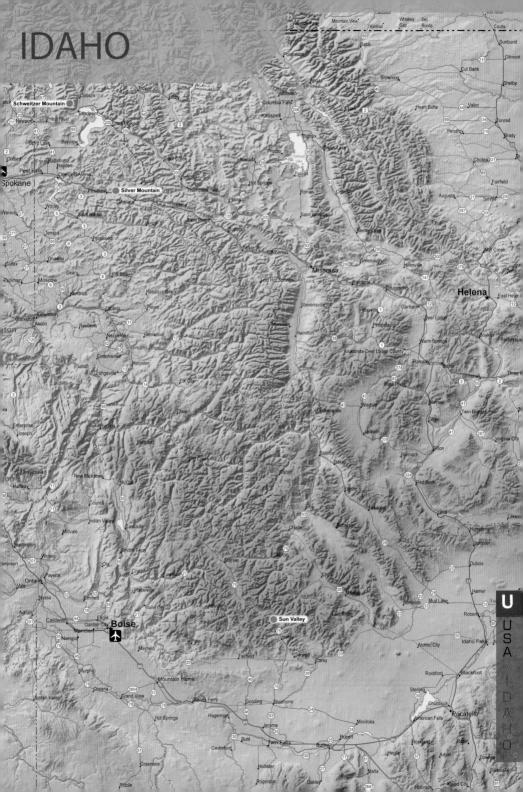

Lying about an hour's drive north of Couer D'Alene. Idaho, (and about an hour and a half south of the Canadian border) is the town of **Sandpoint**. Sandpoint is in the lucky position of having one of the coolest snowboarding spots in the North-western United States. A mere 10 minutes drive up a beautiful wooded ascent takes you to the Schweitzer basin. Probably unheard of by anyone that hasn't spent time in the area. On top of the amazingly laid back atmosphere of the Northwest in general, Schweitzer enjoys a very low "I snowboard so I'm great" bullshit factor, a problem that needs addressing both in the UK and central states like Utah and Colorado. The resort has a good lift system with reasonably priced lift tickets at \$45 a day for the whole mountain - this may also include some excellent night riding on one of the many well lit runs. If you haggle, you might get some bargains for multi-day tickets, or if you are with a group.

FREERIDERS are assured plenty of powder days and an enormously varied selection of terrain from the super steep chutes on the west side of the front half of the mountain, to an amazingly long (and tiring) blue run that starts from one of several high speed, no-queue lifts about 100 feet from the day-lodge. The ridge that links the runs together along the top of the mountain also provides a breathtaking view of Lake Pend O'Reille.

FREESTYLERS have a magical mountain do to their tricks on. A favourite with local students, this overlooked mountain has not 1 but 2 terrain parks. There's the **Freestyle Garden** that is perfect for novices with assorted rails and jumps. If you want something more substantial check out the **Stomping Grounds Park** which features a rail garden, booters and competitions that are held throughout the winter.

PISTES. There's plenty of groomed stuff on offer and speed perverts can make good on runs such as **Cathedral** and **Zip**

BEGINNERS have no need to worry here as all the novice runs are well away from the main runs so helping to prevent mass collisions, and serviced by a separate chair lift

OFF THE SLOPES. All your local needs are mainly provided down in **Sandpoint** 2 miles away. There is some accommodation available at the base area close to the slopes such as The *Green Gables Lodge* or in one of the condos. Far cheaper lodging can be found in Sandpoint where you will find a basic but okay selection of shops, restaurants and bars. For a burger try the *Powder House* and for a beer give *Roxy's* a try

384 USQ WWW.WORLDSNOWBOARDGUIDE.COM

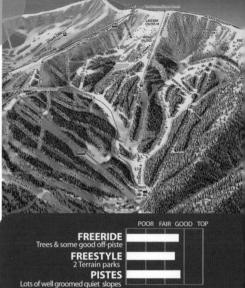

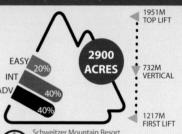

10,000 Schweitzer Mountain Road, Sandpoint, ID 83864 TEL: 001 208-263-9555 WEB: www.schweitzer.com EMAIL :ski@schweitzer.com

WINTER PERIOD: Nov to April LIFT PASSES Half day pass \$41

1 Day pass - \$49, Night pass - \$15, Season pass \$699 BOARD SCHOOLS

One day with pass and board/boots \$59 Three days with pass & board/boots \$99 HIRE Board & Boots \$30/40 day, Helmets \$7

NIGHT BOARDING

Friday/Sat 3pm till 8pm from mid Dec- mid March

CAT/SNOWMOBILES

www.selkirkpowdercompany.com run CAT boarding and snowmobile tours into the backcountry tel: 866.464.3246

NUMBER OF PISTES/TRAILS: 64

LONGEST RUN: 4.3km

TOTAL LIFTS: 10 - 6 chairs, 3 drags, 1 Rope tow LIFT CAPACITY (PEOPLE/HR): 8,092 LIFT TIMES: 9.00am to 4.00pm

ANNUAL SNOWFALL: 7.6m SNOWMAKING: 10% of slopes

BUS from Spokane to resort takes 90 mins
FLY to Spokane Int, 86 miles south west is served by most
carriers. Sandpoint airports handles the seriously minted
DRIVE From Spokane, take I-90 east and then Hwy 95

north via the town of Sandpoint. Schweitzer is another 2 miles on. **TRAIN** Sandpoint is nearest station. Amtrak has trains from Chicago & Seattle, 2 miles from resort

Okay but basic

A smaller resort than **Schweitzer**, and much closer to civilisation, is Kellogg, Idaho. A small mining town in north central Idaho, about 40 minutes from Couer D'Alene, Kellogg has the honour of running the longest gondola ride in the world, which culminates at the day lodge of Silver Mountain. Essentially composed of two resorts, the new Silver Mountain lift system and the incorporated Jackass Ski Bowl provide a superb set of runs, although the intermediate rider is better catered for than freestylers or super euro-carvers. In fact, the only real downside to this hidden gem of a mountain is the fact that it is infested with cat tracks linking one run to the next. Easy on skis, a real drag on a board. However, to be fair to the resort management, they are dealing with the problem by getting rid of a lot of the cat tracks. Overall, the mountain offers a fair selection of long steeps with generally great snow and weather conditions. The seven lifts are quick and easy to negotiate

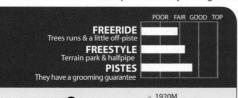

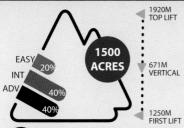

Silver Mountain Ski Area 610 Bunker Avenue, Kellogg ID 83837 TEL: 001 (208) 783 1111

WEB: www.silvermt.com EMAIL: infosm@silvermt.com

WINTER PERIOD: late Nov to early April LIFT PASSES Day pass \$40, Night pass \$12 Season pass \$379/559 early bird/normal priceBoard SCHOOLS Group lesson from \$20, Private 1 hr \$49 **NIGHT BOARDING**

running most Friday & Saturday nights until 9:30pm

NUMBER OF PISTES/TRAILS: 67 LONGEST RUN: 4km TOTAL LIFTS: 7 - 1 Gondola, 5 chairs, 1 drag LIFT TIMES: 9am - 3.30pm

LIFT CAPACITY (PEOPLE PER HOUR): 8,200

ANNUAL SNOWFALL: 6.35m **SNOWMAKING:** 15% of slopes

BUS from Spokane takes 80 mins to Kellogg. FLY to Spokane Int, which is 70 miles west of the resort. Missoula 130miles, Seattle 350 miles

DRIVE From Spokane, take I-90 west past Coeur d'Alene and then a further 40 miles on to Kellogg. Silver Mountain is only 1/4 of a mile from Kellogg.

and mercifully lift lines are tiny. Slope facilities are a bit suspect, the day lodge is far less impressive than that at Schweitzer, and the food is both mediocre and extortionate. But a major plus is the very low lift prices, with a day pass from only \$24 bucks during the week.)

FREERIDERS will find that the backcountry stuff is thin on the ground - unlike tree stumps, grit, and large rocks, which seem to litter a good deal of the area outside the fences. However, some very nice, but challenging, freeriding can be had on areas like the Rendezvous or down the Warner Peak.

FREESTYLERS note that this is not a place loaded with natural freestyle terrain. However, to counter this there is a good terrain park and halfpipe called the Trench which is built and shaped to conform with competition standards located up on Noah's.

PISTES. You can lick it down the slopes here with some degree of style. There are a number of long cruising trails that are groomed to perfection. The **Tamarack** is a fantastic two and a half mile long trail to try out.

BEGINNERS have a mountain that is well suited to their needs, with a host of novice trails offering easy sedate descents.

OFF THE SLOPES. You can lodge close to the slopes, but in general the main thing to do is base yourself down **Kellogg**, which is 2 minutes away. The town offers a good choice of local facilities with very reasonable prices for lodging and general living. The Silver Ridge Mountain Lodge offers some good packages.

U

SA

A resort that will suit all riders

Sun Valley dates back decades and comes with a fair share of its own history. Said to be the USA's oldest ski resorts, Sun Valley has managed stay up with the times and today is a resort that is a match for any other destination in the country. Located in the southern part of Idaho and east of the capital Bosie, what you have here is a resort for every one from advanced air heads to total first timers, although it's fair to say that the beginner terrain is a bit limited. On and off the slopes the whole area has a rather strange feel to it with a mixture of the Old Wild West and a hint of Europe thrown in. Its set to a back drop of a large rideable area which covers

over 2000 acres and split over two main areas known as Dollar/Elkhorn and Bald Mountain. Dollar/Elkhorn area the smaller and best for beginners while Bald Mountain is the place to head for to ride some advanced steeps. Whichever area you try out, you will be met with excellent slope facilities which incorporates a high tech automated snowmaking system that covers over 78% of the slopes.

FREERIDERS who know what life is about and can handle a board at speed will be able to prove it on the slopes up on Bald Mountain which has a good selection of advanced and intermediate trails. The bowls below the **Seattle Ridge** are superb and will keep you amused for days with some nice powder stashes. There's some great hikes dropping in to some incredible backcountry, but you're gonna have to kidnapp and tourture a local

FREESTYLERS are well catered for here with a halfpipe that measures 350 foot long by 80 foot wide and is located on the **Dollar area**. Riders can also purchase a budget priced lift ticket that covers Dollar and the pipe area. Around the whole area freestylers will find loads of awesome natural hits to get air off.

before they'll tell you.

PISTES, Nutters who consider themselves to be of the advanced grade, should look no further than the slopes off Bald Mountain where you'll find a first class selection of long, well pitched cruising runs

BEGINNERS should be aware of the difference between the main areas. If you are a total first timer to snowboarding then stay away from Bald Mountain and check out the offerings on Dollar. The local ski school offers clinics from \$45 a session for all grades.

OFF THE SLOPES, Sun Valley is a resort that is fully geared up to handle visitors needs. There is a good selection of slope-side accommodation and excellent resort services with some nice restaurants and good bars, but note this is not a cheap resort. The town of **Ketchum** is only a mile away, but is the cheaper option. Bars of note are the Roosevelt Tavern and Whiskey Jacques

386 USQ WWW.WORLDSNOWBOARDGUIDE.COM

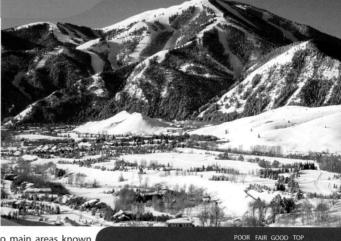

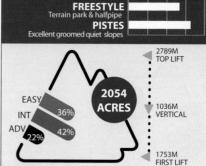

FREERIDE

Trees & some some bowls to play in

Sun Valley Company Post Office Box 10, Sun Valley, Idaho 83353 TEL: 208-622-2001

WEB: www.sunvalley.com EMAIL: ski@sunvalley.com

WINTER PERIOD: mid Dec to late April

1 Day Pass \$74,5 out of 6 days \$345, Season \$1950 BOARD SCHOOLS 2 hours group \$45, 3 days 6 hours \$115, Private 1 hour \$95

NUMBER OF PISTES/TRAILS: 75

LONGEST RUN: 5km TOTAL LIFTS: 19 - 16 chairs, 3 drags

LIFT CAPACITY (PEOPLE/HR): 26,780 LIFT TIMES: 9.00am - 4.00pm

ANNUAL SNOWFALL: 6m **SNOWMAKING:** 30% of slopes

BUS Shuttle bus from Boise, Twin Falls, Pocatello and Idaho falls

FLY into Sun Valley/Friedman Memorial Airport in Hailey, 12 miles away. Connections from Salt Lake City, Boise

DRIVE From Boise, head south on I-84 and then via hwy 20 at Mountain Home to hwy 75 heading north following signs for Ketchum and then onto Sun Valley.

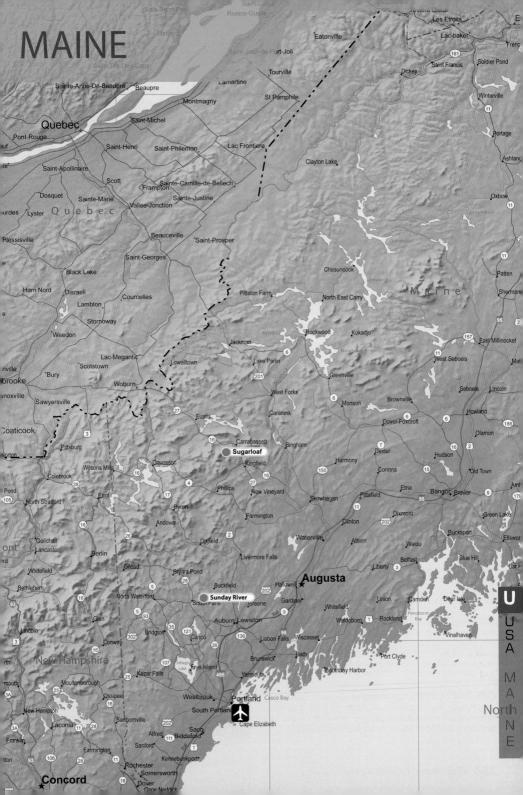

east coast standards. Sugarloaf is a big resort and a highly rated one that is well worth taking the time to visit. Located around two and a half hours drive time from Portland, this is a relatively easy place to get to and one could quite easily spend a week riding here on a mountain that has the only treeless summit with lift access in the east. Another notable point is that unlike many other east coast resorts, Sugarloaf manages a longer season than many other east coast destinations as the resort is able to keep hold of its snow very well. What's more, they back up their real snow with snowmaking facilities that cover almost 94% of the mountain. In truth this is a mountain that will mainly

appeal to freeriders and carvers. The 131 well groomed and well set out runs offer some very challenging runs with the option to ride down some extreme steeps and fast double diamond black trails.

FREERIDERS are going to feel very much at home here, with a good choice of descents that include acres of summit bowl riding and over 500 acres of treeriding terrain. Some of the most challenging terrain to check out can be found off the Spillway chair lift, while for a less stressing descent, the **Gauge** is okay.

FREESTYLERS can be seen kicking off natural hits all over this mountain as the place lends itself very nicely to natural freestyling. If you can't find a decent hit to please your desires, than Sugarloaf has 3 terrain parks and large halfpipe with huge walls and nice transitions. The main park, Pipeline comes loaded with hits galore with rails, spines and big gaps. Beginners can get their first air in the Quarantine Zone, before progressing to the Stomping Grounds on the double diamon Chaser run.

PISTES. Riders of all levels will find an abundance of runs to choose from which are laid out all over the mountain starting out at the summit and allowing for long cruising runs all the way back home

BEGINNERS are presented with numerous trails that are mainly laid out across the lower section of the mountain and although the resort has a lot of good novice areas, the main section is often clogged up with skiers and others using the routes as access to the base, and base lifts.

OFF THE SLOPES local facilities are well placed for the slopes with lots of condo's available for letting at reasonable rates. Around the resort you will find a good selection of restaurants and a number of nightspots.

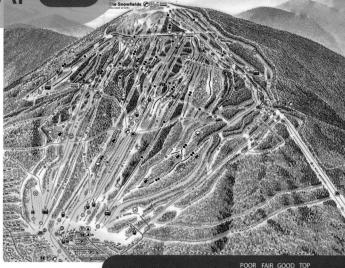

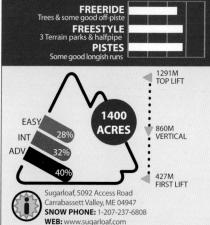

WINTER PERIOD: mid Nov to end April LIFT PASSES Half-day \$51-53, Day Pass - \$63-67 4 of 5 days \$205-230, Season Pass \$1259

BOARD SCHOOLS board clinics \$70 inc board and pass HIRE board & boots \$32/day, 6Days \$153

NUMBER OF PISTES/TRAILS: 131

EMAIL: info@sugarloaf.com

LONGEST RUN: 5.6km TOTAL LIFTS: 15 - 13 chairs, 2 drags LIFT CAPACITY (PEOPLE/HR): 21.810

LIFT TIMES: 8.30am to 3.50pm **ANNUAL SNOWFALL: 5.23m** SNOWMAKING: 94% of slopes

BUS from Portland can take a good 3 hours. FLY to Portland which is 110 miles away. DRIVE From Portland travel north on the I-95 to Augusta, then take the 27 via Farmington to reach the resort. The journey by car will take about 2 1/2 hours.

TRAIN Amtrak run trains to Waterbury and Rutland, then take a taxi

SUNDAY RIVER

Some good treeriding and terrain parks

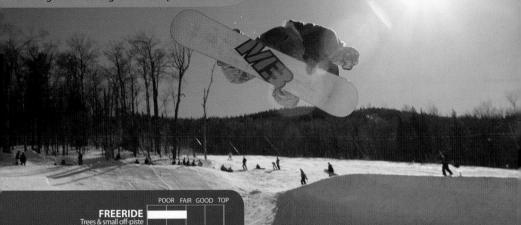

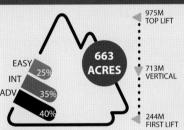

FREESTYLE 4 Terrain parks & 2 halfpipes

> **PISTES** Lots of little runs

Sunday River Ski Resort P.O. Box 450, Bethel, ME 04217 PHONE: (207) 824-3000 WEB: www.sundayriver.com EMAIL: info@sundayriver.com

WINTER PERIOD early Nov to early May LIFT PASSES Half-day \$48, 1 Day pass \$63 3 Day pass \$171,6 Day pass \$318

BOARD SCHOOLS Beginner packages inc lift ticket, lesson & rental 1 day \$75, 2 days \$120.

90min group lesson \$30, Private lessons \$70 1hr, \$110 2hrs HIRE Board & Boots \$30 per day NIGHT BOARDING No

NUMBER OF PISTES/TRAILS: 128 LONGEST RUN: 5km

TOTAL LIFTS: 18 - 15 chairs, 3 drag

LIFT CAPACITY (PEOPLE PER HOUR): 32,000 LIFT TIMES: 8,30am to 3:30pm

ANNUAL SNOWFALL: 6.35m **SNOWMAKING:** 92% of slopes

CAR From Portland, head north on I-95 to exit 63 and then take Hwy 26 to Bethel which is 6 miles from Sunday. Follow Route 2 East for 2.6 miles then left onto Sunday River Road. Total 65 miles, 1 1/2 hrs

FLY to Portland Int, with a transfer time of 1 3/4 hours. Boston 172 miles, 3hrs away.

BUS services from Portland can take 1 3/4 hours.

TRAIN to Portland

Sunday River, which happens to be one of the major resorts in the American Skiing Co's portfolio, has rapidly grown from a local snowboarder's haunt to a fairly happening place in a very short space of time. Located a stone's throw away from the state border with New Hampshire, Sunday River attracts a lot of city dwellers from Portland and other nearby towns, to its simple but extremely well laid out slopes that cover eight linked mountains with three resort base areas. Once you arrive, it's not long before you appreciate just why this place is a popular destination with many of Maine's snowboarders and skiers alike as this is an excellent east coast resort which is thick with trees from the top to bottom on all the mountains. All the runs are hacked out from the dense pine to form a cluster of trails suitable for all styles and level of rider, in particular freeriders who know how to go for it. The eight mountain peaks are all open to snowboarders, with over 120 well looked after runs that get a good annual covering of real snow and are backed up by major snowmaking facilities that covers nearly all of the trails. The one off putting point is the crowds, particularly at weekends when the whole mountain can become a bit busy.

FREERIDERS will find that a week's stay here will not be wasted provided you get out and explore all eight mountains. Each one offers something a little different to the last, although in the main they don't vary too much. Still, the resort management have planned the runs and offer different slope pitches and terrain features that will catch you out if you are not concentrating on what you are doing. For those riders who can handle fast steeps, the double blacks on Oz Peak and **Jordan Bowl** (especially the double black Caramba) are

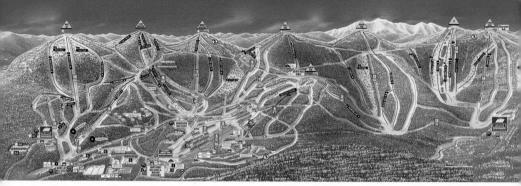

the places to head for. However, beware of Kansas, a long, flat muscle-pumping traverse used to get you back to the main area, the trick here is to keep you speed up. Some good tree-riding can be found on the Baker Mountain.

FREESTYLERS will find lots of natural hits to catch air, and plenty of places for jibbing off logs and other obstacles. However, for those who like things laid on, Sunday offers a lot more than many other resorts by providing four terrain parks loaded with all sorts of hits, a boardercross circuit and two halfpipes.

PISTES, People who like speed and steeps mixed in together can crank some fast turns on the White Heat trails, which is one of the steepest runs on the east coast. The trails on the North Peak are ideal for intermediate riders who like to take it easy.

BEGINNERS here have a resort that is superb for learning at with a large choice of easy runs to try out. The local ski-school offers a great teaching programme called the 'Perfect Turn Snowboard 'Clinic', where they guarantee to teach you to ride in a day, with a maximum of six people in a class.

OFF THE SLOPES, local services are initially provided in the base areas where you will find a good selection of slope side lodging with condo's being the main choice. However, you may find it better to take the four mile drive back down to Bethel which plays host to all your needs. This is an easy-going and laid back kind of place that offers far more options for lodging, eating out or going for a beer. Bethel also offers cheaper facilities because as with most resorts. if you stay on or near the slopes, prices go up, and this place is no exception.

Good ACCOMMODATION exists at the base of Sunday's slopes with a big choice of condo's. For riders on a budget then The Snow Cap Lodge Dorm is a good place to stay. On the other hand, if you have the cash then the Jordan Grand Hotel, which is on the slopes, is the place. Here they have all the facilities of a hotel which include a swimming and health club, bar lounge and dining room.

FOOD. Sunday River hasn't always had a good reputation for it's eating out. But things are changing with a good selection of restaurants on the slopes, or close by. In many of the lodges or hotel-condo's one is able to fine something that will please. You can get a decent steak in places like the Hill Trading restaurant. or a good Italian meal at Rosett's.

NIGHTLIFE is probably Sunday River's main let down. This is basically a place for lame heads into apres and all the horrible stuff that comes with it. There are a number of okay bars such as Bumps, the Foggy Goggle or Suds Pub and the Sunday River Brewery, but they all seem to think that sad music and silly games are cool.

SUMMARY

This is a place that offers some great all round freeriding to suit all levels. There is some excellent treeriding to be had and good beginner areas.

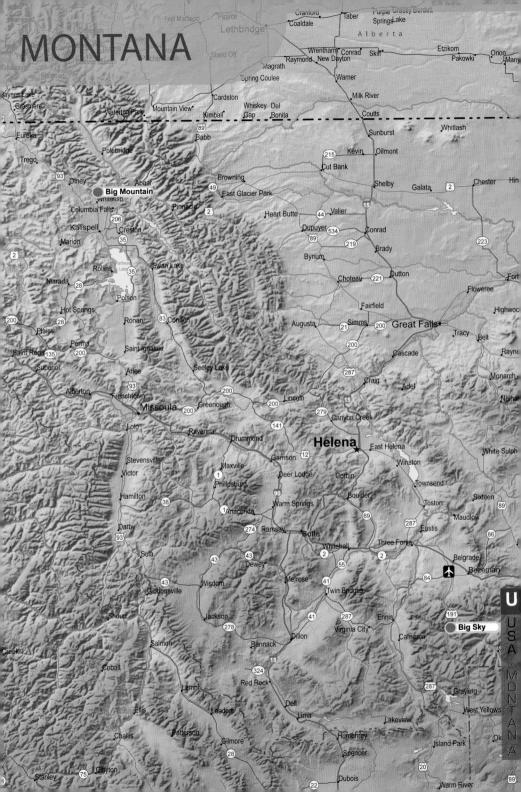

Big Mountain, which is closely linked to the nearby town of Whitefish, attracts visitors from places such as Seattle and up in neighbouring Canada. However, it doesn't attract too many of them so it never becomes overpopulated here. Some riders combine a trip to Big Mountain with a trip to Fernie, Canada which is only 2 hours away. Excellent transport links exist making this an easy place to get to either by plane or by train. Amtrax runs a daily service to Whitefish, called the Empire Builder Passenger service to and from major cities like Seattle and even Chicago. Overall this is a place that keeps things simple and affordable, both on the mountain and around town. The slopes operate a good lift system and provide heaps of annual snow. They don't bother with snowmaking here as they simply don't need it. The real stuff covers a mountain that offers a mixture of wide open bowls, wooded glades and great cruising runs.

FREERIDERS are in for a major treat at this place with

POOR FAIR GOOD TOP **FREERIDE** Trees & some good off-piste **FREESTYLE PISTES** Courduroy 'tastic

Photo: ©Brian Schott

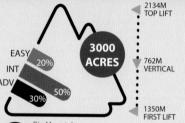

Big Mountain

PO Box 1400, Whitefish MT 59937

TEL - 1-(800) 858-3930 WEB: www.bigmtn.com EMAIL: bigmtn@bigmtn.com

WINTER PERIOD: late Nov to early April LIFT PASSES Day Pass - \$52, Season Pass - \$690

BOARD SCHOOLS

Full day group \$50 Half Day \$35 Full Day Private \$310 Half Day \$160

HIRE Board and boots \$20/30, Helmet \$5 SNOWMOBILES 1/2 day \$130, Full day \$230 NIGHT BOARDING 4pm to 9pm Fri and Sat. Pass \$14

NUMBER OF PISTES/TRAILS: 91

LONGEST RUN: 5.3km

TOTAL LIFTS: 11 - 9 chairs, 2 drags

LIFT CAPACITY (PEOPLE PER HOUR): 13.800

LIFT TIMES: 9.00am to 9.00pm

MOUNTAIN CAFES: 10

ANNUAL SNOWFALL: 7.62m **SNOWMAKING:** 5% of slopes

CAR In the US, take Interstate 90 until you're eight miles west of Missoula. Take US Highway 93 north 110 miles to Kalispell. From US-93 toward Whitefish, turn RIGHT (North) onto Baker Ave, City Hall will be on your right. Head (North) over the Viaduct, go straight

onto Wisconsin Ave through the lights. 3 miles ahead, turn RIGHT (North) onto Big Mountain Rd. 8 miles up the road you'll find Big Mountain Village.

FLY Glacier Park International Airport (FCA) has non-stop flights from Salt Lake (Delta), Minneapolis (Northwest), Spokane and Seattle (Horizon) arriving daily.

BUS services from Calgary, but not direct. Local bus services are available from Glacier and nearby towns of Browning and Whitefish. TRAIN take Amtrak from Seattle, Portland and points east, including Minneapolis and Chicago. Multi-night package deals,

including lodgings and ski tickets, are available by calling (800) 858-3930. Shuttle services ferry skiers from the Whitefish station to Big Mountain.

SOZHAZ

a fantastic offering of deep powder, big bowls, lots of trees and great natural terrain features. Basically, the mountain splits into three marked out areas. There's the Main Mountain, which has the most trails and something for every level, the North Side, which has a splattering of tree line black and blue runs and the Hellroaring Basin, which is an area mainly suited to advanced freeriders with riding on black and double black trails.

FREESTYLERS can have lots of fun here and any rider that doesn't appreciate this mountain should give up boarding and become a girl guide. This place is ideal for freestylers. Apart from lots of natural features, there is a massive terrain park off the Silvertip chair complete with table tops, berms, gap iumps etc.

THE PISTES are long and wide corduroy trails, that can be found all over the mountain. It's ideal for riders who want to turn into white van man, or just fancy some easy cruising.

BEGINNERS have a great mountain with lots of easy trails especially at the lower sections. There's a number of the blues are suitable for quick learners and novices to ride from the top of the mountain all the way to bottom.

OFF THE SLOPES

Big Mountain offers a good choice of local services with a wide range of options for lodging, eating and having a good night out. The facilities at the base of the slopes are very good and will provide you with most of your basic needs with condo's that have restaurants and bars. Around the base village you will also find a few shops, but in truth the biggest choice of shops and all other local services can be found back down in the sprawling and old fashioned town of Whitefish. Here you will find a place where locals treat you with respect.

ACCOMMODATION is provided at the slopes or in Whitefish. If you stay near the slopes you will be able to find a condo or a bed in one of the lodges at reasonable prices however if you base yourself down in Whitefish, you will be able to get better deals. There is a hostel called the Non Hostile Hostel that offers cheap bunks 001 (406) 862 7383.

FOOD. Big Mountain and Whitefish provide good and simple choices for going out and filling your stomach at a price to please everyone. You can pig out at The Stube & Chuckwagon Grill which serves excellent food all day long. The Moguls Bar and Grill is an ideal place to get breakfast before hitting the slopes and is located near the base of Swift Creek chair lift. In Whitefish the Buffalo Cafe is a good place to eat.

NIGHTLIFE here is very laid back, but that's not to say that you can't have a stomping time. Highly rated by the visiting ski groups is the Stube & Chuckwagon Grill which goes in for too much après ski stuff, is still a cool bar. The Great Northern in Whitefish is not a bad joint which has a good selection of beers.

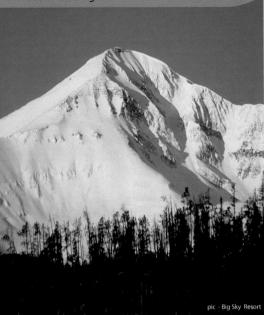

Big Sky is a typical corporate style resort which only goes back to around 1973, when the place was first built aided by millions of corporate dollars. Located just south of **Bozeman** in the northern Rockies, Big Sky is an impressive place, where you can do some serious riding on crowd-free slopes that rise above the tree lines. The rideable area is reached by Big Sky's tram and is spread over **Andesite Mountain** and **Lone Mountain**, which rise up to 3,400 meters. This has led to the claim that Big Sky has the largest vertical in the US. The two mountains, with a total of 100 trails, are connected by just seventeen lifts, consisting of some very fast chair lifts that can move 20,000 people uphill per hour. Your lift pass is also accepted in nearby **Moonlight Basin**.

FREERIDERS will find this is a great place to get a fix. A good trail is the **Big Horn** which begins as an unchallenging trail that passes through woods, before dropping sharply into a bowl with banks and some good hits. Some of the most challenging terrain can be found if you first take the **Lone Peak chair**, and then hike up to reach the ridge off the south-facing summit. For those who know what they're doing, you get the option to go for it down loads of chutes.

FREESTYLERS looking for some natural hits, would do well to check out the gully formed down the side of **Lower Morning Star**, which is pretty cool. And if this is not enough, then Big Sky has a wheel-carved halfpipe and a good series of hits in the two terrain parks, **Swiftcurrent** and Ambush Park, which will both keep grommets happy for days on end

PISTE. Riders of the piste should get a good buzz out

of these slopes, with plenty of wide open groomed trails that allow for some serious cranking it over turns. Check out the stuff off the Ram Charger quad, where you can descend at speed. Intermediates will dig the wide terrain on **Elk Park Ridge**, where you can crank some wide turns and take some easily stoppable spills

BEGINNERS will find plenty of easy terrain to practice their first moves, with the best novice stuff on the south side of **Andesite**, off Southern Comfort chair lift. The local ski-school handles all levels of tuition with full beginner programmes.

OFF THE SLOPES

Big Sky is not a place for the budget conscious. The modern town is a friendly place which looks after its visitors well and offers all the things you would expect of a tourist trap. Lodging is a mixture of condos and hotels along with a number of expensive restaurants and a few okay bars.

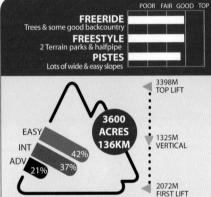

Big Sky Resort, P.O. Box 160001 1 Lone Mountain Trail, Big Sky, MT 59716 **TEL:** 001 800-548-4486

SNOW PHONE - 001 406-995-5900 WEB: www.bigskyresort.com EMAIL: info@bigskyresort.com

WINTER PERIOD: end Nov to mid April LIFT PASSES Half-day \$54, 1 Day pass \$69 6 day pass \$384, Season (unlimited) pass \$1135

BOARD SCHOOLS 2hrs group \$42, Private 2hours \$195 HIRE Board and boots \$36/day

NUMBER OF POSTES/TRAILS: 150 LONGEST RUN: 9km

TOTAL LIFTS: 17 - 1 Gondola, 1 cable-car, 12 chairs, 3 drags

LIFT CAPACITY (PEOPLE/HR): 20,000 LIFT TIMES: 8.30am to 4.00pm

ANNUAL SNOWFALL: 10m SNOWMAKING: 75% of slopes

BUS services from Bozeman take about 1 1/2 hours. www.karststage.com run a shuttle service, tel: 406.556.3500.

TAXIS tel: 406.995.4895

FLY to Bozeman Int, with a transfer time of 1 1/2 hours.

DRIVE From Bozeman, head south on Hwy 191 direct to Big Sky.
Bozeman to resort is 45 miles. 1 hour drive time.

394 USQ www.worldsnowboardguide.com

BRIDGER BOWL

Great funky laidback freeriders resort

When people think about snowboarding in Montana they usually picture Big Sky or Big Mountain, but there is another resort that also starts with a "B" and is just as good; Bridger Bowl. Located near the funky college town of Bozeman, Bridger Bowl is an undiscovered gem. This small-medium sized resort can be a powder-hounds dream.... during the 03/04 winter season Bridger got puked on, receiving over 100 inches in 3 days...that's about 2.5 metres in 3 days! Have you heard the expression "bring your snorkel"? Well, people were

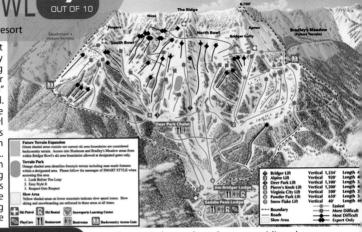

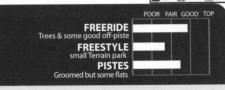

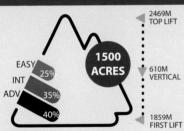

Bridger Bowl Ski area 15795 Bridger Canyon Road , Bozeman, MT 59715 TEL - 406 587-2111

WEB:www.bridgerbowl.com EMAIL: skitrip@bridgerbowl.com

WINTER PERIOD: Dec to April LIFT PASSES 1/2 Day Pass \$33, Day Pass \$41 3 days \$114, Season \$595

BOARD SCHOOLS 90min group lesson \$30

Private lessons \$65 for 90mins, all day \$230

RENTAL Board & boots \$23 per day

SNOWMOBILES Not at the resort but snowmobile tours around Yellowstone National Park are extremely popular.

NUMBER OF RUNS: 69 TOTAL LIFTS: 7 - all chairs LIFT TIMES: 9.00am - 4.00pm

LIFT CAPACITY (PEOPLE PER HOUR): 7,300

ANNUAL SNOWFALL: 9m SNOWMAKING: 4% of area

BUS Grevhound services Bozeman. FLY into Bozeman on United, Horizon, Delta or Northwest

DRIVE 16miles from Bozeman. Traveling West on the I-90 take the first Bozeman Exit (East Main Street) and travel about 3/4 mile to the second traffic light. Take a right turn on Rouse and stay on the road all the way to Bridger Bowl. Rouse becomes Bridger Canyon Road outside the city limits

actually using them when they were riding the snow was that deep. If you would like a day off the board drive the 90 miles down to the famous Yellowstone National Park to checkout Old Faithful Geiser and the buffalo! They have recently been granted permission to expand nto Slushmans and Bradley's meadow which flank the resort, this will eventually open up 611 acres of new terrain.

FREERIDERS The resort can basically be divided into two bowls, one on the North side and the other on the South side. Most of the resort has wide open terrain with some areas of wicked gladed runs. The lower half of the resort is fairly mellow, however Bridger's redeeming feature is the area known as "The Ridge". This is the area at the very top of the resort which is composed of the steepest runs on the mountain and where everyone heads to on powder days. To get there it's a 400ft vertical hike up from the top of the highest lift. The hike is worth it as the area has many steep chutes and the best snow conditions at Bridger. You must carry an avalanche beacon, shovel and probe to access this area.

FREESTYLERS. Bridger Bowl is definitely a freeriders resort but they have relented and built a small terrain park. Its located between Bridger and Deer Park lifts above Boot Hill, but even so go freeride!

PISTES. Riders will enjoy Bridger's beautifully groomed runs, however these are usually of low angles so hardcore carvers may become bored.

BEGINNERS will love Bridger's terrain. The lower runs are a novice's paradise...nothing too scary. As you progress you can move further and further up the mountain as your ability improves.

OFF THE SLOPES. All the action after hours takes place in the nearby town of Bozeman. It may not be a bustling metropolis, but it is a fun town to spend a few days in. This is mostly likely to do with the large amount of college students who attend Montana State University and who frequent the many bars and cool micro-breweries. There's something to suit all budgets, from backpackers to those with money to spare. Food Find out which bars are having a 'chicken wing' special!

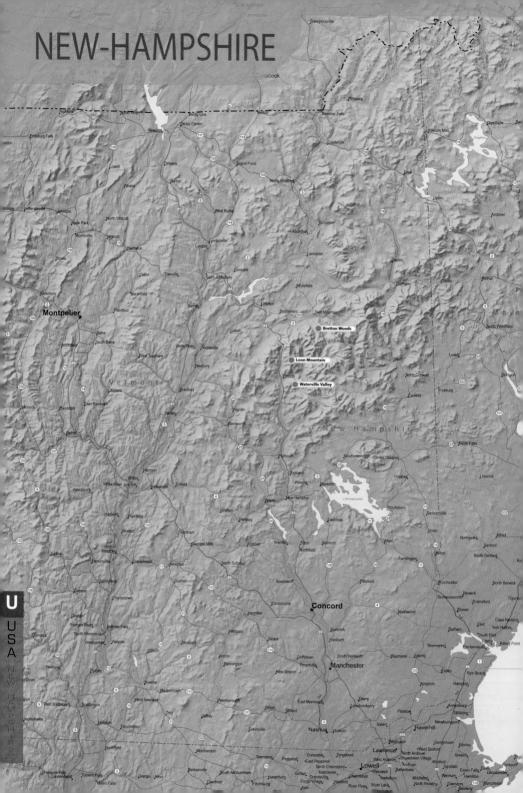

Simple and unadventurous, good for beginners

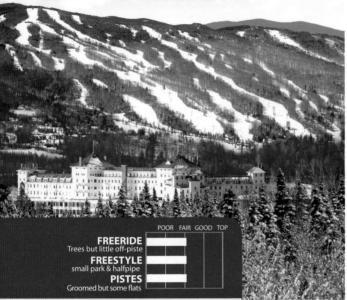

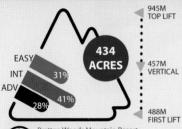

Bretton Woods Mountain Resort Route 302, Bretton Woods, NH 03575 TEL - 603-278-3320

WEB: www.brettonwoods.com

WINTER PERIOD: MID Nov to end April LIFT PASSES 1 Day \$57-64, 5 of 6 Days \$295 Night 4pm-9pm \$19, Twighlight 2pm-9pm \$39 Season \$499

BOARD SCHOOLS 90min group lesson - \$27

HIRE Board and boots \$33/day

NIGHT BOARDING 5 trails & 2 lifts open Friday, Saturday and the holiday periods

NUMBER OF PISTE/TRAILS: 101 TOTAL LIFTS: 9 - 6 chairs, 3 drags LIFT TIMES: 8.30am - 9pm

LIFT CAPACITY (PEOPLE PER HOUR): 14,000

ANNUAL SNOWFALL: 5m SNOWMAKING: 92% of slopes

BUS Services from Boston will take 3 hours. FLY to Boston, in Maine, transfer time of 2 1/2 hour. DRIVE From Boston, head north on I-93 via Manchester and Concord turning left at signs for Twin mountain along route 302. Boston to the resort is 165 miles

Bretton Woods lies 165 miles north of Boston and 100 miles north of Manchester and claims to be the largest resort in New Hampshire. However, claiming to be the biggest at something is not always an indicator of how good you are. What you have here is a respectable mountain that by east coast standards is fairly decent. Some 93 runs are hacked out of dense trees that cover the whole mountain from the summit to base. The slopes, which are in view of Mt Washington, are currently spread out over two peaks, Mt Rosebrook and West Mountain with the trails all working their way back down into one main base area. Soon to open will be another ridable area, that of Mt Stickney, What Bretton seems to be about to the casual observer, is a place that likes to keep things simple and one that attracts a lot of family ski groups. Constantly expanding, this is a resort that is best suited to beginners and intermediate carvers although freeriders who like easy slopes with trees will also fair well here. In recent years major expansion

plans have lead to the area almost doubling in size with the opening of the West Mountain which is a nice area for advanced riders who like to shred tight trees. All the trails and lifts connect up well and getting around the three slope faces can be done with ease. But that said, riders who prefer steep trails that last more than a few turns, may find that anything more than a couple of days on these slopes may become a bit tedious. On the other hand, a 10 year old kid taking their first snowboard trip with their parents will enjoy a weeks stay.

FREERIDERS do have a mountain that allows for easy going riding which also means taking in some treeriding. But this place is by no means a good freerider's resort, there's nothing that adventurous to take on and the few advanced runs that there are, don't take long to conquer. More terrain was opened last season in Rosebrook Canyon providing some steep gladed runs.

FREESTYLERS are presented a mountain that is basically dull when it comes to finding good natural hits. They do exist but not many. However, there is a 500ft halfpipe to check out.

PISTES. Boarders who like to take it easy will enjoy Brettons Woods. In the main, this is a good simple cruising resort, with a number of decent trails especially those on Mt Rosebrook

OFF THE SLOPES. Local attractions and services are provided at the base of the slopes. What you are offered is of a very high standard, the only problem being that the place is very boring and not much fun.

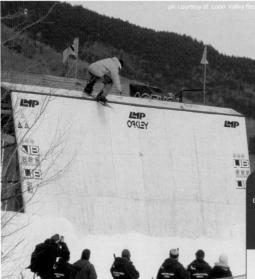

New Hampshire breeds a lot of resorts, most of which are frankly crap. However, **Loon Mountain** is one of the state's better offerings with a good friendly snowboard attitude. Located in **White Mountain National Forest**, Loon is the highest mountain in New Hampshire and a very popular resort that attracts a lot of punters. The resort has been going through a multi-million dollar expansion programme and has recently expanded the ride area with new lifts and services. The 275 acres of terrain is nearly all covered by snow cannons, so when the real stuff is lacking, they can still ensure good coverage. Despite Loon's small size and the odd lift line, it's a good place to ride, with a mixture of varied terrain to appeal to most recreational boarders of intermediate standard.

FREERIDERS have a tree-covered mountain that allows for some good riding experiences. The **Kissin' Cousin** is a popular warm-up area, before trying out the likes of **Speakeasy**, reached by the Kancamagus chair. The **East Basin** is also a popular freeride area, where you'll find some decent wind-lips to track up.

FREESTYLERS have a full-on fun-park called **Skid Road**, which snowboarders travel a long way to ride. Located on **Lower Flying Fox** and approximately 1,500m long, the park has plenty of very big hits including a 100 metre halfpipe, and was voted 16th best park in the US. Not bad for an east coast resort

PISTES. Riders of the piste will soon realise that Loon is the mountain for them. It offers great pistes for you to carve out some big turns on long, well prepared trails. Some of the best runs are the **Flume** and the **Upper** and **Lower Walking Boss**, an area that offers some well maintained pistes on either blue or black trails. There is also plenty for novice and intermediate riders

BEGINNERS will find plenty here. The best and easiest stuff is found on the **West Basin**, while the mid-section of the Seven Brothers chair offers something a little more testing. Loon Ski School offers a very good learning snowboard clinic

OFF THE SLOPES.

Local services are plentiful in either **Loon**, **Lincoln** or down in the famous hippy hangout of **Woodstock**. All three towns are friendly and look after their visitors well. Food around the area caters well for all tastes and pockets. The *Old Mill* is good for seafood, while *Elvios* is the pizza place, and The *Woodstock Inn* is good for bar food. There are also a few good late-night hangouts in either Loon, Lincoln or Woodstock.

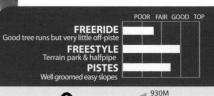

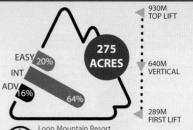

Loon Mountain Resort RR1, Box 41 , Kancamagus Hwy Lincoln, NH 03251

TEL: 603-745-8111
WEB: www.loonmtn.com
EMAIL: info@loonmtn.com

BOARD SCHOOLS Half day Group \$35/39

Full Day Group \$74/79

HIRE Board and boots \$38/day, 5 days \$180

NUMBER OF PISTES/TRAILS: 45 LONGEST RUN: 4km

TOTAL LIFTS: 10 - 1 Gondola, 6 chairs, 2 drags, 1 magic

LIFT CAPACITY (PEOPLE/HR): 11,865 LIFT TIMES: 8.30am to 4.00pm

ANNUAL SNOWFALL: 3m SNOWMAKING: 96% of slopes

BUS services from Boston can take 21/4 hours to Loon. FLY to Boston, with a transfer time of 2 1/4 hours. DRIVE From Boston, head north on I-93 to exit 32 at Lincoln. Then go east along R-122 to Loon Mountain. Boston to resort is 132 miles. 2 hours drive time.

398 USQ www.worldsnowboardguide.com

WATERVILLE VALLEY!

Not hot, but not bad

Waterville is an easy-going, laid back place that is part of a programme called the Peaks of Excitement, a group of resorts working together. This means that your lift pass can be used at over 20 other places, giving a combined area of around 2,000 acres. The resort is only two hours from Boston and can be easily reached by bus or car. The slopes are a two minute drive from the village and serviced by a regular shuttle bus to the lifts. Waterville really tries hard to please snowboarders, with four fun-parks. However, the resort is a busy place at weekends, and being quite small, it can feel a bit cluttered at times. Advanced riders don't have a host of challenging trails, in the main this is an intermediate's and fast learning novice's

FREERIDERS may not have the biggest or most

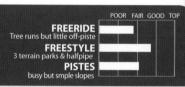

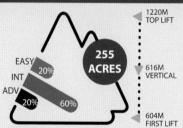

Waterville Valley Resort 1 Ski Area Road, PO Box 540, Waterville Valley, NH 03215

TEL: 1-800-GO-VALLEY (468-2553) WEB: www.waterville.com

EMAIL: info@waterville.com

WINTER PERIOD: Nov to April LIFT PASSES Day pass \$55, 2 day pass \$100 BOARD SCHOOLS Burton LTR package of learner lift pass, rental & lesson \$69 per day. 2hr lesson \$31. Private lessons

\$67/75 per hour HIRE Burton Board & Boots \$31/33 per day. Helmets \$10/12 per day

NUMBER OF PISTES/TRAILS: 52 LONGEST RUN: 5km TOTAL LIFTS: 12 - 8 chairs, 4 drags

LIFT TIMES: 9.00am to 3:45pm LIFT CAPACITY (PEOPLE PER HOUR): 14,867

ANNUAL SNOWFALL: 3.55m SNOWMAKING: 100% of slopes

BUS from Boston take 2 hours to Waterville. FLY to Boston, with a 2 hour transfer time. DRIVE From Boston, 130 miles, 2hrs. Take I-93 N to Exit 28, 11 miles via Rt. 49 to resort.

Fron New York, 325 miles, 6hrs. Take 1-95 to I-91 to I-84 to Mass. Turnpike to I-290 to I-495 to Rt. 3 N to I-93 N to Exit 28, then 11 miles via Rt 49 to resort

FREESTYLERS and trick merchants have three funparks and a massive halfpipe to play in. The parks (shamefully open to skiers), are spread out around the slopes and offer something for all levels. The Exhibition **Terrain Park** (located near the base) is a pro-level park and features quarter-pipes, rail slides, table-tops and gaps and the superpipe. The Boneyard (located on Periphery) is a step down for more intermediate riders. The little Slammer is for junior grommets, and has some 8-10ft jumps of various guises and a few wide rails.

PISTES. People who can handle a board on its side have just one steep double black to go for - True Grit. Alternatively, the cluster of blues that descend from the summit make for nice easy riding on pleasant and well groomed trails

BEGINNERS only have a couple of dull green trails at the base, with a number of over-rated blues higher up that can be tackled quite easily by those with a few days under their belt.

OFF THE SLOPES. Local facilities, a few minutes from the slopes, are without frills. Accommodation covers condos, hotels and an array of B&B's. Prices are affordable and a number of weekly packages are available at reduced rates. Dining out offers no great surprises, with a simple choice of restaurants providing local dishes, fast-food and deli stuff. For some decent food check out Chile Peppers or Alpine Pizza. Night action is dull, but the Zoo Station and Legends 1291 are okay for a beer.

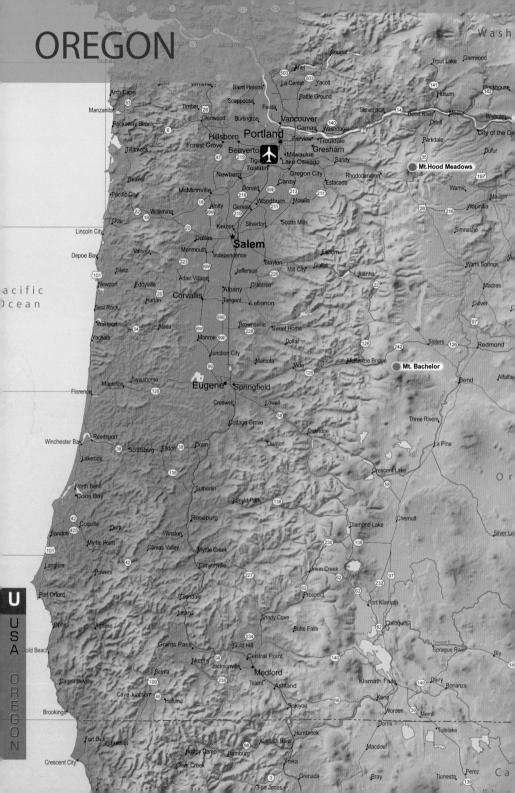

Full-on freeriders resort; top open tree-lined riding

Mt Bachelor is located in the Cascade Mountains of Central Oregon, 20 miles from the booming resort town of Bend. The snow-capped, dormant volcano is unique in that it is conical-shaped with seven highspeed quads, offering 360 access to the whole area. Chutes and gullies created long ago by lava flows, gives the terrain a shape and contour found in few other places. Combine 370 inches of annual snowfall,

Mt. Bachelor, Inc. P.O. Box 1031, Bend, OR 97709 TEL: (800) 829-2442 **SNOWFONE:** (541) 382-7888 WEB: www.mtbachelor.com EMAIL: info@mtbachelor.com

WINTER PERIOD end Nov to mid May LIFT PASSES Half-day \$45-50, 1 Day pass \$55-60 5 of 7 Day pass \$250-280, Season pass -\$950 BOARD SCHOOLS 3 hours group inc board and pass \$50

private \$60/hr. On Friday they run freestyle & halfpipe lessons \$39 for 2hrs

HIRE board and boots \$26/day **SNOWMOBILES** Yes **NIGHTBOARDING** No

NUMBER OF PISTES/TRAILS: 71 LONGEST RUN: 3.5km TOTAL LIFTS: 12 - 10 chairs, 2 drags LIFT CAPACITY (PEOPLE PER HOUR): 21,000

LIFT TIMES: 9.00am to 4.00pm **MOUNTAIN CAFES: 20 ANNUAL SNOWFALL: 8.89m**

SNOWMAKING: none

CAR Portland via Madras & Bend. Mt Bachelor is 203 miles. Drive time is about 3 1/2 hours.

FLY to Portland International, transfer time to resort is 3 1/2 hours. Local airport is Redmond, 15 miles

BUS There are daily bus services from both Portland airport and Redmond domestic airport. 4 shuttles a morning leave from the Park-N-Ride in Bend (7am, 8:15,9:30,11:15) to the mountain \$5

TRAIN to Chemult 60 miles away

NEW FOR 2006/7 SEASON: Pine Marten Express lift to

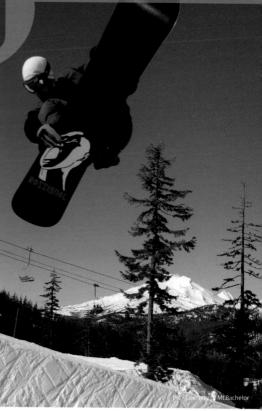

howling winds that create fairy-tale wind-lips, and you're left with acres of terrain that rival the best of any manmade park. Weekly storms rock the mountains, forcing you to frequently use force to steer through the dense weather systems. But even before the clouds clear and the sky is blue again, Mt Bachelor is damn fun!

FREERIDERS-if the summit is open, be sure to make the 10 minute hike to the top of the Cirque Bowl. You will find here an extra large cornice (that grows to 45 feet) and the infamous Jamo Jump, where you can fling yourself silly. Also accessible from the summit chair is Mt Bachelor's Backside, where you are sure to find fresh snow and solitude. You can use the 2 mile long Northwest Express chair to access a vast amount of steep bowls and perfect tree runs. There are minimal man-made runs here, and the ones that are cut are narrow and winding.

FREESTYLERS-the Outback has many BMX and skate park-like runs that are easy to find by following the tracks. On crowded days, head over to Rainbow chair, which unfortunately is as slow as shit, but there are many natural quarter-pipes and rollers untouched by the weekend crowd. If you're man enough, ask some local jackass about the Compression jump, which on good days allows you to travel an unlimited distance before shooting up the side of the Cindercone. If natural terrain is not for you, Mt Bachelor maintains Mt Bachelor maintains four terrain parks, and a Superpipe which was used for 2006 Olympic Qualification events.

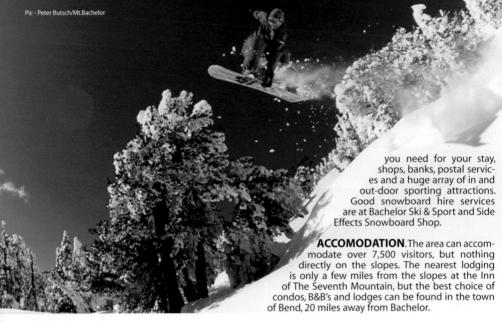

PISTES. Riders who don't like bumps on the piste will find that Bachelor has them in mind and has grooms its trails to perfection. The runs off **Skyliner** and **Pine Marten** chairs are great intermediate and novice trails, but if you have the bottle then head to the summit and ride the unpisted open steeps of the Cirque - but don't bail!

BEGINNERS-this is a mountain that you'll appreciate, with its selection of good, easy green runs that can be ridden from the mid-section of the Pine Marten chair. The runs descend in a manner that allow you to steer onto a more interesting and challenging blue as you gain confidence. The local snowboard school is really good, and the staff know how to turn you into a fast freeriding god within a day or two. A day's all-in programme will set you back

just \$40, and for those who want to make it big, sign up for one of High Cascade's winter camps.

OFF THE SLOPES

Mt Bachelor doesn't offer any substantial slopeside facilities. However, excellent laid back local services with a warm welcome are available 20 miles away in Bend or Sunriver. A free, daily and regular shuttle bus service runs to and from the slopes. Hitching to the mountain is also a good bet and cars do stop to pick you up. Bend and the surrounding area has everything

FOOD. There are no big surprises when it comes to restaurants. What you are offered is a good, but somewhat basic selection of eatries where you can wine and dine down in **Bend**, or have a snack attack up on Bachelor. The *Taco Stand* is the place to fill yourself with a burrito bomber: this beauty will clog up any 15 gallon pressure-locked toilet. *Stuft Pizza* is the place for pasta dishes. On the Mountain locals call *Scapolo's* in the Pine Marten Lodge from the chairlift and have pizza waiting when they arrive.

NIGHT-LIFE at Bachelor is not exactly the most happening. However, things liven up in Bend where there are enough joints to drink and dance in until you drop. Try *Evil Sister Saloon* if you're inclined to the 'alternative' end of the spectrum. *Legends* is also a cool hangout with large screens and a decent beer.

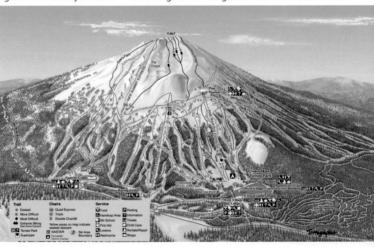

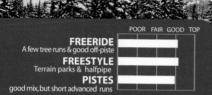

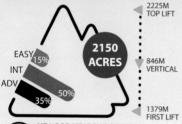

MT. HOOD MEADOWS SKI RESORT P.O. Box 470, Mt. Hood, OR 97041-0470 TEL: 503.337.2222

WEB: www.skihood.com EMAIL: info@skihood.com

WINTER PERIOD mid Nov to early June **SUMMER PERIOD** July to August LIFT PASSES 1 Day pass \$52-60, Half-day \$45-50. Night only \$23, 4 of 6 Days \$160, Season pass \$999

BOARD SCHOOLS Group lessons \$35 for 90mins Beginner package \$99 for 3 days lift, lesson & hire. Private lessons \$65 hour

HIRE Board & boots \$28 per day, demo kit \$40

NIGHT BOARDING 240 acres including park & pipe. Wednesday, Thurs & Sun nights till 9:00 PM. Fri & Sat nights until 10:00 PM.

SNOW CAT Super Bowl Snow Cat provides 1,700ft

vertical dropping into Heather Canyon. Head to top of Cascade Express \$10 a trip.

NUMBER OF PISTES/TRAILS: 87 LONGEST RUN: 5km TOTAL LIFTS: 10 - 10 chairs LIFT CAPACITY (PEOPLE PER HOUR): 16,145 LIFT TIMES: 8,00am to 10,00pm **MOUNTAIN CAFES: 2**

ANNUAL SNOWFALL: 9.15m SNOWMAKING: none

CAR From Portland take Hwy 26 east to Government Camp; then north on Hwy 35 - 10 miles to Meadows. 75 miles total, drive time is about 1 1/2 hours.

FLY to Portland International. Transfer time to resort is 1 1/2 hours. Vancouver 74 miles

BUS There are daily bus services from Portland airport as well as good car hire services. Weekend day trip specials from Portland, return \$20 leaves 6:40am returns 4:00pm tel: 503.BUS.LIFT /287.5438/

TRAIN to Portland 69 miles on

FREERIDERS-this mountain is very much for you: the terrain, which may not offer a super amount of challenging stuff or be the most extensive in the world, is still perfect wherever you go. The Super Bowl is a black graded area, with a series of descents on open terrain. The notable thing about the Super Bowl, is that it's not serviced by a lift line; instead you get up on a snowcat for around \$10 a go

FREESTYLERS-there natural hits everywhere and also a good fun-park off the Hood River chair. However, the fact that skiers are allowed in the park with so much good natural terrain on offer, make it hardly worth using. You can have a great time riding the hits around Chunky Swirl and the Texas run. If you're a pipe hound, then you'll usually find it well maintained but often very busy with local air heads.

PISTES. The from runs Cascade are the best in terms of wide, open riding trails, with a couple of decent blue trails down to choose from. There isn't an abundance of steeps for long fast descents, but what is there is excellent

BEGINNERS are treated to a good number of trails that are easy to reach and easy to negotiate. Mt Hood Express gives access to some interesting green runs and some tame blues. The local snowboard school has a host of teaching programmes for all levels, including a Mountain Master Programme

OFF THE SLOPES. If you're the sort of person that doesn't want the normal, tacky, overpriced tourist facilities found in many resorts, then this place will please you. What you have is a laid back and very basic place where the locals are cool. Timberline Lodge (the location for the film 'The Shining') is the only real slopeside accommodation which is open all year, but prices can be a bit steep. A good option would be to stay down in Government Camp opposite Ski Bowl which is only a few miles away. Alternatively you

could base yourself in the town of Hood River, 36 miles away, which has loads of facilities.

ACCOMMODATION is provided in various locations, with the more expensive near the slopes at Mt Hood. Mt Hood Hamlet B&B has rates from \$95 tel (800) 407 0570. While down on Hood River you can get a bed at Prather's Motel for around \$45 a night. The Bingen School Hostel has nightly rates from \$15 and is a good budget hangout.

FOOD. If you're the sort of person that wants to dine out night after night eating fine haute cuisine dressed in a tuxedo, then firstly see a shrink, and secondly visit another resort. This place is for those who like

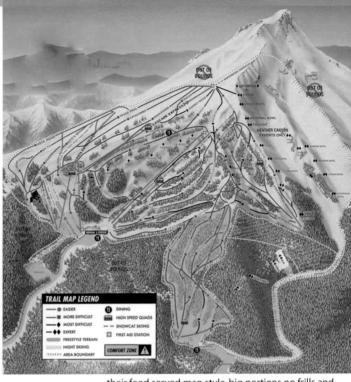

their food served man style, big portions no frills and cheap. Wherever you stay, there are plenty of budget food-stops. Huckleberry's does a damn fine breakfast and is open 24 hours. While down in Hood River, Bia City Chicks is good.

NIGHT LIFE. Hood may seem to be quiet and tame from the outside, but in fact things can get very lively and in a snowboard way, kick off nightly with a lot of hardcore boozing, especially in the no frills Government Camp or in Mt Hood at the likes of the Alpenstube. The biggest selection of night action takes place in Hood River.

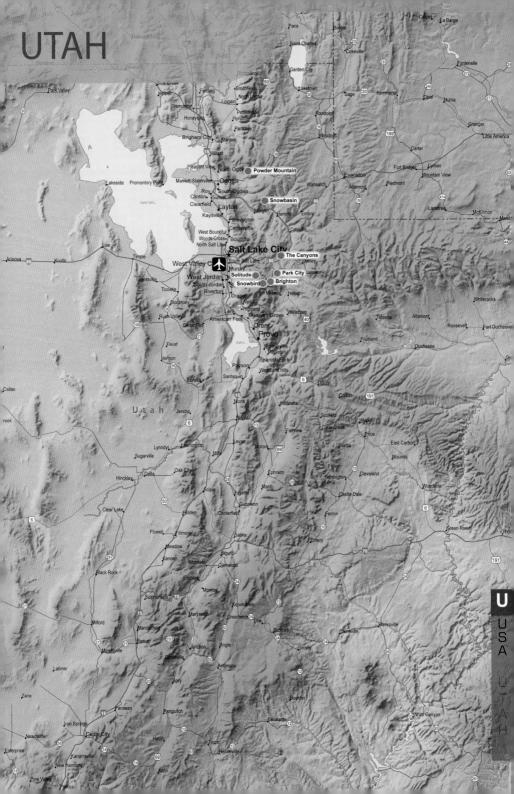

Over-rated, some good freeriding if prepared to hike

Brighton is generally talked of as the snowboarding capital of Utah, but that is overrated. Brighton is located at the top of Big Cottonwood Canyon and most of the mountain is lacking in vertical and challenging terrain. The pipe sucks and the regulars here are not a friendly crowd. There are some really good riders but they don't appreciate visitors crowding the snowboard parks and they will always be the first to let you know it. However, Brighton has been 500

TABLESTICE

TO STATE OF THE STA

welcoming pleasure seekers to its slopes since 1936 and is fully open to snowboarders. Brighton is also close to the snowboard friendly resort of Solitude.

FREERIDERS will want to head straight for the Millicent lift. The **Wolverine Cirque backcountry** is out of this world. This area may require a hike out, but it is well worth the effort. **Scree-Slope** rocks too. It accesses a sweet cliff/shoot area, which goes all the way over to Camera Land and Mary Chutes backcountry. An easy hike to the top of **Preston Peak** from the Snake Creek Express leads to some super tree runs in Snake Bowl. Hidden Country backcountry also has a limitless possibility of tree runs and powder shoots after a good storm, but it tends to get tracked out pretty fast.

FREESTYLERS will be disappointed with the pipe but the park is very well maintained. It has a bunch of decent table tops and spine jumps and is not usually crowded during the week.

THE PISTES of Brighton don't have a lot to offer. There are only a few fast groomers off of **Millicent** and **Evergreen**. The rest of the mountain just does not maintain enough vertical

BEGINNERS would really enjoy learning on this mountain. A large portion of the terrain is not too steep or technical. The Explorer lift is a great place to start and there are numerous runs off of the Majestic lift that beginners would be comfortable with. Sunshine off the Snake Creek Express is a long run, but mellow.

OFF THE SLOPES things are remarkably different to on the slopes because in truth there is nothing here other than a couple of basic lodges and a few bed and breakfasts haunts. You should stay in a neighbouring resort or down in **Salt Lake City.**

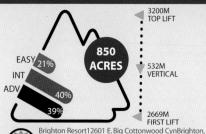

PISTES

many slopes lack pitch

Utah 84121 **TEL:** 801.532.4731

WEB: www.skibrighton.com EMAIL: info@skibrighton.com

WINTER PERIOD: Nov to April LIFT PASSES 1/2 Day Pass \$37, Full Day \$49 Season \$895, Night pass \$30

BOARD SCHOOLS 2 Hour lesson, lift and equipment - \$61 private \$145 Half day \$295 Full Day

HIRE Board and boots - \$26/32 per day

NIGHT BOARDING 200 acres, 22 runs are floodlit & open Monday-Saturday from 4:00pm-9:00pm

NUMBER OF PISTES/TRAILS: 66 LONGEST RUN: 3 miles TOTAL LIFTS: 7 - all chairs

LIFT CAPACITY (PEOPLE/HR): 10,950 LIFT TIMES: 9.00am to 9.00pm

ANNUAL SNOWFALL: 12.7m SNOWMAKING: 24% of slopes

the resort is 35 miles.

BUS from Salt Lake City takes 45 mins FLY to Salt Lake City, with transfer time of 35 minutes. DRIVE From Salt Lake City head east along highway 190 Canyon Road all the way up to Brighton, Salt Lake City to

406 US www.worldsnowboardguide.com

Good freeriders resort

Park City, which played host to the 2002 Olympic Winter Games, is by far the most famous resort in Utah and also one of the most expensive. However, don't let the fact that this is a costly place with a bit of an attitude put you off. In terms of what there is to ride and the way the place is laid out, Park City is cool. With some 100 named trails and over 3300 acres of linked terrain, no-one is going to feel left out here. For the 2002 Olympic Winter Games, Park City was home to skiing's giant slalom and as well as the snowboard races and when you see this place, it's easy to see why. This is a place that knows how to put on a show, (even if the snow can often be a bit dodgy).

FREERIDERS will be wetting themselves once they see what awaits them on these slopes, which stretch out over a number of peaks. If you like back-country riding then check out **McConkey's bowl**

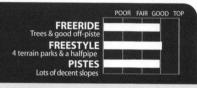

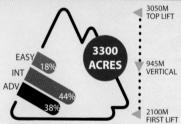

Park City Mountain Resort P.O Box 39, Park City, UT 84060 TEL: 435.658.5560

WEB: www.parkcitymountain.com EMAIL: info@pcski.com

WINTER PERIOD: mid Nov to mid April LIFT PASSES Day \$61,5 of 7 days \$335, Season \$1050 BOARD SCHOOLS Group 3 hours from \$70

HIRE Board & Boots \$31 per day

SNOWMOBILES:90 mins \$50

NIGHT BOARDING: from end Dec to April

NUMBER OF PISTES/TRAILS: 100 LONGEST RUN: 5.6km TOTAL LIFTS: 14 - all chairs LIFT TIMES: 9.00pm LIFT CAPACITY (PEOPLE PER HOUR): 27,200 MOUNTAIN CAFES: 5

ANNUAL SNOWFALL: 8.89m SNOWMAKING: 47% of slopes

FLY to Salt Lake City, 45 mins transfer DRIVE from Salt Lake airpoty head East on Interstate 80 for 4.4miles, then onto I-15 South for 2.5 miles, continue I-80 Eastbound for 21 miles. Take Kimball Junction/Park

City exit # 145.Take UT-224 for 6 miles, turn right onto Empire Avenue to resort

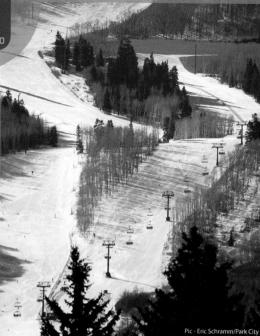

where there are some great double diamond runs that weave through the trees. If riding deep powder in bowls is your thing then this place has some fantastic bowls that involve some hiking and then dropping in, notably the trails on **Jupiter**. Here you will find some black diamond rated trails that can be ridden down to a chair lift, but be warned, this area is for experts.

FREESTYLERS who want to catch big air off natural hits are going to love this place. The mountain is littered with hits galore whether it be up in the bowls or down on the lower pisted areas. The resort also builds numerous terrain parks with man-made hits of every shape. Jonesys Park is great for beginners, while the biggest Pick n'shovel park is great for the intermediate. Kings Crown Super Park is for the mad and Pros only, and if that's not enough, to cap it all there the serious Eagle Superpipe located at the top of the Payday trail. The pipe and the Payday park are flood lit for night riding and are open daily from 9 till 19.30.

PISTE huggers are also in for a good time here. There is a fine choice of good cruising trails such as the runs off the King Con chair lift.

BEGINNERS who have never ridden will soon be able to get to grips with things here, as this is a very good first timers resort.

US

OFF THE SLOPES. Around town there are lots of things to do as well has offering fantastic nightlife. No other resort in Utah packs in as many facilities as this one. There is every imaginable type of accommodation available although not many are aimed at budget riders. However, a good cheap option is the *Park City Youth Hostel* (www.parkcity.com tel 435 655 7255). Don't listen to the stories about the Mormon drinking laws, they do exist but they just make things more amusing. Ask a local bartender what the score is on this.

Great freeriders resort with some cool CAT boarding

Powder Mountain can be considered as Utah's best kept secret. It is just outside of the small mountain town of Eden, north of Salt Lake City, and does not attract the crowds like many of the resorts larger near Salt Lake City and Park City. The resort has a decent 2800 acres of lift served terrain, however the real joy of the resort

is to make use of

POOR FAIR GOOD TO **FREERIDE** Trees & HUGE backcountry **FREESTYLE** 2 Terrain parks & halfpipe **PISTES** some groomed slopes

the shuttle, snow CAT and the guided tours to give you another 2800 acres of pristine backcountry.

FREERIDERS will be stoked to find that Powder Mountain is one giant playground. Most of the terrain is a variety of tree shots, rock drops, and open powder fields. There are great lines off either side of Straight **Shot** and from the top of **Cobabe Canyon**. Riders will also fall in love with the backcountry area known as Powder Country which is well known throughout the region. These impressive steeps are easily accessible from the Sundown lift and drop to the highway where a shuttle service runs for another ride up. Powder has super cat skiing from the top of **Lightning Ridge**. There's 700 acres of powder. A 30min hike to James Peak gives access to a number of chutes and bowls, it costs \$7 for a trip up. Group tours are available at \$80/125 half/full day to these areas. Tel: 801-745-3772 ext 156

FREESTYLERS If you search a little, you can find plenty of natural hits to play on. The **boulder field** on lower Straight Shot and the trees off of East 40 have some nice kickers. There's the Sundown Park off the Confidence lift which is lit at night, and has a half decent pipe (usually open by mid-January). There should be a good selection of features in the Hidden Lake terrain park

BEGINNERS should all learn to ride at this resort with ease, Sunrise, Sundown, or Hidden Lake lift would be good places to start while the Picnic and Mushroom runs are nice mellow runs to follow up on.

OFF THE SLOPES. Resort lodge restaurants are the only places to eat nearby and the only accommodation at the mountain is the Columbine Inn, where rooms and condos are available. The best bet for inexpensive food and accommodations is 19 miles away in the city of Ogden. Here you will find a large selection of everything, birds, booze and music, to mention but a few.

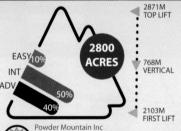

PO Box 450, Eden, UT 84310

TEL: (801) 745-3772 WEB: www.powdermountain.com

EMAIL: powdermountain@powdermountain.com

WINTER PERIOD: mid Nov to mid April LIFT PASSES Half-day \$42, 1 day lift pass \$50 1 Day (inc night) \$55, 5 day lift pass \$225 (inc night) Night pass £19, season from \$470

BOARD SCHOOLS Private lesson \$59 per hour

Group lessons \$30 for 2.5 hours

HIRE Board & Boots \$27 per day

HELIBOARDING For heli-boarding around the Ogden area call Diamond Peaks Heli-Ski Adventures (801) 745-4631.

CAT/BACKCOUNTRY \$8 per trip to Lightning Ridge NIGHT BOARDING Off Sundown Lift & Tiger t-bar till 10pm

NUMBER OF RUNS: 113

TOTAL LIFTS: 7 - 4 chairs, 2 Drags, 1 Platter LIFT TIMES: 9:30 AM - 4:00 PM

MOUNTAIN CAFES: 4

ANNUAL SNOWFALL: 8.89m SNOWMAKING: none

FLY to Salt Lake City, transfer time of 1 hour. DRIVE From Salt Lake City head north on the I-15 north to Ogden 12th Street exit. Head East on the 39 past Ogden Canyon, continue on 158 to resort. 55 miles total.

Decent terrain and good for a few days

Snowbasin is located north of the city of **Ogden**. Unfortunately, they hold so many races here that the John Paul Express, which takes you to the men and women's downhill courses and which accesses a large kick ass part of the mountain, is usually closed of for competitions. Still, there are a lot of other runs to check out with a good supply of black ones at the upper area and a number of intermediate trails leading from the top to the bottom, taking in a few trees en-route.

FREERIDERS will like this mountain more than anyone else. In general the mountain is not extensive and a week's stay would be overdoing it. However, there is a good selection of black marked slopes to keep most riders interested for a day or two. The Strawberry Express is good for access to backcountry gates.

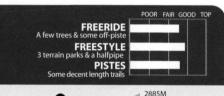

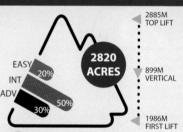

Snowbasin: A Sun Valley Resort 3925 E. Snowbasin Rd. Huntsville, UT 84317

TEL: (801) 620-1000 WEB: www.Snowbasin.com EMAIL: info@snowbasin.com

WINTER PERIOD: early Dec to mid April LIFT PASSES Day \$60, Half Day \$50, season \$800 BOARD SCHOOLS Group lessons \$40 for 2 hours Private lessons \$135 for 2 hours

NUMBER OF RUNS: 104 LONGEST RUN: 5.6km

TOTAL LIFTS: 12 - 1 tram, 2 Gondolas, 6 chairs, 2 drags, 2

magic carpets

LIFT TIMES: 9.00am to 4.00pm

LIFT CAPACITY (PEOPLE PER HOUR): 14,650 **MOUNTAIN CAFES: 3**

ANNUAL SNOWFALL: 10m **SNOWMAKING:** 22% of slopes

FLY to Salt Lake City, transfer time of 50 mins DRIVE From Salt Lake city take US-89 northbound, take exit 326, onto I-84 eastbound, exit 92. Take Old Highway and turn left on State Road 167, then turn left on State

Road 226 heading west for 3 miles. 33 miles in total. BUS services from Salt Lake City take 50 mins

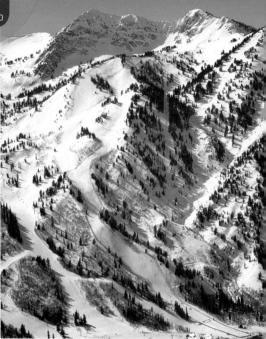

FREESTYLERS will find 2 terrain parks, one at the base and another on Porky Face. The Krazy Kat park at the base has some boxes, a couple of rails and a table top. while the Apex Park at the top of Porcupine lift has some bigger jumps and a 1/4 pipe. There's a superpipe at the bottom of the Grizzly downhill slope

PISTES. Theres some nice steep options like the men's and women's downhill courses when races are not going on. Most of the mountain is intermediate groomers with some nice long trails.

BEGINNERS have a good resort for learning the basics at and although there are not loads of green easy trails. what is on offer is okay, especially the beginner terrain off of Becker Chair.

OFF THE SLOPES. Forget about any slope side facilities, however, **Ogden** has everything you could possibly want. The Alaskan Inn 001 (801)-621-8600 is pricey and the rooms fill up fast, but it is fun and is right in Ogden Canyon, closer to the resorts.

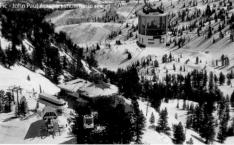

Snowbird is unquestionably the choice mountain for intermediate and expert snowboarders. It has the most vertical terrain of any Utah resort and a pretty decent halfpipe. Skiers tend to out-number riders on this mountain, but the attitude is not competitive. Over the years, this is a resort that has become well known for its steep terrain and fantastic powder, trees, bowls and gullies along with some okay novice terrain. In all honesty, this place is for riders who can ride, because nearly half of the mountain is rated as advanced. If you like going balls out down serious steeps then Snowbird is your heaven, but be warned, if you fail to respect any of the slopes, you may go home in a body bag.

FREERIDERS should take the Mineral Basin lift off the backside of **Hidden Peak** which accesses some of the most epic snow and terrain imaginable. It is easy to spend an entire day there after a good storm and never get bored. On the other hand, once you take the tram to the top of **Hidden Mountain**, you can't really go wrong no matter what face you drop in off. There are plenty of cool runs like Silver Fox, Great Scott, and Upper Cirque, and Gad Valley. It is also not a bad idea to save some quality time for **Thunder Bowl**, accessible by the Gad 2 lift.

FREESTYLERS have a new superpipe located on the Big Emma run in Gad Valley which was dug out in the summer of 05. Besides that, you will have to use some creativity to find hits outside of the two parks. The Beginner Terrain Park is next to the Super Pipe and can be accessed from the Mid-Gad, Gadzoom and Wilbere chairlifts. The Expert Terrain Park is accessed by the Baby Thunder lift and has a sires of rails and hits.

BEGINNERS will quickly find that Snowbird is really an intermediate to expert mountain and might get bored on the limited availability of easy runs. However, the easy area known as the Baby Thunder, is good.

OFF THE SLOPES. Local services are sparse to say the least. There are a couple of lodges close to the base lifts along with a few restaurants and a couple of bars. But don't expect much, or anything cheap.

410 USG www.worldsnowboardguide.com

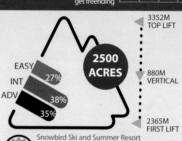

P.O. Box 929000, Snowbird, UT 84092-9000 TEL: 1-801-742-2222

WEB: www.snowbird.com EMAIL: info@snowbird.com

WINTER PERIOD: mid Nov to mid May LIFT PASSES

Half-day \$53/45 inc/excluding tram use Lift pass \$62/51 inc/ex, 5 day pass \$240, Season \$1300 BOARD SCHOOLS Half-day improvers workshops \$56.

Beginners package inc lift, lesson, hire \$99 for 1 day, \$149 3 days. Private 3hr \$275. Secret spots day for advanced freeriders \$90 per day

HIRE Board & Boots \$31 a day, \$45 demo kit HELIBOARDING 7 runs/day \$525/770

NIGHT BOARDING Chickadee lift open until 8:30 p.m for night boarding on wednesdays and fridays

NUMBER OF RUNS: 85 LONGEST RUN: 3.5 miles

TOTAL LIFTS: 12 - 1 tram, 10 chairs, 2 drags LIFT CAPACITY (PEOPLE/HOUR): 16,800 LIFT TIMES: 9am to 4:30 pm

ANNUAL SNOWFALL: 12.7m SNOWMAKING: 1% of area

FLY to Salt Lake City, transfer time 45 mins DRIVE From Salt Lake City head east along 1-80 and 1-215 south and leave at exit 6 following the route for little Cottonwood Canyon. Salt Lake City to the resort 25 miles.

BUS services from Salt Lake City takes 45 mins. Contact 1.800.232.9542 to book 40min shuttle to resort from airport.

NEW FOR 06/07 SEASON: Peruvian lift replaced with a new high-speed quad. 550ft tunnel will provide access to Mineral Basin but probably not until 2007/8 season

SOLITUDE

Super terrain but limited air possibilities

Solitude is a nice change

Solitude is a nice change of pace because Solitude is a nice change of pace because it does not seem to attract hoards of people like the other Salt Lake resorts, plus the mountain kicks ass! There is also a great variety of terrain and a way of spreading out the crowds so that the lines in any one area do not get too long. The attitude is low key and the regulars are super friendly.

FREERIDERS will have

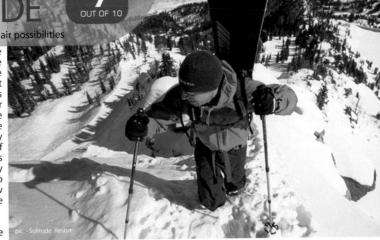

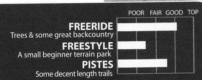

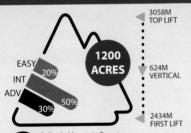

Solitude Mountain Resort 12000 Big Cottonwood Canyon, Solitude, UT 84121

PHONE: 801.534.1400 WEB: www.skisolitude.com EMAIL: info@skisolitude.com

WINTER PERIOD: mid Nov to mid April LIFT PASSES Morning pass \$44, Afternoon pass \$42 Day pass \$50, 2 days \$96 BOARD SCHOOLS

Beginners package \$85 for day hire, lift pass & 2hr lesson HIRE Board & Boots \$20/30 half/day GUIDES Backcountry tours available \$150 for a full day inc pass, lunch,

and bleeper

NUMBER OF PISTES/TRAILS: 64 LONGEST RUN: 5.6km TOTAL LIFTS: 8 - all chairs

LIFT TIMES: 9.00am to 4.00pm LIFT CAPACITY (PEOPLE PER HOUR): 12,550

MOUNTAIN CAFES: 3

ANNUAL SNOWFALL: 12.5m SNOWMAKING: 30% of slopes

FLY to Salt Lake City, transfer time of 50 mins DRIVE From Salt Lake City head east along I-80 and south on I-215 and exit at junction 6 to Wasatch, You'll find the resort 14 miles up Big Cottonwood Canyon

BUS services from Salt Lake City take 50 mins

no problem having the time of their lives at this resort. The summit lift is sure access to some of the sweetest powder country in Utah. Honeycomb Canyon is long and extreme and offers freeriding at its best. The Evergreen area is a must and the Headwall Forest rarely gets tracked out. The best freeriding on this mountain is the Solitude backcountry area, only accessible by hiking. These impressive steeps and powder fields drop down onto Brighton Ski Resort, but by staying far left, you will find trails that wrap back around to Solitude.

FREESTYLE. Expert Freestylers will probably hate it here as the Terrain Park is dedicated solely to beginners. However, everyone was a beginner at some stage and those learning will enjoy the 2 table tops, one fun box and the set of rollers on offer.

THE PISTES accessed by the Eagle Express are where there are plenty of fast cruiser runs like the **Challenger**, **Gary's Glade** and **Inspiration**. Riders will also be happy with a handful of smooth runs off of the Summit chair such as Dynamite and Liberty. The Apex chair will get you to a few short groomers as well.

BEGINNERS will find that this mountain is a great place to first try snowboarding at. There is a good area for learning right off of the Moonbeam II chair, where you will find plenty of good easy runs to keep you happy for a while. North Star and South Star, off the Sunrise lift, are also great beginner runs. First timers can also warm up on Easy Street off the Link chair.

OFF THE SLOPES. You can stay close to the slopes in one of the lodges or condo units offering a choice rooms at generally high rates. The *Powderhorn* is Solitude's newest place for lodging offering visitors somewhere to stay that is both good and convenient, but it's not cheap. Eating out options are basic, however, the *Creekside* makes fantastic pizza's. Nightlife's pretty quiet. Riders looking for a bit of a party are best off heading into **Salt Lake City.** You can chose to stay up at the resort, however, if you are on a budget your best bet would be to stay in a cheap hotel near the mouth of the Big Cottonwood Canyon.

great boarders resort, not for absolute beginners

The Canyons is Utah's newest resort and one of the largest with over 3625 acres of fantastic terrain to check out that makes this part of the Rockies a pure dream. Newest Canyons may be, but in fact this place has been around for quite some time but under another name,

BEGINNERS must study a lift map or seek advice from a local in order to get to the best of the easy terrain, which in truth, is rather limited. However, if you're a quick learner then it's fine.

OFF THE SLOPES. The Canyons has some base area accommodation and other local services. However, the best option in terms of choice and prices is either down in **Park Cit**y or back along in **Salt Lake City**.

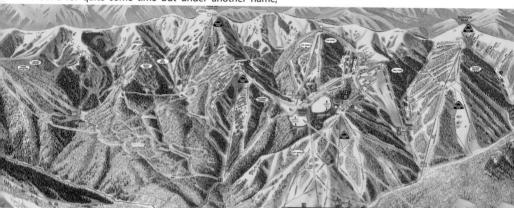

that of **Park West**. However, that's neither here nor there, what this place is about is the future. This massive mountain, which is covered in trees from top to bottom, is constantly expanding by opening new areas all the time and upgrading base facilities year on year off. Indeed Canyons has big ambitions and plans to one day be the biggest resort in the US. And when you see what they have achieved so far, perhaps it could happen. But for now this is a mountain that has everything to turn the aspiring freestyle junkie into a pro air head, or a freeride grommet into a mountain guru. You have deep gullies, massive powder bowls and natural hits galore wherever you go.

FREERIDERS have landed in paradise when they get here. You simply won't believe not only the amount of terrain, but also the diversity of it all. The Tombstone Express will take you to some super terrain, but make sure you study your lift map, it would be easy to head off down a steep trail above your ability. However, one of the best areas to visit is the **South Side Chutes** off the Condor chair lift, where you will find a series of steep chutes.

FREESTYLERS who have been wondering which place to check out in Utah, should look no further than this resort. The Canyons is a mega freestylers hangout having loads of natural halfpipes with excellent banked walls. And as if having perfectly formed natural pipes wasn't enough, the resort also has a first class superpipe. For rails and hits take the Sun Peak Express chair to the Snow Peak area where you'll find the extensive Sobe terrain park.

PISTES. Riders of any level will find that this is a fine resort to practice cranking out some turns at speed. There are loads of carefully prepared pistes that will keep you happy for days on end.

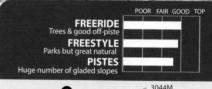

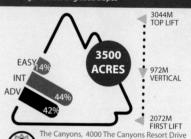

Park City, UT 84098
PHONE: 435-649-5400
WEB: www.thecapyons.com

WEB: www.thecanyons.com EMAIL :info@thecanyons.com

\$64 2hr group lesson, \$110 private lesson HIRE Board & Boots \$34 per day, demo stuff \$45

NUMBER OF PISTES/TRAILS: 146 TOTAL LIFTS: 16 - 1 Gondola, 13 chairs, 2 drags LIFT CAPACITY (PEOPLE/HOUR): 25,700

LIFT TIMES: 9am to 4:00 pm

ANNUAL SNOWFALL: 9m SNOWMAKING: 5% of area

FLY to Salt Lake City, with transfer time of 45 minutes (32 miles).

DRIVE Salt Lake City head east along I-80. Salt Lake City to the resort is 32 miles.

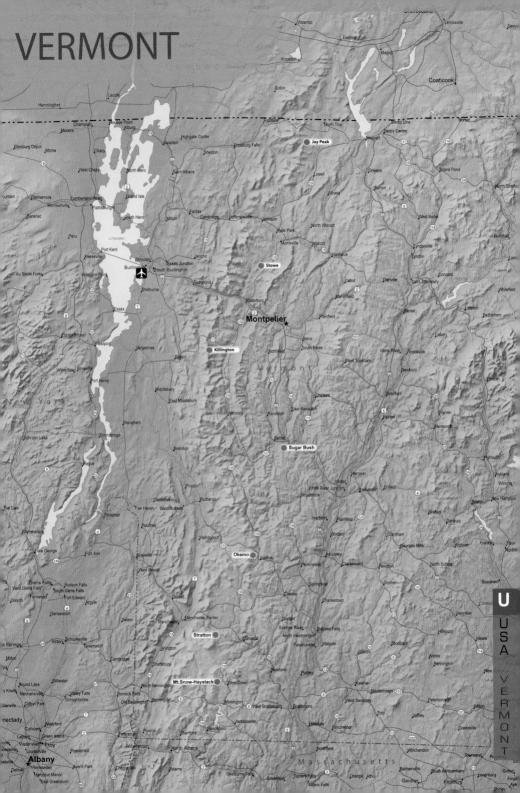

Jay Peak, located in the far northern part of Vermont and close to the Canadian border, is not a bad place and one that attracts a fair few riders from within the state and across the border in Canada. Indeed the resort is actually owned by a Canadian resort company and you can even use Canadian dollars to pay for your lift ticket. For an east coast resort, Jay has a fairly good annual snow record, and although the amount of snow that falls here is no match for the resorts in the Rocky Mountains, is still good for the east and you can usually be guaranteed some fine powder each year. It is also notable that although it may not be a very big place, the amount of good hardcore and tree riding stands out's. Much of the mountain is fully open to snowboarders and is rated for advanced and intermediate riders, novice terrain is very limited. The resort has a modern lift system which includes a 60 person tramway and a series of chair lifts and T-bars. The location of Jay Peak may be the chief reason for this place for not becoming overcrowded while lift lines are either nonexistent or very small, except over holiday periods and weekends.

FREERIDERS will find that the offerings on Jay Peak are pretty good and will allow advanced and intermediate riders the chance to ride hard and fast with some excellent powder spots, some very fast chutes and lots of tight trees. Note, the resort has a strict policy when it comes to riding in the woods. Basically you must take responsibility for your own actions if you ride out of bounds, you must be a competent rider and you must not go alone. Areas such as Buckaroo, the Everglade or the Beaver Ponds Glades are pure nectar and will excite all riders.

FREESTYLERS have 4 terrain parks and a boardercross trail. But with so much natural freestyle terrain on offer, the man made hits are almost not needed but great to learn on. The Canyonland is home to an amazing natural halfpipe that should keep you amused for hours.

PISTES. Boarders who dig the piste have a nice number of cruising trails set out everywhere

BEGINNERS are the one group who may find this place not for them. There are novice areas but they are very limited.

OFF THE SLOPES. Jay Peak is a small town and has a limited amount of accommodation on offer. However, prices are not too bad and around town you will be able to go out and get a good meal with a reasonable choice of restaurants. Night life, however, is tame.

414 USQ WWW.WORLDSNOWBOARDGUIDE.COM

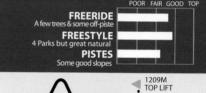

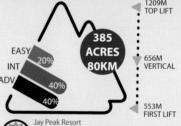

Route 242, Jay Peak, VT 05859. TEL: 001 (802) 988 2611

WEB: www.jaypeakresort.com EMAIL :info@jaypeakresort.com

WINTER PERIOD: Nov to April

LIFT PASSES Half day \$42, Full Day \$58, 5 Days \$215 BOARD SCHOOLS Group lesson morning \$28, full day \$48 Private lesson 1hr for \$50, full day \$230

Beginner package - pass, rental & lesson \$49 for full day HIRE Board & Boots Day/5 days \$58/\$215

LONGEST RUN: 3miles

TOTAL LIFTS: 8 - 1 Gondola, 5 chairs, 1 drags, 1 magic

LIFT CAPACITY (PEOPLE/HOUR): 12,175 LIFT TIMES: 8.30am to 4.00pm

ANNUAL SNOWFALL: 9m SNOWMAKING: 85% of slopes

FLY to Monteal in Canada, transfer time of 11/2 hours. DRIVE From Montreal head south on I-10, 35 & 91 & Hwy 100 via Newport. Montreal to the resort = 70 miles. Boston is 3 1/2 hours New York City is 6 1/2 hours.

BUS services from Montreal takes 1 1/2 hours. TRAIN AMTRAK Vermonter to St. Albans, 45 minutes away. Good boarder's resort with ample, diverse terrain

Killington is a big resort - the Beast of the East as the locals like to call it. If you thought the east coast of America was lame and no match for the central or western resorts then think again. Killington has seven mountains of steeps, bumps, mega carving terrain, loads of fun-parks and halfpipes, all serviced by a modern and well equipped lift system that includes an artistically painted and heated gondola. Visitors arriving here thinking that they will have the place licked in a day or two will be surely tested. You will need at least a couple weeks to ride all the runs and then a further month just to get to know what you have just been down. Killington reportedly has the largest snow-making facilities in the east, and like a number of other US resorts, it's a particularly snowboard-friendly place having hosted many snowboard events. The United States Amateur Snowboard Association once chose Killington as its training ground, and it's easy to see why: the terrain is perfect for all levels and all styles.

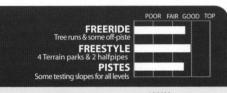

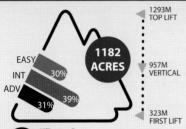

Killington Resort 4763 Killington Rd, Killington, VT 05751 TEL: 001 (802) 422 - 6200

WEB: www.killington.com EMAIL: info@killington.com

WINTER PERIOD late Oct to earlt May LIFT PASSES 1 Day pass \$69/74, 5 Days \$255 **BOARD SCHOOLS** Group lessons \$35 for 90mins Beginner package \$99 for 3 days lift, lesson & hire

Private lessons \$65 per hour HIRE 2 Days Lift Pass and Hire \$181, Board & Boots \$31 per day

NUMBER OF RUNS: 200

MOUNTAIN CAFES: 9

TOTAL LIFTS: 32 - 2 Gondolas, 22 chairs, 8 drags LIFT CAPACITY (PEOPLE PER HOUR): 52,973 LIFT TIMES: 8.30am to 4.00pm

ANNUAL SNOWFALL: 6.4m SNOWMAKING: 72% of pistes

NIGHT BOARDING No.

CAR 23/4 hours from Boston 193 to south of Concord,NH. 189 north to us 4 Rutland, Exit 1 in Vermont. Follow US4 west to Resort FLY to Boston, but theres no direct transfers.

Pic copyright Skye Chalmers

One thing that boarders should be aware of is traversing, as it's very easy to end up spending a lot of time travelling across the mountain, trying to get around. An excellent tool here is the free Ride Guide which tells you everything worth knowing, from a snowboarder's perspective, about the mountain and surrounding town - you can pick up a copy at the ticket office.

FREERIDERS have a mountain that often seems to vary at every turn: you get to ride lots of bumps - Superstar on Skye Peak and Outer Limits on Bear Mountain for instance; plus there are lots of trees to ride in, with numerous 'secret' trails to search out. If you're after a heart tester, check out the steeps at Killington Peak off the Cascade chair, where you have a choice of tree-lined steep blacks.

FREESTYLERS have four terrain parks and two halfpipes. The main pipe in the wild fire park has 18foot walls and is 425 foot long. And as well as the pipe having great transitions and sounds blasting out, you can also get a burrito pipe side. As well as featuring four terrain parks, one of which is now on the Timberline, there is now a boardercross course on the Dream Maker area. Killington offers a pipe-only pass for \$20

PISTES. Riders who want it steep will love Killington's terrain, which ranges from ultra-wide, straight down trails like Double Dipper, to narrower, more traditional runs such as East Fall or Royal Flush. Other notable spots are on Ram's Head, Snowdon or Skye Peak.

A

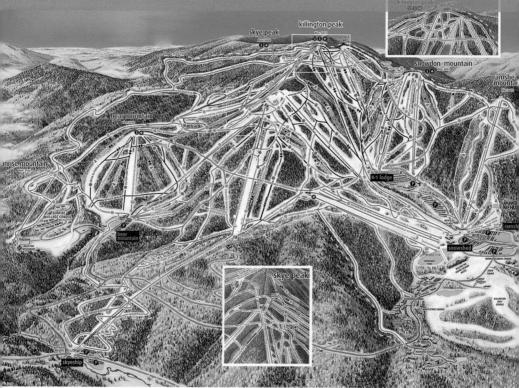

BEGINNER'S areas are excellent. However, like a lot of New England resorts, they can get busy at weekends. Stick to mid-week if possible as there are no crowds and empty runs. The Killington Snowboard School is excellent and offers every level of tuition, at prices worth paying. A day's ride package costs \$65.

OFF THE SLOPES. Local facilities are extensive and varied, with a purpose-built village at the base of the slopes. However, by far the bulk of local hospitality is stretched along the access road. If you're prepared to pay for the convenience, then try to stay at the base; the cheaper thing to do is move away from Killington and hang out in one of the smaller hamlets. This way you get a better feel of the place and the locals are easier to get to know. Wherever you stay, it's always good to have a car, although there are shuttle bus services. For snowboard services check the Ride On or Darkside shops.

ACCOMMODATION here is a bit hit and miss in the sense that there is no real town to speak of. There are some slopeside condos, but they don't come cheap. A full range of lodging options can be found stretched along the five mile access road, and offers dozens of cheap B&B joints to motels.

FOOD is standard grade, east coast, with big portions, lots of variety with over 60 restaurants throughout the area and in every price bracket. *Churchills* is noted for its steaks but isn't cheap and may entail a drive to get to it along route 4. Also highly rated is *Hemingways*, a super dollar hungry restau-

rant. For a decent and filling breakfast, why not check out the *Kodiak Cafe*. Or for a reasonably priced burger visit *Peppers bar*.

NIGHT-LIFE in and around Killington is noted for being well suited to snowboarders. There is a host of evening spots where beer and local birds are available to all, and which can be very lively most evenings while rocking 'til late. *The Pickle Barrel* is known for having a good vibe as is the *Wobbly Barn* with live bands and rowdy crowds.

SUMMARY. Very good snowboarder's resort with ample, diverse terrain to suit all styles and levels. Lots of good local services but not a convenient layout. Money wise: In the main very pricey but with options for budget riders to make it.

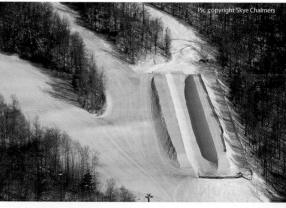

MT.SNOW-HAYSTACK OUT OF 10

Basic but good riding

Mount Snow and Haystack are located in the Green Mountain National Forest, and like many of the east coast resorts within easy reach of major towns and cities, the area sees plenty of weekend skidwellers. Mount Snow and Haystack are, in fact, two separate resorts that are not, unfortunately, linked by lifts or snow trails. However, they are only a few minutes apart via the regular shuttle bus operating between the two areas. Collectively, the two areas have some 145 trails that are sold as one when you buy a lift pass. In the main, the whole place forms a cruisy mountain, best suited to intermediates and novices, with some decent-sized runs and interesting terrain features with hits, rollers, flats and trees. Be warned that at weekends and holiday periods, long lift queues do appear.

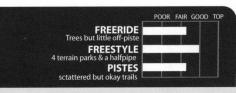

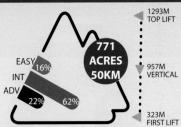

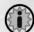

105 Mountain Road, VT 05356 TEL: 001 (802) 464 3333

WEB: www.mountsnow.com EMAIL: info@mountsnow.com

WINTER PERIOD: Nov to April LIFT PASSES Day pass \$57/68 (hi/low season) 6 Day \$240-336

BOARD SCHOOLS private \$87/hr 6 hours \$360 3 day learner package \$175 includes rental, lift pass & 8hrs tuition HIRE Board and Boots \$36/day 5 Days \$121

NUMBER OF PISTES/TRAILS: 104

LONGEST RUN: 4km

TOTAL LIFTS: 19 - 15 chairs, 1 drag, 3 magic carpet LIFT TIMES: 8,30am to 4,00pm

LIFT CAPACITY (PEOPLE PER HOUR): 30,370

ANNUAL SNOWFALL: 4.21m SNOWMAKING: 76% of slopes

on Rts 100 to Mt Snow.. Boston to resort is 134 miles, 2 3/4 hours. BUS Greyhound and Vermont Transit, tel: 802-254-6066 run services to Brattleboro. www.adventurenortheast.com run buses from New York City, tel: 718-601-4707

TRAIN The Amtrak Vermonter to Brattleboro or the Ethan Allen Express to Rensselaer/Albany

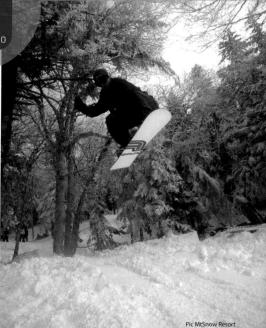

FREERIDERS coming here for the first time will find that the slopes on Mount Snow will offer challenging and difficult terrain. Advanced freeriders should head up to North Face with its series of blacks and double blacks which will test you with a mixture of bumps and groomed terrain. On Haystack, The Witches double blacks offer some interesting riding, but they're quite short.

FREESTYLERS are best checking out the slopes on Mount Snow, where you'll find a good series of well constructed man-made hits in the shape of four parks, at Carinthia you have Inferno for the air heads, and El Diablo for the intermediate, Un Blanco Gulch off Canyon trail is for the beginner while Grommet located on Beaver Hill is for the first timer in a park. Also at the base of Carinthia, The **Gut Pipe** is consistently rated as one of the top 10 pipes in the country, it's 460-feet long with 18-foot walls. All parks are designed by Ken Gaitor once of Brighton Utah. Also of interest is the Beartrap area which blast music all day.

PISTES. Boarders wanting to lay down some turns at speed can do so with ease on Snowdance, one of the blues from the Summit Cafe. The North Face area on Mount Snow is good for fast full on steep descents

BEGINNERS tend to stay on Mount Snow, where there is a good layout of easy trails. Haystack has a complete beginner-only area. Ride On Snowboard School offers a Guaranteed Learn to Ride session, at \$50 all-in.

OFF THE SLOPES. There is accommodation at the base of the slopes. Mount Snow Condominiums offer very good facilities which include a pool, but it's not a cheap option. A far greater selection of services can be found at West Dover or Wilmington, both inside a 10 mile radius. The lifestyle here is nothing amazing: a few bars and a number of places to eat give a laid back feel to the place, without any ego.

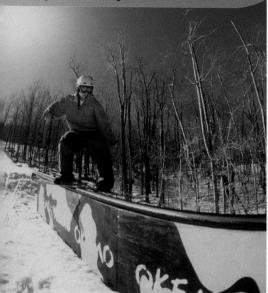

After spending a couple of days on **Okemo**, you will notice the incredible core of talented riders who call Okemo home. There is tons of diverse terrain to ride, with over 100 trails, so you can find plenty of room, no matter what type of rider you happen to be. The lift system at Okemo is rarely busy, but if you don't have a leash you won't be welcome, so come equipped

FREERIDERS who like bumps must check out Ledges, Chief and The Plunge. Recommended gladed runs are Double Diamond and Outrage. Both are long, steep and covered by snowmaking machines, which means that they open early and stay open late into the season. Okemo has expanded and now has new glades in the South Face area known as **Forest Bump** offering even more tree riding! Once you're clear of the trees and bumps, you won't believe the huge, ultra-long, rolling trails that are Okemo's trademark. Sapphire, World Cup, Coleman Brook, and Tomahawk are just a few trails that are perfect for going fast and boosting huge airs. For safety's sake, always use a spotter.

FREESTYLERS won't want to miss okemo's snow-board parks, or the massive super pipe, which measures over 500 feet and is served by the Pull surface lift. There's also the Hot Dog Hill's mini pipe ideal beginners. Nor'Easter Super Park located on the Nor'Easter trail is by far the resorts biggest park. The Dew Zone is next to the superpipe while the Blind Faith Terrain Park has some big table tops. Located at Jackson Gore is the Snowskate Park with some rails and kickers. The Hot Dog Hill Mini Park is for beginners.

PISTES. Riders have 117 trails to choose from, so every standard of boarder should find something to please them, with the best terrain for fast turns being located

on the upper sections.

BEGINNERS are extremely well catered for at Okemo and for those who need to brush up or learn something new,there is an award-winning snowboard school catering for all levels and style of rider, with the beginner terrain being easy to handle. A First Tracks programme costs from \$45 a day.

OFF THE SLOPES there are plenty of places to stay, with the usual array of hotels, motels and even a youth hostel. Prices will suit every budget, whether it be a slopeside condo or a giant B&B. To dine in style, *Nikki's* or *DJ's* is the place, whilst *Savannah's* is the joint for burgers. If you want a good drink with your food, then head for the *Black River Brew Pub*.

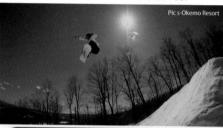

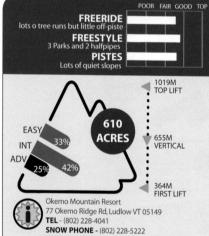

WINTER PERIOD: early Nov to late April LIFT PASSES 1 days \$63/69, 5 Days \$250/254 HIRE Group \$33hr, Private \$80/hr

BOARD SCHOOL Board and Boots \$33/day, 5 Days \$135

NUMBER OF PISTES/TRAILS: 117 LONGEST RUN: 7.2km TOTAL LIFTS: 18 - 12 chairs, 5 drags, 1 magic carpet

WEB: www.okemo.com

EMAIL: info@okemo.com

LIFT CAPACITY (PEOPLE/HOUR): 32,050 LIFT TIMES: 8.00am to 4.00pm

ANNUAL SNOWFALL: 5.08m SNOWMAKING: 95% of slopes

FLY to Boston, with a transfer time 3 hours. Albany 2Hrs DRIVE From Boston, head north on I-93 to Hwy 89, turning off at junction 9 for route 103 via Ascutney and Ludlow.Boston to resort is 150 miles. 3 hours drive time. BUS services from Boston can take 3 hours.

418 USQ www.worldsnowboardguide.com

Stratton is generally recognised as the home of snowboarding, well at least on the east coast. A decent-sized resort, Stratton was one of the first areas in the US to give snowboarders access to its mountain. It is also noted for not only being the original home and test area for Jake Burton and his Burton Snowboards, but also as the place where America's first pro-snowboard school was set up and the home to the world's longest running snowboard competition. The US Open, which uses what is reputed to be the best halfpipe on the planet. The Green Mountain Race Series also comes to Stratton for a couple of events. Midweek you are up

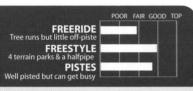

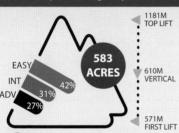

Stratton Mountain Resort

RR 1 Box 145., Stratton Mountain, Vermont 05155-9406 TEL: 802-297-4000

WEB: www.stratton.com

EMAIL: infostratton@intrawest.com

WINTER PERIOD Nov to May

LIFT PASSES 1 day \$65/748, 5 days \$220/240 BOARD SCHOOLS 1 3/4hr group from \$35

1 3/4hr private from\$85

HIRE burton boards \$39/45 day, kids \$35/39 day **NIGHT BOARDING No.**

NUMBER OF RUNS: 90

TOTAL LIFTS: 16 - 1 Gondolas, 10 chairs, 2 drags,3 Magic Carpets

LIFT CAPACITY (PEOPLE PER HOUR): 36,000

LIFT TIMES: 8.30am to 4.00pm **MOUNTAIN CAFES: 8**

ANNUAL SNOWFALL: 4.32m SNOWMAKING: 90% of pistes

CAR Take Route 2 west to I-91. Go north to exit 2 and follow signs to Route 30 north, then drive 38 miles north to Bondville, VT. Total distance 146 miles, drive time is about 3 1/4 hours.

FLY to Boston International. Transfer time to resort is 3 1/4 hours. Local airport is Albany 90 miles.

TRAIN to Brattleboro, 40 miles away

BUS There are daily bus services from Boston airport and from Albany airport.

and down the mountain in a flash, but at the weekend, lift queues appear as everybody from New York and Boston arrive en-mass. However, with 40 years history as a ski resort, the management know how to keep things moving along to everyone's satisfaction. Riding here will suite everyone although riders who look for extreme or big cliff jumps may be a little disappointed. Still this is a resort that has a good annual snow record and one which offers snowmaking facilities covering over 82% of the terrain on offer.

FREERIDERS who like their terrain carved out of tight trees, won't be disappointed as all the trails are hacked out of thick wood from top to bottom. For a good ride fix, the rollers and banks on the intermediate/novice terrain of Black Bear and the Meadows should do the trick. Riders with some know-how should check out the Upper Tamarack and if you are looking for some open trees, Freefall is the place.

FREESTYLERS hanging around the lower mountain can use the high-speed, six-person chair to access one of four fun-parks and the super pipe. All the parks have a series of table-tops, gaps and ramps, and to keep you interested they regularly build new hits. The superpipe in the Power Park also has a loud sound-system, and floodlights for hitting the walls at night. The four parks are set up for Beginner to Expert, so when you enter a specific park you know what you're letting yourself in for. The East Byrneside park has a boardcross along side it's jibs.

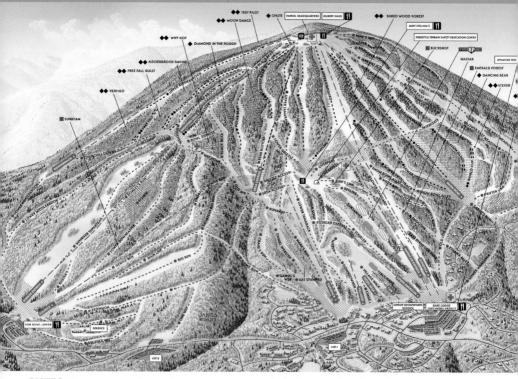

PISTES. The runs are well pisted and wide enough to allow you to put in some fast, continuous runs, without too much fear of a collision. Pistes of note are North American, Upper Standard and Lifeline. They look after the pistes here but get up early and get them while there still corduroy as there are often ice patches come the afternoon.

BEGINNERS and novice riders will have the whole of the lower mountain to explore, plus easy routes from the summit. The runs are particularly well suited for first timers, but at weekends the flat pitches become crowded, so expect a few collisions. Snowboard tuition is first class at Stratton with loads of lesson programmes.

OFF THE SLOPES

Whether you're planning a week's trip or a two week stay, you won't be disappointed with what you find both on the slopes and off them. At the base of the mountain is a compact alpine style village with more or less everything you need. The scene can't be described as wild and in your face, but it is out there and with plenty going on. The place has a warm and welcoming atmosphere, and although you pay for it, services are very good. Shopaholics will love it here as there are dozens of stores and malls to help while away your time. There's also a very good sports centre in Stratton, where you can tone up, have a massage, or simply perve at the women doing their exercises.

ACCOMODATION. With nigh on 20,000 visitor beds around the area, lodging options are really good, with the usual offerings of condos, lodges, fancy, over-priced hotels or basic B&B haunts. The *Lift Line*

Lodge has rates from \$70, while the Stratton Mountain Inn has rates from \$90 and offers good services in the centre of the village.

FOOD. Eating out options are a little disappointing, with the choice of expensive, bland food in a pompous restaurant, or cheap, bland nosh at a fast-food outlet. However, if you search around, you will find something to please your pallet. The *Sirloin Saloon* fries up some damn fine steaks and the *Base Lodge Cafeteria* dishes up a decent breakfast. Pizza lovers should check out the offerings from *La Pizzeria* while *Red Fox* is the Italian place.

NIGHT-LIFE in Stratton is okay but not spectacular. The *Base Lodge* is the first port of call in the early evening hours, where you can play pool, pinball and a juke box pumping out up-to-date sounds. Later on check out the *Green Door Pub* for a few lively beers, or *North Grill* to sample some blues in a laid back atmosphere.

STOWE

Okay fun resort

If you're after some serious east coast riding, then the popular resort of **Stowe** is your place. It's a proper mountain spread over three distinct areas, each one lending itself to a different level of ability: **Spruce Peaks** is the beginner/intermediate area (a little isolated from the main

FREERIDE
Tree runs but little off-piste
FREESTYLE
3 terrain parks & a halfpipe
PISTES
Busy but good intermediate runs

POOR FAIR GOOD TOP

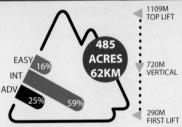

Stowe Mountain Resort 5781 Mountain Rd, Stowe, VT 05672

TEL: 1-800-253-4754 WEB: www.stowe.com EMAIL: info@stowe.com

WINTER PERIOD: mid Nov to late April LIFT PASSES Half-day \$58, 1 Day pass \$66/70 Night & Day \$76, Night pass - \$24, 2 Day pass - \$120

5 Day pass - \$275, Season pass - \$1507

BOARD SCHOOLS privte 1hr/\$93 half day \$216. Group from \$37

HIRE board & boots \$31 extra days \$25

NIGHT BOARDING thursday-saturday the Perry Merrill and Gondolier trails open until 9pm

NUMBER OF RUNS: 48 LONGEST RUN: 6km

TOTAL LIFTS: 12 - 1 Gondola, 9 chairs, 2 drags

LIFT TIMES: 8.30am to 9.00pm

LIFT CAPACITY (PEOPLE PER HOUR): 15,516

ANNUAL SNOWFALL: 6.35m SNOWMAKING: 90% of slopes

FLY to Boston Int, with a transfer time of 2 1/2hours.
Burlington International Airport is 45 minutes away

PRIME From Boston head porth on 89 and turn off at

DRIVE From Boston, head north on 89 and turn off at junction 10 on to route 100 to Stowe village. For the resort continue and take Route 108 the Mountain Road to the resort.

Boston to resort is 198 miles. 2 1/2 hours drive time. **TRAIN** Amtrak run to Waterbury, then its a 15min taxi to the resort

BUS services from Boston take 3 3/4 hours

ride area); **Mt Mansfield** is accessed by the fastest 8-person gondola in the world, and is an intermediate's paradise with great cruising terrain, perfect for those who like to carve. The final area is the largest, and a perfect mix for each style in the advanced stages. Because Stowe is a popular hangout with city slickers and weekend tourists, the lifts can get clogged on weekend mornings, but don't be put off - a short wait will be awarded with a good long run.

FREERIDERS may find the area under the gondola fun with heaps of tracks through trees, and plenty of places within the main area to disappear into. Liftline and National are rather tame trails having been widened over the years, and are only cool if you are into bumps. Nosedive is good for freeride and carving, with the rest of the Mansfield area consisting of intermediate terrain, including a few good natural hits and jumps on the trail's edge.

FREESTYLERS are going to kick arse on any mountain after a session in one of three fun-parks at Stowe. The top choice park is the specially designed Jungle, located on the Lower Lord area which is easily reached from Lift 4. Stowe also has a pipe, and the resort even provides a park for beginners and novices, alongside 20 minute lessons called Ouick Trick at \$15.

PISTES. There's plenty of piste riders in evidence at Stowe, with the runs on Mt Mansfield having some nice, tame trails suitable for picking up speed & cranking over some turns

BEGINNERS will surprise themselves when they see how quickly they can progress on the abundance of easy slopes, especially if they are aided by the teaching staff at the local snowboard school who have more teaching programmes available than you could poke a stick at, ranging from novice to freestyle camps.

OFF THE SLOPES. The village is about six miles from the main slopes and is reached by a free shuttle bus. There are plenty of places to lay your head along the road to the lifts, with the usual choice of condos and B&B's. Stowe doesn't have the most radical night-life, although you can eat and drink well in a number of restaurants and bars, with the cool, friendly locals. The *Rusty Nail* is a hot spot for beer and music.

SUGARBUSH

Not a bad group of mountains

Located along the Mad River Valley is the very snowboard friendly resort of Sugarbush, a mountain resort that is not bad and well worth a visit if you are in the area. Sugarbush is split over six connected mountain areas, all of which offer different features for different abilities. A short distance from Sugarbush is a resort called Mad River Glen, however, don't bother with this arse

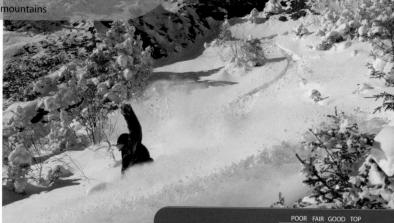

of a place because in 91 they banned snowboarders apparently to preserve the area's unique character; their exact words . Still, today there's no such problem here at Sugarbush, which has been operating as a resort since 1958. Today Sugarbush is a modern and well equipped resort with state of the art snowmaking facilities that reach almost 70% of the slopes. Mind you the resort has a respectable real annual snow fall of some 716 cm per season, making artificial snow not always so important. The six rideable areas are split up as, Castlerock Peak, which is home to some major expert terrain, Cadd Peak, which is the location for the Mountain Range Snow Park and good intermediate runs, Lincoln Peak, which has a splattering of good carving trails and some trees, Mount Ellen, which is the highest in the resort, North Lynx Peak home to a lot of novice terrain and finally Slide Brook Basin. You can ride all the areas on one lift pass and all are connected by the array of chair and drag lifts.

FREERIDERS should first make for the Lincoln Peak where you will be able to sample some major runs via the Castlerock chair. This area is mainly for riders who know the score, if you are easily frightened, forget it. However, if you are up to it then you won't be disappointed.

FREESTYLERS need to head to the park and pipe over near the Mt.Ellen Lodge. Its served by its own chair. Its graded by the Smart Style system, with separate lines for different abilities, and features a decent number of rails and kickers and a reasonable halfpipe. Around the resort there is also an abundance of natural hits for catching air off.

THE PISTE riders can pick and choose really what they want. The area has a cool choice of groomers. Some of the runs on Lincoln are ideal for speed.

OFF THE SLOPES Sugarbush offers a large number of accommodation options, from quality hotels to basic bed and breakfast homes. Dining out is also rather good around here, however, the same can't be said for the nightlife, it's very lame indeed.

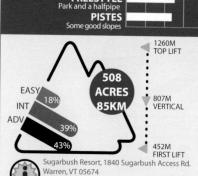

FREERIDE
Tree runs but limited off-piste

FREESTYLE

PHONE: (802) 583-6300 WEB: www.sugarbush.com

WINTER PERIOD: Nov to April LIFT PASSES 1 day \$63-67, Half-day \$54, 5 of 6 days \$285, season \$899 BOARD SCHOOLS group 2 hours \$37

private 1 hour \$82 all day \$297 HIRE board and boots \$30/day

NUMBER OF PISTES/TRAILS: 115 TOTAL LIFTS: 17 - 14 chairs, 3 drags LIFT CAPACITY (PEOPLE/HOUR): 25,463 LIFT TIMES: 8.30am to 4.00pm

ANNUAL SNOWFALL: 6.6m **SNOWMAKING:** 68% of slopes

FLY to Burlington Airport which is a 45min taxi away from resort. Boston airport approximately 3 hours drive/bus away.

DRIVE Southbound: take I-89 south to Exit 10 Waterbury, Route 2 south to Route 100, through Waitsfield then right onto Sugarbush Access Road. Northbound: take I-89 Exit 9 on to Route 100b onto to 100 through Waitsfield, then right onto Sugarbush Access Road.

BUS services available from Boston

TRAIN Waterbury and Rutland nearest stations, Amtrak runs trains from Washington DC, Baltimore, Philadelphia and New York

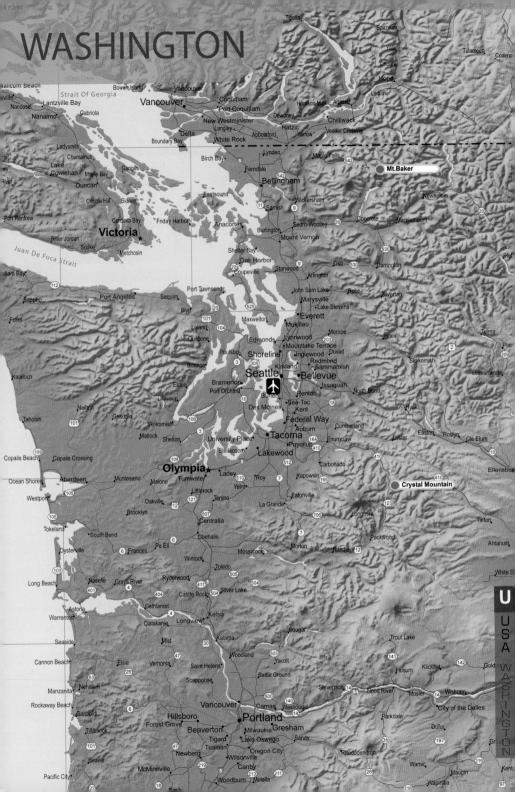

Good freeriding for this up & coming resort

Located mid-way into Washington State, an hour and twenty minutes from Seattle, Crystal is yet another yankee freeride classic, unspoilt by skiers, for riders in the know. The terrain is spread out over four peaks, with an awesome amount of backcountry riding. The resort was taken over in 97 and since then they've added new lifts and other modifications. They've finally had their master plan approved so starting in summer 2007 should be the building of a new tram and an additional

POOR FAIR GOOD TOP **FREERIDE** Tree runs & good off-piste **FREESTYLE** Park and a halfpipe

lift . Crystal's already rising profile is bound to increase which may have the adverse effect of bringing in more skiers - presently there is a balanced mix, leaving the slopes crowd-free and lift queues short.

FREERIDERS, miss this place and you're missing out on life; the terrain is pure freeriding and South Back is the place to check out if you're willing to do some hiking. From the summit of **Throne**, you get to ride what can best be described as heaven - unfortunately it is not for wimps being a steep with a double black diamond rating. Less daunting but still a big buzz are the runs off Summit House, while the trails in the North Back area on the likes of Paradise Bowl are total joy.

FREESTYLERS won't need man-made facilities at Crystal Mountain, as there is plenty of natural freeride terrain to catch big air. However, there is a pipe off the Rendezvous chair, but it's not up to much. The Boarder Zone fun-park, located off the Quicksilver chair, has a number of hits, but like the halfpipe, it doesn't live up to what nature can offer.

PISTES. Boarders who stick to the piste can have as good a time as those looking for the untamed, with a choice of excellent slopes that will please advanced and intermediate riders, even if some of the trails are not too long.

BEGINNERS can't do much worse than at Crystal. Only 13 of its trails are fine for novices, but what is on offer is excellent and easily reached from the base. And like many US resorts, a number of the higher rated runs are not that tricky, so many of the red trails can be licked by a competent, fast-learning novice.

OFF THE SLOPES. No big surprise here, the village at the base of the slopes is simple, basic, but good enough, with affordable places to sleep and eat in to suit all tastes and pockets. For a bed check out The Alpine Inn, which is close to the slopes and good value. For a feed try the Cascade Grill which serves a good breakfast. The main hangout for booze is the Snorting Elk Cellar, but unfortunately it's not a place for babes.

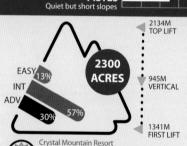

PISTES

1 Crystal Mtn Blvd. Crystal Mt, WA 98022

TEL: 001 (630) 663 2265 WEB: www.skicrystal.com EMAIL: comments@skicrystal.com

WINTER PERIOD: mid Nov to mid April LIFT PASSES Half Day \$48, Day \$53, Night \$28, Season

BOARD SCHOOLS 2Hr Group \$35, Private 1 Hr \$65 HIRE board and boots \$30/day

NIGHT BOARDING 4pm to 8pm Friday and Saturday nights

NUMBER OF PISTES/TRAILS: 50 LONGEST RUN: 2.5 miles

TOTAL LIFTS: 10 - 9 chairs, 1 magic carpet LIFT CAPACITY (PEOPLE/HOUR): 19,110

LIFT TIMES: 8.30am to 4.00pm

ANNUAL SNOWFALL: 9.65m SNOWMAKING: none

FLY to Seattle, 76 miles north of Crystal. DRIVE From Seattle head south on I-5 and exit onto Hwy 164 and then Hwy 410 east to Crystal Mountain. Seattle to

resort 76 miles. 1 1/2 hours drive time.

BUS services from Seattle take around 1 3/4 hours. The www. quickshuttle.com costs \$60 including lift pass and picks up 7:15 from Seattle or Tacoma. Tel: 1-800-665-2122

NEW 2006 AND ONWARDS. As part of a hige masterplan a new tram is planned once they can sort out the cost and is expected to start summer 2007 and take 2 years. Also Northway chairlift planned.

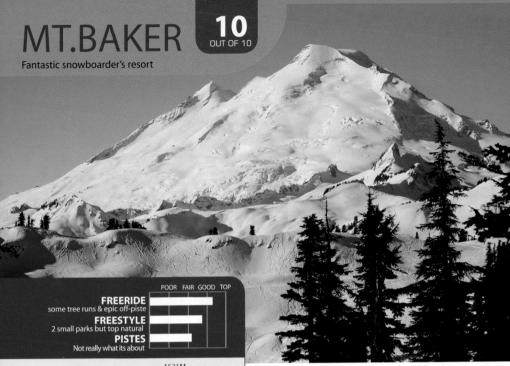

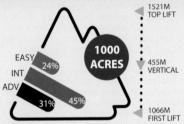

Mt Baker Resort Office 1019 Iowa St, Bellingham, WA 98229-5818 **TEL:** (360) 734-6771

WEB: www.mtbaker.us EMAIL:snow@mtbaker.us

WINTER PERIOD Nov to May LIFT PASSES Weekday \$35, Weekend \$45 Season pass \$635 NIGHT BOARDING No

NUMBER OF PISTES/TRAILS: 30 LONGEST RUN: 3km TOTAL LIFTS: 9 - 7 chairs, 2 drags LIFT CAPACITY (PEOPLE PER HOUR): 6,000 LIFT TIMES: 8.30am to 4.00pm MOUNTAIN CAFES: 3

ANNUAL SNOWFALL: 16.38m SNOWMAKING: none

CAR From Seattle take the I-5 South, take exit 255 at Bellingham and continue on the State Hwy 542 for approximately 56 miles. Drive time is about 2 1/2 hours. FLY to Seattle International. Transfer time to resort is 2

hours. Local airport is Bellingham 56 miles away.

TRAIN to Bellingham (56 miles)

 ${\bf BUS}$ from Seattle take 3 hours and 1 1/4 hours from Bellingham airport.

If sex was a mountain, Mt Baker would be the orgasm, because this treasure is pure snowboarding heaven, with a snowboard history that is written in big letters. In the early days when other ski resorts had their heads up their arses and were banning snowboarders, this amazing place took a far different view. That foresight has crowned Baker as one of the best unspoilt snowboard resorts in the world, with a snow record to be envious of It also holds the world record for most snowfall for a resort in a season, set back in 98/99 with a staggering 29m. On average they get 16m which explains why theres never been any plans, nor will there be of adding snowmaking to their facilities. Mt Baker is also the home to the legendary Banked Slalom race, which is held every year. Located in the far north of Washington state, Mt Baker was home to the late legend Craig Kelly, who liked riding Baker's terrain so much, he moved there. Due to Baker's isolation it has the added advantage that it doesn't attract hoards of day-tripping skiers, leaving the slopes bare and the lift queues at a big fat 'zero'. The slopes span two mountains - Mount Shuskan rising to 2,963m (9,720ft), and Panorama Dome with its more modest summit of 1,524m (5,000ft). Both mountains offer the opportunity to ride steeps and deep powder, with the majority of advanced piste set out on the Panorama side. Runs like the Chute are set to test anyone, but be warned, parts of it are really steep and carry avalanche warnings. Overall, Baker is a mountain where you need be fully aware of your surroundings and not take any chances. One wrong turn could easily see you returning home to mum in a black body bag!.

FREERIDERS wanting to explore the amazing off-piste should seek the advice of a local rider; it's the only way to locate the best stuff, of which there are heaps. The amazing amount of unrestricted freeriding terrain is truly awesome and will keep you riding happily forever.

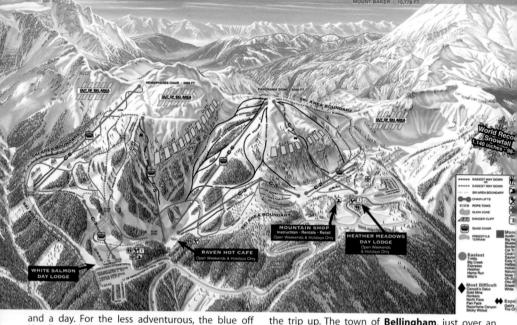

Number 8 chair in the Shuskan area is well worth a ride, offering piste-loving freeriders the opportunity to shine at speed.

FREESTYLERS will love the whole area, particularly the natural halfpipe that runs from the top of the two Shuskan chair lifts. This is where the Banked Slalom is held and, apart from beginners, is a must for all freestylers and freeriders. The run drops down a long winding gully and is totally magic. There are 2 small terrain parks off chair 8 and 3 that feature a few kickers and rails.

PISTES. Riders who only want to pose whilst laying fast tracks on perfectly prepared piste should stay away. Mt Baker is not a motherly resort it's a wild freeride place, although there are some runs to blast down. It's best to buckle in with soft boots and go freeriding which this place is meant for,

BEGINNERS won't be disappointed with Mt Baker, with the option of learning on plenty of easy runs that are spread out around the area, the best being located on Shuskan. The local snowboard school is well established and offers a number of teaching programmes for all levels, with an emphasis on general freeriding.

OFF THE SLOPES

Riders who like everything on their doorstep will not be happy as the only facility at the base is a car park. Baker is not a gimmick, so you do have to put yourself out which is another reason why it's so good. The slopes of Mt Baker are located 17 miles from the main local services which can be found in the low-key town of Glacier, a simple and unspoilt place. Local services may be a bit thin on the ground, but don't let that put you off. What is offered is cheap and damn good value, making a week or even two, well worth the trip up. The town of Bellingham, just over an hour away has an even greater selection of lodgings, sporting facilities and other visitor attractions.

ACCOMMODATION is only possible down in Glacier which has a number of options at very reasonable prices. Cool places to contact for a bed, are Glacier Creek Lodge, Mt Baker B&B, Diamond Ridge B&B or a condo at the Mt Baker Chalets & Condos.

FOOD. The options for getting a meal on the slopes or down in Glacier may be a bit limited in terms of choices of restaurants, but what is available will do nicely. During the day you can pig out on the slopes at the White Salmon Day Lodge which has very reasonable rates. The new Raven Hot cafe has fast become a major day time hangout whilst also serving up some wicked food. Down in Glacier, Milano's Cafe is the place to check out, where they do great pasta dishes.

NIGHT-LIFE. One of the beauty's of this place is it's laid back atmosphere, which applies equally to the night life in Glacier, the perfect snowboard scene-laid back and cool. There is no hype, no après-ski crap and no gits in silly hats playing party games. What you get is basic, offering a good laugh and messy late night drinking sessions, resulting in some killer hangovers.

ROUND-UP

BLUEWOOD

RIDE AREA: 430 acres **NUMBER RUNS:** 24 27% easy, 43% intermediate, 30% advanced

TOP LIFT: 1728m BOTTOM LIFT: 1385m VERT: 343m

TOTAL LIFTS:3 - 2 chairs, 1 drag LIFT PASS:1/2 Day, \$27 Day \$34

CONTACT: P.O. Box 88, Dayton, WA 99328 **PHONE:** 509/382-4725 **WEB:** www.bluewood.com

HOW TO GET THERE: located in the Umatilla National Forest, 21 miles

from Dayton

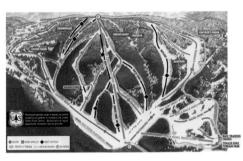

49 DEGREES NORTH

RIDE AREA: 2325 acres NUMBER RUNS: 42 30% easy, 40% intermediate, 30% advanced TOP LIFT: 1759m BOTTOM LIFT: 1195m VERT: 564m TOTAL LIFTS: 5 - 4 chairs. 1 drag

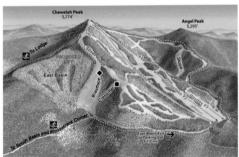

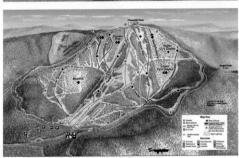

LIFT PASS:1/2 Day, \$27 Day \$29-35 RENTAL: Board & Boots \$28 per day

LESSONS: Private lessons \$45 per hour, then £20 ph Beginner package \$39 for 90min lesson, lift pass & rental

CONTACT: PO Box 166 , Chewelah, WA 99109 TEL: 866-376-4949 WEB: www.ski49n.com

HOW TO GET THERE: From Spokane take HWY 395 north to Chewelah (42 miles). Turn east (right at stoplight)on to Main Street to Flowery Trail Road

SUMMIT AT SNOQUALMIE

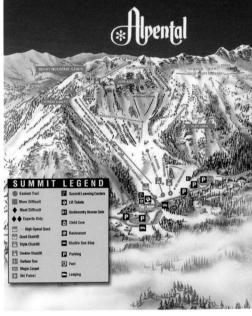

RIDE AREA: approx 300 acres + 500 backcountry NUMBER RUNS: 76

TOP LIFT: 1597m BOTTOM LIFT: 795m VERT: 695m TOTAL LIFTS: 28 - 19 chairs, 6 drags, 3 magic carpets FREESTYLE FACILITIES: 4 terrain parks & halfpipe

ANNUAL SNOWFALL: 11.27m

LIFT PASS: Full 9am - 10pm day pass \$45 Half day \$36, Night pass 4pm-10pm \$28

NIGHT BOARDING:Till 10pm

RENTAL:Board & Boots \$32 per day, \$26 night

LESSONS:Beginner 2hr lesson \$37, package including pass 8 equipment \$62. Private lessons \$58/\$99 for 1/2 hours

CONTACT: 1001 State Route 906, Snoqualmie Pass, WA 98068

Exit 53 for Summit Central, Tubing Hill and the Demo Center

TEL: (425) 434-7669 WEB: www.summit-at-snoqualmie.com

HOW TO GET THERE: 52 miles East of Seattle, Washington, via Interstate 90. Take Exit 52 for Summit West and Alpental DAOZ-IMPS POC

GRAND TARGHEE

A resort for powder hounds

Freeriders in search of powder and lots of it, will find that Grand Targhee is the perfect place to find it. This fantastic resort is a US powder heaven, with an average snowfall of over 1,280cm a year making riding powder a buy word here, even the piste map shows the powder terrain levels so novices can even try out powder stashes. What you have here in this low key resort are two mountains - Fred's Mountain which can be reached via three chair lifts and a drag lift, and Peaked Mountain accessible only by snowcats. Both mountains offer

POOR FAIR GOOD TOP **FREERIDE** Tree runs & CAT off-piste **FREESTYLE** 2 small parks but good natural **PISTES** Not well groomed

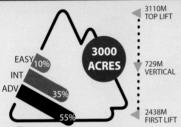

Grand Targhee Ski & Summer Resort Box Ski, Wyoming 83422

TEL: 001 (307)-353-2300 WEB: www.grandtarghee.com EMAIL: info@grandtarghee.com

WINTER PERIOD: Nov to April LIFT PASSES Day pass \$55, 3 Days \$159, 5 Days \$260 BOARD SCHOOLS 2hr group \$45, 1 hr private \$70

Mountain guide 3 hrs \$175 HIRE Board & Boots \$29 per day pro kit \$40

SNOWMOBILES Targhee Snowmobile Tours offer day trips through Yellowstone National Park, www.tetonvalleyadventures.com

CAT BOARDING Full day: \$299, Half Day: \$225 Reservations and deposit are required, call ext. 1355

NUMBER OF PISTES/TRAILS: 62 LONGEST RUN: 4km

TOTAL LIFTS: 5 - 4 chairs, 1 Magic Carpet

LIFT TIMES: 9.30am to 4.00pm

ANNUAL SNOWFALL: 12.8m **SNOWMAKING:** 5% of slopes

FLY to Salt Lake City International. Transfer time to resort = 5 3/4 hours. Local airport = Teton Peaks 13 miles away.

DRIVE Idaho Falls via Driggs.Grand Targhee is 87 miles. Drive time is about 1 3/4 hours. *Salt Lake City is 289 miles, which will take about 5 3/4 hours.

BUS from Idaho Falls take 1 1/2 hours and 5 3/4 hours from Salt Lake City airport (289 miles). Buses from Jackson or Teton contact www.jacksonholealltrans.com tel: (307) 734-9754. Price \$69 including lift pass

NEW FOR 06/07: some work on the area served by the Sacajawea lift opening up some tree runs.

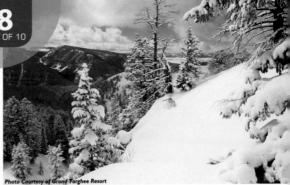

the chance to do some full-on freeriding on crowd free slopes that will suit advanced and intermediate riders in the main. The trails on Fred's Mountain are a collection of short blacks that snake through a smattering of trees with a couple of nice, wide open blue runs. If you're the adventurous sort, then Peaked Mountain should be the place to get your fix. This is where you get to ride perfect freeride territory with the help of snowcats - a local company offers snowcat tours for around \$299 a day. Tours are accompanied by guides and limited to 10 people per cat; prices include a lunch. Peaked Mountain is not exclusively for advanced riders; in fact most of what is on offer is graded green and blue, with a couple of black descents that take in some thick trees.

FREERIDERS will soon work out that this is a resort for them. The terrain on both mountains lends itself perfectly for both piste and backcountry riding. You'll find a number of steep black trails on Fred's Mountain, but most of them are quite short.

FREESTYLERS have a naturally formed halfpipe that provides air heads with some interesting walls to ride up. There is also a killer boardercross circuit that needs to be treated with full respect. The Trick Town park has a number of rails & jumps and theres also a beginners park, the North Pole. However, man-made obstacles aren't really necessary in Targhee; the place is riddled with natural hits, many of which are known only to the locals. However, the riders here are cool and will happily take you to the best launch pads and show you how much diverse, natural freestyle terrain there actually is. For those who want it man made there are two small parks, one for total beginners

PISTES. There's not too much smooth grooming here, the generally uneven slopes will take you out if you edge over without good speed control. This is another US resort that isn't about the piste, so if it's flat and smooth piste you want, you best look elsewhere.

BEGINNERS are the one group who may feel left out here. Although there is some novice areas around the base, there's not much of it. Still, if you're a fast learner then don't be put off.

OFF THE SLOPES what you get is both basic and very limited. There is only a handful of buildings at the base area offering a number of high quality lodges, hotels and a few local shops all close to the slopes. The village has a very relaxed and laid back appeal to it, but if you're the sort that wants a resort loaded with the usual tourist aizmo's, foraet it.

WSQ www.worldsnowboardguide.com 429

Challenging terrain offers top backcountry freeriding

Jackson Hole is a truly all American resort and comes with cowboys, saloon bars and high peaks. Not the typical tree-lined rolling mountains found in a lot of ÚS resorts, Jackson is a high peaked mountain resort that is located in a large valley some 10-40 miles wide and 50 miles long. At the base of the slopes is a small village called Teton, 10miles away from the main town of Jackson Hole, which has the much smaller resort of Snow King rising out of it. Jackson Hole is a resort that will appeal to snowboarders that like a challenge. Much of the terrain is rated black, offering some steep sections with trees and long chutes. Back country riding is also a major option as there are vast amounts of terrain to check out. To get the best of it, there are a number of specialist backcountry tour operators, offering daily tours with prices starting at around \$300. For the start of the 2006/7 season the aeriel tram that took you to the top of Rendezvous Mountain will no longer be there, but is set to be replaced for 2008/9.

FREERIDERS should love it on Jackson's slopes, with a host of marked out trails and acres of backcountry terrain to explore in areas such as the Green River Bowl or Cody Bowl. Backcountry guides are on hand to help you, and you can sign up for half day, full, or two day guiding sessions for around \$325. But note that you are strongly advised to always check with the areas Bridger-Teton Backcountry avalanche hazard and weather forecast before going anywhere. Some of the best riding

can be found on Rendezvous mountain which was once noted for having the biggest vertical descent in the US, some 1261 metres. Once you get off Rendezvous' old tram, you drop down into a cool playground, offering a great selection of chutes, jumps and big drop-ins, Jackson also features Corbett's Couloir, a famous vertical drop into a marked run that will leave you breathless.

FREESTYLERS will certainly appreciate Jackson. From the Thunder Chair you will be able to reach a natural pipe. The Paintbrush and Toilet Bowl also offer loads of hits, where you can ride for hours off and over loads of good natural stuff. If this isn't enough, then check out the man-made park at the

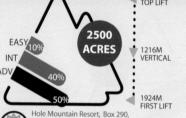

3395 West Village Drive, Teton Village, WY 83025 TEL: 1-307-733-2292

WEB:www.jacksonhole.com EMAIL: info@jacksonhole.com

WINTER PERIOD: early Dec to early April LIFT PASSES Half-day \$52, Day \$70, 6 Days \$390, Season \$1595

BOARD SCHOOLS Private lessons half/all day \$265/\$445 3 Day beginner package lesson, lift pass, hire \$210

Group lessons 3hr \$80 HIRE Burton Board & Boots \$26.5 per day

NUMBER OF PISTES/TRAILS: 111

LONGEST RUN: 7.2km

TOTAL LIFTS: 12 - 1 Aerial tram, 1 Gondola, 9 chairs, 1 Magic

LIFT CAPACITY (PEOPLE PER HOUR): 12.096 LIFT TIMES: 8.30am to 4.00pm **MOUNTAIN CAFES: 3**

ANNUAL SNOWFALL: 11.6m SNOWMAKING: 10% of slopes

CAR From Idaho Falls take US26 East to Swan Valley, then pick up the ID31 to Victor, then the ID33 (it becomes the WY22) over the Teton Pass to resort. 90 niles, 1 3/4hrs

Salt Lake City is 299 miles, which will take about 5 3/4 hours. FLY to Salt Lake City International. Transfer time to resort is 5 3/4 hours. Local airport is Jackson, 10 miles away.

BUS from Idaho Falls take 1 1/2 hours and 5 3/4 hours from Salt Lake City airport (299 miles). www.jacksonholealltrans.com run shuttles from Salt Lake tel: 800-652-9510

NEW FOR 06/07: new East Ridge Chair will take you to NEW the summit until the new Tram is built, which should be in 2008/09 season

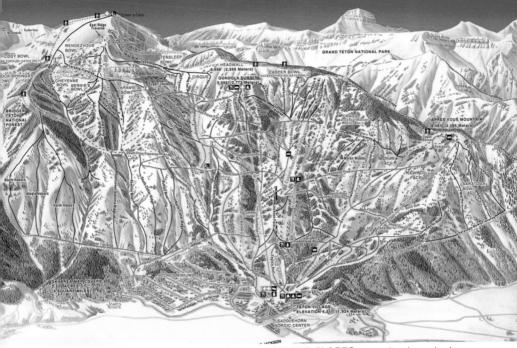

bottom of the of Apres Vous chair. There's also a beginners area the Eagle's Rest mini terrain park along with a 450ft pipe with a rope tow and sound system

PISTES. People who want to push it should check out **Gros Venture** as this is the place for experienced speed merchants. The run is over 3 km long and drops away, forming an excellent testing trail Intermediates (and those not so sure of themselves) should try out Casper Bowl or Moran Face on Apres Vous Mountain.

BEGINNERS will find Jackson's mostly steep and testing terrain a bit daunting, but don't fret; most novices should manage to get around after a few days, although they should probably avoid the Rendezvous area. First timers have the chance to progress quickly, especially on the runs found at the bottom of Apres Vous mountain, reached off the Teewinot chair. A high level of instruction is available including halfpipe training run camps for women.

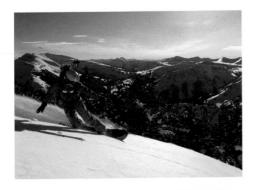

OFF THE SLOPES. Immediately at the base area of the slopes lies the resort of **Teton Village** which is more or less your typical horrid ski resort all in set up. That's not to say it's not welcoming, it is, and locals will make your stay a good one. However, the town of Jackson which is a 20 minute bus ride away operating on an-all day basis, offers a more sedate time with a heavy dose of pure outback Americana. Around town there is a lot of activities and not all costing the earth, which makes the place cool and worth it. There is a number of good snowboard shops to check out: such as the Hole in the Wall, or the Bomb Shelter.

ACCOMODATION. The area has a vast array of lodging. There is plenty near the slopes in Teton Village where you can kip close to the slopes at the Hostel for around \$5 a night. For a bigger selection and cheaper prices check out the offerings in Jackson, 10 miles from the slopes.

FOOD. If you don't leave here over weight, then see a shrink. The place has dozens of places to get food from, whether it is a supermarket, fast food joint or an up-market restaurant frequented by fur clad clueless city slickers. Prices to suite all are possible but on the whole, dining out is not a cheap experience here. However, Bubba's is comes highly recommended and serves some great chicken dishes. The Snake River and Otto Brothers brew pub are also noted for their good food.

NIGHT LIFE here is just how it should be, with something for all with a snowboard flavour. Options for some night action exist in either **Teton Village** or **Jackson** itself. Teton is a lot quieter than Jackson, with *Mangy Moose, the Stagecoach* or the *Rancher* all being popular hangouts. As for local talent, the place seems a bit of a guy place but there is some skirt to be had.

WSQ www.worldsnowboardguide.com 431

SOUTH AMERICA

Argentina 433
Bolivia 444
Chile 439
Mexico 444
Peru 444
Venezuela 444

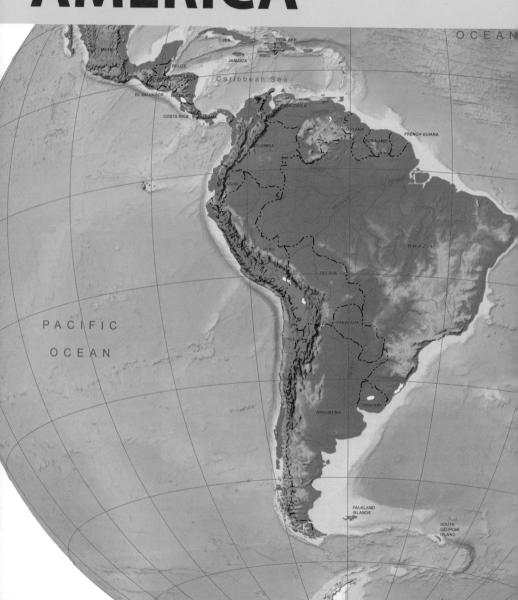

ARGENTINA

Argentina is a country that is split by the awesome Andes Mountain range which is home to a vast array of ski resorts, from large 'internationally acclaimed' chic areas to small and humble 'local hills'. Take your pick: they're relatively easy to get to and can be pretty cheap when you're there.

Argentinean resorts are mainly located in two regions along the Andes: the High Andes between Santiago (Chile) and Mendoza (Argentina), and the Lake District/Patagonia further south. The regions differ in many aspects; the High Andes region contains a bunch of resorts in the area around South America's highest peak, Aconcagua, close to areas such as Los Penitentes and Las Lenas. The resorts are high, much above the tree line, and receive good light snow due to their high altitude. They are also considered to be 'top notch' resorts and this is reflected in their prices of accommodation and other resort services.

Flights from London to either Buenos Aries cost from £600 return, and take about 14 hours. The airport is well out of town so a taxi back into the city centre costs around £20, but try bargaining as it works. Car hire is expensive; from AR\$120 a day plus mileage. Argentina has an exhaustive network of long distance buses which aren't your stereotype 'latin America' affair. Distances are long but the buses are comfy, and due to the heavy competition are often half empty. If you can spare the extra few dollars go for a "coche cama" which means 'bed coach' or reclining seat.

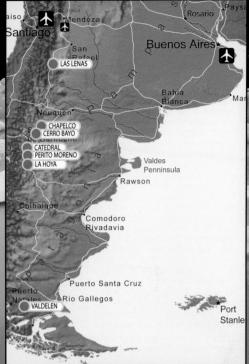

Traveller's cheques may be cashed at banks and large hotels but with dire rates of commission being taken in. It's better to bring plastic and use the common placed cash machines to withdraw money when you need to, you get a better rate and less commission charged. The peso is more stable these days, but many hotels still quote in US\$, and you can still often pay for things in US\$.

Night clubs in Argentina usually do not start until midnight. All common drugs (dope etc) are illegal with heavy penalties if caught. Paperwork, if you are rumbled, takes forever to sort out and you can bank on being inside for a long time before it's sorted. The people are among the friendliest and welcoming in the World and Spanish (castillano) is the main language. It's worth having a few phrases of Spanish up your sleeve, though many people in the tourism industry and local boarders can often speak some English.

CAPITAL CITY: Buenos Aries POPULATION: 39.9 million HIGHEST PEAK:

Cerro Aconcagua 6962 m LANGUAGE: Spanish

LEGAL DRINK AGE: 18 DRUG LAWS: Cannabis is illegal and

frowned upon **AGE OF CONSENT: 16**

ELECTRICITY: 220 Volts AC 2-pin **INTERNATIONAL DIALING CODE: +54**

CURRENCY: Peso (AR\$) = 3 peso 1EURO = 3.9 peso **DRIVING GUIDE**

All vehicles drive on the right hand side of the road

SPEED LIMITS:

40kph cities 60kph other built-up areas 80kph highways 120kph motorways

EMERGENCY

Ambulance - 107 Fire - 100 Police - 101

TOLLS

Toll booths on motorways. DOCUMENTATION

EXCHANGE RATE: UK£1 = 5.7 peso US\$1 Must have an international drivers licence & passport if hiring a car

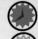

TIME ZONE

GMT/UTC -3 hours

ARGENTINA SNOWBOARD ASSOCIATION Doblas 14 - 1st floor **Buenos Aires** ARG-1425

Tel: +54 1 490 29209

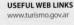

CHAPELCO

Basic resort but something for everyone

Just above the town of San Martin De Los Andes lies the resort of Chapelco which despite being a small resort still offers a big variety of terrain for all types and levels of rider. The arrival of a new resort director has led to the development of a number of snowboard friendly policies on the mountain, including the construction of a permanent halfpipe accessed from the Palito drag lift, and a programme of snowboard demos and freestyle classes. A low elevation means unreliable snow cover at the base area but up at the mid station things are usually fine. The resort has a good reputation among Argentine boarders, but due to its North facing aspect suffers unreliable snow conditions at times. The slopes are equipped with a modern lift system and a

number of mountain cafes. But note, food and drink on the mountain is expensive.

FREERIDERS will find, that when the lower section has snow cover, it offers a rolling terrain of fast cruising dotted with cat track hits. The moss shrouded Lenga trees are well spaced for excellent tree riding off the sides of the mid and lower pistes, but lack pitch in places. Steeps are found on the faces of Cerro Teta and the La Pala face (40 degree) which remain unpisted and are fed by a speedy quad and poma drag respectively. Although short these faces provide the buzz that the freerider is looking for with 3-10m cliff bands laying down the gauntlet between the Teta and the La Puma areas. The back bowl offers superb powder if you're willing to do the one hour hike back out.

FREESTYLERS have a permanent halfpipe accessed from the Palito drag lift which the locals session all day long. On a good day the Perímetro terrain park has 3 kicker lines of various grades and a rail line.

PISTES A lack of good piste grooming means the runs are bumpy and rutted, making this place not so ideal for beginners and speed freaks alike.

BEGINNERS have an mountain with 40% of the terrain graded to suite their needs, but its not all ideal or super easy.

OFF THE SLOPES. The town is small enough to be able to walk everywhere. Accommodation can be found in San Martin 18 miles from the base. The *Poste del Caminero Hostel* has bunks from \$10 a night and there is a helpful tourist office to get you sorted. Check out the 'Deli' by the lake for cheap snacks and the best priced beer in town. There are also a couple nighclubs and laid back bars.

everyone

POOR FAIR GOOD TOP

Some trees and good off-piste

FREERIDE
A park & a half-pipe
PISTES
Usually bumpy

Perfood and drink on

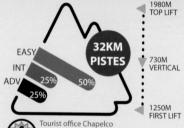

Cumbres de Chapelco, 233 Suipacha LOC 20. **TEL**: ++54 (0) 1 350 021

WEB: www.cerrochapelco.com EMAIL:info@cerrochapelco.com

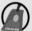

WINTER PERIOD: July to Sept LIFT PASSES 1 Day pass 113 pesos

5 Day pass 526 pesos, Season 2954 pesos BOARD SCHOOL Morning/Afternoon 2.5hr lessons 3 days 165 peso. Private lesson 77/439 for 1/6hrs

RENTAL Hire shop at the foot of the Hill Board & Boots 47-59 peso per day, 5 days 207 peso

NUMBER OF RUNS: 22 LONGEST RUN: 5.3km

TOTAL LIFTS: 10 - 1 Gondolas/cable, 5 chairs, 4 t-bars CAPACITY (PEOPLE/HOUR): 11,600

LIFT TIMES: 9.00am to 4.00pm MOUNTAIN CAFES: 8

ANNUAL SNOWFALL: Unknown SNOWMAKING: none

FLY to Buenos Aires and then inland to Bariloche and then take a bus or taxi to Chapelco

TRAIN to Bariloche with a two hour transfer time to the resort with onward travel by bus or taxi to Chapelco. **CAR** Via Bariloche, hea d north to San Martin de Los

Andes on highway 234 and then take the bumpy dirt road Hwy 19 to reach the resort.

LAS LENAS

Very good resort - when it snows

Las Lenas is the largest resort in Argentina and has become a major destination for pro-riders, be they a sponsored rider doing some race training, or an air head getting the latest action with a film crew for a new video we've all seen before. It's no wonder that those in the know, and those with the money, come here when you look at what the resort has to offer. It's steep, offers the rider big mountain terrain and it's high elevation should ensure good deep fluff, while the 14 lifts access 40 miles of piste and

FREERIDE
No trees but huge off-piste

A terrain park but little natural

FREESTYLE

PISTES

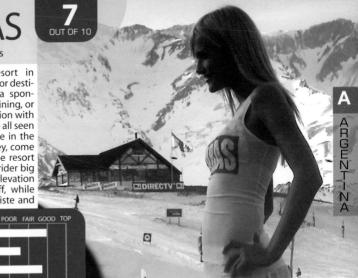

Good pistes 3340W TOP LIFT 568 1200M VERTICAL 2240M FIRST LIFT

Tourist office Las Lenas Valle de Las Lensas, Malargue-Mendoza 5613

TEL: ++54 (0) 1 627 71100 WEB: www.laslenas.com

WINTER PERIOD: July to Oct LIFT PASSES

Day pass AR\$138 (peak dates) 6 Day AR\$657

Season AR\$2247

BOARD SCHOOL Private lesson 224 pesos for 2 hours Group lesson 2.5hrs a day for 3 days 267 pesos

NIGHT BOARDING Almost 1 mile of piste open Wednesdays and Saturdays until 8pm

RENTAL Board & boots hire 54 pesos for day, 5 days 217

NUMBER OF RUNS: 22 LONGEST RUN: 7km TOTAL LIFTS: 13 - 7 chairs, 6 t-bars CAPACITY (PEOPLE/HOUR): 9,000

LIFT TIMES: 9.00am to 4.00pm **MOUNTAIN CAFES: 3**

ANNUAL SNOWFALL: 6-8m SNOWMAKING: 40%

FLY: to Buenos Aires and then inland to Mendozas, transfer to resort takes 5hrs. One flight a week to Malarque airport from Jorge Newbury Airport (Buenos Aires), transfer to resort takes 1 hr.

COACH: Overnight coach services available from Buenos Aires. Resort buses free and operate 24hrs

TRAIN: to Malargue, 40 miles from Las Lenas and will take 1 hour to reach Las Lenas.

CAR:450 km away from Mendozas, head south on highway 40, and Provincial 222 to Las Leñas, 20 km after the city of Los Molles

an abundance of challenging off piste terrain. Although this is easily the most challenging area in S.America, Las Lenas also has its bad points. Its high altitude renders it totally above tree line and the snowfall can be very sporadic, but when it dumps you get feet of it (annual snowfall can vary from less than 1m to over 10m). The lift system is also extremely slow, and when theres wind storms (which there often are) the lifts can be shutdown until they pass, which is fine, but usually you're still sat on them shivering away. The later the season the worse things tend to get.

Although more overseas visitors are trying Las Lenas, its still very much the resort for the seriously minted and famous Argentinians. Afraid to lose their designer shades, you can often find off-piste areas untracked for days, weeks if you're lucky enough to get on the snowcat. You'll also find the nightlife different, clubs don't get going until midnight and stay open to 5am and people are remarkably sober, but the ladies are truly to die for. The exchange rate means that whilst its extremely expensive for Argentinians, you'll be able to enjoy yourselves no matter what budget.

FREERIDERS willing to do the short hikes can get to 50 degree faces and big ball cliff drops making this place a freerider's dream. When its open, the Marte chair delivers you to terrain that is possibly the best that the Southern Hemisphere has to offer. Ask in the wine bar about a guide and examine the off-piste maps on the walls for all the runs you'll need. From the top of the Marte head down toward the Iris t-bar, once the patrol have made you sign your life away, you can drop into one of the many chutes that will end up at the top of the Vulcano lift. For AR\$25 peso you can take a ride in the snowcat, where you'll be almost guaranteed in getting fresh tracks for the next couple of hours. You'll find it next to the first aid hut on the Apolo run.

FREESTYLERS will find a park at the base which is the setting for the Reef big air comps. Its very snow dependant, but when theres snow theres a good variety of jumps and some rails.

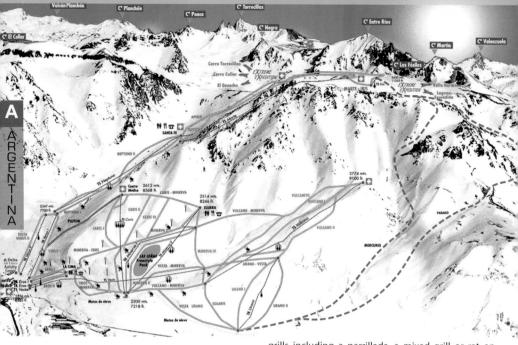

PISTES. Theres some well groomed fast trails and some great steep un-groomed runs. The Vulcano and Apolo runs have good long wide pistes.

BEGINNERS may struggle a little here with most of the slopes geared towards intermediates. Venus is one of the few beginner runs but due to its flatness, people coming from the Marte will try and fly down it, and you can find your self skating if you take a tumble. There are lessons available, and some of the instructors do speak english but often not fluent.

OFF THE SLOPES

The village is small but has a number of plush hotels and some cheaper apartments available. There is a supermarket selling most things, but if you want any thing fresh then bring it with you. Theres a cash machine, a couple of board shops, restaurants and the usual tourist trappings in the mall, but thats about it. The nearest town is Malargue about an hours drive away.

ACCOMODATION in Las Lenas is pricey (4 star hotels), though it is often easy to get a bed in the 'workers' dormitory for US\$10 per night. There are a number of apartments available if you can't quite stretch to the Piscis or Otherwise the nearest 'affordable' beds are in **Malargue**, a small town down the valley, where you'll find hotel rooms from US\$20 a night.

FOOD wise the 5* Piscies do a good AR\$50 peso 3 course meal at one of their 2 restaurants and the food at the Aries can be very good. Apart from hotels, *El Refugio* do a reasonable fondue and *Huaco* some good steaks. If its burgers then the Innsbruck is ok, and the UFO Point do great pizzas. A good way to end the day is a meal at *La Cima*, situated at the top of the Eros lift. They serve authentic Argentinian

grills including a parrillada, a mixed grill or rat on stick depending on your viewpoint. The place really kicks off once the eatings finished and the band start playing. If you're eating on a budget then you'll find a restaurant in the workers accomodation, open to all its AR\$15 peso for a 3 course meal including wine. The local supermarket stocks everything you'll need if you're self catering, however fresh vegtables are rare so make sure you stock up before arriving.

NIGHTLIFE starts late and finishes early, so its just as well the lifts don't close till 5pm. Do what the locals do and grab a beer or a chocolate, sit outside or in the *Innsbruck* or *UFO point* until about 6pm then take a break. Around 9pm the restaurants will start to open up, grab some food then head to one of the late bars. *The BU bar* above the *Corona Club* is a good place to hang, and they often have bands playing. UFO Point and Corona Club take alternate nights, things don't start getting lively until its past midnight and theres usually a cover charge to get in. They certainly know how to party, but you wont find many people drinking so at least you'll always get served quickly. For a change in atmosphere the tiny wine bar's a good place to chat to locals whilst you sup a good Malbec.

PUCON

5 OUT OF 10

Snowboarding on a live volcano

PISTES

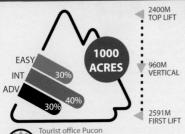

Pucon. Villarica TEL: ++56 (0) 1 350 021

WEB:www.puconchile.com EMAIL:snowboard@puconchile.com

WINTER PERIOD: June to Sept LIFT PASSES 1 Day pass - 13,500, Season pass - 150,000 BOARD SCHOOLS Private lessons US\$25 for 55mins Group lessons US\$15 for 90mins

NUMBER OF RUNS: 32

TOTAL LIFTS: 9 - 4 chairs,6 drags LIFT CAPACITY (PEOPLE PER HOUR): 5380

LIFT TIMES: 9.00am to 4.00pm

ANNUAL SNOWFALL: Unknown SNOWMAKING: none

BUS services from Santiago are possible with a change over, and will take around 12 hours.

FLY to Santiago, 492 miles from Pucon.

DRIVE Via Santiago, head south on highways 5 and 119 via Temuco and Villarrica and then on up to Pucon.

Pucon is a friendly and laid back place situated on the slopes of the **Villarica Volcano** in the Lake District region. It provides the rider with a perfect natural funpark for freestylers and cool freeriding destination. It should keep

all snowboarders no matter what your ability, busy and content for a good seven days or more, although the volcano is still live and smoking. The resort is made up of four old creaking chairlifts and three drags, all but one of which are above tree line. Plans are afoot to install a further lift above the long left hand chair to access the steeper higher terrain. The feeling of riding the mountain is unique. The previous volcanic eruptions and lava flows have left behind a terrain of rollers and deep gullies. While the lift-accessed area is not particularly large and the lift positioning unimaginative, it contains some excellent freeriding/freestyle terrain with never ending hits, cornices and huge natural halfpipes that easily compensate for the lack of steeps. In short it's a playground. Snow quality varies due to the lower elevation and local climate factors. Storms roll in from the Pacific and drop their load, or the mountain may become fogged in. Winds quite often affect the operation of the old lifts.

FREERIDERS should check out the gullies on the left, and the cliff banks on the far right of the area. Steeper freeriding can be found by hiking from the tops of lifts, and guides (essential) can be hired in town to hike to the crater if you long to stare into the fiery bowels of the Earth before riding back to the base for a coco.

FREESTYLERS are presented with an okay terrain park when conditions permit. You should find 2 kickers, a hip and some rails. However, whether there is a park or not, the area has so much natural terrain for getting air, that it's not really needed. There are some major cliff jumps and big banks here.

PISTE bashing it's not the thing here.

BEGINNERS will manage here but in truth there are better places.

OFF THE SLOPES. Access to the resort is by hitching at the foot of the access road or by minibus taxi (\$6 per person return) from agencies in town. Adventure tourism is big in Pucon. Rafting (\$20-35) is a buzz; take the upper trip as the lower one is for wusses. The nearest accommodation is found in Pucon 1 mile away where you can get a cheap bed from as low as \$8 a night. Good night time hangouts include *Mamas and Tapas* where local girls strut their stuff, and *Piscola*.

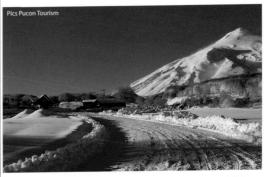

TERMAS DE CHILLAN

Very good resort

Termas De Chillan is a small resort positioned on the south facing slopes of a dormant volcano and boasts the longest season of any of the S. American resorts, Despite a good snow record the resort has done little to make the most of it and offers only three ageing chairlifts and three drags. Most of the terrain is above treeline with the lower chair retrieving adventurous boarders from the trees and depositing them back at the base. The upper chair, Don Otto, not only accesses the best freeriding terrain on the mountain, but also holds the record for being the longest chairlift in S. America (2.5 Km). It is also one of the oldest and slowest and its

frequent closure whenever the wind blows, means it's long overdue for replacement. The alternative when this chair is down is to ride a succession of three drags, (the middle poma holding the record for 'most blokes rendered infertile') to access some neat gullies with big banks. Plans have been made to extend the top drag further into the higher terrain which otherwise is rewarding but the hike-to country.

FREERIDERS will find what is regarded by locals as the best on offer, is accessed via a 10 minute hike from the top of the temperamental Don Otto chair. Hiking right from the top of this the rider is rewarded with 890 vertical meters of open bowls that exit into a series of 35-45 degree chutes back into the base. With pisting operations seemingly unheard of here the area is a freeriders dream. Beware though, avalanche control is also almost unknown of and you'd be lucky to ever see the ski patrol.

FREESTYLERS have an occasionally constructed snowboard park reached off the middle poma.

PISTES. Riders who require pisted corduroy tracks may want to stay away

BEGINNERS, if it were not for the way the lifts are laid out, then this would be an ideal novices haunt, but it's not.

OFF THE SLOPES. Without your own transport access to the base is dependant on either hitching (relatively easy) or if you're staying in Chillan, taking the early bus.

With the nearest 'town' being 50 miles away the resort has developed a complex of hotel and condo's below the base, mainly catering for affluent Chilean and visiting westerner. This accommodation is far out of reach of the average boarders pocket making finding somewhere to sleep nearby a problem. Four bed apartments (\$25 per-person) can be rented at Las Tranoas 10 km from the base.

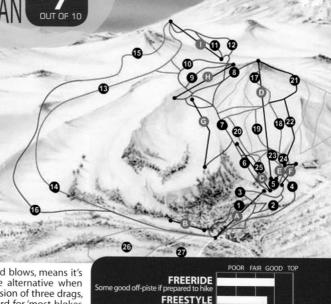

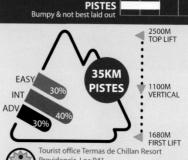

Providencia, Loc P41 TEL: ++56 (0) 2 252 5776

WEB:www.termaschillan.cl WINTER PERIOD: June to Oct

LIFT PASSES 1 Day pass - \$19, Season pass \$415

LONGEST RUN: 13km TOTAL LIFTS: 9 - 4 chairs, 5 drags CAPACITY (PEOPLE/HOUR): 6,500 LIFT TIMES: 9.00am to 4.00pm

ANNUAL SNOWFALL: Unknown SNOWMAKING: none

TRAIN to Chillan which is only 30 miles away from the resort

FLY to Santiago which is over 350 miles away. DRIVE From Santiago, head south on highway 5 to Chillan and then turn off to Termas via Pinto.

ROUND-UP

ANTILLANCA

Antillanca is vet another volcano based resort. However, unlike similar hangouts there is at least some good backcountry tours you can take and without too much hiking or traversing, though vou'd better be tooled up incase you get lost on one of the many other volcanos in the area. The pisted areas provide some basic freeriding above and amid trees. Nothing is laid on for freestylers but there are rocks to get air from. Good facilities are available at Antillança's base area

Easy 20%,Intermediate 30% Advanced 30%. Expert 20% Top Lift: 1534m Bottom Lift: 1070m Total Lifts:5 - 1 chairs, 4 drags How to get there: Fly to Santiago, then bus which will take over 10 hours

ANTUCO

Number of Runs: 13

Antuco is one of Chile's resorts that can easily be over looked, simply because there is not much to look at. Located on a volcano (like so many other resorts in this part of the world). Antuco is a place best left to locals in the area. It's certainly not worth going out of you're way to visit. The two runs wouldn't hold the attention of a nat beyond 30 seconds. Beginners can have fun, but freestylers forget it as should piste loving carvers.

Best lodging are local and local services can be found at Los Angeles (not the US city), 40 minutes away

Number of Runs: 2 Easy 20%,Intermediate 50% Advanced 30% Top Lift: 1850m Vertical Drop: 450m

How to get there: Fly to Santiago, then bus via Los Angeles 40 mins away

EL COLORADO

30 miles, or 40 minutes from the capital is El Colorado, Chile's biggest resort. Being so close to Santiago has its draw backs as the slopes can often get very busy with Chile's high earning city dwell-

ers who have been coming to the resort for skiing, since the

thirties.u The 25 marked out trails cater for everyone's needs especially advanced riders although the off-piste is a bit naff. However, this is a good resort for piste carvers and novices. Expensive lodging, restaurants and bars are all slopeside

Number of Runs: 25 Easy 40%,Intermediate 20% Advanced 30%, Expert 10%

Top Lift: 3333m Bottom Lift: 2430m Vertical Drop: 903m

Total Lifts: 18 - 4 chairs, 14 drags Lift pass:Day Pass - \$29

How to get there:

FLY: Fly to Santiago, then bus, which will take 40 minutes.

BUS: Bus service from Santiago, US\$13 round trin DRIVING: 39km east of Santiago

LA PARVA

La Parva is another resort in the throws of Santiago, and another popular modern affair loaded with all the razzmatazz and trappings found at many big foreign resorts. However, this is not big resort, but rather a good two days and its an all done sort of place . Still what is available is extensive, well set out and caters well for piste lovers and fast riding freeriders with some nice blacks and expert trails to try out. Lots of good local facilities are provided at the base area of the slopes, but nothing comes cheaply.

Number of Runs: 20 Easy 15% ,Intermediate 55% Advanced 30% Top Lift: 3630m Vertical Drop: 960m Total Lifts:14 How to get there: Fly to Santiago, then bus, which will take 50 minutes

Visitors could be excused for getting a bit confused when they arrive here. Nothing to do with the slopes, but more to the fact that there are to Lliamas here with both using the same name and both similar in character, with much the same terrain, number of runs and lifts that serve them. Another common feature about this place is that for any fast riding

thrill seekers, pick somewhere else, as this place is very flat and basically boring. Best lodging and local facilities are in Temco, 5 minutes away.

Number of Runs: 7 Easy 20%.Intermediate 60% Advanced 20% Top Lift: 1800m Total Lifts:5 How to get there: Fly to Santiago and then to Ladeco 55 minutes away

PORTILLO

in 2004 new \$1.4 million guad chairlift to access

the Plateau side of the resort quickly

Portillo is a world renowned American run resort located at the foot of Aconcagua. Its high elevation provides it with plenty of dry snow making for good powder. 12 lifts access some 22 pistes and an abundance of steep off piste faces. Heli operations will take those with flexible enough plastic to higher elevations and descents. Heli operations will take those with flexible enough plastic to higher elevations and descents. The resort is distinctly up-market offering expensive accommodation and eating in its ugly complex of posh hotels, condos and slightly cheaper 'dormitories'

Easy 10%,Intermediate 70% Advanced 20% Top Lift: 3348m Total Lifts:12 - 7 chairs, 5 drags How to get there: Fly to Santiago and then bus 2 hours away. DRIVING: Access Portillo by hitching from Los Andes, via the access road, 100 miles

Ride area: 800 acres

Number of Runs: 22

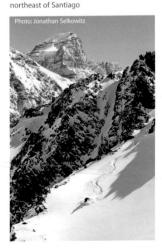

ROUND-UP

BOLIVIA

CHACALTAYA is the highest resort in the World at 5420 metres, with the fastest and

hardest drag lift. It's 30km from La Praz. The one run has a vertical drop of 200 metres and is serviced by 1 rope tow. The season is from November until March.

MEXICO There are plans to create a resort on a huge volcano in the Iztaccíhuatl-Popocatépetl National Park. The 5000m high volcano, if developed, would become one of the highest resorts in the world - not far behind Chacaltaya Bolivia. If all goes well there will be an \$11 million investment from businesses in Japan. Let's hope it gets off the ground then we can have Tequila on the slopes, as long as the volcano doesn't erupt.

PERU

PASTO-RURI/HUASCARAN the second highest resort in the World at 4800 metres. The Cordillera Blanca area is the only area where it is possible to board. From the nearby town of Huaraz there are several places where you can hire gear, and some organised trips are possible, or you can grab a local guide. Pastoruri Glacier is the most recognised area

Believe it or not but the Mayor of Puerto Rico has unveiled plans to build a six storey fake Snow Dome. Whatever next? A Jamaican Bobsled team? When asked about the need for a snow dome, Mayor Mendez is reported as saying "The dreams are the seed of our realities". I think he's been smoking a little too much of another seed you may more commonly associate with Puerto Rico.

VENEZUE

at 1600-4765 metres s truly a high altitude resort with 4 lifts. Well in fact the lifts are one long line of 4 cable cars which take over an hour to reach only 2 runs at 1km each so it won't keep you busy for long. That's the theory anyway, the reality is that the rely open, and even rarer theres any snow to board on. Merida is 680 km south west of Caracas and a good one to tell your mates you've visited, but not one

to head to for an action packed season

AUSTRALASIA

Australia New Zealand 446 452

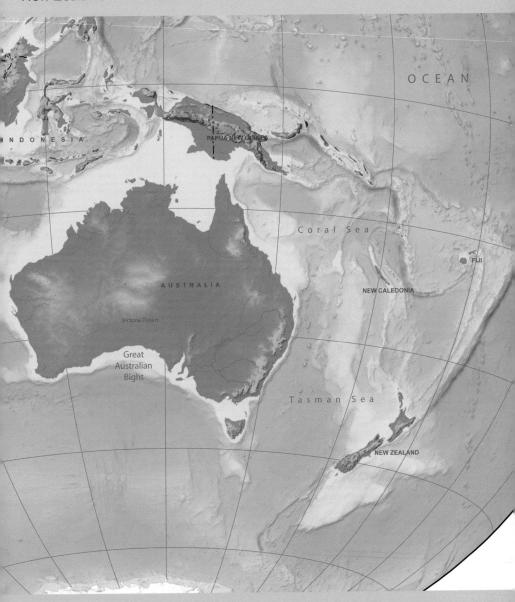

AUSTRALIA

Australia has some nine resorts located on the eastern mountain ranges on the state borders of New South Wales and Victoria. There are also places to ride on the separate southern island of Tasmania. All the main resorts are easy to reach from the two major ports of entry, Melbourne and Sydney. Overall Australian snowboarding opportunities are no where near as good as what is available in Europe, North America or at nearby New Zealand. Still to make up for dull mountains with below average slopes, the aussies have a reputation for being party animals.

Road travel in Australia is good but with the draw back of having to pay high toll charges at the entry gates to some mountain ski areas. Once through the entrance gate, snow chains must be carried at all times. It is illegal not to have them and could result in a A\$200 fine. There are internal flights from Melbourne and Sydney to airports closer to the resorts, but prices are pretty steep. If a train ride through the countryside is what you seek enroute to a resort, then central station in Sydney or Spencer Street in Melbourne is where to head for. Melbourne doesn't have any direct train line going to any of the apline regions, however theres a train service direct from Sydney to Jindabyne, the major station for NSW resorts. Bus companies run daily trips from the major dries to the bigger resorts. Costs vary, but for around your A\$55 you can kick back and watch a video while some one else does the driving.

Accomodation will vary depending on your budget. Five star chalet lodges, club lodges and hostels can be found above the snowline but it may be cheaper if a bed is sought in a nearby town.

If you want to spend a season in Australia, it would be best to get here in late April, as this is when resorts start advertising job vacancies. The normal Australian winter season is between June and mid September.

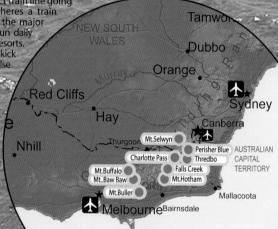

CAPITAL CITY: Canberra POPULATION: 20.2 million HIGHEST PEAK:

Mount Kosciuszko 2,229 m LANGUAGE: English

LEGAL DRINK AGE: 18 DRUG LAWS: Cannabis is illegal AGE OF CONSENT: 16

ELECTRICITY: 240 Volts AC 3-pin

INTERNATIONAL DIALING CODE:

All vehicles drive on the left hand side of the road

SPEED LIMITS:

110km/h Motorways 100km/h normal 60km/h built up areas

EMERGENCY

For police, fire and ambulances dial 000 **TOLLS**

A few, on some motorways . more info www. hillsmotorway.com.au

DOCUMENTATION

Driving licences and permits must be carried at all times

SEATBELTS

It is illegal to travel without a seat belt on

TIME ZONE

Victoria & New South Wales UTC/GMT +10 hours

SKI & SNOWBOARD AUSTRALIA (SSA) Level 1, 1 Cobden Street

Tel: (03) 9696 2344 Fax: (03) 9696 2399 Email: info@skiandsnowboard.org.au Web:www.skiingaustralia.org.au

USEFUL WEB LINKS

5th Melbourne, 3205

www.australia.com www.visitvictoria.com www.visitnsw.com.au

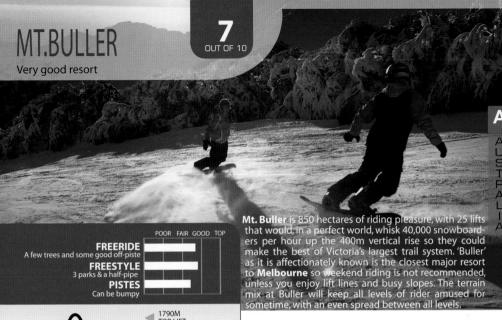

EASY 80KM 70P LIFT 400M TOP LIFT 400M VERTICAL ADV 30% 45% 1390M FIRST LIFT 1390M FIRST LIFT

Mt Buller, Victoria, Australia 3: TEL:+61 3 5777 6077 WFR: www.mthuller.com.au

WEB: www.mtbuller.com.au EMAIL:info@mtbuller.com.au

WINTER PERIOD: June to October LIFT PASSES

Day pass \$88 or \$140 inc board hire 3 Days \$242 , 5 Day \$388 , Season pass \$1230

BOARD SCHOOLS

3hr lesson & day pass \$124.5 days lift pass + 3x2hr lessons \$499 55min private lesson \$103, full day \$539

NIGHT BOARDING

Bourke Street on Wednesdays and Saturdays 7pm until 10pm. \$16

TOTAL PISTES/TRAILES: 19 LONGEST RUN: 2.5km TOTAL LIFTS: 14-chairs, 8 drags, 3 Magic carpets LIFT CAPACTITY: 40,000 people per hour LIFT TIMES: 8.30am to 5.00pm

ANNUAL SNOWFALL: 1.5m SNOWMAKING: 15% of pistes

Mirimbah visit www.buslines.com.au/mmbl

FLY: Fly to Melbourne international airport which is 248 miles away and will take 5 hours by bus to reach BUS: V/Line run twice daily services from Spencer

Street Station in Melbourne 8:30am/6pm to Mt Buller.

www.vline.com.au tel: 136 196. MMBL run transfers from Mansfield/

CAR: Via Melbourne, take the Maroondah highway route 153 north to Mansfield and then follow signs for Mt Buller.

NEW FOR 2006: \$4 million spent on improvements including \$1 million on snowmaking system. Expansion and new layout of park, purchase of Park Bully groomer. FREERIDERS who like their terrain with a side serve of steeps, should head for the summit and try to tame Fannys Finnish or Fast One which are Bullers most notorious black diamond runs. If you have conquered Fannys then it must be time to head backcountry with the best reached by hiking out past the fire hut on the summit to a place known as Buller Bowls. The bowl is serious terrain that will avalanche if given the chance, so it is best to check conditions with the ski patrol. If tree runs take your fancy then slip off the side of Standard and make tracks between the snowguns. If you are early it is possible to get fresh tracks in the powder stashes in this area.

FREESTYLERS have an abundance of natural hits which makes the trails resemble a spread out fun-park. There's a boardercross and halfpipe located at skyline. Bluff View has a beginners park, intermediates head to Baldy park and pro's feast at the Summit Terrain Park

PSISTES .The runs can often be a bit rutted, but with some good early morning grooming, speed freaks can cut some nice fast tracks down a number of well spaced trails to suit all levels.

BEGINNERS will manage perfectly well at Buller, with a good selection of easy slopes that are crowd free on weekdays but crowd drenched on weekends. Rookies should go and get a lesson from one of the professional instructors at the ski school, which also offers a 'Discover Boarding' lift ticket.

THE TOWN

Off the slopes Mt Buller is a equipped resort with great options for doorstep riding. Buller has the most on-mountain accommodation in Victoria, so guests can stay above the snowline and take full advantage of the fact that Buller has the largest number of alpine restaurants and night-spots in the state with partying up here going on until day light hours. But note this is an expensive resort that attracts Aussie's finest.

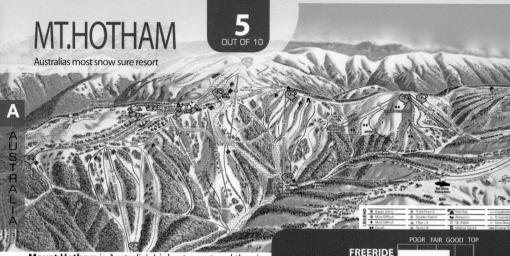

Mount Hotham is Australia's highest resort and thus is the most snow sure area. The slopes area is a mixture of easy to negotiate beginners runs to tricky fast steeps that often cross between the more gentle slopes, so novice beware, one minute you could be riding down a simple blue and the next minute hurtling down a steep black trail (study your piste map). Generally this is a resort that will suit intermediate freeriders with a number of very good trails that take you off the piste and in and out of open bowls and wide snow fields.

FREERIDERS. Some of the best freeride trails can be found off the **Heavenly Valley** chair lift which will give you access to some short but steep blacks that although may not take too long to do, they will however, test you to the limits. Over the last few years the resort has expanded its terrain cover which now includes some double diamond runs that are seriously steep and not for wimps. They are reached by the Gotcha chair lift which also takes you over to some nice blue out back trails.

FREESTYLERS who like fly high off natural hits will find loads of cool drop offs and lots of natural lips to gain air from. There is also a cool halfpipe and okay terrain park to check out.

PISTES. Boarders will love this place as it will suite your style of riding with twisting fast trails that take you over the whole area.

BEGINNERS only have a couple of green trails which are located right up at the top of the Summit chair, however quick learners will soon be able to tackle the array of blue trails with some of the most interesting to be found off the Village quad chair lift.

THE TOWN

Generally this is an expensive resort but it offers lots of things to do, all of which are well appointed for both on the slopes and the slope side village. Off the slopes visitors will find an abundance of resort facilities with a large selection of well placed hotels, lodges and other accommodation outlets that collectively can sleep over 4000 holiday makers. The village has a good selection of places to get a meal in and a number of good late night drinking outlets.

FREESTYLE
A park & a half-pipe
PISTES
Some good trails

1825M
TOP LIFT

ADV

ACRES

400M
VERTICAL

Trees and some good steeps

PO Box 140, Bright, VIC 3741, Australia **TEL:** (03) 5759 4444

1425M

FIRST LIFT

WEB: www.ohau.co.nz EMAIL:groups@hotham.albury.net.au

WINTER PERIOD: June to Oct LIFT PASSES Half-day \$70, 1 Day \$87AU 5 Day \$392AU. Season \$1142AU

BOARD SCHOOLS

Lesson & lift pass \$96.5 Days lessons & passes \$434

NIGHT BOARDING

Wed & Sat 6.30pm to 9.30pm at the Big D Quad Chair . \$11 for pass

LONGEST RUN: 2.5km

TOTAL LIFTS: 13 - 10 chairs, 3 drags LIFT TIMES: 9am to 4.30pm

LIFT CAPACITY: 24,485 people per hour

MOUNTAIN CAFES: 2

ANNUAL SNOWFALL: 1.5m SNOWMAKING: 5% of area

FLY: Hotham airport 20 miles away from resort fly from Sydney or Melbourne.

CAR: From Sydney take Hume Highway to Albury-Wodonga and follow the snow signs to Yackandandah then turn off to Myrtleford. At Myrtleford turn on to the Great Alpine Road to Bright, then Harrietville and Mount Hotham.

BUS: Coach services from Sydney, Melbourne and overnight from

TRAIN: From Sydney the XPT connects with Trekset Coaches at Wangaratta and Hoys

Po Box 42, Pershier Valley. NSW TEL:+61 (02) 64 59 44 21 WEB: www.perisherblue.com.au

WINTER PERIOD: June to October LIFT PASSES Half-day \$AU73, Day pass \$91 3 Days \$259, 5 Days \$393, Season \$1066

1605M

FIRST LIFT

BOARD SCHOOLS

2hr lesson + day lift pass \$122, beginners \$98 5 days of 2hrs lessons + pass \$497 Just 2hr lesson \$45. Private lesson \$98 for 1hr

RENTALBoard & Boots \$36.50 for day **NIGHT BOARDING**

Tuesdays and Saturdays 6:30 to 9:30 on the front valley. Halfpipe is floodlit on saturdays. Pass price \$21

TOTAL PISTES/TRAILES: 95 LONGEST RUN: 2.5km

TOTAL LIFTS: 50 - 12 chairs, 34 drags, 4 ski carpets LIFT CAPACTITY: 52,903 people per hour

ANNUAL SNOWFALL: 2.5m SNOWMAKING: 5% of area

FLY: Snowy Mountain Airport (Cooma) 1hr from sydney, and 1hr from resort. Fly to Sydney airport with a 6 hour

CAR: From Sydney, head south to Jindabyne and then take the Kosciuszko road to reach Perisher Blue (about 6hrs).

Jindabyne to Perisher is 20miles (33km).

BUS: SnoBus Snowscene Express from Brisbane/Gold Coast Tel. 07 3392 1722. Valley Bus and Coach Services operate from Sydney and Canberra Tel. 02 6297 6300.

TRAIN: to Jindabyne station, 45 minutes away.

NEW FOR 2006: Extended snowmaking, new \$400,000 groomer, improved lift access. Increased use of snow fences to collect snow. Tube Town will have its own snowmaking and lighting system

Perisher Blue is in the Kosciusko National park in the Snowy Mountains. Mt Kosciusko, the highest point in the country is called Australia's 'Super Resort' as it has come about through the amalgamation of a number of resorts including, Perisher, Blue Cow, Guthega and Smiggins. There are 1250 hectares of rideable terrain with an elevation to 2054m. However the vertical descent is only about 350m. Nevertheless they have installed 50 lifts and the Australians make the most of the terrain available. Another plus is the huge amount of encouragement for snowboarders. There is a fun-park, a separate Board Riders school a woman's snowboard programme, a Board rider's guide and the Addiction Snowboard store where they will tune and groom your stuff. In September 2005 during the resorts 10th anniversary, it hosted Australia's first Burton Snowboarding Open. The mountain itself has a good range of difficulties but unfortunately the black runs are few and far between. Also if you stick too much to pisted areas you will find little to challenge riders above intermediate standard. Most of the black runs are accessible by T-bar only and it really is a drag.

FREERIDERS should check out the Guthega and Blue Cow areas. There are winding creek beds and some nice little rock drop offs. For powder try out the Burnum, Eyre and Leichhardt runs, thought don't bother in September as it's all gone.

FREESTYLERS have 3 parks for different abilities and a dedicated rail park. They've made big improvements over the last few years, and theres even a snowskate park. The superpipe often play host to events, running alongside is a beginners pipe. The parks run the full gammet of toys from a boardercross style series of quarter pipes to plastic picnic tables, barrels and rails.

BEGINNERS will find plenty of open easy slopes. However, although there are 50 lifts most of these are T-bars and J-bars which are slow and not very snowboarder friendly.

THE TOWN

Hotels in the resort cost at least \$130-A a night. However you can stay just outside the resort for around \$65 for bed, brekie and a huge supper. Don't worry about getting around because there is a free bus service between Perisher and Smiggins every ten minutes. There are no hostels or lodges for riders on a tight budget but if you ask around you could secure some floor space with a local rider. Night life here comes as standard grade Australian, very boozy and very basic with Ozzy girls flashing their tits.

One of the best overall resorts in Oz

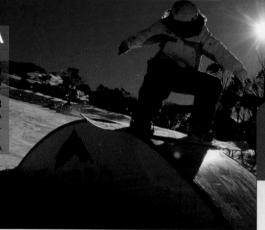

Thredbo is a large resort that has the highest lift access slopes and longest trail in Australia. Extensive use of snowmaking and good piste grooming make this a cool place for a weeks stay. The terrain here is equally matched for all levels and styles of riding with much of the mountain suited to intermediates. Although there are a number of steep advanced runs to keep hardcore freeriders happy for a good few days.

FREESTYLERS will also be pleased to find that there are a number of places to gain air from some big natural hits. There is also a good halfpipe and terrain park which has a series of man made jumps.

PISTES. Boarders have some really nice runs to excel on including a rather long trail that measures almost 6km (the longest trail in Australia).

BEGINNERS. The beginner slopes here are ideal for first timers with easy runs on the upper sections as well as on the lower areas making the whole mountain accessible.

OFF THE SLOPES. The nearest accommodation and local facilities are located at the base of the slopes with a selection of hotels restaurants, sporting attractions and shopping. Nightlife is very lively but basic.

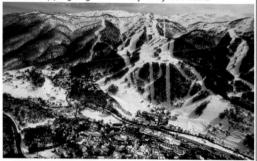

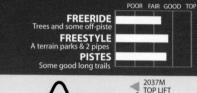

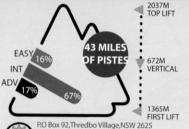

WEB: www.thredbo.com.au EMAIL:reservations@thredbo.com.au WINTER PERIOD: June to Oct

TEL: (02) 6459 4100

LIFT PASSES Day Pass AU\$91,5 Day Pass \$388, Season \$1033 **BOARD SCHOOLS**

1day, 2hr group lesson \$115.6 days \$564.1hr Private lesson \$109 RENTAL

Board and boots \$74 per day

NIGHT BOARDING

Thursday night and Crackenback Supertrail on saturday. 6:30 - 9:30pm through July and August, Completely free!

LONGEST RUN: 5.9km TOTAL LIFTS: 14 - 7 chairs, 5 drags, 2 magic carpets

ANNUAL SNOWFALL: 2m

FLY: Cooma nearest airport. Flights from Sydney take 1 hour, www.rex.com.au. Canberra 2 1/2hrs from resort.

Sydney/Melbourne 6 hrs. CAR: Sydney CBD to Thredbo - Once on the M5 there

are only 3 sets of traffic lights to Thredbo. The Kosciusko Alpine Way between Thredbo and Jindabyne is fully sealed and is clear of snow at most times during winter so it is easily accessed by two wheel drive vehicles, chains may be required. Melbourne to Thredbo - the Kosciuszko Alpine Way is now fully sealed.

BUS: Most major cities are linked by daily service to Thredbo. Greyhound operated a Sydney service, Suimmit Coaches from Canberra. Clipper coaches operate a regular service from and to Sydney (Prices start from \$134 per adult return).

NEW FOR 2006 SEASON: 1st year of 3 which will see \$6mil spent on snowmaking equipment. Free night boarding, and a new park bully groomer.

ROUND-UP

CHARLOTTE PASS

Charlotte Pass is located some 310 miles (500 km) south of Sydney. The resort is the highest in New South Wales and provides a rather small amount of rideable terrain with only five access lifts. Overall the area will suit slow learning beginners and carvers without a brain. Still the slopes are crowd free and will do for an afternoons fun. But forget about staying for more than a day or two (dull is the word).

Accommodation is conveniently located near the slopes at the Kosciusko Chalet, which offers mid priced beds, eating and a bar.

Ride Area: 50 hectares Number of Runs: 19 Top Lift: 1954m Bottom Lift: 1760m Vertical Drop: 189m Total Lifts: 5 - 1 Chair, 3 Drags, 1 portable tow Lift Capacity (People per Hour): 2600 www.charlottepass.com.au

FALLS CREEK

Falls Creek is a well developed modern resort that will make a weeks stay well worth it, but any longer a bit tedious. The 90 or so marked out trails are evenly split between beginner and advanced level, but although there are a lot of runs none are that long. Still the terrain is good and expert riders will find a selection of steep runs off the Ruined Castle chairlift which also gives access to some open sections and a route down to the terrain park. The terrain park has a 120m superpipe, the first in Australia. Carvers who like to go fast, will be able to down the fast blacks of the Internation t-bar, while beginners will find the Eagle chair gives access to good nursery slopes.

Lots of accomodation exists at the base of the slopes in Falls Creek village where you will find shops, bars and restaurants.

Ride Area: 75km Number of Runs: 92 Easy 17% Intermediate 16% Advanced 23% Top Lift: 1780m Bottom Lift: 1600m Vertical Drop: 360m Total Lifts: 15 Lift Capacity (People per Hour): 20,000

MOUNT BAW BAW

Mt Baw Baw is a small resort and the closest to the city of Melbourne. Overall nothing grabs you about this place unless you are a total beginner with a few

hours to kill. The eight lifts cover a mixture of uneven terrain with a splattering of trees and gentle pistes that will suite carvers.

Local facilities are basic but very good with a choice of lodges and holiday apartments although not all that affordable apart from the Youth Hostel ++64 (0) 65 1129.

Ride Area: 30 hectares Number of Runs: 14 Easy 25% Intermediate 64% Advanced 11% Top Lift: 1564m Bottom Lift: 1460m Total Lifts: 5 - all drags www.mountbawbaw.com.au

MOUNT BUFFALO

Mount Buffalo is not only a well established resort with a long history as a ski resort, but also a dull boring novices hangout that will bore the tits off any advanced freerider within an hour of being here

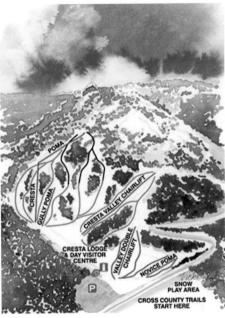

Ride Area: 15km Number of Runs: 14 Easy 50% Intermediate 40% Advanced 10% Top Lift: 1695m Total Lifts: 5 - 2 Chairs, 3 Drags Lift Capacity (People per Hour): 20,000 www.mtbuffalochalet.com.au

MOUNT SELWYN

Mount Selwyn is a small resort that is the ideal family ski resort, but is totally dull for any advanced snowboarder. The small amount of terrain on offer is best suited to piste loving, slow going carvers. The nearest accomodation and local facilities are to be found in the town of Adaminaby

Ride Area: 45hectares Number of Runs: 10 Easy 40% Intermediate 48% Advanced 12% Top Lift: 1614m Bottom Lift: 1492m Vertical Drop: 122m Lifts: 12 - 1 chair, 7 drags, 4 tows Lift Capacity (People per hr): 9.500

New Zealand consists of two main islands, North and South. Whakapapa and Turoa are the only commercial resorts on the North Island, so most visitors will use Queenstown, Wanaka and Christchurch as a base for visiting the South Island resorts. Winter season generally lasts between June to October.

There are twelve commercially owned and operated resorts and a dozen or so 'Club Fields' run by non-profit club committees. Small, social and New Zealand made, they are a classic piece of Kiwiana and well worth while checking out. In recent years many people have rediscovered the charms and attractions of Club Fields. They are tured by the uncrowded slopes, with the spectacular setting of the Southern Alps, spread out as a back drop.

The commercial resorts have spent big over the last 5 years building parks and pipes. It is now the standard that every resort has a decent park and at least one halfpipe. This has been spured on even further with New Zealands first dedicated terrain park resort. Snowpark, which opened a couple of seasons ago:

Taking a 'Snowboard Tour' is a good idea if you're visiting NZ for a short time, as it would help maximise your time on the mountain. There are a number of companies offering all inclusive boarding tours for New Zealand, shop around because prices are competitive.

New Zealand resorts tend to have very limited onmountain accommodation, so you will be most likely staying in some nearby town. Naturally, these vary in size as does the night-life from the busy party towns to the quieter club fields. Queenstown has over 20 bars and clubs and is often referred to as the action and adventure capital of NZ.

NZ's international gateway airports are, Auckland and Wellington for North Island and Christchurch and Queenstowns for the South Island. The average flight time from London is 21 hours with a few stop overs.

Driving in NZ is an economical way to get around. If you'r e looking to drive to some resorts then you will probably need chains. A lot of the drives to the resorts are on unsealed and very dodgy dirt roads. Car hire services are available at all the airports and when hiring, ask about deals for road trips to the mountains, these can include discounts on accommodation and lift passes. Campervans are a cheap hire option, with a five day hire costing from \$460. As well as the usual hire companies, there are some that specialise in longer term rental for backpackers, with prices from \$25 per day. More info take a look at www.rentalz.co.nz Do check and make sure you are allowed on certain roads with a hire care.

Bus travel in NZ is cheap and convenient, either with a local bus company or one of the majors with most resorts covered. You can travel from Queenstown to Christchurch for around \$40.

Most resorts can be reached by train which is not that expensive. However, you will need to transfer by local buses, in most cases under 12 miles.

Great Barrier

Island Auckland Nortz Island Whakapapa/Turoa Cape Farewell Wellington Westport Soûtz Island Cape Pallister Mt.Lyford **NEW ZEALAND** Mt.Hutt Porter Heights Christchurch Ohau Mt.Dobson Cardrona Coronet Peak Treble Cone Remarkables ueensto Snowpark Dunedin Stewart Island CAPITAL CITY: Wellington **DRIVING GUIDE** TIME ZONE POPULATION: 4 million All vehicles drive on the left hand side UTC/GMT+12 DST +1 hr (March - Oct) HIGHEST PEAK: of the road Mount Cook 3764m SPEED LIMITS: LANGUAGE: English 50kph (31mph) Towns NEW ZEALAND SNOWBOARD ASSOC **LEGAL DRINK AGE: 18** 100kph (60mph) Motorways O Box 18911 DRUG LAWS: Cannabis is illegal **EMERGENCY** South New Brighton **AGE OF CONSENT: 16** Fire/Police/Ambulance - 111 Christchurch, New Zealand TOLLS Tel: +64 3 382 2206 Fax: +64 3 382 2106 **ELECTRICITY:**

No tolls, but check if hiring a car that

International Driver's Licence not required, but must carry home driving

its allowed on all roads

DOCUMENTATION

licence.

Web: www.nzsba.co.nz

Email: nzsba@xtra.co.nz

Tourist board - www.newzealand.com

Aukland airport - www.auckland-airport.co.nz Coach - www.intercitycoach.co.nz tel:09

USEFUL LINKS

623 1503 www.skilakewanaka.com

10.3

CURRENCY: New Zealand Dollar (NZ\$) EXCHANGE RATE: UK£1 = 3

INTERNATIONAL DIALING CODE: +64

Euro=2 US\$1 = 1.6

230 Volts AC 2-pin

FREERIDERS will love it here. There is a fantastic variety of snow-gathering gullies and plenty of rocks to throw yourself off. Keg and Arcadia are the areas where Cardrona holds it's National Extreme Championships. Records have been set by dropping down the 30 metre plus Eagle Rock in Captain's Basin, so if you're feeling suicidal this one is for you. If the runs within the boundary don't satisfy you, you could go heli-boarding in Cardrona's expansive back bowls.

Chutes reached off the La Franch chair.

FREESTYLERS are provided with a 800m boardercross course and a cool 1000m terrain park that comes loaded with a large table top, spines, jumps and rails. There are also four halfpipes including 2 superpipes, reached off the Macdougall quad chair lift. The 90m beginner's pipe has a not too intimidating 3m high wall; at the other end is the 140m Johnny Holmes Superpipe with 5m high walls.

PISTES. Riders will find either of the two main faces ideal for laying out some big turns on. The Sluce Box is a great carvers run.

BEGINNERS may find the novice slopes a bit overcrowded on weekends and during holidays. However, persevere as this is a resort that should appeal to first timers with nice beginners runs of the Macdougall quad, which allows for easy progression.

OFF THE SLOPES. life goes on in the town of Wanaka (20 miles), or Queenstown (35 miles). Wanaka is the quieter of the two and more relaxed place with a number of cool bars and plenty of cafes. Overall, prices for accommodation are good and affordable. If you get to know the right people you'll be able to join in on the popular past time of 'Keg' parties.

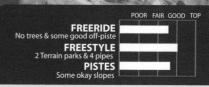

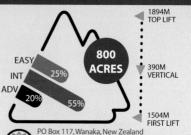

GENERAL INFO: Tel: +64 3 443 7341 **WEB:** www.cardrona.co.nz Email: info@cardrona.com

WIN LIFT Half

WINTER PERIOD: late June to Oct LIFT PASSES Half-day pass \$54

1 Day \$74, 5 Days \$330, Season pass \$1049 Offers exist for early bird season passes before April 30th.

BOARD SCHOOLS

Group lessons 2hrs \$47. courses exist for those wanting to obtain NZ certification in Snowboard instruction. also pipe camps with exclusive use of one of the pipes and park technique courses. Expect to pay around \$600-700 for a 10 day rider improvement course. Around \$380 for a 5 day pipe camp (passes extra).

HELI BOARDING

numerous operations in Wanaka, Queenstown and the surrounding areas. Expect to pay around \$600-700 for 4-5 drops. If you're there for the season, look out for "locals day" deals.

LONGEST RUN: 1.6km (1 mile)

TOTAL LIFTS: 3 chairs, 1 drag, 3 x Magic Carpets

LIFT TIMES: 9am to 4.00pm

LIFT CAPACITY: 7,700 people per hour

MOUNTAIN CAFES: 4

ANNUAL SNOWFALL: 2.7m SNOWMAKING: 30% of slopes

FLY: Fly to Christchurch 3 1/2 hours away. Air New Zealand to Wanaka from Christchurch, 1 lunch time flight per day. Queenstown is 60 minutes from Cardrona. Wanaka is 35 minutes from Cardrona.

BUS: Pre book seats in Wanaka and Queenstown. Buses usually leave at 08:30 and return at 16:00. Prices around \$25 return. CAR: From Christchurch, take routes 1,8,8A and 89. Takes around 3 1/2 hours. 277 miles (446km). Queenstown is 36 miles (58km).

2006:NZ\$2million spent on snowmaking equipment, groomer and beginners terrain park

454 US WWW.WORLDSNOWBOARDGUIDE.COM

Good freeriding & park, cracking do anything town

oronet Peak Tourism

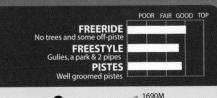

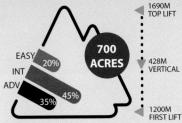

PO Box 359, Queenstown, NZ

GENERAL INFO:++0064-3-442 4620 WEB: www.nzski.com/coronet

Email: service@coronetpeak.co.nz WINTER PERIOD: June to Oct

LIFT PASSES

Day pass NZ\$84,5 Day pass - \$355 Season pass \$1699 (inc Hutt, Oahu, Remarks)

ROARD SCHOOLS

Group lessons NZ\$47 1hr50. New 3hr freestyle lessons \$85, 10:20am RENTAL

Board & Boots NZ\$51 per day, good stuff \$61

NIGHT BOARDING

Mid July to mid Sept, Friday & Saturday nights 4pm to 9pm (NZ\$39)

LONGEST RUN: 2.4km

TOTAL LIFTS: 6 - 3 chairs, 1 drag, 1 magic carpet, 1 beginner tow LIFT TIMES: 9am to 4.00pm

MOUNTAIN CAFES: 3

ANNUAL SNOWFALL: unknown SNOWMAKING: 20% of slopes

FLY: to Christchurch international Transfers take 5 1/2 hours. Queenstown has small airport, 10 miles away BUS: A bus from Queenstown will take around 20 min-

utes, costs \$18 return and rund 4 times every morning, tel: 03 442 8106. From Christchurch, its 6 hours. TRAIN: Trains to Queenstown

CAR: From Queenstown, drive to Christchurch. From there to Cornet Peak about 10 miles (18 km). Drive time is about 20 minutes.

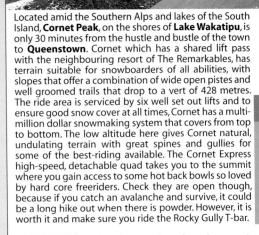

FREERIDERS will find the runs down from the summit pretty cool, especially the M1. Advanced riders should try out the series of blacks from the summit known as the Exchange Drop, which if you don't treat with respect will make your eyes water as you do DROP. Powder hounds looking for some steep, deep, fluffy stuff need to check out the back bowls or the terrain around the Sarah Sue run, but note riding down this area does entail a hike back up to the resort to get on the lifts again.

FREESTYLERS should try out Sara Sue off Greengates for some big spine jumps, banks and natural quarterpipes. Cornet is continually developing its terrain parks theres 2 FIS quality halfpipes and a terrain park either side of the Million Dollar run. Cornet gets pretty

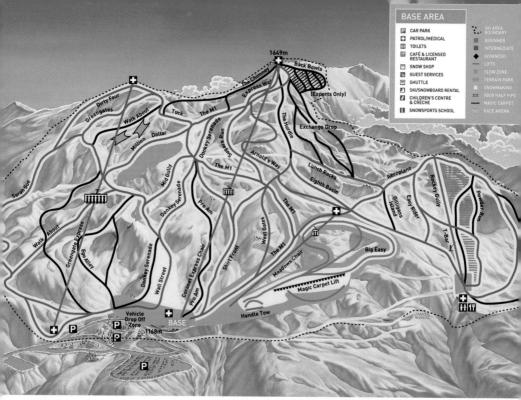

crowded so be careful. The patrollers, including some on snowboards, are serious about using look outs on blind jumps, especially down Exchange Drop, where you would do well to obey the No-Hit/No Jump and slow down zones to avoid any trouble.

PISTES. Carvers will enjoy the long blue trail known as the M1 as well as the runs known as Greengates and Million Dollar, which are pisted to perfection and great for leaving some nice long lines on.

BEGINNERS will find the best stuff is off the Meadows chair and alongside the learners poma. But there isn't a mass of novice trails here, although what is available is still good. The local ski school offers a 'Snowboard Starter' package for \$60 and is well worth the money as instructors know their stuff.

THE TOWN

After hard days riding, the next best thing is to be able to hang out in a place that offers you a good choice of accommodation, plenty of restaurants and loads of bars with varying price ranges to suite all pockets. And that is exactly what you get in Queenstown, a big town full of all the joys and spoils to make a week a month or even a year an eventful one. Queenstown has every possible holiday services you could want and a vast array of outdoor sport activities. You can take part in paragliding, rock climbing, go jet skiing or even have a game of golf (if you?re sad enough) or really bored.

ACCOMODATION. The choice of lodging around

here is very impressive, but forget about any beds slopeside. Queenstown is the best place to be as it has the biggest selection and best budget options, but its also close to all the off-slope action. Motels are a common form of accommodation around here as are bed and breakfast homes. Bungy Backpackers is a cheap hangout. Tel ++64 03 442 8725

FOOD. Being a big town, as one would expect, there is a massive choice of restaurants and cheap cafes in Queenstown. Every type of food is available with lots of options to eat cheaply. Notable places for a feed are; The Cow, which offers moderately priced pizza and spaghetti. Berkels Gourmet frys up a good burger, while Gourmet is good for breakfast.

NIGHT LIFE, in Queenstown rocks hard and late. Locals here like and know how to party hard, and if there's nothing laid on then guaranteed something will happen to set the evening off. The choice of bars is great with some good boozers, such as the Red Rock Cafe which also serves good bar food. The World Bar is also cool hangout.

SUMMARY

Good freeriding resort offering some very nice powder areas. The resort management has a healthy attitude towards snowboarding here.

On the slopes: Really good

Off the slopes: Very good

Money Wise: Overall this is an expensive resort but offers good value.

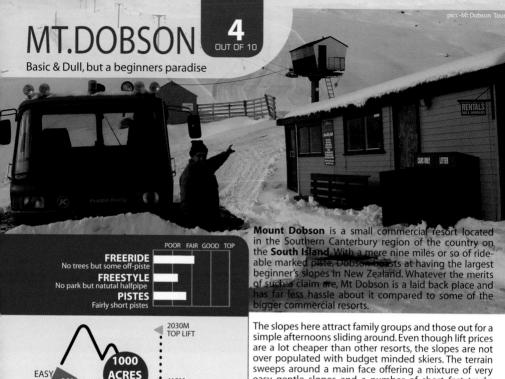

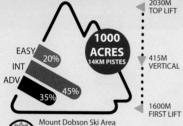

30 Alloway Street, Fairlie South Canterbury, New Zealand GENERAL INFO:+64 3 685 8039 WEB: www.dobson.co.nz

Email:mtdobson@xtra.co.nz

WINTER PERIOD: late June to Oct LIFT PASSES Half Day NZ\$40, 1 Day pass - NZ\$57

3 Days \$171,5 Days \$242, Season \$450

BOARD SCHOOLS

Group lessons \$24. Private lessons \$50 RENTAL

Board & Boots \$47per day

TOTAL PISTES/TRAILES: 14 LONGEST RUN: 2.4km

TOTAL LIFTS: 4 - 1 chairs, 2 drags, 1 learner rope LIFT CAPACTITY: 4000 people per hour

LIFT TIMES: 9am to 4.00pm MOUNTAIN CAFES: 1

ANNUAL SNOWFALL: 2m SNOWMAKING: some

FLY: Fly to Christchurch airport 2 1/4hrs away. BUS: Bus services with change overs at the town Fairlie. TRAIN: services to Timaru, 65km miles from the resort. CAR: 184km From Christchurch, take highway 1 south

and highway 8 to Fairlie and then 11km on to Mt Dobson.

2006: some snowmaking equipment installed & some runs

easy gentle slopes and a number of short fast tracks which are all serviced by drag lifts.

FREERIDERS of an intermediate level will find a day riding the slopes here is not a bad way to pass some time. The best of which will be the trails on the main face of the T-bar, and runs off the West and East trails. Riders, who like something to get stuck into and need a few challenges, may find Dobson a little repetitive and lacking in general interest. However, there is some nice challenging riding in the back bowls and the series of short blacks that drop down from the West and East runs, will give you something to think about. The Bluff is not a bad run and has a few humps en-route to the bottom of the Platter 2 drag lift.

FREESTYLERS will find it hard pressed to find anything man made to fling off. There is a natural half-pipe to be found off the west trail, but thats about it.

PISTES. Riders who like to do big wide turns but don't like to do them for too long, will find Mt Dobson perfectly in tune with their thinking and liking. Nothing here takes that long to carve up, with only a couple of fast pisted tracks to choose from.

BEGINNERS will find the whole place a joy and even though a number of the runs graded "Difficult and intermediate" are a bit over rated and can be challenged after a short time by most.

OFF THE SLOPES, accommodation and other local facilities are offered in the towns of Fairlie or Kimbell. What you get in either, is very basic, affordable and sufficient for a few days stay. Night life is very tame and not up to much.

5 OUT OF 10

Mount Hutt is the third resort in Mount Cook Line's 'Big Three', located 30 minutes from Methven. This is an early opening resort mainly thanks to its snowmaking facilities as well as the high altitude. You can enjoy some of the best snow cover for the longest season in the South Island. The 9 lifts service an excellent expanse of terrain for everybody to take advantage off. Being one of NZ's biggest commercial resorts means that Mt Hutt can become very busy, attracting a lot of family ski groups. However, don't let that stop you, the resort is very snowboard friendly and there are plenty of good areas to ride with out crashing into two plankers all day. As with most of the NZ resorts access is via an ungraded road, which can be closed during snow or windy storms.

FREERIDERS who like the challenge of steep and extreme terrain, then the **South Face** is covered with double black diamond runs to test the cockiest of riders. Other great runs to check out, especially for ungroomed and touched powder, are **Towers** and **Virgin Mile**. Here you can ride free of crowds but remember that Mt Hutt is a very popular resort so move fast on powder mornings to get the best uncut stuff which there is plenty off on offer with no need to hike to.

FREESTYLERS There's a large earth sculpted 10,000m2 terrain park packed with tabletops and spines. There are also 2 halfpipes. You will find plenty to jump and launch off down Exhibition Bowl, Morning Glory and through Race Hill, although exercise some caution on these blind jumps. If possible have someone spotting if possible especially if there are races or training in the area.

PISTES. Any carvers gracing the slopes in hard boots will find some nice corduroy terrain around Broadway to carve up.

BEGINNERS. Mt Hutt is considered one of the best learning resorts in NZ with novice trails serviced by fixed grip tows.

OFF THE SLOPES

You can base your self in **Methven**, **Christchurch** or **Ashburton**, all offering a variety of accommodation, food and nighlife. Methven is the closest, just 30 minutes away. Budget accommodation is limited so try to book ahead. There are plenty of restaurants and cafes serving a variety on dishes at varying rates. Night life is okay in the bars but avoid the cheesy discos.

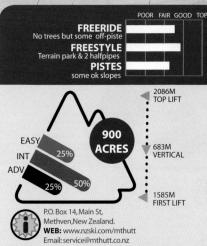

WINTER PERIOD: early June to late Oct

Half-day pass \$52, 5 out of 7 Days Pass - \$355

TOTAL LIFTS: 4 - 3 chairs, 1 magic carpet LIFT TIMES: 9am to 4.00pm

LIFT CAPACITY: 9,200 people per hour

FLY: to Christchurch airport 90 mins away.

CAR: From Christchurch, take highways 73 & 72 trrough Tardhurst and Homebush to Metven and then on up to Mt Hutt.

BUS: Bus services from Metven direct to Mt Hutt take 30

min (www.ridesnowshuttles.co.nz, tel: 03 302 1919). The Snowbus runs direct daily connections from Christchurch

(tel: 0800 7669 287), also Mt Hutt Express 0800 80 80 70

Day Pass \$79, Novice lift day pass \$41

LIFT PASSES

Board & Boots NZ\$47 per day

RENTAL

BOARD SCHOOLS Group lessons 2hrs NZ\$48

LONGEST RUN: 2km

MOUNTAIN CAFES: 2

ANNUAL SNOWFALL: 1.8m

SNOWMAKING: 15% of slopes

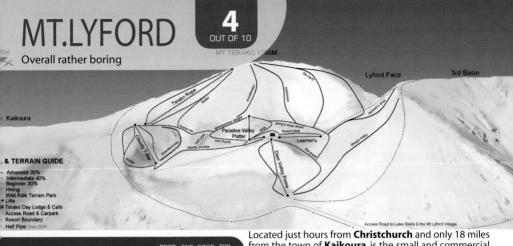

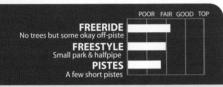

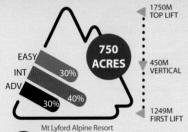

Private Bad, Waiau North Canterbury, New Zealand GENERAL INFO:+64 3 315-6178 WEB: www.mtlvford.co.nz EMAIL: lyfordski@xtra.co.nz

WINTER PERIOD: June to Oct LIFT PASSES Half-day NZ\$45, Day pass NZ\$50 Season \$329

BOARD SCHOOLS

Group lessons \$15 per hour, Private lessons \$45 per hour RENTAL

Board & Boots \$40/30 per day/half

TOTAL PISTES/TRAILES: 14 LONGEST RUN: 2.4km TOTAL LIFTS: 6 drags LIFT TIMES: 9am to 4.30pm **MOUNTAIN CAFES: 1**

ANNUAL SNOWFALL: 2.6m SNOWMAKING: none

FLY: Fly to Christchurch airport 2hrs away. BUS: Hurunui run custom service around local area including Christchurch

tel: 0800 0811 55 or www.Hanmer.biz

Daily Express service from Kaikoura (60km) \$35 return, tel: 0276 298 083

CAR: From Christchurch, take highway 7 north and highway 70 via Culverden and Waiau to reach My Lyford. 146km total.

from the town of Kaikoura, is the small and commercial resort of Mount Lyford. This totally privately owned mountain may not be the biggest resort in New Zealand, but by the same token it's not the smallest, and unlike some of the other commercial resorts. Mt Lyford is far more affordable and offers great value for money for any rider who can handle a few days. Mt.Lyford is a very snowboard friendly hangout and on occasions has boarders out numbering skiers. Still who ever is there, will tell you that its pretty dull for any more than a couple of days if you stick to the marked slopes but great if you go heli-boarding into the backcountry areas. The area gets good natural snow cover that is spread out over two areas which are somewhat different to each other. The lake Stella area a short drive around the mountain, is the advanced riders spot while beginners will find the best slopes on the Terako field.

FREERIDERS should make their way to the top of Mt **Terako** via the Terako lift for some uneven terrain. From the top and after a short hike, you can either ride down the series of steep blacks such as Die Hard, or you can elect to take the slightly easier runs such as the Thriller. Riders who can afford it and want to ride some backcountry powder, will be able to experience the best stuff by taking a heli-board trip with Hanmer Helicopters.

FREESTYLERS. The small Wild Ride terrain park has one kicker and a selection of rails and boxes. In 2005 they shelled out on a pipe-cutter and dug out the 120m halfpipe, but the poor season meant it wasn't fully operational. Away from the park, you will find a few rocks to leap over and one or two wind lips but nothing major.

PISTES. Piste huggers will find the least to do here if your only desire is corduroy trails. However, an hour here will allow for some fun. Only 20% of the rideable area is groomed.

BEGINNERS will love Mt Lyford because you can practice your thing on some very tame slopes, which are free of large ski groups. The only thing is that all the lifts are drags.

OFF THE SLOPES the by word is, 'very basic and dull'. There is chalet accommodation along the access road but little else. Keith's Cafe is the place for breakfast while the Lodge Hotel will provide some evening madness.

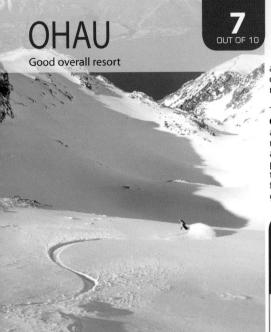

FREERIDERS are most at home here. Apart from the two learner areas at the base and the wide groomed Boulevard Run, the terrain is generally steep. Left of the T-bar, is the steepest part of the area with the **Escalator** trail being the steepest run on the mountain.

The strong-nerved should consider traversing further than Escalator, past the Rock Bluff and ride down to the Platter lift. The face above the day lodge, with the **Sun Run** trail on it, offers some steep runs and because it gets sun early in the day, it's often the best place to ride in the morning. On the other face, the Exhibition and **Escalator** runs, remain in the shade until late in the day.

FREESTYLERS will have to make do with natural hits, if getting high on a board is you're type of fix, nothing is laid on here.

PISTES. Hard-core pisters may at first feel left out, however after some close examination, you will soon see that there is enough pisted carving trails to shine on, with runs like the Shirt Front, where you can give some style at speed.

BEGINNERS tend to hang out on the **Boulevard run** although it does get a little steep in places (below Top Flat). Boulevard does give less confident riders a good reign of the mountain and a few ski areas have such an easy run from there highest point.

STAYING

The Ohau experience is best enjoyed by staying at the Ohau Lodge, situated at the base of the mountain. Food and booze are available in the Lodge on back down in the town of Twizel. Wherever you decide to chill out, there's a good choice of cool hangouts with reasonable prices for booze.

460 USQ www.worldsnowboardguide.com

Some would say that you haven't truly snowboarded in New Zealand until you have spent a day at Ohau Ski Area and a night at the Ohau Lodge. Seemingly in the middle of nowhere, about half way between Queenstown

and Christchurch, most people make the mistake of only visiting Ohau for a day en-route between other resorts.

The views alone here are amazing with Mount Cook, NZ's highest mountain, in sight all around the area. This internationally renowned snowboarders resort offers some excellent riding for all levels on amazingly crowd free slopes with a fair share of good powder days. Riders come here because they know that this place cuts it, without any hype of bull shit, just a damn fine mountain that will please hardcore freeriders with a good choice of steeps.

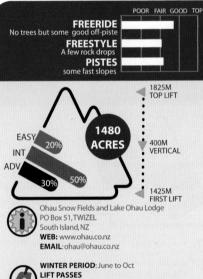

1 Day pass - NZ\$58 or \$47 for house guests **BOARD SCHOOLS**

Group lesson \$36 1.5 hours, Private lessons \$72 per hour

RENTAL

Board & Boots \$45 per day

NUMBER OF TRAILS/PISTES: 11

LONGEST RUN: 1.9km TOTAL LIFTS: 3 - 1 chair, 1 drag & a magic carpet

LIFT TIMES: 9am to 4.30pm

LIFT CAPACITY: 2295 people per hour

MOUNTAIN CAFES: 1

ANNUAL SNOWFALL: 1.8m SNOWMAKING: none

FLY: to Christchurch airport 2hrs away. BUS: Bus services from Christchurch with changes at

Twizel or Omarama CAR: From Christchurch (320km), take highways 1 and

8 via Twizel (52km away). Take the 9.6 km access road to the resort. Wanaka is 155km away

NEW FOR 2006 SEASON: Magic carpet to replace the NEW Sbeginners' tow. The Boulevard gully widened, Mike's Meander developed into a new trail, and top chair extended to give access to Back Bowl

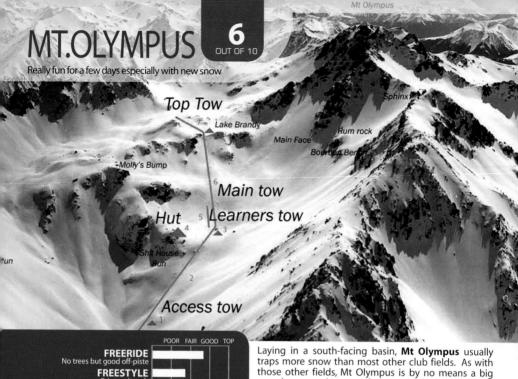

1880M TOP LIFT 148 CRES 450M VERTICAL 1430M FIRST LIFT

ring a shovel

go find freshies

PISTES

Mt Olympus Ski Area PO Box 25055, Christchurch GENERAL INFO:+64 3 3185 840 WEB: www.mtolympus.co.nz EMAIL:mtolympus@xtra.co.nz

WINTER PERIOD: early July to start Oct LIFT PASSES

Day pass \$25/50 for members/non-members Week pass \$250/600 respectively Accom, dinner and breakfast \$35/70 or just bed \$15/25 **BOARD SCHOOLS:** Tuition available

TOTAL LIFTS: 4 - All the infamous 'nutcracker' rope tows MOUNTAIN CAFES: 1

ANNUAL SNOWFALL: unknown SNOWMAKING: none

FLY: Fly to Christchurch airport 125km away BUS: Contact Black Diamond Safaris tel: 0274 508 283 CAR: The only way to get to Mt Olympus is by car. Its a 45km drive from Windwhistle along an unsealed road. Make sure you're carrying chains. The drive from Christchurch is 125km.

those other fields, Mt Olympus is by no means a big area, however there are fun times to be had as very little people ride at these areas and fresh tracks are usually plentiful.

FREERIDING. The club fields are a freeriders paradise. There's no grooming but plenty of interesting terrain from wide open faces like Main Face to the cool chutes coming down the areas' namesake. The off-piste possibilities are unlimited, but make sure you have a chat with patrol to find out about current avalanche conditions before heading off.

FREESTYLERS. There's no traditional terrain park but the whole area has cool places to build kickers to launch you skyward.

BEGINNERS. There is a short beginner's tow but it is located near the lodge which is accessible by either a more advanced rope tow or by walking! Beginner riders are better off learning to ride at one of the commercial ski areas like Mt Hutt or Porter Heights.

OFF THE SLOPES

The best way to experience the club fields are to stay the night before riding. That way you can get the latest on the snow conditions and in the morning you just walk out the front door right on to the snow. The Top Hut is a very cosy lodge with 10 bunk styled rooms with hot showers! \$55 is what it will cost you for accommodation, dinner and breakfast. There's even a qualified chef! There's also the Bottom Hut which costs \$25 but you have to supply your own food. The nearest town is Methven 58km away, its not exactly lively there, but there are some reasonable places to stay and most importantly a pub.

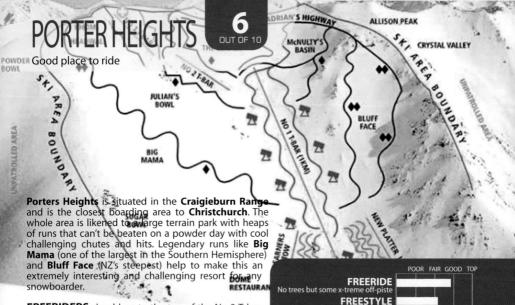

FREERIDERS should go to the top of the No 3 T-bar, because from here the mountain is yours. The view of **Lake Coleridge** and surrounding mountain ranges is spectacular. Don't hang around sightseeing for too long though - the first tracks on **Big Mama** aren't available all day. It is a reasonably easy traverse (with a little climbing) along a ridge line to the top of Big Mama, but it's not until you're standing at the top of the slope that you realise just how long the run is. It is a huge 620 vertical metres from top to bottom - one of the largest vertical drops in a lift accessed area in NZ. If you're fit enough to enjoy long powder runs, Big Mama is heaven.

If you prefer chutes, traverse to the left from the top of lift No 3 T-bar to **Aorangi Chutes** and the Leapers, where the terrain is steep and the chutes are narrow. Bluff Face is another cool place to ride reached via a traverse down to McNulty's cat-track and hike up to the summit of **Allison Peak**. The Powder Bowl and Crystal Valley runs are both outside the ski boundary. There is a great boarding to be had on both, but the hike can be a mission. For reasons of safety, inform the ski patrol if you intend to go into any of these areas.

FREESTYLERS have a lot here to check out here if man made stuff isn't your bag with heaps of good natural hits dotted around the whole area.

PISTES. Riders will find the runs down either side of the No 1 T-bar have a reasonably consistent gradient and make excellent cruising runs for intermediate boarders

BEGINNERS will find the runs limited to a few short flats at the base area which are serviced by a couple of easy to use lifts.

THE TOWN

The best place to base yourself for local services, is in nearby **Springfield**, where there's some good lodging options, good eating out and great night time happenings shared with friendly locals.

462 USG www.worldsnowboardguide.com

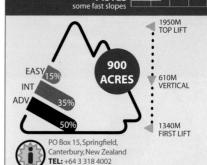

PISTES

No park, but good natural

EMAIL: ski@porterheights.co.nz WINTER PERIOD: June to Oct LIFT PASSES

WEB: www.porterheights.co.nz

Morning/Afternoon \$40, Day pass - \$60 Season pass - \$720 (\$299 earlybird)

BOARD SCHOOLS

Lesson (2hrs), lift and equipment & all day pass - \$90 Group lessons 2hrs \$25. Private lesson \$70 per hour RENTAL: Board and boots \$43 per day

NUMBER OF TRAILS/PISTES: 17

LONGEST RUN: 720m

TOTAL LIFTS: 5 - 3 drags, 1 platter tow, 1 beginner tow

LIFT TIMES: 9am to 4.30pm

LIFT CAPACITY: 3000 people per hour

MOUNTAIN CAFES: 1

ANNUAL SNOWFALL: 2.9m SNOWMAKING: 10%

FLY: Fly to Christchurch airport 1 hour away (89km). BUS: Bus services with change overs at the town Springfield. Snowork run transport from Christchurch (leaves 7:15am) 550 return www.snowork.com

CAR: 89km from Christchurch, take highway SH73 via Darfield, Springfield and past Lake Lyndon, take porter heights turn-off TRAIN: services to Springfield, 12 miles from the resort.

MT.POTTS

Fresh lines, no people, awesome terrain

:s - mtpotts backcountry

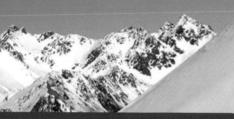

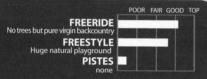

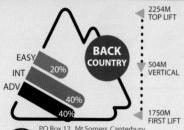

PO Box 12, Mt. Somers, Canterbury **GENERAL INFO: 0800 SNOWCAT** WEB: www.mtpotts.co.nz EMAIL: mc@mtpotts.co.nz

WINTER PERIOD: end July to late Sept CAT-BOARDING

NZ\$399 for full day cat-boarding (12-14 runs), includes helicopter pickup from the Mt Potts lodge to the snowcat and lunch

HELI-BOARDING

Pure Heli - 5 runs in the Two Thumbs Range, 17,000ft vertical \$765 Heli Max - 8 runs around Mt Potts, 22,000ft vertical \$650

BOARD RENTAL

Board & Boots \$35 day

TOTAL PISTES/TRAILS: none LIFTS: No lifts at resort. Only cat and heli-boarding available **MOUNTAIN CAFES: 1**

ANNUAL SNOWFALL: 11m SNOWMAKING: none

FLY: includes helicopter pick up from Mt.Potts lodge and heli back to the lodge at the end of the day. Private flights available from Queenstown or Christchurch, 2 day package \$950. Just return flight from Christchurch

to Mt.Potts from \$198 CAR: Drive to Mt.Potts lodge, 1 hour from Methven near Christchurch

Since Mt Potts is good enough for the Burton and Salomon Teams, then you know it's definitely good enough for you! Mt Potts is currently the only catboarding operation in New Zealand. They now also offer some great heli-boarding. The worst part about staying there is trying to choose which to do! Mt Potts is located in the Canterbury region of the South Island, about 2 ho from Christchurch, an hour from Methven and no from the more famous commercial ski area of Mt Hutt. You'll need to be at least an intermediate boarder to enjoy things, and it's a good idea to need to book in advance. Mt Potts receives a hell of a lot of snow... and it helps being the highest 'resort' in the South Island.

Heli and catboarding is all about freeriding and Mt Potts delivers. The Mt Potts guides can get you to pretty much any type of terrain you desire. From wide open bowls to sphincter tight chutes you can find it in Mt Potts lease area. The great thing about heli/catboarding in New Zealand is that the heli, and therefore groups, tend to be small, therefore it's easy for the guides to keep watch over everyone, so if you have an advanced group you can explore the terrain more so than if you were in Canada where they strictly enforce where you can and can't ride (this may also be due to the higher risk of avalanche there).

CATS. They've been cat-boarding at Mt Potts since 1999. To get from the lodge to the cat-boarding staging area you get a flight in the heli! There's terrain to suit all abilities and you will get in as much vertical as if you went heli-boarding. Riders do 12-14 runs for a total of 18,000ft of vert. Perhaps the best run of the day is the last run which is a 2km cruise down to the helicopter which flies you back to the lodge and some après drinks.

HELI-BOARDING started at Mt Potts during the winter of 2005. The great advantage of it being a 'new' operation is that the vast majority of terrain (i.e. pretty much all of it!) has never seen a pair of skis or a board!! On our visit there we were doing runs that had never been ridden before...and that's fairly common!

BEGINNERS need to go to Mt Hutt! Heli/catboarding should be done by riders of at least an intermediate level.

OFF THE SLOPES

It's strongly recommended to stay at Mt Potts Station (lodge) the night before you fly. That way you can meet the guides and fellow riders and be ready for the day's adventures. Dinner, bed and breakfast and staying in a Shared Room is \$89pp and for a Twin Room it's \$99pp.

Even though dinner is a set menu the food is really good! You can even see the menu on the Mt Potts website. Breakfast is really good to, with a choice of cereals, fruits, juice and a cooked breakfast.

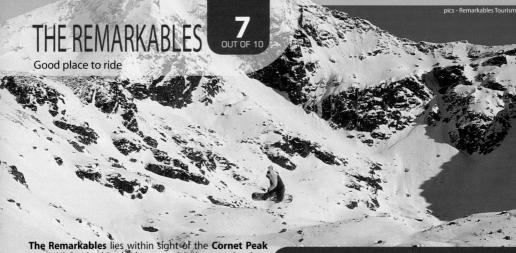

resort. Higher in altitude, the car park is the same level as Cornet's summit, with the result being that the mountain is very craggy and rocky. The Remarkables tends to be a lot quieter than Cornet Peak with fewer skiers. It also gets some incredible powder days and offers terrain for every style and grade of rider. The area is some what sheltered but still gives out plenty of sun and loads of natural snow. The Homeward runs are the place to shred some deep powder where you can ride some long floating turns with an amazing back drop. The Homewards take you right down to the access road to catch the shuttle bus back to the base building in order to do the whole thing again. The runs here are accessed by three chairlifts. The Alta double chair services the best intermediate terrain to suit carvers or freeriders. The Sugar quad is the lift to take to get access to some good advance terrain and competent intermediate stuff. However, advanced riders looking to cut it in style and be pushed to the fore should check out the runs found off Shadow lift.

FREERIDERS prepared to do some hiking, and after checking the snow conditions with the patrol, can reach some major dogs bollocks terrain with big chutes and scary steeps. Turn left off the **Shadow** and hike 20 minutes up to the ridge to access the area known as Elevator above Lake Alta. If you continue up along the ridge then the chutes get narrower and more extreme, so be bloody careful if you don't want this to be your last ever run. Go left off Sugar for the **Toilet Bowl** a freeriders heaven, which again takes you to the access road and the shuttle bus.

FREESTYLERS, the Xbox Terrain Park that has tripled the size of the old terrain park, and includes a 150m superpipe. Riders will find plenty of cliffs and rock drops to get air from, especially in areas around Sugar and Alta. There are also plenty of cat-tracks to drop off.

PISTES. Riders will find a number of runs to laying out big super G turns on but in truth this is not a groomed piste lovers home.

BEGINNERS have two superb learner areas with fixed grip tows and an excellent snowboard school that will soon get you sorted out and cutting the mountain up in style.

THE TOWN. Read the **Queenstown** section in the Coronet peak review

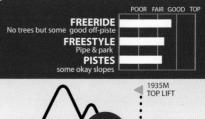

550

CRES

357M

1603M

VERTICAL

PO Box 359, Queenstown, New Zealand

TEL: +64 (0) 64-3-4424615 WEB: www.ohau.co.nz EMAIL: ohau@ohau.co.nz

WINTER PERIOD: June to Oct LIFT PASSES

Half day \$49, 1 Day \$84, 5 Day pass - \$355 Season pass - \$1699

BOARD SCHOOLS

Group lessons 1hr50 NZ\$47 Freestyle lessons \$85 1hr50 from 10:20am

RENTAL

Board & Boots \$51 per day

LONGEST RUN: 1.6km TOTAL LIFTS:5 - 2 chairs, 3 drags LIFT TIMES: 9am to 4.00pm LIFT CAPACITY: 3000 people per hour

MOUNTAIN CAFES: 1

ANNUAL SNOWFALL: 2.7m SNOWMAKING: 10% of pistes

FLY: Fly to Christchurch or Queenstown. BUS: services from Queenstown to the resort are available on an hourly basis (4 times in morning) \$18 return, contact skishuttle@coachline.co.nz ot tel +64 3 442 8106

CAR: From Christchurch, take highways 1, 8, 8A and 89. The drive time is around 6 hours.

464 USQ WWW.WORLDSNOWBOARDGUIDE.COM

SNOWPARK

Exactly what it says on the tin.

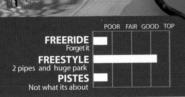

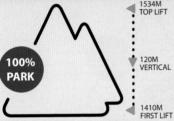

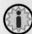

Snow Park Ltd, Cardrona Valley RD1. Wanaka 9192 TEL:+64 3 443 9991

WEB: www.snowparknz.com EMAIL: info@snowparknz.com

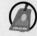

WINTER PERIOD: June to Oct LIFT PASSES

1 Day Pass NZ\$66, half day \$55 5 day anytime \$279, Season \$599-1099

BOARD SCHOOLS

4 day pipe camps on offer throughout for \$375 (ex. passes) RENTAL

NO rental equipment available, demo equipment available. Rent equipment in nearby Wanaka and Queenstown.

HELI-BOARDING

Heliboarding available in nearby Wanaka and Queenstown. Expect to pay \$500-600 for 4-5 drops.

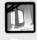

TOTAL PISTES/TRAILES: 1 TOTAL LIFTS: 1 Chair LIFT TIMES: 9am to 4.00pm **MOUNTAIN CAFES: 1**

ANNUAL SNOWFALL: 0.5m SNOWMAKING: 100% of area

FLY: Fly to Queenstown (55km) or Wanaka (35km) BUS: Daily to the Park from Queenstown contact snowbus@paradise.net.nz, or from Wanaka contact 03 443 8422 or email ewa@adventure.net.nz

CAR: From Lake Wanaka its 35km up the Cardrona Valley From Queenstown its 1 hr.

2006: lots of playing with diggers resulting in most of the advanced jumps are now earth formed, providing more snow to expand the intermediate facilities. Planning to build an artificial cliff drop.

Snowpark is New Zealands latest resort, only opening four seasons ago, and is the only one dedicated to freestyling. You'll find it on the South Island, about 35km from Wanaka. Natural terrain wise this place will not get your pulse racing, but natural is not was this place is. What you get is a resort packed with pipes, rails, hips, boxes the lot; and a team dedicated to making it happen and happen big. There's no equipment hire so make sure you turn up with everything.

This place is packed with features, and is perfect for the pro as much as the novice taking their first steps into the park. Most of the major features are dug out of the landscape, so they should be open all season.

The Super Pipe is designed to full World Cup spec, and theres another suitable for beginners. Theres a 50x8m 1/4 pipe, this year they're looking at 40+ rails, boxes and hits of varying sizes for all abilities. To ease progression they have 3-4 sizes of each rail, and a similar setup for the boxes. Theres an increase in the number of beginners jumps this year, and its graded to get you ready for some of the monsters such as the 100ft kicker they built for Burton.

Behind the back of the 1/4 pipe theres also a skate park to try out, you can rent the equipment if necessary or for \$10 a day just enjoy the skatepark.

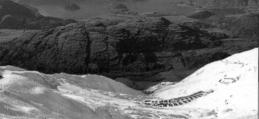

FREERIDERS will like it here especially when there has been some fresh snow. A particular good area to drop into is Powder Bowl. A wide open slope leading into the lower gullies for some big powder turns and super floating glides. For the more adventurous the offpiste in the Matukituki Basin is the place to check out.

FREESTYLERS should head to the top and from the summit, drop into the Saddle Basin alongside the Saddle double chair, to take advantage of loads of natural hits and halfpipes to gain maximum air time. The Gun Barrel, which is also reached from the summit, is another legendary, long natural halfpipe where banked slalom events are regularly held. The terrain park on **Pete's Treat** is loaded with rails and boxes and if you're still not satisfied and in need of an adrenaline rush, there are loads of big drops offs and rocks of all sizes dotted all over the mountain.

PISTES. Carvers need not feel left out as Treble Cone has done lots of work developing a series of well groomed runs down the face of the mountain which are ideal for laying down some big wide arcs.

BEGINNERS may note that although Treble Cone is not known as a beginners mountain don't be put off, as there is still enough to try out without killing yourself on the first day. Its skiers who can't handle it here, not fast learning boarders.

THE TOWN

Away from the slopes local services are provided down in Wanaka, a quiet and relaxed place that provides good places to kip and a few bars popular with snowboarders. For some decent food why not try Kai Ahaka for a tasty treat and great coffee. The Pot Belly Stove also serves decent local food. Places to check out for a beer are the likes of the Barrows, which is the locals haunt, or Outback bar which has a pool table and serves booze until late.

466 USQ WWW.WORLDSNOWBOARDGUIDE.COM

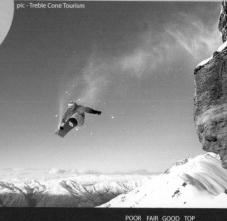

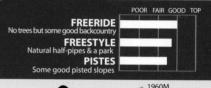

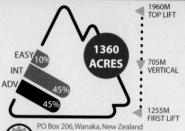

EMAIL: info@treblecone.co.nz WINTER PERIOD: June to Oct

WEB: www.treblecone.com

LIFT PASSES Half-day NZ\$59, Day pass - NZ\$89

TEL: +(03) 443 7443

Beginners day pass \$40,5 Days \$299 Full Seasons Pass \$1299, Weekday Seasons Pass \$850-999

BOARD SCHOOLS

Group lessons NZ\$45 per hour, Private from \$77 per hour earlybird or \$95 per hour anytime. Full day private \$365

RENTAL Board & Boots NZ\$47 per day. Inc lift pass \$110

NUMBER OF PISTES/TRAILS: 60

LONGEST RUN: 4km TOTAL LIFTS:4 - 2 chairs, 1 drag, 1 Magic carpet

LIFT TIMES: 9am to 4.00pm

LIFT CAPACITY: 6905 people per hour MOUNTAIN CAFES: 1

ANNUAL SNOWFALL: 2.5m SNOWMAKING: 10% of pistes

FLY: Fly to Christchurch or Queenstown or direct to Wanaka (NEW direct Air NZ flight)

BUS: Bus services from Queenstown to the resort are available on an hourly basis. Shuttles from Wanaka by Edgewater Adventures and Alpine Coachlines NZ\$27 return

CAR: From Christchurch, take highways 1, 8, 8A and 89 to Wanaka. The drive time is around 5 hours. 30 minutes drive from Wanaka, 1.5hours from Queenstown via Crown range

NEW FOR 2006 SEASON: \$1.5 million spent on improvements. 3 runs widened - Easy Rider, Big Skite and Raffills Run. Snowmaking facilities increased by 50%

TUROA Simple but good resort

7

year, depending on the amount of snow cover.
Because the area is so large and conditions can vary so much, it is worthwhile spending time in the bars down in **Ohakune**, meeting the locals first hand and finding out where the current best spots are. The runs marked on the trail map are really of little more than aesthetics value. There are countless possible routes and like Whakapapa on the other side of the mountain, the fun of riding at Turoa is finding them.

Turoa and sister resort **Whakapapa** make up New Zealand's largest resort. Turoa is covered with gullies, bowls, walls and wide slopes;

the type of terrain only found on a volcano. Conditions can vary incredibly from year to

POOR FAIR GOOD TOP

FREERIDE
No trees but excellent off-piste
FREESTYLE
A park & good natual terrain
PISTES
Good mix of pistes

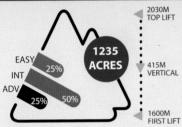

PO Box 46, Ohakune TEL:+(06) 385 8456

WEB: www.mtruapehu.com EMAIL: info@mtruapehu.com

WINTER PERIOD: June to Nov LIFT PASSES

Half day \$46, 5 Day pass - \$340 1 Day pass - NZ\$76 inc board & boots \$116

Season \$679 valid at Whakapapa as well.

BOARD SCHOOLS

Beginner lessons inc equipment & pass \$72

RENTAL Board, boots \$45 per day

TOTAL PISTES/TRAILES: 43 LONGEST RUN: 4km TOTAL LIFTS: 9 - 4 chairs, 5 drags LIFT CAPACTITY: 10,400

people per hour LIFT TIMES: 9am to 4.00pm MOUNTAIN CAFES: 3

ANNUAL SNOWFALL: 2m SNOWMAKING: 5% of slopes

FLY: Fly to Auckland and inland to Palmerston.BUS: Snow Express run daily bus services from Ohakune tel: 06 385 4022. The Ohakune Shuttle runs a night \$2 night bus around town

TRAIN: Train services to Ohakune (10 miles).

CAR: From Auckland, head south on highways 1, 3 and 4 to Ohakune and then on to the resort. Journey time 4 1/2hrs

FREERIDERS of an advanced level should get to the top of the High Noon T-bar. From here you can appreciate the scope of the place and get an idea of where you'd like to ride. The runs out to your right (Limit, Solitude and Layback) are long runs in wide open spaces, where the thrill of riding down an active volcano can be fully realised. The runs way out to your left (Speedtrack, Main Face and Triangle) are a little steeper. There is nowhere on Turoa where the urge to climb Ruapehu's Peak is stronger than when viewing Mangaheuheu Glacier, from the Glacier Entrance run. If you want to hike to the top, check with the ski patrol on the best route and do not go without telling them. They'll also appreciate it if you can report to them on your return. It doesn't matter which route you take from the peak back to the ski area, they are 475 of the most unforgettable vertical metres in New Zealand.

FREESTYLERS have a good park with some big hits and cool rails, however on a powder day, which don't occur with great frequency in the North Island, Turoa's walls and gullies beckon you to charge hard. There's nothing like launching off **Clays Leap** or the **Mangawhero Headwall** and landing in the safe hands of powder.

PISTES. There are a few good groomed runs early in the morning, but things soon get rutted

BEGINNERS will find the **Alpine Meadows** area beside the car park the place to start out on. The cafeteria is right beside it so its never too far to go for a bit of a warm up.

THE TOWN

There is an abundance of local facilities in **Ohakune**, only 10 miles away. There's a great amount of bars in Ohakune, sometimes refered to as the "Queenstown of the North Island". On Tuesday nights the place to be is the Turoa Lodge as that's where all the mountain staff hang out. Accommodation is provided as cheap B&B's, inexpensive motels and pricey hotels. Food and drinking is plentiful. The Fat Pigeon is the place for breakfast.

FREERIDERS who know what's what, will be aware of the awesome area known as the Pinnacles. Simply put, if you're not a damn good advanced rider, then stay away. The Pinnacles are a series of cliff runs that will wipe the lights out for good if any rider mucks up!

FREESTYLERS will be pleased to know that Whakapapa has a nice halfpipe located at Hut Flat. The Moro Terrain Park in the Rockgarden area is geared towards intermediates. There are some awesome new box rails, including a Battleship Box which is almost 6m long!

PISTES. Riders can carve away for days on well groomed trails and take a week to do them all a few times over, with a number to test the best of the edge merchants.

BEGINNERS. Whakapapa is the perfect place for beginner boarders to learn. Happy Valley is an area that is located at the base area and is physically separated from the main runs so beginners can learn in a safe environment. Check out the Discover Snowboarding packages that include lift ticket, lesson and board hire.

THE TOWN

Heaps of good locals facilities exist in varying villages all in easy reach of the slopes. Prices vary, but on the whole well affordable and worth the effort of a weeks stay.

Best option for nightlife is finding out where the staff are! Thursday nights is the big night at the Tussock Bar in Whakapapa Village because it is employee pay day. The other popular hangout spot is Schnapps in National Park on Thursday nights and the weekend. There is accommodation to suit all budgets from backpackers to a 5 star hotel. See the Mt Ruapehu website for details.

POOR FAIR GOOD TOP **FREERIDE** No trees but some serious off-piste FREESTYLE Terrain park & halfpipe **PISTES** Some well pisted slopes

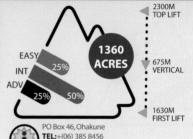

WINTER PERIOD: June to Nov LIFT PASSES

Half day \$46,5 Day pass - \$340 1 Day pass - NZ\$76 inc board & boots \$116

Season \$679 valid at Turoa as well.

BOARD SCHOOLS

Beginner lessons inc equipment & pass \$72 RENTAL

Board, boots \$45 per day

NIGHT BOARDING

6pm to 9pm in Rockgarden area

NUMBER OF PISTES/TRAILS: 30

LONGEST RUN: 2.8km

TOTAL LIFTS: 13 - 7 chairs, 6 drags, 1 learner rope

LIFT TIMES: 8.30am to 4.00pm

LIFT CAPACITY: 23,000 people per hour

MOUNTAIN CAFES: 6

ANNUAL SNOWFALL: 2.5m **SNOWMAKING**: 20% of pistes

FLY: Fly to Auckland airport and inland to Taupo airport. TRAIN: services are possible to National Park, which is 12 miles away.

BUS: Sno shuttle run daily from Taupo (7.15am) and Turangi (7.50am) tel: 07 377 0435.

CAR: From Auckland, head south on highways 1 to Taupo and then on to Whakapapa (4hrs journey time)

NEW FOR 2006 SEASON: \$30m in new development over the next two years. New 4-seater Tennants Express chair

CLUB FIELDS

In recent years many people have rediscovered the charms and attractions of Club Fields. They are lured by the uncrowded slopes, with the spectacular setting of the Southern Alps, spread out as a back drop.

Facilities at the club fields tend to be duite modest and basic, there are no club fields with chair-lifts, but some do have T-bass or platter lifts. The most corrinon lift is the rope tow. If you contact the club offices in advance and fell-them the day you wish to come they are help arrange a dide-for they can help arrange a ride for you by patting you in touch with someone else who is driving there. Local Ski or Snowboard Shops will sometimes have booking sheets of people who are going or want to go to a club field.

All the club fields have on-mountain lodging available. This can

range from dormitory

cabin style, to double rooms with

en-suite. If you are planning on staving overnight on the mountain, ring ahead to check there are vacancies because often they have large groups and clubs booked in or staying and may be full up, depending on bed numbers. There are package deals available which can include accom-modation, an evening meal and breakfast, and discounted day

passes (and some-times transport). There are cheaper prices staying mid-week and for a week. This is a great time to go because there is usually no one else to share the slopes with.

For day visitors, there is a cafeteria or snack shop for food. It is a good idea to bring a few of your own munchies too. There is usually a

communal dining and

kitchen area where you can prepare and eat food.

At some club fields you can buy alcohol (mainly beer), but supplies can run out, so if you are staying a night of more it would be rise to bring your own, if you are one of those people who need a couple of cold ones to finish the day. Check with the ski area first about their policy on alcohol.

STRATFORD MOUNTAIN CLUB

Ride area: 100 acres Runs: 10

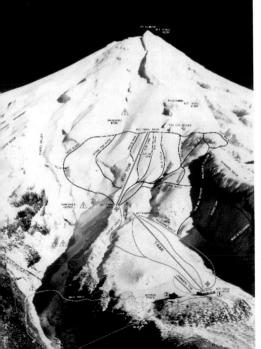

Easy 5%, Intermediate 30%, Advanced 65%

Top Lift: 1680m Bottom Lift: 1260m

Total Lifts: 4 - 1 t-bar, 3 rope tows

Contact:

PO Box 3271, New Plymouth, New Zealand

Phone: +64 027 2800 860. web: www..snow.co.nz/manganui

20km from Stratford, take the sealed access road off highway 3 for 18km, 20 min walk from carpark

HANMER SPRINGS Easy 10%, Intermediate 60%, Advanced 30%

Hire: Available on slope

Lift passes: Day pass \$5 for a member \$40 otherwise

Accomodation \$5 for a member, \$25 otherwise. Membership \$120 Total Lifts: 2

Contact:

PO Box 66, Hanmer Springs, Phone: (025) 341 806

www.skihanmer.co.nz

Take the access road Clarence Valley road from Hamner Springs.

155km from Christchurch & Kaikoura

BROKEN RIVER

Top Lift: 1820m Bottom Lift: 1400m

Ride Area: 300 hectares

Board School: Private \$42 per hour

Group lesson \$20 per hour

Lift passes:Day pass \$42

Overnight accomodation: \$25 - White Star Chalet,

\$48 - Broken River Lodge, \$70 - Lyndon Lodge

Total Lifts: 5 tows

Contact:

PO Box 2718, Christchurch, New Zealand, Phone / Fax: (03) 318 7270 www.brokenriver.co.nz

1 1/2 hours west of Christchurch on State Highway 73 (the Arthur's Pass Road approx 8km past Castle Hill Village). Follow 6km access road

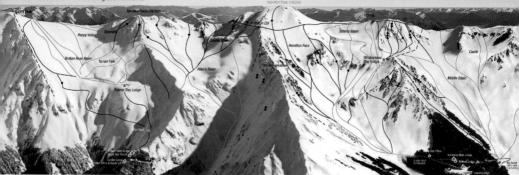

CRAIGIEBURN

Top Lift: 1811m Bottom Lift: 1308m

Ride Area: 101 hectares

Intermediate 55% Advanced 45%

Total Lifts: 3 rope tows Board School: Goup lesson \$20 per hour. Private lesson \$30 per hour

Hire: No hire equipment available

Lift passes:Day pass \$25 member, \$44 non-member Accomodation \$65 non-member. \$2 tow belt hire per day

Box 2152, Christchurch, New Zealand, Tel: +64 3 365 2514

www.craigieburn.co.nz Location:

From Christchurch take highway 73 to Craigieburn for 110Km, 1 1/2 drive time then take 6km access road

INVINCIBLE SNOWFIELDS

Privately owned and operated area on the South Island, about 50km from Queenstown at the head of Lake Wakatipu. The resort operates on demand, and is very weather dependent, basically its run on peoples days off.

Included in the price is a helicopter to and from the area, and once there a single 700m rope tow serves the area. Overnighters can stay in the hut on the slope, theres no electricity so its candles and gas burners, and you'll need to bring your own sleeping bag.

Top: 1800m Bottom: 1500m

Total Lifts: 1 rope tow

Hire: Board & Boots \$35 day Lift passes:

Prices based on 5 people, prices drop up to 20% for larger groups 1 day \$445, 2 days \$580 (inc overnight stay), 3 days \$750

Invincible Snowfields, Rees Valley Station, Glenorchy 9195, Otago, Tel: (03) 442 9933. Email:info@invincible.co.nz Web:www.invincible. co.nz

Location

Glenorchy is north-west of Queenstown (50km), at the Head of Lake Wakatipu. From Glenorchy its a further 15km to the Helipad (sealed & unsealed).

MOUNT CHEESEMAN

Top Lift: 1845m Bottom Lift: 1552m

Easy 15%, Intermediate 50%, Advanced 35%

Total Lifts: 3 - 2 pomos, 1 rope tows

Hire: Board & Boots \$35 day

Lift passes: Group lesson \$20 per hour. Private lesson \$45 per hour. Beginners lesson, hire & lift pass \$58 per day

PO Box 22178, Christchurch, New Zealand, Phone: +64 3 344 3247 www.mtcheeseman.com

located in the Craigieburn Range, 112km (1.5hrs) from Christchurch on SH 73, take the 12km unsealed access road to resort sign posted 1km past Castle Hill Village

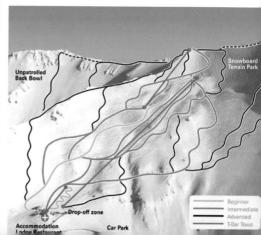

AFRICA & MIDDLE EAST

Algeria	479
Cyprus	472
India	485
Iran	473
Israel	479
Lebanon	475
Morocco	476
South Africa	479
Turkey	477
United Arab Emerator	179

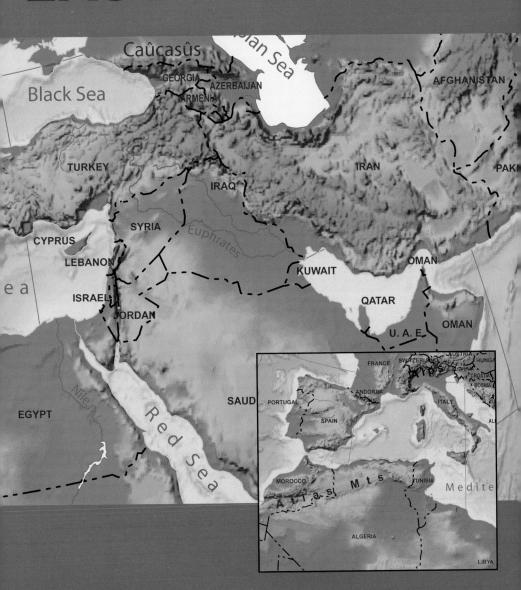

CYPRUS

Right slap in the middle of the Mediterranean island of Cyprus towers Mount Olympus. At just under 2000m it's able to collect enough snowfall from late December to March to have its own resort. Originally built and operated by the British army after the Second World War, the 1960's saw the Cyprus Ski Club take over the resort and since then they installed more lifts and expanded the terrain. It's about an hour to drive from Nicosia and Limassol or a short drive from Troodos village.

Not surprisingly the season is very hit and miss; as the snow doesn't tend to last too long once on the ground, with rocks showing through after about 4 days without snow. However when the snow is good then there are a few trees to board through. The 4 drag lifts are old but keep going all season without a hitch. Unfortunately they seem to have lost the keys to the piste basher as it is seldom used.

The slopes can be busy at the weekends and holidays, but it's normally extremely quiet during the week, with just a few people on the slopes. Locals are only just beginning to recognise snowboarding and at the moment only skis are available to rent from the store situated next to the café which is adjacent to the 'Sun Valley' run. Boards can be purchased from Force Eight Sports in Limassol.

During heavy snowfall, the local police will stop vehicles from reaching the slopes unless you're in a 4x4 or using snow chains. You can have some fun for a few days, find your board legs for the season, get some weird looks from the local (pink all-in-one wearing) skiers, and in the afternoon you can go and sit on the beach.

FREERIDERS. When there is show the double black diamond (pah) slopes of the Jubilee and Racing runs are as steep as it gets here. There are plenty of trees

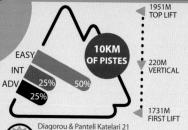

Office 101 Libra House, P.O.Box 22185 1518 Nicosia, CYPRUS

TEL: +357 (22) 675340
WEB: www.skicyprus.com
EMAIL:info@CyprusDestinations.com

WINTER PERIOD: Jan to March LIFT PASSES

Half-Day pass CYP 8.5, Day pass CYP 12.5 **BOARD SCHOOLS**

1hr group lesson CYP 8, 1hr private lesson CYP 20 **RENTAL**

Board & Boots 8/32CYP per day/week at the resort. Mavros Sports & ThreeSixty in Nicosia and Force 8 Sports in Limassol also hire hear.

NUMBER OF TRAILS/PISTES: 16 LONGEST RUN: 0.9km TOTAL LIFTS: 4 t-bars MOUNTAIN CAFES: 1

FLY: Fly to Larnaca airport

CAR: From Limassol or Nicosia follow signs for Troodos, through Moniatis village to troodos square, then follow signs to Mt. Olympus . After 1.3km take steep left for Sun

Valley area (1km) or continue for 1km to reach North Face area

FREESTYLERS. Not much fun for the freestylers with no park and very few natural hits.

PISTES. You will find the slopes narrow (20/25 m) and badly maintained.

BEGINNERS. Good for beginners to learn the basics.

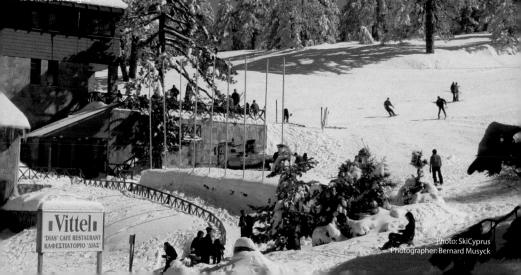

IRAN

Check official travel advice for current conditions before heading there, but Iran is cheap, the food is excellent, you can drink the tap water, and most importantly there are some excellent snowboard resorts.

The Germans, who were building much of Iran's railroads in the early 1930's introduced Iranians to skiing, and the building on the resorts begun. In 1947 the Iranian Ski Federation was formed, and in 1951 the first chair lift was built. It may be surprising to hear that 30% of all people on Iranian slopes are snowboarders. The ski lifts are well maintained and there have been no accidents in the past twenty years.

Iran has two big ski resorts; Shemshak and Dizin. Both resorts are within 2 hours drive from the capital, Tehran. There are a total of 20 resorts in the Country, although most of them will have little more than a couple of tows.

HOW TO GET TO THESE RESORTS

You will have no problems arriving at Tehran airport with your own snowboard equipment, but make sure it is in a snowboard bag. It is best to get a taxi from the airport into Tehran - it will cost \$6 maximum and will take half an hour. You cannot rent cars here so it is best to organise a bus tour from Tehran to the ski resort. This only costs \$6-\$7. You can either go up for the day or you can leave the tour and stay in the resort for the week then catch a tour bus back down. Go to one of the many sports/ski shops in Tehran to organise a tour.

GENERAL RESORT INFORMATION

Their season is from the beginning of December to the end of March. You can easily go off piste, and there are vast fields of powder. However, there are no ski patrols recording the avalanche risks nor triggering off avalanches where needed to reduce the risk. It is possible to hire a guide to go off piste for \$5-6 per day. The guides are experienced and are usually trained in Austria or Switzerland.

There are also capable mountain rescue teams. There are no heliboarding facilities. Most of the time the weather is reliable so you are sure to get a good weeks riding whenever you go. There are a variety of lifts in these resorts ranging from gondolas and chairlifts to button lifts. Also, it is wise to take your own food to the resorts. Look out for a town called Fasham on the Way to Shemshak – you can buy all your basics there.

ACCOMMODATION

The concept of bed and breakfast accommodation is non-existent in Iran. However, because accommodation is cheap why not stay in a 4 star hotel for \$50 per night for a double room. Head to the north of the Tehran; this is the safest and has upmarket hotels like the Hilton and Sheraton. You can contact the Iranian tourist board and ask them to organise accommodation for you in Iran.

WHAT TO WEAR

On the slopes it is fine to wear your normal snowboard gear. However, if you are a girl make sure you are wearing a hat. If it is sunny and you are boiling it is not advisable to strip off to your t-shirt on the slopes if you are male or female. At all other times women have to cover their hair and body but you do not need to wear a black cloak or chador. Instead it is fine to wear a colourful thin silk scarf tied under your neck and wear loose trousers, shirts with long sleeves, and a loose thin jacket that reaches down to your knees. It is fine to smoke anywhere except while walking along the street. Guys should nor wear shorts and it is best to wear long sleeved shirts.

THE FOOD

The food is unbelievably tasty – with fresh kebabs, amazing rice based dishes, fresh cheese, a lot of vegetarian dishes, amazing sweets, and an array of fruits to choose from. The thing you do have to be careful about are eating salads and herbs that haven't been washed properly. However keep in mind it is absolutely safe to drink the tap water. Also check out Arak – Iranian vodka made with raisins and dried apples containing 35-45% alcohol. It is illegal for Muslims to drink Arak, but not for Armenian Christians to drink it. Therefore as tourists, you can buy Arak from the Armenians for approximately \$3 for 2 litres.

MORE INFO

The tourist board can organise accommodation for you, work out an itinerary, give advice on prices and give telephone numbers for places, and its ok, they speak English. Contact Iran Tourism and Touring Organisation by email at info@itto.org

Iran Ski Federation,

Shahid Shirodi Sports Complex, Varzandeh St., Shahid Mofatteh Ave., Tehran, I.R. Iran. Web: www.skifed.ir Email: office@skifed.ir tel: +9821 8825161-2

DIZIN

If you continue along the road for another 30mins after Shemshak you will reach Dizin. At an altitude of 12,900 feet this is the highest snow resort in Iran and attracts the most amount of snow. Iran gets powder snow by the bucket load - it is common for 50cm to land overnight during a dump in Shemshak, and even more in Dizin. However, because of the huge amount of snow there are a lot of avalanches, and the Iranians just let them happen naturally. There is no dynamite bombing, therefore there is a risk that the road to Dizin might be blocked with snow. However, in the past three years the road has been open most of the time. To be on the safe side check at Shamshak before driving.

2650m to 3600m

Runs: 16 25% Easy 44% Intermediate 31% Advanced Lifts: 13 - 3 Gondolas, 2 chairs, 8 drags Location: Tehran 123km away and Shemshak is 71km

Dizin is a completely different resort to Shemshak. The views are amazing, as you can see unending mountain ranges and there is a clear view of the highest mountain in Iran, the semi-active volcano, Mount Damavand. Also, it is possible in this larger resort to see all nine runs. Like Shemshak, the runs are wide, long and interconnecting but there are no trees. However, the slopes are not as steep and thus attract beginners through to advanced riders. The prices for ski pass and hired equipment is the same as in Shemshak. It is also easy to find accommodation here.

SHEMSHAK

Shemshak is only a 45-minute drive from Tehran and the most popular resort. The route is stunning, with interesting towns to stop at on the way, and if you are hungry try out the amazing kebabs. Shemshak is well known as a resort for advanced skiers and snowboarders. The slopes are steep and funnily enough, have names such as The Wall. There are approximately eight extremely long runs with access to off piste slopes. Iranian slopes are generally long, wide, interconnect and there are no trees. This resort is undulating so it is hard to see all the different slopes. There are cafes on the slopes and hotels and chalets at the bottom of the slope. It is extremely easy to find accommodation as a lot of people only come here for the day or they stay at their own chalets. A one day ski-pass costs a measly \$12 for an adult. It is also very easy to hire snowboard equipment. A whole setup for a day will cost \$15, and don't worry its not second hand Russian stuff, a lot of it is brand new.

2550m to 3050m. Runs: 16. Lifts: 7 - 2 chairs, 5 drags Location: 57 kilometres north-east of Tehran

If you want to have good après-snowboard sessions this is the place to be. A lot of the Persians who come here are young, rich students studying in America or Europe and are probably on holiday seeing their parents. Practically all of them speak English, they are very western in their outlook and they are up for a damn good party. Shemshak is known as the party resort. It's best to check out a group of snowboarders that look friendly and go up and chat, mention that you have heard that this is the party resort and they are sure to tell you what's going on.

ROUND-UP

ALGERIA

There's one resort here called Chsea, and it's best to take you own equipment. The capital is Algiers and it's a 3 hour flight from the UK. Travel to the south of Algeria is not recommended due to suspected terrorist groups. Chsea, 70 km from Algiers, has been out of bounds of late so check Foreign Office advice. keep your head down and don't flash your cash. Their season is December to March.

CHSEA 1860 to 2508m Lifts: 2

Runs: 4km pistes 50% beginners 50% Intermediate

afghanistai

An English newspaper, The Independent, has reported that an ex-warlord wishes to build a 600 bed resort on the former front line battle field with Russia. After the Russians left they then fought off the Taliban. Let's hope he gets his plans off the ground and, if he does, I wouldn't be the first to explore the back country, as the area has its fair share of mines and the remnants of US cluster bombs. www.independent.co.uk

SRAEI

Israel has one major resort Mt. Hermon, located in the Golan Heights near the border between Israel and Syria. The resorts had US\$1million recently spent on updating the lifts and other facilities. There are 4 funiculars and 5 chairs covering 45km of pistes, but no sign of any terrain

SOUTH AFRICA

Capital: Pretoria - Cape Town Time Zone: GMT + 2 hours Top peak: MtAuxSources 4165m

Mostly people visit South Africa for safaris but there is a mountain with snow making facilities. Be careful here as crime is rampant, but on the whole you'll find a warm welcome. In Gauteng there's an artificial indoor

TIFFINDELL Top: 3001M

This is the only place in South Africa with snow making facilities, but its enough to give it a full 100 day season from May to September. They've built a small terrain park this year with a couple of kickers and a rail. In addition to the 450m beginners slope and the 600m intermediate one, theres also access to a chute and about 1.5km of off-piste runs. Located on Southern Drakensberg Mountains on Mt Ben Mc Dhui, www.snow.co.za

ASIA

 Armenia
 508
 Kyrgszstan
 509

 China
 481
 Nepal
 509

 Georgia
 508
 Pakistan
 509

 Japan
 486
 Russia
 495

 Kazakhstan
 508
 Taiwan
 509

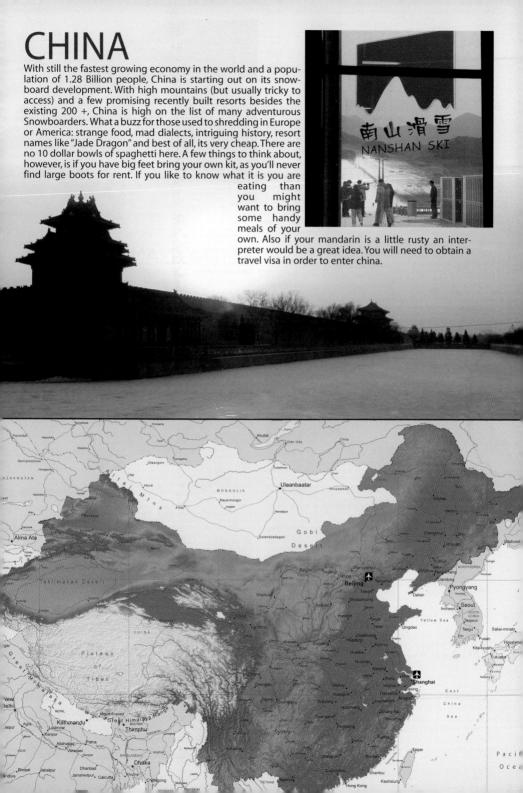

BADALING RESORT

It is located 70 km from downtown Beijing and easily accessible on the Badaling Expressway. The Bus 919 from Deshengmen Station in Beijing City stops nearby to the Resort.

The resort has three slopes, one chairlift and two draglifts. The team over there are used to Snowboarders, and in 2006 they built China's highest Quarterpipe (10m) for the Oakley Style Masters/ Arctic Challenge. One day of cheerful playing costs 220 RMB, on weekends 340 RMB.

BEI DA HU SKIRESORT

Located 50 km outside the city of Ji Lin in the Ji Lin province. Utilizing 8 lifts and 13 runs. This is one of the largest mountains in northeastern China. The runs are long and wide and it gives you great views of the surrounding countryside. The food is ok and there are plenty of small restaurants scattered around the base area. Lodging is available but you will need to call ahead of time to make reservations. This ski area is undergoing massive renovations and upgrades so keep an eye on this diamond in the rough.

BAI OING ZAI SKI AREA

This resort is located 15km outside the northern city of Shenyang in the Liao Ning province. While the mountain is small it is home to the Chinese national snowboard team . It has a Halfpipe (which is closed to the public when the kids are training) as well as an aerials training facility. It has three runs serviced by 1 double chair and 3 drag lifts. It is extremely busy on the weekends and empty during the week. The food is excellent but you have to make reservations for

lunch 1 or 2 days in advance.

JING LIAN HUA SHAN

Located 50 km outside of the capital city of Beijing. It boasts 1 quad and 6 drag lifts servicing 6 runs and 1 snowboard park. With weekend crowds in excess of 5000 it can be a little overwhelming. Night boarding is available and there is excellent food and accommodation right at the base of the mountain. Spaces are limited so reservations are a must.

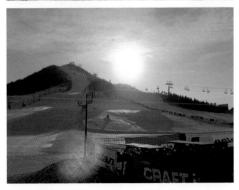

BEIJING OIAOBO ICE & SNO WORLD

The only indoor ski resort in Beijing Area is located in Miyun County. It takes a one hour ride from Beijing City to get there. It has two slopes with each one drag lift. There may be a few kickers and a waterslide pool, but that's temporary. The snow conditions are ok, it's typical indoor-fake snow. Hospitality Services are available, ask for rooms in advance.

BEIJING SHIJNGLONG

In 1999 this resort was the first area around Beijing to open for wintersports. It is a 90 min drive from the capital city. Shijinglong has 3 pistes; the longest being 1km, and served by two drag lifts and one old chairlift. Keep an eye out for some kickers and rails, but it's never sure if the management will spend

money on a professionally groomed park for each season. There are restaurant facilities and hotels nearby. Food is ok, but book rooms in advance, especially around the national holidays and on weekend it gets crowded. Boarding will cost 140 RMB for two hours on weekends, 190 RMB for four hours – the fee includes locker, rental and if you drive a car, the parking.

CHANG CHUN LIAN **HUA SHAN**

Located about 30 km outside the city of Chang Chun in the Ji Lin province. This brand new ski area is setting the standard for ski areas in China. It has 1 quad chair, 1 double and 5 drag lifts servicing 15 trails including a brand new snowboard park and mogul run as well as night boarding. The food and accommodation is possibly the best in China. Beautiful scenery and a lack of crowds make this one a must when you are on a trip through the northern parts of China.

JADE DRAGON MOUNTAIN RESORT Located close to Tibet and has an altitude of 3500

metres which is accessed by a cable car. There are no set out runs and there are plenty of trees to dodge and often loads of snow. Being located so close to Tibet means that you may have to apply for a special travel visa. Traveling in this part of the country is extremely difficult if not impossible.

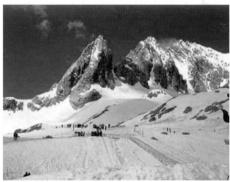

NANSHAN RESORT

The resort lies 80 km northeast from Beijing. If you go by public transport, take a bus from Dongzhimen to Miyun and then take a taxi. Nanshan offers 3 chairlifts, 2 draglifts and a beginners area. There is a snowpark, with a mini 1/2 pipe but it's not groomed all season. The Nanshan Open is held every year in January, and it held China's first professionally organised Snowboard Event in 2003. Off the slopes, you can choose from a Chinese and a Western style restaurant which offers a buffet. There are small lodges and rooms available, book in advance. Prices to hit the slope vary from 220 RMB on weekdays and 360 RMB for weekends.

WANLONG SKI RESORT The resort opened in 2003 and is located at

The resort opened in 2003 and is located at Honghualiang Mountain (2110.3m) in Hebei Province, 12 km away from Chongli Zhangjiakou. It takes about four hours by car to get there from Beijing City on highways and countryside roads. Wanlong has two chairlifts and one drag lift, and the longest piste is almost 3 km. The temperatures are frigid in winter with an average of –15 degrees, it can be quiet windy which makes it feel way colder. There is a snowpark, but not groomed all season. Take your shovel with you just in case you catch fresh powder. You'll find rooms in the nearby town, but there is a restaurant on site.

YABULI INTERNATIONAL

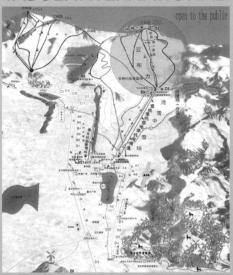

is the oldest resort in China, it opened in 1980. Public access was given in 1996 due to the 3rd annual Asian Winter Games. The resort is in the far north east of China near the Russian border in the Heilongiiang province. It's not particularly high, at under 1500 metres, but can boast Central Asia's longest run at 5km and has an average snow fall of around 50 cm. They claim 12 runs and 8 lifts, with reality 1 maybe 2 runs with one old double chair. There is a super pipe, but unfortunately it is off limits to the public. With temperatures as low as -40 you better take a good coat, especially if you want to take advantage of the night boarding. The night boarding area is tiny; a 100m slope with a small drag lift. Many of the hotels in the area only have hot water between 7 and 9 pm. And reservations are a must.

YUNFO MOUNT RESORT

This resort will host the first TTR Women event ever held on Chinese soil in 2006. The steady Halfpipe is sure to be in the best shape possible. There is one (hardly used) chair lift and two drag lifts. Costs are different during the week and on weekends too – 180 RMB for 1/2 day to 260 RMB.

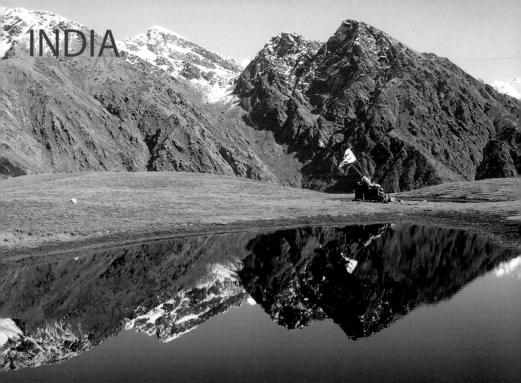

One of the best areas to ride is the resort known as Auli, near Joshimath in the Garhwal Himalayas, where snowboarding expeditions have taken place. Manali is a place that offers some serious heli-boarding while the areas known as Narkanda and Kufri are only suitable for total beginners and as such they have very little in terms of facilities and are not really recommended. The Indian season is best from mid-December to the end of March. All the areas offer a variety of terrain with a lot of freeriding and backcountry hikes, although you should only go backcountry riding in India with a knowledgeable mountain guide and the full kit.

AULI

is located in the Garhwal Himalayas and lies at an altitude of 2,500-3,048m in the province of Uttaranchal close to both the Chinese and Nepalese borders. It is within sight of Nanda Devi which, at 7816 metres, is one of the world's highest mountains. Boasting 12 miles of wooded piste and an average snow fall of 3 metres, the Winter Games Federation of India holds many events here, and they even have two German built piste bashers. There are some budget huts which are government run near Auli, and a few options for food. At all resorts in India it's important to take your own equipment. The best way to get here is by private car or to take a train from Delhi to Haridwar. From here many buses go to Josimath then vou'll have to take a taxi

GULMARG

is in the disputed region of Kashmir. A ceasefire has tentatively been in place since 2004 but the odd bomb still goes off. Although tourists haven't been targeted recently, in the past Kashmiri separatists have kidnapped and executed a few westerners. There is a new \$8million Gondola which will take you to 4150 metres. From there you can take one of the drag lifts or descend the vertical drop of 1400metres. This winter resort was first developed in the late 1940's, and you don't have to look too hard to find traces of the Raj. The golf course is one! The closest airport is Srinagar 60 km from resort.

Other snowboard areas are. **KUFRI**

is in the Himachal region 9 miles from Shimla and is a flat place which suites beginners.

NARKANDA

is in the Himachal region, 40 miles from Shimla with, the top lift at 3143m. MANAII

is also in the Himachal region just 35 miles from MUNDALI AND MUNSIYARI

are in the Uttaranchal region. **ROHTANG**

is in the Himachal region just 30 miles from Manali.

All the Indian resorts provide very basic local facilities but are very chean indeed and we all love curry

CAPITAL CITY: Tokyo POPULATION: 127.6 million HIGHEST PEAK:

Mt.Fujiyama 3776m LANGUAGE: Japanese

LEGAL DRINK AGE: 18 DRUG LAWS: Cannabis is illegal

AGE OF CONSENT: 16 ELECTRICITY: 100 Volts AC 2-pin

INTERNATIONAL DIALING CODE:

CURRENCY: Yen (JPY) EXCHANGE RATE:

UK£1 = 210 EURO = 143 US\$1 = 111 AU\$1=84

All vehicles drive on the left hand side of the road

SPEED LIMITS:

30km/h side streets 40km/h towns

50km/h non built-up areas 100km/h Expressways

EMERGENCY

Police 110 Fire/Ambulance 119

TOLLS

Expressways charge per km. Approximate cost from Tokyo to (near) Hokkaido 14,000 ven

DOCUMENTATION

Must have an international drivers licence & passport if hiring a car

TIME ZONE

UTC/GMT +9
No daylight saving changes

Shibuya-ku

Tokyo 150

Tel - +81 (0) 3 5458 2661 Web: www.so-net.ne.jp/jsba

JAPAN TOURIST INFORMATION

10 Fl., Tokyo Kotsu Kaikan Bldg., 2-10-1, Yurakucho, Chiyoda-ku, Tokyo 100-0006

Tel:(03)3201-3331 Fax:(03)3201-3347 www.jnto.go.jp

You may know that Japan is famous for over weight blokes wresting in giant G-strings, but are you aware that it boasts over 500 ski resorts? As a small country which is about 80% mountainous, wherever you are in Japan, there is bound to be a piste within range, from the sub-tropical island of **Kyushu** in the south, to the Sibberian-esque **Hokkaido** in the north.

However, with that being said, this huge number is a little deceiving. As with their cars, cameras and computers, the Japanese do with ski resorts what they do best: miniaturise. Though some resorts do match those in Europe and N. America for lift capacity, Japanese ski areas are generally much smaller, some consisting of just one lift and a single short run. However, the presence of the winter Olympics twice in this country prove that Japan has what it takes to provide world class terrain, and more importantly, world class snow.

In Japan you'll find deep, light powder through paper birch studded slopes, warm hospitality, and vending machines that sell beer and young girls knickers. Many of the resorts offer night riding sessions till 11pm, and there are even a few 24 hour resorts, perfect for those who may have slung too many sake's down their throat.

Lift Passes cost between ¥3000 to ¥5000 for a day, and only a small discount is given for multiple days. However, it's possible to by half day and single run tickets, a good money saver if the weather's bad/you're hung over. Despite its high tech reputation, credit cards are not widely accepted, and it's best to carry cash. It's worth buying your pass at a convenience store (conbini) such as Lawson, Family Mart or Circle K, as you will get about ¥1500 of lunch vouchers included in the price, a better deal than at the resort itself.

TRAVELLING AROUND

Train – Japan's rail network is expensive, but you get what you pay for – a clean, quick, punctual service, and it's worth riding the Bullet Train, (which is the world's fastest), for the experience alone. If you're going to be using the trains a lot, buy a Japan Rail Pass (only available outside of Japan), which gives you unlimited travel for a fixed time period. Prices range from £150 for a 7 day pass, to £280 for a 21 day pass. Storage for boards and other large luggage is not well catered for, so use a Takkyubin company. They provide a great service that delivers your gear to any address in Japan, for around just £8 a piece which saves a lot of hassle. Look out for their service counters at airports and train stations.

Car – You'll need an International Drivers License to drive here, but they drive on the left, and most road signs are in English. Watch out for kids and grannies cycling on the wrong side of the road, it seems to be legal here! Hire cars aren't cheap, and the numerous toll roads can really pump up the price of a road trip, so unless you're in a group, a car isn't the best option.

Bus – There is an extensive bus network that will whisk you away to any resort in Japan. Overnight buses offer spacious reclining seats (a far cry from National Express!) and the competition is so strong that it's easy to pick up a great package deal, includ-

ing bus, lift pass and accommodation, for much less than it would cost separately, so it's well worth a look.

THE SEASON

Like the rest of the Northern Hemisphere, Japan's winter runs from December to March. The country cops cold air streams coming down from Siberia which pick up moisture on their way over the Sea of Japan, and when they hit the mountains they bust their almighty load all in a big way. The result: a country that receives one of the highest snowfalls in the world.

Japan is made up of four main islands, and all have some ski areas, but for the crème of the crop, the main island of Honshu, and the northern island of Hokkaido are where it's at. All but a handful of tiny ski areas now allow boarding on their grounds, and many have full terrain parks with half pipes, chunky cheese wedges, and some lengthy rails. Katsuyama Ski Jam boasts a 55m beast – currently thought to be the longest in the world!

With beautiful mountains comes tranquillity, or so you'd think, but if you like to cruise down the piste with nothing but the sound of powder spurting out of your exhaust, you might find Japan's love for blasting out music across the pistes a little rude at first. Forget the serenity and think crass J-pop mixed with phat hip hop coming at ya from a lift pylon.

Japan is famous for being a super high tech country having pimped out their Nintendo's and Playstation's to the rest of the world. However, in many aspects they are still in the stone age. Although you would be hard pushed to find a drag lift in a Japanese resort, the existence of rusting, one man chair lifts is common. These are an experience in themselves to ride; with no foot rests, or safety bars of any kind, hold on tight for the ride of your life. Their toilets too, are somewhat of a gamble. Either you get the power arse washer model complete with heated seat and control pad resembling a console, or you get a hole in the ground.

There is an age old misconception that Japan is a) expensive, and b) crowded. While a trip here is obviously going to cost more than a jaunt to Andorra, the general cost of living is on par with the UK, with many things being considerably cheaper. Petrol for instance is a third cheaper than the UK, a pack of twenty ciggies will set you back just £1.50 and eating out is a generally a bargain, as you can pick up a filling set menu for less than a fiver.

Whilst Japan does have a population density higher than that of Europe, this doesn't mean that the slopes are crowded. In fact, the Japanese tendency to work insanely long hours (e.g. 12 hour days, 6 days a week) mean that apart from Sundays, resorts are often very quiet. One man powder sessions have been known, which adds a new slant to the mantra "No friends on a powder day"!

OFF THE SLOPES

You may have heard that the Japanese are a shy, reserved race, which is true to some extent. However, get out of the big cities to the more remote areas and you will be treated with genuine kindness and

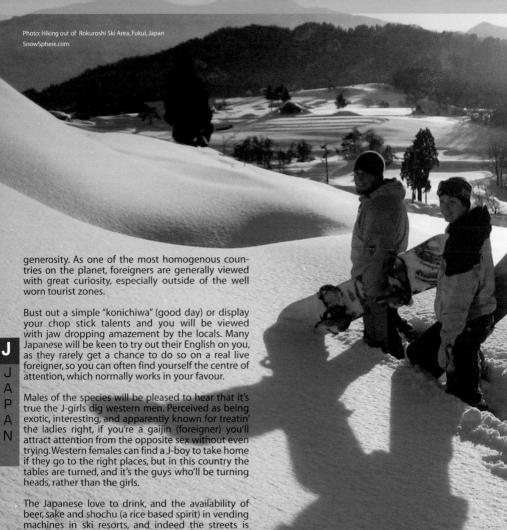

testament to this. Though resort nightlife doesn't match that in the west, there are always a few bars and clubs to get friendly with the locals. Once the alcohol starts flowing, the Japanese lose all trace of their stereotypical shyness, so expect to be questioned about anything, from the length of your dong, to the size of your boobs.

One of the best things about Japan is the abundance of both indoor and outdoor public hot springs, known as onsens. With so much geothermal activity, onsens are everywhere, and many ski resorts have them on site. This is the perfect way to relax those aching muscles after a day on the slopes. These are almost all single sex affairs, as it is onsen law to bathe in your birthday suit. The standard procedure is to shower down first, and then take a dip in the tub; bombing is most certainly a faux pas. For those that have ink, a word of warning: in Japan, tattoos are generally frowned upon by the older generation. This is because until recently tattoos were the trade mark of Japanese Mafia (Yakuza) members. Many

Onsens bar entry to those with tattoos, and some even display signs to this effect.

Aside from snow, Japan has tonnes to offer the traveller, from magnificent ancient temples, to the neon bustle of the cities complete with karaoke bars and love hotels. Even the humble supermarket with its octopus tentacles, pig intestines, and unidentifiable vegetables, becomes a tourist attraction for the wide eyed westerner, so it's worth taking a few days off from riding to lap up a little eastern promise.

So, if you want to ride somewhere off the beaten track, see a country which is wildly different from the west, which offers some of the world's best powder riding and most importantly, visit a country where you can buy not only beer, but porno mags and sex toys from vending machines, it's gotta be Japan....

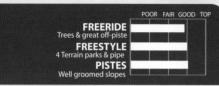

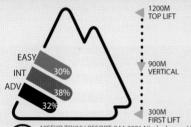

NISEKO TOKYU RESORT, 044-0081 Niseko kogen Hirafu 204 Kutchan cho, Abuta Gun Hokkaido, JAPAN TELEPHONE: 0136-22-0109

WEB: www.niseko-tokyu.co.jp / www.grand-hirafu.jp EMAIL: hirafu@resortservice.co.jp

WINTER PERIOD: Dec to early May LIFT PASSES

1 Day Pass 4300 yen, 5 days 18,300 Night Pass - 2700, Season 87,000

HIRE Snowboard hire is available from plenty of places on the mountain. Goodsports has a great range and is on the main road half way up the hill to the lifts.

BOARD SCHOOL Half day 3,200yen, full day 4,800 Learner Day package 2hr lesson, hire & lift 6,800yen

SNOWMOBILES Snowmobile tours are available from 7800 yen. Deep powder riding available.

NIGHT RIDING here is regarded as a must do. Large ride area including tree runs and terrain parks, till 9pm every day

TOTAL NUMBER PISTES/TRAILS: 34

LONGEST RUN: 5.6km

TOTAL LIFTS: 20 - 1 Gondolas, 19 chairs LIFT CAPACITY: 22,300 people per hour

LIFT TIMES: 8.30am - 9.00pm **MOUNTAIN CAFES: 7**

ANNUAL SNOWFALL: 11m SNOWMAKING: none

FLY:International flights available to and from Chitose Airport, Sapporo approx 2 1/2hrs from resort BUS: Bus Service from Chitose Airport, Sapporo to Niseko-Hirafu. 8 times daily 38,500 yen return

CAR: Sapporo to resort is 102.1km, approx 2 1/2hrs drive Take nakayama pass(route230) for 66km, then Kyougoku (route276) for another 30km, then (route 343) to resort

TRAIN: To Kutchan station, 15 mins away take a bus or taxi to resort. Kutchan to Sapporo (Hakodate Line) approx 2 hours

well with resorts in mostly a freeriders resort and the n be its big mountain terrain, however it also has parks incredible night riding and a modern lift system.

Niseko gets on average a good 11m of light dry powder. so during the months of January and February you can expect regular and major dumps. Niseko is essentially one mountain although it is divided up into three linked areas covered by one mountain pass. This area does have avalanches so check with the ski patrols to get the latest info. The tops of Annupuri, Higashiyama, and Hirafu are all within a few hundred metres hike of the top of the mountain (1308m). From here you can ride down backcountry to Goshiki Onsen (hot springs) on the opposite side of the mountain. To get back you'll need a taxi or the infrequent bus.

FREERIDERS should head straight to the peak. After a 20min hike from the top chair you reach the peak of Mt Annupuri. From here your options are close to 360 degrees with views from volcano to sea. The terrain is endless with open powder bowls, trees and gullies. The length of your ride is governed by how far you want to hike to get back inbounds. The hike back is along a cat track however some runs off the peak can get you back to a lift without hiking. The backcountry is sensational with plenty to choose from all within easy access of the resort. Backcountry tours are available from Niseko Powder Connection +81-136-21-2500 or the Niseko Outdoor Adventure Sports Club tel +81 136-23-1688, which has a shop near the Hirafu base. A full day costs 7000-8000 yen

FREESTYLERS are well catered for with 1 halfpipe and 4 terrain parks. The terrain parks range from pro to beginner and are well made and maintained with a good variety of hits and rails. Also if you look hard enough you will find plenty of hits built by enthusiastic locals.

BEGINNERS can start on their own slope without feeling in the way and then slowly graduate up the mountain at their own leisure. With easy runs available from top to bottom beginners can also enjoy the 900m of vertical Niseko-Hirafu has to offer.

OFF THE SLOPES

Accommodation is found in the village directly below the lifts and ranges from five star hotels to family owned pensions. **Food** in Niseko-Hirafu is excellent, the variety of local traditional places is superb with each one creating its own unique atmosphere. The bu-cha bar & restaurant is a great place to go for a meal or just to have a cheeky one off the wood. Hank's a cosy little cabin where Hank cooks up meals on an open fire and Bia Cliff serves great food and is open late. There is also a couple of mini marts for groceries and alcohol. There are more options in the town of **Kutchan** (15 mins away). Nightlife is rather laidback but can get amped up at certain times of the year if you know where the parties are. Plenty of bars to choose from and most are open to the early hours if you're feeling thirsty. Fatty's bar is two trucks parked together to create a unique bar.

SKI-JAM

Good for a day

Marketed as the biggest ski area in west Japan, Ski Jam attracts crowds from Osaka and Kyoto who come to enjoy the tree lined slopes and well maintained terrain parks. However, in comparison to European and N. American resorts, the skiable area isn't particularly large; there is enough terrain to keep intermediates happy for a couple of days, but you'd get bored if you stayed for much longer. There is a hotel complex at the base of the slope and there are several mountain restaurants and cafes. It also offers mountain biking and paragliding come summer, making it an all year round destination for outdoor enthusiasts.

The mountain itself can be quite beautiful, with some lovely runs through birch and pine tree lined slopes. Unfortunately a lot of the best terrain is cordoned off, and be careful when ducking ropes, as the ski patrol tends to be quite strict here and will clip or even confiscate your ticket if you persistently offend. TIP: If you're going just for the afternoon, it's worth hanging around the entrance of car park and asking people who are leaving if they want to sell their ticket. The going rate is Y1000, and occasionally for free. You may need a little Japanese to pull it off, so get your phrase book ready!

FREERDING There's plenty of nice wide open slopes for cruising, and some nice birch and pine tree runs if you're willing to duck the ropes.

FREESTYLERS will have fun on the various terrain park features. Two different areas are maintained – one with small jumps and rollers, the other with several rails and boxes, and some larger jumps, but there is no half pipe. This resort recently built what was thought to be the world's longest rail at 55m long, but there are plans to make it even longer in future!

BEGINNERS will find gentle slopes which are ideal for learning and Ski Jam offers lessons in English, but beware if you're visiting on a Sunday, as it can be dauntingly busy!

OFF THE SLOPES The nearest town is **Katsuyama**, which is a 20 minute drive down from the resort, but there's not a lot going on here; it claims a population of 30,000 but it feels more like 3000. It has all the normal services - banks, big supermarkets and plenty of small restaurants, but the town is very spread out and lacks any real heart. There is a famous two day fire and taiko drum festival called 'Sagicho' every February, which is well worth seeing if you're around. There is also an amazing temple here which is stunningly beautiful in the snow, and inside you'll find Japan's largest seated Buddha statue - which is HUGE!

In terms of night life, this place is dead, but there are a couple of quality restaurants, most notably *Atom Sushi*- a

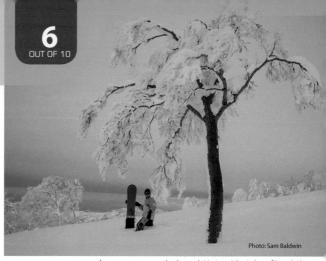

cheap conveyor-belt sushi joint, (their beef"sushi" is a must!), and Yamada Katsudon, a quaint, family run restaurant which serves delicious Katsudon - breaded beef, pork or prawns in a delicious BBQ style sauce - get a full set for just £4!

POOR FAIR GOOD TOP

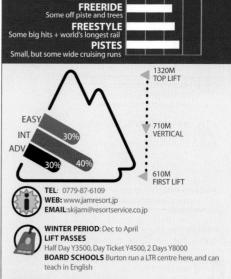

NUMBER PISTES/TRAILS: 12 LONGEST RUN: 4.8km TOTAL LIFTS: 9 - all chairs

MOUNTAIN CAFES: 3

ANNUAL SNOWFALL: 8.6m SNOWMAKING: none

TRAIN: Direct to Fukui station

FLY: Closest international airports are Osaka Kansai, & Nagoya.

CAR: 3hrs drive from Suita (245km) and 2hrs 40 from Ichinomiya (182km)

BUS: service runs from Fukui station to resort. For services from/to Okayama Tel:086-226-1515, or Osaka tel:06-6345-5671

HOKKAIDO ISLAND ASAHIDAKE ONSEN

Other Hokkaido Hills, are **Asahidake** and its located in the centre of Hokkaido with one lift and you're free to make your own route down (a major draw point in regulated Japan). There are plenty of trees and with Hokkaido's excellent snow record there is usually plenty of powder

RIDE AREA: 100acres

Kagoshim

RUNS: 4 LONGEST RUN: 2.2km TOTAL LIFTS:1

TOP LIFT: 660m BOTTOM LIFT: 140m

CONTACT: Tel: 0166-68-9111 www.asahidakeropeway.com

HOW TO GET THERE: You can take a bus from Asahikawa Station (4 per day) take Tenninkyo/Asahidake route (no. 66) from the No. 4 bus stop outside.

FURANO

Furano is a major summer and winter resort. It is run by the Prince Hotels Group, which offers the largest hotel slopeside. There is also plenty of accommodation to be had in the town. It can be reached by

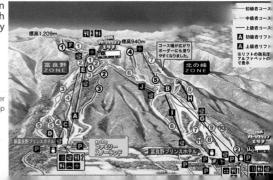

bus from either Sapporo or Asahikawa (the nearest airport). This place is one of Japan's most famous ski areas and has hosted World Cup ski events. There's a big night skiing area, plenty of trees and natural hits for freeriders and also long groomed runs for carvers. In the centre of Hokkaido it is known to get very cold in January which means the powder usually remains fine.

TOP LIFT: 1209m BOTTOM LIFT: 250m

TOTAL LIFTS:17 RUNS: 12

CONTACT: http://www.princehotels.co.jp/furano-e

HOW TO GET THERE: Furano station - 10 mins away, 60 minutes from

Asahikawa Airport. Buses available from Sapporo and take 3 hours

NISEKO KOKUSAI MOIWA

Niseko Kokusai Moiwa is a cheaper and much smaller resort on a lower peak just to the west of the main mountain. It is probably only worth a trip if you have more than 3 or 4 days in the area, but it is reputed to offer some great backcountry riding

RIDE AREA: 8 runs TOP LIFT: 800m BOTTOM LIFT: 330m TOTAL LIFTS: 4 HOW TO GET THERE: Niseko Station - 20 mins away

SAPPORO KOKUSAI

Sapporo Kokusai is 30 minutes from **Sapporo**, is well set up for boarders with both a park and pipe. You can find good freeriding and some excellent riders. Japanese who decide to do a season but don't want to move to a resort itself, often take a part time job in Sapporo and spend their free time riding here. Sapporo was one of the first in Japan to actively encourage riders. The run below the gondola is fun, while a hike to the top gives access to some backcountry.

RUNS: 7 TOTAL LIFTS:5

TOP LIFT: 630m BOTTOM LIFT: 140m CONTACT: www.sapporo-kokusai.co.jp

HOW TO GET THERE: Sapporo Station - 90mins away

TANIGAWADAKE TENJINDAIRA

Tanigawadake Tenjindaira is a small ski area and if you stick to the marked courses you'll soon get bored. Despite this it's popular with local riders because of the large backcountry area that it gives access to. It's also a high level resort by Japanese standards and is open with natural snow from December to May. Located just above Minakami in Gunma Prefecture, this is a place where you have to be careful not to be caught by the ski patrol if you decide to ride off into the unknown. The Japanese call such patrols urusai, which means 'loud' or "noisy". There are quite a few riders who base themselves here for a season partly because of the cheaper season pass. The best time to visit is between mid-January and the beginning of March, when there is enough snow to ride down to the base of the gondola giving the resort an extra 300metres of vertical. The only problem is that your day lift pass doesn't cover the gondola so if you try a longer run you should do it late in the

day or make sure that you can afford the #5 a time gondola charge

Honshu Island

ARAI MOUNTAIN

Arai Mountain Resort has been running for just over 10 years and was developed by the Sony Corporation. As a result the facilities are quality, and unlike a lot of other Japanese resorts the lifts are all new and fast. It's definitely one of the best resorts on Honshu and attracts some very good riders. It often hosts rider camps in the spring and international contests. The terrain is in a bowl and even allows for a little hiking (unfortunately banned by most resorts here). There a very well kept 100m pipe but the main attraction is the powder resulting from the big dumps (04/05 season 6.5m) because of its location in the first mountain range west of the Japan Sea. This could also be seen as its main drawback as it is a long way from Tokyo. Snowboarders just edge out the number of skiers, and theres night boarding on saturday nights

RIDE AREA: 100acres TOTAL RUNS: 11

RUN DIFFICULTY: Easy 30%, Intermediate 45%, Advanced 25%

TOP LIFT: 1280m BOTTOM LIFT: 340m LONGEST TRAIL: 5.4km TOTAL LIFTS:6

LIFT PASSES: Day pass 4,500 yen, nightboarding 2,000 yen

CONTACT: www.araimntspa.com

HOW TO GET THERE: To get to Arai. take the bullet train to Nagano (2 hours from Tokyo) then a local train (1hr 40mins) then a free shuttle bus (15-mins) to the slopes. All this will set you back about 90 USD in train fares, so it may be worth looking into bus tours if you don't have a rail pass

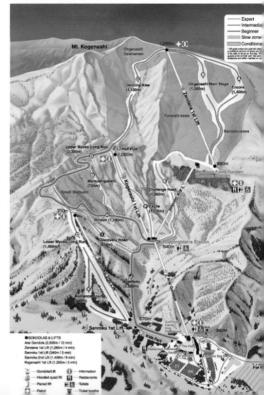

FUKUI IZUMI

This small ski area has just two lifts, but is a popular hang out for local freestylers due to the abundance of rails and jumps. Despite the 4 hour journey, it's often frequented by people from **Osaka**, so it must have something going for it. This is home to the "Mixture" crew – a collective of local Japanese skiers and snow-boarders who rip! (www.mixture-web.com)

GALA YUZAWA

Conveniently located, it even has its own bullet train stop, (one along from Echigo Yuzawa) this is a modern set-up, especially popular with the younger day trippers. Here you don't have to endure a 10-minute bus journey but you will have to put up with higher prices and unfriendly staff (even a single locker costs #5).

RIDE AREA: 126acres RUNS: 15 TOTAL LIFTS:11

TOP LIFT: 1181m BOTTOM LIFT: 800m

CONTACT: www.gala.co.ip

HOW TO GET THERE: Gala Yuzawa train station at resort

HACHIMANTAI

Hachimantai in the Tohoku region could be done as a "day" trip with the overnight bus from Tokyo, but really it's pretty far north on the way to Hokkaido. There are plenty of good natural hits, an excellent halfpipe and some decent backcountry.

HAKUBA 47

Hakuba 47 opened in 1990 and was one of the last bastions of ski only areas, but now fully embraces boarders. It's linked to the tiny resorts of Hakuba Goryu and limori which altogether provide 14km of pistes set in about 350 acres.

Hakuba is home to the R-4 terrain park and the 135m FIS standard half-pipe. There's 3 separate lines, the pro-line includes a 20m kicker and a 12m table-top with up to 20 features depending on conditions. The dedicated park team make sure it's kept in top condition.

RIDE AREA: 350 acres TOTAL RUNS: 23

RUN DIFFICULTY: Easy 30%, Intermediate 40%, Advanced 30%

TOP LIFT: 1676m BOTTOM LIFT: 876m

LONGEST TRAIL: 6.4km TOTAL LIFTS: 9

LIFT PASSES: Half day pass 3,500 yen, Day pass 4,500 yen

5 weekday pass 15,000 yen , Season 58,000 yen

CONTACT: www.hakuba47.co.jp

HOW TO GET THERE:

Bus: Free bus from Nagano station to resort. Leaves 9:10 and returns 16:35, tel 0261-75-3147 to reserve

Train: Bullet trains from Tokyo go 10 times a day to Nagano station then take a bus to Hakuba. Train costs 7,970 yen, Alpico Bus 1,400 yen (one way)

Car: From Tokyo take the Chuo Expressway for 182.1Km, then Nagano Expressway for 33.1Km, then pick up the Route 147 & 148 for 51Km. Approx 4hrs travel time.

JOETSU KOKUSAI

Joetsu Kokusai is a little further afield (30-mins by bus). It has one of the largest terrain parks (i.e. more than 4 jumps) in Japan and two good pipes. These are both in front of the Edwardian looking hotel. For freeriders the Osawa slopes are best. This is a good resort for boarders, although some of the lifts are old and slow. It is not worth visiting the peak.

KANDATSU KOHGEN

On a good snow day this is the pick of the resorts near to the station and offers some steep terrain and tree runs below the lifts. The black runs aren?t groomed so leaving plenty to shred

KUZURYU

Another one of Japan's "micro resorts" this small area has just 4 lifts and little in the way of freestyle terrain. However, it's never busy, and you can have fun dipping in and out of the powder, dropping ledges and slashing the snow banks.

MANZA ONSEN

Manza Onsen is a high resort by Japanese standards but also pretty small. Just down the road from Manza Onsen is Omote Manza which is a more popular resort with boarders.

MUIKAMACHI HAKKAI-SAN

Muikamachi Hakkaisan can be a powder paradise in January and February. It is an hour further west from Echigo Yuzawa (30-mins by local train to Muikamachi, then 30-mins by bus). Because of this it is usually less busy but still managable in a day trip from Tokyo. The resort is especially popular with skiers out to enjoy the moguls, so there is usually plenty of terrain left for freeriding. Below the gondola is a 3km downhill course that will take it out of you. The No. 3 chairlift lets you enjoy a shorter workout. The Raku (easy) course allows you to cut through the thick forest and offers plenty of air points but there is no pipe or park. The area itself is one of the most famous in Japan for sake (rice wine) which you will no doubt get to taste if you stay here. In the winter 'Atsukan' (hot rice wine) is good for warming you up, it's available here and in all other resorts.

www.princehotels.co.jp/ski/hakkaisan

MYOKO KOHGEN

15 minutes by bus from Echigo Yuzawa this resort offers all types of riding. There is a pipe, a tiny park and plenty of terrain to keep freeriders happy. Out of the resorts, near to EY station it's perhaps the only one where freeriders could enjoy consecutive days and actually find something different.

NAEBA

Naeba is perhaps the most famous resort in Honshu and more like a western one in terms of the number of hotels and other things going on.lt is a 45-mins bus journey from Echigo Yuzawa station. Snowboarding has been allowed all across the hill since the 98/99 season and they have now built their own mini park and regularly host air contests. However, there is no pipe and the resort is best for freeriders. Similarly to Niseko and Zao, you can happily enjoy three or four days here without getting bored. There are

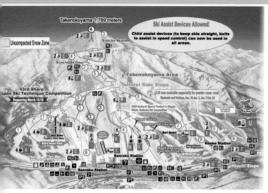

some excellent tree runs if you duck the ropes and because of the lack of Japanese who do this you're always able to make your own tracks. The best spots for doing this are below the No. 1 gondola, and of the No. 2 gondola.

Accommodation in Naeba is operated by the Prince Group, which offers a variety of modern slopeside accommodation (++81 (0) 257-89-2311). If you call in advance there are usually special deals going, including lift pass. Oji Pension (0257-89-3675) is just 5 minutes walk behind the Prince Hotel, and is run by the friendly Mr. Sakamoto. He has a stock of new rental boards and a Brazil shirt signed by Pele. A futon, breakfast and evening meal should cost around 7500 yen, and he can sort you out with lift pass discounts

RIDE AREA: 486 acres TOTAL RUNS: 28

RUN DIFFICULTY: Easy 30%, Intermediate 40%, Advanced 30%

TOP LIFT: 1789m BOTTOM LIFT: 900m

LONGEST TRAIL: 4km TOTAL LIFTS: 29 - 3 Gondolas, 26 chairlifts LIFT PASSES: Half-day pass 3500 yen, Day 4000 Yen, Night Pass 2000 CONTACT: http://www.princehotels.co.jp/ski/naeba-e/index.html HOW TO GET THERE:

Train: Take the Joetsu Shinkansen to Echigo Yuzawa Station (40 mins away) then pick up a Prince Hotel bus

Car: Take Tsukiyono Interchange on the Kanetsu Expressway, exit Highway 17 for 33 kilometers. Take the Yuzawa Interchange onto Highway 17 and continue for 21km

NOZAWA ONSEN

Nozawa Onsen is a major ski resort in Nagano with a big area and beautiful views. Riders were banned up till '98 and were only allowed on a few green runs in '99. Nowadays you can roam free and there's a terrain park & pipe. At rougly 1000 acres its one of

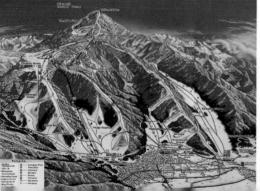

the biggest resorts in Japan. It's famous for its hot springs and thus has plenty of accommodation on offer.

OZE TOKURA

Oze Tokura is a small resort within 3 hours drive of Tokyo. It has become well known by dedicating itself to snowboarders and organising regular events. The mountain itself is nothing special, but freestylers should enjoy the funpark and halfpipe

SEKI ONSEN

Seki Onsen is a resort, which understands the needs of the powder hounds. Near the west coast in Niigata Prefecture it has a great snow record, often with 1m plus dumps overnight in Jan/Feb. There's a decent pipe and some good natural hits and kickers. Locals or the patrol will advise you on back country riding they'll also tell you that you have to take responsibility for yourself, although in the land of group culture it's cool to find somewhere that lets you do this. Seki Onsen is the home resort for Masanori Takeuchi, a well-known Japanese rider.

SHIGA KOHGEN

Shiga Kohgen includes about 10 separate resorts, among which is Yakebitaiyama where the first Olympic snowboarding gold medal was won

SHIRAMINE

Located in the prefecture of Ishikawa, Shiramine is a great little ski ground. Though small, the lifts offer access to some steep, deep, terrain with plenty of trees, and this place is never busy, and has been know for some awesome powder days.

ZAO

Zao is a major winter resort. The runs are long and well suited to carving or freeriding but with only a limited amount of off-piste and tree runs

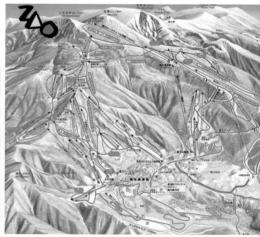

The West's influence has taken over and Russia is not the place it used to be. Snowboarding, especially freestyle, is becoming increasingly popular. Almost every major region has its own snowboard resort and almost every resort has some sort of snowboard terrain park or at least a half-pipe. Specialized magazines and websites appear almost every month and you see more and more snowboards around every winter.

The main advantages of snowboarding in Russia are the huge amounts of snow, lower prices, and exotic locations. Add to this some great sightseeing to be made along the way and you'll get an unforgettable experience. The disadvantages are that the resorts are quite small (the largest has only 35 km of runs) and some have long lift queues.

Most of the better resorts in Russia are very suitable for freeriders. The best and perhaps the most known places to snowboard in Russia are Elbrus and Cheget mountain, Kamchatka, and Sheregesh.

The first, **Elbrus** (southern Russia), is the highest peak in Europe and offers a lot of great off-piste terrain. It is also easily accessible with a plane from Russia or Europe and can be quite cheap.

Kamchatka is the exotic volcano land located close to Alaska (USA), on the east coast of Russia. It will be like a paradise for advanced riders who will love doing heli-boarding and riding the beautiful terrain along the volcanoes. It is quite remote, though, and even though helicopter rent and living costs are not too high, the overall price of the trip can be quite

CAPITAL CITY: Moscow POPULATION: 142.8million HIGHEST PEAK:

Gora El'brus 5633m LANGUAGE: Russian LEGAL DRINK AGE: 18 DRUG LAWS: Cannabis is

illegal
AGE OF CONSENT: 16
ELECTRICITY:

220 Volts AC 2-pin, 50hz INTERNATIONAL DIALING

CURRENCY: Ruble EXCHANGE RATE:

UK£1 = 50 Euro1 = 34 US\$1 = 27 NZ\$1 = 17 CAN\$1=24

CODE: +7

All vehicles drive on the right hand side of the road

SPEED LIMITS:

60km (37mph) towns 90km (55mph) outside towns Speeding fines payable, "unofficial" payment not uncommon

EMERGENCY

01 - Fire 02 -Police 03 - Ambulance

Very few car hire companys rent cars without a driver for you. Some very dodgy roads, less than half of roads are sealed

DOCUMENTATION

Home driving licence and a russian translation of it. Passport.

TIME ZONE
UTC/GMT+3 hours
Daylight saving time:+1 hour

RUSSIAN SNOWBOARD FEDERATION

Ananyevskiy pereulok, 5/12, office 161 Moscow 125502 www.snbrd.ru

TRAINS

Train services around the country are okay and very affordable. The metro trains in Moscow are superb with stations that are a work of art. It is also possible to take trains from the west to the east, but you will need to change trains on route as Russia uses a different rail gauge.

BUS

Buses services in Russia are cheap and on the whole good but they are also notoriously slow and time tables are a myth.

FLY

Gateway international airport is, Moscow (Sheremetevo). The airport is 18 miles out of the city.

Approximate global air travel times to Moscow: from: London 5^{1/2} hours Los Angles 17^{1/2} hours, New York 14 hours

way to russ

Sheregesh is a major Siberian resort, which offers lots of super powder snow terrain for freeriders. It can be accessed via Trans-Siberian or with a plane and is quite cheap. A real rough, cold, but enjoyable Siberian experience.

A few resorts at Urals -- **Abzakovo, Bannoe** and **Zavyalikha** -- are more suitable for freestylers. The riding area is quite small, there's not too much snow at times, but the natural hits and occasional snow-board parks can occupy you for a couple of days.

VISA INFO

All visitors to Russia must have a passport and a valid visa. The maximum visa time for a tourist is 30 days, however, various other visas are available, such as a business visa which can last for up to 60 days. A transit visa only lasts for 24 hours and is used for individuals who intend only to pass through the country en -route to another. There is a charge for visas and delays brought about due to too much bureaucracy. Contact national embassies for full details.

HEALTH

A helpful point to note is that most UK visitors can get free emergency medical care provided the individual has a valid passport.

If you ever thought about taking a Trans-Siberian railway, then **Baikalsk** is your chance to "kill two rabbits with one shot." This small, but well maintained resort on the shore of the biggest and deepest lake in the world - Baikal - is located just a few hundred meters from a Trans-Siberian stop (just after Irkutsk) and can be a refreshing stop after a 4-day train journey.

Krasnaya Polyana is the Russian version of Sierra Nevada: the Black sea is less than an hour drive away. It is also the most comfortable and the most westernized resort, but the most expensive in Russia.

The capital city Moscow has quite a few snowboard areas in the city and around. The most notable are **Volen and Stepanovo, Sorochany,** and **Ya-Park** (features a terrain park and a half-pipe). They are all located very close to each other 1.5 hours drive to the

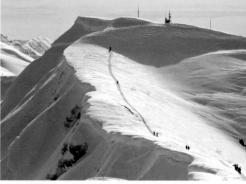

north of Moscow. **Kant** is only a 30-minute metro ride from the center, but it's too small.

pic -One of Moscows hills, Chris Horner

The "northern capital" of Russia, St. Petersburg, also has an area about 1.5 hours to the north of the city, where you can find similar resorts: **Snezhny, Zolotaya Dolina,** and **Krasnoe Ozero.** They all have something to offer to snowboarders: terrain parks, half-pipes, big-airs, and cheap self-catering accommodation.

All resorts have a good range of accommodation for

any budget and demands (except Moscow, where everything is too expensive), and lots of cafes and restaurants. All the resorts listed here provide snowboards for hire (but some resorts have a poor choice) and the board leashes are never required. Snowboarding is possible from mid-November to late April (till August at Elbrus), but the temperatures can go as low as -25 in mid February. English is spoken by some Russians in Moscow and St. Petersburg. but not much elsewhere, so learning at least the Russian cyrillic alphabet will make things a lot easier.

Make Your Way to Russia!

Log on to www.waytorussia.net travel guide to learn how to:

Get a Russian Visa

A simple 3-step process, no reservations, no ties.

Find Accommodation

Apartments, hotels, chalets for all budgets.

Travel to and around Russia
 Get there for as little as £40 one way.

Have a Great Time

The best places to go out are listed in our destination guides.

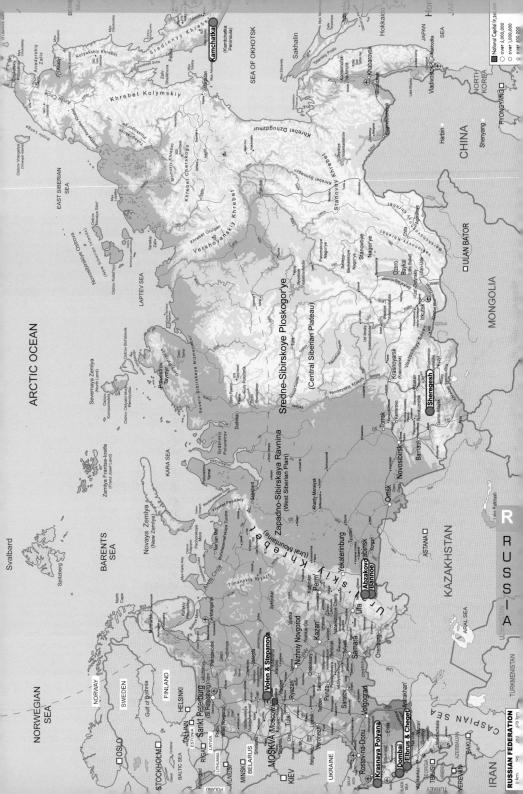

DOMBAI

6 OUT OF 10

Crowded but has a pioneering feel to it

Set amongst the Caucasus Mountains near the Georgian border is Dombai. It has a unique atmosphere and is often visited by Russian tourists and locals who tend to go up the mountain to eat, view the peaks and drink Vodka as opposed to boarding. The riding is good with plenty to suit all. The lower slopes provide some runs through the trees which are gentle and ideal for beginners. Even though the mountain has three piste bashers, grooming is infrequent and piste markings generally range from poor to non-existent. There are lots of hiking options available although Russians are not big on going off-piste.

The chair lifts and cable cars are from the bygone era and nothing is new. You will see some of the most ingenious repair work undertaken. Take for instance the broken perspex windows of the gondola car, they have drilled holes either side of the crack and then sewn it together. The lifts are interesting with a "pay as you ride" system. When lifts are down, some of the piste basher drivers charge each person to ride on a Cat Track tour. Safety is not high on the list of priorities, but it has to be remembered that this is Russia and anything goes.

FREERIDERS will get the most out of this place. Due to the limited number of snowboarders (about 5%) who come here you can be sure when the powder falls it can be ridden for days with no chance of being tracked out.

FREESTYLERS. There's nothing laid on during the winter season. Facilities arise only at the end of March for the Spring Snowboard Camp when dozens of Russian freestylers come here to practice.

BEGINNERS. The runs are not recommended for beginners, you'll find them steep and often icy except for a few lower runs. Besides, there are no markings on the runs and too many people riding in all directions

OFF THE SLOPES. Dombai is a relatively small settlement, so in terms of entertainment and apres-ski it's quite a dull place, but the mountains are really beautiful. Most of the people who live at Dombai earn money for the whole year during the winter time renting out their apartments to tourists. The locals are friendly and are very pleased to meet foreigners, especially English speakers, as they like to practice their language skills and love to share their drink with you.

ACCOMODATION.There are two large hotels - "Gornie Vershiny", tel +7(87864)58236, 58230, 58192 - rooms 800-1000R per night) which is 50-150 m from the lifts, and "Dombai" (\$30-\$100 per night for a double), which is 100-150 m from the lifts. Among smaller and nicer hotels are "Zolotoy Mustang" (tel +7(87872) 5-83-33, +7(928) 945-6504 - shared accommodation 500R (\$18) per person per night, rooms start at \$70 per night) and "Solnechnaya Dolina" (tel +7(87864)58269, 58291 - \$30 per person per night), 100 m from the lifts. There are also about 15 other small hotels and many private apartments to rent. During the high season and official holidays (29 December - 8 January, 4-8 March) it is hard to find an available room and you have to book two weeks beforehand.

FOOD. There are many cafes and restaurants. A meal costs \$10. The most popular cafe is "U Zuly" - you have to book the table a day before. Food is filling, try the Georgian hot cheesebread called 'Khachapuri.

NIGHT TIME madness is best sampled in the *Hotel Gornye Vershiny*. There are two disco/bars and a few places to eat. The ground floor disco is generally more for locals with a mixture of European and old Russian "Pop". Snowboard videos are shown behind the DJ's stand and the place has a distinct 70's feel purely by accident. A swimming pool and a sauna is also available in the hotel but you may need a health card to get in.

LIFT PASSES 1 day pass: 600R 6 day pass: 3200R, 10 day pass: 5000R HIRE Board & boots 300R per day BOARD SCHOOL 300R for 1 hour NIGHT BOARDING Yes

NUMBER OF PISTES/TRAILS: 10 LONGEST RUN: 5km

TOTAL LIFTS: 12 - 1 Gondolas, 5 chairs, 6 drags MOUNTAIN CAFES: 5

LIFT TIMES: 9am to 4.30pm

BUS from Mineralnie Vody bus station to Teberda (20 km from Dombai). The price is 150 R (55), takes 7 hours. The timetable is changing frequently and is totally unpredictable.

FLY Aeroflot Airlines & Siberia Airlines fly to the region. You can fly from Moscow Domodedovo or Moscow Sheremetyevo to Mineralnie Vody. A return costs \$200-\$350 inc taxes and takes 2.5 hrs

TRAIN from Moscow to Mineralnie Vody or Cherkessk (takes about 25 hours, costs 1500 R (\$59) one way. Then take a bus to Teberda or a taxi to Dombai.

CAR Via Mineral nye, you need to head south for a few kms along the M29, cutting off at Essentuki on to the A157 and the A155 via Teberda and to Dombai.

It is **not recommended** to go by car all the way from Moscow. The road is in a poor condition and the trip can be dangerous in the Caucasus area.

ELBRUS & CHEGET

Freerider's dream but nightmare lifts queues

Elbrus is the highest ski & snowboard resort in Europe (Val Thorens eat your heart out). It's located in Kabardino Balkaria republic in Russia, between the Black and Caspian seas at Elbrusie National Park, close to the Georgian border. The centre of it all is the famous mountain Elbrus which with its 5643 m is the highest in Europe. This place is the local freeriders' mecca, offering lots of clear, open powder snow terrain, as well as the opportunity to snowboard until as late into August (on Elbrus). Elbrus actually has two main riding areas: Elbrus itself, and the lower Cheget, which is about 2 km to the south. Cheget is known to be a skier's paradise, and is very underestimated for boarders; the terrain is steeper and more technical than Elbrus's powder trails. Most of area at **Elbrus** is unmarked and people are simply too scared to explore the unmarked trails, and with its better snow record its more of pure Freeriders destination.

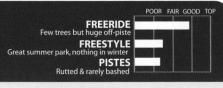

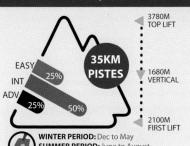

SUMMER PERIOD: June to August LIFT PASSES 50-70R single, 350R per day **BOARD SCHOOL.**

freeride course \$40 per day or \$180 6-day course

NUMBER OF RUNS: 21 LONGEST RUN: 7km TOTAL LIFTS: 8 - 2 cable-cars, 2 chairs, 4 drags

BUS All depart from Mineralnye Vody. The journey takes 2-3 hours, costs about 200 R (\$7) by bus, about 1000 R (\$35) by taxi. Beware of local taxis, as their main entertainment is to bargain, so you'll have to chat for

half an hour, before you can drive. Welcome to southern Russia. FLY Aeroflot and Sibir Airlines have direct daily flights from Moscow to Mineralnye Vody, which take 2.5 hours and cost about \$200 return.

TRAIN station is Mineralnye Vody. Daily train #34 from Moscow Kazansky station to Vladikavkaz bring you to Mineralnye Vody in about 28 hours. A better train is from Moscow Kursky to Kislovodsk (#27) also takes about 28 hours. The price is about 2200 R (\$80) one way in 2nd class.

CAR Long and it poor road quality. However, if you're up for it, you need to go along the federal route from Moscow to Rostov-na-Donu, then drive to Mineralnye Vody and from there it is a 2-3 hour jouney by car to Terskol.

The main problem with the resort are the long lift queues (especially on Elbrus - people can spend literally hours queuing) and the bad maintenance of the pisted runs; plenty of ice, stones, bumps etc. So get to the lifts as early as you

can and keep clear of the pistes. New lifts at Elbrus are a fairytale, cash flows into the local lefties pockets as long as the old lift is the only way up so they're not exactly interested in changing the status quo; it's a mafia thing no less.

The local people are very friendly and hospitable, but have the southern temperament, so if you are nice to them, they will be nice to you. If you look like an arrogant rich foreigner showing off the latest gear, you'll get it all broken against your head. Officially, the season starts in December and ends in May, but it's recommended to go in February when there's the most snow.

FREERIDING. Elbrus is perfect if you're after some offpiste terrain with clear views and powder snow, but the majority of the terrain is above tree level. As with any place, you need to have a clear idea where you're heading when venturing off piste. A good but tough place to start is Garabashi (aka "Bochka" - the highest lift point on Elbrus - 3780 m) from where you can go down towards Stary Krugozor. You will also find some very good freeriding at the top of Cheget (after the last 300-m drag lift, but keep close to the Ai Café). There's also heli-boarding tours available all over the mountain. ask the Terskol travel agency about this. If you are on a tight budget, you can get a near heli-boarding experience by renting a snow cat, which can take you to Priyut 11 (4800 m). It'll cost \$150 for 15 people, so if it's full it'll only cost you \$10.

FREESTYLE. The KingSizePark at 3750m is easily Europes highest park, but is only built for the summer camps that are run by SPC (see summer boarding section), so in the winter you'll have to seek out your own fun, but theres plenty of air opportunities on both mountains.

BEGINNERS. This is not a beginners' resort, as most piste runs are for intermediates and are not looked too well after. Besides, you're risking spending 4 hours a day in queues.

OFF THE SLOPES. The main settlement is Terskol which is at the bottom of Elbrus mountain. Azau station is about 4 km which is where the lifts to Elbrus are located. Cheget is about 4 km from Terskol. Terskol is a small southern settlement and is very hospitable with a lot of accommodation, cafes, and services. Nightlife it might get a bit rowdy. . If you are worried about terrorism with Chechnya not far away then don't worry about it. There's 500 km and a huge mountain range in between and no problem has ever been reported even during the war.

If you want to stay as close to the Elbrus lifts as possible try Azau hotel (tel +7 928 2796212) or Krugozor hotel (same tel). Both are wooden cottages with all the amenities, and will cost 500R per person. Also try "Logovo" at Azau plain (tel +7 866 38 7 11 12). Close to the Cheget lifts, is Cheget tourbase (+7 866 38 71339), from \$35 for a room. You can book through www.go-elbrus.com if your Russian isn't too hot. There are a lot of cafes and restaurants in the main village Terskol, as well as Azau and Cheget tourbases.

USQ www.worldsnowboardguide.com 499

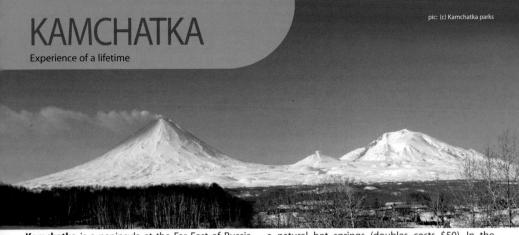

Kamchatka is a peninsula at the Far East of Russia close to Alaska. Apart from volcanoes and geysers the region is famous for great heliboarding opportunities. Advanced riders from all over the world come to Kamchatka from December to March to experience the untouched snow-fields set in the land of volcanoes. Kamchatka is a top destination for all Russian riders, but you have to know what you're doing and have a guide who can help you find your way back to the helicopter waiting somewhere down the mountain for you.

Most of the boarders prefer to ride at Viluchinskiy (2173 m), Mutnovskiy (2323 m), Avachinskiy (2741 m), Goreliy (1826 m), Opala (2460 m) volcanoes. The average route lengths is 6 km, the average vertical drop is 1500 m. The helicopters are paid on a flight time basis. The price per flight hour is \$500 - \$1800 depending on type of helicopter. There are several agencies which provide heliboarding tours, but you need to book it at least a month before. Helicopters take off from Elizovo, a village 30 km from the local city Petropavlovsk-Kamchatky. The only local company which hires helicopters is Krechet Ltd, http://krechet.farhost.ru . The helicopters are paid on flight time basis. The price per flight hour is \$500 - \$1700 depending on the type of helicopter. Maximum capacity (with equipment) is usually 12-20 people, so if you're in a group it can be relatively cheap.

www.kamchatka-parks.com run 8 day heliboarding trips, it costs 575 euros for everything except getting there and the helicopter. You can expect to pay around 1200 euros for the helicopter based on a group of 10 people sharing. www.helipro.ru also offer tours.

Away from heli-boarding there are a couple of tiny resorts dotted around the area, but none of them of any real note. The 3 main resorts are Krasnaya Sopka, Morosnaya and Edelveis. Each resort has nothing more than a couple of drags serving 3 or 4 slopes, the longest of any of the slopes here are just over 1km, and there are certainly no terrain parks.

OFF THE SLOPES

There are several hotels in Elizovo, the most popular is "Golubaya Laguna", it has a small aqua park and 500 USQ www.worldsnowboardguide.com

a natural hot springs (doubles costs \$50). In the centre of Petropavlovsk-Kamchatsky, usually occupied by American hunters and Japanese tourists is the *Petropavlovsk hotel*. Recently renovated, all the staff speak English. There is a bowling alley and a bar in the building. Double- \$88 in brekfast. Tel.: +7 4152 5-03-74 or visit www.petropavlovsk-hotel.ru for more details. The *Avacha Hotel* charges \$76 for a nice clean Double. The only casino "Collisem" in the city is in the same building. This hotel located in the middle of the city – not far from ocean, there are daily shops near and many restaurants, market is in front of it. There are TV-sets, fridges and phones in the rooms. They have a travel agency and a DHL courier office. English-speaking staff. Address: Leningradskaya str., 61

There are numerous restaurants and cafes in the city. A meal costs \$5-\$10 per person. There's virtually nothing going on in the evenings, but if you manage to hang out with local skateboarders and snowboarders (of which there are many), you're guaranteed to have good time Russian style.

Wist of the Control o

FLY Flight is the only option (except occasional ferries) to get to the region. There are no roads to connect peninsula with the mainland of Russia.

Aeroflot Airlines, Siberia (S7), and Transaero Airlines can be used to get in to the region. You should fly to Petropavlovsk-Kamchatsky. A return flight from Moscow costs \$500-\$700 with taxes and takes about 9 hours. The best offers are usually by Siberia (\$7) which offers specials to snowboarders.

S

Earliest powder in Russia but expensive

If you are not a Siberian probably the only single reason to go to Sheregesh is the local snow. Starting from the beginning of November until the beginning of March there's at least 1 m of high quality snow. The local powder is dry and fast and is considered to be the best snow in Russia. It's only the dedicated that make it to Sheregesh. You'll have to endure an 8-hour trek from Moscow, the famous Siberian frost, and almost as importantly a lack of après ski. Sheregesh is a remote miners settlement in Siberia near Novokuznetsk (Kuzbass mines). About twenty years ago the ski resort was built at the nearby

POOR FAIR GOOD TOP **FREERIDE** Trees but no real off-piste FREESTYLE Nothing except the odd bump **PISTES** Good place to learn

1270M TOP LIFT 600M VERTICAL 670M FIRST LIFT WEB: www.sheregesh.ru EMAIL: admin@sheregesh.ru

TOTAL LIFTS: 6 - 2 chairs, 4 drags LIFT TIMES: 9.30am - 5pm **MOUNTAIN CAFES: 1**

CAR not recommended all the way from Moscow. The road is about 6000 km with little infrustracture along the way.

FLY Aeroflot Airlines, Siberia Airlines and Transaero Airlines fly to the region. You can fly from Moscow Domodedovo or Moscow Sheremetyevo to Novokuznetsk (preferably) or Novosibirsk. A return flight costs \$250-\$400 with taxes and takes about 4hrs.

TRAIN Direct from Moscow to Novokuznetsk (about 60 hours, costs 1800 R one way). Direct from Moscow to Novosibirsk (48 hours and costs 1200 R one way).

BUS too far from Moscow to take a bus. From Novokuznetsk 200R one from Novosibirsk - 300 R (\$11) one way, 6-8hrs journey (depends on

the route). There are more frequent buses to Tashtagol the town just in 17 km from Sheregesh. You can go to Tashtagol first, and then take a local bus form Tashtagol to Sheregesh or take a taxi for 200 R.

Zelenaya mountain. With the growing popularity of ski and snowboard in Russia the town itself has been transforming gradually. It is expanding with new cafes and hotels, catering for more and more tourists each year. The resort itself is developing rapidly with new lifts being built every season. Sheregesh is the only place in Russia where one can find a lot of snow as early as November, which is why it attracts many snowboarders from all over the country. The Russian snowboard team trains in this region as well.

FREERIDERS will find conditions more to your liking than the resort in terms of the run lengths or variety. Its not going to be too challenging for advanced boarders, however there is some good treeriding to be had.

FREESTYLERS are rare guests. Bring a shovel and find somewhere off the main pistes to build something as you won't find anything laid on by the resort

BEGINNERS. Most of the runs are not too steep and are suitable for those getting their snowboard legs, this is a good place for easy boarding and to work on technique. Unlike most of the Russian resorts the runs are maintained in a good condition.

OFF THE SLOPES. Sheregesh is a medium sized miners settlement, so it's not really a great party place, unless you're lucky enough to get together with some locals to experience a few-day long vodka marathon (which is sure to end badly). There's a number of snowboard competitions taking place at the mountain every year, during which there's a good chance to hang out with some snowboarders.

The nearest hotel to the mountain is "Gubernskaya" hotel. The rooms cost \$100 / night (for a double) over there. The other expensive option is "Elena" hotel for the same price. There are many small budget hotels where you can find a room for \$50 per night. Rooms are available even during the high season, so is not necessary to book ahead. Prices start at 600 R (\$23) per apartment (up to 6 persons). To find a place, go to Dzerjinskogo ulitsa (the central street of the Sheregesh settlement) and ask for available rent ("arenda kvartiry"). There are several cafes and restaurants which are located mostly in hotels. More cafes can be found at the bottom of the mountain. where you can have a meal for 200-400 R (\$6-\$12).

USQ www.worldsnowboardguide.com 501

VOLEN & STEPANOVA

Fine for beginners or to escape Moscow

Volen & Stepanovo are probably the best resorts in Moscow region and located about 60 km north from the city. Over the last few years four new ski & snowboard parks have opened in the area; Volen, Stepanovo, Sorochany and Yakhroma. Volen has two main ski areas: the Volen park itself and Stepanovo, which is Volen's small appendix about 5km away. Volen has guite short runs (the longest one is 450m) and is full of drag lifts, so the place is good for occasional riding if you are in Moscow, but is quite unexciting if you

are after some real snowboarding. Stepanovo (which is a 5km or a 10-minute ride by bus from Volen) is worth visiting because, at 1km, it has the longest run of all the slopes around Moscow. Even though it is marked as red, it is pretty easy and is completely empty on weekdays. There's quite a lot of snow during winter in Russia and snowmaking facilities ensure you can ride from December up to the beginning of April.

FREERIDING. Both Volen & Stepanovo are mostly manmade hills, so there's no possibility of long runs or off-piste

FREESTYLER. The Flammable Park is located in Volen, but it's kind of abandoned just a few bumps unless theres an event on. On busy days snowboarders usually gather with shovels and make hits for themselves on one of the slopes. You can also choose the areas between the runs to practice your skills, which is what most snowboarders end up doing there anyway.

BEGINNERS. If you are just starting to snowboard, Volen and Stepanovo might be a good place, as there is a good snowboard school and snowboard equipment hire (quite pricey, though), the instructors hold the Russian Ski & Snowboard Federation certificates and were trained by the French, but probably won't speak English. Most of the slopes are easy and on a weekday they are quite deserted, so you will feel more confident learning.

OFF THE SLOPES. There is one hotel and a few houses for rent. The accommodation is good, but expensive ranging from 2000R (\$70) to 3400 R (\$120) per night. You can usually just except if there's a holiday. Food. There is a Swiss, Italian, and Japanese restaurant, but at 650R for a meal it's quite expensive. Weekend brunch is 1400R. Pizzeria Trattoria has lower prices from 300-400R.

The bars are not really worth visiting, however, if you need a break or a beer, there are two of them on top of the hills, and there's a silly disco every night from 10pm.

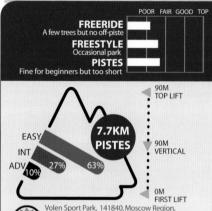

WINTER PERIOD: Dec to early April LIFT PASSES in Volen:

Yakhroma Town, Troitskaya St., #1

TEL: +7 (095) 961-00-50

EMAIL: melena@volen.ru

WEB:www.volen.ru

10 single lifts: 150R (Mon-Fri), 350R (Sat & Sun) in Stepanovo: 10 Lifts: 300R (Mon-Fri), 700R (Sat & Sun) BOARD SCHOOL

550-700R per hour inc lift pass, but English rarely spoken RENTAL Board & Boots 250/1300R per hour/day NIGHT BOARDING Yes till at least midnight

NUMBER OF PISTES/TRAILS: 18 LONGEST RUN: 1km

TOTAL LIFTS: 9 - 2 chairs, 7 drags LIFT TIMES: Volen:10 am - 1 am

Stepanovo: 10am - 12 am weekdays till 2am w/ends MOUNTAIN CAFES: 5

ANNUAL SNOWFALL: Unknown SNOWMAKING: 100% of slopes

CAR Take Dmitrovskoe Shosse and head north out of Moscow. Drive 46 km, 3 km after Dedenevo village turn left (there will be a sign and a huge billboard). After you cross the river, turn right to Volen through Yakhroma town. If you turn left after the river, you'll get to Stepanovo, but the road is a bit dodgy, so drive carefully.

Takes 1.5-2hrs. Print out this map before driving: http://www.volen.

FLY To Moscow (46km away), Riga (Latvia) or Tallin (Estonia), where you can take a train to Moscow for about \$50 US one way.

TRAIN go to Savelovsky station in Moscow (metro Savelovskaya, grey line, center) and take a train to Yakhroma. It takes about 1 hour 15 from where you can take a taxi (about \$3) or use a daily mini-shuttle that departs every Tuesday, Wednesday and Thursday at 10.45, 12.05, 15.10, 17.10 and 19.20

BUS every hour from 8am until 8pm departing from Altufievo metro station (grey line, North-West Moscow), which goes to Dmitrov. You need to get off before Dmitrov in Yakhroma town and take a taxi/ shuttle from there. About 2.5 hours total.

ROUND-UP

ABZAKOVO

Abzakovo is considered to be one of the best developed resorts in Ural mountains, which divide Europe and Asia. Even though the number of slopes is minimal comparing to European resorts and the total riding area is not that large, it might be very suitable for beginners and can be a nice and refreshing stop if you're riding along the Trans-Siberian railway (which passes 400 km away). The nearby Bannoe resort has another 15 km of piste riding area with 2.5 km runs and might be interesting for freestylers, who will find lots of tree-covered terrain there as well as a halfpipe. The local snowboarders (who come from Urals) consider Abzakovo the best mountain in their region, because it provides some freeride and freestyle opportunities, and the prices are relatively low. However, as there's not much snow, you will often see rocks sticking out, so you can freeride, but it will kill your board. Off the slope you will find lots of accommodation, restaurants, and entertainment, suitable for any budget. Because Abzakovo is visited by the Russian president Putin every year, it tends to get a lot of investment, making it stand out among other Russian resorts. However, this does not make it overexpensive, as you can still find accommodation for \$10 per night, and a meal won't cost you more than \$5.

FREERIDERS will find some off piste terrain here, but as there's not much snow, the rocks and stones that stick out can be annoying. Many people come back from Abzakovo with scratched boards, so be careful

FREESTYLERS will find some interesting areas in between the runs, but it's not really the place, unless you find some local snowboarders and build a few hits together. Most of the runs are very suitable for beginners and as they are not steep, this is a good place for easy boarding and to work on technique. Relatively long runs are usually well-maintained, except if there's too many people in which case it can get a bit hard. Watch out the drag lifts though, as some of them are really steep

OFF THE SLOPES. Abzakovo base is very close to the mountain and it costs about 300R (\$11) per night if you stay in a basic shared room, and 750 R (\$25) if you need a better quality private accommodation. There are also some cottages for rent and a hotel all quite close to the mountain. You might get a free room if you just show up, but it's better to contact the resort to book beforehand. There are also some hotels in town and a good choice of more comfortable accommodation in the nearby Bannoe resort, which is 25 km away. There are lots of cafes and restaurants at the bottom of the mountain and in town, where you can have a meal for about \$5-\$10. There are some clubs and bars, but the nightlife has a peculiar Russian way to it, which means a lot of vodka and funny music.

RIDE AREA: 18km LONGEST RUN: 2.8km

TOTAL RUNS: 13 75% easy, 23% intermediate NIGHT BOADING: till 11pm

WEB: www.abzakovo.ru EMAIL:info@abzakovo.ru

BANNOF

Bannoe is one of the newest resorts in the Russian Ural mountains, which divide Europe and Asia. Although it is not an especially exciting place to snowboard (the longest runs in the area are 2,5 km and there are only 3-4 runs at every resort), it is considered to be the most modern resort in the region and this year they are planning to open 3 more pistes, 2 of which will be 3km long with 450m drop, bringing the total ride area to 15 km. It has also one of the biggest vertical drops of all resorts at Urals. Even though the riding area is guite small, it will keep you occupied for a day or two, and you can always go to the nearby Abzakovo, which has more runs. However, the tree-lined runs in Bannoe are quite picturesque at times and you might be tempted to stay longer. Also, the resort was built not so long ago you can use its lift system to get to some nice areas, which were not yet turned into piste runs. Be careful though, as there's not much snow, there's lots of rocks and you might kill your board.

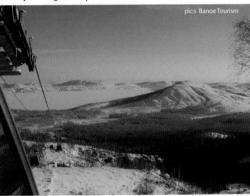

Bannoe is located on the shore of Yakty Kul lake in Bashkortostan republic of Russia, 40 km from Magnitogorsk, 25 km from Abzakovo resort. Like nearly all resorts in Urals, Bannoe was originally built by one of the steel producers of the area for its employees, but despite this fact it's not only for skiers: in 2004 they built a 60-meter long halfpipe for snowboarders. Russian snowboarders like the Urals, as it is not too far from the European part of the country and provides a good level of comfort. Bannoe resort claims the first gondola lift in Russia and has ambitious plans to expand. The apres-ski here is determined to compete with the Alpine resorts for the skiers' money, however, as it is just starting you won't find a lot of entertainment here yet. If you get bored, you can always go to the nearby Abzakovo resort which has livelier nightlife. The season normally starts at the end of November and with the help of snow machines continues until the end of April. However, the best riding is between January and March.

TOP: 940m BOTTOM: 490m RIDE AREA: 7km LONGEST RUN: 2.5km

TOTAL RUNS: 4 - 50% easy, 50% intermediate

TOTAL LIFTS: 2 - 1 gondola and 1 drag

HIRE: Board & Boots 1000R per day, 5800 for 7 days

LIFT PASSES: 1 day: 1000R 3 days: 2000R 7 days: 4000R

NIGHT-BOARDING: until 10pm CONTACT: Metallurg-Magnitogorsk Ski Center on Bannoe Lake

Russia, Magnitogorsk, 455002, Kirova St., #74

WSQ www.worldsnowboardguide.com 503

LOCATION: Fly to Magnitogorsk from Moscow in 2hrs (40km from Bannoe) or take a 24hr train for 200R. Local bus from Magnitogorsk towards Ufa (about 100 R (53) for this 1-hour journey). A taxi from the airport is about 900R (530).

KHIBINY

Kirovsk is a small town at Kola peninsula at the north of Russia (close to the border with Finland). The town is located in the region of Khibiny mountains, which look more like big hills rather than small mountains. The total riding area is tiny and can be explored in two days. Riders are mostly locals or from the nearby Murmansk city. Most of the tourists come to ride there during march-april when it is snowy and sunny. The station is overcrowded at weekends.

There's not much off-piste riding and most of possible routes are transformed into almost regular runs in several hours after the snowfall - too many riders for a small area. There is a ski-jump but boarders can't use the ski-jump as it's for the local ski-jump school only. Beginners will find lots of easy runs, but tricky drag lifts accessing them. Novice riders will need a partner to help them get at the top.

Local population is 35,000. Most of the people work at the local chemical plant. The city itself is clean and safe, but run-down. There are two clubs and several restaurants, but the nightlife is in its infancy here and is very boring. There are 4 hotels at the city. The closest to the mountain are "Kaskad" (\$50 for double) and "Khibiny" (\$20 for double). The best hotel is "Severnaya" (a double for \$70) but it is in 1.5 km from the lifts and you'll have to take taxi every-time. Most of the riders rent apartments from locals. The average price is \$10 per person. Landlords meet every train from Moscow or St.Peterburg & propose apartments right at the station.

KRASNAYA POLYANA

Krasnaya Polyana is the most sophisticated ski and snowboard resort in Russia. Sometimes called the "Russian Courchevel", this resort is famous for its well-maintained pistes, quality apres-ski, and overly high prices. The lifts are fast and convenient, the runs are in a very good condition, the local rescue team is considered to be the best in Russia, plus lots of comfortable mini hotels at the village and cozy apresski bars. Krasnaya Polyana is located just 45 km from Adler city (a famous summer destination in Russia on the shore of Black Sea) where there is a recently renovated airport and a train station making it the most accessible mountain resort in the European part of Russia. A flight from Moscow takes 2.5 hours, and a transfer to the ski station takes 1.5 hours more. Easy access makes hundreds of Moscow riders spend week-ends at Kransya Polyana during the season (middle of December - begging of March). The locals are very friendly and the resort is completely safe. The only disadvantages of the resort are its small size and mild climate (affected by the nearby sea), which means that there is a risk to find too little snow at the lower runs even in January. Always check the level of snowfall at the resort before going there (their website usually has the up-to-date information). The prices for the lifts are too high and the accommodation is more expensive than at other Russian resorts (although cheaper than in Europe). However, if you

want to ride in the Russian mountains and have the western standard of service, that's the best place to go. Besides, there are plans of massive expansion, so who knows, maybe in a few years this place will be one of the greatest destinations.

Freeriders can explore snow fields along higher runs or ride through the forest along lower runs. Remote snow fileds can be accessed by a helicopter. No snowboard park and no halfpipe. Freestylers usually come in groups of 8-10 and build all the facilities by themselves. Runs are very good for beginners - wide, snowy and not steep. The best resort in Russia if you're just starting.

Krasnaya Polyana is a small village. Dozens of B&B, chalets and several large hotels can be found around there. There is no specific entertainment center in the village, so the riders spend their apres ski in the nearest bars and cafes. "Munhgausen" is the most famous bar located just near the bottom lift. A meal at local cafes and restaurants costs about 150-400 R. The largest and the most expensive hotel is Radisson SAS Peak hotel where you can always find a room for \$200. Medium priced mini-hotels, such as "Tri Vershiny" and "Rodnik" will cost around \$30-\$50 per night per person including breakfast. For budget travellers renting a room or apartment at a private house is the best option (around \$15 per night).

TOP: 2228m BOTTOM: 540m TOTAL LIFTS: 4 chairs

RIDE AREA: 25km LONGEST RUN: 13km

TOTAL RUNS: 5 - 55% easy, 40% intermediate , 5% advanced HIRE: Board & Boots 500R per day LESSONS: 1000R for 2hrs

LIFT PASSES: 1 day:650R 3 days: 2000R 7 days: 4500R WEB:www.kraspol.ru EMAIL:admin@kraspol.ru

LOCATION: Fly to Adler from Moscow in 2 1/2hrs (45km from resort) or take a 24-50hr train for 1900R. Regular buses from Adler to resort. Alternatively a taxi ride will cost about \$20-\$30.

KRYLATSKOYE

Krylatskoye used to be the only OK Moscow's local resort, but not any more. Even though it's only 30 m from the center of the city, the trip is not worth it, because the resort is too small, crowded, and the lifts are ancient. The slopes are short (200-250 m) and often icy. There are also some small natural drop offs and a few hits available. The only reason to go there is to see the place where freestyle snowboarding started in Moscow and every year there is Nescafe "Pure Energy" festival (in February) where you can witness Russian freestylers in action.

SPARROW HILLS

Sparrow Hills is situated in the south-west of Moscow just next to the Moscow State University. There are three simple slopes, about 200 metres in length, which form a backdrop to the very impressive ski jumps located here. Two lifts serve the runs. The resort is located just next to the impressive Vorobyevy Gory ("Sparrow Hills") metro station and the observation deck where you can get a great view of Moscow on a sunny day.

504 WSG WWW.WORLDSNOWBOARDGUIDE.COM

The Alps resort is up near the DMZ (De Militarized Zone) about 5 hours drive NE of Seoul; so close you can almost see North Korea from the summit. The surrounding army bases and numerous military checkpoints give the area a frontier feel. In this remote location not far from Seorak San (S.Korea's version of the Matterhorn), and only 20 minutes from the East Sea (Sea of Japan), Alps Resort claims to receive the largest natural snowfall in South Korea, a whopping yearly average of 200cm. It's a small resort even by Korean standards. Eight pistes cut through trees accessed by 5 of the world's slowest lifts. Four of which don't open any new terrain that can't be

reached by taking the Champion chair to the

summit. FREERIDING. Don't come here for the freeriding. With more snow than anywhere else in Korea there is the potential for some fun runs down the gullies at Alps but the trees are not well spaced. These runs are usually fenced off and guarded by the resorts army

trees and powder so if you do take off into these thickly forested gullies they are unlikely to pursue you. Should you be apprehended, speaking quickly in English

Photo: Angus Baillie

of ski patrollers who seem to make it their

mission to eliminate fun. That said, the ski patrol is inexperienced when it comes to

> is usually enough to deter any further reprimand.

> > FREESTYLE.

Natural hits are

fairly limited

across

the resort

but the

Champion B run to the skiers right at the summit has some fun little hips before it leads down into the board park. This is known as the "Board Play Zone" and is also serviced by the Alps chair. It contains a variety of small boxes and rails and two poorly maintained table tops. Helmets must be worn.

PISTES. All of Korea's resorts are immaculately groomed. At Alps speed freaks can cut some nice turns down the steep Paradise and Champion A runs. Even though this resort is extremely small, on weekdays you'll be one of only 5 or 10 people on the mountain and should be able to carve the corduroy for most of the day.

BEGINNERS. If rookies avoid the Paradise and Champion lifts there isn't much on this mountain that can't be mastered in a day. There is a snowboard school but don't expect to find an English speaking instructor.

OFF THE SLOPES. The resort hotel is a rip off. Many rooms don't have a bed so you must sleep in the Korean style - wrapped in a blanket on the floor. A much better option if you have a car or don't mind bussing it to the slopes each day is to stay at the **Hwangtae village** ten minutes down the road. These rooms cost only 40 000 won per night and you can cram as many people in as you like. They're in a really cool setting and there is some OK hiking from your door.

Food wise, don't buy a hamburger anywhere in Korea. But try one of the numerous Dak Galbi restaurants near the resort. It's a delicious chicken stew sort of thing that you eat from the BBQ as it's being cooked in front of you.

There is a ment cranks

small nightclub in the baseof the resort hotel which out some bad Korean Techno. It's good for a laugh on weekends but don't bother during the week.

EA

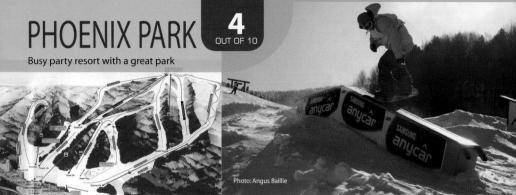

Dominating a pleasant valley in the **Balwang Mountains**, three and a half hours East of Seoul, **Pheonix Park** is one of Korea's more popular resorts. Several big high rise hotels provide a constant supply of people for the numerous nightclubs and for the mountains not so plentiful lifts. There are eight and if you want to ride here on the weekend then you'd better be prepared to spend a lot of time in their enormous queues.

A fast gondola hauls people to the summit, deceptively named Mont Blanc and from here one can survey the resorts 8 or 9 pistes. These are cut through trees and all but the Champion course yield very little to challenge even a novice snowboarder. However what this place lacks in freeriding terrain it makes up for with superb freestyle facilities and a pumping nightlife.

FREERIDING. Don't be deceived by this mountain's name. At only 1,050 metres high it is no Mont Blanc. Its trees are too thick and the natural snow in this area too limited to allow for much free riding.

FREESTYLE. Pheonix Park was one of the first resorts in Korea to target snowboarders and now maintains a nice Super Pipe and a pretty decent terrain park. Both can be reached using the **Hawk lift** at the top of which you'll find a good array of rails and booters leading down to a few really solid table tops and one of the best half pipes in the country. Even when the rest of the resort is overflowing with people the park is pretty uncrowded aside from a few trendy Korean guys and girls displaying the latest gear. Let it be known that even though snowboarding and the time needed to go snowboarding are to relatively new things for Korea's youth, they have attacked it with gusto. Spend a moment as a spectator in the terrain park and you'll see some innovative, technical manoeuvres thrown down by the locals.

BEGINNERS. The main worry for beginners will be dodging the thousands of other beginners hurtling out of control over each others skis and boards and into spine crushing collisions with other people, trees, rocks and fences. Aside from that and the slightly steep Paradise Course the mountain should be fairly manageable. A snowboard school is available and though English speaking instructors can be found, I suspect that their instruction might do more harm than good for your snowboarding. It is interesting to note that in Korea snowboarders are expected to remove their boards before catching a

chairlift eliminating the difficult task for beginners skating your board on and off of lifts.

OFF THE SLOPES the clubs, or "discotheques" as the locals call them, can be found in the basements of the numerous hotels that dominate the resort's landscape. They all have a dance floor and hundreds of tables. Traditionally in Korea you can't order a drink without a side dish so this means you have to be seated to drink. It's a weird set up but don't stress - snowboarding in Korea is about being seen and where better than on the dance floor. Korean people hit the soju (pumpkin/bamboo wine) early and party till late. Oh, and beware, the dominant tunes in these clubs are bad Korean remakes of bad American pop songs that they'll crank at maximum volume

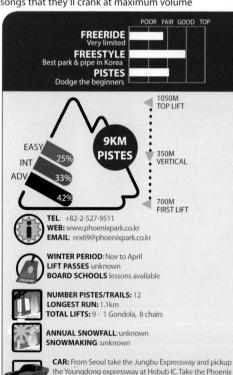

Park turn-off at Myunon IC

BUS: Shuttles available from Seoul (Glass Tower) to resort leaving at 9am everyday and twice at weekends and costs 24,000 return

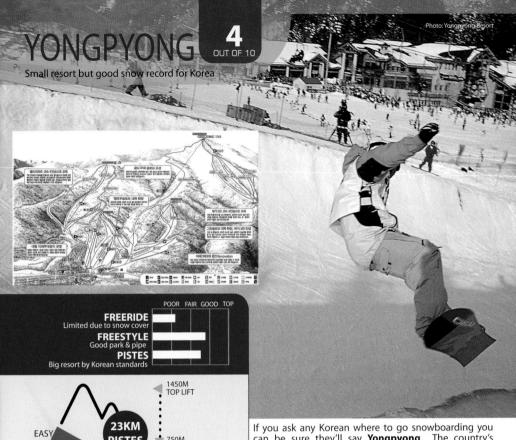

750M VERTICAL 700M FIRST LIFT 232-950 Gangwon-do, Pyungchang-gun,

Doam-myeon, Yongsan-ri 130 TEL: 82-33-335-5757

WEB: www.yongpyong.co.kr EMAIL: klaatu@yongpyong.co.kr

WINTER PERIOD: Nov to April LIFT PASSES

1/2 Day Pass 45,000, Day Pass 56,000

NIGHT BOARDING

Night Pass 32.000 and you can board until 4am RENTAL

Board & Boots 25,000 per day

TOTAL NUMBER PISTES/TRAILS: 31

LONGEST RUN: 5.6km

TOTAL LIFTS: 14 - 1 Gondola, 13 Chairlifts LIFT CAPACITY: 25,000 people per hour LIFT TIMES: 8.30am to 4am

ANNUAL SNOWFALL: 2.5m SNOWMAKING: unknown

FLY: Fly to Kangneung or Yang Yang International airports which are the closest, or fly into Seoul.

CAR: 200km (2hrs) from Seoul.

BUS: Daewon Express Bus run daily from Seoul leave at 9am from Lotte Mart, Gate#4 of Jamsil Station and cost 26,000 return. Tel: +82-2-575-7710 to reserve a seat

can be sure they'll say Yongpyong. The country's oldest and most popular ski resort is located at the end of a three hour traffic jam near the East Coast city of Gangnung. Another resort of the Balwang Mountains in which Phoenix Park is also located, Yongpyong has twelve fast lifts and a classy base lodge. It has been the ace in the hand of several unsuccessful bids by Korea to host the Winter Olympics and by far the coolest place to say you went skiing on the weekend. Even if all that means these days is that you queued for hours and spent a few minutes bouncing from one collision with an out-of-control skier to the next. But that's on weekends. During the week this place is practically empty and does a good impression of a European resort.

FREERIDING. Like all of Korea's resorts the tree riding is limited by lack of snow.

FREESTYLE. Looking cool is the most important thing in Korea and where better to do this than in the terrain park. So naturally Korea's coolest ski resort has the biggest terrain park. An assortment of rails and booters should keep you styling in very clear view of the Gondola. It's classic the hoots and cheers you'll get for the simplest of manoeuvres.

OFF THE SLOPES there's a large number of expensive Hotels complete with fancy restaurants, bars, Karaoke & nightclubs. If your budget doesn't cover this then the hostel has Ondol rooms for 70,000 (you kip on the heated floor) or bunks from 176,000 per night.

ROUND-UP

ARMENIA

TSAKHKADZOR

is situated in the Kotayk region, 50km north of Yerevan, was once a soviet Olympic training ground. Lately a lot of investment has been pumped into the resort and there has been talk of Russian gangster money along with Austrian cash buying new lifts and snow cats. Construction of a new hotel is well under way. Tsakhadzor translates to Valley of Flowers, so why not take your Mum? www.winterarmenia.com

GEORGIA

Home to the fantastic Caucasian Mountains which stretch over the border into Russia. They are better known for climbing and hiking so there are few winter resorts here. All of them are basic and could do with a lot of investment. Georgia had a peaceful revolution in 2003 with the ex-Communist leader running back to his mates in Russia. Foreign investments isn't forthcoming, but with all that dodgy money floating around in Russia, you just don't know what will happen here over the next few years. If you use public transport keep an eye on your bags, as people here are skint and petty crime is a particular problem in the capital Tbilisi.

BAKURIANI

is located in the Minor Caucasian Mountains, about 90 minutes from Tbilisi in the south east of Georgia. It has 2 lifts and a few runs which wind their way through the trees. The highest point is 1800m and the season starts in November, which is early compared to Western Europe. Accommodation is available in local guest houses or a run down 3 star hotel.

GUDAURI RESORT

is at 2000m with 2 chairs taking you up over a thousand metres to 3010m. From the top you have the option of 16km of pistes or a hike to some back country terrain. The resort is good for beginners and intermediates but advanced riders will get bored quickly. The lowest chair starts behind the Sport Hotel allowing you to Board to the door. Gudauri is 120km north of Tbilisi which is 1 ½ hours drive. Heliboarding is also available.

KAZAKHSTAN

Kazkhstan is a former part of the Soviet Union that's known for its vast flat steeps and home of the soviet space program. In its far south-east corner lies part of the Tien Shan mountain range known as the celestial mountains, an absolute gem of a place. Its best known peak is Khan Tengri (7010 metres) which is supposedly the World's most beautiful mountain and a Mecca to many a climber. The place has still got all the hang ups of the old Soviet Union with a big police presence, road blocks to look for capitalist spies from the west and a need to carry your passport everywhere you go. If you travel independently you will get hauled off the bus at every check point, by police with bigger hats than a New Orleans pimp. For the best boarding you will need a helicopter (see our heliboarding section).

ALMA-ATA

pronounced Almarty is the Capital. Its a mix of Russian and Kazakh people which has been described as a huge knocking shop no ones heard of. Its a great place to drink vodka and check out the locals, and also a good base for the only real resort Chimbulak, which is home to the soviet ski team and the highest and largest ice rink in the world.

CHIMBULAK

An hour's drive from Alma-Ata at 2200 metres is the village of Chimbulak which has hotels, board hire, bowling and vodka fuelled Russians. It's a good little resort to get your legs ready for that helicopter you're going to get. Other than a few rope drags there are 3 chairs that can handle up to 900 people/hr, taking you from 2200 m to 3160 m. The resort is sheltered by imposing peaks on it's flanks, which helps with the temperature. There are also some trees to head for if the visibility is bad. The fun park has some hits and a few slides and is open from 10 till 5. You can sort out transport to the resort with one of the many agents in Alma-Ata. To save cash take a Lada taxi but make sure you've sorted out the return price before you leave town or once you're up there it'll cost the price of a new Lada to get back.

KYRGSZSTAN

Kyrgyzstan is a place for boarders who like a hike or have loads of cash for a helicopter. The neighbour of Kazakhstan, Kyrgyzstan is a lot more laid back and cheaper. You won't get stopped by the police but you might get taxed by a local if you walk through one of the parks alone at night. Mind you, it kicked off big time in the summer of 2005. Bishkek, the Capital, saw riots with government buildings stormed and shops looted. It eventually calmed down when the President did a runner and a new parliament was formed. Elections are planned for Nov 05 so it might happen again then.

Bishkek has wide tree lined streets which are surrounded by huge snow covered peaks. 80% of this country is mountainous and most of the other 20% is lakes. During Soviet rule most of Kyrgyzstan was out of bounds to foreigners due to missile testing in Lake Issyk Kul and near its border with China. Home to felt hats, goat head polo and wrestling on horse back while covered in goose fat, the Kyrgyz are a hospitable lot. The main drink in the countryside is fermented mare's milk, which tastes like sour yogurt and turns the local men into giggling kids. The food is mostly meat based with horse a favourite. In the countryside you see herds of horses waiting for the pot. Since the break up of the Soviet Union, the Kyrgz have embraced independence, setting up their own currency and welcoming investment from the west. Unfortunately lorry loads of plastic junk and rip off clothes from China have also arrived.

Heliboarding here is basically the same as in Kazakhstan but a little cheaper. You may even find that you'll stay in Karkara camp and use the same helicopter as you would if you booked it in Kazakhstan. The main advantage along with cost is if you start your trip in Kyrgyzstan you will only need a Kyrgyz ha (See heliboarding section).

ALA-ARCHA

A 30 km Lada drive from Bishkek leads to the Ala-Archa National Park, which is a steep sided treed valley with a small resort at its top. The accommodation is a modern A frame hotel located a few km after the park gate. Last spring the road in was taken out by a huge land slide but they've been working really hard to rebuild it and a temporary route has been set up. The valley is lined with 5000 metre plus peaks and cascading glaciers. There are 4 lifts drag lifts starting at 3400 metres going up to 4000 metres and 4 runs, but basically you can go anywhere you want. The whole resort is on the Ala-Archinsky glacier so watch out for crevasses. The best thing to do is leave the lifts alone and get your board on your back to get some really fresh lines. There are loads of slopes to choose from with hat fulls of snow but there is no reliable mountain rescue so you're on your own.

NEPAL

In 2003 permission was granted to the Himalayan Heli Ski Guides (HHMG) to become the first company to operate Heli Skiing in Nepal. It's now possible to board in the Annapurna region and there are plans to open up the Everest area to trips. More info can be found on www.heliskinepal.com

PAKISTAN

MALAM JABBA

is the only real resort in Pakistan. It's 314km from Islamabad with the closest airport being Saidu Sharif 51km away. The resort is in the Swat Valley, at a height of 2896m. It's not the biggest resort in the world, with 2 chairs and a 200m vertical, but it does get a respectable 5m of snow a season, and has fantastic views of the mighty Hindu Kush, the Karakuram and Black Mountains ranges. The resort was built with the assistance of Austrian government and holds events for local ski clubs including the army. The place went up for sale in 2002 but has not yet been sold. The government hopes the resort will help the surrounding Swat Valley known as "The Cradle of Buddhism" to develop and generate some foreign cash, as long as the cease fire with India holds.

TAIWAN

The Taiwanese invented grass skiing so lets leave them to it. They also produce Hi-Tec boarding wear, goggles etc.

INDEX

49 Degrees North	427	Boi Taull	233	El Colorado	443
Abzakovo	503				
		Boreal	363	El Formigal	233
Adelboden	242	Bormio	185	Engelberg	250
Ala-archa	509	Borovets	275	Fairmont Springs	328
Alagna Valsesia	206	Braehead	121	Falls Creek	451
Allenheads	119	Braunwald	268	Fagra Club	475
Alma-ata	508	Breckenridge	367		475
				Faraya Mzaar	
Alpbach	80	Brecon Beacons	119	Feldberg	173
Alpe D'huez	130	Bretton Woods	397	Fellhorn	177
Alpe Du Grand Serre	168	Bridger Bowl	395	Fernie	312
Alpine Meadows	344	Brighton	406	Fieberbrunn	84
Alto Campoo	233	Broken River	469	Filefjell Skiheiser	218
Alyeska	341	Bromont	334	Flaine	139
Andalo	183	Bukovel	295	Folgarida	192
Andermatt	243	Butorowy Wierch	285	Foppolo	193
Antillanca	443	Bydalen	238	Fukui Izumi	493
Antuco	443	Cairngorm	223	Funasdalen	238
Anzere	244				
		Camp Fortune	334	Furano	491
Apex Mtn	308	Canazei	186	Gala Yuzawa	493
Arai Mountain	492	Cardrona	454	Galtür	85
Åre	236	Castleford	121	Garmisch	174
Arinsal	76	Castle Mtn	300	Gausdal	218
Arosa	245	Catedral Alta Patagonia	437	Gaustablikk	218
	440	Cerler			
Arpa			233	Geilo	210
Asahidake Onsen	491	Cerro Bayo	437	Glencoe	225
Astun	233	Cerro Castor	438	Glenshee	226
Auffach / Wildschonau Valley	116	Cervinia	187	Gol	218
Auli	485	Chacaltaya	444	Gourette	168
Auron	168	Chamonix	133	Grandvalira	72
Avoiriaz					
	131	Champery	268	Grand Targhee	429
Axamer Lizum	81	Champoussin	269	Gray Rocks	334
Badaling Resort	482	Chang Chun Lian Hua Shan	483	Gressoney	206
Bad Gastein	82	Chapelco	434	Grindelwald	251
Bad Hofgastein	116	Charlotte Pass	451	Grong	218
Bad Mittendorf	116	Chateau D'oex	269		314
				Grouse Mtn	
Bai Qing Zai Ski Area	482	Chatel	136	Gstaad	252
Bakuriani	508	Chimbulak	508	Gubalowka	285
Balderschwang	177	Chsea	479	Gudauri Resort	508
Banff	302	Claviere	188	Gulmarg	485
Bankso	274	Club Tobo	334	Hachimantai	493
Bannoe	503	Copper Mountain	369		
				Hafjell/lillehammer	218
Baqueria Beret	229	Corno Alle Scale	206	Hakuba 47	493
Bardonecchia	184	Coronet Peak	455	Hanmer Springs	469
Bareges	168	Cortina	189	Harper Mountain	328
Bear Mountain	346	Cotes 40-80	334	Harrachov	278
Beatenberg	268	Courcheval	137	Heavenly	349
Beaver Creek	365	Courmayeur	190		
				Hemavan	238
Beijing Lian Hua Shan	482	Craigieburn	470	Hemlock Valley	328
Beijing Qiaobo Ice & Sno World		Crans Montana	246	Hemsedal	211
Beijing Shijnglong	483	Crested Butte	371	Herlikovice & Bubakov	278
Bei Da Hu Skiresort	482	Crystal Mtn	424	Himos	123
Belle Neige	334	Cudworth Ski Area	335	Hintertux	86
Bettmeralp	268	Cypress Mtn			
			311	Hlidarfjall	180
Bialka	283	Davos	248	Homewood	363
Big Mtn	392	Diamond Peak	347	Hopfagarten	87
Big Sky	394	Dizin	474	Hoven	218
Big White	309	Dodge Ridge	348	Hovfjallett	238
Bielasnica	294	Dombai	498	Idre Fjall	238
Bjorkliden	238	Donovaly			
			289	Igls	88
Bjornrike	238	Dragobrat	295	lmst	116
Blackstrap	335	Durango	373	Ingman	294
Blafjoll	180	Edelweiss Valley	334	Innsbruck	88
Bluewood	427	Elbrus & Cheget	499	Invincible Snowfields	470
Blue Mountain	335	Ellmau/scheffu	83	Ischql	90
S CONTRACTOR OF STREET			00	ischigi	30

INDEX

Iso-syote	127	Les Arcs	145	Nanshan Resort	483
Isola 2000	140	Les Deux Alps	147	Narkanda	485
Jackson Hole	430	Les Diablerets	270	Narvik	213
Jade Dragon Mountain Resort		Les Gets	169	Nendaz	257
483		Levi	127	Neustift	116
Janske Lazne	278	Leysin	255	Nevis	224
Jasna	287	Le Massif	330	Niederau	117
Jay Peak	414	Limone	196	Niseko	489
Jebel Toubkal	476	Little Red River Park	335	Niseko Kokusai Moiwa	492
Joetsu Kokusai	493	Livigno	197	North Star	363 285
John Nike/bracknell	121	Lliama	443 398	Nosal Nozawa Onsen	494
June Mountain	351	Loon Valley	375	Oberammergau	177
Kaimaktsalan	179 179	Lovelands Madonna Di Campiglio	198	Oberau	. 117
Kalavrita Ski Center Kamchatka	500	Malam Jabba	509	Obereggen	206
Kanat Bakiche	475	Malbun	271	Obergurgl	99
Kandatsu Kohgen	493	Mammoth	354	Oberstaufen	178
Kaprun	92	Manaii	485	Obertauern	100
Kasprowy Wierch	285	Manza Onsen	493	Oetz	117
Kaunertal	93	Marmot Basin	303	Ohau	460
Kaustinen	127	Mayrhofen	97	Okemo	418
Kerlingarfjoll	180	Meiringen-hasliberg	270	Olos	127
Keystone	374	Meran 2000	206	Oppdal	214
Khibiny	504	Meribel	149	Ordino/arcalis	75
Kicking Horse	315	Merida	444	Oukaimeden	476
Killington	415	Meri - Teijo	127	Ounasvaara	127
Kimberley	316	Metabief	170	Oze Tokura	494
Kirkwood	352	Metabief	177	Pal	76 276
Kitzbühel	94	Michlifen	476	Pamporovo	318
Klosters	269	Milton Keynes	121 280	Panorama Park City	407
Kobla	293 127	Milzkalns Mission Ridge Ski Area	335	Parnassos Ski Center	179
Kolin Hiihtokeskus	295	Mittenwald	177	Pasquia Ski Slope	335
Kopaonik Kraniska Gora	291	Montchavin	170	Passo Tonale	199
Kranjska Gora Krasnaya Polyana	504	Monte St.anne	331	Pasto-ruri/huascaran	444
Krylatskoye	504	Montgenevre	151	Pas De La Casa	74
Kufri	485	Morgins	270	Perisher Blue	449
Kuhtai	95	Morzine	152	Perito Moreno	438
Kungsber-get	239	Mountain High	357	Phoenix Park	506
Kuzuryu	493	Mount Baw Baw	451	Piancavallo	207
Kvitfeĺl	218	Mount Buffalo	451	Pila	200
Laax/flims	253	Mount Cheeseman	470	Pinzolo	207
Lake District Ski Club	119	Mount Selwyn	451	Pitztal	101
Lake Louise	301	Mount Seymour Resort	328	Pohorje And Areh	293 294
Lakis	127	Mt.baker	425	Poiana Brasov Polana Szymoszkowa	285
Laqlouq Village	475	Mt.batchelor	401 447	Porter Heights	462
Las Lenas	435 353	Mt.buller Mt.dobson	457	Portillo	443
Las Vegas	141	Mt.hood	403	Powder King	328
La Clusaz La Foux D'allos	168	Mt.hotham	448	Powder Mtn	408
La Grave	142	Mt.hutt	458	Prato Nevosa	201
La Hoya	438	Mt.lyford	459	Pra Loup	170
La Joue Du Loup	168	Mt.norquay	305	Primeros Pinos	438
La Molina	230	Mt.olympus	461	Pucon	441
La Norma	169	Mt.potts	463	Pukkivuori	127
La Parva	443	Mt.rose	363	Pyha	127
La Plagne	143	Mt.snow-haystack	417	Ramkalni	280
La Rosiere	169	Mt.washington	323	Rangger Köpfl	89
La Tania	144	Muikamachi Hakkai-san	493	Red	319
La Thuile	194	Mundali And Munsiyari	485	Reina Trase	280
Lech/zürs	96	Mutters	89	Riksgransen	237
Lecht	226	Myllymaki	127	Risoul/vars	153 202
Lenzerheide	269	Myoko Kohgen	493 493	Roccarasso Rogla	293
Les Angles	169	Naeba	433	nogia	200

MUE	A				
Rohtang	485	St.moritz	261	Velka Raca	289
Rougemont	270	St.wolfgang	117	Verbier	262
Ruka	124	Stari Vrh	293	Villard De Lans	170
Saalbach/hinterglemm	102	Stary Smokovec	289	Villars	264
Saas-fee	258	Steamboat	377	Vitosha	277
Sainte Foy	155	Stoneham	332	Vogel	292
Saint Lary	156	Storlien	239	Volen & Stepanova	502
Salen	239	Stowe	421	Voss	219
Salla	127	Stranda	218	Wagrain	118
Samoens	170	Stratford Mountain Club	469	Waldring	118
Santa Caterina	207	Stratton	419	Wanlong Ski Resort	484
San Sicario	203	Stryn	215	Wapiti Valley	336
Sappee	127	Stubai Glacier	112	Waterville Valley	399
Sapporo Kokusai	492	Sturgis Assiniboine	336	Wengen	265
Sauze D'oulx	204	Sugarbush	422	Westendorf	113
Savognin	260	Sugarloaf	388	Whakapapa	468
Schladming	104	Sugar Bowl	362	Whistler/blackcomb	324
Schlick 2000	89	Sulden	207	Whitewater	327
Schliersee	176	Summit At Snoqualmie	427	White Track	336
Schruns	117	Sunday River	389	Willingen	178
Schweitzer Mtn	384	Sunshine Village	306	Windischgarsten	118
Seefeld	105	Sun Peaks	322	Winterberg	178
Seki Onsen	494	Sun Valley	386	Winter Park	382
Seli & Tria-pente Pigadia	179	Swinhope	119	Yabuli International	484
Sella Neva	207	Szczawnik	295	Yad Moss	121
Serfaus	117	Table Mountain Park	336	Yllas	127
Serre Chevalier	158	Tahko	126	Yongpyong	507
Sestriere	207	Tamworth	121	Yunfo Mount Resort	484
Sheffield Ski Village	121	Tanigawadake Tenjindaira	492	Zaarour	475
Shemshak	474	Tatranska Lomnica	288	Zagarkalns	280
Sheregesh	501	Telluride	379	Zakopane	284
Shiga Kohgen	494	Termas De Chillan	442	Zams	118
Shiramine	494	The Alps Resort	505	Zao	494
Sierra At Tahoe	359	The Canyons	412	Zell Am See	114
Sierra De Estrela	220	The Cedars	475	Zell Im Zillertal	115
Sierra Nevada	231	The Remarkables	464	Zermatt	266
Silver Mtn	385	The Snowpark	121		
Silver Star	321	Thierbach	118		
Sjusjoen	218	Thredbo	450		
Skálafell	180	Tiffindell	479		
Ski-jam	490	Tignes	160		
Skibaan Casablanca 365	271	Trebevic	294		
Skipark Ružomberok	289	Treble Cone	466		
Ski Timber Ridge Slavsko	335	Tremblant	333		
Sljeme Mountain	295 294	Tromso	218		
Snowbird	410	Trysil	216		
Snowmass	376	Tsakhkadzor Turoa	508		
Snowpark	465		467		
Snowplanet	271	Twin Towers Ski Area Tysovets	336		
Snowworld	271	Uludag	295 477		
Snow Basin	409	Vail	380		
Snow Valley	271	Valdelen	438		
Sölden	106	Valdez	339		
Solden	72	Valdras	040		

339 218

75

280

165

163

207

205

207

166

219

Soldeu

Söll

Solitude

St.anton

St.gervais

St.johann

Sparrow Hills

Spicak Spindleruv Mlyn Squaw Valley

73

411

108

504

278

278

360

109

157

111

Valdres

Vall Nord

Valmiera

Valmorel

Val D'isire

Val Di Sole

Val Gardena

Val Senales

Val Thorens

Vassfjellet